THE THYSSEN-BORNEMISZA COLLECTION

Twentieth-century Russian and East European painting

THE THYSSEN-BORNEMISZA COLLECTION

Twentieth-century Russian and East European painting

John E. Bowlt and Nicoletta Misler

GENERAL EDITOR IRENE MARTIN

Zwemmer

© The Thyssen-Bornemisza Collection 1993
First published 1993 by Zwemmer
an imprint of Philip Wilson Publishers Ltd
26 Litchfield Street, London WC2H 9NJ

Distributed in the USA and Canada by Rizzoli International Publications, Inc
300 Park Avenue South, New York, NY 10010

ISBN 0 302 00619 2
LC 92-063275

Designed by Gillian Greenwood
Photography of the Thyssen Collection by Giuseppe Pennisi
Typeset in Photina by Southern Positives and Negatives (SPAN), Lingfield, Surrey
Printed and bound by Snoeck, Ducaju & Zoon, NV, Ghent, Belgium

Contents

Acknowledgements

Preparing this catalogue raisonné has been a challenging, exciting and complex procedure, and it has involved the co-operation of many people in many countries. Investigation into the Russian and Hungarian avant-gardes is an intriguing occupation, but one fraught with danger, and the questions of attribution, dating, provenance and condition discussed elsewhere in this volume have been a constant subject of discussion and commentary. Unfortunately, space does not permit us to name all those individuals who, with their various talents, helped us to resolve some of these questions as we prepared the manuscript. In any case, primary appreciation must go to Baron and Baroness H.H. Thyssen-Bornemisza for, without their magnanimity, this collection and, therefore, its catalogue would not exist. We are also very grateful to Irene Martin, Curator and Administrative Director of the Thyssen-Bornemisza Collection. From the inception of this project, Irene Martin has offered practical counsel, while manifesting an unfailing sense of measure and an unrelenting sense of humour. We are also very grateful to her staff at the Villa La Favorita who manifested kindness and patience in attending to our many queries and requests.

Our research was conducted in museums and libraries worldwide and we are especially grateful to the directors and staff of the following institutions: the Bakhrushin State Central Theatre Museum, Moscow; the Institute of Modern Russian Culture, Los Angeles; the J. Paul Getty Center for the History of Art and the Humanities, Los Angeles; the Los Angeles County Museum of Art; the Museum Ludwig, Cologne; the Museum of Modern Art, New York; the Muzeum Sztuki, Lodz; the Nesterov Museum of Visual Arts, Ufa; the Pushkin Museum of Fine Arts, Moscow; the Russian State Archive of Literature and Art, Moscow; the Russian State Library, Moscow; the Samara Art Museum, Samara; the Shchusev Museum, Moscow; the State Art Museum of Latvia, Riga; the State Museum of the Arts of Georgia, Tbilisi; the State Museum of Theatrical and Musical Art, St Petersburg; the State Russian Museum, St Petersburg; the State Tretiakov Gallery, Moscow; the University of California, Los Angeles; and the University of Southern California, Los Angeles.

During our researches, we consulted with many individuals over questions of provenance, dating and comparison, and we should like to acknowledge our appreciation to the following in particular: Nina Andronikashvili-Kakabadze, Natalia Avtonomova, Elena Basner, Herman Berninger, Alexander Borovsky, Boris Brodsky, Jean Chauvelin, Andrew Crispo, Marinella D'Alessandro, Charlotte Douglas, Andrei Drevin, Ekaterina Drevina, Valerii Dudakov, Irina Dzutsova, Rosa Esman, Ella Freidus, Krystyna Gmurzynska-Bscher, Nina Gurianova, Ingrid Hutton, Annely Juda, Dora Kogan, Mark Konecny, Vladimir Kostin, Christa Kotrouzinis, Paul Kovesdy, Evgenii Kovtun, Eduard Kulagin, Alexander Lavrentiev, Ada Lebedeva, Irina Lebedeva, Nina and Nikita D. Lobanov-Rostovsky, Myroslava Mudrak, Martin Müller, Larisa Oginskaia, Alexander Parnis, Evgeniia Petrova, Gleb Pospelov, Alla Povelikhina, Vasilii Rakitin, Alla and Yurii Rusakov, Andrei de Saint-Rat, Dmitrii Sarabianov, Elena Sedova, Alexandra Shatskikh, Bella Solovieva, Alena Spitsyna, Serge-Aljosja Stommels, Nina Suetina, Kirk Varnedoe, Milda Vikturina, Liudmila Vostretsova and Thomas Whitney.

Our special thanks go to Emil Bosshard, Head of Conservation at the Thyssen-Bornemisza

Collection, for his invaluable advice on questions of condition, technical examination and restoration, to Aneta Zebala for her fine photography and to Thea Durfee and Alexandra Ilf for their ready assistance in locating ancillary materials and in assuming responsibility for the substantial correspondence with public and private collectors. We would also like to extend our gratitude and appreciation to our editors, Sarah Bland, Celia Jones and Joan A. Speers, for, without their patience, care and steady assistance, this book would not have reached its publishable state.

John E. Bowlt and Nicoletta Misler

Foreword

The catalogue of the twentieth-century Russian and East European paintings in the Thyssen-Bornemisza Collection is written by two of the most eminent scholars in the field, John Bowlt and Nicoletta Misler. Their three introductory essays put the works in context and are accompanied by a glossary of terms and acronyms for easy reference. The authors have taken great care to give an honest evaluation of the attributions and to place the works in the general history of Russian and East European art.

Drs Bowlt and Misler have sought to give full curatorial data on the paintings and to illustrate the various movements of the early twentieth century in Russia and Eastern Europe: Neo-Primitivism, Cubo-Futurism, Suprematism and Constructivism. The Thyssen Collection includes most of the major and some lesser known names of these movements and thus gives an overall view of the experimental investigation of the arts in Russia earlier this century.

Baron Thyssen-Bornemisza began collecting these works in 1973 with the purchase of *Still-life* by Alexandra Exter [13] and over the last twenty years the collection has grown to include over sixty items, the most recent purchases being *Proun 1c* by El Lissitzky [36] in 1988 and *Miracle of the soup* by Boris Grigoriev [21] in 1991. By this time the market in the arts of the Russian avant-garde had risen from obscurity to prominence. Major museums and collectors of the West sought these works, thereby increasing the demand even further.

The field of twentieth-century Russian art is fraught with problems of attribution and only recently, with the opening up of the archives and repositories in Russia and the Ukraine, have these problems begun to be resolved. The provenances of some of the works are sketchy, having appeared in the West from Russia through unknown or secretive means. Since it was illegal to sell art for foreign currency and to export without permission from the Soviet Union, it was not possible to reveal the sources of those works which reached the western markets; a situation which allowed unscrupulous persons to export works with questionable attributions. Without the means to do comparative research in the Soviet museums until recently, it is not surprising to find misattributions in this or any Russian avant-garde collection.

This volume of the Thyssen series has been the most disquieting to produce due to these attribution difficulties. From the start of the project it was clear that the problems must be confronted, despite the effect it might have on many associated with the Russian avant-garde.

John Bowlt and Nicoletta Misler have done thorough studies of each work. They have checked the provenances with scholars and families in Russia and have studied comparable works in the museums of Russia and the former Soviet republics. Where there were questions as to their authenticity, examinations of infra-red reflectographs and X-rays were made, and chemical analysis of pigments were taken to try to verify the authenticity of the attributions.

It is hoped that the authors' diligent examinations and the exposure of the questionable works will lead to the re-examination of other collections in the West and in Russia, and eventually to a clear and honest listing of the *oeuvre* of these artists.

Irene Martin
ADMINISTRATIVE DIRECTOR AND CURATOR

The Russian avant-garde

'Objects have vanished like smoke'[1]
Experiments by the Russian avant-garde in the Thyssen-Bornemisza Collection

Notes
1 K.Malevich, *Ot kubizma i futurizma k suprematizmu* (1916); trans. in Bowlt (1988), p.119
2 Gray (1962)
3 The first public auctions of Russian avant-garde art took place at Sotheby's, London, in the early 1970s, i.e. 1 July 1970, 12 April 1972, 29 March 1973, 4 July 1974 (see Auction abbreviations)

The simple phrase, 'the Russian avant-garde' is one that has achieved great resonance and is now associated with an astounding variety of names, styles and even nationalities, despite the fact that some of these have little to do with the mosaic of experimental movements that transformed cultural procedures in Moscow, St Petersburg and other cities during the 1910s and 1920s. After the rediscovery of the 'Great Experiment' in the 1960s thanks to Camilla Gray's pioneering monograph on the subject,[2] and the first gallery exhibitions and auctions,[3] commercial and academic interest in the Russian avant-garde has accelerated at a remarkable pace, and in the process has gathered such varied accretions that it now encompasses stylistic categories which include *fin de siècle* art and Socialist Realism, fictitious artists and an ever-increasing number of what might be called 'posthumous masterpieces'. Apologists for nineteenth-century Realism such as Filipp Maliavin, pedantic enemies of the avant-garde such as Alexandre Benois, artists of Armenian, Baltic, Georgian, Jewish, Polish and Ukrainian origin – all these disparate elements have been gathered under the umbrella of the Russian avant-garde. This may be as much the result of the Post-Modernist celebration of uniformity as factual inaccuracy, but whatever the interpretation, the Russian avant-garde has become an indefeasible part of contemporary artistic vocabulary and the works themselves are enjoyed by those very classes and establishments that the avant-garde wished to ridicule and destroy.

In view of such terminological vagueness, it would be well to attempt to define the principles of the Russian avant-garde by focusing on the undisputed revolution in form and content made by Russian artists in the early years of this century. The Russian works in the Thyssen-Bornemsiza Collection help us to do this, for they represent in microcosm the Russian avant-garde and provide a solid foundation upon which a critical argument and appreciation can be built. At the same time, this discussion does not seek to provide an exhaustive definition or redefiniton of the term, for the following reasons: the Russian avant-garde did not exist as a cohesive, titled movement; its primary representatives – Alexandra Exter, Pavel Filonov, Natalia Goncharova, Mikhail Larionov, Kazimir Malevich, Liubov Popova, Alexander Rodchenko and Vladimir Tatlin – did not favour the term, and even their apologists and critics, while referring to progressive, leftist or very new art, rarely used the word avant-garde.

Obviously, in spite of the fashionable tendency towards standardization, there remain certain undeniable artistic high-points in the 1910s and 1920s that cannot be belittled: Larionov's formation of the Jack of Diamonds group in 1910 with its active integration of French Cubism, German Expressionism and indigenous Russian culture, the 1913 production of the 'Dada' opera *Victory over the Sun* in St Petersburg, which anticipated Malevich's *Black Square* of 1915, Tatlin's meeting with Picasso in Paris in 1914 and his elaboration of the concept of the abstract relief, Filonov and his physiology of painting, the onslaught of the First World War and the artistic response to its violence, the October Revolution and its call for an agitational or ideological art, and the Constructivists' replacement of art by design. No history of modern Russian culture can ignore these milestones, and however much historical distance now

causes the blurring of aesthetic perimeters, confuses stylistic progression and leads us to apply modern prejudice to the past, events such as these remain central to the Russian avant-garde.

Of course, the avant-garde did not suddenly appear, just as Malevich's objects did not suddenly disappear; rather, it was the interpretive consequence and amalgam of many earlier trends: the Neo-Nationalists' concentration on folk art at Abramtsevo and Talashkino in the later nineteenth century anticipated the Neo-Primitivist movement led by Goncharova and Larionov; the Symbolists' denial of the physical world provided a vital impetus towards abstraction; and even the St Petersburg Academy of Arts, for all its oppressive pedagogy, provided basic formal training through tabulations and physiological reductions that are recognizable in the minimal forms of Suprematism and Constructivism. Is it so very far from the nineteenth-century text-books showing how spheres, cubes and rectangles should be depicted to Malevich's Suprematism (see [39], [40]), from anatomical atlases to Filonov's heads (see [16]), or from perspective drawings to Popova's architectonic paintings (see [45–7])?

Still, Neo-Nationalism, Symbolism and the Academy merely provided signals and allusions, and their rituals could not have accommodated such extreme actions as the incorporation of hair-rinse into professional painting (Larionov), the exclusive concentration on formal reduction at the expense of all figurative reference (Suprematism), the conscious rejection of the artist in favour of the engineer (Constructivism) and, most importantly, the deliberate and obdurate mixing of low and high cultures. A professional exhibition praising and incorporating 'low' art would have been unthinkable in 1900, but it was quite feasible by 1910. Indeed, on 10 December that year just such an exhibition opened in Moscow – called the *Jack of Diamonds*, which, when judged from any standpoint, was certainly avant-garde.[4]

Unused to such raucous sobriquets, people supposed that the *Jack of Diamonds* indicated a gambling-house or a brothel, and few understood that it was an art exhibition. But today, this group and its exhibitions are recognized as fundamental in the annals of the Russian avant-garde. Established by Larionov and his friends, the 'Jack of Diamonds' group elicited immediate associations with the uniforms worn by prisoners and was a clarion call to outcasts and radicals to slap the face of public taste. The leading members of the Jack of Diamonds – Goncharova, Vasilii Kandinsky, Larionov, Aristarkh Lentulov, Malevich and Tatlin – shook traditional Russian culture through their investigations into such weird and wonderful artistic ideas as Neo-Primitivism, Cubo-Futurism, Rayonism, Suprematism and even a Proto-Post-Modernism called Everythingness. At the 1910 Jack of Diamonds exhibition not only were the pictures themselves ugly and scandalous, but the installation itself was provocative. The poet and critic Maximilian Voloshin commented:

> The organizers have done everything to infuriate the viewer's eye. . .In hanging the exhibition, the artists have put the pictures as closely together as possible – four rows, one above the other, at different levels. Artists have brought in their stretchers, too, and even sketched some rather rude caricatures on the walls.[5]

In this way, the Jack of Diamonds turned the exhibition into exhibitionism, provoking and polemicizing with the public, a form of interaction vital to the dissemination of avant-garde ideas, especially in 1912–16.

Dismissing the facile realism of the nineteenth century and the strained sensibility of Decadence, these dissident artists argued that Moscow was now the axis of modern art and that they were bringing a freshness and energy to the tired artistic routine of Western Europe, even

4 For information on the Jack of Diamonds see Pospelov (1990)
5 M.Voloshin, 'Bubnovyi valet', *Russkaia khudozhestvennaia letopis*, no.1, St Petersburg, 1911, pp.10, 11
6 N.Goncharova, Preface to catalogue of her one-woman exhibition, Moscow, 1913, Eng. trans. in Bowlt (1988), p.56
7 A.Shevchenko, *Neo-primitivizm* (1913); trans. in Bowlt (1988), p.45

though they expressed gratitude to Western painters 'for all they have taught [us]'.[6] In their quest for new concepts and systems, painters such as Goncharova, Kandinsky, Larionov and Malevich gave pride of place to the traditions of their local arts and crafts such as the toy, the icon, the *lubok* (a cheap, handcoloured print), the distaff, embroidery and urban folklore, borrowing motifs and devices that they then transferred to their own artistic repertory. Neo-Primitivism was the direct consequence of this: for example, Goncharova interpreted ordinary scenes of the peasant life that she knew so well – working in the fields, treading wine, fishing (see [18]), folk dancing – with an emphasis that, in turn, left a strong imprint on the early Malevich; Larionov, on the other hand, Goncharova's life-long companion, looked more to the city with its graffiti, whore-houses, stores and taverns for inspiration (see [31], [32]).

Rural, patriarchal traditions played a vital role in the development of the Russian avant-garde artists, and their awareness of their cultural heritage was especially acute. As Shevchenko declared in his Neo-Primitivist manifesto of 1913: 'icons, *lubki*, trays, signboards, fabrics of the East, etc. – these are specimens of genuine value and painterly beauty'.[7] Several paintings in the Thyssen-Bornemisza Collection demonstrate the degree to which domestic culture moulded the aesthetic response of Modernist artists. David and Vladimir Burliuk (see [4] and [5]), Marc Chagall (see [6]) and Larionov were among those who paraphrased their domestic heritage in their own paintings, drawings and lithographs. Like Gauguin in Polynesia, Vladimir Burliuk, Goncharova, Larionov, Malevich and their colleagues also 'went native' in their search for a more pristine artistic expression, paying particular attention to the life and culture of their own people – the Russian and Ukrainian peasants (see [5] and [18]). They also examined children's drawings, Black African art and Siberian relics, concluding that these artefacts expressed a higher reality as yet untouched by the artificial values of urban civilization. Such artists were fascinated by the bright colours, crude lines and raw humour of folk art, adjusted its form and content to their own artistic approaches and even revived it as a socio-political weapon, as did Lentulov, Vladimir Maiakovsky, Malevich, Ilia Mashkov and others in their patriotic posters for the Contemporary Lubok enterprise in Petrograd during the First World War.

Of course, this should come as no surprise, for such painters were attending art school (*c*1910) at exactly the time when ancient Russian art and architecture were becoming the subject of close intellectual and aesthetic attention, as witnessed by the *Exhibition of Ancient Russian Art* held at the Moscow Archaeological Institute in 1913. The families of most of the avant-garde artists (obviously, Chagall and El Lissitzky are exceptions) were Orthodox and the customs and rituals of the Orthodox service and calendar (the icon and the iconostasis, the clerical vestments, the holiday processions, etc.) made a deep visual impression. After all, Malevich placed his most radical creation (the *Black square*) in the *krasnyi ugol* ('beautiful', i.e. 'holy' corner) at the exhibition *0.10* in Petrograd in 1915–16. Moreover, Goncharova not only studied Medieval Russian art, but also tried to revive it within a new idiom, depicting numerous saintly and apostolic scenes – and often eliciting ecclesiastical and civil wrath. Suffice it to recall her contribution of the four-part *Evangelists* (1910) to the *Donkey's Tail* in 1912 which was banned by the censor at the instigation of the Holy Synod, because of alleged incompatibility between image and title. It is important to remember that the Russian avant-garde tended to regard the icon, like most other artefacts, as a formal exercise rather than as an instrument of ceremony, the approach that Larionov followed in organizing the *Exhibition of Icons and Lubki* in Moscow in 1913 (containing 129 icons from his own private collection). In other words, it was

the vibrant colours or perspectival deformations rather than the 'utilitarian' meaning of the icon that prompted artists to study the Russian icon, the *lubok* or the wooden toy and to interpret these qualities in their paintings, as did Goncharova in *Fishing* [18]. Shevchenko observed in his Neo-Primitivist manifesto of 1913:

> For the point of departure in our art we take the *lubok*, the primitive art form, the icon, since we find in them the most acute, most direct perception of life – and a purely painterly one, at that.[8]

Henri Matisse came to the same conclusion after visiting Moscow and St Petersburg in 1911:

> The icon is a very interesting type of primitive painting. Nowhere have I ever seen such a wealth of colour, such purity, such immediacy of expression. It is the best thing Moscow has to offer.[9]

Concurrent with their examination of domestic Russian culture, the members of the Jack of Diamonds group, and of the three other exhibition groups that Larionov founded between 1912 and 1914 (the Donkey's Tail, the Target, and No.4) which included Chagall, Malevich, and Tatlin, also responded to French Post-Impressionism and Cubism. Some, such as Marie Vassilieff (see [58]) moved to Paris permanently, some travelled to Paris for extended periods (Chagall), some visited Paris (Larionov in 1906 and Lentulov in 1911–12), others knew the paintings by Braque, Gauguin, Matisse and Picasso in the collections of the Moscow merchants Ivan Morozov and Sergei Shchukin, or they contented themselves with illustrated articles on modern French art in Russian periodicals. That Larionov scrutinized Gauguin's Polynesian images is clear, for example, from his *Blue Nude* of 1906–8 [29].

It should also be remembered that Cubism was not the only French movement to attract the Russian avant-garde artists and that they often used the word Cubism as a generic term to accommodate other 'new' ideas, for example, the Delaunays' Simultanism, which exerted an appreciable influence on the work of Alexandra Exter, Larionov, Lentulov, Georgii Yakulov, and Kirill Zdanevich. In this Simultanist or Orphist context there were many points of contact between the Russians and the French: in 1905 Exter had been living in the same Paris pension as Sonia Delaunay; Larionov met Sonia at the Russian section of the *Salon d'automne* in 1906; Lentulov visited the Delaunays in the autumn and winter of 1911–12; all parties were fascinated by electric light, the cinema and the effect of rapid movement through illuminated, urban space (see [32]); they often contributed to the same exhibitions such as the *Blaue Reiter* in Munich in 1911–12 (as did David Burliuk with his *Landscape* [4]), the *Jack of Diamonds* in Moscow in 1912 (three works by Delaunay), the *Salon des Indépendants* in Paris in 1913 and *Der Sturm* in Berlin in 1913 to which Goncharova and Larionov contributed (see [19] and [30]). They were all keenly interested in the legacy of French colour theory, especially as developed by Michel-Eugène Chevreul, and pursued parallel interpretations as may be seen in the researches of André Lhôte and Mikhail Matiushin and his disciples such as Ksenia Ender (see [11] and [12]).

This might account for the compilation and proliferation of colour discs and colour primers used in educational courses in Moscow and St Petersburg/Leningrad in the 1910s and early 1920s – from Ivan Kliun and Gustav Klucis to Malevich and Matiushin. Of particular importance here was the 1926 Russian translation of Wilhelm Ostwald's *Farbenfibel* edited by Sergei Kravkov, and Matiushin's colour primer, *Zakonomernost izmeniaemosti tsvetovykh sochetanii* [The Conformity of the Changeability of Colour Combinations], published in 1932, on which the Enders also collaborated (see [11] and [12]). Exter's paintings of 1912–14, for example *City at night* (1913, St Petersburg, Russian Museum), *Florence* (1914–15, Moscow, Tretiakov Gallery), and *Still-life* (1913, [13]), executed under the influence of her sojourns in

8 Shevchenko, op.cit., p.46
9 Matisse in an interview with the St Petersburg newspaper, *Protiv techeniia*; quoted in Y. Rusakov, 'Matisse in Russia in the Autumn of 1911', *Burlington Magazine*, London, May 1975, p.289
10 A. Exter, 'Novoe vo frantsuzskoi zhivopisi', *Iskusstvo*, nos.1–2, Kiev, 1912, p.43; Exter is referring to the work of Robert Delaunay
11 Livshits/Bowlt (1933/1977), 81
12 N. Ya-o, 'Vystavka 1915 goda', *Mlechnyi put*, no.4, Moscow 1915, p.63
13 Opening lines of Maiakovsky's poem 'A vse-taki' [And Yet], 1914; trans. in V. Markov and M. Sparks, *Modern Russian Poetry*, London (MacGibbon) 1966, p.529
14 P. Ettinger, 'Vystavka Obshchestva "Bubnovyi valet"', *Russkaia khudozhestvennaia letopis*, no.5, St Petersburg, March 1912, p.9
15 M. Larionov and N. Goncharova, 'Luchisty i budushchniki' [Rayonists and Futurists] (1913); trans. in Bowlt (1988), p.89

Paris, carry recognizable elements of the Delaunays' polychromatic system, evident especially in the colour discs reverberating as street lamps, and in what Exter herself described as 'centrifugal force…and concentration of light'.[10] Larionov's Rayonism also seems to borrow both forms and themes from Simultanism and Italian Futurism, as is clear from his *Street with lamps* (1913, [32]).

———————————————

All this goes to show that the Russians were *au courant* with Western trends, although their free interpretations indicated the force of their own creative originality and national bias rather than any sense of obligation to Paris, Munich or Milan. By 1912 Goncharova was already maintaining that Moscow was the artistic equal to Paris, and, indeed, by then the social, economic and cultural fabric of the city was in a state of dynamic flux. As the first skyscrapers and other fantastic feats of engineering (electric lifts, telephones, motor cars) appeared, the architectural profile of Moscow, the big village, changed rapidly. Art, literature and music also assimilated and expressed these changes and the traditional criteria of good taste and restraint were replaced by assertions that Velasquez and Raphael were philistines of the spirit,[11] by a 'broken table-leg, a sheet of iron, and a broken glass jug',[12] and by poems that compared the street to the nose of a syphilitic.[13] Commenting on the 1912 session of the *Jack of Diamonds*, the critic Pavel Ettinger wondered 'where bluff ends and genuine research begins.[14]

'Bluff' is an important word in any discussion of the Moscow avant-garde, for it was very much an extension of its street life – of its circuses, flea markets and the *balagany* [fun-fair booths] with their conjurors and pedlars, and the foul language, gaudy clothes and publicity stunts of such radical artists as David Burliuk and Larionov bring to mind these public amusements. Maiakovsky used to wear a yellow waistcoat, David Burliuk wore a top hat, a wooden spoon, and a lorgnette, Vasilii Kamensky also wore a flowered waistcoat, and Goncharova and Larionov painted cryptic designs on their faces, shoulders and breasts. All these gestures expressed their fundamental desire to make 'high' art 'low' and 'low' art 'high'. Indeed, many of Larionov's artistic devices relate to this market-place, for there are ideas and themes in his art and personal behaviour that can be deciphered or clarified only through reference to popular entertainments, pastimes and the life of the street. Naturally, the performance media appealed to the ebullient and tempestuous Larionov who functioned more by spontaneous intuition than by accepted convention and norm. Of course, more intellectual painters such as Kandinsky were also drawn to the circus, identifying natural gesture and instinctive movement with the clown and the comedian, although they regarded this more as a theoretical programme which could help to raise 'low' to 'high' – whereas Larionov favoured quite the opposite approach. His renderings of gypsies, soldiers, bakers (see [30]) and street-walkers are clear testimony to his wish to undermine and short-circuit the canons of taste, which he also extended into his boisterous activities such as face-painting, pornography, shocking titles for exhibitions (e.g. *The Donkey's Tail*) and, in general, 'acting up'. In other words, artists and writers such as David Burliuk, Goncharova, Larionov and Ilia Zdanevich were amplifying and adjusting the old routines of the clown, the quack and the magician, and then presenting them as 'art'. As Larionov and Goncharova declared in their 1913 Rayonist and Futurist manifesto: 'Art for life and even more – life for art!'[15]

With its more southern temperament, its confusion and devil-may-care attitude, Moscow

was the primary forum for the rowdy confrontations between the leftists and their bemused if not scandalized public. But in the 1910s it was not the only centre, for St Petersburg was almost as important in its tolerance, if not encouragement, of radical initiative, for example, the 1913 production of the innovative opera *Victory over the Sun* and Malevich's contribution of thirty-eight Suprematist paintings to the *0.10* exhibition in 1915–16. Above all, St Petersburg is remembered as the home of the Union of Youth, an artistic and literary community that, like the Jack of Diamonds and the Blaue Reiter, did much to propagate the new aesthetics via exhibitions, lectures, publications and performances.

The Union of Youth was an exhibition society, a publishing-house, a library and a cultural centre, but perhaps its greatest claim to fame is its patronage of the transrational or Dada opera called *Victory over the Sun*. With experimental music by Matiushin, libretto by Khlebnikov and Kruchenykh, and sets and costumes by Malevich, *Victory over the Sun* marked a turning-point in the Russian Cubo-Futurist movement, for it integrated many new cultural concepts of disharmony, neologistic language and even abstract art. As such, the Union of Youth was an eclectic group, propagating the work of David Burliuk and Matiushin, Malevich and Olga Rozanova, Exter and Ivan Puni (Jean Pougny), Filonov and Tatlin. The Union of Youth also accommodated a curious latter-day Symbolism that drew upon both Russian Decadence and Central European Expressionism, inspiring the perturbing visions of Filonov (see [16]) and Boris Grigoriev (see [21]), to name but a few. In fact, founded in the northern capital, the Union of Youth manifested a more Nordic or Teutonic orientation and strove to establish direct contact with both Scandinavian and German artists. For instance, the Union was in close touch with the Blaue Reiter group and, later, with Herwarth Walden's gallery Der Sturm, and its members included the Latvian artist and critic Vladimir Markov (Voldemars Matvejs) who, incidentally, conducted an eager correspondence with Kandinsky in Munich. Markov was one of the very first researchers to examine Black art, the art of China and of Easter Island as artistic rather than ethnographical statements and to try and define the characteristic aesthetic differences between the art of the west and that of the east.

The Union of Youth published Markov's article 'Principles of the New Art' in its journal in 1912 – a major contribution to the primitivist debate – in which he distinguished between Occidental art ('constructive') and Oriental and 'primitive' art ('non-constructive'). He developed his argument in his several discourses on 'primitive' art, emphasizing that individual caprice, chance, intuition and spontaneity were more essential to the artistic process than the academic canon:

> Playing with free forms creates new values that possess distinctive plastic qualities and a distinctive power of expression.[16]

Concepts such as 'liberty' and 'primitive' were essential to Markov's lexicon and connected him immediately to such artists as Kandinsky, Larionov and Rozanova, all of whom sought inspiration in 'low' culture, whether a child's toy or an African mask. Rozanova, for example, also writing in the Union of Youth journal, maintained that the new experimental painting was very much an outgrowth of the intuitive principle; the painter and musician Matiushin studied the casual forms of driftwood and tree branches; while Malevich, formulating Suprematism in 1915, also saw 'free form' as a key ingredient of his abstract system.

Indeed, the terminology and metaphors, e.g. 'intuition' and 'boundless horizons', that Markov used in his commentary on 'primitive' art bring to mind the writing style of Malevich

16 V.Markov, 'O "printsipe tiazhesti" v afrikanskoi skulpture' (1913–14), *Narody Azii i Afriki*, no.2, Moscow, 1966, p.150. His essay 'The Principles of the New Art' (1912) is trans. in Bowlt (1988), pp.23–36. For further information on Markov see I.Buzhinska (compiler), *Chteniia Matveiia*, Riga (Zalkaln Museum) 1991
17 I.Kliun, 'Iskusstvo tsveta' [Colour Art] (1919); trans. in Bowlt (1988), p.143
18 D.Kharms, 'Na smert Kazimira Malevicha' (1935) in George Gibian (ed.), *Daniil Kharms. Izbrannoe*, Würzburg (JAL) 1974, p.255
19 M.Kunin, 'Ob Unovise', *Iskusstvo*, nos.2–3, Vitebsk, 1921, p.16

who, as a member of the Union of Youth, was familiar with the Latvian's arguments. Malevich also explored the Neo-Primitivist aesthetic, but he found Markov's values of fortuity and spontaneity not in the Eskimos and the natives of Black Africa, but in the Russian and Ukranian peasants, and comparative reference to their icons, fabrics and furniture might help to explain his choice of colours, simple forms and geometric arrangements. Even so, Malevich is remembered above all for his non-figurative paintings, and while the image or, rather, concept of the peasant was an integral part of his pictorial vocabulary, it is with Suprematism that Malevich achieved his international reputation. Malevich painted his *Black* and *Red squares* in 1915, first showing them publicly at the exhibition *0.10*, alongside other experimental paintings by Kliun, Popova, Rozanova, Nadezhda Udaltsova et al. But while these severe geometric compositions were unprecedented to an audience totally unprepared for such a radical statement, they seemed to rest upon a rigorous and orderly system which generated individual works of art to be hung on the wall as they had been done for centuries past. In this sense, Suprematism, at least, with its painted planes and constant white backgrounds intended to be viewed frontally, was relying on a well-established tradition. Although it may have marked the end of that tradition, it was still part of it, as Kliun explained in his critique of 1919:

> The nature that was ornamented by the Neo-Realists and the Neo-Impressionists was torn to pieces by Futurism. Suprematism has carefully painted these benumbed forms with different colours and presents them as a new art.[17]

However, Malevich and Suprematism never ceased to fascinate, for, as Daniil Kharms wrote in his poetical obituary, Malevich 'seems with his hands to part the smoke',[18] that is to say, Malevich never doubted his own artistic path, beckoning many younger artists to follow him. Shortly after the *0.10* exhibition, for example, he assumed leadership of the so-called Supremus circle which also included Exter, Popova, Rodchenko, Rozanova and Udaltsova; after the Revolution a new generation came forward, especially during Malevich's tenure as professor at the Vitebsk Practical Art Institute – including Ilia Chashnik, Nina Kogan, El Lissitzky, and Nikolai Suetin. Obviously, the environment in Vitebsk stimulated artistic research and development for, by the end of 1919, Malevich had formed a substantial community of young Suprematists. Wearing tiny black squares on their clothes, these artists contributed to the formation of Unovis [Affirmers of the New Art] in 1920, even though some of the members were very young (Chashnik was seventeen, while Lev Yudin was only sixteen). Until Malevich's departure for Petrograd in April 1922, Unovis did much to propagate his Suprematism, tabulating, describing and elaborating its principles in theoretical tracts and works of art. For example, Unovis produced the Kruchenykh/Matiushin *Victory over the Sun* with designs by Ermolaeva in February 1920, published its own journal and also Malevich's *O novykh sistemakh v iskusstve* [On New Systems in Art] in 1919 and his *Suprematizm, 34 risunka* [Suprematism 34 Drawings] in 1920 [in fact published in 1921], lithographed, allegedly, by Lissitzky.

Much influenced by his friendship with Malevich in Vitebsk, Lissitzky transferred his allegiance from Chagall, inventing his concept of the Proun (Project for the Affirmation of the New) as an extension of the Suprematist doctrine. In February and May 1920 the Unovis artists also 'painted the town' with Suprematist designs and revolutionary slogans, remembered now in Lissitzky's poster *Beat the whites with the red wedge*. As one Vitebsk correspondent wrote:

> The whole town was clothed in squares, circles, and triangles, things had become terribly primitive, absurd, ridiculous.[19]

For Malevich's contemporaries such as Exter, Popova and Rozanova, Suprematism also provided a new and potential direction after their flirtations with Cubism and Futurism. Exter, for example, painted Suprematist paintings from 1916 while applying Suprematist motifs to her concurrent and subsequent book, textile and stage designs (see [15]). Popova interpreted Suprematism in her magnificent paintings, for example *Painterly architectonics* [47] and then in her dress and accessories designs. Even so, apart from the functional designs, these investigations were still much indebted to the conventions of the studio painting, intended to be observed on the wall and at a fixed, static distance just as in the Renaissance, the Enlightenment and the Realist nineteenth century.

That is why Tatlin perhaps was more radical than Malevich, because his volumetrical investigations into abstract, material combinations – his reliefs – were certainly unprecedented, and if Malevich, ultimately, concluded an august tradition, Tatlin established a new one, Constructivism (even though he did not call himself a Constructivist). Tatlin also aspired to dismiss the element of private taste, to insist upon an objective or rational approach to creativity and to ally art with engineering and industrial design – manifest in his Monument to the III International and in his prototypes for clothing, a stove, furniture and an aeroplane (the so-called Letatlin). Still, Tatlin's pronounced orientation away from surface to public space disguises his artistic genesis, for he started his artistic career as a painter, paying equal attention to Cézanne and to icons, as the critic Nikolai Punin observed in his 1921 monograph.[20]

Although there can be no question that Tatlin's reliefs and utilitarian designs are dynamic, innovative and revolutionary, the great care and sense of measure with which the artist selected and collocated his materials might also betray a certain nostalgia for a 'return to order', especially after the 'bluffs' of the Jack of Diamonds group. Indeed, it is relevant to recall that some of Tatlin's colleagues such as Yurii Annenkov and Vladimir Lebedev trained at the St Petersburg Academy of Arts and that they produced their own careful collages and compositions not only because they were keen explorers of new avenues of artistic enquiry, but also because they were excellent draughtsmen, had studied anatomical atlases, and had mastered the fundamental prerequisites of *chiaroscuro* and perspective. Punin explained this apprarent paradox:

> We had all grown tired of the approximations and conventions of aestheticism, and we were no less tired of the trotting races of the Futurist derby. We were seeking a strong and simple art.[21]

Tatlin's reliefs were very much a gesture to this 'strong and simple art', and we can understand why Popova, in particular, with her practical personality and clear convictions was drawn to them. After all, her studies in Paris with Henri Le Fauconnier and Jean Metzinger granted her a sobriety and reason that many of the Russian avant-gardists did not exercise. Although Popova was also indebted to Malevich's Suprematism, it was Tatlin's new objectivity that encouraged her to explore the pictorial relief, architectonic painting and later to move into industrial design. In 1922 Popova bade the new artist move

> from an analysis of the volume and space of objects (Cubism) to the *organization of the elements*, not as a means of representation, but as integral constructions (whether colour-planar, volumetric-spatial or other material constructions).[22]

Construction, then, became a key word in Popova's new vocabulary, reinforcing her commitment to Tatlin's rather than to Malevich's artistic world-view and preparing her for her collaboration with Vsevolod Meierkhold in 1922–3. After all, it was in her Constructivist

20 N. Punin, *Tatlin. Protiv kubizma*, Petersburg (IZO NKP) p.121
21 N. Punin, 'Iskusstvo i revoliutsiia'; quoted in V. Petrov (introduction) in I. Punina (ed.), *N. N. Punin, Russkoe i sovetskoe iskusstvo*, Moscow (Sovetskii khudozhnik) 1976, pp.16–17
22 L. Popova, 'For the Museum of Artistic Culture' (1921); trans. in D. Sarabianov and N. Adaskina, *Liubov Popova*, New York (Abrams) 1989, p.359
23 A. Benois on Malevich's *Black square* of 1915; quoted in N. Sokolova, *Mir iskusstva*, Moscow (Gosudarstvennoe izdatelstvo) 1934, p.201
24 V. Ivanov, *Borozdy i mezhi*, Moscow (Musaget) 1916, p.140
25 A. Bely, *Lug zelenyi. Knigu statei*, Moscow (Altsion) 1910, p.21
26 I. Selvinsky et al., 'Manifesto of the Literary Centre of the Constructivists (1923)'; quoted in G. Weber, 'Constructivism and Soviet Literature', *Soviet Union*, III/2, Pittsburgh, 1976, p.297
27 Malevich, op. cit., p.118

installations for *The Magnanimous cuckold* (1922) and *Earth on End* (1923) that Popova, as it were, complicated and expanded Tatlin's counter-reliefs, creating walk-through sculptures that were functional, universal and neutral in the sense that the actors could use them as props at any time, in any place and for any performance. Moreover, if Popova regarded the installation on stage as a scenic relief, she interpreted the human body as a kinetic construction, emphasizing its articulated mobility in her light, efficient and 'democratic' textile and dress designs of 1923–4.

The common denominator of Malevich's Suprematism, Tatlin's reliefs and Popova's architectonic paintings and stage-sets is their bare essentiality or, rather, lack of ornament, decoration and superfluous detail. They are what they are and make no claim to be 'beautiful' or 'serious', offering a basic schema instead of a filigree façade. A primary question that comes to mind at this juncture is why Malevich – and other artists – arrived at this minimal reduction, this 'zero', after intepreting and assimilating such a rich gamut of styles, subjects and concepts. Instead of abundance and wealth, the result is an 'arte povera' – a 'cult of emptiness…the gloom of nothing', as one critic remarked.[23] Why did objects vanish like smoke? How is this paradox to be explained? We are bound to take account of this question, for such minimalism is one of the key characteristics of the Russian avant-garde.

The Symbolist poet and philosopher, Viacheslav Ivanov, once observed that the artist's task was to produce a 'second nature, one more spiritual, more transparent than the multi-coloured peplos of nature'.[24] He maintained further that only the authentic poet or painter could achieve this goal, because the inspired artist was a seer – optically and metaphorically. This aspiration towards a more transparent condition was encouraged by the tenet that the material components of reality were but mere reflections of the 'real', ulterior reality, and that the arts, therefore, should strive to 'remove material'.[25] This basic concept of clairvoyance and ulterior condition relates to two themes that are essential to our understanding of the Russian avant-garde: on the one hand, the idea of abstraction such as Rodchenko's famous monochrome triptych of 1921 (*Triptych of pure colours: red, yellow, blue*; Moscow, Rodchenko family) and, on the other, the actual use of transparent or semi-transparent elements in the work of art (for example Tatlin's inclusion of glass in his reliefs). Surely, a principal source of inspiration here was the traditional role of the seer who peered through the dark veil to glimpse the true illumination, even if that illumination proved to be simply a mirror of 'here'.

A reasonable deduction, therefore, is that the less material employed in the creation of the work of art, the more transparent it becomes. It aspires, so to speak, towards impalpability, towards the art of the invisible, in other words music, as in Kandinsky's *Improvisations*. But there is also scientific evidence to assume that less is more, evidence promulgated by the Constructivists – as they declared in 1923:

> From the aeroplane engine to the radio transmitter, the size and substance have decreased, while power has increased geometrically. From Neanderthal man to the 19th century, the load of energy per man has increased from 1.4 hp to 6.6 hp. Thus, in the course of tens of thousands of years, this load has scarcely increased, but in the dynamic epoch of the twentieth century the curve of this load has flown dramatically.[26]

Eventually, this process of removal cancelled all superficial ingredients from the work of art, including colour, so that what remained was essential movement, as it was in Malevich's white-on-white paintings of 1917–18 and his Suprematist pencil drawings (see [40]). Perhaps this is the key to Malevich's enigmatic statement: 'I've transformed myself in the zero of form'.[27]

White, or white and black, like 'nothing', is an important component of the avant-garde production in the 1910s and early 1920s, as Rodchenko also demonstrated in his *Black and black* cycle of 1918–19 and Paul Mansouroff in his painterly formulae of *c*1920 (see [41] and [42]). True, these examples may have lost the initial, metaphysical premise according to which the 'real' reality is located in some secret substance beyond the world of tawdry appearances. While parallel at least visually, to Malevich's emblematic identification of white with eternity, the monochromes of the younger avant-gardists are often *aesthetic* statements, elegant and whimsical, graceful and restrained, that now lack the occult connotations of Suprematism. But taken as a specific orientation within the avant-garde, this concern with invisibility seems to extend the basic idea that reality lies beyond the world of appearances and the Symbolist assumption that all is movement, that a moment cannot be halted, and that life is a 'chain of my doubles denying each other, man "becomes", but never "is"'.[28]

The concentration on skeletal composition in black and white and a deep concern with the interior structure of things might have been occasioned by the general interest in X-ray photography and vivisection. This association is apparent in Klucis's axonometric paintings (see [27]) and suspended constructions of 1920–21, Rodchenko's works of 1921 which look like the rib-cages of outlandish beasts and even in Varvara Stepanova's stick figures of the same period (see [51] and [52]). Similarly, Rodchenko's photographs of metal-frame constructions such as the Shukhov Radio Tower (1929) also betray this interest in somatic structure. But perhaps the most obvious gesture to this alliance between zoology and art is to be found in the analyses that Paul Mansouroff conducted when he was director of the Experimental Section of Ginkhuk in 1923. As a colleague of Filonov, Malevich and Matiushin at Ginkhuk, Mansouroff pursued a specific line of enquiry into the possible links between aesthetic and anatomical form, between artistic effect and anatomical-corporeal function. To this end, Mansouroff compiled an elaborate programme of research, embarking upon his so called 'painterly formulae, and 'painterly tensions' (see [41] and [42]), a few of which incorporated natural elements (a stuffed bird, a piece of wood, a butterfly), but most of which are in themselves abstract bodies, ordered, minimal and articulate. As in the case of Klucis, Rodchenko, the Stenberg brothers, Tatlin and others, Mansouroff was also trying to expose and reconstitute the primary artistic elements in the same way that scientists – through X-rays and microscopy – were charting basic cellular and plasmatic structures.

It is particularly in this orientation towards a formal Minimalism on the one hand and a metaphysical aspiration on the other that the Russian avant-garde manifests its synthetic derivation. But this constant striving towards 'nothing' also betrays another, although closely related condition – that of violence, both actual and metaphorical. After all, the term 'avant-garde is a military one and it is perhaps not accidental that the Russian artistic avant-garde reached its creative zenith during the First World War, the October Revolution and the Civil War. Viewed from any standpoint, it was an avant-garde of violence, born of violence, that spoke and depicted violence and that violated all aesthetic and stylistic conventions. In practical terms, this violence can be understood on many levels, for example, as a real-life drunken brawl that Larionov depicted (see [31]) or as an iconoclasm symbolized by Malevich's placing of the *Black square* in the 'holy corner' of *0.10*. The opera *Victory over the Sun* was also an opera of violence in which Nero, grave-diggers, people of ill-intent, enemies, muggers, strong-men and devils interacted to provide the environment in which an aviator crashed to the stage in Act III. We should remember also that *Victory over the Sun* alternated with Maiakovsky's *Vladimir*

28 V. Ivanov, *Po zvezdam*, St Petersburg (Ory) 1909, p.52
29 'Opiat futuristy (vmesto peredovoi)' *Akter*, no.4, Moscow, 1913, pp.1–2

Maiakovsky: A Tragedy (designed by Filonov and Iosif Shkolnik), starring a Man without an Ear, a Man without a Head and a Man without an Eye and a Leg. Formally, too, the avant-garde perpetuated violence to text and image, piercing and rupturing with bayonets, saws, sabres and scissors as Malevich did in his *Englishman in Moscow* (1913, St Petersburg, State Russian Museum) or dwelling on the maimed and decomposing as did Filonov (see [16]).

The artists of the Russian avant-garde also violated their public, and their interaction with reader, spectator and listener was one of brutal intolerance or at least gross neglect. The avant-garde created its paintings, poems and plays in spite of the audience – symbolized so well by Vasilisk Gnedov's declamation of the 'Poem of the End' (1913) in which the last section is a blank page or by Nikolai Evreinov's play called *The Fourth Wall* (1915) in which the actors seal off the stage so that they will not be bothered by the audience. This anti-social spirit of avant-garde performance and the obvious desire to shock the bourgeoisie distinguishes much of the experimentation of the 1910s and early 1920s, whether the pigs trotting in and out of Larionov's paintings or the uncomfortable rigour of Meierkhold's Constructivist productions. A constant butt of parody and aesthetic assault,

> we the audience were abused by the Futurists and with all the words at their command...A disgraceful, brazen and talentless can-can reigns dissolutely in the temples of art, and, grimacing and wriggling on its altars are these shaggy young things with their orange shirts and painted faces.[29]

Perhaps this penchant for violence and enforced change, albeit on an aesthetic level, predisposed some representatives of the Russian avant-garde towards involvement in the revolutionary movement from 1917. It is, however, in a wider philosophical framework and not in a narrow political one that mention can be made of the avant-garde's engagement with the October Revolution, especially when we bear in mind the issue of tradition and precedent. Well before this Russian writers and artists had already been describing the imminent cataclysm and had pointed to the Russo-Japanese War and the 1905 Revolution as the justification of their prophecy. Valerii Briusov's poem 'Griadushchie gunny' [The Coming Huns] (1904–5) and Kandinsky's painting *Red square* (1916–17, Moscow, State Tretiakov Gallery) are just two of the artefacts that extend this apocalyptic sentiment. Even though very few of the primary artists were declared enthusiasts of Marxist ideology, many of them equated artistic innovation with political dissidence, contending that their artistic boldness had in some way anticipated the October Revolution. Among them were Filonov, Malevich and Tatlin. However, it would be inaccurate to suppose that all radical artists were sympathetic to the new régime or that all its artistic and literary apologists were 'avant-garde'. Furthermore, it would be wrong to describe the cultural ambience after the October Revolution as completely 'leftist', for it was a mélange of different styles and trends from Academic Realism to Suprematism. Indeed, the continued connections with nineteenth-century Realism – which, for example, Filonov held in high regard – helped to foster the exclusive emphasis on this style during the Stalin years.

Of course, the Revolution of October 1917 exerted an appreciable influence on the course of Russian art, even though this influence should not be exaggerated out of proportion. True, the

Revolution destroyed, damaged or, at least, undermined many cultural structures, yet, on the other, it stimulated many of the radical movements already active by 1917 and suddenly allowed avant-garde artists to assume positions of politcal and pedagogical power. This official recognition of artists such as Malevich, Popova, Rodchenko and Tatlin derived from a variety of conditions, but, above all, several of the leftist artists felt a strong allegiance to the Revolutionary cause, contending that radical art and radical politics appealed to the same sensibility. Moreover, the ranks of the avant-garde increased as prodigal sons – Chagall, Naum Gabo, Kandinsky, Anton Pevsner, David Shterenberg et al. – returned from abroad. These clement conditions ensured that many such artists could now take up important positions in the new society, something that led to the strong, if transitory, dictatorship of the Left, especially in Moscow.

In March 1918 Moscow replaced Petrograd as the Russian capital and Moscow gained an even more forceful position in the evolution of modern Russian culture. True, major artists such as Filonov continued to work in Petersburg (it became Leningrad after Lenin's death in January, 1924), and, of course, Vitebsk, where Chagall and then Malevich reformed the Vitebsk Practical Art Institute. But in the 1920s Moscow dictated government commissions, organized many of the key exhibitions, such as $5 \times 5 = 25$ in 1921 with Exter, Popova, Rodchenko, Stepanova and Vesnin, played a formative role in the restructuring of the art schools and, ultimately, dictated artistic policy. Many of these measures fell under the responsibility of the Commmissariat of Enlightenment and its director Anatolii Lunacharsky who, himself a writer and a critic who had long lived in Paris, appreciated or at least tolerated the more extreme manifestations of cultural investigation, inviting Rodchenko, Shterenberg, Tatlin and many other leftists to join the Visual Arts Section of his Commissariat (IZO NKP). This Section, in turn, did a great deal to disseminate the ideas of the avant-garde – by acquiring works for museum inventories, organizing 'think-tanks' such as Inkhuk and RAKhN and supporting major commissions such as Lenin's Plan of Monumental Propaganda (1918 onwards) and Tatlin's Monument to the III International (1919–20).

Many groups, representing the most diverse styles, tried to determine what proletarian or Communist culture should be, but it was the Constructivists who contended that their movement was the most convincing expression of the new ideology inasmuch as it, too, presented itself as a universal and total application, one oriented to technology and the factory and, ostensibly, devoid of national, local or private justifications. In addition, the Constructivists argued that the traditional arts were necrotic and that the new communication systems of photography, cinematography, commercial advertising, industrial design, sports and Taylorism (scientific management) should replace painting and sculpture as cultural productions. Spurning opposition, the Constructivists did not hesitate to impose their views emphatically and raucously, and their leftist dictatorship was a striking precedent to the cultural intolerance of the Stalin era – in word, if not in deed. For the Constructivists the word was much more important than the deed, not only because they amplified the tendentious doctrines of their nineteenth-century predecessors such as Mikhail Bakunin and Nikolai Chernyshevsky, but also because they lacked the wherewithal to implement their often utopian projects, so that their slogans, maxims, formulae, and manifestos remained their strongest contribution to the new culture. Tatlin's Monument, Lissitzky's Moscow skyscraper, Rodchenko's kiosks – hardly any of these fabulous projects were realized.

In any case, Constructivism received many definitions and the Constructivists did not always

30 This is how the critic Nikolai Punin described Malevich and Tatlin respectively; see E.Kovtun, 'K.Malevich. Pisma k M.V. Matiushinu', *Ezhegodnik rukopisnogo otdela Pushkinskogo doma na 1974 god*, Leningrad (Nauka) 1976, p.183

practise what they preached (Popova and Rodchenko, for example, continued to paint 'aesthetic' paintings), and perhaps the movement was really not so new and revolutionary as its enthusiasts maintained. For example, many of the bold experiments in the visual arts that are often regarded as the consequence of the October Revolution or of political dictates were created or anticipated well before 1917. Moreover, the formal simplicity of Constructivism, with its emphasis on streamlining and industrial efficiency, qualities identifiable with Varvara Stepanova's robotic figures (see [51] and [52]) or Vesnin's new architecture [see 59], was a logical response not necessarily to Socialist demands, but rather to pre-existing artistic movements as well as to the substantial attainments in applied design by avant-garde artists *before* the Revolution – posters and book designs by Malevich and Tatlin, accessories by Exter and Puni, dresses by Goncharova and Rozanova, etc.

Be that as it may, the Constructivist world-view did owe a great deal to the political behests of the Revolution, and its most vociferous members – Alexei Gan, Rodchenko and Nikolai Tarabukin, were proud of their political allegiance. In this sense, Rodchenko was the Constructivists' Constructivist, for as a leftist artist, he responded immediately to the political, social and cultural demands of the new Russia, identifying industrial design and photography as the primary media. As early as 1916, Rodchenko contributed six compass-and-ruler drawings to Tatlin's Moscow exhibition called *The Store*, and then went on to execute a series of 'Minimalist' paintings that relied upon the pure interplay of textures, colours, rhythms and forms. Rodchenko's triptych of red, yellow and blue, shown at $5 \times 5 = 25$ in 1921, was one of the most radical expressions of the avant-garde, for it concluded the ancient tradition of 'pure' art while introducing the new era of 'production art'.

The Constructivists were not alone in the 1920s. Quantitatively they were certainly not in the majority and the more we examine the later phase of the avant-garde, the more we are surprised by the continued diversity of concepts and styles, at least until the universal imposition of Socialist Realism in the early 1930s. Many experimental artists of the time were not supportive of Constructivism and were opposed to its influence, even though they, too, felt their art to be revolutionary and *engagé*. David Kakabadze continued to render homage to the Cubism of Juan Gris and Louis Marcoussis (see [23]), while Filonov and his pupils such as Tatiana Glebova (see [17]) never doubted the potential of studio art, producing some of their most haunting imagery in the 1920s. The terms Expressionism and Surrealism come to mind here, movements that left an appreciable influence on Soviet artists of the mid-1920s, especially on the members of OST [Society of Studio Artists] such as Sergei Luchishkin, Yurii Pimenov, Alexander Tyshler and Konstantin Vialov, who were especially interested in the concurrent work of the German Expressionists such as Otto Dix and George Grosz. The OST artists demonstrated that studio painting could, indeed, take account of the new subject-matter and render sports, industry and young pioneers in a gripping, laconic and still experimental style. In emigration Boris Grigoriev also continued to develop his own Expressionism or 'Neue Sachlichkeit', as is clear from his *Miracle of the soup* [21].

In spite of the steady return to Realism, the late 1920s in Soviet Russia still boasted an artistic plurality. Even as late as 1929, the Tretiakov Gallery in Moscow gave Malevich a large one-man show and the Russian Museum was planning Filonov's – just as Tatlin was designing his fantastic aeroplane, Letatlin. But time was running out, for by 1929 Malevich and Tatlin, the proprietors of the 'heavens' and the 'earth' of the avant-garde,[30] were middle-aged, and their eccentric visions seemed irrelevant to a society attending to the urgent tasks of the first Five

Year Plan, collectivization and the cult of the leader. What was needed was an art-form that could be read without difficulty, that expressed commitment to Stalin's Socialist reconstruction, and that could still imbue respect through its invocation of the classical canon. Furthermore, conservative artists and critics who supported a return to the academic style now seized the reins of bureaucratic power, arguing for the establishment of a Union of Soviet Artists and an Academy of Arts in Moscow and taking revenge upon those avant-garde radicals who, just after the October Revolution, had ousted them from their own positions of influence and prestige. But even as late as 1932, the year in which all artistic groups were cancelled by the decree 'On the Reconstruction of Literary and Artistic Organizations' and in which the term Socialist Realism was invented, it was by no means clear what artists should depict. Socialist Realism answered these questions. The smoke cleared and the objects reappeared or, at least, so it seemed.

In formal terms, Socialist Realism was an artistic and literary style that was advanced as a response to the basic questions confronting the new Soviet state: What is proletarian culture? What is Soviet art? In 1934, the concept was advocated as the only legitimate style at the First Congress of Soviet Writers in Moscow where a number of key politicians, writers and artists spoke, and although Stalin himself was not present, he surely agreed with the basic tenets of its Socialist Realist charter ratified by Maxim Gorky and Andrei Zhdanov:

> Socialist Realism. . .requires of the artist a true, historically concrete depiction of reality in its Revolutionary development. In this respect, truth and historical concreteness of the artistic depiction of reality must be combined with the task of ideologically transforming and educating the workers in the spirit of Socialism.[31]

It is immediately clear that Socialist Realism contained a number of orientations that removed it from other Realisms such as nineteenth-century Critical Realism or American Social Realism. Soviet Socialist Realism was intended to evoke the future, not the present, some golden land beyond the horizon, eternal sunshine and infinite space, and it was concerned with process and building rather than with completion, with youth rather than with old age, with concrete description rather than with allusion, with transition and rite of passage rather than with arrival or departure and with warmth rather than with cold. The typical Soviet painting of the 1930s expresses this vision – the mirage of the Communist paradise that lies somewhere beyond the world of immediate appearances. This might explain the theme of abundance at a time of widespread starvation seen in *Collective farm harvest festival* by Sergei Gerasimov (1935, Moscow, State Tretiakov Gallery); of industrial prowess and conquest of nature seen in Serafima Riangina's *Higher, ever higher* (1934, Kiev, State Museum of Russian Art); of the benevolent and welcoming leader (when he was remote and inaccessible) seen in Vasilii Efanov's *A memorable meeting* (1938, Moscow, State Tretiakov Gallery).

The problem with Socialist Realism was that it had plenty of new content, but little new form. On the one hand, its art and literature were meant to portray the new and spectacular transformations of Stalin's Russia (electrification, collectivization, industrialization), and yet it had also to appeal to the verdict of ages and receive a universal seal of approval. That is one reason why Socialist Realism drew freely upon old-established symbols of prestige and power while applying them to the new social and political reality – whether in the depiction of simple workers enjoying the bourgeois pastime of mountain-climbing or the pastiche of Doric, Corinthian and Babylonian columns for the various designs for the Palace of the Soviets in the early 1930s. But if culture was the superstructure above the economic base, then Socialist

31 From the 'First Section of the Charter of the Union of Soviet Writers of the USSR' (1934); trans. in Bowlt, op. cit. p.297

Realism had to look and feel different from any preceding feudal or capitalist art-form, since the Soviet Union was, allegedly, entering a totally new, but predictable economic system. In other words, Stalin's culture denied the present in the affirmation of the future.

It would be conventional to end by repeating the platitude that the Russian avant-garde was replaced (or rather, subsumed) by Socialist Realism. In general terms, that is true, for the individual experimentation, creative freedom and governmental tolerance that the Russian avant-garde had enjoyed in the 1910s did not continue under Stalin and the tragic history of that cultural compromise need not be repeated here. At the same time, there remain enigmatic parallels and affinities between the noble aspirations of the avant-garde and the doctrine of Socialist Realism, and although it would be facile to insist on deep philosophical and stylistic likenesses and to deduce that Socialist Realism was the logical outcome of the avant-garde enterprise, nevertheless, the aspiration to deform the present so as to form the future remained an important common denominator. In its invention of presence where there was absence, Socialist Realism constructed an intricate façade on a building that did not stand and glorified objects where there was only smoke, for, like Malevich's Suprematism, it celebrated that which did not exist and continued to do so for the next fifty years.

The Hungarian avant-garde

The Hungarian avant-garde was a constellation of the most diverse artists and writers active between $c1908$ and $c1935$, including Sándor Bortnyik (see [2], [3]), Jószef Czaky, Béla Kádár (see [22]), Lajos Kassák (see [24]), László Moholy-Nagy (see [43], [44]), Hugó Scheiber, János Máttis-Teutsch, Lajos Tihanyi and Béla Uitz. Many of these individuals were leftist both aesthetically and politically and were keen supporters of the Activist ideology that Kassák formulated in 1915, many of them travelled outside Hungary in France, Germany, Austria and Russia, and all of them were exposed to a plurality of cultural influences.

One of the distinguishing features of the Hungarian avant-garde is, indeed, its international stance, for there are references to French Cubism (Kádár, Tihanyi), German Expressionism (Uitz), Italian Futurism (Scheiber) and Russian Contructivism (Bortnyik, Kassák, Moholy-Nagy) as well as to the Northern Romantic tradition (Máttis-Teutsch). The transcendence of national frontiers is one of the most forceful elements of the Hungarian avant-garde, and between 1900 and 1930 not even the leading artists of Moscow and St Petersburg assimilated and retailored such a multitude of styles. Moreover, the Russian avant-garde took much of its creative vigour from local, ethnic traditions and the artistic lexicons of Natalia Goncharova, Mikhail Larionov and Kazimir Malevich relied heavily on the canons and rituals of Russian folk art. The Hungarians, on the other hand, made scant reference to the culture of the Hungarian peasants, seeming to prefer the international to the national. Of course, this does not mean that modern Hungarian art is a condensation impervious to indigenous tradition, and some of the apologists of Hungarian Post-Impressionism drew on patriotic sources. Jószef Rippl-Rónai, for example, who was especially close to the French Nabis, was drawn to combinations of green and red, as if identifying the principal colours of the Hungarian tricolour as his artistic and national leitmotiv. As a matter of fact, painters such as Rippl-Rónai played a major role in the evolution of the new, radical generation of Hungarian artists after $c1910$. In opposing the jejeune canons of academic art and the salon, Rippl-Rónai and his colleagues lent a new strength to Hungarian art, prompting the establishment of innovative groups such as Nyolcak (The Eight) in 1909. Disseminating the codes of Post-Impressionsim and Fauvism to their students, these mentors left a deep imprint on the nascent avant-garde – something manifest, for example, in Kassák's early flirtation with Symbolist poetry, culminating in the publication of his book of poetry called *Isten báránykái* [Little Lambs of God] in 1910.

Nevertheless, the method of the academy did not die, and perhaps a strong reason why so many of the experimental artists of Hungary were affiliated with the Bauhaus in the 1920s (political sympathies aside) is because of this historial emphasis on academic instruction in Budapest, in other words, on the exact sciences and the philosophy of reason with the dependence upon order, logic and analysis. Directly or indirectly, this tradition seems to have influenced the public conception and reception of the scholar and artist in Hungary, and just as many distinguished mathematicians and physicists of our own time are of Hungarian extraction, so the constructive arts (Constructivism, Kinetic art) owe much to Hungarian artists (Vilmos Huszár and De Stijl, Moholy-Nagy and the Bauhaus, Victor Vasarely and Op art). Photography, geometric abstraction, the printing arts, functional design – the Hungarian

avant-garde made a unique contribution to these formal exercises in technological disciplines. At the same time, their attainments in the Constructivist aesthetic should not make us disregard their interpetations of other stylistic systems.

A principal reason for such versatility is to be found in the ideological engagement of many of the artists in question and their aspiration to wield art as a weapon in the struggle to build a universal Communist culture. This was the clear assignment of the journal *MA* [Today] published in Budapest in 1916 and then in Vienna in 1920. In other words, the political connections of the Hungarian avant-garde, encouraged by the Hungarian Revolution of October 1918, and the establishment of the temporary Hungarian Soviet Republic in 1919, fostered the dismissal of private, local issues in favour of a universal style. The theses advocated by Bortnyik and Kassák or by the critics Ernö Kállai and János Mácza (Ivan Matsa) extended the demands voiced by their Russian colleagues: art should reject its traditional role as an instrument of fictional narration and cosmetic decoration. It was argued that geometric abstraction, with its absence of 'local colour', was the legitimate expression of world revolution, for it was an art that would be recognized by the proletariat worldwide. Kassák's Activist manifesto *To the Artists of All Nations!* in 1920 and the elaboration of his theory of Bildarchitektur in 1922 are extensions of this sentiment.[1]

The Activists reinforced their position in 1918–19, but they had existed in spirit, if not in name, since 1915, when Kassák established his journal *A Tett* [Action]. *A Tett* derived from Franz Pfemfert's German Expressionist magazine *Die Aktion*, and, likewise, was a political vehicle that opposed the Imperialist war, exposing the corruption of bourgeois society and promoting the cause of Socialism and Communism – as did its successor *MA* the following year. Still, unlike *Die Aktion* in Berlin, *A Tett* did not always view the future of mankind within an urban environment, did not always celebrate industrial progress and did not emphasize Marx's doctrine that, with the foundation of international Communism, town and country would integrate. Moreover, the literary repertoire of *A Tett* included works by Walt Whitman and Emile Verhaeren, Symbolist poets who questioned the validity of an expanding urban civilization. Consequently, even for the extremist Kassák, Modernism in Hungary did not represent only urban Futurism and the machine aesthetic, although, of course, Kassák and Moholy-Nagy were drawn to this in the 1920s. Activism also denoted a 'rural' Modernism, an 'organic aesthetic'. After all, two of the most remarkable artists of the Hungarian avant-garde, Kádár and Teutsch, painted animal and vegetable forms, heeded nature's inner sound and were little attracted to the hustle and bustle of the modern metropolis.

In other words, the Hungarian avant-garde was moved by two essential impulses – a Modernism of the city and a Modernism of the country. The Hungarians knew the urban and urbane visions of Toulouse-Lautrec, Braque, and Carlo Carrà and produced interpretations such as Scheiber's night-club and café scenes; but they also drew on the Romantic landscape tradition of Eastern and Northern Europe. Indeed, an examination of the galvanizing rhythms of Teutsch's watercolours and sculptures of c1919–20, brings to mind the disquieting animations of nature by the Lithuanian artist Mikolajaus Ciurlionis in which natural forms might assume human outlines; or the 'landscapes from all points of view' by the St Petersburg artist and muscian Mikhail Matiushin and his disciples such as Ksenia Ender (see [11–12]). It would be a revealing exercise to try and retell the history of modern art from the 'rural' viewpoint and to redress the aesthetic imbalance that has occurred as a partial result of our preference for the Cubists' intellectual order and the Futurists' glorification of industrial and

Notes
1 Trans. from the German trans. of the manifesto in *Wechsel Wirkungen*, 1986–7, pp.49–51. The manifesto was first published in *MA*, no.1–2, Vienna, 1920
2 *Magyar aktivizmus*, exh. cat. Pecs, Janus Pannonius Museum, 1973, unpaginated
3 According to C.Sík, 'Kassák in the Museum', *The New Hungarian Quarterly*, Budapest, Summer 1974, p.79
4 For a fuller discussion of the emigration of Hungarian artists and critics to Soviet Russia see J.Bowlt, 'Hungarian Activism and the Russian Avant-garde', Santa Barbara/Kansas City/Champaign 1991–2, pp.145–67
5 This is how Lissitzky referred to the tenth figure (bearing a red square instead of a heart) in his folio of lithographs, *Die plastische Gestaltung der elektromechanischen Schau 'Sieg über die Sonne'*, Hanover (Leunis and Chapman) 1923
6 L.Kassák, 'Kiáltvány a müvészetért', *MA*, Budapest 1918, 1st special number (Nov.). This and subsequent English trans. have been made from the collection of unpublished trans. from the original Hungarian into Italian compiled by Giampiero Cavaglià. The authors would like to thank Dr Cavaglià for allowing the use of these materials. This particular statement appears in the Cavaglià TS, p.14

military hardware. The animal and vegetable worlds are unruly, defiant and primitive, but artists such as Heinrich Campendonck, Marc Chagall, Kádár, Franz Marc, Matiushin and Teutsch found there a vigour and vitality lacking in their contemporary urban milieux.

Nevertheless, in the context of the Hungarian avant-garde, it is the hard-edge, geometric, and 'technological' artists – Bortnyik, Moholy-Nagy, Kassák – who have gained precedence. This may be explained again by reference to the political and urban ambience of such artists. They were committed, articulate and activist, desirous of transforming art into an instrument for Socialist progress and many of their creative gestures are connected to this tendency. For example, after his early interest in Symbolist poetry, Kassák was confronted with modern art at an exhibition of Futurists and Expressionists in Budapest in 1913 – which excited him precisely by the orientation towards industrial development: Carrà's picture called *Funeral of the anarchist Galli* (1911, New York, Museum of Modern Art) included in the exhibition, inspired Kassák's first major critical essay.[2] Moreover, Kassák founded *A Tett* as a gesture of solidarity with the politicized Berlin Expressionists, and the magazine was so adamant in its advocacy of the new artistic and political ideas that it was liquidated in 1916 as being 'detrimental to the war effort'.[3] *MA* was no less didactic, affirming a clear liaison with the Bolshevik insurrection in Russia and, during its five years of existence as a magazine and exhibition centre, it gave constant attention to political and cultural events in Moscow.[4] In other words, the Hungarian avant-garde, at least as linked to Kassák's Activist group, owed much of its public recognition to this political commitment, and some of its primary members emigrated to the Soviet Union.

How then, are the pathetic fallacy of Kádár, the graphic Expressionism of Uitz, the Bauhaus geometry of Moholy-Nagy and the new plasticity of Bortnyik to be reconciled? Perhaps there is a common philosophical denominator – the implied rejection of the political status quo and the summons to revolution. For many of those who welcomed the International Style and Communism in the 1920s in the wake of the Russian, German and Hungarian revolutions, the future generation was to be, literally, a new race: El Lissitzky's immortal 'New Man',[5] was to have had heightened perceptual reflexes, to have drawn upon endless resources of natural energy and to have travelled intergalactically (Malevich); the New Man was to have inhabited a luminous space of transparent materials (Moholy-Nagy) and pure, functional forms (Kassák), while in harmony with the animal world (Kádár).

Clearly, the Hungarians were rarely content with mere formal combinations, but aspired towards a utilitarian, functional aesthetic. In this sense, Moholy-Nagy's design experiments, Kassák's polygraphical projects, Uitz's social commentaries, Bortnyik's establishment of the Mühely school of design in 1928, Kemény's Socialist Realist criticism and Mácza's sociology are extensions of this extrinsic orientation of the Hungarian avant-garde artists and of their constant desire to change socio-political structures by means of artistic ones. The same attitude was manifest in the very choice of titles for their radical magazines *A Tett*, *MA* and *Egység* [Unity] and in their enthusiasm for German Expressionism. These circumstances help to explain the Activists' cult of particular historical figures, such as the anarchist Mikhail Bakunin and the Marxist Ervin Szabó, and their unabashed call for the reintegration of art into the service of politics even before the proclamation of the Republic of Soviets in March 1919. For example, in his November 1918 *Declaration for Art*, Kassák asserted that:

> We [artists, poets, anarchists] do not wish to be the toy of a dominant class or the parasites of somnolent strata, but, side by side with the exploited workers, we are the fanatical bearers of the banner of a new and free human community.[6]

Arpád Szélpál developed this idea of the marriage of the artist and the worker:

> The man of Communism [is] not a proletarian exile transformed (degraded) into a robot, but
> is an individual who can realize himself. His form of life is not work, but art...Art as intuition
> must of necessity precede science...Consequently, next to Communism...art can serve and
> guide the new man now liberated by art.[7]

Incidentally, it is important to note in both these statements that neither spokesman is equating avant-garde art with a specific political party or is assuming that art would be used by a party mechanism in order to further party aims. Ultimately, this subtle hiatus contributed to the rift between the Hungarian avant-garde and Béla Kun's revolutionary government in June 1919.

Of central concern to the highly politicized Hungarian avant-garde was Russia's October Revolution of 1917. Like some of the Russian avant-garde, the Activists identified the 'activism of their drawings with the activism of the political and social mass movement of the Revolution'[8] and assumed that the Communists' ascendancy would guarantee the free practice of their radical art. But, by and large, the Hungarian artists and critics such as Ernö Kállai, Kemény, Mácza and Uitz seemed to be more politically motivated than their Russian colleagues, and, indeed, Moscow and St Petersburg/Petrograd never had the equivalents of the Budapest Galileo Circle and Sunday Circle at which radical artists and radical politicans exchanged ideas about the political destiny of the new art. Even so, the Hungarians were drawn to Russia primarily as a political matrix, as an experimental laboratory in which Socialism and Communism were being researched for a subsequent, international application. Indeed, Hungarian political thinkers, including Béla Kun, learned a good deal about Marxism during their military incarceration in Russia during the First World War.[9] Even Kassák, not a perceptive political being in spite of his radicalism, looked to the ideas of Bakunin and Lenin for cultural elucidation before the Hungarian Revolution, including references to their writings in the early issues of *MA*.

It is not surprising that the revolutionary regimes in Russia and Hungary behaved in similar ways in the context of cultural policy and there are many evident artistic and political parallels. Both governments, for example, established bureaucratic mechanisms for organizing and controlling art education, censorship, exhibitions, museums and the nationalization of private collections, for example the People's Commissariat for Enlightenment (NKP) directed by Anatolii Lunacharsky in Moscow and the People's Commissariat for Public Education directed by Zsigmond Kunfi (Commissar) and György Lukács (Vice-Commissar) in Budapest. Initially, both organizations tolerated a wide spectrum of artistic styles and procedures, although the avant-garde artists and critics (Natan Altman, Malevich, Nikolai Punin, Tatlin/Béni and Noémi Ferenczy, Kassák, Jolán Szilágyi, Uitz) played a crucial role in the administration and reformation of the visual arts. Both the Commissariat and the Ministry, for example, sanctioned and encouraged programmes of monumental propaganda in Moscow and Budapest. Immediately, therefore, the poster emerged as a primary vehicle of information distribution, and many of the Russian and Hungarian radicals designed images that drew on common themes of proletarian solidarity, the Red Army, brotherhood, and so on, including Maiakovsky, Dmitrii Moor, Gustav Klucis, Lissitzky, Malevich, Róbert Berény, Mihály Biró, Bortnyik, Uitz and Marcell Vértes. Both progessive and conservative artists responded to the call to transform cities by concealing the architectural symbols of the old order with panels, banners, flags and slogans that often incorporated Suprematist or Expressionist motifs. Mácza recalled the May Day celebration in Budapest in 1919:

7 Szélpál, 'Müvészet és kommunizmus', *MA*, no.3, 20 Dec. 1918; trans. in Cavaglià, pp.45–6

8 E.Kállai, *Neue Malerei in Ungarn*, Leipzig (Klinkhardt und Biermann) 1925, unpaginated

9 On Kun's experiences as a prisoner-of-war in Russia see R.Toekés, *Béla Kun and the Hungarian Soviet Republic*, New York (Praeger) 1967, pp.49–57

10 I.Matsa, 'Vospominaniia', D.Bizo and O.Shvidkovsky, *Sovetsko-vengerskie sviazi v khudozhestvennoi kulture*, Moscow (Nauka) 1975, p.100

11 Cavaglià, p.19

12 P.Kéri, 'Mácza', *Az ember*, Budapest, 15 April 1919; quoted in Cavaglià, p.22

13 G.Lukács, 'Felvilágesitásul', *Vörös Ujság*, Budapest, 18 April 1919; quoted Cavaglià, p.23

14 [B.Kun], 'Részlet Kun Bela válaszából az országos pártgyülés második napján', *Vörös Ujsag*, 14 June 1919; quoted Cavaglià, p.27

15 L.Kassák, 'Levél Kun Bélahoz a müvészet nevében', in *MA*, no.7, 15 June 1919, pp.146–8; quoted Cavaglià, pp.27–8

16 A.Szélpák, 'Kun Bélavák', *MA*, no.7, 15 June 1919; trans. Cavaglià, p.3

Artists...attempted to dress up the city for the free May Day festivities...grandiose decorations in the centre of Budapest that stretched from the Square in front of the Parliament as far as the Millenium Monument...the sculpture of Marx by György Zal, the enormous panels by Béla Uitz, the rich ornament of the streets where the brilliant crimson of the flame of revolution was fluttering.[10]

Like Lenin and Lunacharsky, Kun and Kunfi believed in the need to select and reprocess the most expedient parts of the literary and artistic heritage in order to create a new proletarian culture. They also realized that the establishment and consolidation of such a culture could not be achieved immediately and that it would evolve as a natural consequence of the move towards the Communist state. It is improbable, however, that Lenin or Kun understood what a new visual art could mean or that their artistic taste could ever have advanced beyond personal preferences for Lev Tolstoi, Michelangelo and Beethoven – one reason why, in both post-Revolutionary Moscow and Budapest, the 'revolutionary' fare being offered to the masses consisted of 'Strauss, Verdi, Puccini and Wagner'.[11] From the first days of the two revolutions, therefore, it was clear that the politicians' taste did not coincide with that of the radical artists and that this communication gap would lead to a divorce between the two camps. As Kassák and Uitz continued to call for permanent revolution, the members of Kun's government reacted ever more sharply against the political independence and the aesthetic experimentalism of the avant-garde artists. In an article entitled 'Mácza' (a direct reference to János Mácza) in April 1919, Pál Keri affirmed that it was more valuable for the masses to enjoy bourgeois culture now deprived of its original meaning than to be estranged by the élitism of the avant-garde.[12] Lukács added that, in any case, the avant-garde did not represent the cultural policy of the Hungarian Communist Party and that it had become a mere fashion.[13] Kun himself entered the polemic in June 1919 with his notorious dismissal of the avant-garde as a 'product of bourgeois decadence',[14] and Kassák's acerbic response,[15] together with Szélpál's ironic comment that if Activists were decadent then so were the Socialists since both were the consequence of the capitalist system,[16] served as an official pretext for terminating *MA* in Budapest.

With the resignation of Kun and the collapse of the Hungarian Republic of Soviets on 1 August 1919, and the establishment of the Hórthy regime, many radical artists and writers emigrated to Berlin, Prague, Paris and especially Vienna – where Kassák, Moholy-Nagy, and Kállai re-established *MA* the following year. The Vienna group, which also included Bortnyik, still regarded Budapest as their national and spiritual home (Bortnyik returned there in 1925, Kassák in 1926) and their artistic and publicist activities were still bolstered by the utopian vision of a successful Hungarian revolution. *MA* continued in Vienna until 1926, and, while maintaining its interest in literature and politics, now gave much more attention to the new painting, graphics and sculpture, and, as several critics have pointed out, the decisive, unifying visual element here was the influence of the Russian avant-garde, specifically, the geometric experiments of Naum Gabo, Klucis, Lissitzky, Malevich, Rodchenko and Tatlin. In the spring of 1921 *MA* published its first Constructivist manifesto just a few months after the Constructivist exhibition organized by Georgii and Vladimir Stenberg and Konstantin Medunetsky in Moscow, and continued to inform its readers of the new Russian art until its closure in 1926. In 1922 members of the *MA* group, including Kállai, Kassák and Kemény travelled to Berlin to see the *Erste Russische Kunstausstellung* at the Galerie Van Diemen. Also in 1922 the journal *Egység*, published by Aladár Komját and Uitz in Vienna, published Gabo's and Anton Pevsner's *Realist Manifesto*, the so called Programme of the First Working Group of Constructivists and a text by Uitz on Suprematism.

Indeed, by 1922–3 the movement of international Constructivism was unthinkable without the Hungarian contribution, as was demonstrated by the strong Hungarian contingent at the Bauhaus – Alfred Forbàt, Moholy-Nagy, Farkas Molnár, Andor Weininger – and in the Lissitzky/Hans Arp survey – *Die Kunstismen* – published in 1925. Furthermore, like their Russian, German, Polish and Czech colleagues, the Hungarian Constructivists gave particular attention to architecture and design as the most potential vehicles of Constructivist ideas, especially temporary and mobile architecture (kiosks, display stands, interiors, furniture). Marcel Breuer, Kassák, Moholy-Nagy, Péri and many other Hungarians achieved prestigious reputations as designers in the 1920s and, while some of them distanced themselves from the original formulae of Russian Constuctivism, the initial impact of Lissitzky, Rodchenko and Tatlin is undeniable. 'The new form is architecture', wrote Kassák in 1922.[17] Five years later he published Lissitzky's essay on the new Russian architecture in his new Budapest magazine *Dokumentum*.[18] During the early 1920s a number of direct parallels can be traced between individual Hungarian and Russian artists – Bortnyik and Malevich, Kassák and Rodchenko, Moholy-Nagy and Lissitzky, Uitz and Rodchenko. Some of these interconnections can be explained by the wide dissemination of illustrated articles and reviews dealing with Suprematism and Constructivism that appeared in *MA*, *Egység*, and Sándor Bartha's Vienna journals *Akasztott Ember* [Hanged Man] (1922) and *Ek* [Wedge] (1923–5). But more often than not, these coincidences in artistic thinking came about through personal encounters in Berlin. As Moholy-Nagy recalled much later:

> In 1922…El Lissitzky, Ilya Ehrenburg and later Gabo, came to Berlin.They brought news of Malevich, Rodchenko and the movement called Suprematism. The Dutch painter, Theo van Doesburg, told about Mondrian and neoplasticism; Matthew Josephson and Harold Loeb, the editors of *Broom*, and the painter Lozovick, about the USA…Out of these discoveries developed the Constructivist Congress of 1922 in Weimar, manifestos of the Hungarian review *MA*, of which I was then the Berlin representative, and exhibitions, all of which gave us greater assurance in regard to our work and future artistic prospects…[19]

One of the favourite points of rendezvous was Gert Kaden's studio where Gabo, Kemény, Lissitzky, Moholy-Nagy, Péri, and Hans Richter used to meet, and all, of course, were involved in the various activities of Der Sturm gallery and magazine. Hungarian and Russian artists formed a major component of Herwarth Walden's repertoire, he often showed them – singly or in groups – and the journal, with essays by Kállai, Kemény and many others, was an important interchange of artistic propagation and critical commentary for the Russo-Hungarian context. As a result of this sudden, increased availability of the ideas and images of the Russian avant-garde, many direct and indirect borrowings, plagiarisms and interpretations ensued which caused, and still cause, a good deal of discussion. It seems clear, for example, that Lissitzky's abstract system of Prouns (Projects for the Affirmation of the New) with their axonometric planes defying gravity, left a deep impression on Bortnyik and Moholy-Nagy, as is manifest from a simple comparison of the two lithograph albums published by the Kestner Gesellschaft in Hanover in 1923, Lissitzky's *Die plastische Gestaltung der Elektro-mechanischen Schau 'Sieg über die Sonne'* and Moholy-Nagy's *Kestnermappe*. Moholy-Nagy's incorporation of the human hand into his self-portrait of *c*1925 also brings to mind Lissitzky's use of the same motif in his photograph called *The constructor* of 1924.[20] Moreover, Moholy-Nagy's experimental photographs from and of balconies seem to have been recaptured by Rodchenko, an apparent borrowing that led to a bitter polemic on the pages of *Novyi lef* in 1927–8.[21] In turn,

17 L.Kassák, untitled intro. to L.Kassák and L.Moholy-Nagy, *Buch neuer Künstler*, Vienna (*MA*) 1922, unpaginated. For information on Hungarian architecture of this period see Merényi *Cento anni architettura ungherese*

18 L.Kassák, 'A mai prpsz épitészet' [Russian Architecture Today], *Dokumentum*, Budapest, March 1927, pp.17–20

19 Moholy-Nagy, 'Abstract of an Artist' (1944), K.Passuth, *Moholy-Nagy*, London (Thames and Hudson) 1985, p.381. Also see ibid., pp.24–5 and 28–9 for Passuth's discussion of Moholy-Nagy and Malevich, Gabo and Pevsner

20 Moholy-Nagy's (?) photographic self-portrait with his outstretched hand is reproduced in *Wechsel Wirkungen*, 1986–7, p.578. Lissitzky used the motif on a number of occasions, i.e. apart from his famous self-portrait called *The constructor* (1924), he also incorporated it into his illustration called *Boat ticket* for Ilia Erenburg's *Shest povestei o legkikh kontsakh*, Berlin (Helikon) 1922, and his cover for the Vkhutemas programme Moscow (Vkhutemas) 1927

21 For information on the polemic see 'Illiustrirovannoe pismo redaktoru', *Sovetskoe foto*, no.4, Moscow 1928, and A.Rodchenko: 'Krupnaia bezgramotnost ili melkaia gadost?', *Novyi lef*, no.6, Moscow, 1928, pp.42–4

22 E.Kállai, 'A konstruktiv müvészet társaddalmi és szellemi távlatai', *MA*, 30 Aug. 1922, pp.55–9

Rodchenko's, Klucis' and Lissitzky's photomontages and photocollages of the 1920s seem to have been appreciated and applied by the Hungarians both in their abstract compositions (e.g. Kassák) and in their agit-designs (e.g. György Kepes).

This intense cross-fertilizaton of visual images, strengthened by the political rapprochement, was prompted further by the presence of many Hungarians in Moscow which, from 1919, became the temporary or permanent home for many artists, writers and politicians in exile. For those Activists still fired by the Communist spirit, Moscow was the Mecca to which they turned, and the III International Congress held in Moscow in June–July 1921 attracted several of their number. By the mid-1920s there were so many Hungarian émigrés living in Moscow that they established a special Union of Hungarian Revolutionary Writers and Artists, and even published their own magazines – *Sarlo és kalapács* [Hammer and Sickle] and *Uj hang* [New Voice]. In the early 1930s the Hungarian emigration to the Soviet Union accelerated dramatically as both Hungary and Germany consolidated their Fascist power.

In the 1920s and 1930s these direct contacts between Hungarian artists and the Soviet Union were reinforced further by the strong Hungarian presence at international exhibitions in Moscow, Leningrad and other cities. For example, the *First Universal German Exhibition* in Moscow, Saratov and Leningrad in 1924 contained works by members of the Hungarian avant-garde who were then living in Germany, including Bortnyik, Béla Kádár, and Moholy-Nagy. Two years later the State Academy of Artistic Sciences (GAKhN) organized the exhibition called *Revolutionary Art of the West* which also contained works by Bortnyik and other Hungarians. There were at least five other Moscow exhibitions over the next decade that carried works by Hungarian artists, although, for the most part, they were posters, caricatures and book designs; in any case, by the mid-1930s the words 'Activist' and 'avant-garde' had become terms of condemnation and abuse.

To a considerable extent, the artistic output of revolutionary Hungary (and Russia) relates to the concept of psycho-physical transformation. Painters and poets exposed the ills of the old society, built prototypes for new social coefficients (Kassák's and Bortnyik's Bildarchitektur) or drafted projects for the future society. The deep concern with design in all disciplines – whether in Hungary, Russia, Poland or Germany – reflected this aspiration towards global revolution. Bortnyik's architectonic experiments, Kassák's typographical layouts, Moholy-Nagy's light modulator – such things were, indeed, what Kállai called the 'social and intellectual perspectives of constructive art'.[22] But this brave new world did not come into being, and the perfect forms which we have inherited are only elegant fragments of the total transmutation that the artists envisaged.

Russian works in the Thyssen-Bornemisza Collection

Note
1 For further information see the select bibliography and the General works on Twentieth-century Russian, Hungarian and Polish Art

There are many accumulations of Russian pictures in the West, but few collections. The fifty-nine paintings and drawings by thirty-three Russian, Hungarian and Polish artists described in this Catalogue Raisonné do, however, constitute a collection, a private one, formed by all the elements that inspire such enterprises – personal discretion, emotional sensibility, geographical accident and financial solvency. A collection it is because the whole is greater than the sum of its parts and, as a totality, it provides a rich, integrated, and original contribution to our understanding of artistic experimentation in the early decades of this century.

The volume describes the Russian and East European works that Baron Hans Heinrich Thyssen-Bornemisza has acquired over the last twenty years. It includes artists such as Sándor Bortnyik, Marc Chagall, Alexandra Exter, Pavel Filonov, Natalia Goncharova, Lajos Kassák, Ivan Kliun, Mikhail Larionov, El Lissitzky, Kazimir Malevich, László Moholy-Nagy, Liubov Popova, Olga Rozanova and Władysław Strzemiński, many of whom were part of the Russian avant-garde, the constellation of artists, writers, musicians, critics and collectors that transformed the evolution of Russian culture during the early years of this century. Of course, the chronologies of the Russian, Hungarian and Polish avant-gardes, have been the subject of many publications and there is no need to repeat them here.[1] Rather, the purpose of this volume is to provide full curatorial data for the objects concerned and, in so doing, to discuss them as primary illustrations of aesthetic directions such as Cubo-Futurism, Suprematism and Constructivism.

Although the corpus of material in the Thyssen-Bornemisza Collection cannot compete with the large depositories in the Russian Museum, St Petersburg, or the Tretiakov Gallery, Moscow, it is a strong sampling and, when integrated with the pictures by Vasilii Kandinsky (discussed by Peter Vergo in the volume on twentieth-century German painting in the Collection), constitutes a major and unique collection of Russian art. With the exception of Vladimir Tatlin and his reliefs, the Collection includes the primary names and movements: Goncharova and Larionov (Neo-Primitivism), David and Vladimir Burliuk, Exter and Rozanova (Cubo-Futurism), Ilia Chashnik, Malevich, and Nikolai Suetin (Suprematism), Alexander Rodchenko and Alexander Vesnin (Constructivism). There are also less familiar artists such as Yurii Annenkov and David Kakabadze who deserve clearer recognition, as well as casual works and a number of pieces that still defy conclusive attribution. The general impression, then, is of a radical laboratory or, as the Russians would say a *tvorcheskaia kukhnia* [literally, 'creative kitchen] where the entire process of artistic investigation and analysis can be observed in all its unpredictability and incongruity.

The Russian segment of the Thyssen-Bornemisza Collection is especially important. On the one hand, it contains masterpieces by the prime movers of the Russian avant-garde; and, on the other, in its very disparateness, it reflects the vagaries, improvisations and pressures that accompany the building of any art collection of this kind. Indeed, the Russian Collection can and should be regarded precisely as a further and perhaps final chapter in the recognition and propagation of twentieth-century Russian art in the West, continuing the long adventure already experienced by other collectors such as George Costakis, Nina and Nikita D. Lobanov-Rostovsky, Peter Ludwig, George Riabov and Thomas Whitney. In some senses, the Thyssen-

Bornemisza Russian holdings represent the conclusion to this tale, simply because the Collection, begun in 1973, cannot be duplicated, and the reason for this is not simply a commercial one, even though in the market-place the price for a work by, say, Chagall or Malevich, is now extremely high, if not, prohibitive. Rather, it is a question of accessibility, for even if unlimited funds were available, a similar collection could not be assembled, because practically all Western and Soviet Sources have been exhausted. Financially and physically, it is becoming increasingly difficult to acquire primary, high-quality works of the Russian avant-garde, although the international demand for such material is greater than ever.

The history of collecting modern Russian art has yet to be written. It is a fascinating and intricate history because it encompasses not only individual collectors from the famous Pavel Tretiakov in the late nineteenth century to the mysterious George Costakis during our time, but also the entire issue of private and public art markets in Russia before and after the October Revolution, the redistribution and conversion of Russian works of art during the Soviet period, the peculiar network of private collectors under Stalin, Khrushchev and Brezhnev, and the wide diaspora of collectors and art-works in Europe and the United States that continues to this day. In other words, there are many precedents, although few equals, to the Thyssen-Bornemisza Russian Collection and it can and should be viewed as the continuation of a long tradition of collecting Russian art both at home and abroad, both in the nineteenth century and the twentieth century.

As the capitalist economy of Late Imperial Russia advanced, Moscow and St Petersburg society at the turn of the century began to assume certain customs and rituals that are more often identifiable with financial affluence and cultural recreation: an aspiration towards, and claim to, intellectual awareness, an increased desire to contribute to scholarly convocations devoted to the arts and, not least, an intense interest in connoisseurship and in the collecting of works of art, both antique and modern. As far as artistic preference is concerned, the new Moscow élite was contemporary rather than retrospective in its taste, although many of them were also fascinated by their indigenous past, especially Petr Shchukin, brother of the more famous Sergei. They did not attempt to copy the artistic inclinations of the old aristocracy by procuring Italian Renaissance and Old Dutch Masters, as the Demidovs and the Stroganovs had done. Rather, they concentrated on the new art – Impressionism, Post-Impressionism and Symbolism. Certainly, members of the old Russian aristocracy such as the Gagarins, the Golitsyns and the Tolstois were still active as patrons and collectors at the beginning of the century, but their conventional role as the arbiters of taste was quickly assumed by the members of the new Russian middle class, especially the Moscow merchants or business-people such as the Girshmans, the Morozovs and the Riabushinskys.

Even so, it is important to remember that during the years *c*1900–*c*1916, that is, the 'Silver Age' of Russian culture, Moscow did not have a well-developed art market, although it was one of the four of five centres of the international avant-garde. Like their noble predecessor, Catherine the Great, local collectors of antiquities, oriental art, Old Masters and modern French painting bought works through galleries and auction houses in Berlin, Paris, Rome, London and New York, and rarely in Moscow, unless, of course, their interest was in Russian icons and contemporary Russian painting. The one commercial gallery in Moscow, the Le Mercier Gallery founded in 1909, which, in any case favoured the decorative arts and eclectic shows, had only limited financial success because of this traditional bias towards the West. St Petersburg did not fare much better, although the break-up of impoverished estates and the sale of their contents

2 Livshits/Bowlt (1933/1977), p.116. For further information on collectors and dealers in pre-Revolutionary Russia see C.Burrus, *Les collectioneurs russes*, Paris (Chêne) 1992; B.Brodskij, *Tesori vietati*, Florence (Ponte delle Grazie) 1992; N.Dumova, *Moskovskie metsenaty*, Moscow (Molodaia gvardiia) 1992. The journal *Nashe nasledie*, London, 1988–92, published a number of articles on Russian private collections, past and present, for example, S.Shuster, 'Vremia peremen' no.1, 1989, pp.120–23; N.Vernova, 'Prednaznacheno Petergofu' no.6, 1989, pp.7–15. Under the auspices of Valerii Dudakov, himself a collector of Russian Modernist art, the Soviet Culture Foundation organized a number of important exhibitions of works from Russian private collections. See, for example, *Avanguardia russa*, exh. cat. Milan, Palazzo Reale, 1989; *100 Years of Russian Art*, exh. cat. London, Barbican Art Gallery, and other cities, 1989
3 For information on the collecting activities of Morozov and Shchukin see B.Kean, *All the Empty Palaces*, London (Barrie and Jenkins) 1983. Also see A.Fedorov-Davydov, *Russkoe iskusstvo promyshlennogo kapitalizma*, Moscow (GAKhN), 1929, especially chaps 6, 7 and 8

did contribute to a vigorous auction market there just before the Revolution. The one private art gallery in St Petersburg, the so called Art Bureau, that Nadezhda Dobychina founded in 1910, dealt only with contemporary Russian art, for example, Chagall, Goncharova (see [18]) and Grigoriev, and gained a positive reputation thanks to the obdurate bargaining powers of its abrasive, no-nonsense proprietess who 'dealt with the artistic Olympi of both capitals as she would with her household ménagerie'.[2]

Moscow could not boast a Madison Avenue or New Bond Street, but at the beginning of this century it was poised to enter the international art market. At that time Moscow had two important public art museums – the Tretiakov Gallery and the Museum of Fine Arts (later called the Pushkin Museum of Fine Arts); it had two major art schools – the Institute of Painting, Sculpture and Architecture and the Central Stroganov Institute of Technical Drawing, numerous private studios as well as reasonable art supply stores, a good rental exhibition space called the Art Salon (also called the Mikhailova Salon) (sec [19]) and many exhibition societies. By the mid-1900s, then, the Moscow art scene was diverse and potential, although a particular point of emphasis as far as the Moscow merchants were concerned was Impressionism, Art Nouveau and Symbolist painting, and works by artists of the pre-avant-garde such as Pavel Kuznetsov and Mikhail Vrubel enjoyed a particular vogue. Incidentally, radical artists now associated with Cubism, Futurism and abstract painting such as Goncharova and Larionov were also represented in these collections – but by early, moderate works. In any case, both communities, the Modernists painters and their merchant sponsors, were united by their mutual position as the artistic and social avant-gardes of their time, rather like the dissident Realists of the 1870s–1880s *vis-à-vis* Tretiakov. Both parties possessed an entrepreneurial spirit that imparted a constant energy and optimism to their daily lives, and both, in that respect, assumed responsibility for the transformation of Russia's social and cultural institutions. Last but not least, these merchants and their artist friends often enjoyed the same bohemian privileges of all-night parties, tango dancing and occult séances, and their encounters at private homes and clubs played a vital role in the evolution of Moscow's art market, often leading to studio visits, portrait commissions and private subsidies as well as to the direct purchase of works.

Of particular import to the general development of the Moscow art market and to the Russian avant-garde were the collectors Ivan Morozov and Sergei Shchukin, both members of the merchant community.[3] The most celebrated of the Morozovs was Ivan, the owner of textile mills, whose collection of modern Western European paintings achieved international repute. But in addition to his interest in French masters, Morozov also purchased works by young Russian painters, including Goncharova, and Valentin Serov's portrait of him (1910, Moscow, Tretiakov Gallery) indicates the respect and sympathy that he enjoyed among the Russian artists of his time. Starting his collection of French Impressionists and Post-Impressionist pictures only in 1903, Morozov soon owned one of the greatest collections of such art, rivalled only by that of Shchukin. His villa on the Prechistenka, the interior of which was reconstructed along the lines of an art gallery, contained examples of Bonnard, Cézanne, Denis, Gauguin, Matisse, Renoir etc., and by 1917 the number of such works totalled two hundred and fifty. Morozov was in personal contact with many of these artists, and it was on his invitation that Maurice Denis came to Moscow to paint the panneaux for his villa. Morozov's collection of French paintings was catalogued by Sergei Makovsky and published in the journal *Apollon* in 1912, issue no.3–4.

Sergei Shchukin started his equally famous collection of modern Western European art in the late 1890s and within a few years he owned examples of all the principal Impressionists, including Degas, Monet and Renoir, housed in his eighteenth-century villa on Znamenskii Lane. The most valuable part of his collection was a room devoted to Gauguin, although in later years he gave particular attention to the Cubists such as Braque, Derain, Le Fauconnier and Picasso and to artists of rather different trends such as Max Liebermann and Odilon Redon. Like Morozov, Shchukin was in close touch with Western and Russian artists, inviting Matisse to visit Moscow in October, 1911. The catalogue of Shchukin's Western masters was published in 1913 and the entire collection was re-catalogued in 1918 on its transference to the Museum of Fine Arts (Museum of New Western Painting).

Through their collections, Morozov and Shchukin exerted an appreciable influence on the formation of the Russian avant-garde, and Moscow artists such as Goncharova (see [18]) and Larionov (see [29]) paraphrased a number of the Gauguin and Matisse canvases that they examined in these merchants' homes. By and large, however, the Moscow merchants did not favour the extreme artistic manifestations of the avant-garde and expressed little interest in the abstract art of Malevich and Tatlin. Suprematist painting and assemblages of material were too radical even for the new and vigorous class, and the exhibitions and societies that propagated these art forms after 1910, for example, the Jack of Diamonds, were rarely patronized by the Girshmans, the Morozovs, the Riabushinkys and the Shchukins. In fact, the real avant-garde had no developed market, and if the public attended their exhibitions it was out of curiosity and jocularity, not aesthetic delight. After all, how could one take artists seriously who painted their faces and wore wooden spoons in their button-holes?

By 1912 the political mood of Moscow was different from what it had been in 1905–6, when the art of the Symbolist poets and painters had responded to a longing for peace in a society rocked by the first Revolution and the tragedy of the Russo-Japanese War. On the eve of the First World War, the Moscow merchants awoke from their azure dreams, realizing that their way of life was threatened by inevitable and profound changes. This growing unease and insecurity might explain the switch in artistic taste from the unusual in art to historicism and retrospectivism. The return to convention was manifest, for example in the application of the Neo-Classical style to the new villas and dachas of the bourgeois patrons and in their support of more academic or 'Acmeist' values rather than Cubo-Futurism and Suprematism, and Boris Grigoriev's painting (see [21]) enjoyed particular recognition because of this.

With the outbreak of war, this new conservatism among the Russian merchant class strengthened, forcing an irreparable break between their artistic aspirations and the extreme developments of the avant-garde (Malevich painted and exhibited his *Black square* in 1915). By then the circle was fast closing. Surrounded by the subversive logic of Matisse and Picasso, by the grandeur of salon portraits and the erotic bagatelles of the Decadents, the Girshmans, the Riabushinskys, the Morozovs and the Shchukins confronted the October Revolution. The resultant closure of the stock-exchange, the liquidation of assets, the nationalization of private collections, the ban on the exportation of art objects and, above all, the virtual disappearance of the merchant class led immediately to the collapse or at least transmutation of the Moscow art market.

In turn, this sudden disappearance of an entire social class with material means and artistic taste contributed to the emigration of many artists who had relied on it for patronage and commissions. One result of the exodus was that groups of Russian artists converged in the most

4 For information on Russians in Berlin see R. Wiliams, *Culture in Exile*, Cornell University Press (Ithaca) 1972; L. Fleishman et al., *Russkii Berlin 1921–1923*, Paris (YMCA Press) 1983; T. Beyer Jr. et al., *Russische Autoren und Verlage in Berlin nach dem Ersten Weltkrieg*, Berlin (Spitz) 1987; F. Mierau (ed.), *Russen in Berlin*, Leipzig (VEB) 1987
5 E. Roditi, 'Entretien avec Marc Chagall' *Preuves*, Paris, Feb. 1958, p.27

unlikely places as they travelled towards Western Europe, especially Berlin and Paris, and then the Americas. For many Russian artists just after the Revolution, Berlin was the primary destination,[4] where the most diverse personalities, ideas and events could be encountered in the early 1920s, a diaspora of Russian intellectuals and business-people, which culminated in the presence of over a quarter of a million Russian refugees in Berlin by 1923. One consequence of this emigration was a brilliant mosaic of Russian artistic, literary and theatrical enterprises, fragile and short-lived, but vital to the development of the 'other' Russian culture. Altman, Chagall, Grigoriev, Kandinsky, Lissitzky – not to mention their numerous literary colleagues such as Andrei Bely, Ilia Ehrenburg and Viktor Shklovsky – lived and worked in Berlin in the early 1920s, contributing to a cosmopolitan mix of people, ideas, and events: the elegant, but anachronistic *Zhar-ptitsa* [Firebird] magazine, the exhibition of Konstantin Korovin at the Galerie Carl Nicolai in 1923 and Der Blaue Vogel cabaret on the one hand; and the Constructivist review *Veshch/Gegenstand/Objet*, Ivan Puni's one-man show at Der Sturm in 1921 and Tairov's Chamber Theatre on tour in 1923 on the other. As Chagall said of those days:

> After the war, Berlin had become a kind of caravansary where everyone travelling between Moscow and the West came together . . . In the apartments round the Bayrische Platz there were as many samovars and theosophical and Tolstoyan countesses as there had been in Moscow . . . In my whole life I've never seen so many wonderful rabbis or so many Constructivists as in Berlin 1922.[5]

After Berlin, Paris and then New York became the major points for the emigration, and Russian artists, especially the younger generation, contributed to many enterprises. The artistic level of the Russian opera and ballet companies, cabarets, publishing-houses, fashion ateliers, film companies and restaurants where the émigré artists worked was extremely uneven, but the general orientation was towards the decorative effects of the Ballets Russes rather than the severe geometries of the hard-edge avant-garde.

Of course, the general division of Russian art before the Revolution into radical and conservative factions – the avant-garde and the passé-istes – continued, except that the avant-garde now acquired a close association with leftist politics. The *Erste Russische Kunstausstellung* held in Berlin in 1922, for example, was presented and perceived as a Soviet exhibition, even though many of the works had been executed before 1917 and even though it was organized primarily to raise foreign capital rather than as a showcase for the new Russian art. Katherine Dreier, who bought several pieces there, including Malevich's *Knife-grinder* (1914) and Udaltsova's *At the piano (c*1914) (both of which are now at the Yale University Art Museum in New Haven), seems to have been prompted as much by this leftist identification as by aesthetic concerns. But the 1922 exhibition was not the only Russian show and throughout the next decades both the Soviet Union and the émigré community arranged exhibitions of both 'radical' and 'conservative' art – from the *Russian Art Exhibition* at the Grand Central Palace in New York in 1924 to the *Art Russe* at the Palais des Beaux-Arts in Brussels, in 1928.

However inaccurate the association of 'abstract' art with 'Communism', the Suprematism of Malevich and the Constructivism of Rodchenko were long considered to be subversive or 'unaesthetic' and, both in Stalin's Russia and in the West, the Russian art market depended almost exlusively on the art of the past (icons, eighteenth-century portraits) or on the stylized pictures and designs of the *fin de siècle* generation, especially Léon Bakst, Alexandre Benois, Konstantin Somov and Sergei Sudeikin. The main Russian dealers in Paris from the 1930s

onwards, such as Simon Bolan, Alexandre Djanchieff, Lev Grinberg, Isaar Gourvitch, Popoff et Cie and A la Vieille Russie, propagated this particular taste but ignored the avant-garde. Furthermore, those émigrés who are now connected directly with the avant-garde endeavour such as Yurii Annenkov (see [1]), Chagall (see [6]), Alexandra Exter (see [13–15]), Goncharova (see [18–20]), Kandinsky, Larionov (see [29–34]) and Paul Mansouroff (see [41–42]) either made their careers as European artists refusing to align themselves with a specific political system, or quickly entered relative obscurity. Until the 1960s, then, 'modern Russian art' included the late impressionism of Isaak Levitan and the dazzling decorativism of Bakst, the graphic vignettes of Somov and the Art Deco of Simon Lissim, but not the avant-garde, and the few eccentrics who did collect Russian art, such as Mikhail Braikevitch, Abraham Herenroth, Lev Kamyshnikoff and Boris Pregel, supported and promoted this good taste. Curiously enough, the private art market in Stalin's Russia also preferred the golden mean, and such leading collectors as Ilia Zilbershtein in Moscow, Boris Okunev in Leningrad and Aram Abramian in Erevan rarely gave their attention to the avant-garde. Even in the more liberal times of Khruschchev and Brezhnev, the next generation of Russian collectors, for example Nikolai Blokhin in Moscow and Boris Vasiliev in Leningrad, was not especially drawn to abstract art – with the notable exception of George Costakis.

It was in the late 1940s that one collector in particular, Georgii Deonisovich Kostaki, decided to change his orientation from antiquities and Old Master paintings to the Russian avant-garde. Parts of the story of this paradoxical individual and his extraordinary collection of works by the Burliuks (see [5]), Ivan Kliun, Lissitzky (see [36]), Malevich, Popova (see [45–6]), Rodchenko, Rozanova, etc. have been narrated and there is no need to repeat the basic information here.[6] Suffice it to recall that from the 1950s onwards Costakis was the only comprehensive collector of such material either in Soviet Russia or in the West, and while other collectors such as Abram Chudnovsky (see [7]) and Yakov Rubinshtein owned avant-garde works, they could not rival the richness and diversity of the Costakis enterprise.

Baron Thyssen began to assemble Russian works in a consistent and ordered fashion only in the mid-1970s, when artists such as Malevich, Popova and Rodchenko had already become scholarly and commercial commodities, were sought after by museums and private collectors and were included in numerous exhibitions in Western Europe and the United States,[7] and this late start explains a number of the features peculiar to the Collection. For example, by and large the works were acquired not from the artists or their families, but through private galleries and agents specializing in Russian art, such as the Leonard Hutton Galleries in New York, the Galerie Gmurzynska in Cologne, Annely Juda Fine Art in London, and the Galerie Jean Chauvelin in Paris. In some cases, the works were well known – such as Goncharova's *Fishing* [18] or Popova's *Painterly architectonics. Still-life (Instruments)* [45] – and their provenance was clear, but in other cases, the works suddenly appeared in the West after sinuous and sinister journeys from the East. The result was that the itinerary of many works was not recorded or publicized and that the acquisitions were not accompanied by extensive documentation – which has made the task of curatorial description especially difficult. Needless to say, in the 1970s and 1980s this twilight zone provided fertile ground for the dissemination of fabulous rumour, factual error and downright fraud.

6 The main source of information on Costakis and his collection is Rudenstein (1981)
7 Of the many exhibitions of the Russian avant-garde during the 1970s–early 1980s, particular note should be taken of the following: New York, 1971–2; *Progressive Russische Kunst*, Cologne, Galerie Gmurzynska, 1973; London, 1973–4; Cologne, 1974; Cologne, 1975; London, 1976; *Russian Suprematist and Constructivist Art, 1910–1930*, London, Fischer Fine Art, 1976; Cologne, 1977; *Sammlung Costakis*, Dusseldorf, Kunstmuseum, 1977; London, 1977; *Paris–Moscou 1900–1930*, Paris, Centre Pompidou, 1979, *Moskva–Parizh 1900–1930*, Moscow, State Pushkin Museum of Fine Arts, 1981; Cologne, 1979–80; Los Angeles/ Washington, DC, 1980–81; *Art of the Avant-garde in Russia: Selections from the George Costakis Collection*, New York, Guggenheim Museum, and other cities, 1981–3; *Art and Revolution*, Japan, Seibu Museum of Art, 1982
8 Lozowick (1925). Exter's *Still-life* [13] is reproduced there
9 Karpfen (1921)
10 Umanskij (1920)

These circumstances alone would indicate that collecting Russian art, especially the avant-garde, is a complex and hazardous endeavour and, unlike other artistic areas of financial and intellectual commitment, the Russian avant-garde presents the aspiring collector with distinctive problems that both attract and repel. Until the 1960s, for example, there was no firm conception of the 'Russian avant-garde', and although both galleries and auction houses carried scattered works by Lissitzky, Malevich, Popova, Rodchenko and, of course, Chagall and Kandinsky, there was no consistent demand for, or understanding of, the Russian avant-garde. Moreover, before the 1960s there were very few individuals, either in the West or in the Soviet Union, who maintained a particular interest in the subject, although Alfred Barr, Jr, should be remembered for his dedication to the avant-garde at the Museum of Modern Art, New York, and the Ukrainian-American artist, Louis Lozowick, who published the first English-language survey of the subject in 1925,[8] remained an enthusiast throughout his life. In the wake of the October Revolution, other historians living in the West, such as Fritz Karpfen[9] and Konstantin Umanskij,[10] published reports on the new Russian art, but until 1962 Lozowick's *Modern Russian Art* remained the most complete story of that fabulous era. In that year Camilla Gray published her comprehensive study of the Russian avant-garde, *The Great Experiment: Russian Art 1863–1922*, an event that signalled the beginning of a rapid revival of interest in the subject: since then over one hundred and thirty monographs on the subject have appeared in English, French, German, Italian, Japanese and Russian.

The momentum was maintained in July 1970 when Thilo von Watzdorf organized the auction of 'Twentieth Century Russian Paintings, Drawings and Watercolours, 1900–1925' for Sotheby's in London, the first public auction devoted to the Russian avant-garde. This was an intimate sale of ninety-one works by artists such as D. Burliuk, Chagall, Goncharova, Larionov, Malevich and Tatlin, offered to a small audience at low prices (£1,700 for a Goncharova oil, £1,500 for a Malevich Suprematist drawing, £220 for a Tatlin theatre costume, etc.). It was a long way from the pomp and circumstance of Sotheby's sale of 'Russian Avant-garde and Soviet Contemporary Art' in Moscow in July 1988, at which Rodchenko's painting called *Line* fetched £330,000. But the fact that by the early 1960s Sotheby's had delineated a new area of investment and was offering important paintings not only indicated a seriousness of commercial purpose, but also sanctioned the social legitimacy of the field, for the subsequent decade witnessed an unprecedented wave of interest: Sotheby's and then Christie's followed with other auctions, many new publications appeared and galleries such as the Grosvenor Gallery and Annely Juda Fine Art in London, Chauvelin in Paris, Gmurzynska in Cologne and the Hutton in New York organized important exhibitions of the avant-garde. The role of these private galleries in the promotion and appraisal of modern Russian art has been enormous and in many cases the catalogues that they printed for their exhibitions are primary source-books for the study of the avant-garde.

This upsurge culminated in three memorable museum shows – *Russian and Soviet Painting* at the Metropolitan Museum of Art, New York, in 1977, *Paris–Moscou 1900–1930* at the Centre Pompidou, Paris, in 1979, and *The Avant-garde in Russia: 1910–1930* at the Los Angeles County Museum of Art and the Hirshhorn Museum and Sculpture Garden, Washington, DC, in 1980–81. Since then, there have been over one hundred exhibitions devoted to the Russian avant-garde in public and private galleries throughout the United States, Europe, the Soviet Union and Japan. True, just a decade or so ago, the subject was still fraught with the difficulties of territorial access and political bias, but the late Brezhnev and Gorbachev eras witnessed the

Soviets' increasing recognition of the avant-garde as a valuable component of the Russian cultural heritage, and the result was a series of major exhibitions that drew substantially on domestic holdings such as the two-part *Art and Revolution* at the Seibu Museum, Tokyo, in 1982 and 1987, the *Müvészet és Forradalon/Art and Revolution/Kunst und Revolution* at the Palace of Exhibitions, Budapest, and the Museum für angewandte Kunst, Vienna, in 1987–8, and the *Arte Russa e Sovietica* at the Lingotto, Turin, in 1989. These events have been complemented by major restrospectives of artists such as Filonov, Goncharova, Klucis, Larionov, Malevich, Rodchenko and Popova. In turn, prices for Russian abstract or non-objective pieces have increased dramatically, culminating in the record price of £460,000 for Alexandra Exter's *Colour dynamic composition* (1916–17) at Christie's, London, in April 1990.

The market for Russian art boomed in the 1970s, attracting further public attention and introducing major collectors to the field, including Peter Ludwig and Baron Thyssen who bought his first Russian picture, Exter's 1913 *Still-life* [13], in 1973. Other collectors of more modest means also turned to the Russian avant-garde for refreshing additions, although very few American or European museums made a firm commitment to the subject at that time, an oversight that is to be much regretted. However, this new exposure was also accompanied by negative developments: a network of less than scrupulous dealers claimed expertise in a field of which they knew very little, posthumous masterpieces and reconstructions multiplied, undermining the integrity of the traditional market, and entire legacies (Ilia Chashnik, Vasilii Ermilov, Larionov, Nikolai Suetin, etc.) sometimes authentic, sometimes not, emigrated from the Soviet Union to the West.

This context leads us directly to one of the most vexed questions accompanying the recent rediscovery of the Russian avant-garde and the Thyssen Collection. In this catalogue raisonné of the Thyssen-Bornemisza Russian and East European Collection, the reader will notice the absence of certain famous pieces, once attributed to Goncharova, Ivan Puni and Rodchenko, which had been exhibited, reproduced and described during the 1970s and 1980s as major examples of the Russian avant-garde. However, art-historical and technical investigation now demonstrates that these traditional attributions are inaccurate and for this reason the works have been excluded from the Catalogue. Moreover, the legitimacy of several other pieces, attributed traditionally to Chashnik, Kogan and Lebedev, is now in question, although, biding the results of further research, they are still included in the list. The beautiful *Axonometric painting* [27], formerly attributed to Gustav Klucis, is, unfortunately, a case in point, and, although most hard evidence undermines this ascription, the work is still mentioned under Klucis – more as a caveat and a signal of the complexity of this problem than as a confirmation of previous curatorial assumptions. A catalogue raisonné of this kind is bound to take account of the problem, even if it touches on many delicate issues and affects many people.

These misattributions, deliberate or not, relate to an extremely difficult problem that has accompanied the buying and selling of much Russian art in the West – the frequent impossibility of tracing the provenance, if the work was from a Soviet source. From the 1960s to the 1980s it was illegal for a Soviet citizen to sell a work of art privately for foreign currency and those transactions that did take place between an individual and a Western dealer were made in the strictest confidence. The exportation of works of art from the Soviet Union without special permission was also considered a crime, so that many works reached the West as contraband.[11] Consequently, the provenance often could not be made public and even when the original Russian owner of a work was and is known – Ilia I. Chashnik (see [7] and [9]),

11 For some information on the exportation of Russian art to the West see Williams (1980)

Costakis (see [45]), Anna Leporskaia (see [39]) – the transaction cannot be verified, because the relevant individual has died. Moreover, until very recently the avant-garde holdings of Russian and Ukrainian museums were regarded virtually as state secrets and were not readily accessible – something that made detailed comparative research impossible – even though it now transpires that several major names such as Chashnik, Kogan and Suetin are, in any case, scarcely represented in Russian museums.

The above conditions help to explain the invasion of the art market by 'alien bodies' attributed to Chashnik, Larionov, Lebedev, Malevich, Popova, Puni, Rodchenko, etc., especially examples of geometric abstraction. These paintings and drawings, often elegant and well finished, receive their pedigree through inclusion in museum exhibitions, auctions and publications, and the more closely they are associated with a particular artist, the harder it becomes to remove them from the *oeuvre* of that artist and from the collection to which they belong. That Baron Thyssen has agreed to expose this intervention is a tribute to his perspicacity, and it is to be hoped that his example will lead to the detection and removal of the many dubious elements from other collections of Russian art, private and public, Russian and Western. Be that as it may, the masterpieces by Chagall and Exter, Goncharova and Kliun, Malevich and Popova, to mention just a few of the Russian artists in the Thyssen-Bornemisza Collection, represent a depository of artistic values that, in many cases, were long threatened with neglect and imminent destruction. Because of the socio-political conditions of both the Soviet Union and the Russian diaspora, individual artists as well as entire artistic movements often went unrecognized. Thanks to the enthusiasm of the Baron, many names and artistic achievements have been saved from oblivion to assume their legitimate position in the history of Russian culture.

Notes on the catalogue

The sequence is in alphabetical order according to artist, regardless of nationality.
Signatures and other inscriptions are in Latin letters, unless stated otherwise.
Medium of the comparative works mentioned is oil on canvas, unless stated otherwise.
Dimensions are given in centimetres, height preceding width.
Cross-references to catalogue entries are referred to in square brackets.

Titles of the works

As regards the titles of the works in the fifty-nine entries below, we have followed the argumentation and format presented in previous volumes of the Catalogue (cf. Peter Vergo, *Twentieth-century German painting*, London, Sotheby's Publications, 1992, p.23): when the title of the work is known either through the artist's own inventory list, through reliable indications on the reverse of the work or through exhibition documentation from the artist's lifetime, this has been given in the original language preceded by the English translation. In the absence of such sources, the title with which a work was known previously in the public domain and with which it entered the Collection has been presented as its current identification.

Comparative material

The entries below contain many references to parallel, supplementary and subsidiary works in public and private depositories. A number of the pieces in the Thyssen-Bornemisza Collection exist in several preparatory variants and versions and, where relevant, these have been quoted, described and/or reproduced in the main text. As is often the case with the Russian and Hungarian avant-gardes, some of these paintings and drawings have assumed later titles and dates, are of debatable origin, and are not always by the artists to whom, traditionally, they have been ascribed. Consequently, comparative analysis is rendered especially complex by the presence of such inaccurate and misleading curatorial data, but, even so, we have found it judicious to include substantial ancillary material, even when there is concrete evidence to assume that the complement reproduced is a fake or a reconstruction.

Our immediate task, however, has been to describe, categorize and sanction the validity of the fifty-nine Russian, Hungarian and Polish works in the Thyssen-Bornemisza Collection and not to comment on the validity of the supplementary materials. Consequently, in reproducing parallel examples, we do not comment upon the traditional curatorial data regarding authenticity, attribution, date, title, technique, etc., since to do so would require separate studies of each individual complement. At the same time, the reproduction and repetition of this information does not indicate that we accept and are in agreement.

Translation and transliteration

Only the titles of the principal Russian, Hungarian and Polish bibliographical references are translated in the text. Since much of the supportive material is described or mentioned in Russian sources, the bibliographical details are provided, but rarely the translation, the assumption being that, if the reader does not know Russian, the contents of a Russian publication will be meaningless, even with the title translated into English.

The transliteration modifies the Library of Congress system, and the Russian soft and hard signs have either been omitted or rendered by an 'i' (e.g. Grigoriev). This system is also used throughout the footnotes and the bibliographical data where references involve Russian language sources. This catalogue will be used by people who appreciate the visual arts, but who, for the most part, do not know Russian. Consequently, we have avoided the more sophisticated academic transliteration systems that, to the layman, render a recognizable name (eg. Chashnik) unrecognizable (eg. Čašnik). Many of the Russian artists and writers mentioned in this book spent part of their lives in Europe or the United States and often their names received various, even contradictory, transliterations from the original Russian into the language of their adopted home. For the sake of uniformity, however, we have transliterated the names in accordance with the above system, even when the work may be signed with a contrary spelling. The only exceptions to this are El Lissitzky, Paul Mansouroff and Marie Vassilieff who are known and recognized in the West by this spelling of their names and not as 'Lazar Lisitsky', 'Pavel Mansurov' and 'Mariia Vasilieva'.

Dates referring to events in Russia before January 1918, are in the Old Style and are, therefore, thirteen days behind the Western calendar.

The city of St Petersburg was renamed Petrograd in 1914, Leningrad in 1924, and then St Petersburg again in 1992. However, both the names Petrograd and Petersburg continued to be used freely in common parlance and in publications until 1924. As a general rule, however, Petrograd has been retained here as the official name of St Petersburg for the period 1914–24.

The Christian name and surname of an individual are given in full when he or she is first mentioned in a given section or chapter. Subsequent references to the individual carry only the surname.

Abbreviated references in the catalogue entries may be found in full in the Select Bibliography, the individual artists' bibliographies or the Abbreviations List.

Abbreviations see p.300.

Glossary of terms and acronyms see p.302.

List of works

Note on the comparative illustrations

Our immediate task has been to describe, categorize and sanction the validity of the fifty-nine Russian, Hungarian and Polish works in the Thyssen-Bornemisza Collection and not to comment on the validity of the supplementary materials. Consequently, in reproducing parallel examples, we do not comment upon the traditional curatorial data regarding authenticity, attribution, date, title, technique, etc., since to do so would require separate studies of each individual complement. At the same time, the reproduction and repetition of this information does not indicate that we accept and are in agreement.

Yurii Pavlovich Annenkov 1889–1974

1 The Cathedral of Amiens

1919
Collage (wood, cardboard, photograph and wire on paperboard), 71 × 52 cm
Signed and dated in Russian lower right: 'Yu. Annenkov 1919'
Scattered surface abrasion. Foxing and discolouration of paper and carboard surfaces. Fragile elements are in an
 unstable condition
Accession no.1981.72

Provenance
Private collection, Saint-Maur-des-Fossés
J.Hugues, Paris
Chalette Gallery, New York
Leonard Hutton Galleries, New York
Thyssen-Bornemisza Collection, 1981

Exhibitions
London/Austin 1973, p.21, illus. pl.5 and cover
21 April–2 June 1978, New York, Leonard Hutton Galleries, *Twenty-five Masterpieces of German Expressionism and
 the Russian Avant-garde*, unnumbered
9 March–6 May 1979, New York, Solomon R.Guggenheim Museum, *The Planar Dimension 1912–1932*, no.83,
 colour illus. p.118
Los Angeles/Washington, DC, 1980–1, no.6, illus. p.127
Leningrad/Moscow, 1988, no.1, colour illus. p.29

Literature
G.Veronesi, 'Suprematisti e Costruttivisti in Russia', *L'Arte Moderna*, Milan, VI, no.48, 1967, colour illus. p.90 [as
 Souvenirs]
A.del Guercio, *Le avanguardie Russe e Sovietiche*, Milan (Fabbri) 1970, colour illus. no.LVIII, p.84
E.Saxon, 'Planar Constructions and the Planar Dimension', *Artforum*, XVII, no.10, New York, Summer 1979,
 colour illus. p.59
P.King, 'Move over Picasso – Here Comes the Russian Avant-Garde', *Los Angeles Herald Examiner* (California
 Living Section), 6 July 1980, colour illus. p.7
A.del Guercio, *Russische Avantgarde von Marc Chagall bis Kasimir Malewitsch*, Herrsching (Schuler) 1988, colour
 illus. no.58, p.82

Before the Revolution, Annenkov was closely connected to the artistic and literary worlds of St
Petersburg, although at that time he was recognized primarily as a stage designer. For example,
he was a regular contributor of stage designs to the St Petersburg cabaret called the Crooked
Mirror between 1913 and 1915, one of several intimate theatres active in St Petersburg and
Moscow just before and after the Revolution. Annenkov also contributed to Vera Komissar-
zhevskaia's theatre, where he designed Dickens's *A Christmas Carol* (1914) and Fedor Sologub's
Night Dancers (1915). Perhaps Annenkov's most famous production was his decorative scheme
for *The Storming of the Winter Palace*, a mass spectacle by Nikolai Evreinov, Alexander Kugel,
Konstantin Derzhavin, Dimitrii Temkin and Nikolai Petrov. Presented in the Winter Palace
Square, Petrograd, 6 November 1920, with designs by Annenkov and music by Gugo Varlikh,
The Storming of the Winter Palace was a dramatic re-enactment of the storming of the Winter
Palace during the October Revolution, involving 6,000 actors, 500 musicians and 100,000
spectators.

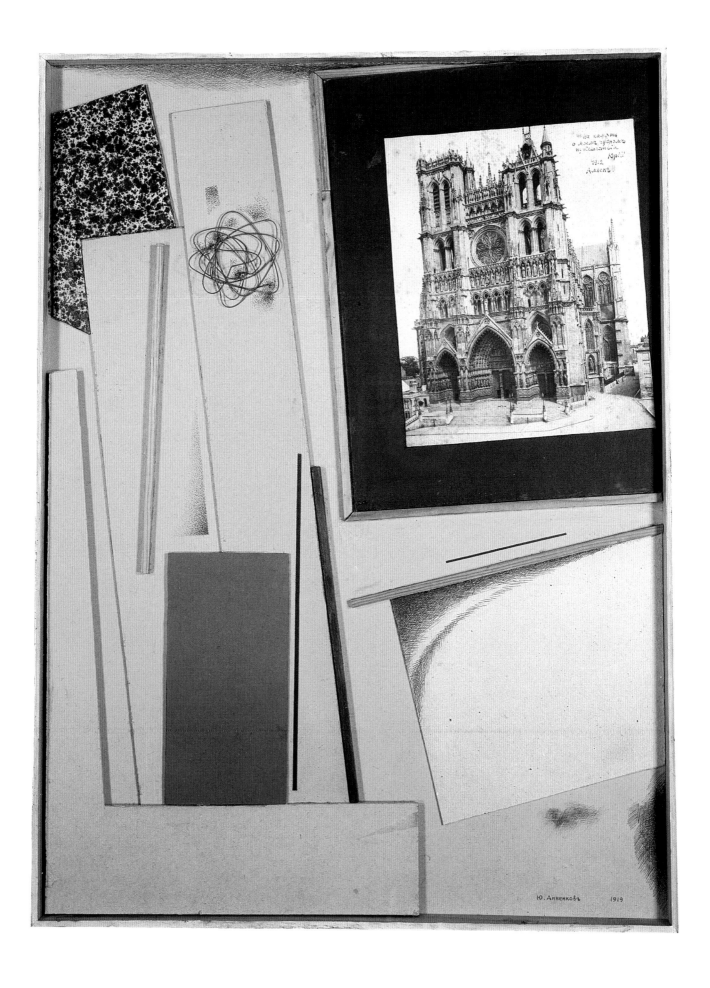

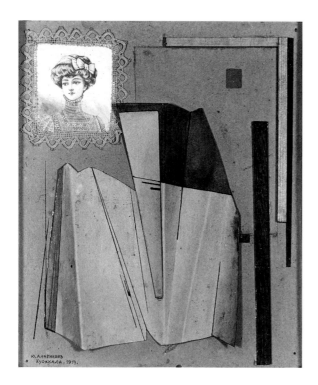

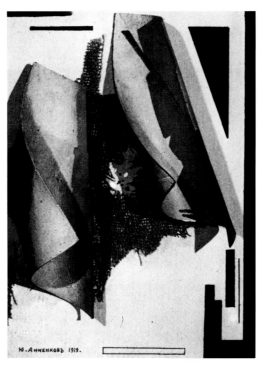

FIG 1 Yurii Annenkov, *Untitled*, 1917, 39.5 × 33.5 × 2.5 cm, collage, assemblage, ink, watercolour on board (Ludwigshafen-am-Rhein, Wilhelm-Hack Museum)

FIG 2 Yurii Annenkov, *Relief collage*, 1919, 33 × 24 cm, paper, canvas and ink (New York, Museum of Modern Art)

However, one of the most remarkable fields of endeavour in Annenkov's artistic career was his portraiture. From the very beginning, Annenkov liked to depict his social and cultural contemporaries – playwrights, actors and writers, including Anna Akhmatova, Natan Altman, Abram Efros, Evreinov, Georgii Ivanov, Lenin, Viktor Shklovsky and Sologub, and many of these likenesses were included in the book *Portrety* [Portraits] which carried appreciations by Mikhail Babenchikov, Mikhail Kuzmin and Evgenii Zamiatin,[1] as well as in Annenkov's two volumes of memoirs. Annenkov arrived at his peculiarly 'prismatic' style through various routes – his training in French Cubism, his interest in photography and his perception of objects and specific details as 'externalizations' of character – an approach that earned him the title of 'Neo-Realist', along with other St Petersburg artists such as Alexandre Jacovleff, Vasilii Shukhaev and Boris Grigoriev (see [21]).[2] The poet Mikhail Kuzmin wrote of Annenkov:

> Apart from transmitting the outer movements, ... Annenkov is most inclined to convey the mobile elements, the wavering atmosphere, the vital current issuing forth from his immobile model (animate or inanimate).[3]

Zamiatin noted the following as he looked at Annenkov's graphic renderings:

> ... they are Japanese four-line *tankas*, they are models of how to present the synthetic image. They contain a minimum of lines, just a dozen lines or so – you can even count them. But these dozen lines or so have as much creative tension as yesterday's art had in a hundred or so.[4]

While not a central supporter of the Cubo-Futurist and Constructivist movements, Annenkov was certainly in close touch with artists such as Mikhail Larionov, Mikhail Matiushin, Olga Rozanova (see [49–50]) and Vladimir Tatlin and was a member of the Union of Youth in St Petersburg. He was always deeply concerned with the intrinsic qualities of art, especially with the expressive quality of line. Like many of his colleagues, Annenkov also experienced the general orientation toward industrial art in the early 1920s, contending that 'art will attain the high-point of its flowering only after the artist's imperfect hand has been replaced by the precise machine'.[5] Some of Annenkov's compositions of this time were, in fact, geometric and non-objective. But, in spite of this brief interest in machine art, Annenkov achieved his greatest results in portraits and book illustrations, especially in his masterly drawings for Alexander Blok's poem *Dvenadtsat* [The Twelve] (1918). Annenkov had many

Notes
1 Yurii Annenkov, *Portrety*, Petrograd (Petropolis) 1922; repr. Strathcona Publishing Co., Royal Oak, n.d. [?1978]
2 E. Zamiatin, 'O sintetizme', ibid., p.24
3 M. Kuzmin, 'Kolebaniia zhiznennykh tokov', ibid., p.48
4 Zamiatin, op. cit., p.39
5 Yurii Annenkov, 'Estestvennoe otpravlenie' in *Arena. Teatralnyi almanakh*, Petrograd (Vremia) 1924, p.114
6 For similar Annenkov collages see the one entitled *Collage* in the collection of the Indiana University Art Museum, Bloomington, IN (1919, 42 × 22 cm, mixed media) and *Objects in a wooden box* (1921, 39 × 26 cm), auctioned as lot 102 at Sotheby's, 4 July 1974
7 See, e.g., *Cathedral arches* (c. 1930, 133 × 97.5 cm, oil on canvas) sold as lot 395 at Christie's, 10 Oct 1990

imitators, and his influence as a decorator and graphic artist can be traced in the work of several important stage and book designers of the 1920s, for example Nikolai Akimov and Valentina Khodasevich.

The Cathedral of Amiens is one of several reliefs that Annenkov produced between 1918 and 1921. For example, it bears a close formal relationship to the untitled collage dated 1917 in the Wilhelm-Hack Museum, Ludwigshafen-am-Rhein (fig.1), and to the 1919 *Relief collage* in the Museum of Modern Art, New York (fig.2). The 1921 *Untitled collage* carrying part of a page from the journal *Zhizn iskusstva* [Life of Art] (see [10 and 41]; fig.3) also shares common features and the collage in the Wilhelm-Hack Museum manifests the same polemic between tradition and innovation as *The Cathedral of Amiens*. The placing together of a greetings-card beauty or a butterfly and a severe abstract composition evokes the double – and ironic – sensation of nostalgia and revolution, as does the reference to a famous symbol of Christianity (Amiens Cathedral) rendered at a time of atheist Revolution. In any case, the care and sobriety with which Annenkov has combined these elements bear strong witness to his aesthetic elegance and sense of measure.[6]

Like *The Cathedral of Amiens*, these works are also signed in the pre-reform Cyrillic orthography and all carry similar stylistic elements in their geometric composition, such as the juxtapositions of thin wooden oblongs and strong graphic lines. *The Cathedral of Amiens* is distinctive, however, in its focus on a specific architectural monument that, obviously, held great fascination for Annenkov. In fact, this particular work can be 'read' as a double interpretation of the subject, as a documentary representation (the attached photograph on the right) and as an abstract rendering on the left, with the strong verticals and the compass flourish repeating the towers and rose window of the Cathedral. The Russian inscription in Annenkov's hand below the photograph of the cathedral reads: 'In memory of my wonderful journey. Yurii, 1912. Amiens'. In 1911–22 Annenkov lived in Paris, studying under Maurice Denis and Félix Vallotton, although the exact circumstances of this personal dedication are not known, and he makes no reference to Amiens in his diaries and memoirs, even though he returned to the theme later on.[7] In emigration Annenkov tended to make copies of earlier works and antedate existing ones; some scholars such as Alexander Borovsky (St Petersburg) and Dmitrii Sarabianov (Moscow), have raised doubts about the dating of *The Cathedral of Amiens*.

Sándor Bortnyik 1893–1976

2 Composition no. 2. Pink and blue

1921
Gouache on paper, 28 × 21 cm
Signed lower right in pencil: 'Bortnyik'
The thin and poor-quality paper is slightly discoloured. The piece had been folded in four and repairs have been
 carried out on the reverse, but the general condition is good
Accession no.1981.15

Provenance
The artist's estate
Private collection, Milan
Sotheby Parke Bernet, London
Thyssen-Bornemisza Collection, 1981

Exhibitions
Ungarische Avantgarde 1971–2, illus. no.69 [unpaginated]
Berlin 1977, no.1/203, p.1/124

Literature
Sotheby Parke Bernet, London, 2 April 1981, lot 210

To a considerable extent, it was the Hungarians and the Poles who assimilated certain concepts of the Russian avant-garde artists, developed them and expanded them into multifarious and original applications. Certainly, it would be misleading to try and locate particular, reocognizably 'Russian' influences in the works of Henryk Berlewi, Bortnyik, Lajos Kassák, László Moholy-Nagy or Władysław Strzemiński, for both the Hungarians and the Poles were well aware of French, German and Italian movements – perhaps even more so than their Russian colleagues – and they drew freely on these ideas. But it was precisely in 1921–2, the date of Bortnyik's *Composition*, that international Constructivism suddenly impinged upon the hybrid of local European styles that the Hungarians and Poles, at least, had concocted from French Cubism, German Expressionism and Italian Futurism during the 1910s. Berlewi moved from his Cubist and Dada painting to his Mechano-Faktur researches, Bortnyik replaced his Synthetic Cubism with geometric abstractions and both Kassák and Moholy-Nagy yielded their Expressionist urges to the cool geometries of Constructivism.

Like Moholy-Nagy (see [43–4]), Bortnyik also recognized the importance of Malevich's Suprematism through Lissitzky's interpretations, which he discussed with his colleagues in Vienna and Berlin in the early 1920s. The abstract conditions of geometric tension and displacement manifest in *Composition* bring to mind Lissitzky's *Prouns* (see [36–8]), and in the simple juxtapositions of diagonals and verticals, circles and quadrilaterals, Bortnyik seems to be formulating a new formal alphabet or 'molecular' rearrangement much in the way that Malevich was doing in his *Suprematism. 34 Drawings* of 1920. Indeed, the Bildarchitektur compositions in Bortnyik's *MA* album of 1921 can be regarded as the same kind of elementary sequence as Lissitsky's and Moholy-Nagy's Kestner portfolios of the early 1920s (see [43]), even though the influence was surely mutual, for we find Lissitzky designing a cover for *MA* in 1922.[1]

Note
1 El Lissitzky designed the cover for *MA*, Vienna VII, no.8, August 1922. For a reproduction see *El Lissitzky: Architect, Painter, Photographer, Typographer* (exh. cat. Eindhoven, Municipal Van Abbemuseum, and other institutions, 1990), p.154, no.83. See [24]

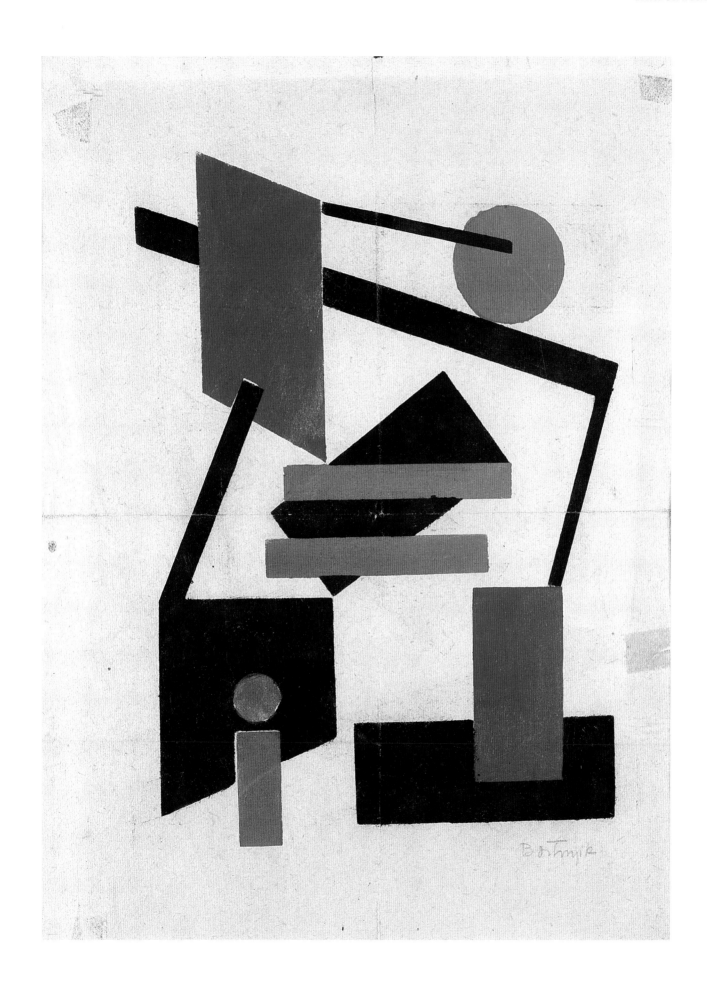

Sándor Bortnyik 1893–1976

3 The twentieth century
XX Szazad

1927
Oil on canvas, 85 × 77.5 cm
Signed and dated lower right: 'Bortnyik 1927'
On the reverse in Hungarian: a label with the words 'Bortnyik Sándor "XX Szazad"' [Sándor Bortnyik '20th
 Century'] and a customs' export permission no.31
The lower edge and sky areas reveal numerous repairs, but the general condition is good
Accession no.1978.61

Provenance
The artist
Galerie Gmurzynska, Cologne
Thyssen-Bornemisza Collection, 1978

Exhibitions
Cologne 1975, no.12, illus. p.53
Recklinghausen 1977, Städtische Kunsthalle (Ruhrfestspiele), *Fliegen – ein Traum*, no.33
Cologne 1986, p.178
Luxembourg/Munich/Vienna 1988–9, no.2, colour illus. p.27

Bortnyik produced this homage to the twentieth century after he had returned to Budapest from his long travels in Austria and Germany, and it demonstrates the influence of many aesthetic systems. The general composition of strong geometric placements and displacements, evoking an ambiguity rather than a definition of place, seems to extend the physical and temporal suspensions of Lissitzky's *Prouns* (see [36–8]) which, of course, Bortnyik knew first-hand from his encounters in Germany. In fact, Bortnyik's Bildarchitektur paintings of the early 1920s are often clear paraphrases of Lissitzky's forms and figures (fig.1), and echo Lissitzky's own description of the *Prouns* – 'as a station on the way to constructing a new form'.[1] The emphasis of *The twentieth century* is, of course, on technology, symbolized here by the aeroplane or by the train in Bortnyik's *Red locomotive (train leaving a tunnel)* (1918; fig.2) – a gesture to industrial progress repeated in many works of the avant-garde, from Malevich's *Aviator* (1914, St Petersburg, State Russian Museum) to Alexander Tyshler's *Woman and an aeroplane* (1927, Moscow, Denisov Collection). The implied promotion of the 'New Man' (the robotic, cool and immortal boxer) also connects to a rich tradition of athletic imagery explored by the European and Russian Modernists – from Farkas Molnár's boxing fresco of 1924 (destroyed) to Alexander Deineka's *Morning exercises* (1932, Moscow, private collection). In any case, Bortnyik's particular definition of the New Man here paraphrases the Triadic figures of Oskar Schlemmer and the reduced mechanical anatomies of Willi Baumeister which he studied during his affili-ation with the Bauhaus, and it was a concept – of the human automaton and the total still-life – that he repeated in other works of the time such as *The new Adam* of 1924 (fig.3) which,

Note
1 Quoted by I.Ehrenburg *A vse-taki ona vertitsia*, Berlin (Gelikon) 1922, p.85

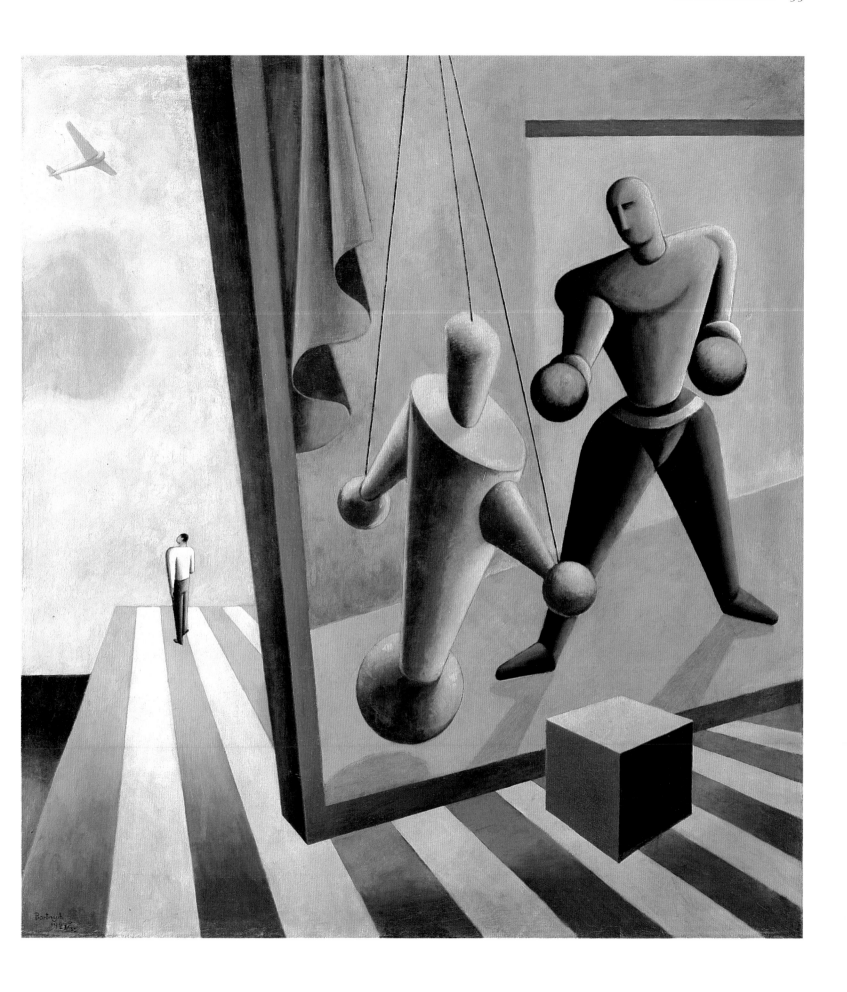

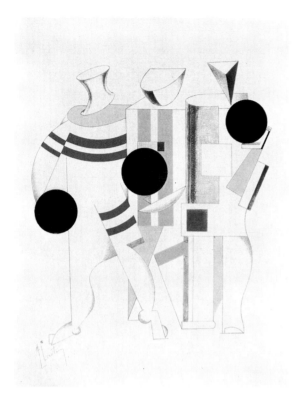

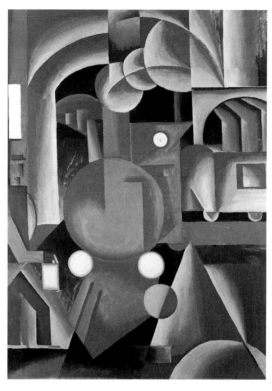

FIG 1 El Lissitzky, *Three sportsmen*, 52 × 44 cm, coloured lithograph; fig 6 from *Die plastische Gestaltung der Elektro-Mechanischen Schau 'Sieg über die Sonne'*, *1920–21*, Hanover, Leunis and Chapman, 1923 (London, Collection Nina and Nikita D. Lobanov-Rostovsky)

FIG 2 Sándor Bortnyik, *Red locomotive (train leaving a tunnel)*, *1918*, *125 × 89.5* cm, tempera on composition board (New Haven CT, Yale University Art Gallery; gift of Collection Societé Anonyme)

FIG 3 Sándor Bortnyik, *The new Adam*, *1924*, 48 × 38 cm, oil on canvas (Budapest, Hungarian National Gallery)

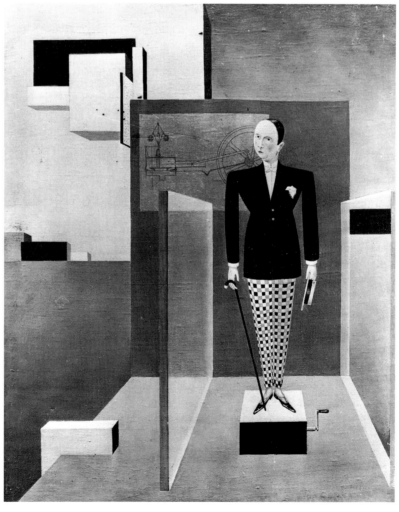

FIG 4 Sándor Bortnyik, *The green donkey*, 1927, 60 × 55 cm, oil on canvas (Budapest, Hungarian National Gallery)

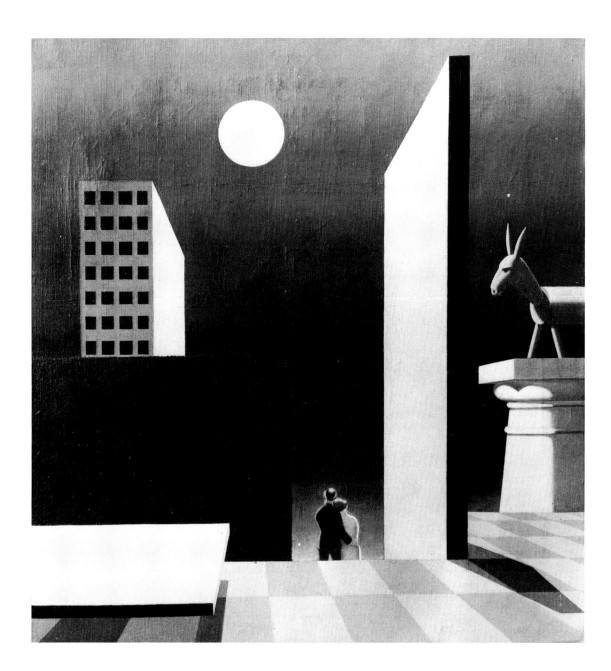

incidentally, includes the image of Lissitzky's *Proun 1C* (see [36]). At the same time, Bortnyik envisaged the encroachment of 'scientific' control over instinct and the isolation of the human being in an increasingly mechanized world – a suspension of normal relationships that evokes the magic mood of de Chirico and and the streamlined luminosity of Léger. Bortnyik described a similar foreboding, twilight zone in other paintings of the mid-1920s such as *The green donkey* (1924) (fig.4).

 The twentieth century serves as a digest not only of contemporary themes such as transport, industry and the anonymous regimentation of mankind in the Machine Age, but also of contemporary art styles from Constructivism to Surrealism. At the same time, Bortnyik celebrates the 'return to order' or, rather, the return to the Purist order advocated by Jeanneret and Amédée Ozenfant (see [14], fig.2) and reflected in much Russian and East European painting of the 1920s – from Exter (see [14]) to Kliun and Ivan Puni.

David Davidovich Burliuk 1882–1967

4 Landscape

1912
Oil on canvas, 33 × 46.3 cm
Signed and dated bottom left: 'D.Burliuk, 1912'
The reverse carries part of a label from the ACA Galleries, New York
The work has been relined with wax and resin, although the stretcher seems to be the original one. The varnish is
 separating and becoming milky in the black area, but the general condition is good
Accession no.1978.78

Provenance
Artist's family
Ella Freidus through the ACA Galleries, New York, 1959[1]
Private collection
Sotheby Parke Bernet, New York
Andrew Crispo Gallery, New York
Thyssen-Bornemisza Collection, 1978

Exhibitions
31 Oct.–18 Nov. 1967, New York, ACA Galleries, *David Burliuk: Selections from Various Periods*, no.5, illus. p.5
Los Angeles/Washington, DC, 1980–81, no.328, illus. p.241
Leningrad/Moscow 1988, no.5, colour illus. p.33

Literature
Sotheby Parke Bernet, 3 Nov. 1978, lot 304
J.Bowlt, ed., *A Slap in the Face of Public Taste. A Jubilee for David Burliuk and the Cause of Russian Futurism*, special
 issue of *Candian-American Slavic Studies*, xx, no.1–2, Irvine, 1986, p.162, fig.22

No history of modern Russian culture can be written without considerable reference to the life and work of David Burliuk who exerted a profound and permanent influence on the development of the avant-garde. As his friend, the poet and painter Vasilii Kamensky, recorded: 'The name of David Burliuk was, and always is, an international name, like the sun in the heavens'.[2] Put differently, David Burliuk was, as Kandinsky called him, the 'father of Russian Futurism'.[3] He was in close contact with the radical artists and writers of his time, although many of them fell out with him owing to his some times overexuberant character, and in the late 1900s and early 1910s he organized or co-organized many of the Cubo-Futurist happenings – art exhibitions, public debates, poetry declamations, publishing-houses. All in all, David Burliuk was a man of inexhaustible energy, playing the role of poet, painter, theorist, buffoon and impresario to the full.

The chronology of Burliuk's apprenticeship as a painter is difficult to establish, in part because he liked to antedate and postdate pictures and also because he left behind many works in various towns as he and his family trekked across Russia and Siberia in 1918–19. Undoubtedly, as a student in Munich and Paris in the early 1900s, he looked carefully at *Jugendstil* and Art Nouveau and, like his brother Vladimir, seems to have been attracted to the *pointillisme* of Paul Signac and Henri Charles Manguin. Even the *Landscape* of 1912 still carries the tell-tale 'spots' that Burliuk sprinkled liberally throughout his works of all periods (cf. *Dnestrov Rapids*, c1910; fig.1). Another crucial moment in David's evolution was the spring of 1910 when, in Moscow, he saw the collections of modern French art belonging to Ivan

Notes
1 According to a letter from Ella Freidus to Irene Martin of the Thyssen-Bornemisza Collection, Lugano, dated 19 Feb. 1992, Burliuk signed the painting during the 1959 transaction
2 Letter from Kamensky to David Burliuk dated 23 Jan. 1927; published in David Burliuk, *Entelekhizm*, New York (Burliuk) 1930, p.3
3 This unlikely statement is ascribed to Kandinsky in the exh. cat. *Oils, Watercolors by David Burliuk*, New York, 8th Street Gallery, 1934, p.3

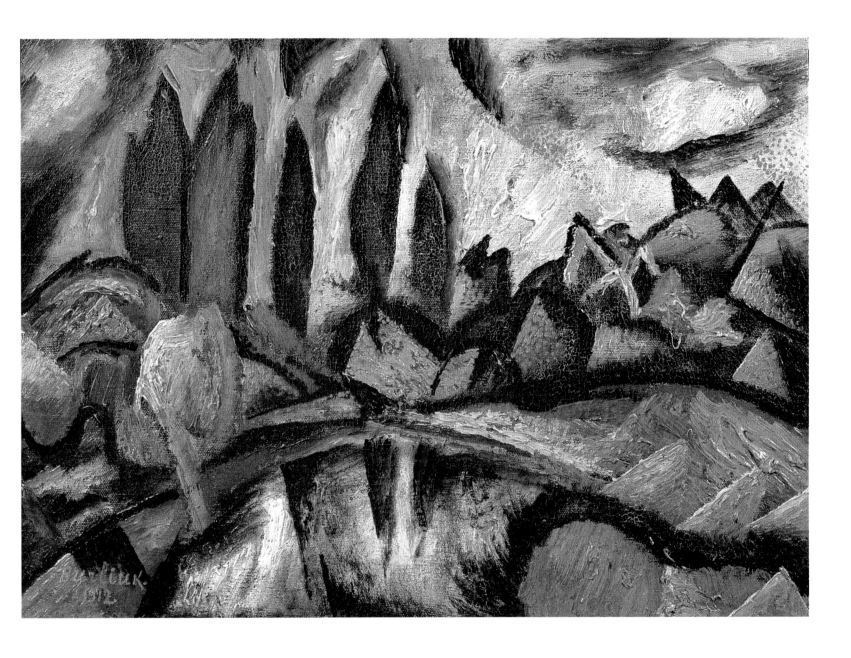

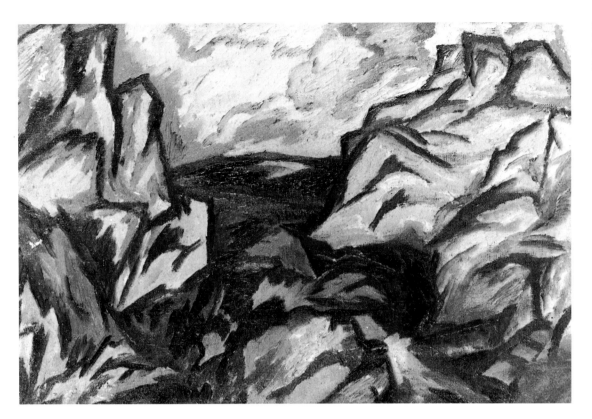

FIG I David Burliuk, *Dnestrov Rapids*, *c*1910, 49 × 65.5 cm, oil on canvas (St Petersburg, State Russian Museum)

Morozov and Sergei Shchukin, after which, as he wrote to Mikhail Matiushin, 'all our old things have been scrapped. Gosh, how difficult, but how heartening it is to start again'.[4] It was then that he saw primary works by Cézanne, Gauguin, Matisse, Picasso and Rousseau. Parallels manifest themselves not only in the choice of theme such as wild landscapes, 'barbaric' peoples and ancient legends, but also in the vivid colour combinations and primitive outlines. But Burliuk was not content with borrowing from the West, and, like his Russian colleagues, he also paid close attention to indigenous art forms, especially the signboard, the naive painting, the icon, the handpainted tray and the *lubok*. The result was sometimes an eclectic mix of Cubism, Futurism and Ukrainian folklore as in the *Bridge. Landscape from four points of view* (1911, 97 × 131 cm, St Petersburg, State Russian Museum) or of commercial kitsch as in so many of the later American works. Ivan Narodnyi, an important poet and critic of the early New York emigration, once said of Burliuk's painting:

> It is an art not to be enjoyed, but feared. It either stimulates or depresses the ocular sense of the eye, and acts like a narcotic drink.[5]

An extreme sentiment, perhaps – but Burliuk's painting does possess a raw vitality and rough strength that link it organically to the archaic fastnesses of his native Ukraine and to the steppes of Chernianka, where he grew up. The absurd proportions of Burliuk's artistic production – an apocryphal 10,000 paintings and drawings from the period 1900–18 – also extend the 'Homeric' proportions of the Chernianka life-style.[6] When, in his poetical description of Burliuk, Velimir Khlebnikov mentioned:

> scarlet paintings, hanging next to green ones, heavily and somberly; others walking like hills, like black sheep, excited by their hairy, uneven surface,[7]

he elicited the primitive force of Burliuk's art.

Perhaps *Landscape* was also done at Chernianka on Count Mordvinov's estate which Burliuk's father managed, although, with its apocalyptic overtones (the ominous sky and red houses), it differs from the more usual, lighter evocations of the local farms and steppes (cf. *Red*

Notes
4 Letter from David Burliuk to Matiushin; quoted in N.Khardzhiev and V.Trenin, *Poeticheskaia kultura Maiakovskogo*, Moscow (Iskusstvo) 1970, p.31
5 I.Narodny, 'The New Icon' in *American Art of Tomorrow*, ed. Mariia Burliuk, New York (Burliuk) 1929, p.7
6 This is how Benedikt Livshits described the life-style at Chernianka. See Bowlt/Livshits (1933/1977), p.45
7 V.Khlebnikov, 'Burliuk' (1921); quoted in Khardzhiev and Trenin, op. cit., p.46

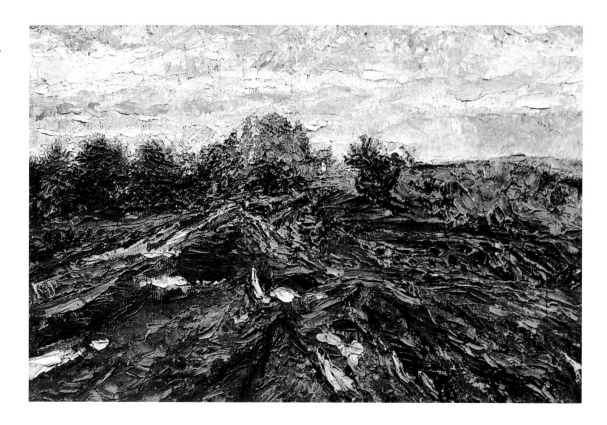

8 Bowlt/Livshits, op. cit., p.51
9 David Burliuk, 'Faktura' in
*Poshchechina obshchestvennomu
vkusu*, Moscow (Kuzmin) 1912,
pp.108–10; Eng. trans. in Los
Angeles/Washington, DC,
1980–81, p.130
10 N. [= D.] Burliuk, 'Kubizm' in
*Poshchechina obshchestvennomu
vkusu*, op. cit., pp.95–101; Eng.
trans. in Bowlt (1988), pp.70–77
11 Quoted in A. and L. Vezin,
Kandinsky et le cavalier bleu, Paris
(Terrail) 1991, p.175–6; original
source not provided
12 David Burliuk, 'Die "Wilden"
Russlands' in W. Kandinsky and
F. Marc, eds, *Der Blaue Reiter*,
Munich (Piper) 1912, p.18; Eng.
trans., K. Lankheit, ed., *Wassily
Kandinsky and Franz Marc. The
Blaue Reiter Almanac*, New York
(Viking) 1974, p.77. David
Burliuk's painting, *Head. Portrait
of the artist's mother* (now lost)
was also reproduced there (p.18/
p.78)

earth, 1909, St Petersburg, Shuster and Kriukova Collection). In this sense, its mood has more in common with the darker strains of German Expressionism and the Blaue Reiter. In any case, *Landscape* is a serious work (and many of Burliuk's works are not), for it demonstrates the artist's careful manipulation of texture or finish (*faktura*), an avenue of enquiry that many of the avant-garde artists and writers followed in the 1910s. As early as 1911, according to the poet Benedikt Livshits,[8] David and his brother Vladimir (see [5]) were already rolling their paintings in the black earth of Chernianka in order to impart a more striking *faktura* to the surface – something that underscores their tactile, sensuous attitude towards the act of painting which is reflected in the agitated, Expressionist landscapes of the early 1900s such as *Landscape* (fig.2). In 1912 David Burliuk even enumerated the kind of painterly surfaces that could be explored by the artist:

I Splinter-like surface
II Hook-like surface
III Earthy surface . . .
IV Blistered surface . . .

with 'granular, fibrous and lamellar' structures.[9] By the end of 1912 David Burliuk was advocating a kind of painting that depended upon the purely visual effect of its internal devices – texture, form, colour, rhythm and weight – and not on its narrative content. In fact, he began both of his principal essays of 1912, on texture and Cubism, with the declaration: 'Painting is coloured space'.[10]

At that time, David Burliuk was recognized as a principal founder of the Russian Cubo-Futurist movement, as a daring innovator and even as an artist to be emulated – as Kandinsky indicated in his thoughts on the December 1911 *Blaue Reiter* exhibition in Munich where, 'My programme is Burliuk, Campendonck, August [Macke], some painters on glass, Schönberg, Bloch and, if possible, a Rousseau (not too big). Then Delaunay'.[11] Attracted to Burliuk's aspiration to cleanse art of 'academicians, the real enemies of art',[12] Kandinsky then invited him to publish his article 'Die 'Wilden' Russlands' in the *Blaue Reiter* almanac.

Vladimir Davidovich Burliuk 1886–1917

5 Ukrainian peasant woman

1910–11 ['1911–12' written on the frame]
Oil on canvas, 132 × 70.5 cm
The work has been relined with glue and the keyed stretcher is not original. The paint surface, partially
 overcleaned, has a tendency to flake and shows old, discoloured repairs. The work seems not to have been
 varnished. The general condition is fragile.
Accession no.1977.106

Provenance
George Costakis Collection, Moscow[1]
Galerie Gmurzynska, Cologne
Thyssen-Bornemisza Collection, 1977

Exhibitions
Leningrad/Moscow 1988, no.5, colour illus. p.33

Vladimir Burliuk excelled as both a portraitist (for example, his famous *Portrait of Benedikt Livshits* of 1911; New York, Collection of Ella Freidus) and a landscapist, and the few works that have come down to us indicate that he was the most talented member of the Burliuk dynasty. Although his artistic training was erratic and he lacked David's organizational skills, Vladimir Burliuk was *au courant* with Cubism and Futurism, and he is now remembered for his exercises in these styles (e.g. *Nude with mandolin*, 1912–13, formerly Paris, Galerie Jean Chauvelin) rather than the *pointillisme* of *Ukrainian peasant woman*.

This large canvas is important for several reasons. Thematically, it demonstrates Burliuk's strong interest in the ethnography of southern Russia and the Ukraine and in the customs and rituals that distinguished those communities, for the costume, jewellery and footwear are painted with particular attention to detail. Stylistically, the picture also demonstrates the artist's interest in the methods of the Impressionists, especially Seurat and Signac, whose work he saw in Paris in 1904 and also at several exhibitions in Russia in 1908–10.[2] Drawn to the liberating principles of Impressionist and Post-Impressionist composition, a number of Russian and Ukrainian artists experimented with the technique before embarking on their own paths of artistry: Natan Altman, Alexander Bogomazov, the Burliuk brothers, Aristarkh Lentulov,[3] Abram Manevich and others paraphrased the *pointillisme* of Signac, while Nikolai Kulbin, an early supporter of Vladimir Burliuk, never abandoned the style, even naming one of his St Petersburg groups The Impressionists (1909). Burliuk repeated this patterning of restrained colour spots in several landscapes and still-lifes of *c*1910 such as *Landscape* (1912, 63 × 84 cm, oil on canvas, Moscow, State Tretiakov Gallery), *Landscape* (1912; fig.1), *Landscape with trees* (?1912, 63 × 84 cm, Moscow, State Tretiakov Gallery) and *Flowers* (?1912, oil on canvas, 48 × 50 cm, St Petersburg, State Russian Museum). Perhaps to some extent Alexandre Benois was justified in referring to such artists as 'pitiful imitators... merely copying their teachers, the French'.[4]

Vladimir Burliuk painted *Ukrainian peasant woman* at a time of growing interest in the indigenous art forms of Russia and the Ukraine. No doubt, his affiliation with the Blaue Reiter –

Notes
1 The painting is accompanied by a certificate in English by George Costakis: 'The painting photographed on the reverse (oil on canvas 173 × 70 cm), is a work by Vladimir Burljuk, which was painted in 1910–11, Stockholm 10 [month illegible] 1978'
2 Works by Bonnard, Manguin, Signac, Vuillard and other French artists were at the first *Izdebsky Salon* in Odessa and other towns in 1909–10; works by Cross and Signac were at the *Salon of the 'Golden Fleece'* in Moscow in 1908 and by Manguin at the *Golden Fleece* exhibition in 1909
3 According to one uncorroborated source, Burliuk married Lentulov's sister in 1909; see *Il contributo russo alle avanguardie plastiche* 1964, p.109
4 A.Benois, 'Kubizm ili kukishizm' (1912); quoted in Livshits/Bowlt (1933/1977), p.75

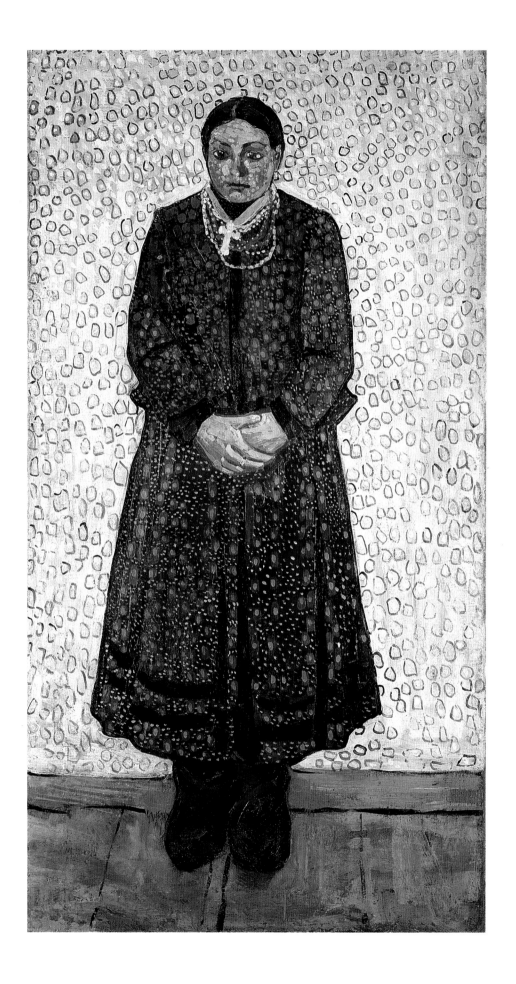

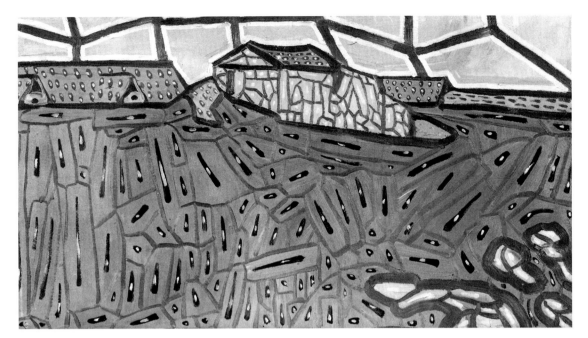

FIG I Vladimir Burliuk,
Landscape, 1912, 95 × 59 cm,
oil on cardboard (Moscow,
Collection Valerii Dudakov
and Marina Kashuro)

with its advocation of the 'primitive' legacies of ancient Europe, the Americas, Polynesia and Africa – helped to reinforce this recognition. In fact, the almanac reproduced three of his paintings within its broad repertoire of modern and archaic images. Certainly, by 1911–12 Chernianka (see p.60) had become a centre for the cultivation of these primitive interests, and the Burliuks used the ancient name of the region – Hylaea – as the name of their group. Consequently, Hylaea became a symbol of their aspiration to provide Russian Cubo-Futurism with an organic, territorial identification – in contrast to what they regarded as the ultra-nationalist and political content of Italian Futurism.[5]

Ukrainian peasant woman is a unique image in the limited oeuvre of Burliuk and no other versions or studies for it seem to have been recorded. It is possible that the woman pictured here in her felt boots, fine dress and necklaces was one of the house-servants at Chernianka, and the prominent non-Orthodox cross that she wears indicates her Uniat or Greek Orthodox faith. According to Myroslava Mudrak Ciszkewycz, a specialist in Ukrainian culture, *Ukrainian peasant woman* is modelled on the so-called Kozak or sarmatian portraits of the eighteenth century. These were renderings of the aristocracy from the Western regions of the Ukraine such as Galicia and Volyn commissioned from artists who usually painted icons and murals – which might explain Burliuk's adaptation of the stark, flattened style and limited palette.[6] Moreover, true to the Neo-Primitivists' frequent manipulation and fusion of 'low' and 'high' genres, Burliuk has raised this simple peasant girl with her modest caftan and timid pose to the noble genre of Kozak portraiture. The woman, therefore, is Ukrainian and not Russian, and the previous, traditional title, *Russian peasant woman*, did not take account of the ethnographical appurtenances that demonstrate her Western Ukrainian origin.

The State Tretiakov Gallery in Moscow possesses the portrait of a *Girl in a yellow kerchief* (c1910; fig.2) which bears some resemblance to [5], while the avant-garde exhibitions of 1910–14 list a few relevant titles under Burliuk's contributions, including *Peasant girl* at the *Jack of Diamonds* (Moscow, 1910–11), but there is no way of identifying these titles with actual works. The *Landscape with trees* in the Russian State Museum in St Petersburg (?1910) relies on the same *pointilliste* technique, but neither this, nor the other concurrent landscapes repeat the important anthropological statement carried in *Ukrainian peasant woman*.

Notes
5 In his polemic against Filippo Marinetti in St Petersburg in 1914, Benedit Livshits argued that Russian Futurism was 'territorial', while Italian Futurism was 'national'; see Livshits/Bowlt, pp.207–10
6 We are indebted to Myroslava Mudrak Ciszkewycz for these observations

FIG 2 Vladimir Burliuk, *Girl in a yellow kerchief*, *c*1910, 89 × 77 cm, oil on canvas (Moscow, State Tretiakov Gallery)

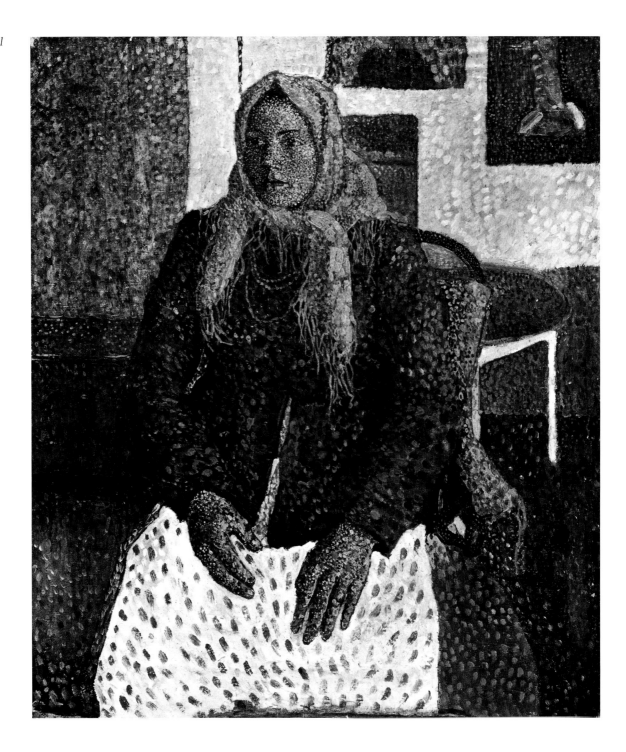

Marc Zakharovich Chagall 1887–1985

6 The grey house
La maison grise

1917
Oil on canvas, 68 × 74 cm
Signed and dated lower left: 'Chagall 1917'
The keyed stretcher is the original one. The varnish is very thin with matte areas, but the general condition is
 good
Accession no.1982.26

Provenance
Collection Paul Pechère, Brussels
Acquavella Galleries, New York
Thyssen-Bornemisza Collection, 1982

Exhibitions
Brussels, Palais des Beaux Arts, 1953, *XXVème Anniversaire*
Charleroi, Cercle Royal Artistique et Littéraire, 1956, *Hommage à Marc Chagall*
Hamburg, Kunstverein/Munich, Haus der Kunst, 1959, *Marc Chagall*, no.67
Paris, Palais du Louvre, Pavillon de Marsan, 1959, '*Marc Chagall*', no.82, illus. p.244
Zurich, Kunsthaus, 1967, *Chagall*, no.59
Cologne, Wallraf-Richartz-Museum, 1967, *Marc Chagall. Werke aus sechs Jahrzehnten*, no.68, colour illus. p.40
Paris, Grand Palais, 1969–70, *Hommage à Chagall*, no.51, illus. p.76
USA tour 1983–4, New York, Metropolitan Museum, and Phoenix AZ, Phoenix Art Museum, only (ex cat.)
Modern Masters from the Thyssen-Bornemisza Collection, 1984–6, no.44, colour illus. p.66
Luxemburg/Munich/Vienna, 1988–9, no.6, colour illus. p.35
Rome, Palazzo Ruspoli, Dec.–March 1990–1, *Capolavori della Collezione Thyssen-Bornemisza. Da V. Van Gogh a P.
 Klee*, no.5, colour illus. p.45
Frankfurt, Schirn Kunsthalle, 16 June–8 Sept., 1991, *Marc Chagall, die russischen Jahre*, no.126, colour illus.
 p.233
Mexico City, Centro Cultural Arte Contemporaneo, Oct.–Jan. 1991–2, *Chagall en nuestro siglo*, no.29, p.104,
 colour illus. p.105

Literature
Paul Fierens, *Marc Chagall*, Paris (G. Crès) 1929, no.10 [as *Paysage grise*]
Charles Estienne, *Chagall*, Paris (Aimery Somogy) 1951, illus. p.36 [as *Paysage grise*, 1920]
Lionello Venturi, *Marc Chagall*, Geneva (Skira) 1956, colour illus. pl.53
Franz Meyer, *Marc Chagall, Life and Work*, New York (Abrams) 1963, cat. no.273, mentioned p.250, illus. p.643
G. di San Lazzaro, *Homage to Marc Chagall*, New York (Tudor) 1969, illus. p.30
Marie-Thérèse Souverble, *Chagall*, New York, 1975, cat. no.22, colour illus.
Simon de Pury, 'Acquis par Thyssen', *Connaissance des Arts*, Paris, Oct. 1983, no.380, p.69, illus. p.64

After his long sojourn in Paris, Chagall returned to Vitebsk via Berlin in summer 1914, where,
because of the First World War and the Revolution, he was forced to stay until June 1920. That
month he moved to Moscow and thence in 1922 to the West, never to return to his native
town. Chagall himself was at the zenith of his artistic career and his private life was blessed with
his marriage to Bella in 1915 and the birth of their daughter Ida the following year. He was
contributing to many exhibitions, and was being recognized increasingly as a major figure of
the Russian avant-garde. The critic Yakov Tugendkhold published a long review in the
prestigious journal *Apollon* (1916, no.2) and, on his return to Vitebsk from Petrograd in 1917,
Chagall assumed the role of People's Commissar for the re-organization of cultural life in
Vitebsk, teaching many devoted students – until the acerbic rivalry with Malevich forced him to
depart for Moscow in 1920. These external circumstances are important for understanding the

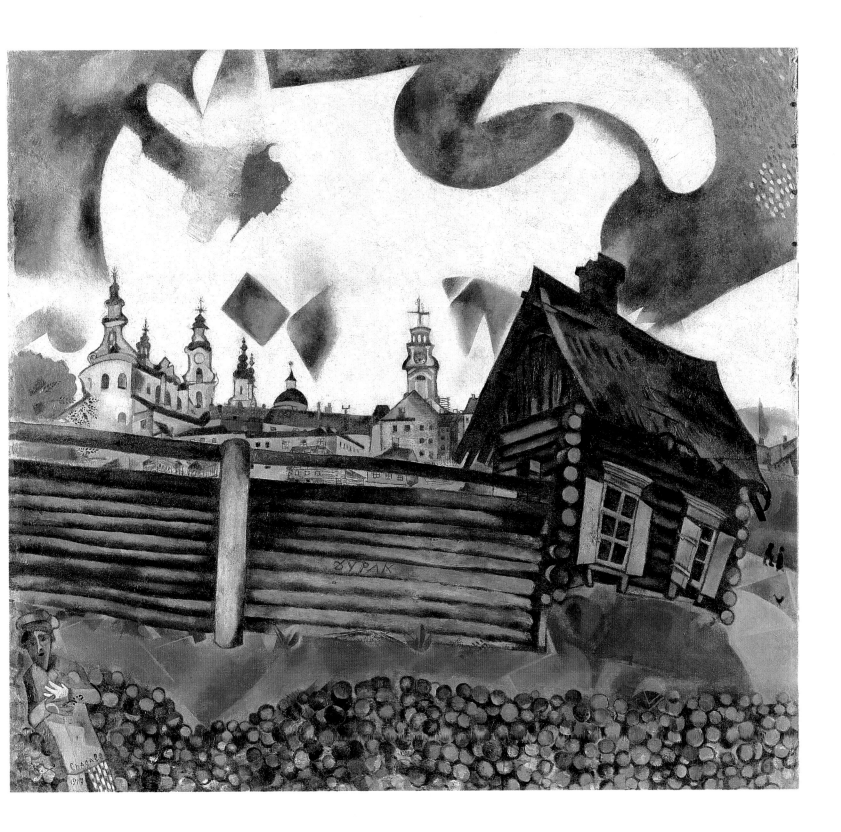

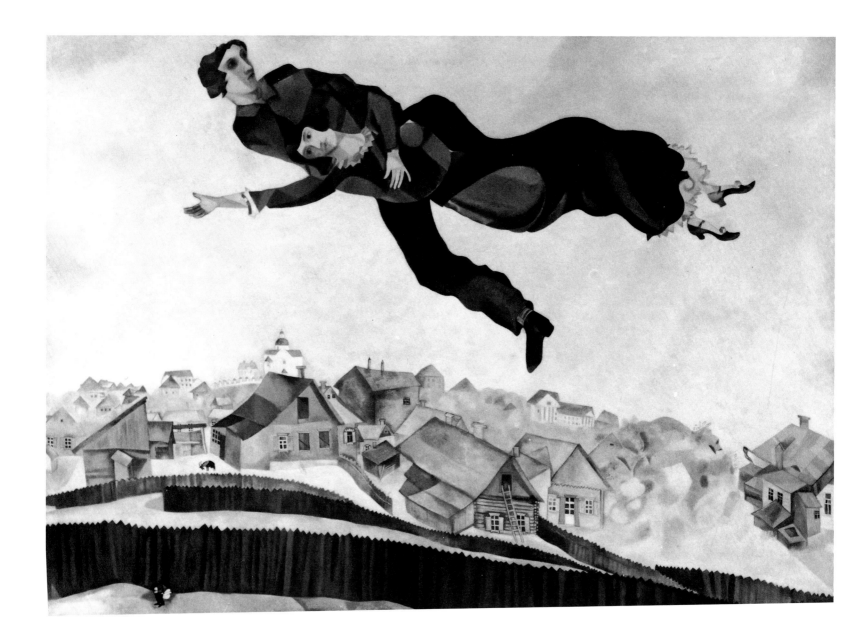

particular style and 'mood' that Chagall expressed during his final Russian period (1914–22) marked by his pictorial celebrations of Russia, Vitebsk and family life, for example *Above the town* (1914–18; fig.1), *Bathing baby* (1916, Pskov, Museum of Art, History, and Architecture), and *Promenade* (1917–18, St Petersburg, State Russian Museum).

The grey house is one of the many views of Vitebsk that Chagall painted during 1914–17, views that combined nostalgic and apocalyptic sentiments. On the one hand, Chagall emphasizes images of the physical and social contrasts of the old city (symbolized by the Cathedral of the Assumption in the background and the 'grey house' – one of the quaint wooden huts that graced the banks of the River Dvina); on the other hand, through the turbulent sky, the tottering house and the confused and lonely figure on the left, Chagall imbues the picture with a foreboding of inconstancy and imminent change. Here, incidentally, are the same rippling, apocalyptic clouds that are seen in *Bella with the white collar* (1917, 149 × 72 cm, oil on canvas, Paris, Centre Georges Pompidou). It is the same integration of past and future that we sense in other concurrent paintings of Vitebsk such as *The cemetery* (1917,

Paris, Centre Georges Pompidou), *Gates of the cemetery* (1917, Paris, Centre Georges Pompidou) and *The blue house* (1920; fig.2) and which, strangely enough, harks back to the disturbing visions of St Petersburg and Vilnius that Mstislav Dobuzhinsky, one of Chagall's early teachers, was also evoking (cf. *The little house in St Petersburg*, 1905, Moscow, State Tretiakov Gallery). Furthermore, Chagall was inclined to repeat the same theme in various colours and shades such as *Lovers in pink* (1916, St Petersburg, Chudnovsky Collection) and *Lovers in green* (1914–15, Moscow, Efros Collection).

As in many of his pictures, Chagall juxtaposes the serious and the lighthearted, especially through his reference to vulgar practices, a visual engagement also shared by his colleagues, David Burliuk, Goncharova, Larionov and Malevich. The figure in cap, shirt and trousers is of particular interest, for, as in so much of Chagall's art, the image carries allusions and *double entendres* which provide the painting with its larger philosophical dimension. The simple title of this picture, therefore, conceals much more complex strata of meaning. Not only is the figure signed and dated 'Chagall 1917', indicating that this is a self-portrait, but also the man's left-hand sleeve sports the Hebrew characters for the Yiddish *shemihl* [fool]. This, in turn, connects with the central graffiti on the fence, the Russian word *durak*, which also means 'fool', the

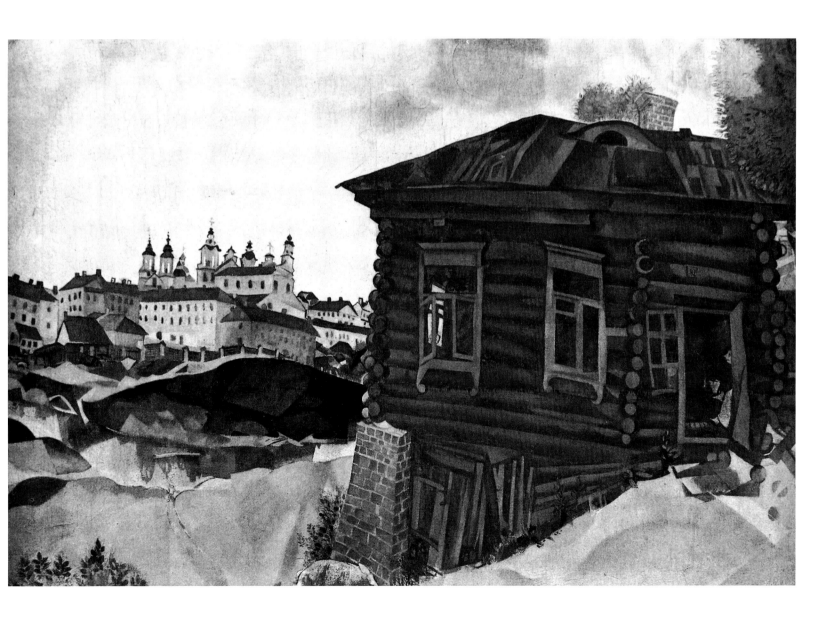

message being that 'Chagall is a fool' or, interpreted in a more existential fashion, that 'Chagall is the village idiot'. Here we see the Hassidic 'fool' or, rather, *yurodivyi* ['holy fool'] whose ecstatic glossolalia and galvanized gestures interested many members of the Russian avant-garde, including the poets Andrei Bely and Velimir Khlebnikov, and the painter Pavel Filonov.

In spite of its overtly simple title, therefore, *The grey house* has associations with many complex and topical issues of the avant-garde, particularly with the culture of the outsider (psychological, such as the 'fool', or ethnic such as the Jews and gypsies) contained within the concrete representation of graffiti and the image of the village idiot. Artists such as David Burliuk, Chagall, Larionov and Malevich were fascinated by the relationship of 'low' to 'high' art and often incorporated examples of the latter into their professional paintings, and through them Chagall, in particular, manifested his 'intuitive understanding for the folk'.[1] Graffiti on fences and walls were an immediate and clear source of inspiration, especially since the messages often included rude words or used a recondite language that was intelligible only to a particular group (e.g. children, thieves and prostitutes). Larionov, in particular, was drawn to graffiti and repeated them literally in his soldier and Venus paintings (e.g. *Soldier relaxing*, 1911, Moscow, State Tretiakov Gallery, and *Venus*, 1912, St Petersburg, State Russian Museum). Both Eduard Spandikov and Kirill Zdanevich recomposed children's drawings and fence-graffiti in their scatalogical drawings, and it is not unreasonable to assume that some of the Cubo-Futurist paintings that incorporate 'low' words, for example the comic verbal 'balloons' looking like graffiti, also including the word *durak* in Larionov's *Dancing soldiers*, of

FIG 3 Mikhail Larionov, *Dancing soldiers*, 1909–10, 88 × 102 cm, oil on canvas (Los Angeles, CA, County Museum)

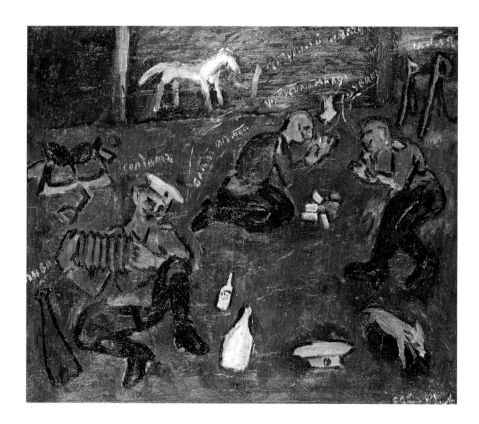

1909–10 (fig. 3) and rebuses (e.g. Goncharova's *Rayonist fountain*, see [19]6) owe their literary dimensions to this interest in graffiti. Occasionally, of course, Chagall included coprophiliac scenes that were even more shocking – or amusing – than graffiti, such as the little man relieving himself by the fence in *Above the town*.

The most graphic way in which the avant-garde artists extended this love of the low into everyday behaviour was through face- and body-painting. Konstantin Bolshakov, David

FIG 4 Marc Chagall teaching at Malakhovka in 1921. His *Grey house* can be seen in the background (photograph courtesy of Christina Burrus, Paris)

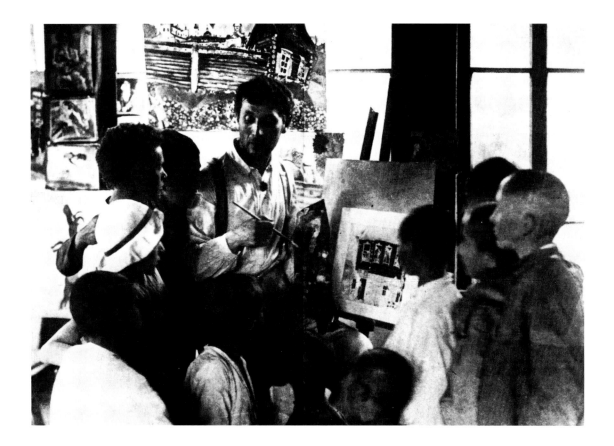

Burliuk, Chagall, Goncharova, Vasilii Kamensky, Larionov, Mikhail Le-Dantiu, Alexander Shevchenko and Ilia Zdanevich all tried their hand at this ancient rite, painting faces with cryptic signs and fragmented words. As Larionov and Ilia Zdanevich declared in their manifesto of 1913, *Why We Paint Ourselves*:

> We paint ourselves for an hour, and a change of experience calls for a change of painting, just as picture devours picture, when on the other side of a car windscreen shop windows flash by running into each other: that's our faces. Tattooing is beautiful, but it says little – only about one's tribe and exploits. Our painting is the newsman...

> Our faces are like the screech of the trolley warning the hurrying passers-by, like the drunken sounds of the great tango.[2]

Of course, Goncharova, Larionov and their colleagues drew on many sources of inspiration for their face-painting. They referred to tattooing, Egyptian body-painting and cosmetic make-up as precedents, and, in applying their mysterious signs and images, they were repeating the incantational and 'liturgical' condition of the witch-doctor, the shaman and the village idiot. Applying graffiti to their faces, therefore, the avant-garde artists appeared at art exhibitions and other public events, inciting both abuse and jocularity in the same way that circus clowns did.

Never a Realist, Chagall's fantasy annoyed more sober observers of reality such as commissars and bureaucrats in post-Revolutionary Vitebsk. In October, 1918, for example, Chagall and his colleagues decorated the streets and squares to commemorate the first anniversary of the new republic, although in a style that elicited bewilderment rather than enthusiasm: 'Why is the cow green and why is the horse flying through the sky, why? What's the connection with Marx and Lenin?'[3] Perhaps Chagall the painter with his improbable and fanciful pictures belongs, ultimately, more to the discipline of theatre than to that of painting.

Obviously, Chagall considered *The grey house* to be an important work. It figures prominently, for example, in the famous 1921 photograph of Chagall teaching at Malakhovka (fig.4).

Notes

1 M. Frost, 'Marc Chagall in the Jewish State Chamber Theatre' *Russian History*, Tempe, VIII, pts 1–2, 1981, p.94. Jean-Claude Marcadé has also examined Chagall's debt to folk culture; see his article 'Le contexte russe de l'oeuvre de Chagall' in *Marc Chagall. Oeuvres sur papier*, 1984, pp.18–23, 62–3

2 M. Larionov and I. Zdanevich, 'Pochemu my raskrashivaemsia' (1913); Eng. trans. in Bowlt (1988), p.82

3 Chagall (1985), p.137

Ilia Grigorievich Chashnik 1902–29

7 Suprematist composition

1923
Oil on canvas, 183.5 × 112 cm
Signed and dated in Russian on *verso* upper left: 'UNOVIS'; lower right 'Il. Chashnik, 23'
The work is unvarnished and the vertical white strip carries horizontal cracks, but the general condition is good
Accession no.1983.36

Provenance
Ilia I. Chashnik, son of the artist, Leningrad
Chudnovsky Collection, Leningrad
Galerie Gmurzynska, Cologne
Thyssen-Bornemisza Collection, 1983

Exhibitions
Cologne 1986, colour illus. p.147
Luxembourg/Munich/Vienna 1988–9, no.76, colour illus. p.175
Zurich 1989, p.98, colour illus. p.99

Literature:
Výtvarné umění, Prague, 1967, no.8–9, illus. p.406
Shadova/Zhadova (1978/1982), no.137 [as *Suprematist construction*, 1921, 147 × 98 cm, and identified as
 coming from the collection of the State Tretiakov Gallery, Moscow]
Zelinsky, *Russische Avantgarde*, no.37, p.147, repeats these mistakes

[7] *verso*

Note
1 Ilia Chashnik: [Project for a
Department of Architecture and
Technology] (1921); Eng. trans.
in *Ilya Chashnik*, 1981, p.18

The most remarkable feature of Chashnik's meteoric career is the prescience of his painting. By 1922 he had mastered the principles of Suprematism through his apprenticeship to Malevich and had emerged as an original and powerful abstract artist. As the inscription on the *verso* of *Suprematist composition* indicates, Chashnik made this work while an eager supporter of the Unovis group and just after he had left Vitbesk with Malevich for Petrograd. In 1923 Chashnik, together with Suetin and other Malevich students, contributed to the Unovis section of the *Exhibition of Paintings by Petrograd Artists of All Directions* in Petrograd (see [41]). The exhibition catalogue, however, contains only a general listing of seventy-nine Unovis works without individual attribution, although a number of pieces are called *Suprematist section* and *Suprematist construction* which might pertain to *Suprematist composition*. The identification on the *verso* could be regarded as a further indication that *Suprematist composition* was, indeed, one of the works at the Petrograd Exhibition.

Chashnik took Malevich's initial Suprematist forms and invested them with an even tauter, streamlined organization – as is manifest in *Suprematist composition*. Inviting comparisons with Mondrian's grid paintings, Chashnik's Suprematist compositions of this period develop sequences of geometric shapes according to a rhythmical or 'choreographic' system. The result is a dynamic visual score that compels the eye to move vertically, horizontally, backwards and forwards. Chashnik employed this notational device in much of his work but *Suprematist composition* is one of the most concise and convincing examples. As he noted in 1920, such paintings prepared the way for the 'construction of individual particles of energy into a systemic whole in space'.[1]

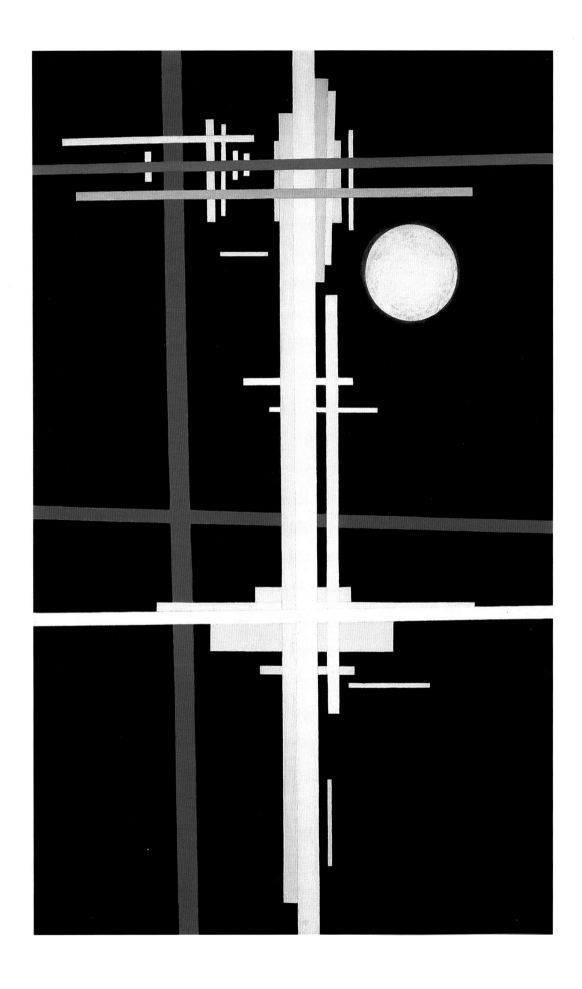

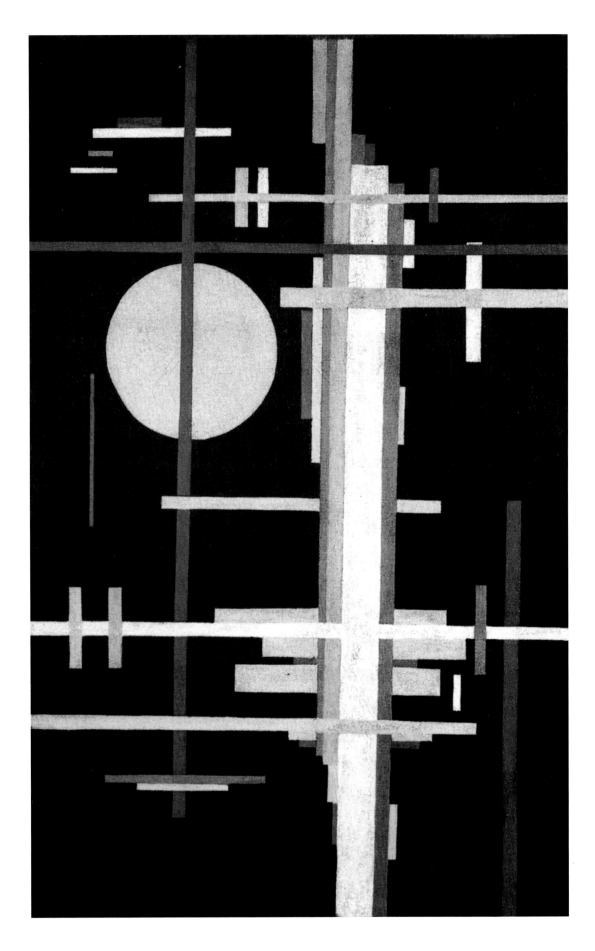

FIG 1 Ilia Chashnik,
Suprematism, 1923–4,
69.5 × 44 cm, mixed media
(Cologne, Galerie
Gmurzynska)

FIG 2 Ilia Chashnik,
Suprematist composition,
1923, 30.4 × 22.3 cm, ink on
paper (private collection;
courtesy of Galerie
Gmurzynska, Cologne)

FIG 3 Ilia Chashnik,
Suprematist composition,
1926–7, 29.8 × 20.3 cm,
gouache, watercolour and
pencil on paper (New York,
Barry Friedman Gallery)

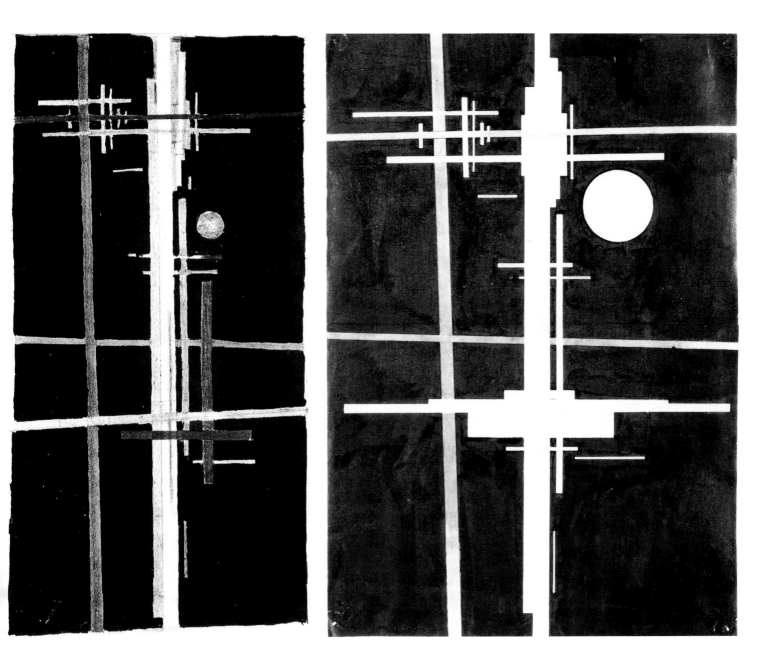

Although a studio painting, *Suprematist composition* might also be perceived as a ground-plan for a complex construction as seen from the sky, reminding us, for example, of Malevich's *House under construction* (1915, Amsterdam, Stedelijk Museum) and of Chashnik's own architectonic projects of the 1920s. Indeed, although he continued to work on paintings until his death, Chashnik turned increasingly to purposeful graphic design, for, perhaps like other students of Suprematism, he felt that the pictorial surface had already been perfected by Malevich and that the only legitimate development of Suprematism was precisely into public space.

Chashnik repeated and paraphrased his designs many times and in different media. *Suprematist composition*, for example, exists in at least four versions: the Galerie Gmurzynska, Cologne, possesses a very similar piece entitled *Suprematism* and dated 1923–4 (fig.1), there is a similar *Suprematist composition* (1923) in a private collection (fig.2), another (1926–7) now belongs to the Barry Friedman Gallery (fig.3) and the Galerie Stolz, Cologne, showed one in their exhibition *Konstruktivismus-Suprematismus* in 1988–9.

Ilia Grigorievich Chashnik 1902–29

8 Composition

1924 (?)
Watercolour and pencil on paper glued on carboard, 14 × 10 cm
The light brown paper appears to have yellowed and carries yellow stains in the background, but the general
 condition is good. Glued to cardboard
Accession no.1976.18

Provenance
Michael Tollemache Ltd, London
Thyssen-Bornemisza Collection, 1976

As with many of Chashnik's and Suetin's sketches, the basic scheme of *Composition* derives from Malevich's Suprematist vocabulary, for its complex axial combination of the curve and the horizontal elaborates the penultimate image in Malevich's album *Suprematism. 34 Drawings* (1920), i.e. the composition with three curved elements known as *Sensation of motion and an obstacle* (fig.1). Chashnik's *Composition*, therefore, should be regarded as a Suprematist exercise or analytical study and not as a perfected work – a project preliminary to a Suprematist painting, relief or, more probably, ceramic ware. The prototypical or improvisational nature of *Composition* would explain the great number of variants and versions on the same geometric theme that Chashnik seems to have made in the early and mid-1920s, sometimes repeating the same positions, sometimes reversing them. Several of these analogies came on to the market in the 1970s and 1980s and were included in exhibitions of the Russian avant-garde, such as the untitled watercolour and pencil piece of c1925 (fig.2), the several works reproduced in London 1977 (nos.13–17), and the watercolour and pencil *Suprematist composition, c1924*, now at the Museum of Modern Art, New York (19.5 × 29 cm). Shadova/Zhadova (1978/1982, no.135) reproduces a 1924 pencil and watercolour sketch called *Suprematism* in which the elements are similar. Chashnik also transposed the basic design here into a white on white relief – according to the reconstruction (fig.3).

As with other Suprematist sketches by Chashnik and Suetin, the ultimate destination of *Composition* seems to have been porcelain, and several of its versions appear within a rimmed circle designated as designs for plates (fig.4). Indeed, Chashnik did apply the basic composition to a tumbler that was produced at the State Porcelain Factory (fig.5). Of course, many avant-garde artists – Natan Altman, Chashnik, Kandinsky, Kliun, Anna Leporskaia, Lebedev, Malevich, Mansouroff, Popova, Puni, Rodchenko, Suetin, Tatlin, etc. – experimented with either industrial or domestic porcelain, even if very few of their prototypes were manufactured. Most of these artists applied severe geometric motifs to the ceramic surface, an orientation that has led some historians to speak of a Suprematist phase in the history of the State Porcelain Factory in the 1920s. The designer Elena Danko welcomed this development, seeing it as a refreshing opposition to the ornamental principles of the agitational or propaganda porcelain being produced there just after the October Revolution:

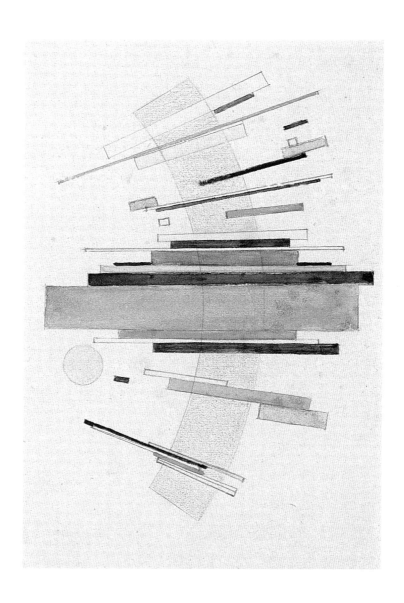

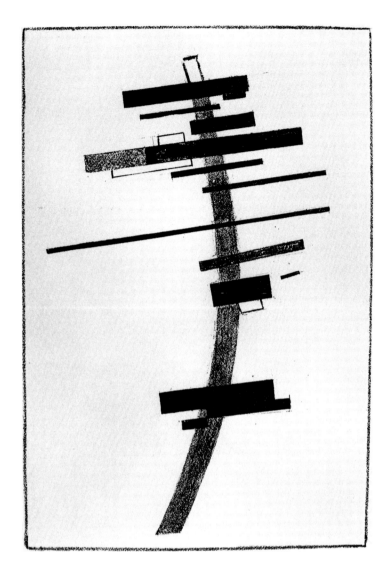

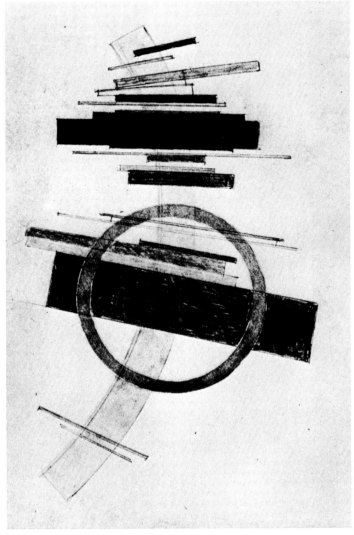

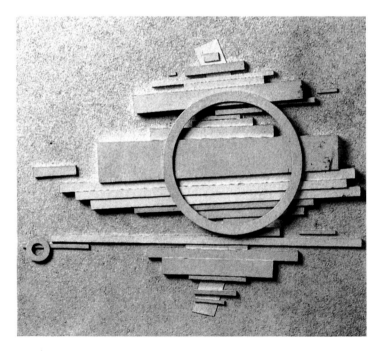

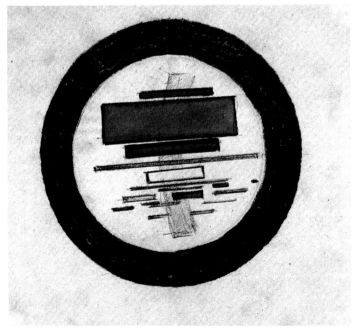

FIG I Kazimir Malevich,
Sensation of motion and an obstacle, 26.8 × 20.2 cm, lithograph; penultimate image from Malevich's *Suprematizm. 34 risunka* [Suprematism. *34 Drawings*], Vitebsk (Unovis) 1920 (Los Angeles, Institute of Modern Russian Culture)

FIG 2 Ilia Chashnik, *Untitled*, *c*1925, 10 × 14.5 cm, watercolour and pencil on paper (Cologne, Galerie Gmurzynska)

Notes
1 E. Danko, 'Novoe Petrogradskogo farforovogo zavoda', *Khudozhestvennyi trud*, no.4, Moscow and Petrograd, 1923, p.16
2 K. Malevich, *Suprematizm. 34 risunka*, Vitebsk (Unovis), 1920, p.2
3 M. Ginzburg, 'Itogi i perspektivy' (1927) in K. Afanasiev et al., *Iz istorii sovetskoi arkhitektury 1926–1932 gg*, Moscow (Nauka), 1970, p.82

The Suprematists, in the persons of N. Suetin and I. Chashnik, have provided us with a substantial number of examples of Suprematist painting on porcelain. In painting, Suprematism consolidates the individual points of a specific system of consciousness, the ultimate aim of which is to fathom non-objectivity... A constructive building of coloured areas has now replaced the decorative treatment of the surface; the aim of porcelain painting as a 'decoration' has now been rejected totally.[1]

The reasons for this volte-face in the State Porcelain Factory in the early 1920s are many, although, of course, the relevance of Malevich, Chashnik and Suetin are primary. Obviously, the white of the pure porcelain surface must have appealed directly to the creator of the *White on white* series of 1917–18: 'The Suprematist eternal white gives a ray of vision for advancing, encountering no boundary... [it is] pure action [which] has affirmed the sign of the purity of human creative life'.[2] Malevich must have regarded porcelain as a propaganda tool that could disseminate the basic Suprematist schemes that he had painted in 1915–16 and then repeated in graphic form in his *Suprematism. 34 Drawings*. So, when Malevich and his students, including Chashnik and Suetin, relocated to Petrograd, they turned to the State Porcelain Factory with enthusiasm, producing some of the most experimental ceramics of modern times. The Suprematists did not reinterpret traditional, floral motifs, but offered to the applied arts a new 'decorative' vocabulary and, occasionally, even new material shapes (e.g. Malevich's teapot or Chashnik's inkwell). Many identified the 'speechless' code of Suprematism, with its organization of geometric forms in cool, technological progressions and its ostensible call to order, as a strong artistic statement that expressed the universal values of science, industry and democracy espoused by the October Revolution. Moreover, abstract art was considered by some to be less ambiguous than narrative ornament, appealing to an international and 'transcendental' consciousness rather than to a narrowly ethnical and national one. Geometric abstraction, like Constructivism, then, was ideologically more secure, since it avoided the 'metaphysical essence of idealist aesthetics while blazing the trail of consistent artistic materialism'.[3]

FIG 3 Reconstruction after Ilia Chashnik, *White on white*, undated, 60 × 53.5 cm, wood and paper (private collection)

FIG 4 Ilia Chashnik, design for a plate, 1923, 17.4 × 20 cm, watercolour, ink and pencil on paper (private collection; courtesy of Galerie Gmurzynska, Cologne)

FIG 5 Ilia Chashnik, tumbler with Suprematist design, *c*1924, Lomonosov State Porcelain Factory, St Petersburg (photograph courtesy of Nina Lobanov-Rostovsky, London)

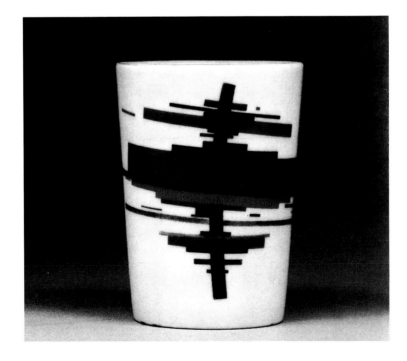

Ilia Grigorievich Chashnik 1902–29

9 White monochrome relief (total or partial reconstruction)

1922(?)
Oil (?) on wooden relief on plywood panel, 100 × 147 cm
Signed and dated in Russian on *verso*: 'UNOVIS Ilia Chashnik Vitebsk 1922'
The work is unvarnished and the background shows cracks and heavy repair. The work seems to have been
 overpainted
Accession no.1980.2

Provenance
Ilia I. Chashnik, son of the artist, Leningrad
Lev Nussberg, Paris
Leonard Hutton Galleries, New York
Thyssen-Bornemisza Collection, 1980

Exhibitions
Düsseldorf, Kunstmuseum, Berlin, Museum für Gestaltung, 10 May–9 Sept. 1978, *Ilja G. Tschaschnik*, no.87, illus.
 p.80
New York, Leonard Hutton Galleries, 2 Nov.–15 March 1980–81, *Ilya Grigorevich Chashnik*, no.38, illus. pp.52–3
 [including *verso*] and colour illus. p.7
Los Angeles/Washington, DC, 1980–81, no.26
Modern Masters from the Thyssen-Bornemisza Collection, 1984–6, no.70, colour illus. p.92
Luxembourg/Munich/Vienna 1988–9, no.75, colour illus. p.173

Literature
M. Betz, 'All and Nothing: The Suprematist Idea', *The Architecture and Design Review*, III, no.1, April 1980, New
 York, illus. p.4

Kazimir Malevich, the inventor and advocate of Suprematism, exerted a profound influence on the evolution of Russian art during the 1910s and 1920s. In fact, it is possible to define two waves, or generations, of experimental artists in Russia, both beholden to the principles of Malevich. The first of these, known as the Supremus circle, included Ivan Kliun, Liubov Popova, Olga Rozanova and Nadezhda Udaltsova (see [25], [45–7], [56], [57]), artists who produced Suprematist works parallel to Malevich's own painting. While, however, impressed by his ideas, they possessed individual talents and used Suprematism – 'the purely painterly work of art'[1] – to express their own ideas of colour and form. As in the case of Kliun and Ivan Puni, their interest in Suprematism arose concurrently with Malevich's experiments and often their pictorial accomplishments were no less original than those of Malevich. Between 1919 and 1925 a new wave of Suprematist artists came to the fore, among them Chashnik, Vera Ermolaeva, Lazar Khidekel, Nina Kogan, El Lissitzky and Nikolai Suetin (see [36–8], [54]), artists who absorbed and refracted Suprematism in a dynamic and potential manner. Within this collection of individuals a single group can be delineated – one that maintained its cohesion

Notes
1 K. Malevich, *Ot kubizma i futurimza k suprematizmu* (1916); Eng. trans. in Bowlt (1988), p.118
2 The Institute went by various names just after the Revolution, including the Vitebsk Academy of Visual Arts, the Art Practical Institute and the Popular Art Institute. By analogy with the restructured art schools in Moscow, Petrograd and elsewhere, the Institute was also called the Vitebsk Svomas. For further information see A. Schatskich, 'Chagall and Malewitsch in Vitebsk' in *Marc Chagall. Die russischen Jahre 1906–1922*, exh. cat. Frankfurt,

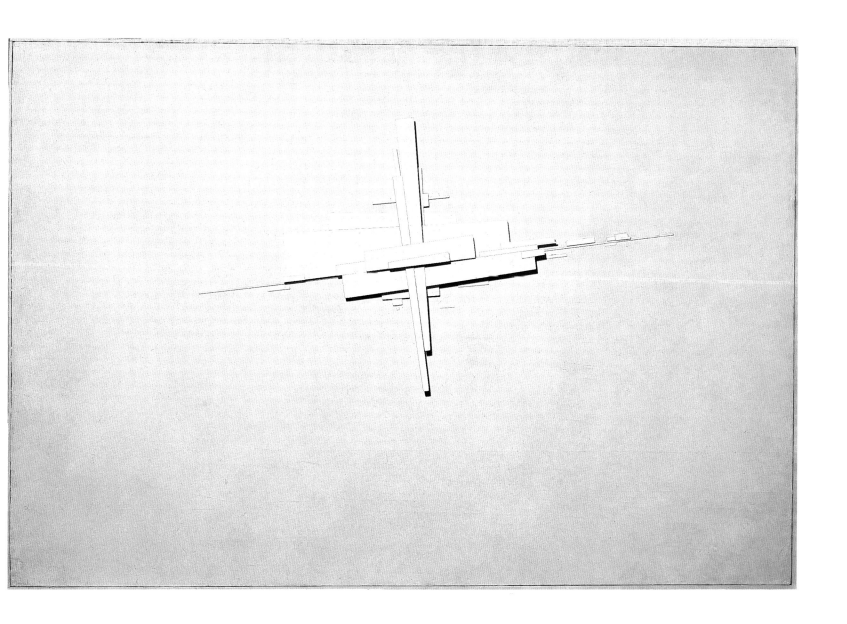

Schirn Kunsthalle, Frankfurt, 1991, pp.62–5
3 M. Shagal [Chagall], 'O Vitebskom narodnom khudozhestvennom uchilishche', *Shkola i revoliutsiia*, no.2, Vitebsk, 1919, p.7

not only through its dedication to Malevich, but also through its common location, the town of Vitebsk, and one of the most active members of this community was Chashnik.

In August, 1918 Chagall was appointed director of the Vitebsk Popular Art Institute[2] and at once began to advocate an art that 'would turn abruptly away from the comprehensible'.[3] By July 1919, the Vitebsk Institute had enrolled six hundred students and its faculty already included Ermolaeva, Kogan and Lissitzky – instructors who would join Malevich later in the year. In November 1919 Malevich joined the Institute and the immediate result was a sharp division of loyalties, some students supporting Chagall, others siding with Malevich, and, despite pleas to stay, Chagall resigned his directorship and left for Moscow. After a brief return to Vitebsk, Chagall left his native city for good in June 1920.

By the end of 1919 Malevich had attracted a strong group of Suprematist supporters, including Chashnik, Kogan, Lissitzky and Suetin, who, with tiny black squares sewn on their sleeves, established Unovis (an acronym for 'Affirmers of the New Art') at the beginning of 1920. These young students proceeded to extend the Suprematist idea into many disciplines

and media – the theatre, typography, architecture and even political propaganda such as Lissitzky's famous poster *Beat the whites with the red wedge*, which was just one component in an elaborate visual transformation of Vitebsk undertaken by Unovis. But Unovis also disseminated Malevich's principles through publications: in autumn of 1920 Chashnik and Khidekel edited the leaflet *Aero* and the first issue of the journal *Unovis*, while Malevich published theoretical tracts as well as his collection of thirty-four Suprematist drawings. Lissitzky also worked on his *Suprematist Tale About Two Squares* in Vitebsk, even though it was not published until 1922 in Berlin. The Vitebsk Unovis served as the axis of a network of affiliations in Moscow, Odessa, Perm, Petrograd, Samara, Saratov and Smolensk.

A primary concern of the Vitebsk Suprematists was with the purpose of the new art, for they all sensed that studio painting had entered an impasse and that it had to be adjusted to the practical exigencies of a proletarian society. In an article entitled 'The New Realism', Khidekel affirmed that:

> Human creativity is not the copying of things, but the creation of new things... The attainments of the canvas are already passé... and if we are still involved with the canvas, then this is only so as to develop its constructive element – a symbol of our perfected creativity in building and invention.[4]

Viewed in this light, the endeavours to extend the Suprematist surface into three-dimensional design and architectural environments at this time, especially on the part of Chashnik, were logical and essential. In 1920 Chashnik, for example, designed a mobile rostrum for political speeches that Lissitzky elaborated four years later, and he and Malevich compiled a complex functional programme for the Unovis curriculum that today sounds more Constructivist than Suprematist:

Department I requires: a) the organization and production of projects of utilitarian value;
b) a new architecture;
c) a new ornament for textiles and metalwork;
d) projects for monumental decors;
e) interior design;
f) furniture;
g) book typography...[5]

The list repeated Malevich's sincere desire that 'our entire world be clothed in Suprematist forms, i.e. our fabrics, wallpapers, pots, plates, furniture, signboards...'[6]

In April 1922 Malevich moved from Vitebsk to Petrograd accompanied or followed by a number of his students, including Chashnik and Suetin, and an immediate effect of the move was a diversification of artistic interests. Ermolaeva turned her attention to illustrating children's books, Khidekel continued to work on architectural projects, Lissitzky concentrated on the printing arts, while Chashnik and Suetin, encouraged by Malevich, applied Suprematist motifs to the ceramic items that they designed for the Lomonosov State Porcelain Factory. The result was the production of cups, saucers, plates and pots often carrying paraphrases or extensions of Suprematist paintings and drawings (see [8]). Indeed, the porcelain utensil provided the students of Suprematism with an unprecedented opportunity for taking their geometric compositions to a utilitarian destination and hence into 'life'. The white of the porcelain presented an ideal surface for ornament, and the fact that a cup, saucer or plate could be moved from one position to another as the owner used it meant that the Suprematist design could now acquire a kinetic dimension.

The ultimate administrative haven of Unovis was Ginkhuk where Malevich was appointed director in 1923 and where several of his students, including Chashnik, worked as research assistants. But Malevich's tenure was brief and Ginkhuk itself closed down in 1926 as a result of increasing pressure from the political and cultural right. Malevich's absence abroad in 1927

Notes

4 L. Khidekel, 'Novyi realizm. Nasha sovremennost', *Unovis*, no.1, Vitebsk 1920, p.1
5 Quoted from *Ilja G. Tschaschnik*, 1978, pp.31–2
6 M. Kunin, 'Ob Unovise', *Iskusstvo*, no.2–3, Vitebsk, 1921, p.16
7 For information on the *arkhitektony* see *Malévitch. Architectones, Peintures, Dessins*, exh. cat., Paris, Centre Georges Pompidou, 1980
8 Untitled text by Popova (early 1920s); quoted in E. Rakitina, 'Liubov Popova. Iskusstvo i manifesty' in E. Rakitina, *Khudozhnik, stsena, ekran*, Moscow (Sovetskii khudozhnik) 1975, p.159
9 V. Tatlin, 'Iskusstvo v tekhniku' (1933), Eng. trans. in *Vladimir Tatlin*, exh. cat. Stockholm, Moderna Museet, 1968, p.75
10 V. Milashevsky, *Vchera, pozavchera*, Leningrad (Khudozhnik RSFSR) 1972, p.203

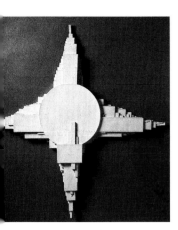

and his renewed concern with figurative painting after his return, Chashnik's premature death in 1929, the rapid orientation towards a Realist art encouraged by the Party apparatus – such conditions could only impede and then halt the further development of Unovis and its programme of universal Suprematism.

White monochrome relief is one of several reliefs that Chashnik is supposed to have constructed before moving with Malevich to Petrograd where, under the master's influence, he proceeded to explore the architectural discipline with his own *arkhitektony* and *planity*. Of course, one of the many curious aspects of *White monochrome relief* is that Chashnik, the apprentice, could have created such a sophisticated and advanced work before Malevich, his mentor, arrived at his definition of the *arkhitekton* in 1923.[7] On a simple level, *White monochrome relief* might seem to be a mere extension of Malevich's *White on white* paintings of 1917–18 (e.g. *Suprematist painting*, 1917–18, Amsterdam, Stedelijk Museum), but, of course, Chashnik was integrating two basic traditions of the avant-garde – the one established by Malevich and his Suprematism and the other established by Tatlin and his reliefs. Although the two artists and their worldviews were scarcely compatible, students such as Chashnik and Suetin took ideas from both parties, combined them and created exciting conclusions such as the *White monochrome relief* or the similar pieces in paper and board called *Reliefs* of 1922–3 such as the white reconstruction dated 1922–3 (fig.1). However, even though many of Chashnik's three-dimensional works have come to be called 'reliefs' and have been included as such in recent exhibitions in the West, there is little evidence to assume that Chashnik himself actually used the term. Rather, he favoured the term *ob'emnoe postroenie na ploskosti* [volumetrical construction on a plane], as is indicated from his posthumous contribution to the Jubilee Exhibition '*XV Years of Visual Art of the RSFSR*' at the State Russian Museum in Leningrad of 1932–3. Chashnik may have also favoured the term *suprematicheskoe sooruzhenie* [Suprematist structure] which was used as the general description of the Unovis contribution – which included reliefs – to the *Exhibition of Paintings by Petrograd Artists of All Directions* in Petrograd in 1923.

Whatever Chashnik's original title, his three-dimensional constructions are neither Malevich nor Tatlin (Malevich did not build reliefs and Tatlin left his textures raw and unpainted), although in all cases the composition or construction was a laboratorial experiment, supplying preparatory data for inventions still to be made. Just as the abstract designs of Popova (see [47], [48]) were, for her, only a 'revolutionary state of form'[8] and part of a process, and just as Lissitzky's *Prouns* (see [36–8]) were junctions between painting and architecture, so Tatlin's – and Chashnik's – reliefs represented a means towards an end. Chashnik seemed to be supporting Tatlin's conviction that these interrelationships of solids and space, curves and straight lines, gravity and elevation might lead to the discovery of coefficients that one day would be developed by the engineer.[9]

Tatlin seems to have stopped making his reliefs *c*1919–20 just as he was working on his model for the Monument to the III International, although before and after that date the principle of the relief was explored by a number of other Russian artists, so that the 1922 exhibition of the *Association of New Trends in Art* in Petersburg was 'full, not of painting, but of counter-reliefs'.[10] Parallel to his painting and drawing, Lev Bruni, for example, produced a number of pictorial reliefs and spatial constructions, incorporating the raw textures of glass and metal. Vladimir Lebedev also turned to assemblage in 1921, creating a series of counter-reliefs out of iron, wood and cardboard. Sofia Dymshits-Tolstaia, a colleague of Tatlin within the Jack of Diamonds group, worked on the aesthetics of glass, producing what she called 'mirages' and contributing six of these to Tatlin's exhibition *The Store* in 1916. Of particular interest, too, are Popova's painted reliefs of 1916–18, figurative and non-figurative, and the reliefs that Alexandra Exter and Ignatii Nivinsky included in their design system for the *First Agricultural and Handicraft-industrial Exhibition* in Moscow in 1923. In December, 1925 RAKhN even organized a lecture and discussion devoted to the concept of the counter-relief.

Viewed in this context, Chashnik's reliefs are logical developments in the move towards

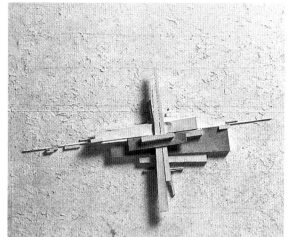

'modern', industrial configurations of forms and towards geometric purity. Chashnik asserted in 1920:

> The systemic study of Suprematism in all its stages and states is the first and fundamental departure-point in the invention of new Suprematist organisms of a utilitarian nature...The designs for Suprematist constructions are the blueprints from which the forms of utilitarian organisms are built and shaped.[11]

Chashnik's theory and practice astound by their precocity, for he was only eighteen when he published his first declarations advocating the primacy of Suprematism. But as with many of the Unovis members, Chashnik the artist oscillated constantly between two and three dimensions, and the reliefs, like the architectural projects of the mid-1920s, seem to be material models intended for the

> engineer, the technician, the astronomer, the chemist and the mathematician. Here the components of an organism are formed, cast and constucted; from here they are dispatched to demonstrate their perfection to the world'.[12]

There is some question as to which parts, if any, of the *White monochrome relief* are the original ones. The catalogue of the 1978 Chashnik exhibition in Düsseldorf and Berlin (no.87, illus. p.80), for example, states that the actual relief is original and that the panel is a reconstruction, whereas the catalogue of the 1980 New York exhibition (no.38) makes no reference to this discrepancy. The Moscow historian, Alexandra Shatskikh, who has done extensive work on Unovis, doubts the authenticity and points out that Chashnik would have been only twenty when he made this remarkably mature and sophisticated relief. She adds that if the piece were by Chashnik then it would have to be of c1925, in part because of its proximity to his *arkhitektony*. Unfortunately, Russian museums possess no reliefs by Chashnik and those

FIG 2 Photograph of the artist Ilia I.Chashnik (son of Ilia G.Chashnik) standing in his Leningrad apartment with the artist Lev Nussberg in front of the *White monochrome relief* (winter 1973–4) (photograph courtesy of Lev Nussberg, Orange, CT)

FIG 3 Reconstruction after *Relief* by Ilia Chashnik, undated, 96 × 147.5 cm, organic glass, gauze, paper and oil (private collection; courtesy of Galerie Gmurzynska, Cologne)

Notes
11 Chashnik, op.cit., in *Ilya Chashnik*, 1981, p.18
12 Ibid.

few two-dimensional pieces that are in museum collections were acquired in 1930 or donated by Chashnik's son (Ilia Ilich Chashnik) in the 1950s. There is a photograph (taken after 1972) of Ilia I. Chashnik standing in his Leningrad apartment with the artist Lev Nussberg in front of the *White monochrome relief* (minus the white plywood border; fig. 2). Nussberg acquired much of the Chashnik estate from the son before emigrating to Europe in 1976 and then to the United States. Nina Suetina, the daughter of Nikolai Suetin and widow of Ilia I. Chashnik, who lives in St Petersburg, mentions that her late husband remade some reliefs with black and white Wattman paper in 1975–6, although examination reveals that there is no paper involved in this piece. A piece very similar in composition and size, a reconstructed *Relief* made of organic glass, gauze, paper and oil (fig. 3), is illustrated in a vertical position in the catalogue of the 1991 Milan exhibition (p. 137).

 As far as technical evidence is concerned, ultraviolet tests revealed that the white ground had been much restored and had been overpainted badly. The second large, oblong body of the centre relief carries two pencil marks, perhaps by a restorer or reconstructor, and there seems to be only one layer of paint on the relief itself, which seems rather fresh. The general impression is that the work is too 'clean' to be seventy years old. The original plywood of the ground panel has been left as a window on the back to reveal the ink or glue (?) inscription in Russian (in full-size characters): 'UNOVIS Ilia Chashnik Vitebsk 1922'. Comparison of the present state of this inscription with the documentary photograph of the same illustrated in the 1980 New York exhibition catalogue (p. 53) indicates that it may have faded. This window is surrounded by two supplemental strata of plywood added subsequently, and the entire work is surrounded by a plywood border painted in white and also added, presumably, at a later date. Laboratory tests were undertaken on pigment samples from the relief components – the parts that, according to previous curatorial data, were supposed to be original – and the findings revealed the presence of titanium white. In France titanium was made commercially available by Bourgeois in 1922 and by Lefranc in 1927, but in Russia it became a common component only after the Second World War.

 [9] *verso*

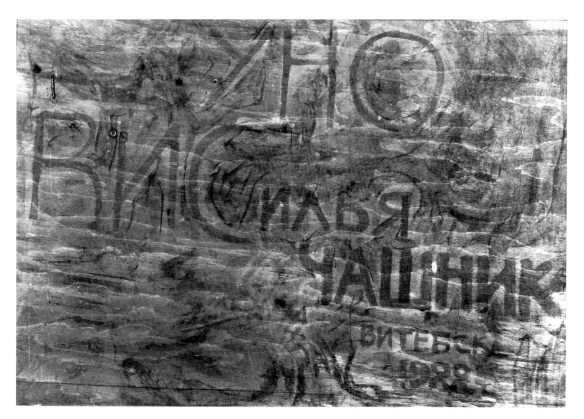

Ilia Grigorievich Chashnik 1902–29

10 Suprematist spatial dimensions no. II (total or partial reconstruction)
Suprematicheskie prostranstvennye izmereniia 11

1926 (?)
Oil (?) paint on wood and glass, 82.8 × 62.3 cm
A paper sticker on the back reads in Russian print: 'Zhizn iskusstva' [Life of Art].[1] The sticker also carries the
 words handwritten in Russian: 'Chashnik. Suprematicheskie prostranstvennye izmereniia 11' [Chashnik.
 Suprematist spatial dimensions 11, 1926]
Glass is chipping at lower edge, and the paint layer (oil?) is grimy, especially in the upper parts, but the general
 condition is good
Accession no.1976.13

Provenance
Family of the artist
Galerie Jean Chauvelin, Paris
Thyssen-Bornemisza Collection, 1976

Exhibitions
Leningrad, State Russian Museum, Nov.–May 1932–3, *XV Years of Visual Art of the RSFSR*
Paris 1977, no.17, colour illus. p.123
Düsseldorf, Kunstmuseum/Berlin, Museum für Gestaltung, Berlin, 10 May–9 Sept. 1978, *Iljaa G. Tschaschnik*,
 no.90, illus. p.81 [mentioned on p.82]
New York 1979, The Solomon R. Guggenheim Museum, *The Planar Dimension: Europe 1912–1932*, no.105,
 colour illus. p.144
Los Angeles/Washington DC 1980–81, no.38, illus. p.140
USA tour 1982–4, no.22, colour illus. p.31
Modern Masters from the Thyssen-Bornemisza Collection 1984–6, no.71, colour illus. p.93
Leningrad/Moscow 1988, no.32, colour illus. p.60
Zurich 1989, p.100, colour illus. p.101

Literature
'At the meeting of the Planes' *Time*, 16 April 1979, repro. p.77

Chashnik wrote in 1920:

> Suprematist constructions are the result of a pure composition of form quite independent of
> content. Their entire semantic meaning is reduced to the resolution of the interrelationships of
> the individual elements, i.e. they depict nothing, they are simply organisms, independently
> composed into a new order of relationships.[2]

Chashnik began a complex series of paintings, constructions and designs in which he strove to
practise what he preached. Although clearly indebted to Malevich, Chashnik was not a blind
imitator and did not, for example, regard the white background as a constant and integral part
of the Suprematist painting or indulge in Malevich's often oblique philosophising. In this
respect, *Suprematist spatial dimensions no.II* is typical of Chashnik's Suprematist development in
the early 1920s, manifesting taut organization, emphasis on a linear grid and primary contrast
between horizontals and verticals. As is indicated in the raised 'urban' configuration of
Suprematist spatial dimensions no.II, Chashnik was also fascinated by the architectural
possibilities of Suprematism and in 1926 he began to build his architectural models as well as
porcelain, projecting a number of axonometric complements to Malevich's *arkhitketony*.

 The identification and dating of *Suprematist spatial dimensions no.II* present problems and
there are serious questions regarding attribution. Even though traditionally the work is called

Notes
1 The paper label seems to be the
top part of the front page of one
of the issues of the Leningrad
journal *Zhizn iskusstva* [Life of
Art] (1923–9), a popular review
among the avant-garde (see [1],
[41]). The connection between
the title of the journal and [10] is
not clear
2 I. Chashnik: 'Suprematizm'
(1920); quoted in *Ilya Chashnik*,
1981, p.17

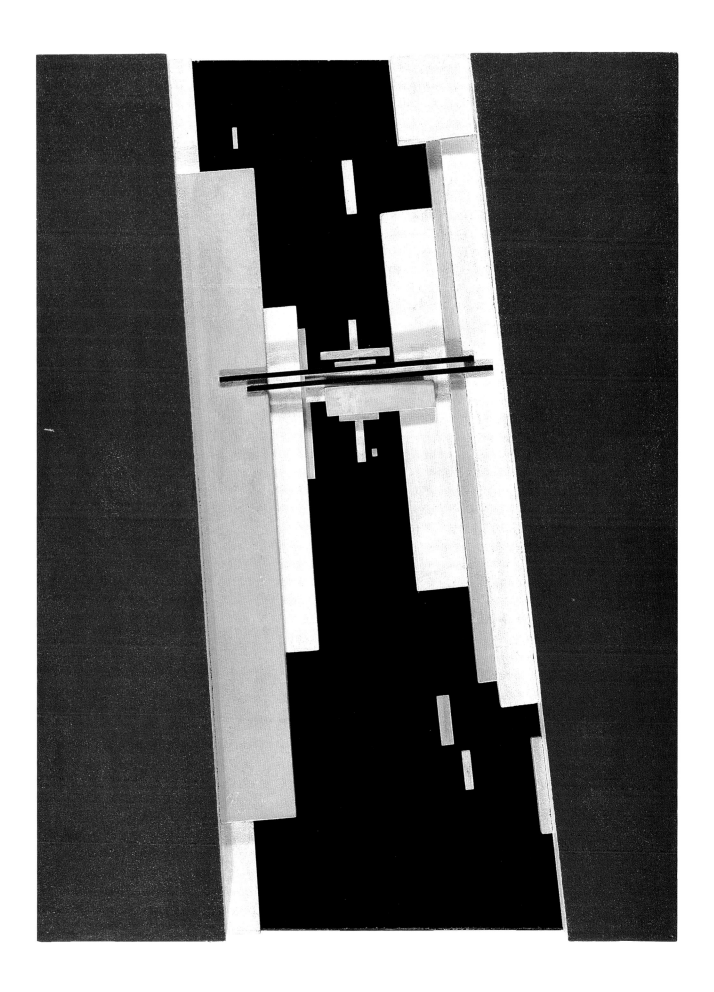

'Suprematist Relief no.II' the words (in Russian) 'Suprematist spatial dimensions II' on the back of the relief seem to indicate its original designation, and, in any case, it has been included in recent exhibitions under various other titles. For example, it is called 'Large suprematist relief' (described as painted wood on partially painted glass, 85×63 cm) at the Guggenheim's *Planar Dimension* show in 1979, which repeats the basic information supplied by the catalogue of the 1977 Paris exhibition, where the work is called 'Grand relief suprématiste', dated 1920–5, and is described as 'bois peint, platre, sur fond de verre peint'. Furthermore, the same catalogue illustrated the piece upside down and showed a different geometric arrangement in the centre – reminiscent of an Orthodox cross (fig.1). However, by the time the piece was shown at the 1978 Chashnik exhibition in Düsseldorf and Berlin (illustrated in black and white in the catalogue as no.90, p.81), it had already been 'corrected' to the present position, although it was still reproduced with the 'Orthodox' configuration in the catalogue of the Los Angeles and Washington 1980–81 exhibition, p.140. Given the strong parallel with the designs in the State Russian Museum, St Petersburg, the present arrangement of the central pieces seems to be the correct one.

[10] *verso* (detail)

Whether the date of 1926 is correct or not, *Suprematist spatial dimensions no.II* is certainly typical of Chashnik's pictorial enquiry of the mid-1920s and there exist several versions and variants. The State Russian Museum, for example, possesses two graphic designs by Chashnik (donated by Chashnik's son in 1953) (figs.2, 3) which are identified as sketches for a poster advertising the fourth issue of the magazine *Sovetskii ekran* [Soviet Screen]. Obviously, for Chashnik, the particular design under consideration was of universal significance, in the sense that he used it in various applications, for example, the *Suprematist spatial dimensions no.II* itself, the *Soviet Screen* designs – and also for a commercial poster advertising benzol of *c*1925.

Chashnik designed the cover for another journal, *Kino zhurnal A.R.K.* [Cinema Journal of the Association of Russian Cinematographers], in 1925 which, according to André B. Nakov (1981, p.59) was formerly in the collection of Anna Leporskaia in Leningrad (see [39]). However, Vasilii Rakitin ascribes the same design to Suetin (Milan 1991, p.56) and refers to a parallel version in the State Russian Museum. In his book (1981, p.90) Nakov also illustrates a similar work entitled *Relief suprématiste* (1926) which is described as belonging formerly to Chashnik's son, I.I. Chashnik, in Leningrad, and which is probably the 'study' that Nina Suetina possesses (see below). A very similar work with almost the same media and dimensions is illustrated as *Relief. Reconstruction* in the catalogue of the 1991 Milan exhibition (p.137) and in colour as *Suprematisches Relief* in the catalogue of the 1992 Cologne exhibition (p.213, no.154), where it is dated 1922 and described as coming from a private collection (fig.4).

As far as technical examination of the piece is concerned, it was noted that the wood seemed old and the piece was very dirty, although the red side panels had been cleaned extensively, parts had been restored and the glass base had been glued on to the wooden stretcher. Ultraviolet tests proved that the bottom and top sides had been partly refixed and repainted, while the very top element of the central relief had been entirely repainted. Microscope examination indicated that the dirt was 'real'. On the other hand, Nina Suetina, daughter of Suetin and widow of Chashnik's son, asserted (Leningrad, spring 1991) that 'this relief was made by my husband and given to Nussberg'; she also maintained that she owns a study for this piece. The Moscow historian Alexandra Shatskikh also maintained (spring 1991) that, were this relief really of 1926, it could not have survived in such a remarkably good condition. Laboratory analyses (now in the Thyssen Collection Archives) revealed the following:

> ...Analysis no.1 contains small quantities of titanium white and, indeed, this is also present in layer c)...the addition of Glimmer and other silicates is at least unusual for pigments of the 1920s. The indicated synthetic pigment color in Analysis no.3 has been known since 1905–06 but had wider application in brand paints only in the 1930s. The connector is oil based. The microchemical suppression corresponds more to a new brand color than to one of over fifty years old. Analysis no.2 shows a probable lazure with vegetable black (charcoal) and iron oxide pigment which imitate dirt.

FIG 1 [10] as reproduced in *Suprématism*; catalogue of the exhibition at the Galerie Jean Chauvelin, Paris, 1977, p.125, as *Grand relief suprématiste*, dated 1920–5

FIG 2 Ilia Chashnik, poster design advertising *Sovetskii ekran* [Soviet Screen], no.4, mid-1920s, 98×66 cm, black and red ink on paper (St Petersburg, State Russian Museum)

FIG 3 Ilia Chashnik, sketch for the poster advertising *Sovetskii ekran* [Soviet Screen], no.4, mid-1920s (St Petersburg, State Russian Museum)

FIG 4 Reconstruction after a 1922 relief by Ilia Chashnik, 5.5×4.2 cm, cardboard and glass (private collection; courtesy of Galerie Gmurzynska, Cologne)

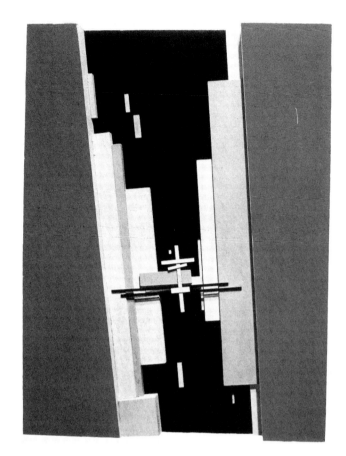
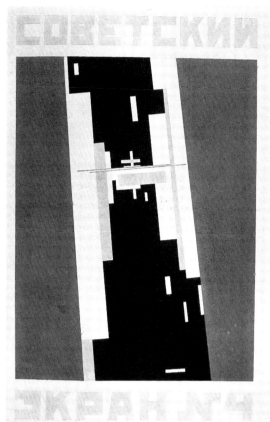

1/2

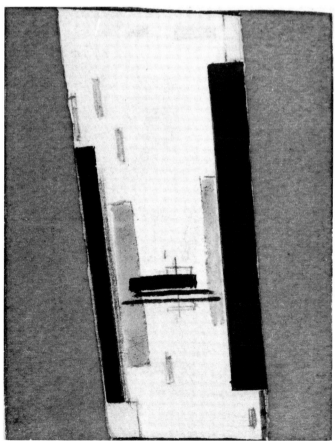
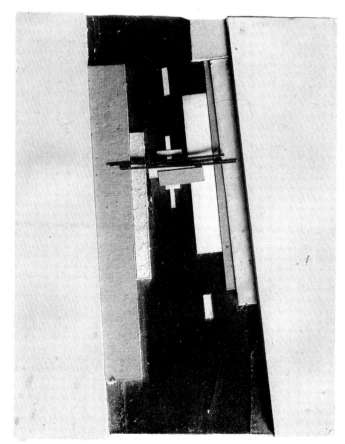

3/4

Ksenia Vladimirovna Ender 1894–1955

11 Untitled

1918
Oil on cardboard, 42.7 × 61.8 cm
The piece is unvarnished and the cardboard is slightly warped, but the general condition is good
Accession no.1978.77

Provenance
Galerie Gmurzynska, Cologne
Thyssen-Bornemisza Collection, 1978

Exhibitions
Cologne 1986, no.106
Luxembourg/Munich/Vienna 1988–9, no.19, colour illus. p.61

The Ender family (Boris, Ksenia, Mariia and Yurii) constituted the most active and inventive group among Mikhail Matiushin's pupils of the 1920s, opposing the geometric abstraction and architectonic experiment that we now tend to identify too exclusively with the Russian avant-garde. Of course, the Enders were aware of the ideas of Kazimir Malevich and Vladimir Tatlin, but the 'organic' abstractions of Matiushin had a greater appeal.

Like Matiushin, Ksenia Ender was deeply interested in the primitive forces of nature, in her essential energy, colour and molecular structure, and also in the possibility of accelerating the evolution of physical processes. The two untitled paintings here reflect these elemental concerns and bring to mind Matiushin's own observations and depictions pertaining to crystalline structures and botanical growth. Matiushin gave special assignments to students, requiring them to depict the 'penetration of forms' or 'geometrization of forms' as manifest in nature. He wrote in 1934:

> Our teacher is nature. We shall never be able to stop observing nature. So as to express her creative essence in more forceful terms, we must observe freely without clinging to familiar details.[1]

A number of Ender's paintings of the mid-1920s, especially the cycle called *Lake*, present natural phenomena as schematic, almost abstract configurations that both integrate and delineate the frontiers between water, earth and sky.[2]

Not surprisingly, Ender accepted Matiushin's so called 'See-Know' system, which he perfected in the early 1920s and which he hoped would:

> teach yourself [sic] to see through the back of your neck, the crown of your head, your temple and even your footprints.[3]

Ender also collaborated with Matiushin on the tabulation of colour properties that he published in 1932 under the title *Zakonomernost izmeniaemosti tsvetovykh sochetanii. Spravochnik po tsvetu* [The Conformity of the Changeability of Colour Combinations. A Colour Primer]. Indeed, the

Notes
1 M. Matiushin, 'Tvorcheskii put khudozhnika' [An Artist's Creative Path] (1934); quoted in Cologne 1977, p.28
2 For relevant illustrations see *Art of the Avant-Garde in Russia: Selections from the George Costakis Collection*, exh. cat. New York, Solomon R. Guggenheim Museum, and other institutions, 1981, pp.85–95
3 M. Matiushin, 'Zor-Ved', *Zhizn iskusstva*, no.20, Petrograd, 1923, p.15

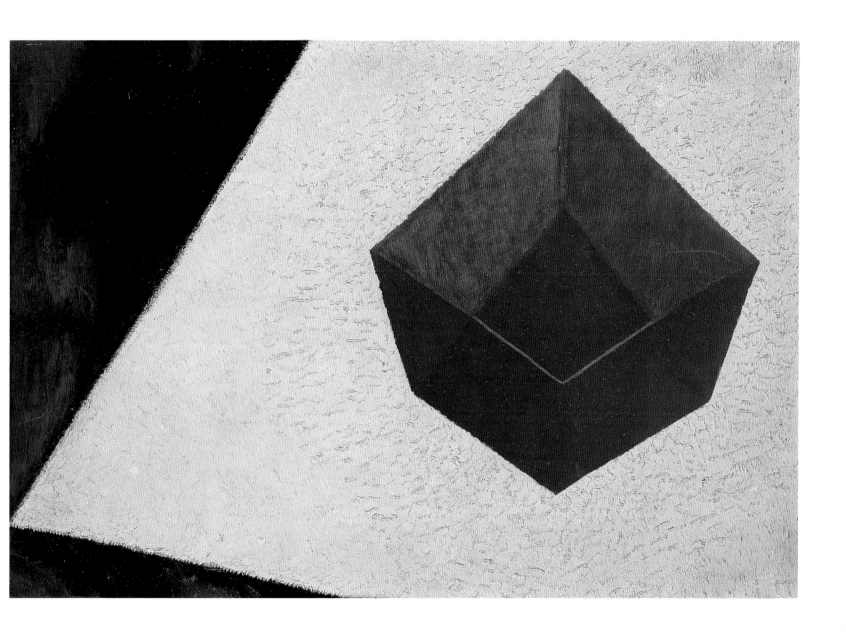

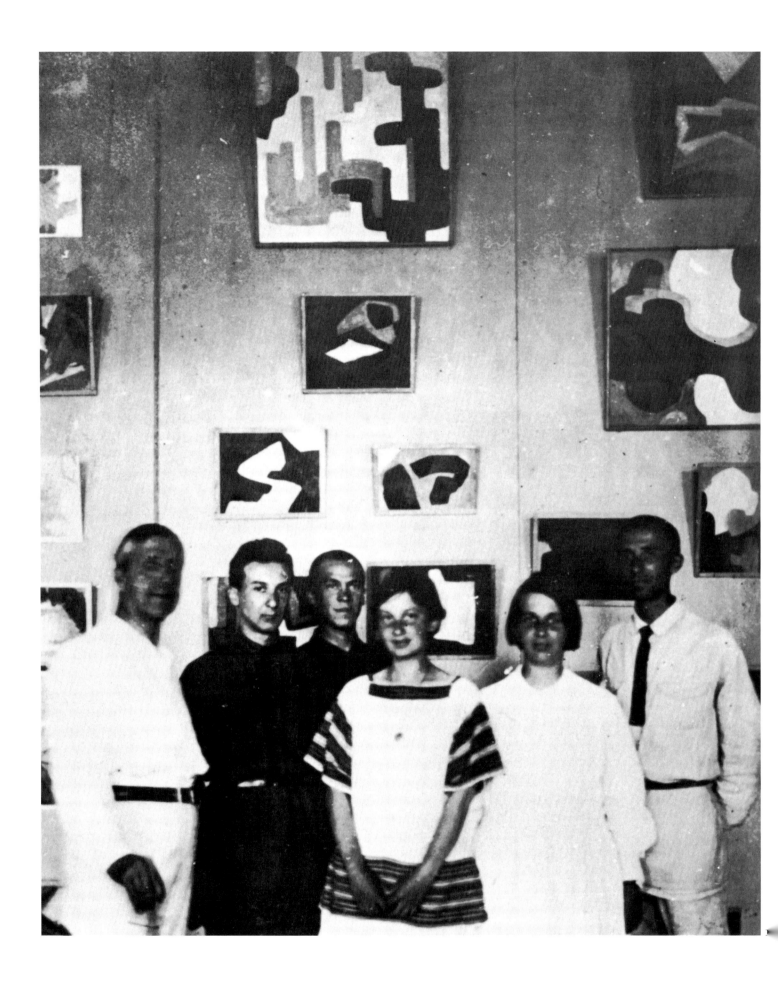

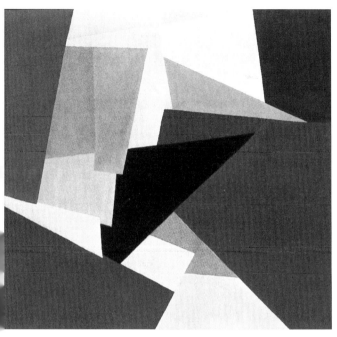

FIG 2 Ksenia Ender, *Untitled*, *c*1920, 30.9 × 40.2 cm oil on canvas (Art Co. Ltd, George Costakis Collection)

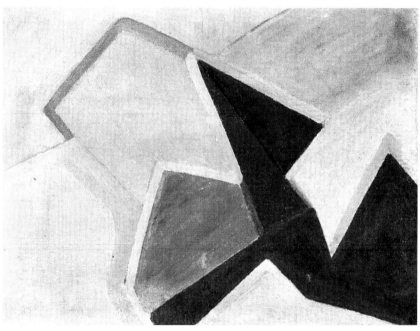

FIG 3 Boris Ender, *Abstract composition*, ?1919–20, 104 × 100 cm, oil on canvas (Art Co. Ltd, George Costakis Collection)

FIG 1 Photograph taken at Ginkhuk in 1924 with (left to right) Mikhail Matiushin, Yurii Ender, Nikolai Grinberg, Ksenia Ender, Mariia Ender and Boris Ender. Works by the Enders hang on the wall behind them (photograph courtesy of Alla Povelikhina, St Petersburg)

Notes
4 M. Matiushin, 'Opyt khudozhnika novogo izmereniia' [An Experiment by an Artist of the New Dimension] (1923): quoted in Cologne 1977, p.33
5 In 1917 Matiushin even prepared a special essay on the subject of the fourth dimension under the title 'Oshchushenie chetvertogo izmereniia' [The Sensation of the Fourth Dimension], but it was not published. For a useful discussion of the fourth dimension and the Russian context see L. Henderson, *The Fourth Dimension and Non-Euclidian Geometry in Modern Art*, Princeton (Princeton University Press) 1983, esp. chap. 5

two untitled paintings in the Collection (see [12]) should be regarded as part of a complex series of exercises in spatial perception inaugurated by Matiushin in the early 1910s and elaborated by him and the Ender group after the Revolution and at Ginkhuk in the early and mid-1920s (fig.1) During their seminars, Matiushin and the Enders researched the whole notion of visual perception:

> …the entire visuality of simple bodies and forms is merely the vestige of a higher organism which in fact is linked to total visuality, just as the sky is with the earth. For [the artist] the sky is not the curtain above eternity and painted blue, but a continuous depth without beginning and without end.[4]

Ender was also interested in the practical application of such ideas and, for example, investigated the potential role of colour in architecture. Like Vasilii Kandinsky and Matiushin, she thought about sound–colour correlations and tried to paint music. Obviously, this work also manifests Ender's interest in inverted perspective and axonometry, and the extension of the half-disclosed polyhedral shape both here and in analogous works such as the untitled oil on canvas (fig.2) alludes to a non-Euclidean geometrical space – something of particular interest to Matiushin and his circle during the 1910s and 1920s that was expressed in his deliberations on the fourth dimension.[5] Since the Enders worked closely together during their apprenticeship to Matiushin, their paintings and drawings are sometimes very similar to one another (fig.3) and also to Matiushin's – something that often leads to misattribution.

Ksenia Vladimirovna Ender

<div align="right">1894–1955</div>

12 Composition

1918
Oil on cardboard, 48.5 × 61.5
The painting is unvarnished. The cardboard is slightly warped and all edges and corners carry old repairs, but the
 general condition is good
Accession no.1980.19

Provenance
Galerie Gmurzynska, Cologne
Thyssen-Bornemisza Collection, 1980

Exhibitions
Cologne 1979–80, no.11, colour illus. p.95 and mentioned p.90
Cologne 1986, illus. p.105
Luxembourg/Munich/Vienna 1988–9, no.18, colour illus. p.59
Zurich 1989, p.26, colour illus. p.27

There is no evidence to assume that *Composition* is the original title of this piece which, in fact, has also been designated as '*Space*' and untitled[1] and stylistically it is very similar to works by Matiushin such as *Painterly-musical construction* of 1918 (fig.1; see over). The similarity between these two works is reinforced by the obvious concern with organic process – a concern that united many of the artists of the St Petersburg and Leningrad avant-garde such as Pavel Filonov (see [16]) and Paul Mansouroff (see [41], [42]). All these artists were involved in the elaboration of the programmes at Ginkhuk and worked closely together in the early 1920s. A second point of visual coincidence between the two pieces is the exposure of the dark background against which the saturated spots in red, yellow and green pulsate and vibrate. Another parallel can be made with Matiushin's *Painterly-musical construction* also of 1918 (fig.2; see over): with the angular arrangements, both pieces transmit an atmospheric refraction and luminescence, even though *Composition* is dark, while *Painterly-musical construction* is lighter in colour and tone.

Note
1 Undated statement by the St Petersburg historian Alla Povelikhina accompanying the transaction of the painting from the Galerie Gmurzynska to the Thyssen-Bornemisza Collection; archives of the Thyssen-Bornemisza Collection

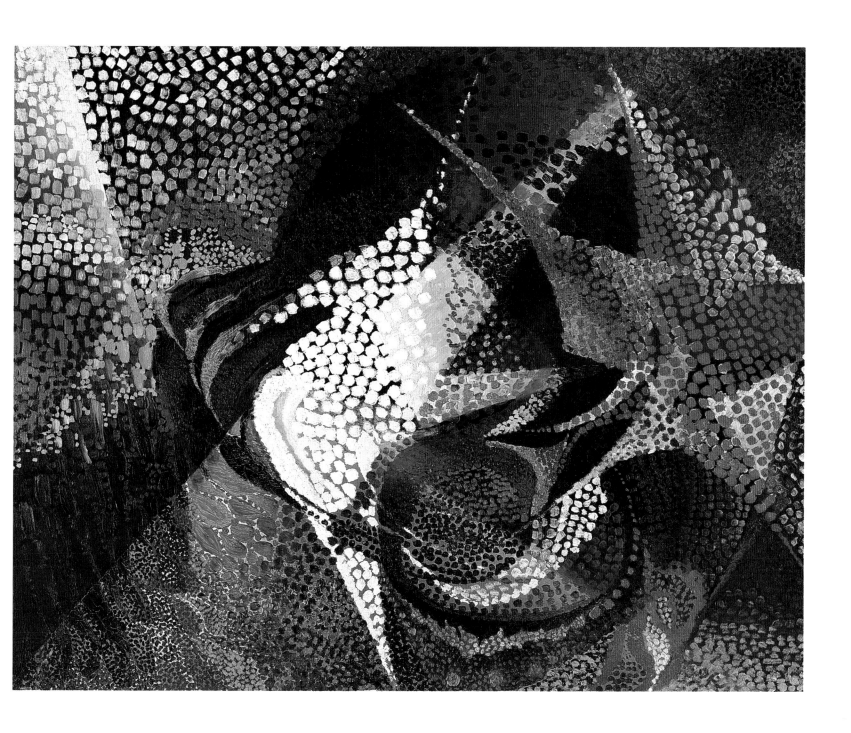

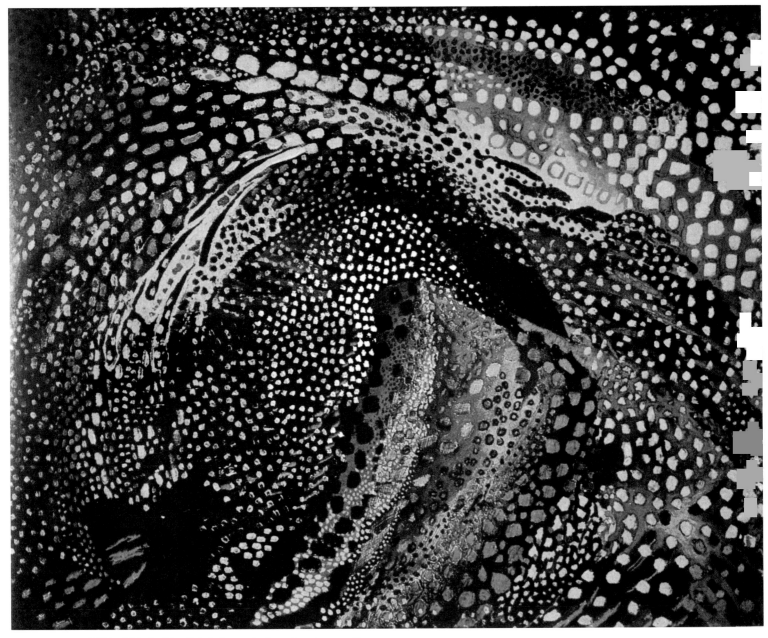

FIG 1 Mikhail Matiushin, *Painterly-musical construction*, 1918,
51 × 63 cm, oil on plywood (Art Co. Ltd, George Costakis Collection)

FIG 2 Mikhail Matiushin, *Painterly-musical construction*, 1918, 51.4 × 63.7 cm, gouache on cardboard (Art Co. Ltd, George Costakis Collection)

Alexandra Alexandrovna Exter

1884–1949

13 Still-life
Nature morte

1913
Oil, tempera and printed matter on paper on canvas, 68 × 53 cm
The paper support and the collage elements show extensive wrinkling and there is marked separation of the collage elements from the surface. Although considerable restoration has been undertaken, the general condition is very weak.
Accession no.1973.26

Provenance
Leonard Hutton Galleries, New York
Thyssen-Bornemisza Collection, 1973

Exhibitions
Moscow, March 1914, *Jack of Diamonds*, no.193 [as *Nature morte*]
New York 1971–2, no.17, colour illus. p.34
Paris, Galerie Jean Chauvelin, May–June 1972, *Alexandra Exter*, illus. p.19
Milan 1979–80, illus. no.428
Luxembourg/Munich/Vienna 1988–9, no.21, colour illus. p.65
Madrid, Centro de Arte Reina Sofia, 1989, *Dada y Constructivismo*, colour illus. p.59

Literature
Tugendkhold, *Alexandra Exter*, illus. pl.II
Lozowick (1925), illus. p.19
H. Wescher, *Die Collage*, Cologne (Dumont Schauberg) 1968, colour illus. pl.72 and mentioned on p.92

According to Yakov Tugendkhold, the *Still-life* was entitled *Nature morte* and dated 1913 and, presumably, this is the same piece that was included as *Nature morte* in the 1914 *Jack of Diamonds* exhibition in Moscow.[1] Over the years, however, *Still-life* has assumed other titles such as *Collage* (Nakov, *Alexandra Exter*, p.19) and the more descriptive *Still-life with bottle and glass* with which it entered the Thyssen-Bornemisza Collection (even though the 'bottle' is, in fact, a carafe).

Exter's concern with the still-life was indebted to her apprenticeship in Paris – and also to her romantic involvement with Ardengo Soffici in France and Italy between 1912 and 1914.[2] Like Nikolai Kulbin and Olga Rozanova (see [49], [50]), Exter contributed three works to the *Esposizione libera futurista internazionale. Pittori, scultori. Italiani-russi-inglesi-belgi-nordamericani* at the Galleria Futurista di Sprovieri, Rome, in the spring of 1914, and there are clear parallels

Notes
1 Tugendkhold, *Alexandra Exter*, pl.II
2 According to the chronology in the exh. cat. *Ardegno Soffici. L'artista, lo scrittore nella cultura del novecento*, Florence, Villa Medicea, 1975, p.18, Soffici met Exter in Paris in spring 1912. Their 'sentimental relationship' seems to have lasted until 1914

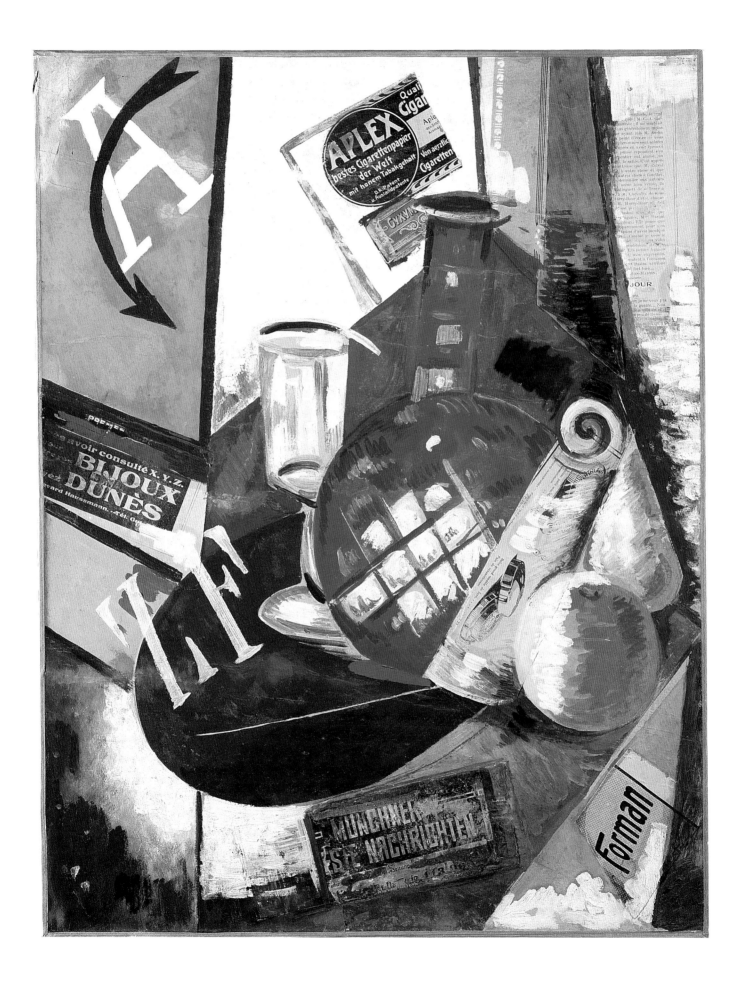

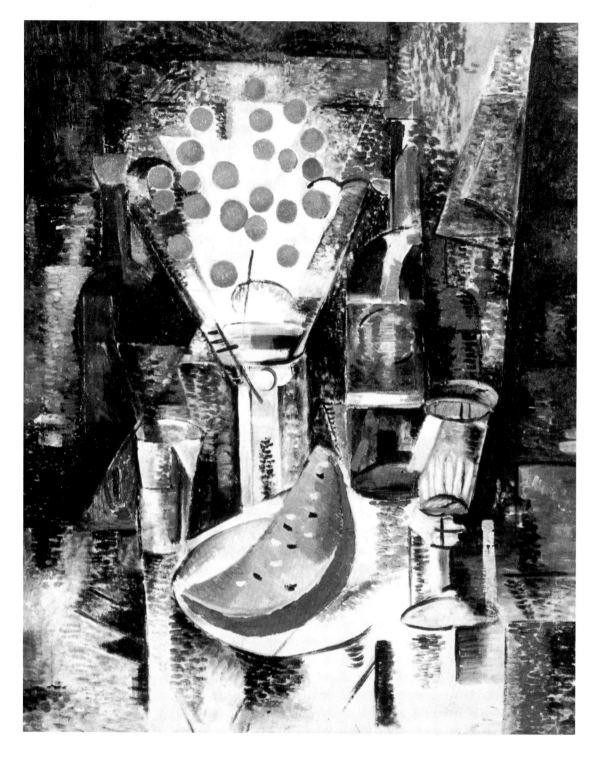

FIG 1 Alexandra Exter, *Still-life*, 1914–15, 89 × 72 cm, oil on canvas (Yaroslavl, Rostov-Yaroslavl Regional Museum)

between her paintings of this time and those of the Italian Futurists. For example, Exter's *Still-life* dated 1914–15 (fig.1) brings to mind Soffici's *Fruit and liqueurs* of 1915 (fig.2). No doubt Exter was well aware of Soffici's concept of Cubism published in the journal *Lacerba*:

> It should be possible to cut up the same painting into more pieces so that each of these, when taken separately, can represent a harmonious pictorial unit.[3]

Perhaps in her *Still-life* of 1914–15 Exter has borrowed the happy image of the water-melon

Note
3 A. Soffici, 'Cubismo e oltre', *Lacerba*, no.2, Florence, 15 Jan. 1913, p.11

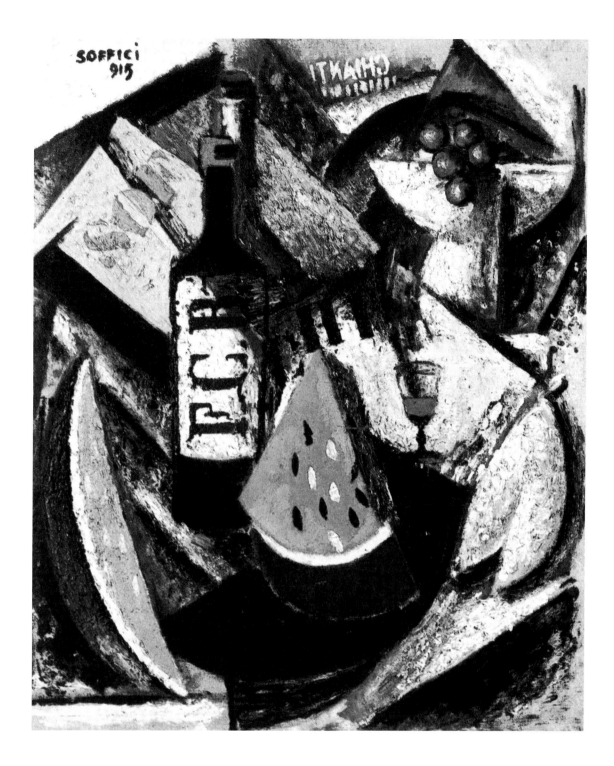

from Soffici's *Fruit and Liqueurs.* The images of the water-melon, bottle and wine-glass interspersed with collages of newspaper and commercial advertisements that recur in Soffici's homages to Cubism of 1913–15 often return in Exter's still-lifes of the same period such as the *Still-life* (dated 1915, but probably earlier; fig.3). This piece is especially close to the work in question, repeating similar images of the glass and carafe, the commercial references and the cryptic letters. Even after Exter returned to Kiev from Paris in July, 1914, she continued to use the same elements, albeit transposed into a Russian-Ukrainian mode – cf. the Russian letters

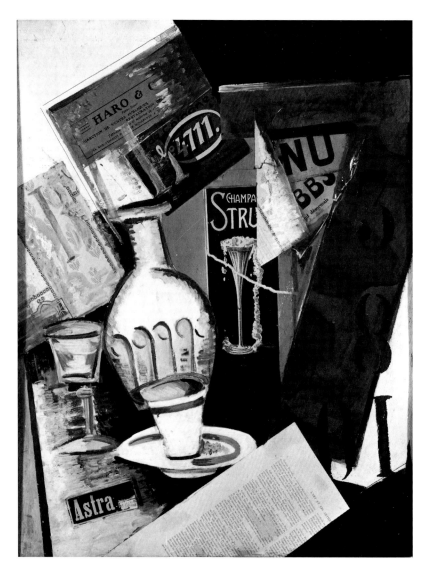

and appliqués of Russian newspaper in *Wine*, 1914 (fig.4) and the Ukrainian Easter eggs in *Still-life with eggs* (1914; fig.5).

The six collages from commercial advertisements in *Still-life* tell us more about Exter's international interests than about the exact date of the picture. The reference to the jewellery store of Dunès in Paris, the Munich newspaper *Münchner neuste Nachrichten*, the German Aplex cigarettes, the French advertments for Forman and boxes and the Russian Sukhumi brand cigarettes represent a casual rather than consistent inclusion of everyday paraphernalia into the Cubist vocabulary. At the same time, the letters 'A Z F' might be part of a private code which, unfortunately, is not decipherable. The visual and verbal result is a playful ornament which, as Tugendkhold noted, avoids the extreme severities of Cubism and expresses the artist's great decorative talent demonstrated so clearly in the spiral curl on the right and the descending arrow on the left. Without making a direct reference to Exter's still-lifes, Tugendkhold stated:

> Exter's decorative instinct has never fallen silent. Her Cubist canvases are always conceived as densely filled carpets evenly saturated with form.[4]

Indeed, Exter achieved her international recognition if not as a carpet designer then certainly as an 'original and bold stage designer', as Marinetti once called her,[5] and her decorative flourish enlivened many productions in the 1910s, and as late as 1921, in her costumes for *Romeo and Juliet*, Exter repeated the 'Baroque' Cubism of the curl in *Still-life* (fig.6).

FIG 3 Alexandra Exter, *Still-life*, 1915 [1913?], 68 × 53 cm, oil, tempera, collage of paper and mica on canvas (Moscow, State Tretiakov Gallery)

Notes
4 Tugendkhold, op. cit., p.12
5 F. Marinetti, 'Una sensibilità italiana nata in Egitto' in G. Ferrara, intro., *F.T. Marinetti. La grande Milano tradizionale e futurista. Una sensibilità italiana nata in Egitto*, Milan (Mondadori) 1969, p.317. Marinetti met Exter while he was in Moscow at the beginning of 1914

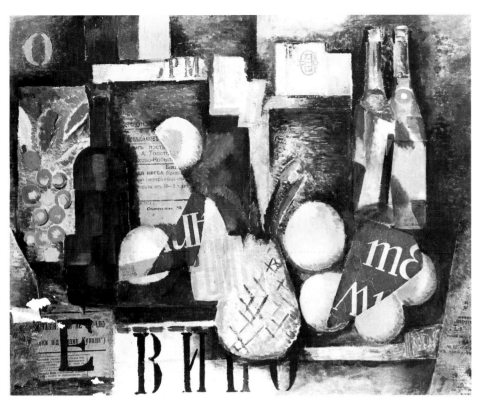

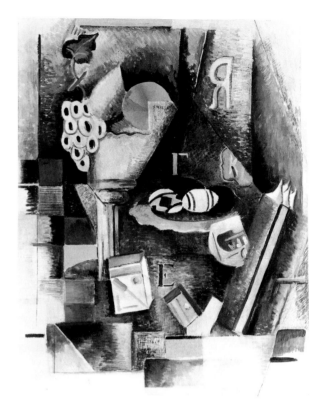

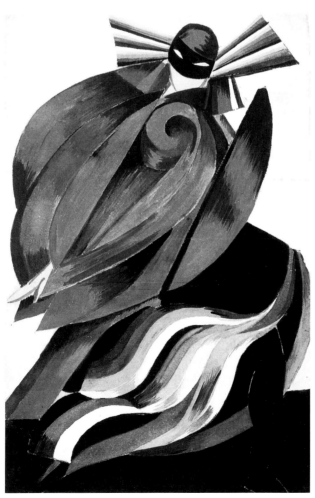

FIG 4 Alexandra Exter, *Wine*, 1914, 65 × 80 cm, collage and oil on canvas (private collection; courtesy of Leonard Hutton Galleries, New York)

FIG 5 Alexandra Exter, *Still-life with eggs*, 1914, 80 × 70 cm, oil on canvas (St Petersburg, State Russian Museum)

FIG 6 Alexandra Exter, costume for the Fourth Female Mask in *Romeo and Juliet*, 1921, 49.9 × 32.4 cm, gouache on cardboard (Moscow, Bakhrushin Museum)

Alexandra Alexandrovna Exter 1884–1949

14 Two women in a garden

1927
Oil on canvas, 86.3 × 69.2 cm
Signed lower right: 'A. Exter'
The reverse carries a label of the Académie d'Art Moderne, Paris
General condition is good
Accession no.1976.78

Provenance
Marc Rosenthal, Paris
Leonard Hutton Galleries, New York
Thyssen-Bornemisza Collection, 1976

Exhibitions
Paris, L'Académie d'Art Moderne, May–June 1928
New York, Leonard Hutton Galleries, 23 Oct.–Jan. 1975–6, *Alexandra Exter Marionettes*, no.29, illus. p.37
Luxembourg/Munich/Vienna 1988–9, no.22, colour illus. p.67

Exter painted *Two women in a garden* as a response to the 'call to order' that echoed throughout Europe and Russia in the 1920s, and it represents her own extension of the New Classicism supported by Picasso, Léger, de Chirico and, above all, the Purism of Ozenfant and Jeanneret (Le Corbusier).[1] Obviously, Exter knew the principles of Purism firsthand, discussing the new theory with Juan Gris, Ozenfant and Jeanneret and reading about it in the relevant publications such as the journal *L'Esprit Nouveau* (Paris, 1920–5) and the Ozenfant and Jeanneret book *La Peinture Moderne* (Paris, Esprit Nouveau, 1927). In 1925–30 Exter taught at Léger's Académie d'Art Moderne in Paris, where Marie Laurencin and Ozenfant were also teaching, and her own exploration of the constructive still-life at this time coincided with Ozenfant's transition from the 'exclusively still-life iconongraphy'[2] to a greater concern with the human figure, albeit

Notes
1 For information on the return to order see *Les Réalismes 1919–1939*, exh. cat. Paris, Centre Georges Pompidou, 1980–81; *On Classic Ground. Picasso, Léger, de Chirico and the New Classicism 1910–1930*, exh. cat. London, Tate Gallery, 1990
2 'Amédée Ozenfant' in *On Classic Ground*, op. cit., p.199

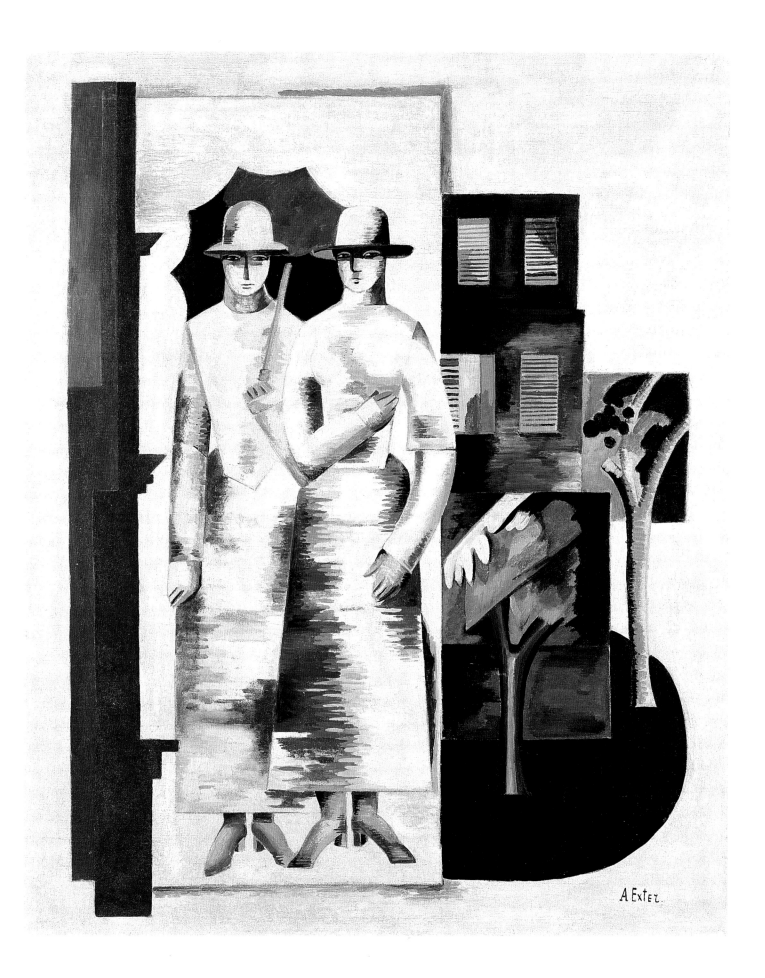

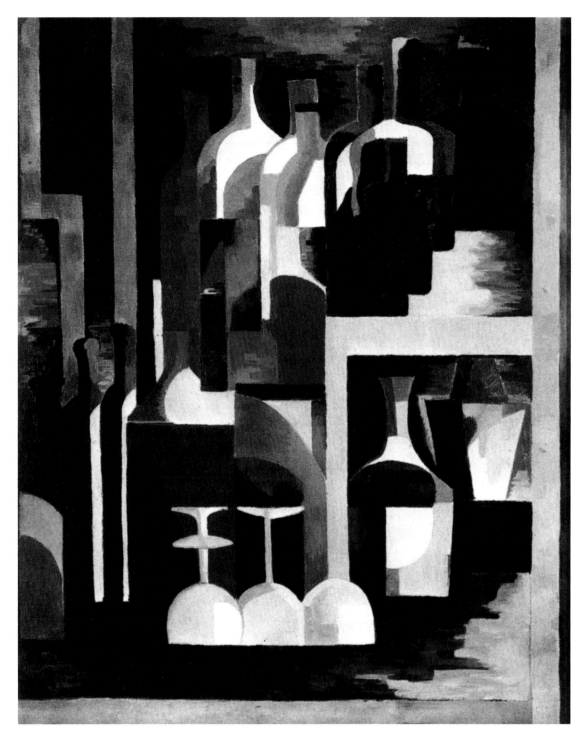

FIG 1 Alexandra Exter, *Purist composition*, 1925, 100 × 89 cm, oil on canvas (Cologne, Galerie Gmurzynska)

within a rigorous formal structure. Exter's *Purist composition* of 1925 (fig.1), for example, owes a great deal to Ozenfant's Purist still-lifes such as *Accords* (or *Fugue*) (1922; fig.2), while *Two women in a garden* already speaks of other influences – even of Magritte's Surrealism. In this sense, Exter was following a path similar to that of the Hungarian Sándor Bortnyik (see [3]).

As Tugendkhold implied in 1922, Exter's primary artistic gift was a decorative one and even in a narrative work such as *Two women in a garden*, she emphasized the two-dimensional 'cult of the plane'[3] in the composition, treating all elements, organic and inorganic, even the

FIG 2 Amédée Ozenfant, *Accords* (also called *Fugue*), 1922, 130 × 97 cm, oil on canvas, (Honolulu Academy of Arts; gift of John W. Gregg Allerton, March 1967)

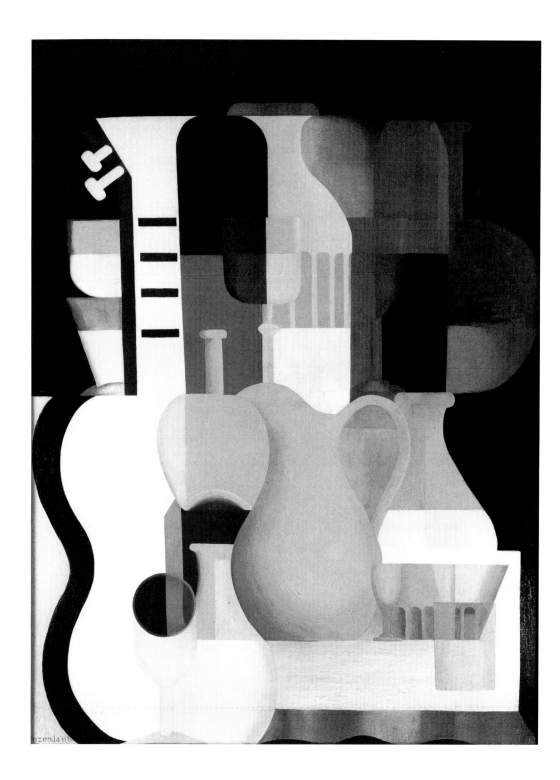

Notes
3 See Y. Tugendkhold on Ozenfant and Purism in *Khudozhestvennaia kultura Zapada*, ed. Y. Tugendkhold, Moscow and Leningrad (Gosizdat) 1928, p.107
4 Tugendkhold, *Alexandra Exter* p.12

volumetrical umbrella, as parts of the 'carpet' that Tugendkhold had associated with her Cubist paintings.[4] Exter's orientation towards a new order of Realism was shared by many of her compatriots living in Paris at this time, including Yurii Annenkov, Alexandre Jacovleff, Vasilii Shukhaev, Léopold Survage and Léon Zack, and many of them – including Exter herself – contributed to the exhibition of *Contemporary French Art* in Moscow in 1928 (where de Chirico, Léger, Ozenfant, Severini et al. were also represented).

Alexandra Alexandrovna Exter 1884–1949

15 Don Juan in Hell tortured by the hangman's servants

1929
Gouache on paper, 51 × 44 cm
Signed lower right: 'Alex. Exter'
The general condition is good
Accession no.1980.20

Provenance
Estate of the artist
Galerie Gmurzynska, Cologne
Thyssen-Bornemisza Collection, 1980

Exhibitions
Geneva, Galerie Motte, July-Aug. 1973, *Vision Russe*, no.17, illus. [unpaginated]
Heidelberg, Heidelberger Kunstverein, 14 July–15 Sept. 1974, *Vision Russe*, no.95, colour illus. [unpaginated]
Cologne 1979–80, no.27, illus. p.122
Cologne 1986, illus. p.108
Luxembourg/Munich/Vienna 1988–9, no.23, colour illus. p.69

Exter did many costume designs for the ballet *Don Juan* based on the music by Christoph Willibald Gluck, choreographed by her friend Elsa Krüger and produced by Lasag Galpern at the Cologne Opera House in November 1929. Similar designs are in public and private collections (fig.1).

After her emigration to Paris in 1924, Exter continued to work for the theatre, even though she was never given the spectacular commissions that she had had from Alexander Tairov at the Moscow Chamber Theatre. Among the plays, ballets, films and revues that attracted her attention in the 1920s were *Othello*, *Faust*, *The Merchant of Venice* and *Don Juan*, although most of her designs remained only as projects and proposals. A few relevant pieces were published in the album of fifteen pochoirs called *Alexandra Exter. Décors de Théâtre* (Paris, Edition des Quatre Chemins, 1930; preface by A. Tairov). Exter's figures, dressed in their vivid costumes, inhabit a Constructivist world of manipulated planes; they move along numerous platforms and

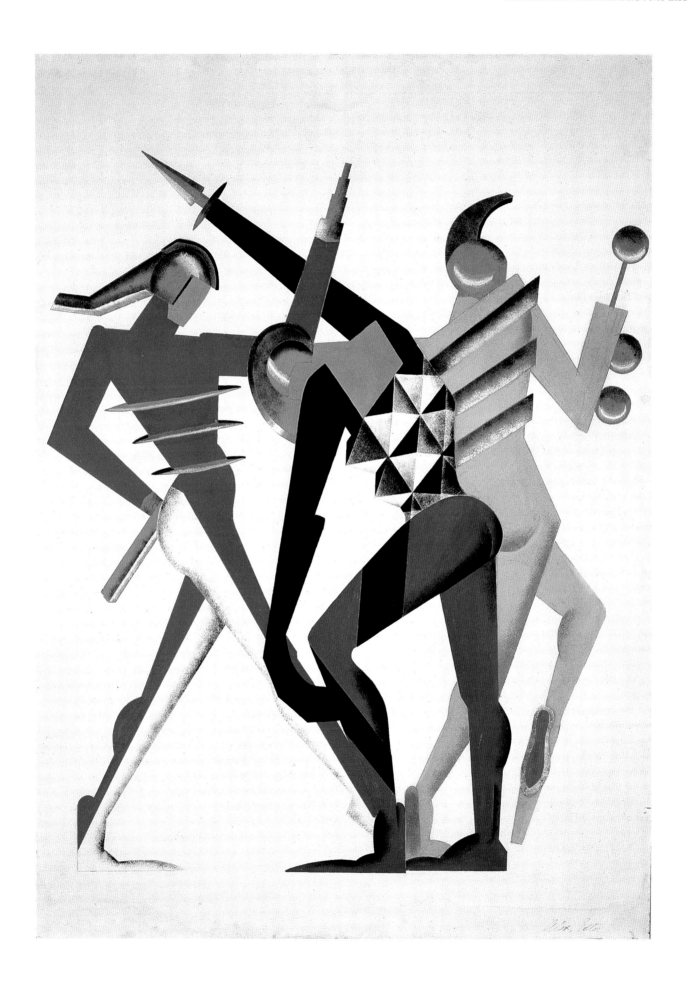

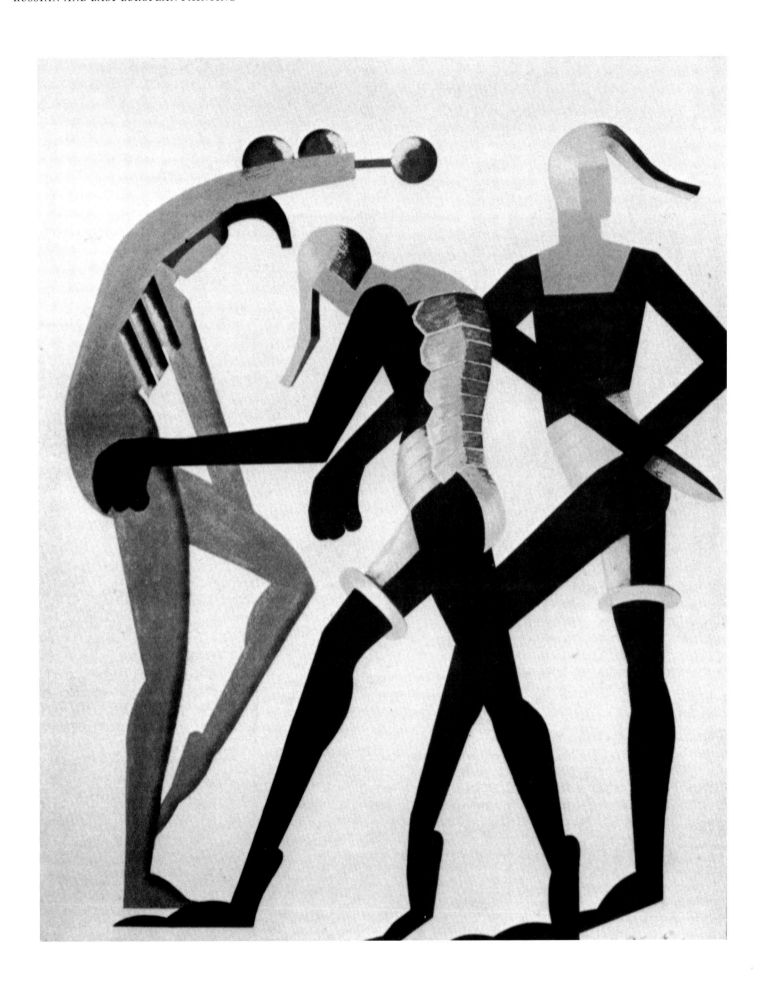

FIG 1 Alexandra Exter,
Acrobats, 1929,
56.6 × 45.2 cm, gouache on
paper (Cologne, Galerie
Gmurzynska)

Note
1 Y. Tugendkhold, 'Pismo iz
Moskvy', *Apollon*, Petrograd,
no.1, 1917, p.72

staircases as they enter and exit powerful interplays of light and colour. Following in the wake of Adolphe Appia and Thomas Gray, Exter became particularly interested in the architectural possibilities of the stage and often used a combination of arches and steps in order to enhance and 'expand' the space on stage (as, for example, in her sets for *Don Juan*). In all her theatre designs, Exter attempted to illustrate the 'dynamic use of immobile form'[1] that she had applied in her first works for the Chamber Theatre, Moscow.

Exter was an accomplished artist whose concern with pictorial construction and three-dimensional spatial resolution led her to the theatrical medium. Unlike many of her colleagues, however, especially those who worked for Sergei Diaghilev's Ballets Russes, Exter was not especially interested in the illusory, ethnographical aspects of the decoration, but rather in the whole notion of material construction, of space as a constituent part of the production. By developing this conception, Exter contributed a great deal to the evolution of the Russian Constructivist movement, especially as it manifested itself in the theatre – and many of the early Soviet stage designers such as Anatolii Petritsky and Isaak Rabinovich were much indebted to her innovations.

Pavel Nikolaevich Filonov 1883–1941

16 Illustration for Velimir Khlebnikov's poem *Night in Galicia*

1913
Ink and pencil on paper, 15.2 × 10.2 cm (image)
The very thin paper, slightly bulging, carries many stains, although the general condition is good
Accession no.1976.48

Provenance
Collection of the family, Leningrad
Nikolai Khardzhiev, Moscow
Sotheby's, London
Galerie Jean Chauvelin, Paris
Thyssen-Bornemisza Collection, 1976

Literature
V. Khlebnikov, *Izbornik stikhov* [Selection of Poetry], St Petersburg (EUY) 1914 [unpaginated lithograph]
Sotheby's, 12 April 1972, lot 22

Filonov made eleven drawings in 'brush, pen and engraving'[1] for extracts from Khlebnikov's poem *Dereviannye idoly* [Wooden Idols] which were included as an unpaginated addendum to the *Izbornik stikhov*, a collection of Khlebnikov's poems published between 1908 and 1914. In spite of the title [A Selection of Poems], the book also included some of Khlebnikov's theoretical deliberations, including his numerical systems, while the selected poems also carried an untitled lithograph by Malevich. The cover carried a portrait of Khlebnikov by Nadezhda Burliuk.

The small booklet *Izbornik stikhov* (21 × 15 cm) was published in a thousand copies in March, 1914, although both the supplemental poems and Filonov's drawings were created in 1913.[2] Filonov's eleven lithographs printed on orange paper by the Svet [Light] Corporation in St Petersburg complemented his special calligraphy for Khlebnikov's two poems 'To Perun' (from the book *Wooden Idols*) and *Night in Galicia* (fig.1). This particular drawing is the second of the nine illustrations interspersing the eight pages of the latter poem, although it seems to have little to do with Khlebnikov's narrative about mermaids, a knight, a funeral, witches and Galician girls. The cycle of illustrations relies heavily on Filonov's standard lexicon of images – the crowned head, the dog-cum-panther, horses, flowers, repeated eyes and windows in towering houses, although, unlike other sheets here, this particular composition did not serve as a preparatory sketch for a later oil painting (cf. *Animals*, 1925, St Petersburg, State Russian Museum).

In his paintings, Filonov would take a simple image such as a face or head and repeat it in many variations and convolutions, producing the simultaneous effect of familiarity and

Notes
1 This is how Filonov's drawings are described on the cover of *Izbornik stikhov*
2 For commentary on the genesis and evolution of the Khlebnikov poems see M. Poliakov, V. Grigoriev and A. Parnis, eds., *Velimir Khlebnikov. Tvoreniia*, Moscow (Sovetskii pisatel) 1986, p.85 *et seq*. Some of Filonov's illustrations to the *Izbornik stikhov* are also reproduced here, including the lithograph of the drawing in the Thyssen-Bornemisza Collection (p.620)

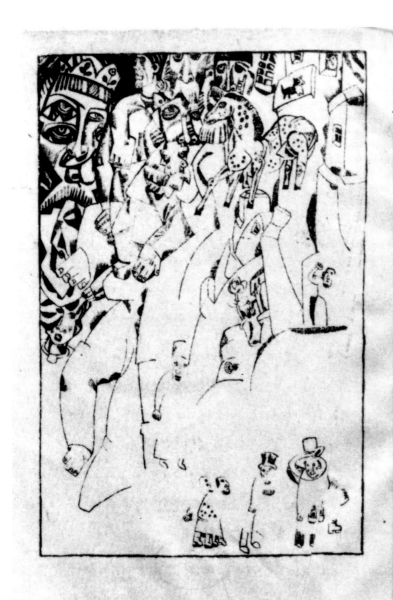
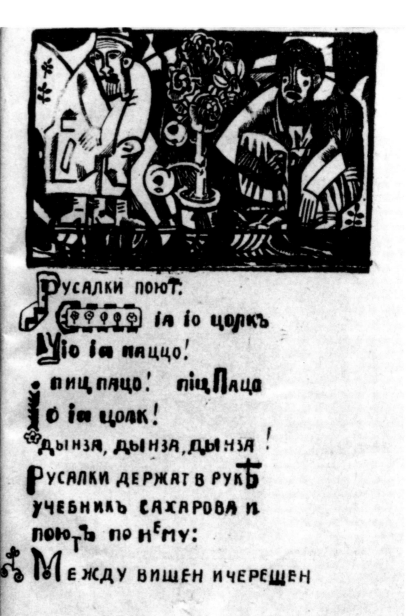

estrangement. Similarly, Filonov investigated an intricate counterpoint of concrete-abstract in his calligraphical designs for *Izbornik stikhov*, where he tried to match Khlebnikov's often abstruse and archaic vocabulary by a more accessible visual entertainment in the form of ideograms. For example, he 'transposed' the penultimate letter of the verb 'they sing' and suspended the middle letter of the verb 'to fly away' above the rest of the word. Consequently, in his speech-creating, his analytical paintings and his ideograms, Filonov was playing a calculated game, inviting the viewer to participate actively in the perception of the artefact.

During 1914–15 Filonov and Khlebnikov were particularly close, if not as personal friends, then certainly as colleagues in the promotion of the new art. As members of the Union of Youth, they contributed to the Cubo-Futurist miscellany *Rykaiushchii Parnas* [Roaring Parnassus] (St Petersburg, Zhuravl, 1914), Filonov drew a portrait of the poet (c1914; fig.2), and Khlebnikov responded to Filonov's experimental painting and poetry with unusual enthusiasm. For

FIG 1 Pavel Filonov, double-spread illustration to Velimir Khlebnikov's poem 'Noch v Galitsii' [Night in Galicia] in V.Khlebnikov; *Izbornik stikhov*, St Petersburg (EUY), 1914, 14.4 × 20 cm, lithograph (private collection)

Notes
3 V. Khlebnikov, 'Ka' in
V. Khlebnikov et al.: *Moskovskie
mastera*, Moscow, 1916, p.55
4 Letter from Khlebnikov to
Matiushin of April 1915; quoted
in N. Khardzhiev and T. Grits,
eds., *Velimir Khlebnikov.
Neizdannye proizvedeniia*, Moscow
(Khudohestvennaia literatura)
1940, p.378

example, he was especially taken by Filonov's oil painting called *Feast of the kings* (1912–13, St Petersburg, State Russian Museum): 'The artist had painted a feast of corpses, a feast of revenge. Majestically, importantly, the cadavers were eating fruits illumined by a fury of grief as if by moonlight'.[3] Khlebnikov was also impressed by Filonov's own neologistic poetry that Mikhail Matiushin published at his Crane Publishing House in Petrograd in 1915 as *Propeven o prorosli mirovoi* [Chant of Universal Flowering]:

Of all the things published by The Crane this book has been published with the best possible taste...

I expect some good things from Filonof the writer. This book does have some lines that are among the best that have been written about the War.

In brief, the book has made me happy by having no commercial path.

'Universal flowering' also sounds pretty good.[4]

The State Tretiakov Gallery in Moscow, also possesses an original ink drawing (1913, formerly in the collection of Alexei Sidorov) for the *Izbornik stikhov*, the first lithograph to *Night in Galicia*, while the Costakis collection contains two ink drawings for the *Izbornik stikhov* (1914; fig.3). Filonov's lithographs for *Izbornik stikhov* are often reproduced (Khardzhiev, *Kistorii russkogo avangarda*, pp.128, 129, and Kovtun *Russkaia futuristicheskaia kniga*, 1989, no.15/2).

FIG 2 Pavel Filonov, *Portrait of the Poet Khlebnikov*, c1914, 19.9 × 14.1 cm, pencil on paper (Moscow, Collection of the Russian State Archive of Literature and Art)

FIG 3 Pavel Filonov, illustration for Velimir Khlebnikov's 'Noch v Galitsii' [Night in Galicia] in Velimir Khlebnikov, *Izbornik stikhov*, 1914, 18.4 × 12.6 cm, ink on paper (Art Co. Ltd, George Costakis Collection)

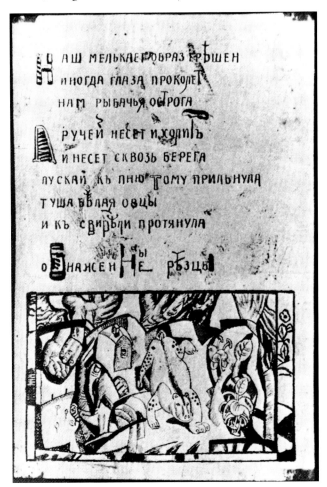

Tatiana Nikolaevna Glebova 1900–85

17 Prison. Panel section for the Press House, Leningrad
Tiurma

1927
Oil on canvas, 236.5 × 153 cm
A piece of canvas has been added to the top of the main canvas. The original edges of the canvas – relined – have
 been removed. The new edges carry scattered losses. General condition is good
Accession no.1984.20

Provenance
Tatiana Glebova, Leningrad
Mikhail Meilakh, Leningrad
Galerie Gmurzynska, Cologne
Thyssen-Bornemisza Collection, 1984

Exhibitions
Luxembourg/Munich/Vienna 1988–9, no.26, colour illus. p.75

Literature
T. Glebova, 'Souvenirs sur Filonov', *Cahiers du Musée National d'Art Moderne*, no.1, Paris, 1985, p.119
T. Glebova, 'Risovat kak letopisets', *Iskusstvo Leningrada*, no.1, Leningrad, 1990, illus. p.36; references there on
 p.30
P. Efimov, 'Obedinenie ''Kollektiv masterov analiticheskogo iskusstva'' (Shkola Filonova)', *Panorama iskusstv*,
 no.13, Moscow, 1990, p.108, [as *Prison* and its whereabouts given as unknown]

The work was formerly known as *Untitled composition* and was assumed to be by Pavel Filonov
(see [16]), although there is no concrete evidence to support such an attribution, especially
since there exist a documentary photograph of Glebova herself with the painting (fig.1) and a
certificate signed by her demonstrating that the painting is, indeed, hers. The Department of
Soviet Graphics at the State Russian Museum, St Petersburg, possesses a *Study for the picture in
the Press House, 'Prison'* which the museum dates as 1927–8 (fig.2). According to the Russian
historian Alena Spitsyna, there is another, similar study in a private collection in St Petersburg
and a preparatory study for the same enterprise is mentioned in the catalogue for the 1977
Cologne exhibition (p.206).

FIG I Tatiana Glebova in her studio in Peterhof, Leningrad (c1982), with the painting *Prison* (photograph courtesy of Alena Spitsyna)

Glebova manifested a particular orientation towards Expressionist themes – see, for example, her *Portrait of the Organist Isaï Braudo* (1930s, 81.5 × 91 cm, oil on canvas, Archangelsk, State Museum of Fine Arts) or *At the concert* (1930; fig.3). Certain images in the former such as the arch, the cage and the sunken eyes, nose and double ears of Braudo's head bear a striking resemblance to parts of *Prison*. Such works describe a cruel, enforced incarceration inflicted upon both men and beasts, eliciting the same untamed primeval energy that we sense in the paintings of the later German Expressionists. Indeed, in their emphasis on the apocalyptic fury of the inhuman city, both the *Portrait of Braudo* and *Prison* are reminiscent of George Grosz (e.g. *Metropolis*, 1916–17, Thyssen-Bornemisza Collection) who, together with Otto Dix and Ludwig Meidner enjoyed a considerable popularity in Soviet Russia in the early 1920s. Filonov was often described as a Russian Expressionist and, in his synthetic history of modern art, the critic Ieremiia Ioffe even compared Filonov to Meidner.[1]

The companion piece, Alisa Poret's *Poor people* (1927; see below) exists in at least two versions – a pencil study in the Lobanov-Rostovsky Collection (fig.4) and an oil called variously *The hardships of the Soviet people* and *La condition humaine* and previously attributed to Pavel Filonov, Pavel Kondratiev or the studio of Filonov (fig.5).

As a primary student of Filonov, Glebova tried consciously and diligently to put his complex theory into practice, and her style cannot be appreciated without due reference to it. Because of their apparent visual resemblance, the paintings and drawings by Filonov's pupils are sometimes ascribed to the hand of the master – as was the case with *Prison*. A central member of

Notes
1 I. Ioffe, *Sinteticheskaia istoriia iskusstv*, Leningrad (Ogiz-Izogiz) 1933, pp.482–85
2 P. Filonov, D. Kakabadze, A. Kirillova and I. Lasson-Spirova, *Sdelannye kartiny*, St Petersburg, 1914; Eng. trans. in Misler and Bowlt, *Pavel Filonov* (1983), p.135
3 Letter from Filonov to Vera Sholpo, 1929; quoted in Misler and Bowlt, op. cit., p.26

FIG 2 Tatiana Glebova, *Study for the picture in the Press House, Prison*, 1927–8, 25.7 × 13.5 cm, indian ink and pencil on paper (St Petersburg, State Russian Museum)

FIG 3 Tatiana Glebova, *At the concert*, 1930, 25 × 34.5 cm, watercolour and indian ink on paper (St Petersburg, State Russian Museum)

the Russian avant-garde, Filonov differed profoundly from the more familiar representatives of the movement such as Vasilii Kandinsky and Kazimir Malevich. By 1912 he was already a 'Cubo-Futurist' (if we may apply that term here) and was fully aware of the great potential of the new Russian art. He declared:

> Make paintings and drawings that are equal to the stone churches of Southeast and West Russia in their superhuman tension of will.[2]

Like his colleagues, Natalia Goncharova, Mikhail Larionov and Malevich, Filonov (and Glebova) was fascinated by primitive art and, like them developed an individual, inimitable style that took account of the methods of the Russian icon, the *lubok* (broadsheet), woodcarving, etc. But Filonov instilled into his disciples such as Glebova the need to master the craftedness or 'made-ness' of the artistic discipline and, for this reason, encouraged them to support certain nineteenth-century Russian artists such as Ivan Aivazovsky and Vasilii Vereshchagin who, according to him, possessed remarkable technical skill. In fact, as Filonov repeated to his students:

> make any work you need with any material, so that the artist and the spectator are affected by its maximum professional and ideological value.[3]

Filonov and his pupils reached this artistic worldview through many avenues – through strict academic training, through interest in Symbolism, especially as reflected in the painting and drawing of Mikhail Vrubel, through Neo-Primitivism and, very importantly, through clear recognition of the Northern European Renaissance. The parallels between the graphic emphasis of Cranach, Dürer and Filonov, or between the allegorical concerns of Bosch and Filonov are particularly worthy of comment. In this respect, the invocation of the term 'Expressionism' – but in the Russian context – seems especially appropriate as a description of the style of Filonov, Glebova and their colleagues such as Kondratiev and Vsevolod Sulimo-Samoilo.

Just as Malevich believed that he would discover Suprematist forms of such economy and purity that they would take off of their own accord, so Filonov maintained that the painting implemented according to his Theory of Madeness would continue to grow even without the

assistance of the master. Glebova also believed this principle and tried to illustrate it in *Prison*. Madeness possessed both a finite and an infinite condition: technical perfection was the stimulus to subsequent evolution or growth, a stage that Filonov also denoted by the term Universal Flowering. He explained in his 1923 manifesto:

> [Universal Flowering] activates all the predicates of the object and its sphere: its existence, its pulsation and sphere, its biodynamics, intellect, emanations, insertions, geneses, colour and form processes – in brief, life as a whole.[4]

In other words, the 'made' painting such as Glebova's *Prison* was to develop in the same way as a plant grows, becoming denser, reproducing its own forms, functioning as an independent body. Consequently, for Filonov and his pupils there could be no such thing as the work of art finished and framed. They regarded their paintings as 'links in a chain'[5] that were not to be broken by the separation of any one part from the whole. Filonov's doctrine also contained another important ingredient, multi-dimensionality, which stressed the indivisibility of his work. He felt that an object should not be depicted on the canvas from a single vantage-point – other angles of vision had to be entertained, a method reminiscent of Matiushin's See–Know theory (see [11], [12]). For Filonov, the painting or drawing was a 'walk-through' space in which all elements, animate and inanimate, connected to each other within that space and also back to the artist or viewer. *Prison* is an example of this universal interconnectedness, for Glebova has tried to view the musculature of the heads, the tectonic displacements of the earth, and the inexorable 'flowering' in the face of suffering and deprivation.

Glebova painted *Prison* while she was a member of the Collective of Masters of Analytical Art led by Filonov, and was much beholden to his doctrine. In June 1925 Filonov was given space in the Academy of Arts, Leningrad in order to conduct courses with a group of students and, as he recorded, this gave rise to the Collective of Masters of Analytical Art. It was among these *filonovtsy* or *filonidy*, who included Glebova, Boris Gurvich, Kondratiev, Poret, Mikhail Tsibasov and other devoted students, that Filonov disseminated the principles of his theory of Analytical Art, and in 1927 the Collective or School numbered over forty. The Collective was never a really cohesive group and in 1930 it divided into two factions. The smaller faction, including Glebova, remained loyal to Filonov; the other, larger faction quickly disbanded and some of its members, for example Evgenii Kibrik, assumed a private and public position hostile to Filonov. Even though Glebova never opposed Filonov, she moved away from his Expressionist style in the 1930s, especially as, under the influence of her husband Vladimir Sterligov (a disciple of Malevich), she came to appreciate Malevich and Matiushin. *Prison*, therefore, is a rare example of the *filonovets* Glebova, most of whose oil paintings of the 1920s have been dispersed or lost.

Although the Collective of Masters of Analytical Art is often referred to as a school, it would be misleading to regard it as a system or programme of regular classes, coursework and homework. As one pupil recalled later, the sessions with Filonov

> bore the character of consultations... Pavel Nikolaevich would make brief remarks, sometimes they would be abrupt. No-one ever objected.[6]

Filonov addressed his students as comrades and, while quite aware of his own artistic supremacy, maintained that anyone could learn to be an artist if the principles of Analytical Art (madeness) were followed and applied. The Collective embarked upon several joint ventures, including exhibitions, stage productions (such as the 1927 *Inspector-General* to which *Prison* has a direct relationship) and the 1933 illustrated edition of the *Kalevala* (Leningrad, Academia) on which Glebova also worked. The Collective was ousted from the Academy in 1927 and ceased to exist officially with the passing of the Party Decree *On the Reconstruction of Literary and Artistic Organizations* in 1932.[7]

Early in 1927 the Futurist poet, theorist and painter Igor Terentiev was commissioned by Nikolai Baskakov, director of the Press House, Leningrad, to stage a production of Nikolai Gogol's *The Inspector-General*. Terentiev accepted the offer and invited Filonov to supervise the sets and costumes, the implementation of which was entrusted to the Collective of Masters of

FIG 4 Alisa Poret, *Poor people*, 1927, 23.3 × 12.5 cm, pencil on paper (London, Collection Nina and Nikita Lobanov-Rostovsky)

FIG 5 Alisa Poret, *Poor people*, 1927, 236 × 153.5 cm, oil on canvas (private collection)

Notes
4 P. Filonov, 'Deklaratsiia "Mirovogo rastsveta"' (1923). Eng. trans. in Misler and Bowlt, op. cit., p.170
5 Y. Khalaminsky, 'Shkola Filonova' in Yu. Khalaminsky, *Evgenii Kibrik*, Moscow (Sovetskii khudozhnik), 1970, p.14
6 D. Pokrovsky, *Trevogoi i plamenem*, undated MS, priv. coll., p.14
7 For more information on the Collective of Masters of Analytical Art see Misler and Bowlt, op. cit., *passim*

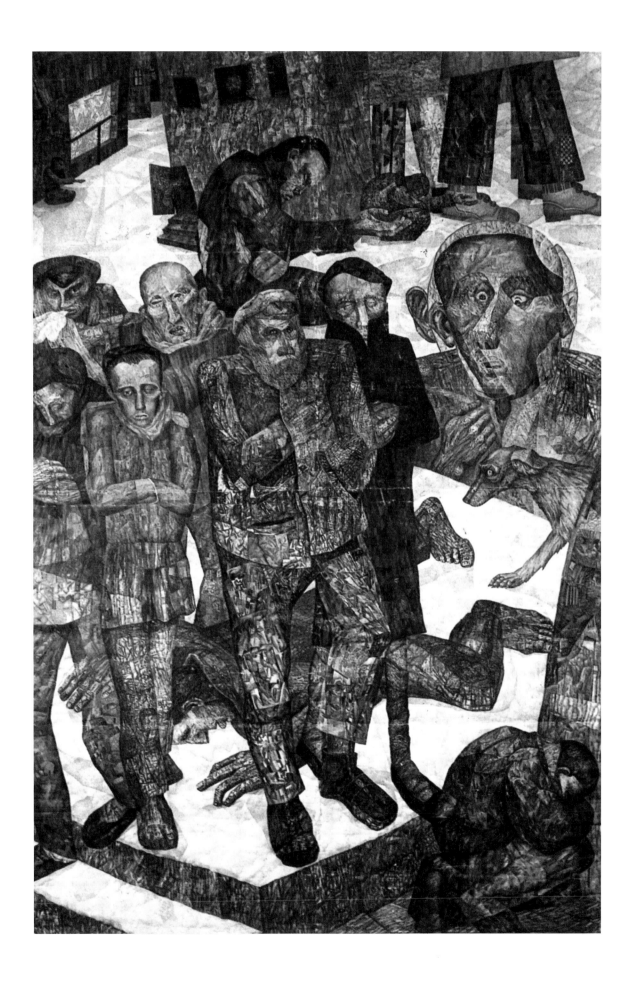

Analytical Art. Terentiev himself had already worked as a producer in Leningrad and Tiflis (Tbilisi) and had just founded a new theatre laboratory at the Press House.[8] Terentiev and Filonov immediately found a common language, evident not only from their respective approaches to Gogol's play, but also in the ways they both dismissed conservative art. But although this commission was a prestigious one, the interpretation so provoked the resentment of the public and the press that both men and their co-workers became the targets of exceptionally strong censure and abuse.

After several delays, the premiere of *The Inspector-General* took place in the remodelled Press House Theatre, on 9 April 1927. The august premises (the Press House occupied what had formerly been the Shuvalov mansion) were also decorated by a 'sculpture-cum-high relief'[9] and 'nightmarish paintings of hallucinations'[10] by Filonov's pupils – what is traditionally called the *Exhibition of Masters of Analytical Art*. The actual sets and costumes for the production designed by Filonov's disciples (including Nikolai Evgrafov, Glebova, Artur Liandsberg, Poret and Sashin)[11] were sharply criticized for their 'irrelevance' to Gogol:

> The red, green and blue costumes for the performance, done by the 'masters' of the Filonov school, above all, confuse the viewer. Apparently, Filonov's scenic exercises, these multi-coloured costumes are meant to take *The Inspector-General* out of its historical framework... but these costumes are simply a caprice, altogether dilettantish, spurious, provincial and downright crude.[12]

Furthermore, the designs, which, incidentally, were contributed collectively and without individual signatures, were linked to what were considered rather salacious antics in Terentiev's interpretation of the Gogol classic:

> In these multi-coloured, painted, Chinese-cum-Parisian costumes which reduce decadent aestheticism in the theatre to self-sufficient snobbism, the actor performs a series of very indecent numbers... [The producer] makes the governor sit in a WC, the governor's wife go around in her pantaloons and another guy go about with a chamber-pot... To the strains of Beethoven's *Moonlight Sonata* Khlestakov takes his candle and goes into the toilet depicted in the form of a tall, black box looking like a telephone booth. And that's where Khlestakov perches himself with Mariia Antonova.[13]

In spite of the negative reception of Terentiev's production of *The Inspector-General* and the Filonov contribution, Filonov and his Collective, including Glebova, were commissioned to decorate a second stage production in April, 1929. This was the play *King Gaikin I* (also called *Activist Gaikin*), an agit-presentation where, as Filonov implied in a lecture at one of the performances, 'essentially, the decoration of the spectacle was nothing less than an agitational, travelling exhibition for the *filonovtsy*'.[14] It was staged for the Vasilii Island Metalworkers' Club in Leningrad and, evidently, was not as experimental as *The Inspector-General*.[15] In his *Autobiography*, Filonov mentions a third theatrical involvement in the 1920s, for a play called *Lenka's Canary*, but it is not known whether Glebova was involved in this production.

Prison is part of a large, double panel that Glebova and her colleague, Alisa Ivanovna Poret (1902–85),[16] designed for the Press House in 1927 in conjunction with the production of *The Inspector-General*, and the fact that the lateral edges of the canvas of *Prison* have been cut indicates that it was once part of a larger canvas. Glebova recalled that they

> used the same canvas divided into two (Poret on the subject of *Poor people*, Glebova on the subject of *Prison*).[17]

Furthermore, on the back of a photograph of *Prison*, Glebova herself described the circumstances as follows:

> This painting (oil on canvas) MOPR (Prison) as P.N. Filonov called it, was painted by me, in 1927–8 as a part of the design for the Leningrad Press House executed by Pavel Nikolaevich's group of pupils, 'The Masters of Analytical Art' under the artistic supervision of Filonov. The canvas was divided into two halves, mine was the left, while Alisa Poret painted her beggars and homeless children on the right side. When the Press House moved to another and smaller

Notes

8 For information on Terentiev see T. Nikolskaia, 'Igor Terentiev v Tiflise' in L. Magarotto, M. Marzaduri, G. Pagani Cesa, eds., *L'Avanguardia a Tiflis*, Venice (Università degli studi di Venezia) 1982, pp.189–209

9 Untitled note in the newspaper *Smena*, Leningrad, 6 April 1927, p.3

10 'Shkola Filonova', *Krasnaia gazeta* [Evening Issue], Leningrad, 5 May 1927, p.5

11 Filonov compiled a list of his students who worked at the Press House; see Misler and Bowlt, op. cit., p.34

12 A. Piotrovsky, 'Revizor v teatre Doma pechati', *Krasnaia gazeta* [Evening Issue], 11 April 1927, p.4

13 N. Zagorsky and A. Gvozdev, 'Revizor na udelnoi', *Zhizn iskussta*, Leningrad, 19 April 1927, p.5

14 V. Gross, 'Filonov v teatre', *Krasnaia gazeta* [Evening Issue], 29 April 1929, p.13

15 For further information on *King Gaikin I* see Misler and Bowlt, op. cit. p.38

16 Nothing substantial has been published on Poret. Her own memoirs are of interest; see A. Poret, 'Vospominaniia o Daniile Kharmse', *Panorama iskusstv*, no.3, Moscow, 1980, pp.345–59

17 T. Glebova, 'Souvenirs sur Filonov', *Cahiers du Musée national d'art moderne*, no.1, Paris, 1985, p.119

18 Statement dated 14 Jan. 1982, in Russian by Tatiana Glebova on the back of a photograph of *Prison* (Glebova Archive, St Petersburg). MOPR is an abbreviation for Mezhdunarodnaia organizatsiia pomoshchi bortsam revoliutsii [International Organization for Helping the Fighters for Revolution]

19 'Shkola Filonora', op. cit. According to eye witnesses (the sculptor Saul Rabinovich and the film director Lev Trauberg), the decorated hall blended with the dramatic production itself, the more so since the actors, wearing their dazzling costumes, sometimes walked out into the auditorium (conversations between John E. Bowlt, Nicoletta Misler and Saul Rabinovich, Moscow, March and June 1986; and between John E. Bowlt, Nicoletta Misler and Lev Trauberg, Moscow, March 1986)

premises, the works were given back to the artists. We divided up our picture inasmuch as
A. Poret moved to Moscow and I stayed in Leningrad. T. Glebova 14 January 1982.[18]

The occasion for this undertaking was the production of *The Inspector-General* at the Press House during which time Filonov and his Collective also organized their *Exhibition of Masters of Analytical Art*. Filonov did not participate in this show, although he gave a public lecture there and used the events to promote his views on what he perceived to be the impasse that modern art had entered, and the means for art to escape from this. In any case, Filonov's influence is manifest in Glebova's resolution – especially in the decomposing double head in the lower left and in the horse's head on the right and in the motif of the faces staring out of windows. The show included twenty paintings, some stage designs and one sculpture, by about thirty-one artists. Among the other artists represented at the Press House (apart from Poret and Glebova), were Alevtina Mordvinova on the subject of *The hanged man*, Yurii Khrzhanovsky on the subject of *Soldiers of the Red Army*, Sulimo-Samoilo on the subject of heads, Saul Rabinovich and Innokentii Suvorov with their sculpture of a worker throwing a member of the bourgeoisie over his shoulder. The general response to these works was not especially positive, as contemporary reviews demonstrate:

> The splendid hall in the style of Louis XVI [the Press House] is certainly not improved by the sheets hanging between the columns completely covered in canvases by the Filonov followers.[19]

It is tempting to interpret *Prison* and *Poor people* as a commentary on the predicament of Filonov and his pupils, their uneasy position *vis-à-vis* the cultural establishment in Leningrad at this time. However, while they were certainly criticized, they were not ostracized as they were later when arrests of individual members began to take place in the early 1930s.

Natalia Sergeevna Goncharova 1881–1962

18 Fishing (fishers)
Rybnaia lovlia (rybolovy)

1909
Oil on canvas, 112 × 99.7 cm
Signed and inscribed on the back in Russian: 'N.S. Goncharova. Rybnaia lovlia' [N.S. Goncharova. Fishing]. This
 is followed by the number 407 and the inscription, now cancelled, 'Ts. 300 r' [Price 300 roubles].[1]
The canvas is slightly deformed in the centre, below the yellow tree, and there is pronounced horizontal cracking
 in the white areas and a general tendency to flaking. The glossy brushcoat of the varnish appears to be recent.
 The general condition of the piece is weak
Accession no.1977.34

Provenance
Natalia Goncharova, Paris
Leonard Hutton Galleries, New York
Thyssen-Bornemisza Collection, 1977

Exhibitions
Odessa [open January–March 1911] 1910–11, *Salon 2 International Art Exhibition*, organized by Vladimir
 Izdebsky [as *Catching fish (Rybnaia lovlia)* at no.93 (?)]
Moscow, Art Salon, August–October 1913, *Natalia Goncharova 1900–1913* [as *Fishers (Rybolovy)* at no.407]
St Petersburg, Dobychina Bureau, March–April 1914, *Goncharova* [as *Catching fish (Lovlia ryby)* at no.112 (?)]
Leeds, City Art Gallery/Bristol, City Art Gallery/London, Arts Council Gallery, 9 Sept.–16 Dec. 1961, *Larionov and
 Goncharova*, no.94, illus. [unpaginated]
Los Angeles, CA, County Museum of Art/Pittsburgh, PA, Museum of Art, Carnegie Institute/New York, The
 Brooklyn Museum, 21 Dec.–13 Mar. 1976–7, *Women Artists 1550–1950*, no.123, illus. p.287
New York, Leonard Hutton Galleries, 18 March–28 May 1977, *Der Blaue Reiter und Sein Kreis*, no.13, colour illus.
 p.54
Modern Masters from the Thyssen-Bornemisza Collection 1984–6, no.43, colour illus. p.65
Leningrad/Moscow 1988, no.6, colour illus. p.34

Literature
Eli Eganbiuri [pseud. of Ilia Zdanevich], *Natalia Goncharova i Mikhail Larionov*, Moscow [Miunster] 1913, p.IX
 [under 1909 (*Rybolovy*)]
Gray, *The Great Experiment*, pl.67, p.117; also mentioned on p.106
Art News, LXVI, no.9, January 1968, p.19
T. Froncek, ed., *The Horizon Book of the Arts of Russia*, New York (American Heritage) 1970, illus. p.261
Chamot, *Natalia Gontcharova*, colour illus. p.31 and on front jacket cover
Dagmar Hnikova, *Russische Avantgarde 1907–1922*, Berne and Stuttgart (Hatje) 1975, colour illus. p.45

The title of this painting is problematic. The number '407' inscribed on the back proves to be of particular importance, for a painting called *Fishers* or *Fishermen* [*Rybolovy*] appears under that number on page 8 in the catalogue of Goncharova's one-woman show in Moscow in 1913. However, a painting called *Fishers* does not figure in the catalogue of the 1914 version of Goncharova's exhibition at the Dobychina Bureau in St Petersburg. On this level, therefore, it would be judicious to retain the original title of the painting in question and call it *Fishers* as opposed to the conventional *Fishing* [*Rybnaia lovlia*] by which it has been known for many years. However, the other Russian inscription on the back of the painting – '*Rybnaia lovlia*' – evidently made by Goncharova much later, translates as *Fishing*, but repeats the title of another picture shown at the 1913 Goncharova exhibition under no.438, which, according to the comments on page 9 of the catalogue, was a watercolour. Matters are confused still further by

Note
1 The *versos* of several of Goncharova's early Neo-Primitivist paintings carry inscriptions with numbers and prices (cf. *Stone maiden. Still-life*, 1908, Kostroma, Regional Museum of Visual Arts, and *Jews. The Sabbath*, 1912 Moscow, State Tretiakov Gallery)

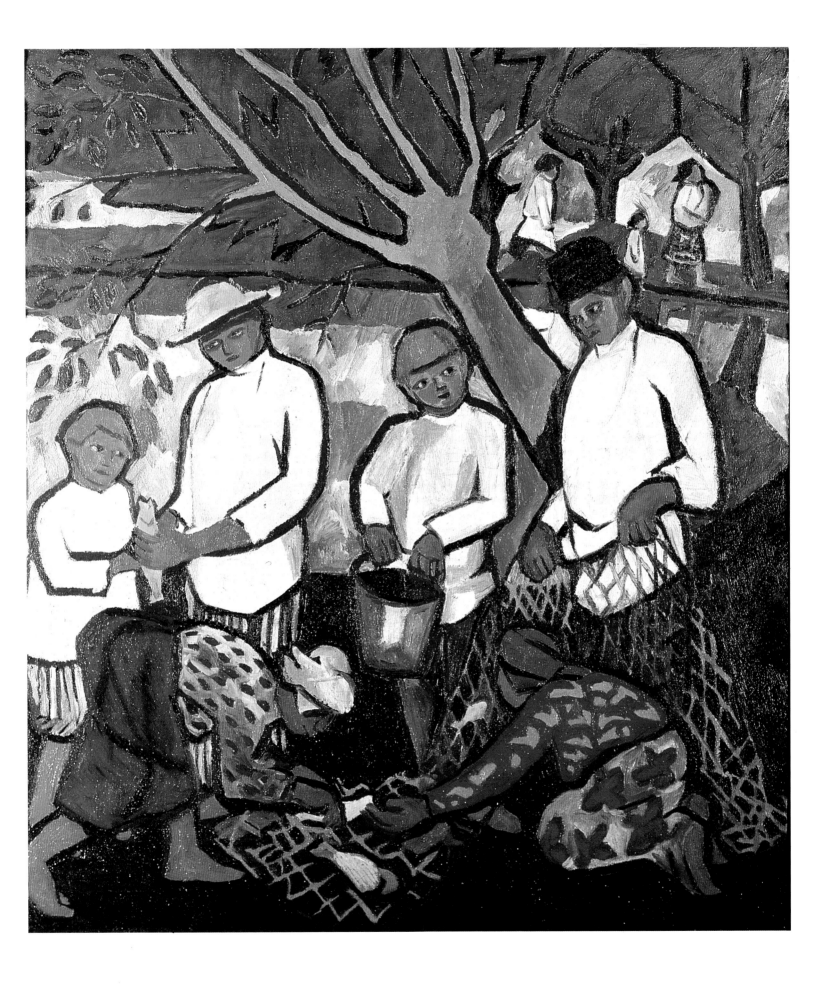

[18] *verso*

the fact that the catalogue of the 1914 St Petersburg exhibition contained a painting called *Catching fish* [*Lovlia ryby*] as no.112, which may or may not refer to the painting in question. Moreover, at this point it is impossible to establish with certainty whether the work called *Catching fish* [*Rybnaia lovlia*] included as no.93 in Vladimir Izdebsky's *Salon 2 International Art Exhibition* in Odessa in 1911 refers to the painting in question or not. Even though the number '407' offers sound evidence for assuming that the initial title was, indeed, *Fishers*, the later inscription by Goncharova, the subsequent perpetuation of the title *Fishing*, and the general profusion of other possible titles (*Fishing*, *Catching fish*, etc.) call into question the application of the '407' title here. In view of these particular circumstances, therefore, the traditional title – *Fishing* – has been retained.

A remarkable poise, common sense and pragmatism characterized Natalia Goncharova, and she demonstrated these qualities not only in sophisticated paintings, but also in the ready application of her talents to book, fashion and stage design. Goncharova, chronologically the primary woman artist of twentieth-century Russia, both cultivated an intellectual interest in the traditional handicrafts and primitive rituals of old Russia and also used these as subjects for her pictures and designs. Goncharova's study of Russian peasant costume and ornament prepared the way for her folkloristic evocations in Diaghilev's productions of *Le Coq d'or* (1914) and *L'Oiseau de feu* (1926) as well as for her book illustrations to Alexei Kruchenykh's *Pustynniki* [Hermits] (1913) or to the Paris edition of the *Conte de Tsar Saltan* (1922). This recognition of the vitality and potential of traditional Russian art forms also prompted her and Larionov to organize an exhibition of icons and broadsheets in Moscow in 1913.

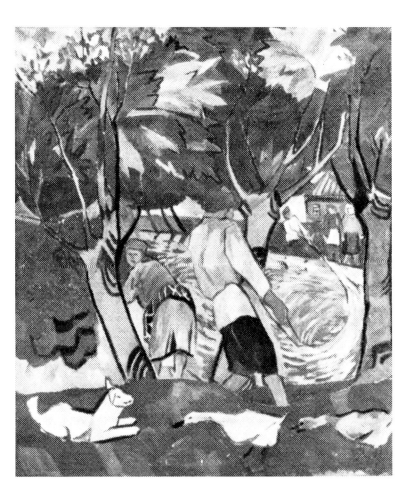

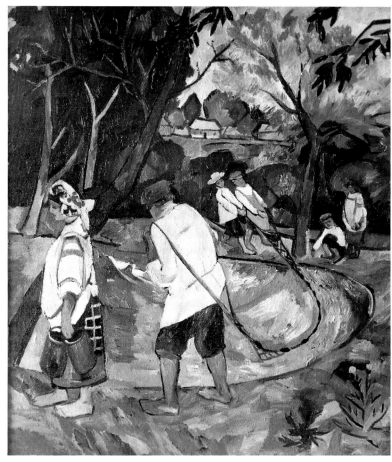

FIG 1 Natalia Goncharova, *Pond*, c1909, 117 × 103 cm, oil on canvas (present whereabouts unknown)

FIG 2 Natalia Goncharova, *Fishers (pond)*, 1909, 116.5 × 102.2 cm, oil on canvas (Des Moines, IA, Louise Noun Collection)

Note
2 N. Goncharova, Preface to exh. cat. of one-woman exhibition, *Natalia Goncharova 1900–1913*, 1913, p.3; trans. in Bowlt (1988), p.57

Naturally, Goncharova's attitude influenced the formal arrangements of her painting, contributing to her intense stylization, her forceful colour combinations and her naive perspectives and proportions. In 1913, Goncharova declared: 'I have turned away from the West... For me the East means the creation of new forms, an extending and deepening of the problems of colour...'.[2] Goncharova's *joie de vivre*, her sympathy for the simple and immediate pleasures of life dictated an obvious preference for simple, figurative painting, and the apparently non-objective works of Goncharova's Rayonist or Rayist period (see [19]) and 'cosmic' period (see [20]) might be regarded as momentary digressions from her fundamental, primitive aesthetic. As a matter of fact, Goncharova's Rayonist works often rely on a figurative and primitive point of departure, for example, her painting *Forest* of 1913 [19], and her depictions of peasants at work and play leave the impression of greater spontaneity and sincerity than the sometimes laboured abstract works.

The painting *Fishing* relates directly to the cycle dealing with Russian peasant life that Goncharova painted with enthusiasm and intensity during the years 1908–11. Goncharova observed the peasants first-hand during her frequent trips to the family country home at Polotnianyi zavod near Moscow, and works such as *Fishing* and, for example, *Spring gardening* (London, Tate Gallery, 103 × 123 cm) are clear extensions of that ambience. The motif of fishing was a common part of her artistic vocabulary and this particular painting compares favourably with others on the same theme such as *Pond* (c1909; fig.1) that Goncharova showed as no.245 at her 1913 one-woman exhibition in Moscow and at the 1961 Goncharova and Larionov retrospective. Another oil painting entitled *Fishers (pond)* (1909) and attributed

to Goncharova is in the Louise Noun Collection (fig.2). *Fishing* can be compared favourably with Goncharova's other explorations of the 'primitive' aesthetic such as *Washing linen* (1910) and *Peasants picking apples* (1911), both in the Tretiakov Gallery, Moscow, *Bleaching linen* (?1909) and *Washerwomen* (?1911), both in the State Russian Gallery, St Petersburg, *Mother* (1909; Penza, Savitsky Regional Painting Gallery), and *Sheep-shearing* (1909, Serpukhov, Historical and Art Museum).

Of particular importance to the development of the Russian avant-garde was the professional artists' rediscovery and reappreciation of the indigenous, traditional heritage. *Fishing* is direct evidence of Goncharova's own response to, and reordering of, certain conjunctions and devices of traditional art in her search for experimental pictorial resolutions. Of course, in the context of Goncharova, the terms 'traditional' or 'primitive' must be used in a broad sense, for they cover not only cultural manifestations of 'primitive' peoples (pre-Christian Russians, the Scythians, the Siberian nomads, the Russian peasantry), but also the great canons of medieval Russian art, especially icon-painting, and the urban folklore of the nineteenth and twentieth centuries. Goncharova and her colleagues also turned repeatedly to the rich legacy of myth and ritual, as she did in her peasant series. Of particular significance for Goncharova and Larionov were primitive art forms such as children's drawing, the *lubok* (cheap, handcoloured print), naive painting, icons, folk costumes, toys, trays, embroideries and woodcarving. In the bright colours, emphatic lines, intense stylization and general optimism of Russian peasant art, they found a vigour and integrity that seemed to be lacking in their contemporary bourgeois culture. Goncharova, Larionov and their immediate colleagues such as Malevich, Alexander Shevchenko (who published the Neo-Primitivist manifesto in 1913) and Tatlin regarded the traditional arts and crafts as a decisive element in the renovation of Russian art and design, even arguing, in 1913, that Russia was part of the East and that the East was the real birthplace of all modern art.

The subject of the Russian avant-garde and popular culture (embodied in the painting *Fishing*) is a vast and complex one that, until recently, has not been the focus of consistent and comprehensive study either in Russia or in the West. One reason for this lacuna is that the potential researcher must be familiar not only with the history of Russian Modernism, but also with a conglomeration of disparate artistic disciplines, levels and conditions that, at first glance, may seem distant, if not irrelevant to Neo-Primitivism, Cubo-Futurism and Suprematism – from rural handicrafts to Siberian effigies, from shaman rituals to peasant festivities, from children's drawings to consumer advertising, from Black art to North Coast Indian art. In turn, each of these categories can be broken down into subsections and explored in contextual comparisons with particular achievements of the Russian avant-garde. We think, for example, of Goncharova's interpretations of peasant costumes and fabrics in her major canvases such as *Fishing* or her stage designs for *Le Coq d'or* of 1914. Larionov and Shevchenko collected children's paintings and drawings, included them in their exhibitions, reproduced them in their publications and even tried to imitate the child's perception of form and space in their own art. The list of such interconnections is extensive, and Goncharova, Kandinsky, Mikhail Le-Dantiu, Larionov, Olga Rozanova and Shevchenko are just a few of Russia's avant-garde artists who sought a new artistic vigour in what is now called loosely 'popular culture'.

Certainly, Goncharova and her colleagues also looked carefully at contemporary Western models including Post-Impressionism, Cubism and Futurism and the combined influences of Gauguin and Matisse are manifest in the colouring and decorative flatness of *Fishing*. The artists of the Russian avant-garde produced innumerable renderings of French works – from Goncharova's and Larionov's paraphrases of Gauguin and Vladimir Tatlin's combinations of Cézanne and Matisse, to Kazimir Malevich's and Liubov Popova's interpretations of Braque and Picasso. In other words, artists such as Goncharova were able to borrow Western forms and reprocess them within their indigenous environment, a procedure that often involved a sudden shift of aesthetic register from 'high' to 'low'. These artists found that the simplest method of

Notes
3 A. Shevchenko, *Kubizm*, Moscow (Izdanie avtora) 1913, p.5
4 N. Goncharova, 'Kubizm' (1912) in Livshits/Bowlt (1933/1977), p.80; trans. in Bowlt (1988), p.78

desanctifying or, as they liked to say, 'de-frenchifying', art was to adjust Western artistic innovations to Russian traditions and to temper or even replace those momentous achievements with the most vulgar manifestations of their local mass cultures. That is how Shevchenko explained the state of affairs in the 1913, when he argued that Picasso's Cubism had already been achieved in 'Russian icons. . .our painted woodcarving, in Chinese wood and bone carving. . .'.[3] The year before, Goncharova anticipated this nationalist affirmation in her impromptu speech at the *Jack of Diamonds* exhibition in Moscow, arguing that:

> Cubism is a positive phenomenon, but it is not altogether new. The Scythian stone images, the painted wooden dolls sold at fairs are those same Cubist works.[4]

Goncharova repeated the sentiments in the preface to the catalogues of her one-woman exhibition in Moscow in 1913.

Goncharova's artistic and intellectual examination of the peasant way of life, peasant rituals and artefacts – represented so well in *Fishing* – extended the general attraction of traditional ritual and custom to the avant-garde, for not only did she and her colleagues discuss such phenomena in critical and theoretical terms, but they also interpreted them (their promenades with painted faces and in outlandish dress bring to mind the *narodnoe gulianie* [popular promenading] at Easter and even the inspired movements of the shaman). In his auto-biographical writings Malevich recalls his proximity to peasant culture with great sympathy; David and Vladimir Burliuk seemed to embody the vastness of their 'primordial' homeland in the Ukraine (see [5]); Goncharova interpreted the Orthodox church service and procession in her religious paintings; and, of course, icons, cleaned and restored to the full force of their colour, left an indelible impression in the saturated ochres and reds of Goncharova's peasants. An amalgam of all these influences, *Fishing* is one of Goncharova's clearest affirmations of the priority of national tradition in the development of modern art.

Natalia Sergeevna Goncharova 1881–1962

19 The forest
La forêt

1913
Oil on canvas, 130 × 97 cm
Signed lower right: 'N. Gontcharova'; also signed lower left in Russian: 'N.G.', signed and titled on the reverse at a
 later date: 'N. Gontcharova, 43, rue de Seine/La Forêt 1913'.
The stretcher appears to be original. Varnish is not evident and the general condition is good
Accession no.1981.71

Provenance
Natalia Goncharova, Moscow
Private collection, Europe
Leonard Hutton Galleries, New York
Thyssen-Bornemisza Collection, 1981

Exhibitions
Moscow, Mikhailova Salon, 24 March–3 April 1913, *The Target*, no.48 [as *Luchistoe vospriiatie* (Rayonist
 perception)]
Moscow, Art Salon, August–October 1913, *Natalia Goncharova 1900–1913*, no.646 [as *Luchistoe vospriiatie
 (preobladanie sinego i korich[nego])* [Rayonist perception (predominance of blue and brown)]]
Moscow, Mikhailova Salon, March–April 1914, *No.4. Exhibition of Paintings. Futurist, Rayonist, Primitive*, no.47
 [as *Luchistyi peizazh* (Rayonist landscape)]
Paris, Galerie Paul Guillaume, 17–30 June 1914, *Larionov–Gontcharova*, no.46 or 47
Paris, Galerie Sauvage, 16 April–7 May 1918, *Exposition des Oeuvres de Gontcharova et de Larionov*, nos.1–15
 [under the category *peintures à l'huile*]
London, Whitechapel Gallery, June–July 1921, *First Russian Exhibition*
Dresden, June–September 1926, *Internationale Kunstausstellung*, no.285 [as *Der Wald*]
Paris, Galerie des Deux Iles, 6–18 December 1948, *Le Rayonnisme 1909–1914. Peintures de Michel Larionov et
 Nathalie Gontcharova*, no.11
Paris, Galerie de l'Institut, 11–21 June 1952, *Exposition M. Larionov et N. Gontcharova* [within nos.27–37]
USA tour 1982–4 [not in catalogue but in addendum for the venue at the Metropolitan Museum of Art in 1982]
Modern Masters from the Thyssen-Bornemisza Collection 1984–6, no.50, colour illus. p.72
Cologne 1986, no.112
Luxembourg/Munich/Vienna 1988–9, no.28, colour illus. p.79

Literature
Simon de Pury, 'Recently acquired Twentieth-century Paintings', *Apollo*, CXVIII, no.257, London, 1983, p.81,
 colour illus. pl.XXXVIII
Simon de Pury, 'Acquis par Thyssen', *Connaissance des Arts*, no.380, Paris, Oct. 1983, p.69, illus. p.64

The forest is a fine example of the pictorial system known as Rayonism or Rayism, that Mikhail
Larionov developed in 1912–13 (see [32–3]) and that Goncharova wished to 'put into
practice'.[1] But although Goncharova herself identified the system as a kind of 'painting based
only on painterly laws',[2] she seems not to have favoured total abstraction in the way that
Larionov did, and most of her Rayonist exercises are figurative and thematic. It is difficult to
appreciate just how much Larionov's Rayonism was indebted to Goncharova's own ideas,
although, certainly, her interest in electric power and light (cf. *Dynamo machine*, 1913, private

Notes
1 N. Goncharova, Preface to exh.
cat. of 1913 one-woman
exhibition; trans. in Bowlt
(1988), p.58
2 Ibid.

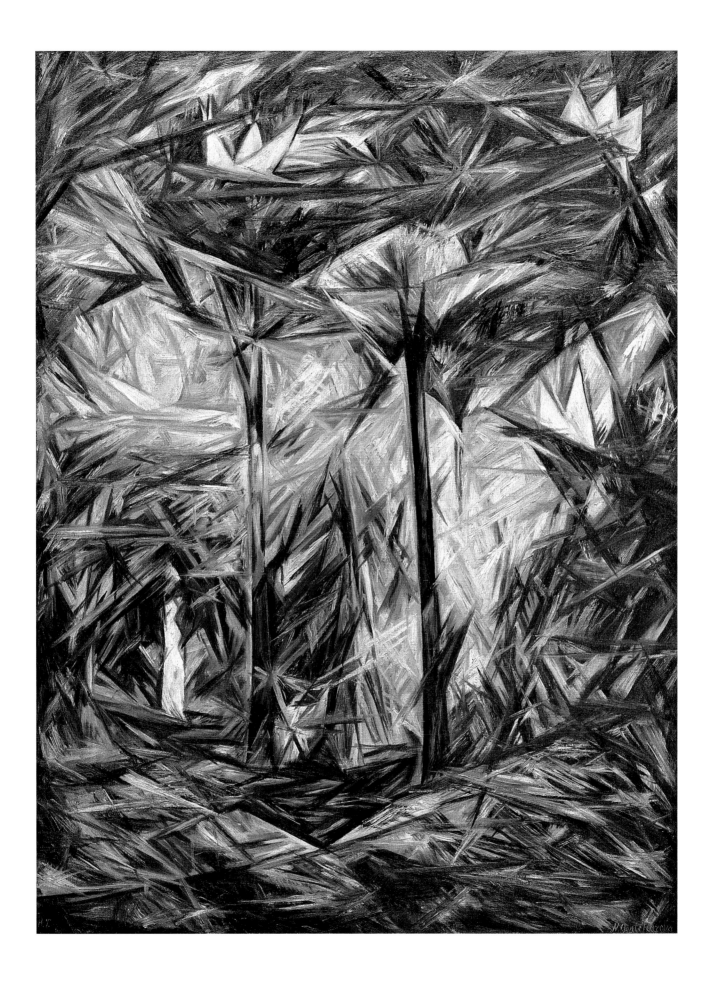

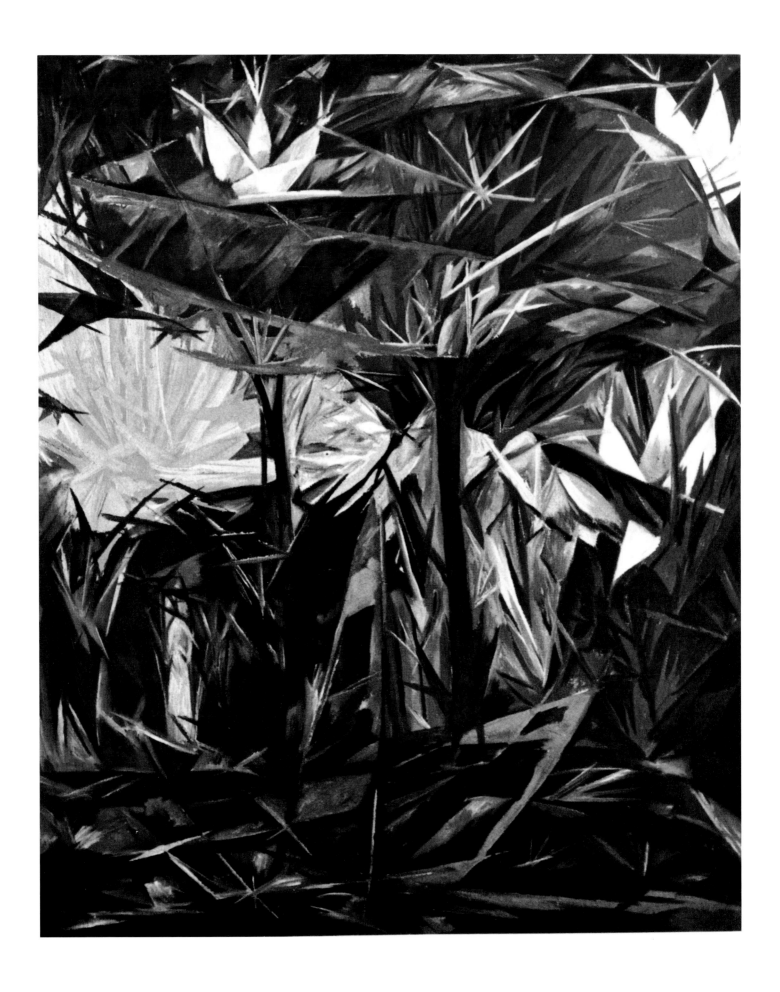

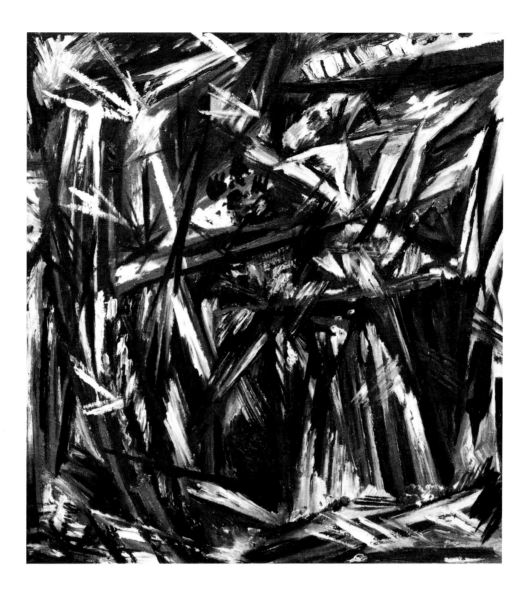

Notes
3 What has come to be called *Green–blue forest* may be the same as the 1913 *Rayonist construction (dominance of blue and green)* mentioned in the list of works in the Moscow catalogue of Goncharova's one-woman exhibition
4 However, the same work is illustrated upside down and called *Rayonist construction* in the 1913 Goncharova catalogue [unpaginated] – something that is tempting to interpret as a Cubo-Futurist 'mystification' rather than as a printer's error

collection, and *Electric ornament*, 1914, Moscow, State Tretiakov Gallery) and in transparency (she submitted four *Constructions based on transparency* to her one-woman exhibition in Moscow in 1913) coincided with Larionov's own amateur studies of physics. But it is important to remember that their Rayonism followed an intense concern with primitive art and rituals and that their Rayonist subjects were not always urban and urbane, but, on the contrary, rural and natural. Indeed, the fields and the forests remained a leitmotiv in Goncharova's experimental work, whether in studio paintings such as *Winter* (?1908, St Petersburg, State Russian Museum) or in stage designs such as the several versions for the enchanted garden in scene I of *L'Oiseau de feu* (1926).

The Staatsgalerie, Stuttgart, owns a 1913 oil by Goncharova that is very similar to *The forest* (*Yellow and green forest: Rayonist construction*, 1913, also known as *Wood: A Rayonist construction*; fig.1). The Museum of Modern Art, New York, also possesses a painting dated 1913 called *Rayonism, blue–green forest*, also known as *Green–blue forest* (fig.2),[3] which is close to the *Forest (Rayonist perception)* (present whereabouts unknown) reproduced in the 1914 St Petersburg catalogue of Goncharova's one-woman exhibition (p.39), although not mentioned in the list of works.[4] It is probable that the work listed under no.646 as *Rayonist perception (dominance of blue and brown)* in the catalogue of Goncharova's one-woman exhibition in Moscow in August 1913 is the work in question, because Goncharova had already sent the

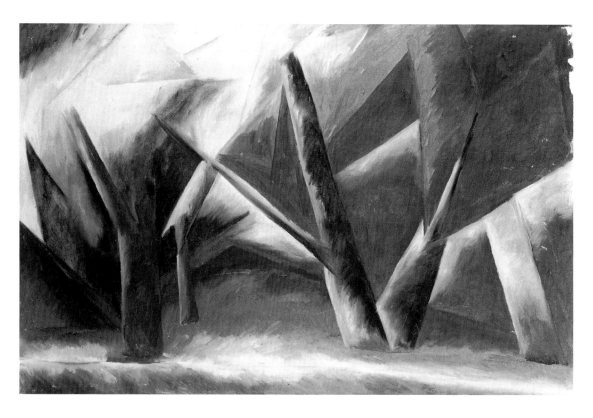

FIG 3 Natalia Goncharova, *Forest red–green*, 1913–14, 57.5 × 80 cm, oil on canvas (private collection; courtesy of Leonard Hutton Galleries, New York)

FIG 4 Natalia Goncharova, *Forest: Rayonist composition*, 1912–13, 59 × 49 cm, oil on canvas (Bari, Collection of Michele Costantini)

FIG 5 Natalia Goncharova, *Rayonist landscape*, 1912–13, 43 × 51 cm, oil on canvas (Rome, Collection Andrea Miele)

FIG 6 Natalia Goncharova, *Rayonist fountain*, also known as *Rebus (Rayonist garden: park)*, 1913, 140.6 × 87.3 cm, oil on canvas (Jerusalem, Collection of Sam and Ayala Zachs)

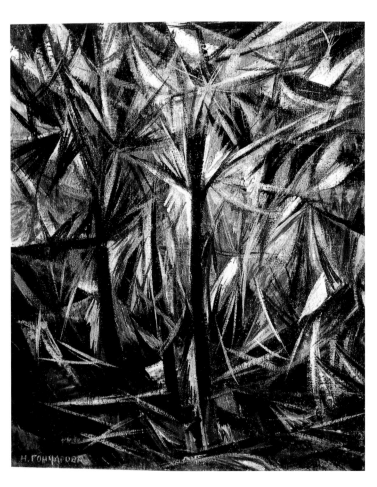

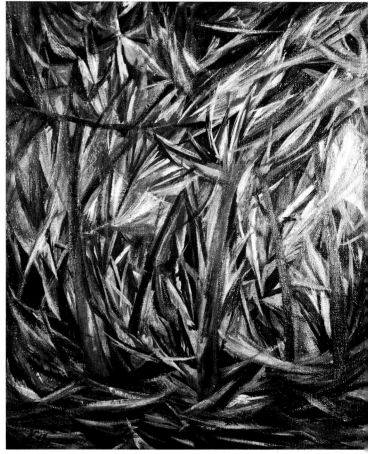

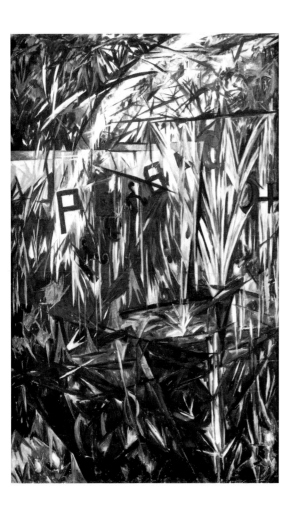

Notes
5 The work is listed in the catalogue of the *Erster Deutscher Herbstsalon* as *Landschaft*, no.151, illus. [unpaginated]. That the 'Stuttgart' painting was not at the 1913 one-woman exhibition is proven by the one-page printed insert that accompanied some of the exhibition catalogues: 'At the present time no.545 *Cats (Rayonist)* and *Landscape (Rayonist)* and *Woman in a hat (Futurist)* [neither of which is indicated in the catalogue] are at the *First German Autumn Salon in Berlin*, organized by Der Sturm magazine'
6 Yet another version, also called *Landscape* and dated 1913, is reproduced in F.Miele, *L'avanguardia* tradita, Rome (Carte Segrete) 1973, p.253

Yellow and green forest to the *Erster Deutscher Herbstsalon* at Der Sturm, Berlin.[5] There are several other 'forest' paintings attributed to Goncharova such as *Forest red–green* dated 1913–14 (fig.3) and *Forest: Rayonist composition* dated 1912–3 (fig.4), and also a curious version called *Rayonist landscape* and dated 1912–13 which repeats the basic scheme of the Thyssen-Bornemisza and the Stuttgart canvases (fig.5).[6] *Lilies (Rayonist construction in brown, green and yellow)* (1913, 91 × 75.4 cm, oil on canvas, Perm, State Art Gallery) and the *Rayonist Fountain* (also known as *Rebus. (Rayonist garden: Park)*; fig.6) both of 1913 are also fine examples of Goncharova's sophisticated application of Rayonism to natural subjects, relying on the same intersections and encounters of prismatic, refracted lines as *The forest*.

Natalia Sergeevna Goncharova 1881–1962

20 Composition with blue rectangle

1950s (?)
Tempera and gouache on paper, 47.5 × 26.5 cm
Stamped lower left with the Russian monogram 'NG'
The *verso* carries the written numbers '32/897'
The paper has been cut along the edges of the painting, but the general condition is good
Accession no.1976.93

Provenance
Natalia Goncharova, Paris
Alexandra Tomilina, Paris
Sotheby Parke Bernet, London
Thyssen-Bornemisza Collection, 1976

Literature
Sotheby Parke Bernet, London, 1 Dec. 1976, lot 263A

Goncharova rarely explored the aesthetic of pure non-objectivity, even though some of her Rayonist pieces of 1912–14 such as *The forest* [19] are highly abstracted. True, Goncharova was drawn to the long, rectangular format and used it in her many panels of geometric nudes and fabulous personages in the late 1910s and early 1920s (e.g. *The seasons* that she painted for Serge Koussetvitzsky, Paris).[1] The blue, 'floating' quality of *Composition with blue rectangle* also brings to mind Goncharova's cosmic paintings that she made after the launch of the first sputnik in 1957 such as *Space* (c1958; fig.1).

Note
1 Goncharova's *The seasons* which she painted for Serge Koussevitzsky in 1922 (each 232 × 100 cm), now in the Tobin Collection at the McNay Museum, San Antonio, TX, are illustrated in Chamot, *Gontcharova* (1972), p.147

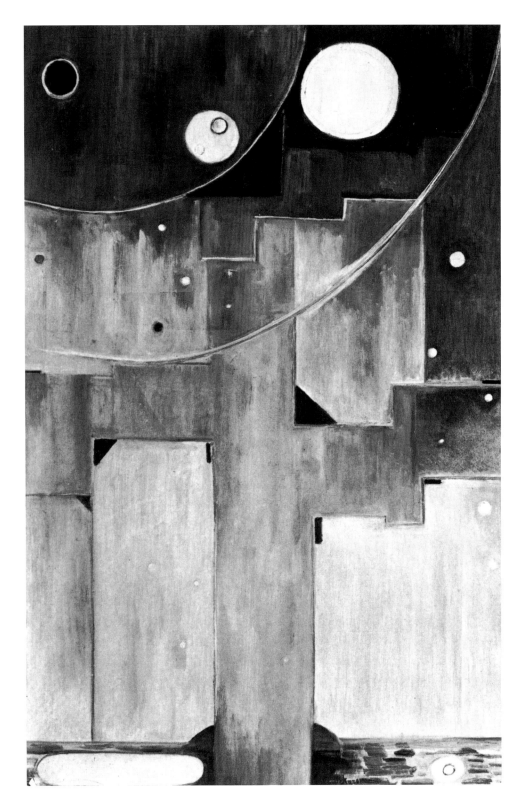

FIG 1 Natalia Goncharova, *Space*, c1958, 55 × 46 cm, oil on canvas (private collection, courtesy of the Arts Council, London)

However, with its strict equilibrium of colour and form, *Composition with blue rectangle* is an anomaly in Goncharova's oeuvre, at least, if regarded as a studio painting. It would be more reasonable to suggest that the work was part of a larger decorative scheme such as a textile or backdrop design, the more so since a watercolour with a very similar composition, with exactly the same measurements and from the same provenance was sold at the same auction in December 1976 (fig.2).

FIG 2 Natalia Goncharova, *Composition with blue triangle*, 1950s, 47.5 × 26.5 cm, watercolour (Sotheby's, London)

Boris Dmitrievich Grigoriev 1886–1939

21 Miracle of the soup
Miracle de la soupe

*c*1925
Oil on canvas, 91 × 89 cm
Signed lower left: 'Boris Grigoriev'
The reverse of the canvas bears the inscription 'no.6. Miracle de la soupe'. The stretcher carries the inscriptions
 'no.103' in black ink, 'no.S2TV' stamped in black; a label 'no.3' is also glued on the stretcher. The back of the
 frame carries the name and address of the framer: 'Louvre Frank & Co., 16 West 22, New York City. Pattern
 270/4 [rest illegible]'
The recent glossy varnish is uneven and there are some deformations along the edges, but the general condition is
 good
Accession no.1991.3

Provenance
Gaston Neuhut, London
Christie's, London
Sotheby's, London
Fisher Fine Art Ltd, London
Thyssen-Bornemisza Collection, 1991

Exhibitions:
Pittsburgh, PA, Carnegie Institute, 13 Oct–4 Dec. 1927, *Twenty-sixth International Exhibition of Paintings*, no.268
Santiago, Museo de Bellas Artes, 1928, *Boris Grigorieff*, no.46
New York, Academy of Allied Arts, 1935, *Boris Grigoriev 1920–1935*, no.15

Literature
Christie's, London, *Impressionist and Modern Paintings, Drawings and Sculpture*, 30 June 1970, lot 282, illus. pl.VIII
Sotheby's, 4 July 1974, lot 134
Sotheby's, 6 April 1989, lot 575, colour illus. p.74
Nashe nasledie, London, 1990, no.4, colour illus. p.52

Like Alexandre Jacovleff and Vasilii Shukhaev, Boris Grigoriev was a member of the second generation of World of Art artists, and he maintained the best traditions of Alexandre Benois, Léon Bakst, Mstislav Dobuzhinsky and Konstantin Somov. Above all, Grigoriev regarded line as the most expressive visual element, and, even in his paintings, line was the dominant component. In the intensity of its emotional value, Grigoriev's line sometimes brings to mind his St Petersburg colleague, Pavel Filonov (see [16]), and the later German Expressionists such as Otto Dix and George Grosz. As Grigoriev once said: 'Line encloses all the weight of form within its angles and dispenses with all the immaterial...Line is the creator's swiftest and most intimate medium of expression.'[1] In the incisive contours of his paintings and drawings devoted to the Russian theme, Grigoriev seems to evoke the very life-force of Russia, 'Portraits of souls, cosmic stylizations. Beneath the impression of a chance characteristic feature of a face, he sees the eternal, permanent physiognomy of the chance model; it is not an episodic visage but, so to speak, its astral essence.'[2] So impressive was Grigoriev's artistic skill that the critic Nikolai Punin, one of the first champions of Grigoriev's art, compared the artist to a coachman who

Notes
1 B. Grigoriev, 'Liniia', in Tolstoi, *Boris Grigoriev. Raseia* [unpaginated]
2 A. Shaikevich, 'Mir Borisa Grigorieva', ibid.

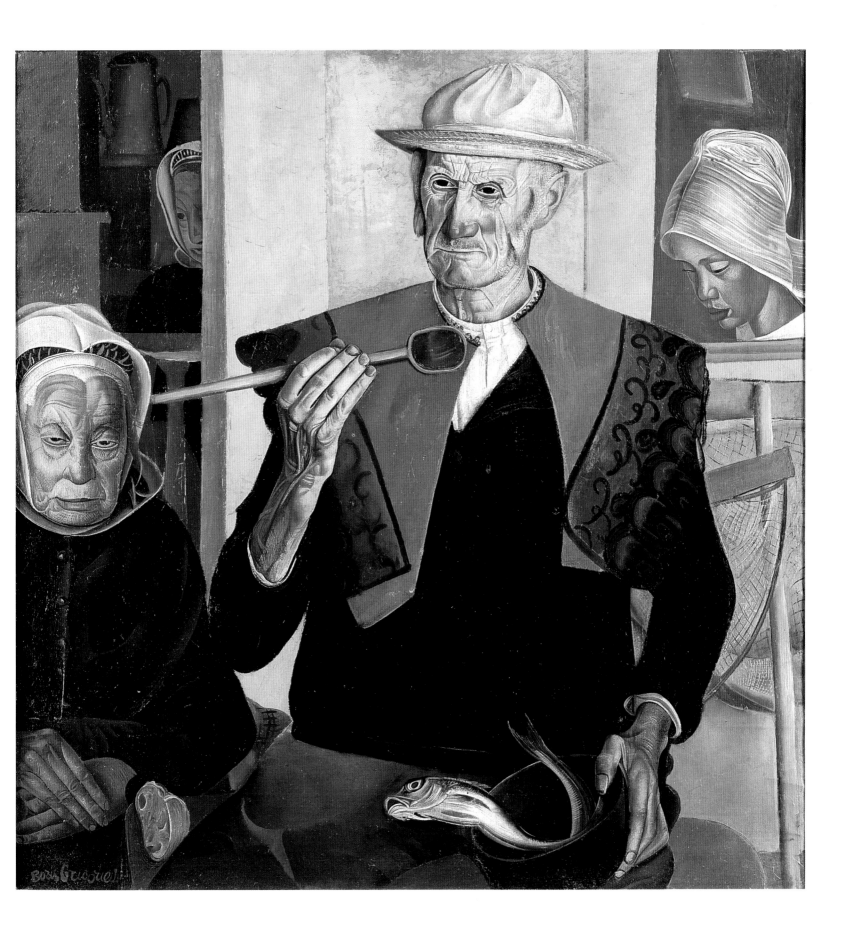

knows every quirk of his horses, their strengths and weaknesses.[3] But not everyone liked Grigoriev's often harsh Realism – as the writer Georgii Grebenshchikov made clear in a letter to Grigoriev in 1935:

> ...your art does not delight in the sense of mastery, IT DOESN'T MAKE ME JOYFUL. Imagine – I like you, but I'm afraid of your art. It emphasizes the negative features of life, the body and even nature too much.[4]

The exact circumstances in which Grigoriev painted this portrait of four Bretons are not known, although, after 1921 he was already living in Paris and was travelling widely in France. In any case, *Miracle of the soup* is part of Grigoriev's so-called Breton cycle – sober portraits of humble folk that he painted with scrupulous attention to detail and that were exhibited and reproduced widely in the late 1920s (fig.2).[5] Impressed by Grigoriev's homage to *Neue Sachlichkeit*, Alexandre Benois described the Breton cycle as a 'brilliant achievement' in his obituary of 1939.[6] Clearly, the portrait is a metaphorical reference to the biblical miracle of the bread and the fish which the old man has just caught in his net. Grigoriev sometimes repeated and paraphrased the faces of personae in other paintings, especially from his cycle called *The faces of Russia* which he published as a collection in 1924. The old man here, for example, reappears in Grigoriev's epic panel called *Visages of the world* [*Liki mira*] that he painted in 1930 (fig.3), while the old lady reappears as the *Old lady from Brittany* that Grigoriev painted between 1923 and 1926 (fig.1).[7] These were cosmic pantheons of individuals, both real and fictional, that Grigoriev seemed to identify as the true instruments of history, however dubious their social position.

Trained at the St Petersburg Academy of Arts, Grigoriev remained loyal to the classical values of technical precision and linear clarity, demonstrated in his remarkable mastery of anatomy and perspective. At the same time, although he did not support the more radical ideas of the Moscow and St Petersburg avant-gardes, Grigoriev was open to many other influences,

Notes
3 Punin, 'Tri khudozhnika', *Apollon*, Petrograd, 1915, no.8–9, p.1
4 Letter from Georgii Grebenshchikov to Boris Grigoriev dated 7 June 1935, in the collection of Cyrille Grigorieff, Cagnes-sur-mer, France
5 *Poverty*, for example, was shown at *Art Russe, Ancien et Moderne* at the Palais des Beaux-Arts, Brussels, 1928 (no.679, illus. [unpaginated]). For illustrations of other Breton types see *Perezvony*, Riga, 1929, no.42, pp.1342, 1343
6 A. Benois, 'Tvorchestvo Borisa Grigorieva' (1939) in I. Zilbershtein and A. Savinov, eds., *Alexander Benois razmyshliaet...*, Moscow (Sovetskii khudozhnik) 1968, p.246
7 We are indebted to Serge A. Stommels for providing information on Grigoriev and the *Miracle of the soup*

FIG 1 Boris Grigoriev, *Old lady from Brittany*, 1923–6, oil on canvas (whereabouts unknown) (reproduced from *Perezvony*, Riga, 1929, no.42, p.1342)

FIG 2 Boris Grigoriev, *Poverty*, c1926, 79 × 79 cm, oil on canvas (present whereabouts unknown) (reproduced from *Art Russe*, exh. cat. Brussels, Palais des Beaux-Arts, 1928, pl.48)

FIG 3 Boris Grigoriev, *Visages of the world*, 1930, oil on wooden panel, 521 × 250 cm (Prague, Narodni Galerie)

and, as *Miracle of the soup* indicates, he was drawn to the reassertion of the *valori plastici* in the late 1910s and early 1920s and shared in the general orientation towards a Metaphysical Realism. In the obvious reference to Renaissance portraiture with the ambiguity of interior and exterior, *Miracle of the soup* brings to mind the works of other St Petersburg artists who attended the St Petersburg Academy, experienced the profound influence of Italian Renaissance painting, and who were also living in France in emigration – above all, Jacovleff and Shukhaev.

Béla Kádár

22 Untitled

*c*1923
Gouache and ink on paper, 18 × 25.5 cm
In good condition
Accession no.1987.1a

Untitled *verso*

*c*1923
Ink on paper, 18 × 25.5 cm
In good condition
Accession no.1987.1b

Provenance
Galerie Gmurzynska, Cologne
Thyssen-Bornemisza Collection, 1986

[22] *verso*

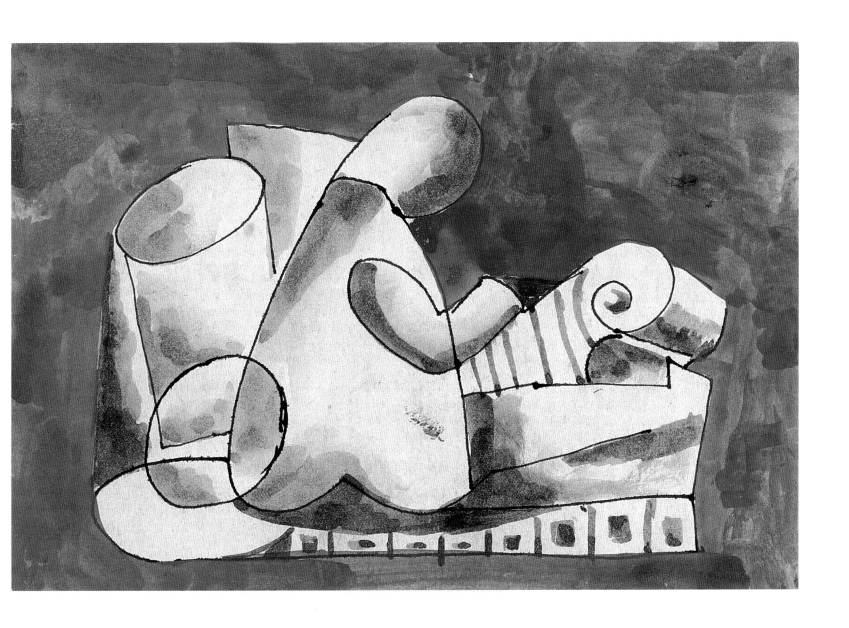

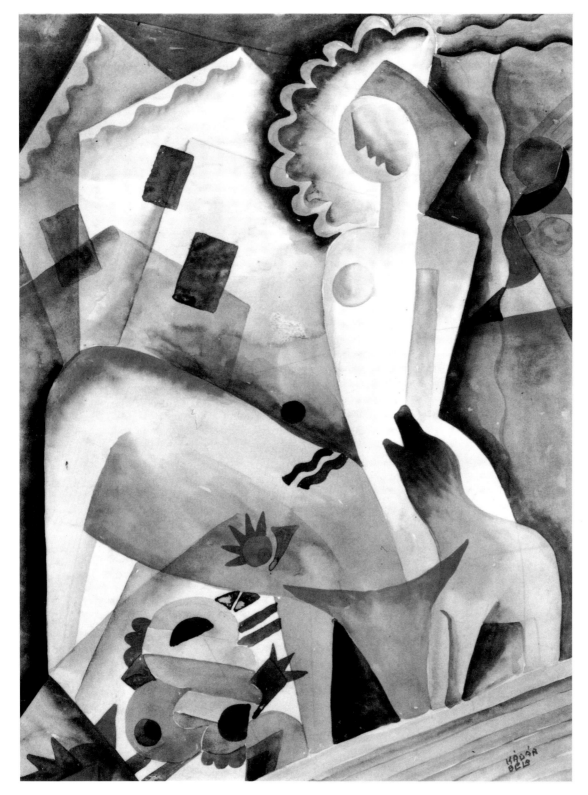

FIG 1 Béla Kádár, *Village scene*, c1923, 22 × 37.5 cm, watercolour on paper (New York, Paul Kovesdy Collection

Kádár was not a committed Constructivist and was not especially sympathetic to the artistic platform of his colleagues Sándor Bortnyik (see [2], [3]), Lajos Kassák (see [24]), and László Moholy-Nagy (see [43], [44]). With his private musings on the animal world, expressed in compositions such as *Village scene* (c1923; fig.1), *Longing* (c1925; fig.2) and even the unfinished drawing of a tree and a man on the *verso* of this piece, Kádár shares the organic Expressionism

FIG 2 Béla Kádár, *Longing*, *c*1925, 35 × 45 cm, tempera on paper (Budapest, Hungarian National Gallery)

of Marc Chagall, Franz Marc and Heinrich Campendonck. Kádár knew their works from his frequent visits to Germany and through his friendship with Herwarth Walden who was especially supportive of Kadar's art in the 1920s.

On this level, Kádár represents the organic or lyrical tendency within the Hungarian avant-garde also supported by György Ruttkay, Hugó Scheiber and János Máttis Teutsch, who still regarded natural forms and not the machine as their artistic departure-point. At the same time, as this untitled gouache indicates, Kádár was interested in the Cubist doctrine, especially as interpreted by Juan Gris, and he explored it in a number of competent exercises in the early 1920s such as *Still-life with chessboard and pipe* (*c*1920, Berlin, Berlinische Galerie).

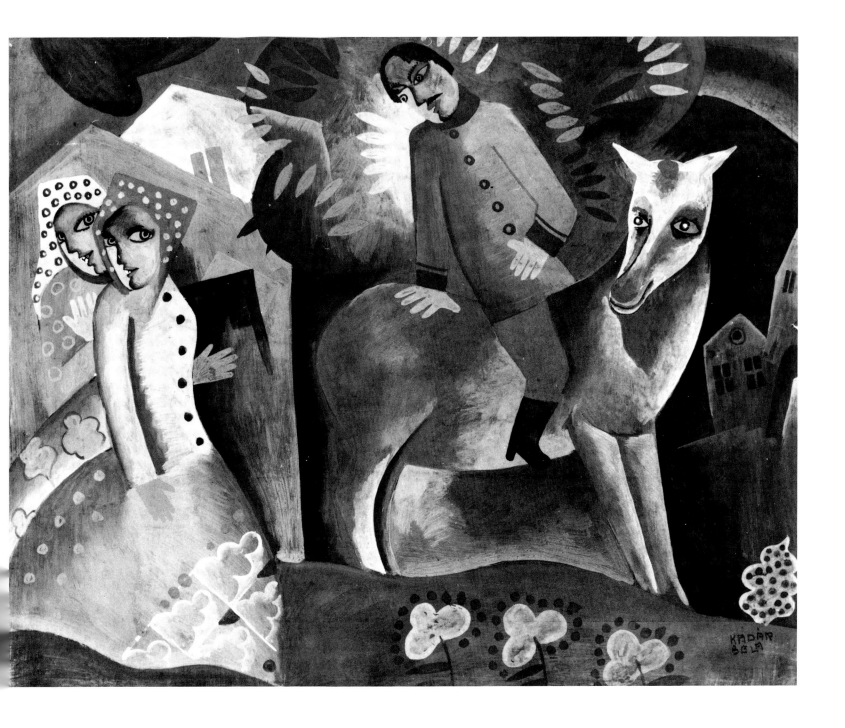

David Nestorovich Kakabadze 1889–1952

23 Untitled

1920
Oil on cardboard, 52 × 61.5 cm
Signed and dated lower right [in Georgian]
Signed and dated on the back: 'D. Kakabadzé, Paris '20'
The recent(?) varnish is very glossy. General condition is good
Accession no.1983.34

Provenance
Son of the artist, Tbilisi
Galerie Gmurzynska, Cologne
Thyssen-Bornemisza Collection, 1983

Exhibitions
Cologne 1986, no.74
Luxembourg/Munich/Vienna 1988–9, no.35, colour illus. p.93

Kakabadze is one of the many non-Russian artists who constitute what has come to be known as the 'Russian' avant-garde which, in fact, was a conglomerate of different nationalities (Alexandra Exter from the Ukraine, Gustav Klucis from Latvia, Władysław Strzemiński from Poland, etc.). Kakabadze maintained a strong commitment to his native Georgia, cultivating a particular interest in its ancient architecture and, even while living in Paris in the 1920s, he contended that 'my work concerns only Georgian culture...I continue to work for the art of modern Georgia'.[1] Even so, Kakabadze's professional training was in St Petersburg and Paris, he was *au courant* with the latest trends of Cubism and Futurism and followed the evolution of the Russian avant-garde with particular attention. Kakabadze made his artistic debut during his university studies in St Petersburg in 1910–14 where, parallel to his courses in physics and mathematics, he also enrolled in the studio of the academic painter and ethnographer Lev Dmitriev-Kavkazsky where he met Pavel Filonov (see [16]). Although Filonov's pictorial style does not seem to have left a deep impression on Kakabadze's development, the basic tenets of Filonov's 1914 manifesto, *Made Paintings*, of which Kakabadze was a co-signatory, guided his aesthetic enquiry into basic questions of composition and design in the 1910s:

> We also affirm that the enormous significance of the drawing, one equal to that of the painting, has long been lost. It has been dissipated through graphics and studies for paintings. And yet the drawing should be a Colossus. It is neither the servant of painting, nor the servant of graphics.[2]

A passionate supporter of the art and literature of Georgia, Kakabadze contributed much to the cultural revival of Tiflis (Tbilisi) in the late 1910s. By then Tiflis was a dynamic centre of creative experiment, an artificial hothouse that forced the most diverse and curious cultural phenomena: one could listen to the poets of the Blue Horns group recite their late Symbolist verse at the Khimerioni Café or the Futurist Alexei Kruchenykh recite his transrational verse at the Imredi Restaurant; one could take a class at Georgii Giurdzhiev's Institute for the Harmonious Development of Man or watch the fabulous Sofia Melnikova dance at the Theatre of Miniatures; one might go to see the new works by Lado Gudiashvili, Kakabadze and Yakov Nikoladze at the *First Exhibition of Georgian Artists* and then try to decipher the single issue of the avant-garde magazine *41°* and its claim to 'use all the great discoveries of its collaborators and place the world on a new axis';[3] alternatively, one could drop by one of the many cafés and

Notes
1 Letter from Kakabadze to the Society of Georgians in Paris dated 8 April 1925; quoted in Beridze, *David Kakabadze*, p.128
2 P. Filonov, D. Kakabadze, A. Kirillova and E. Lasson-Spirova, *Sdelannye kartiny* (1914); Eng. trans. in N. Misler and J. Bowlt, *Pavel Filonov. A Hero and His Fate*, Austin (Silvergirl) 1983, p.136
3 From *41°*, 1919, July; quoted in *Iliazd, Maître d'oeuvre du livre moderne*, exh. cat. Montreal, Galerie d'art de l'Université de Québec, 1984, p.13. For more information on the group see L. Magarotto, M. Marzaduri and G. Pagani Cesa, *L'avanguardia a Tiflis*, Venice (Università degli Studi di Venezia) 1982, pp.120–21, 233–4

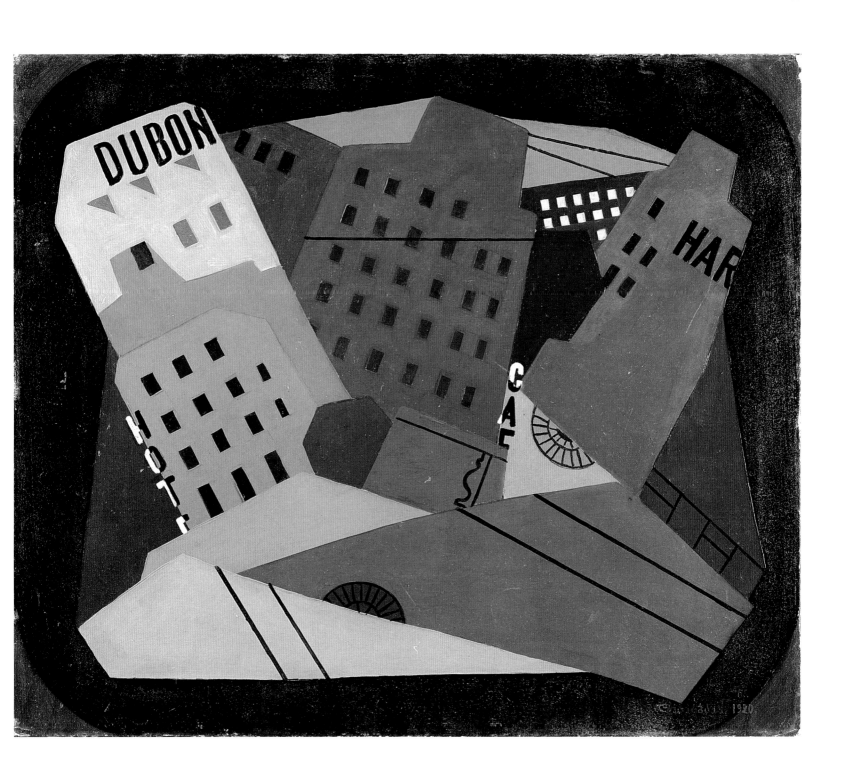

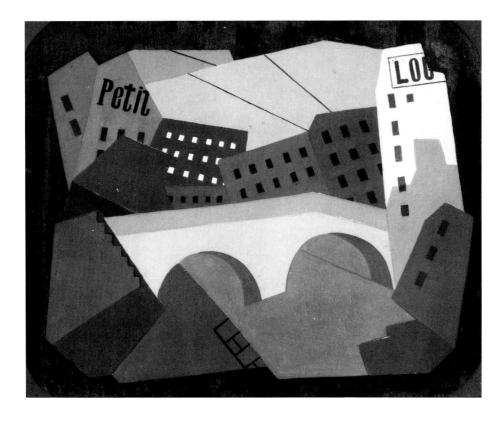

nightclubs such as the the Boat of the Argonauts, the Cup of Tea and the Peacock's Tail and partake of less exacting pastimes. The painter Gregorio Sciltian, who later made his career in Italy, was then staying in Tiflis:

> Every day other representatives of philosophy and art arrived from Russia and they were welcomed with open arms. Poetry and poets were at their apogee. In that city alone one could have counted several hundred of them...
>
> All these people used to hang about the cafés, restaurants and taverns conducting interminable philosophical and artistic discussions and sometimes getting so worked up that hand to hand fighting was the result.[4]

Among these cafés and cabarets were the Fantastic Tavern and the Khimerioni, important meeting-places for poets, painters, composers, actors and critics who contributed much to the Georgian Silver Age. Named after one of Valerian Gaprindashvili's chimeric poems, the Khimerioni opened its doors in April 1919 in the foyer of the Tiflis Artistic Society with its interior decorated by Gudiashvili, Kakabadze and Sergei Sudeikin. Although the murals have not survived, the memoirs of contemporaries tell us that Kakabadze painted one fresco on the theme of *The creator and the muse*, another that included a self-portrait and portraits of the writer Vasilii Barnov and the painter Gudiashvili and that he also painted the ceiling. The activities at the Khimerioni seem to have been nutritional rather than cerebral, the Georgian penchant for merrymaking was certainly not impeded and the café quickly became known for its impromptu balls and Queens of Beauty, its serious drinking and opulent cuisine. Indeed, the ambience was so exotic and carefree that 'deer used to walk freely around the fountain and amidst the tables...sometimes nabbing the fruits and vegetables...'[5]

It was not until his temporary emigration to Paris in 1920 that Kakabadze developed a distinctive and original style of painting, for until that moment his landscapes and portraits had been highly structured and controlled exercises in a late *pointillisme* that had little in common with the more radical conclusions of his St Petersburg and Moscow colleagues. Beginning in 1920, however, Kakabadze pursued a more experimental path that brought him to his planar experiments in Synthetic Cubism and Purism in which the intellectual problems of pictorial

FIG 1 David Kakabadze, *Landscape*, 1920, 53 × 61 cm, oil on cardboard (Tbilisi, Collection of Nina Andronikashvili-Kakabadze)

Notes
4 G. Sciltian, *Mia avventura*, Milan (Rizzoli) 1963, pp.131–2
5 L. Gagua, compiler, *Lado Gudiashvili. Kniga vospominanii. Stati. Iz perepiski. Sovremenniki o khudozhnike*, Moscow (Sovetskii khudozhik) 1987, p.36
6 D. Kakabadze, 'Principles of Painting', *Shvidi mnatobi*, no.1, Tiflis, 1919, p.49 [in Georgian]; quoted in Russian trans. in Beridze, *David Kakabadze*, p.30
7 D. Kakabadze, *Paris Années 1920–23*. Paris (1924) [in Georgian]

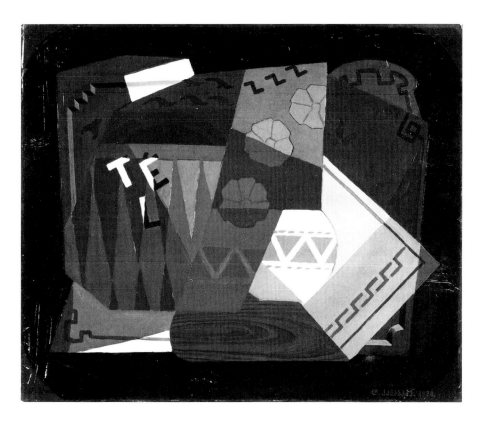

FIG 2 David Kakabadze, *Tableau*, 1920, 50 × 61.2 cm, oil on cardboard (Cologne, Museum Ludwig)

construction, spatial definition and compositional arrangement were of central importance to the artist. He wrote in in one of his theoretical tracts:

> In a painting each part, each plane, each line and each colour should occupy its own place and no part of the painting should be superfluous. . .[so that] if the question – what's that for? – is asked, the response should derive naturally from the constituent parts of the painting.[6]

In the 1920s Kakabadze explored these ideas in a variety of disciplines, figurative and non-figurative, including abstract reliefs and sculptures as well as paintings, some of which are reminiscent of the visceral landscapes of Filonov and Vasilii Kandinsky. Kakabadze showed his works at several prestigious exhibitions and published a number of essays such as the booklet *Paris Années 1920–1923*.[7] Acquainted with many artists in Paris, including Gris, Matisse, Ozenfant and Picasso, Kakabadze retained his artistic identity and applied his energies to many different activities, even inventing and patenting a stereo-cinematographic apparatus. At the same time, Kakabadze did not reject the narrative justification of art and, parallel to his formal researches, continued to draw and paint street scenes and people in a simple and accessible fashion. For obvious reasons, Kakabadze reinforced his commitment to the Realist style on his return to Soviet Georgia in 1927, concentrating on industrial landscapes and scenes of Georgian architecture.

In the 1920s Kakabadze painted a number of compositions such as this untitled piece, especially within the cycle called *Paris* (1920), many of which are still in the family collection in Tbilisi (figs.1, 2). In particular, the work in question bears a close resemblance to the 1920 *Landscape*, sharing the same bridge composition, leaning buildings and boardings as well as basic colours of cream, brown and grey-green. True, Kakabadze interchanged his commercial references – Dubonnet, cinema – but his fascination with the new architecture and streets of Paris remained an integral part of this cycle. As in other Parisian scenes in this cycle, Kakabadze emphasizes a flat, two-dimensional pattern through a strict arrangement of irregular planes. These carry geometrical ornaments reminiscent of wallpaper or a tapestry and this concern with the surface combined with the restrained monochrome of browns and greys brings to mind the concurrent researches of the French Purists (cf. Exter [14]).

Lajos Kassák 1887–1967

24 Untitled

1921
Indian ink on paper, 29 × 23 cm
Signed and dated lower left: 'Kassák 1921 Wien'; signed top right
The paper carries a stain near the top edge, but the general condition is good
Accession no.1978.65

Provenance
Klara Kassák, Budapest
Galerie Gmurzynska, Cologne
Thyssen-Bornemisza Collection, 1978

Exhibitions
Cologne 1975, no.53, illus. p.84
Quadrat, Bottrop Moderne Galerie, 1976, *Osteuropaischer Konstruktivismus*
Berlin 1977, no.1/212, p.1/125
Cologne 1986, illus. p.182
Budapest, Hungarian National Gallery, 1987, *Kassák Lajos 1887–1967*, no.115a, illus. p.158

Literature
Straus, *Kassák*, illus. p.148

This simple ink drawing could be the prototype for, or a version of, one of the black and white illustrations to Kassák's Bildarchitektur manifesto of 1921 (fig.1).[1] It is also closely related to Kassák's many suggestions for the cover of the *MA* magazine (fig.2) and its satellite publications which he edited or co-edited in Budapest and then Vienna. With the circle superimposed upon the forceful diagonal transversing a rectangle and its essential contrast between black and white, it brings to mind many other similar designs of *c*1923, including the cover to his own book of poetry published as a *MA* imprint in Berlin in 1923, *MA Buch. Lajos Kassák, Gedichte* (Berlin, Der Sturm, 1923). The basic composition here recurs in many sketches that Kassák produced in the early 1920s and they often appear in exhibitions and at auction.[2]

During the Budapest period (1916–19) *MA* attracted a dynamic following of artists, writers and musicians who pursued an interdisciplinary approach to the new culture, organizing art exhibitions, dedicating a special issue to Béla Bartók in 1917, and encouraging János Mácza (Ivan Matsa) to establish his experimental theatre the same year. However, *MA* emerged as a truly international endeavour only in Vienna (1920–26) and, as if to demonstrate this, the first number of the new series appeared on May Day 1920, carrying the slogan 'An die Künstler aller Länder'. From their Vienna headquarters Kassák and his associates extended their activities to include special evenings devoted to modern Russian art and modern poetry, and for a while László Moholy-Nagy was Berlin corespondent, thereby forming an important conenction with the Bauhaus. Kassák ensured that his journal continued to give adequate coverage to all the arts and to the latest trends, including the second generation of German Expressionists, the French Surrealists and, of course, the Russian Constructivists. One consequence of this was his *Buch neuer Künstler*, of which he was co-author with Moholy-Nagy, published in Vienna in 1922, a collaboration that seems to have prompted Kassák to

Notes
1 L. Kassák, *Képarchitektúra (Bildarchitektur)*, Vienna (*MA*) 1921; for commentary see J. Szabó, '"Color, Light, Form and Structure". New Experiences in Hungarian Painting, 1890–1930' in Santa Barbara/Kansas City/Champaign 1991–2, pp.134–5. The work under discussion and the linocut version for the Bildarchitektur manifesto are both reproduced in *Kassák Lajos*, 1987, p.158. According to the extended caption there, the originality of this work is 'doubtful'
2 See, for example, Kassák's compositions for *MA* offered as lot 18 at Sotheby's, 4 July 1974 (37 × 28.5 cm, watercolour); and lot 349 at Sotheby Parke Bernet, 3 Nov. 1978 (31 × 22.5 cm, gouache)

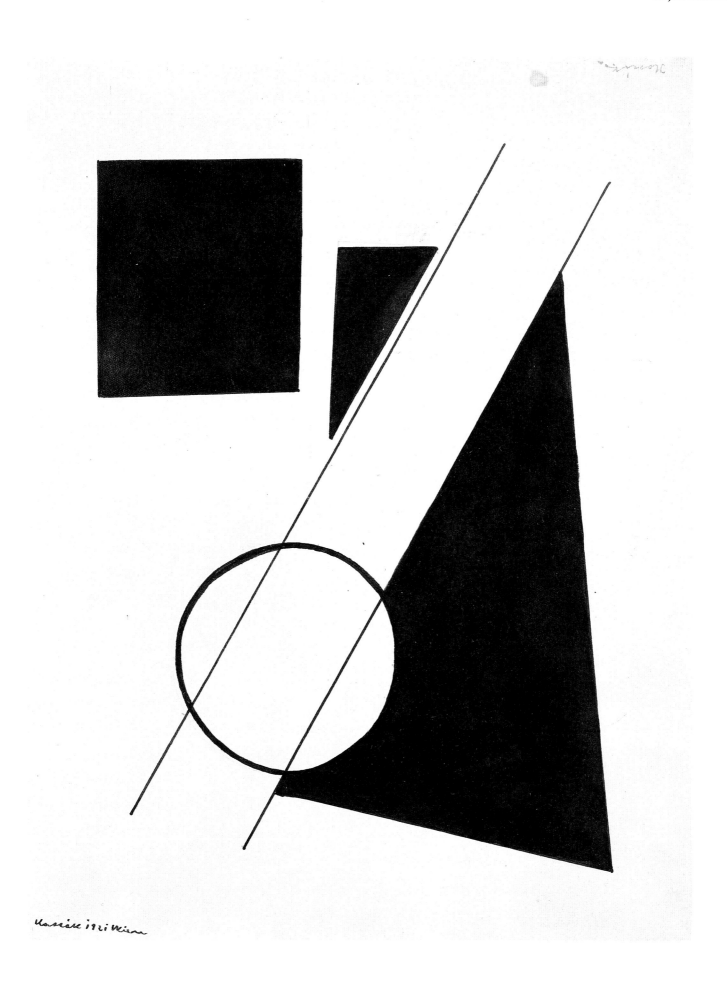

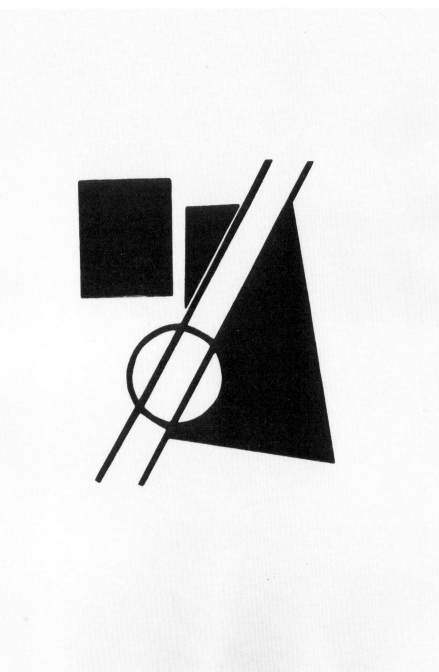

FIG 1 Lajos Kassák, sheet from *Képarchitektúra (Bildarchitektur)*, Vienna, 1921, 26 × 21 cm, linocut (Budapest, Hungarian National Gallery)

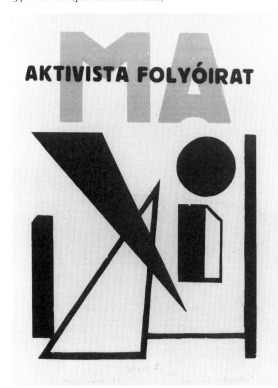

FIG 2 Lajos Kassák, cover of *MA*, Vienna, 1921 37 × 22 cm (private collection)

paraphrase some of Moholy-Nagy's compositions (see [43]). *MA* also acted as the publishing-house for Sándor Bortnyik's album of six Bildarchitektur compositions with Kassák's introduction in 1921 (see [20]).

It was not only *MA* that developed as a dynamic and prestigious propagator of the new aesthetics in Vienna, but Kassák himself also made his real debut as a graphic designer and illustrator there – something indicated by his manifesto on Bildarchitektur in 1921, by the publication of his portfolio of drawings called *DUR-Mappe*, and by the first monograph on him by Endré Gáspár.[3] During the 1910s Kassák enjoyed some recognition as a poet and critic, but not as an artist. He wrote on Italian Futurism, Post-Impressionism and posters, but he drew and painted then only as an amateur and for his own pleasure. All the more remarkable, therefore, that Kassák's first 'public' compositions of c1920 should be so accomplished and effective, as if

Notes
3 E. Gáspár, *Kassák Lajos. Az ember és munkája irta*, Vienna (Fischer) 1924
4 L. Kassák, 'Bildarchitektur', op. cit.; Eng. trans. quoted from *The Hungarian Avant-garde*, 1980, pp.115–7

the preceding decade had served as a period of gestation and meditation, preparing him for the encounter with geometric abstraction, the discipline in which he excelled.

Of all the movements that appealed to Kassák, it was Russian Constructivism that he understood most clearly and applied most creatively. *MA* itself demonstrated a particular bias towards Constructivism, and the group's chief theoretician, Ernö Kállaí, was one of the most astute commentators on the subject. Kassák's geometric designs for *MA* and his own books, his interest in film and scenography and his investigations into architectural design coincided with similar concerns on the part of Gustav Klucis, El Lissitzky, Liubov Popova and Alexander Rodchenko. Moreover, the sentiments of his Bildarchitektur theory (1921) paralleled similar theoretical statements on Constructivism by Alexei Gan, Lissitzky, Rodchenko and other Soviet artists of the time:

> Bildarchitektur $2 \times 2 = 4$.
> Bildarchitektur is the alpha...
> Bildarchitektur has transferred the spectrum of colours into white and black...
> Bildarchitektur does not resemble anything, tells no story, has no beginning.
> It simply exists.
> Thus Bildarchitektur is no longer a picture in the academic sense of the word.
> It is an active companion in our life.
> Bildarchitektur is constructed not inwards from the plane, but outwards from it.
> It takes the surface simply as a given foundation.[4]

The idea of the universality of the work of art, of its applicability to 'life' and of its rejection of the traditional narrative function are also fundamental to the ideology of the Soviet Constructivists. Perhaps in some curious way Kassák's double inverted signatures on the work in question also emphasize the notions of beginning without end, of action and externality, since the immediate effect of this simple device is to question the legitimacy of any one pictorial position, in other words in losing any sense of 'up' or 'down' the work becomes accessible from all points of view.

Ivan Vasilievich Kliun 1873–1942

25 Composition

1917
Oil on canvas, 88 × 69 cm
The canvas has been relined with glue and the stretcher is not original. The surface shows cracks all over and the
 large areas of inpainting (repairs) and the varnish are discoloured. The general condition is fair
Accession no.1977.102

Provenance
Private collection, USSR
Galerie Gmurzynska, Cologne
Thyssen-Bornemisza Collection, 1977

Exhibitions
Lugano 1978, no.54 colour illus.
Los Angeles/Washington DC, 1980–81, no.91, p.168, illus. p.169
Modern Masters from the Thyssen-Bornemisza Collection 1984–6, no.66, colour illus. p.88
Cologne 1986, p.123, colour illus. p.123
Luxembourg/Munich/Vienna 1988–9, no.39, colour illus. p.101
Zurich 1989, p.34, colour illus. p.35

Kliun was an artist of many styles, experimenting with Symbolism, Futurism, Cubism, Suprematism and Purism, although his experiments in abstract painting remain his primary artistic achievement. From 1915 onwards Kliun was a prime mover of Suprematism and a leading member of the Supremus group, at first sharing and reprocessing the abstract principles of Malevich. He wrote in 1915: 'before us in all its grandeur has arisen the great task of creating a form *out of nothing*'. *Composition* extends this radical philosophy for, 'after accepting the straight line as a point of departure, [it] has arrived at an ideally simple form: straight and circular planes'.[1] Kliun continued to develop the Suprematist idiom in the late 1910s and 1920s, although he criticized Malevich harshly and removed the term Suprematism from his pictorial vocabulary, even referring to it as the 'corpse of painterly art'.[2] On the other hand, in 1918, as co-director (with Vladimir Baranov-Rossiné) of the Department of Painting at the Moscow Svomas, Kliun advocated a Suprematist system of painting, although he did not call it that, requiring students to compile elementary tables of form and colour.

Unlike many of his colleagues, Kliun did not transfer his allegiance from easel painting to design, even during the general move from studio to street after the October Revolution. He supported neither Vladimir Tatlin's extension of the relief to utilitarian ends, nor Malevich's endeavours to 'suprematize' the world by applying geometric motifs to porcelain, textiles and architecture. Apart from his occasional book illustrations, his projects for a memorial to Olga Rozanova and his peripheral contribution to the agit-decorations for Moscow in 1918–19, Kliun refused to adulterate what he considered to be the purity of painting and sculpture and, for this reason, clashed with those artists such as Liubov Popova and Alexander Rodchenko, who supported the strong orientation towards industrial design. Kliun, then, was unflinching in his loyalty to painting and had little time for the Constructivists who professed their dedication to the applied arts. Throughout the 1920s and 1930s Kliun continued to experiment with various pictorial styles, from Impressionism to Suprematism, although he gave increasing attention to the possibilities of a new figurative painting and sculpture, to 'subjectness', as contemporary critics called it.[3] Consequently, Kliun allied himself with circles of artists who welcomed a return to thematic art such as OST, Four Arts, and the Society of

Notes
1 I. Kliun, 'Primitivy XX veka' [Primitives of the XX Century] (1915); Eng. trans. in Bowlt (1988), p.137
2 I. Kliun, 'Iskusstvo tsveta' [Colour Art] (1919), ibid., p.143
3 A. Fedorov-Davydov, 'Khudozhestvennaia zhizn Moskvy' in *Pechat i revoliutsiia*, Moscow, 1927, book 1, p.98

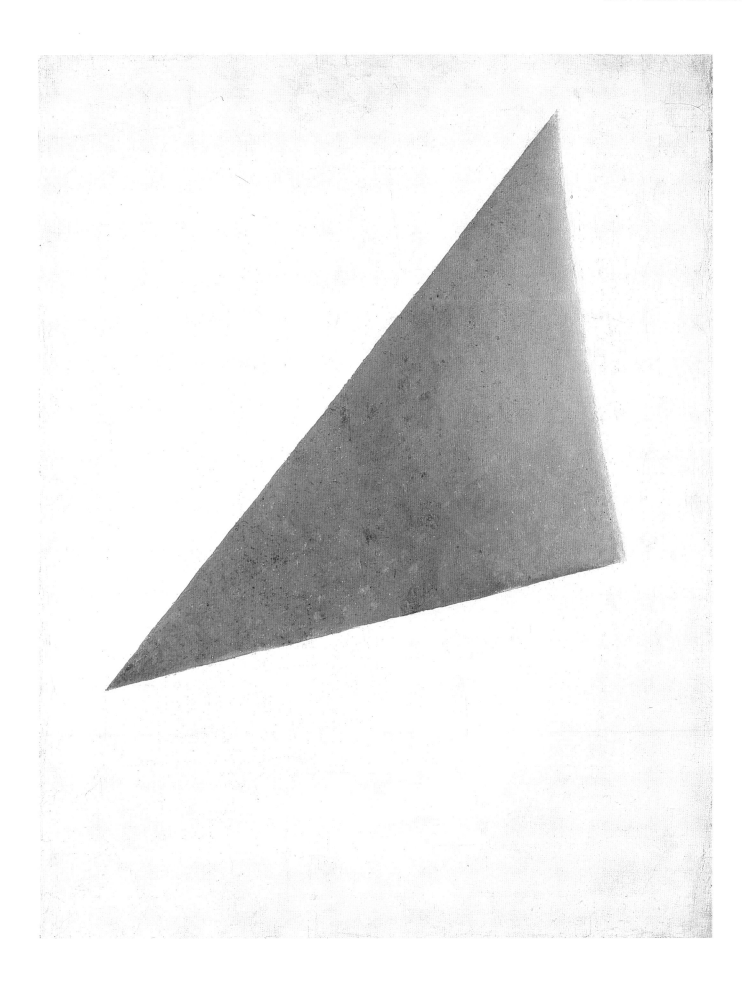

Russian Sculptors. He contributed to their exhibitions and, like them, tried to adjust the traditions of studio art to the new themes of electrification and industrialization. At this time Kliun also manifested a particular interest in French Purism, paraphrasing and elaborating works by Jeanneret, Ozenfant and Léger, and he reasserted his own commitment to Cubism.[4]

Kliun was especially interested in the perception and variability of colour and he elaborated a number of tabulations based on the results of his abstract painting in which he aspired to present a rational explanation of 'colour, form, light and texture (the intensification of colour via light and via contrasts, the influence of adjacent colours on the change of form)'.[5] Vasilii Rakitin, a historian of the Russian avant-garde, has argued that *Composition* is also from the series of 'colour researches' that Kliun was pursuing in the late 1910s.[6] Of course, Kliun was not alone in his interest in the dissolution of form and colour, and several other Suprematists such as Mikhail Menkov reached similar conclusions in the late 1910s (fig.1), and Malevich himself, of course, was drawn to the concept, as is clear from his *Suprematist painting. Yellow parallelogram on white background* (also called *Dissolution of sensation*, 1917–18; fig.2). The Costakis collection contains a number of watercolours and some oils by Kliun that resemble the piece in question, although, as a rule, they are much smaller (figs.3, 4).

The registrar files of the Thyssen-Bornemisza Collection possess a black and white photograph (carrying a certificate of authenticity by Vasilii Rakitin on the reverse) of the work before restoration, showing much dirt and loss of paint.[7]

Notes
4 Kliun explained his views on Cubism in his article 'Kubizm kak zhivopisnyi metod' (1927). Eng. trans. in Los Angeles/Washington, DC, 1980–81, pp.170–1
5 P. Pertsov, *Khudozhestvennye muzei Moskvy. Putevoditel*, Moscow and Leningrad (Moskovskoe kommunalnoe khoziaistvo) 1925, p.88
6 Undated certificate by Vasilii Rakitin in the Archives of the Thyssen-Bornemisza Collection
7 According to Emil Bosshart (conversation with the authors on 9 Jan. 1992), the restoration of *Composition* had been done very badly, but he had rectified this as best he could

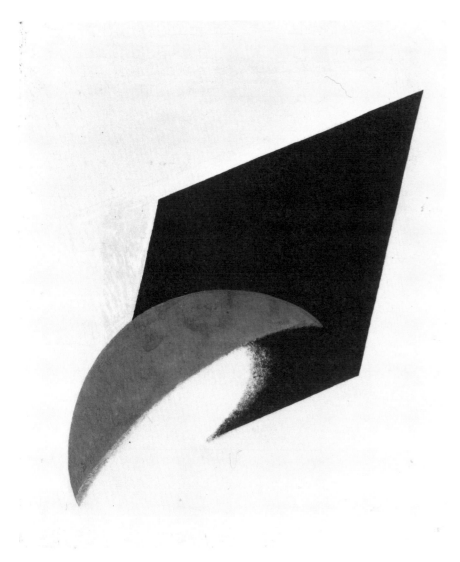

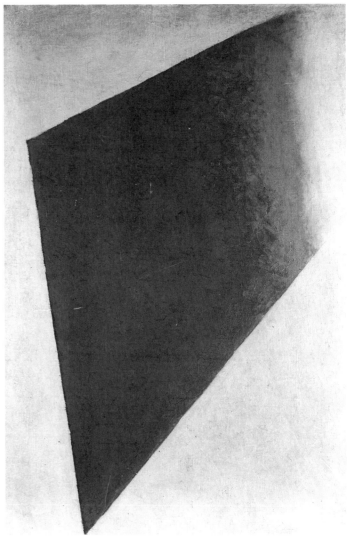

FIG 1 Mikhail Menkov, *Non-objective*, 1919, 64 × 53 cm, oil on canvas (Krasnodar, Lunacharsky Art Museum)

FIG 2 Kazimir Malevich, *Suprematist painting. Yellow parallelogram on white background*, also called *Dissolution of sensation*, 1917–18, 106 × 70.5 cm, oil on canvas (Amsterdam, Stedelijk Museum)

FIG 3 Ivan Kliun, *Untitled*, *c*1917, 27 × 22.5 cm, oil on paper (Art Co. Ltd, George Costakis Collection)

FIG 4 Ivan Kliun, *Suprematist composition*, 1916–17, 32 × 32 cm, oil on canvas, (Art Co. Ltd, George Costakis Collection)

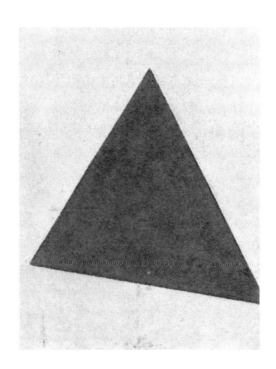

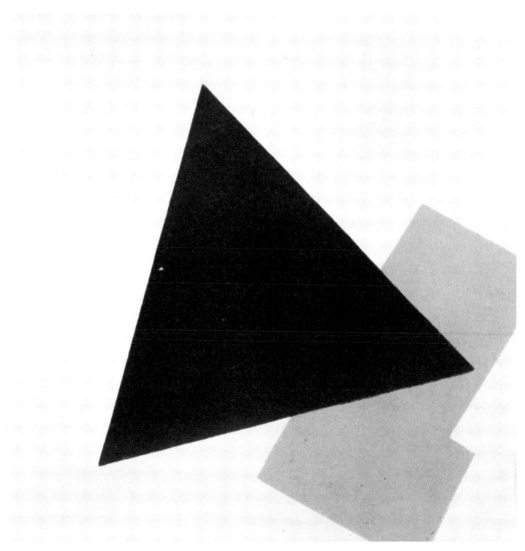

Ivan Vasilievich Kliun

1873–1942

26 Untitled

1921?
Tempera(?) on cardboard, 22 × 26.4 cm
Signed and dated in Russian upper left: 'I Kliun. 1921'
The support shows a slight concave warp and some of the colours carry minute cracks with some cupping. A
 varnish has been applied irregularly lending the work its yellow appearance. Otherwise in good condition
Accession no.1978.91

Provenance
Dorothy Carus, New York
Andrew Crispo Gallery, New York
Thyssen-Bornemisza Collection, 1978

Exhibitions
New York, Carus Gallery, September–October 1976, *The Expressionist Mind/The Constructivist Mind* [no catalogue]
Luxembourg/Munich/Vienna 1988–9, no.40, colour illus. p.103

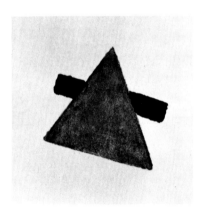 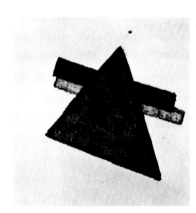

FIG 1 Ivan Kliun, Untitled,
*c*1920, 5 × 5 cm (courtesy of
Paul Kovesdy, New York)[2]

FIG 2 Ivan Kliun, Untitled,
*c*1920, 5 × 5.8 cm,
watercolour (courtesy of Paul
Kovesdy, New York)

Notes
1 These are the pieces from the
sketchbook advertised as Lot 109
at Sotheby's, 12 Apr. 1972.
Subsequently, they entered the
Matignon Gallery, New York,
which used them as the basis of
the exhibition *Ivan Vasilievich
Kliun* in 1983. They were then
sold again as Lots 130 and 131
at Sotheby's, 15 Feb. 1984
2 The watercolours illustrated
here come from the Kliun
sketchbook of 57 watercolours
dated 1916–22 that was shown
at the exhibition *Ivan Vasilievich
Kliun* at the Matignon Gallery,
New York, in 1983

The combination of a basic triangle with two cross-bars on a white ground recurs in a number
of Kliun's works, and he often repeated it as a formal exercise in albums such as the sketchbook
of fifty-seven watercolours that came on to the market in the early 1970s (figs.1, 2).[1] While the
work in question may also be a formal assignment, the fact that there is a preliminary drawing
under the composition might indicate that Kliun intended it to be a more sophisticated and
finished piece.

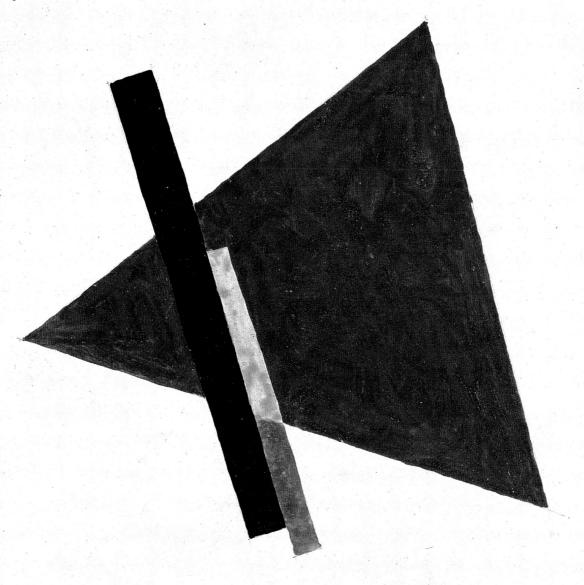

Gustav Gustavovich Klucis 1895–1938

(formerly attributed to)

27 Axonometric painting

*c*1920 (?)
Oil on canvas, 65.5 × 47.5 cm
The stretcher is the original one. The fine fabric canvas has not been relined and there are creases on all sides.
 The matte, unvarnished surface carries extensive, very fine cracking, with scattered cupping, otherwise the
 general condition is good
Accession no.1976.25

Provenance
Annely Juda Fine Art, London
Michael Tollemache, London
Thyssen-Bornemisza Collection, 1976

Exhibitions
London 1976, no.18, colour illus. pl.35
Lugano 1978, no.55; colour illus.
Berlin 1977, no.1/178, p.1/136, illus. no.51
Los Angeles/Washington DC 1980–81, no.98, illus. p.173
USA tour 1982–4, no.19, colour illus. p.28
Modern Masters from the Thyssen-Bornemisza Collection 1984–6, no.68, colour illus. p.90
Luxembourg/Munich/Vienna 1988–9, no.41, colour illus. p.105
Zurich 1989, p.38, colour illus.p.39

Axonometric painting presents the researcher with many problems of authenticity and dating, and, ultimately, its attribution to Gustav Klucis must be placed in serious question. The primary evidence against the traditional attribution comes from a letter written by Klucis's widow, the artist Valentina Kulagina, which refers to the London exhibition *Russian Pioneers at the Origins of Non-objective Art* of 1976 at which *Axonometric painting* was shown:

 (Send to lender via Costakis)
 Dear Sirs,
 I have been shown a reproduction of a work accredited to my husband, the artist Gustav Gustavovich Klutsis, namely, the oil *Dynamic city* (Klucis, *Axonometric painting*, *c*1920, cat. no.18, 66 × 77.5 cm [in London 1976]).
 He never did [this kind] of work – with the introduction of coloured planes. This is an obvious fake; and anyway, the resolution of the piece has clearly been destroyed if compared with an authentic original, where everything is resolved in a grey-black scale and with surface texture.
 The original exists in one exemplar only. Several variants were made on the basis of its painterly resolution, but with the application of photomontage and with photographic, indian ink and pencil elaboration; several lithographic prints were also made from the stone – they were done one by one and are small in dimensions. There were no other works.
 I hope that you will take account of all this.[1]

 Specialists in the life and work of Klucis such as Irina Lebedeva (Tretiakov Museum, Moscow) and Larisa Oginskaia (Museum of A.S. Pushkin, Moscow) also reject the traditional attribution, referring to the two unpublished versions of the list of works which the artist compiled for his

Note
1 The original letter is in the archives of the Klucis family in Moscow and its authenticity has been confirmed by Eduard Kulagin, son of Valentina Kulagina and Gustav Klucis, in a written statement dated 21 March 1991

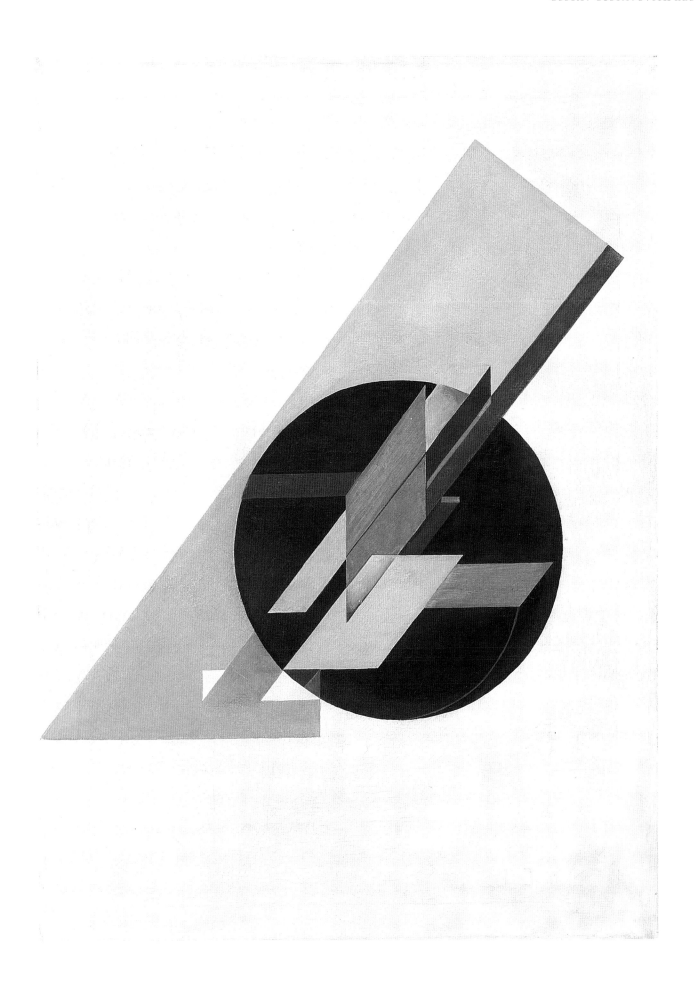

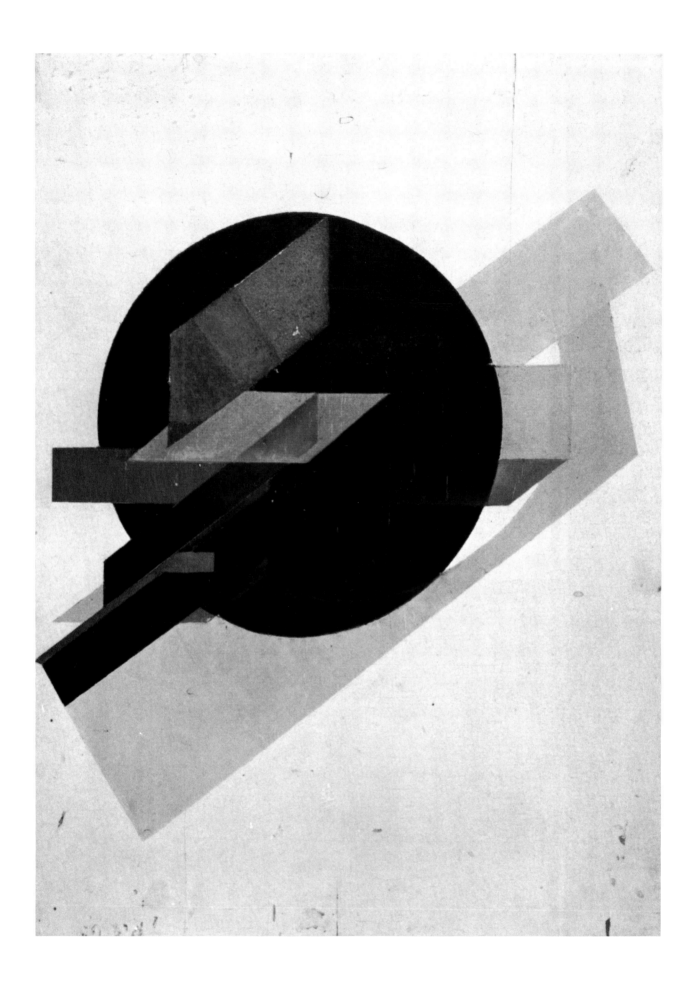

FIG 1 Gustav Klucis, *Dynamic city*, 1919, 87 × 64.5 cm, oil with sand and concrete on wood. In 1928 Klucis retitled this painting *A plan for the city of the future* (Art Co. Ltd., George Costakis Collection)

FIG 2 Gustav Klucis, *Axonometric painting*, 1920, 96 × 57 cm, oil on canvas (Moscow, State Tretiakov Gallery)

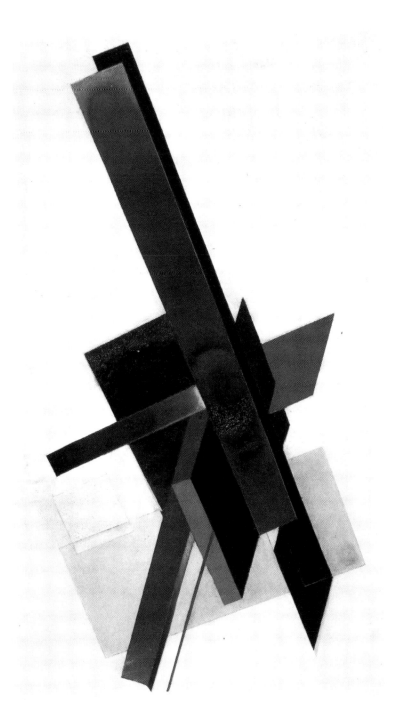

Notes
2 Letter from Larisa Oginskaia to Nicoletta Misler and John E. Bowlt dated 21 Sept. 1990
3 *Dynamic city* is also reproduced in the Kassel catalogue as no.w1.II.2, dated 1919–21; and in Oginskaia, *Gustav Klutsis*, dated 1919–20. The Costakis *Dynamic city* figured at the Klucis retrospective in Riga in 1970 (for a photo of the installation see London 1976, p.36)
4 For details and illus. of relevant studies see Rudenstine (1981), p.210, nos.348–50; and *Gustav Klucis*, 1991, p.80, nos.42, 43

1937 one-man exhibition (not implemented), but which make no mention of *Axonometric painting*.[2] In addition, both Kulagina and Klucis scholars maintain that the artist produced only one oil on canvas with this kind of composition – which served as the unique prototype for the many versions in other media that he produced from 1919 onwards. This prototype is the canvas *Dynamic city* of 1919 which Klucis retitled as *A plan for the city of the future* in 1928 and which George Costakis acquired from Kulagina (fig.1).[3] There does, however, exist a second abstract oil on canvas that Klucis entitled *Axonometric painting* (1920) and donated to the Tretiakov Gallery, Moscow in 1930 (fig.2). Of course, Klucis made many preparatory drawings for both works and some of them have been reproduced.[4] To a certain extent, the basic composition of both pieces is very similar, although it is clear that Klucis wished to make a clear and strict distinction between them – so much so that he overpainted and cancelled a spherical

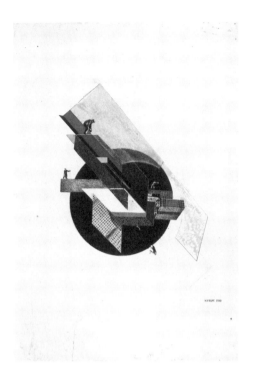

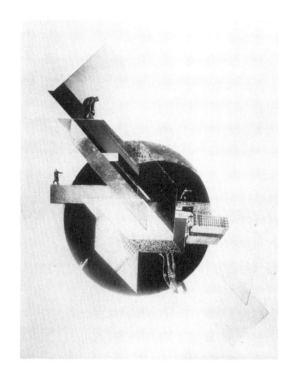

FIG 3 Gustav Klucis, *Dynamic city*, 1919, 37.5 × 25.8 cm, gouache, aluminium, collage, pencil and photograph on paper (Riga, State Art Museum of Latvia)

FIG 4 Gustav Klucis, *Dynamic city*, 1919, 55.7 × 45.7 cm, photomontage and indian ink on paper (Cologne, Museum Ludwig)

FIG 5 Gustav Klucis, *Dynamic city*, c1920, 15 × 12.5 cm, photomontage (Cologne, Galerie Gmurzynska)

FIG 6 Gustav Klucis, *Dynamic city*, 1919–20, 30 × 22 cm, photocollage (private collection; courtesy of Cologne, Galerie Gmurzynska)

FIG 7 Valentina Kulagina, *Dynamic city*, 1923, 26.4 × 18.4 cm, lithograph (Art Co. Ltd, George Costakis Collection)

arrangement that *Axonometric painting* originally carried.[5] Even though the present compositions differ, therefore, there are still many strong connections. For example, both canvases are signed on the back. Secondly, both paintings are highly stratified and rely on many different textures (the texture of the *Dynamic city* is even reinforced by the addition of sand and concrete). Thirdly, the confines of the geometric configurations in both pieces are slightly incised in the material of the painted ground. All these features are missing in the *Axonometric painting* in the Thyssen-Bornemisza Collection, something that is confirmed by laboratory tests undertaken in January 1993, according to which 'The X-ray of this painting shows none of the characteristics of the painting with the same title at the Tretiakov Gallery. No change in composition, no incisions, no application of several overlapping layers, no variation in brushwork structure'.[6]

The formal thesis of the *Dynamic city* prompted Klucis to apply his concept to many other media and, as Kulagina implied in her letter (above), there are lithographs based directly on the composition and many photomontages, photographs, collages and posters that extend or elaborate it. Of particular note is the *Dynamic city* of 1919 in the State Art Museum of Latvia in Riga (fig.3), and the versions in the Museum Ludwig, Cologne (fig.4) and the Galerie Gmurzynska (figs.5, 6). In 1923 Kulagina also made several lithographic copies of the *Dynamic city* (fig.7).[7]

Notes

5 This is proved by results of the X-ray tests undertaken on the painting by the staff of the Tretiakov Gallery. For an appraisal and photographs see I. Lebedeva and M. Vikturina, 'Faktur und Maltechnik – eine exemplarische Analyze' in *Gustav Klucis*, 1991, pp.75–81

6 Letter from Emil Bosshard to John E. Bowlt dated 25 Jan., 1993. The full report is in the archives of the Thyssen-Bornemisza Collection

7 Another lithographic version (23 × 17 cm) attributed to Klucis was sold as lot 81 at Sotheby's, 12 April 1972. Yet another lithograph (23 × 17.5 cm), previously in the collection of the McCrory Corporation, New York, is now in the Museum of Modern Art, New York

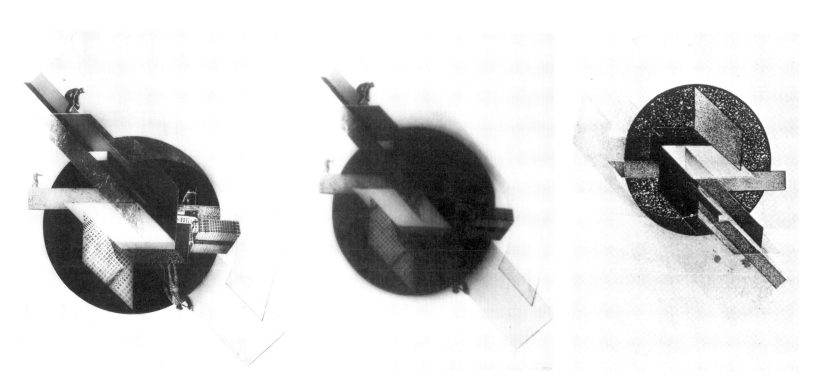

Nina Iosifovna Kogan 1887/?1889–?1942
(formerly attributed to)

28 Suprematist composition

1920–21 (?)
Tempera(?) on canvas, 58 × 37 cm
The medium-heavy canvas has not been relined, but is on a new stretcher. The paint surface seems to have been
 first dirtied artificially and then varnished with a clear varnish. The general condition is good
Accession no.1983.1

Provenance
Galerie Gmurzynska, Cologne
Thyssen-Bornemisza Collection, 1983

Exhibitions
Cologne 1986, p.124, colour illus. p.125
Luxembourg/Munich/Vienna 1988–9, no.42, colour illus. p.107

Suprematist composition presents the researcher with difficult questions of attribution and dating. Although traditionally ascribed to the hand of Nina Kogan, one of Malevich's students in Vitebsk, and dated 1920–21, there is little evidence to conclude that the work is by her. The principal problem regards the oeuvre of Kogan herself which, in practical terms, seems no longer to exist: apart from versions of the stage design for the Suprematist ballet and a tramcar decoration produced in Vitebsk in 1920,[1] Russian museums possess no examples of Kogan's painting, and those works that are in private collections are not accompanied by a reliable provenance index. Indeed, it is curious that all the major Suprematist paintings attributed to Kogan are in private collections and galleries in Western Europe and the USA. Consequently, comparative material is extremely limited and not especially enlightening.

Note
1 Kogan's *Curtain design for a Suprematist ballet* (1920, 22 × 31.5 cm, gouache watercolour and indian ink on paper) is in the Museum of Theatre and Musical Arts, St Petersburg. Another gouache on paper, measuring 18 × 18 cm, and from sheet 21 in the *Unovis Almanac*, no.1, 1920 (Moscow, State Tretiakov Gallery), is illustrated in Zhadova (1982, no.173)

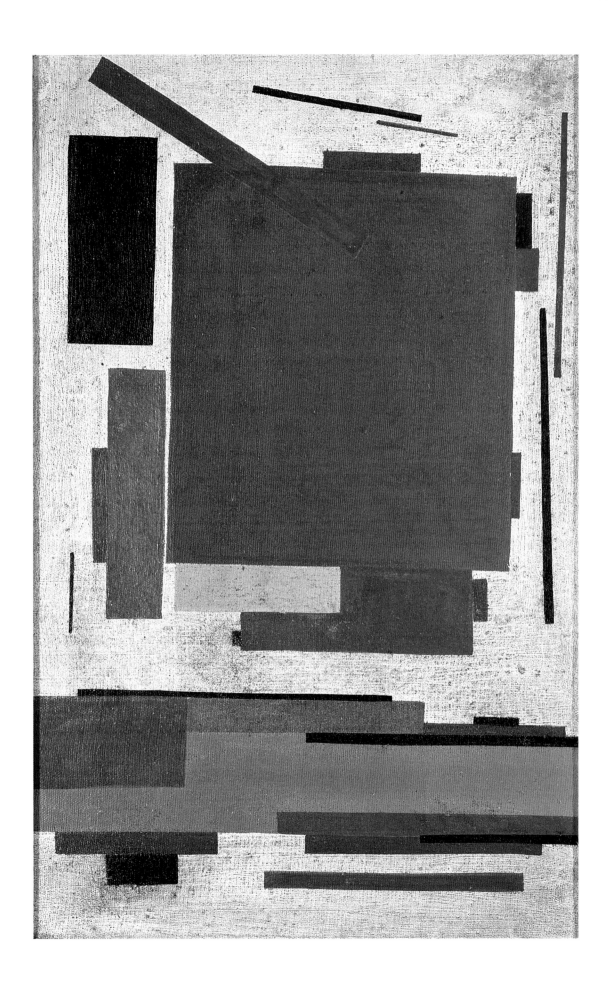

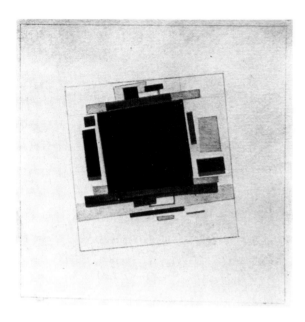

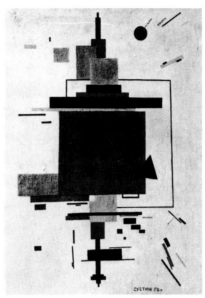

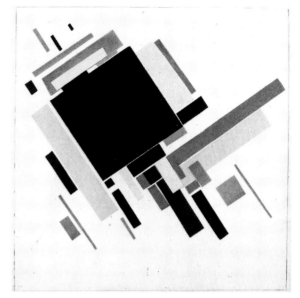

Another problem, characteristic of the Suprematist enterprise in general, is that many of the abstract pieces attributed to Kogan are similar to other pieces identified variously as by Ilia Chashnik (fig.1), Nikolai Suetin (fig.2) and the Vitebsk School (fig.3). As these works demonstrate, a compositional pattern of a dominant, central square surrounded and compressed by rectilinear elements often links all four parties. As a result, it is difficult to establish the rudiments of Kogan's individual style, both because works attributed to her sometimes resemble those of her colleagues and also because the available paintings often duplicate each other: for example, the tempera *Suprematist composition*, also dated 1920–21 and now in the collection of Louise Noun (fig.4) repeats the basic red square, the parallel, horizontal strata, the colour scheme of red, black and yellow on white, and the antiqued patina. Even when we take a broad look at the principal paintings attributed to Kogan in the search for distinctive stylistic characteristics, we do not find consistency or constancy. The *Suprematist composition* in the Noun Collection, for example, contains heavily outlined rectangular elements often devoid of colour that appear in several other pieces attributed to Kogan such as *Suprematist composition* (1920–22; fig.5) – but not in the *Suprematist composition* under discussion. At the same time, this pseudo-graphic element also recurs in works such as the *Composition* of 1920, signed by Suetin, in the Museum Ludwig – which, in turn, resembles the lower part of the Kogan ballet set design.

Among historians of the Russian avant-garde there is no consensus of opinion regarding Kogan's style and application. Vasilii Rakitin has ratified the authenticity of *Suprematist composition*, describing it as a possible study for a decorative panel,[2] but other scholars in Moscow and St Petersburg do not support the deduction. Unfortunately, technical and laboratory analyses, while not conclusive, demonstrate certain irregularities incommensurate with the age ascribed to the painting. For example, tests reveal that the dirt of the patina seems to have been inserted artificially, and although the stretcher is new, the canvas shows no signs of having been removed from a previous one. It is a curious fact that a similar artificial treatment of the patina, a similar emphatic and deliberate imposition of the geometric elements, and a similar strong juxtaposition of bright red and ochre are encountered in a number of other Suprematist pieces of unclarified provenances attributed to Lazar Khidekel, El Lissitzky, Suetin, etc. and presently being offered by private galleries.

FIG 1 Ilia Chashnik, *Suprematist collage*, 1923, 12 × 12 cm, coloured paper on cardboard (private collection)

FIG 2 Nikolai Suetin, *Composition*, 1920, 32.5 × 40.5 cm, oil on canvas (Lugano, Collection Peter Ludwig)

FIG 3 Vitebsk School, (signed 'K. Malevich Vitebsk'), *Suprematist collage*, 1920–23, 19.5 × 19.5 cm, coloured paper on card laid on board (Christie's, London)

Note
2 Undated certificate written by Vasilii Rakitin in Russian: 'Rabota N.Kogan, posledovatelnitsa Malevicha. Chlen gruppy UNOVIS v. 1920–1922 gg. Vozmozhno eto etiud dekorativnogo panno. V.I.Rakitin. Istorik russkogo iskusstva 1910–1920' [A work by N. Kogan, a follower of Malevich. Member of the Unovis group in 1920–22. Possibly a study for a decorative panel. V.I. Rakitin. Historian of Russian art of the 1910s–20s]. The certificate is in the Archives of the Thyssen-Bornemisza Collection

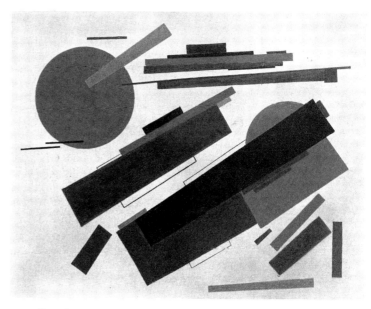

FIG 5 Nina Kogan, *Suprematist composition*,
1920–22, 50 × 62.5 cm, oil on canvas (Cologne, Galerie Gmurzynska)

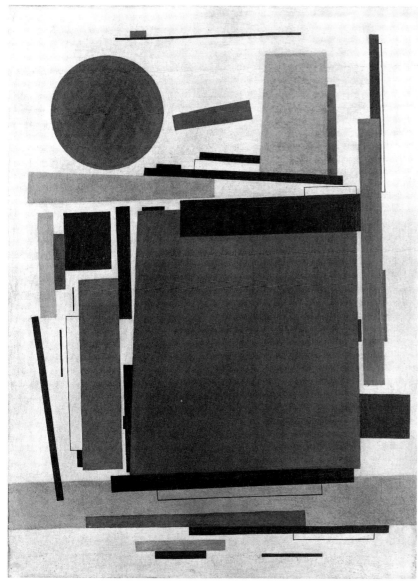

FIG 4 Nina Kogan, *Suprematist composition*, 1920–21, 88.9 × 65.4 cm,
tempera on canvas (Des Moines, IA, Collection of Louise Noun)

Mikhail Fedorovich Larionov 1881–1964

29 The blue nude
Nu bleu

1908 (?)
oil on canvas, 73 × 116 cm
The coarse-weave canvas has not been relined, but the keyed stretcher is not the original one. The surface
 carrries severe cupping and cracking and the general condition requires caution
Accession no.1979.6

Provenance
Mikhail Larionov, Paris
Alexandra Tomilina, Paris
François Daulte, Lausanne
Thyssen Bornemisza Collection, 1979

Exhibitions
New York, Acquavella Galleries, 22 April–24 May 1969, *Michel Larionov*, no.10, colour illus. [unpaginated]
Albi, Musée Toulouse-Lautrec, June–September 1973, *Michel Larionov et son Temps*, no.6
Brussels, Musée d'Ixelles, 29 April–6 June 1976, *Rétrospective Larionov-Gontcharova*, no.10, illus. [unpaginated]

In 1906 Larionov accompanied Sergei Diaghilev to Paris in order to help with the organization of the Russian Section of the *Salon d'Automne*. While he was there, Larionov saw the retrospective *Salon d'Automne. 4ème Exposition. Oeuvres de Gauguin* at the Grand Palais, which reinforced the profound impressions that he had already experienced after seeing the Gauguin canvases in the Sergei Shchukin collection in Moscow. Not unexpectedly, therefore, a number of thematic and formal parallels between Gauguin and Larionov can be found in the latter's early work, such as the *Gypsy in Tiraspol* (1908; fig.1) which combines Gauguin's *No te aha oe riri* (1896, 95 × 130 cm, Chicago, Art Institute) and *Te avae no Maria* (1899, 96 × 74.5 cm, St Petersburg, Hermitage; formerly Shchukin Collection). *The blue nude*, too, recalls Gauguin's Polynesian beauties, also crouched and reclining, such as *Nevermore* (1897; fig.3) which was at the 1906 Gauguin retrospective (no.216 in the catalogue). (*Nevermore*, incidentally, would also seem to have been the departure-point for Henri Matisse's famous *Blue nude* of 1907, although the resemblance to Larionov's would seem to be coincidental.) In any case, Larionov's *Blue nude* is surely one of the most beautiful works of his Fauvist period and in its bold colouring, swelling brushstrokes and variegated texture tells us that by 1907–8 he was no longer a mere apprentice. In intensity and immediacy *Blue nude* has few analogies in Larionov's early oeuvre, although the *Women bathing at sunset* (1908?) and *Bathers at Odessa* (1908?) carry the same incandescent burst of flesh and fire.[1] They can be contrasted with Larionov's 'pre-Gauguin'

Note
1 The present whereabouts of Larionov's two oils, *Women bathing at sunset* (46 × 55 cm) and *Bathers at Odessa* (66 × 95 cm) is unknown. The former is reproduced in colour on the cover of *Rétrospective Larionov*, exh. cat. Nevers, Maison de la Culture de Nevers et de la Nièvre, 1972; the latter is reproduced in colour in the *Larionov–Gontcharova. Rétrospective*, exh. cat. Brussels, Musée d'Ixelles, 1976 [unpaginated]

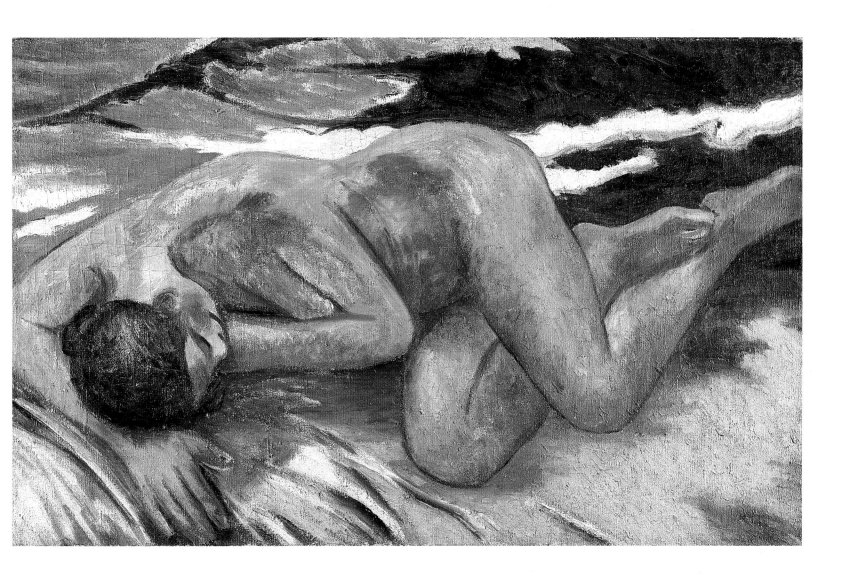

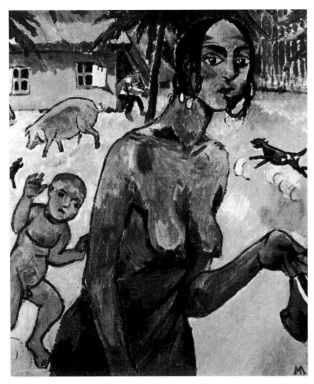

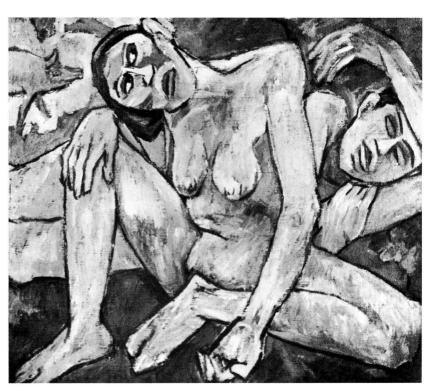

FIG 1 Mikhail Larionov, *Gypsy in Tiraspol*, 1908, 95 × 81 cm, oil on canvas (Moscow, State Tretiakov Gallery)

FIG 2 Mikhail Larionov, *Country bathers*, 1910, 89 × 109 cm, oil on canvas (Krasnodar, Lunacharsky Art Museum)

FIG 3 Paul Gauguin, *Nevermore*, 1897, 60.5 × 116 cm, oil on canvas (London, Courtauld Institute Galleries)

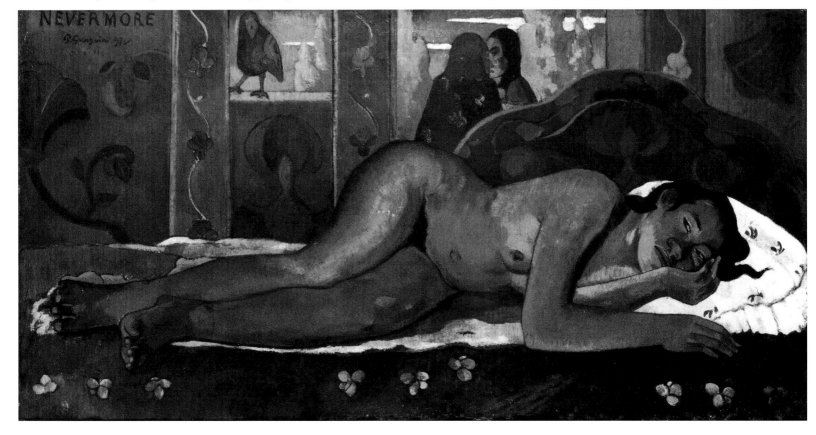

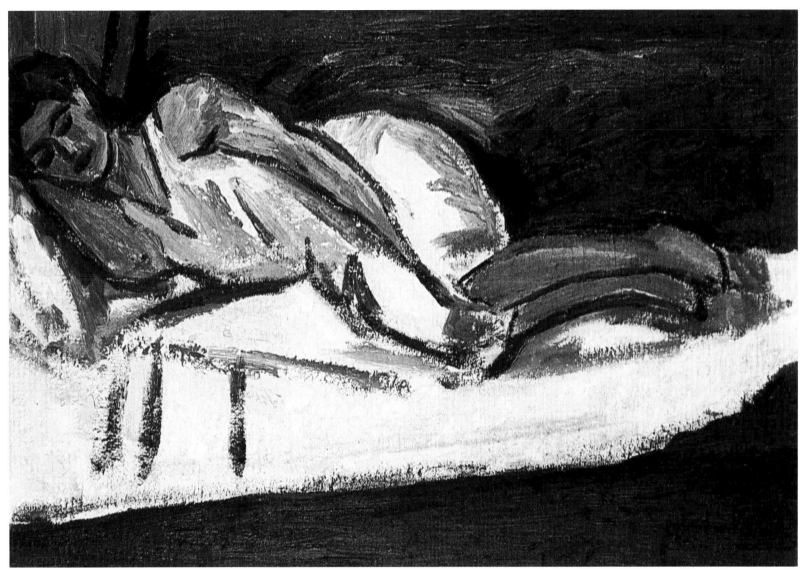

FIG 4 Mikhail Larionov, *Portrait of Natalia Goncharova*,
1910, 49.5 × 69.5 cm, oil on canvas (Moscow, (Cologne, Galerie Gmurzynska)

Note
2 Larionov's oils *Artist's studio* (1906?, 112 × 105 cm, present whereabouts unknown) and *Pink nude* (1906?, 116 × 96 cm, present whereabouts unknown) are reproduced as nos.26 and 27 in *Rétrospective Larionov*, op. cit.

nudes of *c*1906 such as the oils *Artist's studio* and *Pink nude* which, in physical pose and emotional detachment, still pay homage to the tradition of the academic nude.[2]

Just as Gauguin painted his models with a deep personal affection and sympathy, so Larionov also seems to have approached his blue nude as part of his own private and familiar landscape – manifest in the intimate setting of the frontal, crouched position of the sleeping woman. We find very similar elements in his later *Portrait of Natalia Goncharova* of 1910 (fig.4) which also contains the same blue shading and emphatic outlines present, for example, in *Country bathers* (1910; fig.2). True, *Country bathers*, like *Gypsy in Tiraspol*, already belongs to Larionov's Neo-Primitivist period (we note the leitmotiv of the pig in both works) and even *The blue nude*, with its corporeal deformation and enlarged hand, anticipates Larionov's more lapidary and coarser portraits, such as *The baker* ([30]).

Mikhail Fedorovich Larionov 1881–1964

30 The baker
Khlebopek

1909
Oil on canvas, 107 × 102 cm
Signed on the back in Russian: 'M.F. Larionov. Khlebopek' [M.F.Larionov, The baker]
The coarse-weave canvas has not been relined and is on the original stretcher. The surface carries heavy cupping
 and some cleavage, while the varnish produces a high gloss. The general condition is fragile
Accession no.1979.5

Provenance
Mikhail Larionov, Paris
Alexandra Tomilina, Paris
François Daulte, Lausanne
Thyssen-Bornemisza Collection, 1979

Exhibitions
Moscow, Society of Free Aesthetics, 8 Dec. 1911, *One-day Exhibition*, no.89 [no catalogue]
Moscow, Institute of Painting, Sculpture and Architecture, 11 March–April 1912, *Donkey's Tail*, no.110
St Petersburg, Inzhenernaia Street, 4 Jan.–Feb. 1912, *Union of Youth*, no.119
Berlin 1913[?], Galerie Der Sturm, no.13
Paris, Galerie Paul Guillaume, 17–30 June 1914, *Larionov-Gontcharova*, no.22
Leeds, City Art Gallery/Bristol, City Art Gallery/London, Arts Council Gallery, 9 Sept.–16 Dec. 1961, *Larionov and
 Goncharova*, no.29, illus. [unpaginated]
Basel, Galerie Beyeler, July–September 1961, *Larionov–Gontcharova*, no.11
Lyon, Musée des Beaux-Arts, 1967, *Michel Larionov*, no.27, illus. pl.8
New York, Acquavella Galleries, 22 April–24 May 1969, *Larionov*, no.34, colour illus. [unpaginated]
Brussels, Musée d'Ixelles, 29 April–6 June 1976, *Rétrospective Larionov–Gontcharova*, no.37, illus. [unpaginated]
Modern Masters from the Thyssen-Bornemisza Collection 1984–6, no.42, colour illus. p.64

1909–10 were key years for Larionov. By then he had assimilated his lessons from Gauguin and Matisse and was already integrating their systems with his own increasing awareness of indigenous art forms. Larionov came to his Neo-Primitivist concept, well reflected in *The baker*, via many avenues, but especially through his strong interest in signboards, icons, graffiti, *lubki* and other examples of rural and urban folklore. With his impetuous and exuberant temperament, Larionov found the warm colours, crude forms and general vitality of popular art to be to his liking and he transferred many of its subjects and structures to his own paintings. Some of these he showed at the first *Jack of Diamonds* exhibition in 1910 and then at the *Donkey's Tail* in 1912, prompting critics to refer to his 'deliberate simplification and vulgarization of form'.[1] Indeed, in *The baker* Larionov seems to have treated the subject almost as a primitive signboard, exaggerating the texture, weight, mass and colour to draw attention to the narrative.

Larionov frequently depicted scenes of the lower professions, especially barbers, soldiers, prostitutes and bakers, painting them with a deliberately rough and clumsy technique.[2] No doubt, for artists such as Larionov the very act of baking bread also symbolized a primeval activity which coincided with their search for the initial, pristine customs that defined 'primitive' societies. Consequently, the images of the loaf, the baker and the oven figured prominently in their paintings of the early 1910s. For example, we find powerful refractions of

Notes
1 Quoted in V. Lobanov, *Khudozhestvennye gruppirovki za 25 let*, Moscow (AKhR) 1930, p.62
2 For further information on the relationship of the artists of the Jack of Diamonds to urban folklore see Pospelov (1990); J. Bowlt, 'A Brazen Can-can in the Temple of Art. The Russian Avant-Garde and Popular Culture' in K. Varnedoe and A. Gopnik, eds., *Modern Art and Popular Culture. Readings in High and Low*, New York (Abrams) 1990, pp.134–58

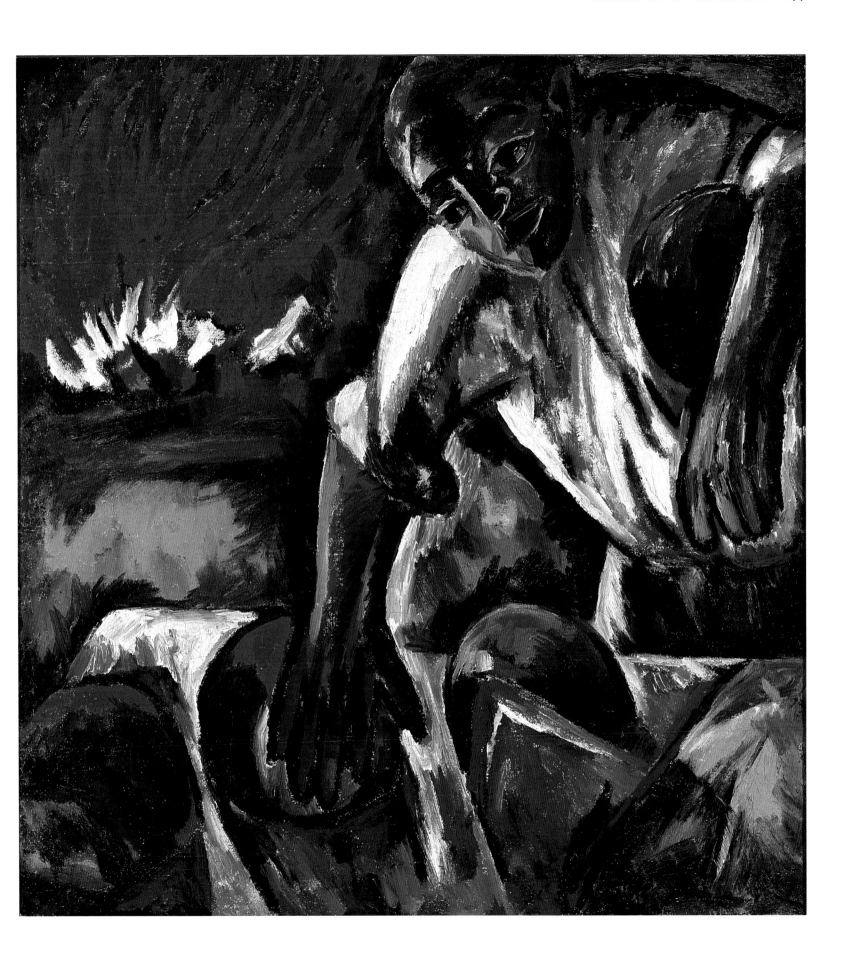

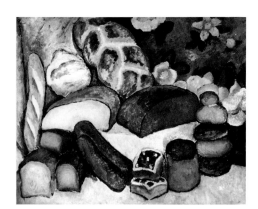

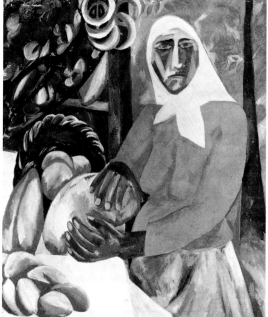

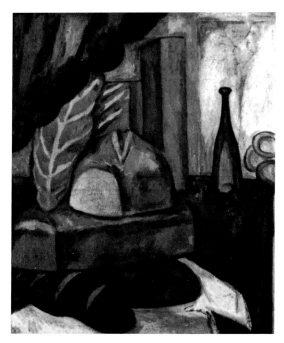

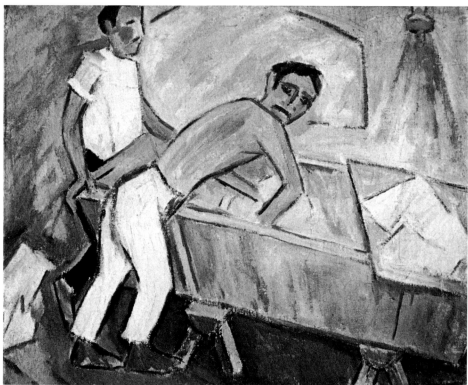

FIG 1 Ilia Mashkov, *Loaves*, 1912, 105 × 133 cm, oil on canvas (St Petersburg, State Russian Museum)

FIG 2 Natalia Goncharova, *Bread vendor*, 1911, 99 × 85 cm, oil on canvas (Moscow, State Tretiakov Gallery)

FIG 3 Mikhail Larionov, *Loaves*, 1910, 102 × 84 cm, oil on canvas (present whereabouts unknown)

FIG 4 Mikhail Larionov, *Kneading dough*, 1909, 55 × 70 cm, oil on canvas (Cologne, Galerie Gmurzynska)

the theme in Ilia Mashkov's *Loaves* (1912; fig.1), Goncharova's *Bread vendor* (1911; fig.2) and, course, Larionov's *Loaves* (1910; fig.3). Larionov explored the theme of the baker in several other canvases such as *The bakers* (1908?, 72.5 × 60.5 cm, oil on canvas, private collection) and *Kneading dough* (1909?; fig.4).

But Larionov's *The baker* also possesses a further metaphorical dimension, for it is not only a description of menial labour in deplorable conditions as in Maxim Gorky's story *Twenty-six Men and a Girl* (1899), but perhaps also a celebration of Vulcan and the cult of fire. In attempting to transmit the sense of raw force and primitive energy, Larionov uses a gestural and violent brushstroke more in keeping with German Expressionism than with the more subtle treatment

of his earlier Impressionist canvases. This helps to explain why the painted consistency of *The baker* is exceptionally brittle and is subject to flaking – for Larionov rejected the traditional, careful deposition of the paint in order to evoke a more elemental and spontaneous effect. Indeed, *The baker* might have fitted well into the display of paintings at Herwarth Walden's Der Sturm exhibition of 1913. In all these details and in this exuberance of primordial virility, *The baker* is close to other portraits of the time such as *Portrait of Vladimir Burliuk* (1910, 133 × 104 cm, oil on canvas, private collection), the *Portrait of Nikolai Burliuk* (1910, 110 × 80 cm, oil on canvas, Cologne, Museum Ludwig) and the *Portrait of Velimir Khlebnikov* (1910; fig.5).

The exhibition list compiled by former owners that accompanied *The baker* on its transference to the Thyssen-Bornemisza Collection in 1979 includes a reference to the Galerie Der Sturm, Berlin, 1913, no.74. Unfortunately, as in the case of *Quarrel in a tavern* [31], this reference is not substantiated by documents. Larionov participated in the *Erster Deutscher Herbstsalon* that Herwarth Walden organized at Der Sturm, Berlin, in September–November, 1913, but he contributed only three pieces under the numbers 248–50, i.e. *Sulvo, Beautiful autumn* and *Seashore and bathers*. True, Larionov also took part in other, mixed exhibitions at Der Sturm, although the catalogues for this period do not list *The baker* or *Quarrel in a tavern*. It is possible, of course, that Larionov took part in one of the many group shows ex-catalogue or that he sent works to Der Sturm that were inventoried but not exhibited.

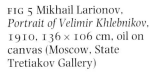

FIG 5 Mikhail Larionov, *Portrait of Velimir Khlebnikov*, 1910, 136 × 106 cm, oil on canvas (Moscow, State Tretiakov Gallery)

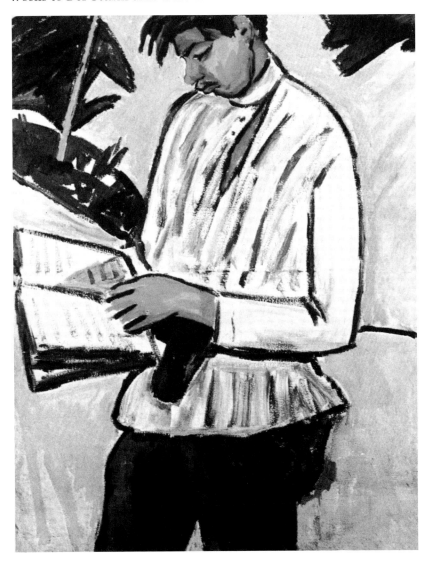

Mikhail Fedorovich Larionov 1881–1964

31 Quarrel in a tavern
Ssora v kabachke

1911
Oil on canvas, 72 × 95 cm
Signed on the back: 'Larionow' and 'Larionoff'; a label of the Galerie Der Sturm, Berlin, on the back carries the
 inscription: 'M. Larionoff [illegible] 40'
The very thin canvas on the original stretcher is not relined and unvarnished. The general condition is good
Accession no.1987.17

Provenance
Galleria Schwarz, Milan
Eric Estorick, London
Sotheby Parke Bernet, London
Galerie Gmurzynska, Cologne
Thyssen-Bornemisza Collection, 1987

Exhibitions
Moscow, Institute of Painting, Sculpture, and Architecture, 11 March–April 1912, *Donkey's Tail*, no.101(?) [The
 piece listed is called *Quarrel in a Tavern (Study)* [*Ssora v kabachke (Eskiz)*]]
Berlin, Galerie Der Sturm, 1913, no.40[?]
Milan, Galleria Schwarz, 15–28 Feb. 1961, *Larionov–Gontcharova*, [ununmbered, unpaginated]
Leeds, City Art Gallery/Bristol, City Art Gallery/London, Arts Council Gallery, 9 Sept.–16 Dec. 1961, *Larionov and
 Goncharova*, no.34 [as *Quarrel in a public-house*], illus. [unpaginated]
London, Grosvenor Gallery, 15 March–14 April 1962, *Two Decades of Experiment in Russian Art 1902–1922*,
 no.31 [as *La Rissa*], illus. [unpaginated]
London, Grosvenor Gallery, Oct.–Nov. 1967, *Aspects of Russian Experimental Art 1900–1925*, no.54
Cologne, Galerie Gmurzynska, 30 April–15 July 1987, *Meister des XX. Jahrhunderts*, p.66; colour illus. p.67
Luxembourg/Munich/Vienna 1988–9, no.44, colour illus. p.111

Literature
E. Eganbiuri, *Natalia Goncharova Mikhail Larionov*, Moscow (Miunster) 1913, illus. p.14 [incorrect pagination]
Sotheby Parke Bernet, 6 Nov. 1979, lot 106, colour illus. [unpaginated]
J.-C. Marcadé, *Le Futurisme Russe*, Paris (Dessain & Tolra) 1989, illus. p.35 [as *Dispute dans un cabaret*]

The public-house, the cafeteria, the brothel, the cabaret and the barracks formed a particular lexicon of images for Larionov who used them in his endeavour to cancel the traditional differences between 'high' and 'low' cultures. Perhaps remembering the bars and music-halls of the French Impressionists and Post-Impressionists, Larionov often turned to the interior of the Moscow public-house and cafeteria, dwelling on the habitués of their rough and ready premises. His *Dance* (1908), *Soldiers' cabaret* (c1910), and *Waitress* (1911)[1] all deal with human encounters, albeit more peaceful ones, within the unsophisticated places of public eating, drinking and entertainment. Of course, the Russian Cubo-Futurists were also known for their uncouth and scandalous behaviour – even for their fist-fights, as in the case of the Malevich–Tatlin confrontation at the *0.10* exhibition in Petrograd in December 1915,[2] and perhaps *Quarrel in a tavern* may be entirely autobiographical.

Notes
1 *Dance* (1908, 66 × 95 cm, Moscow, Tretiakov Gallery) is reproduced in D. Sarabianov, *Russkaia zhivopis konsta 1900-kh-nachala 1910-kh godov*, Moscow (Iskusstvo) 1971, between pp.112 and 117; *Soldiers' cabaret*, c1910, 69 × 98 cm, Basel, Galerie Beyeler, is illustrated in George, *Larionov*, p.71; and *Waitress* (1911, 102 × 70.5 cm, Moscow, State Tretiakov Gallery) is reproduced in Sarabianov, between pp.112 and 117
2 As related by Gray, *The Great Experiment*, p.193; the story may or may not be apocryphal

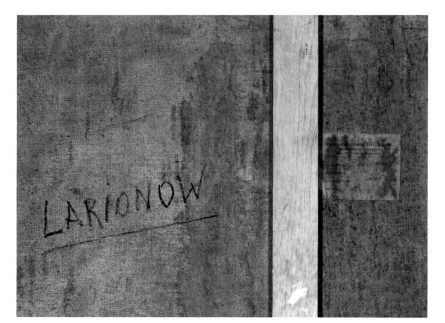

[31] *verso* (detail)

FIG 1 Mikhail Larionov, *Quarrel in a tavern*, 1911, 70.7 × 93.6 cm, oil on canvas (Nizhnii-Novgorod, State Art Museum)

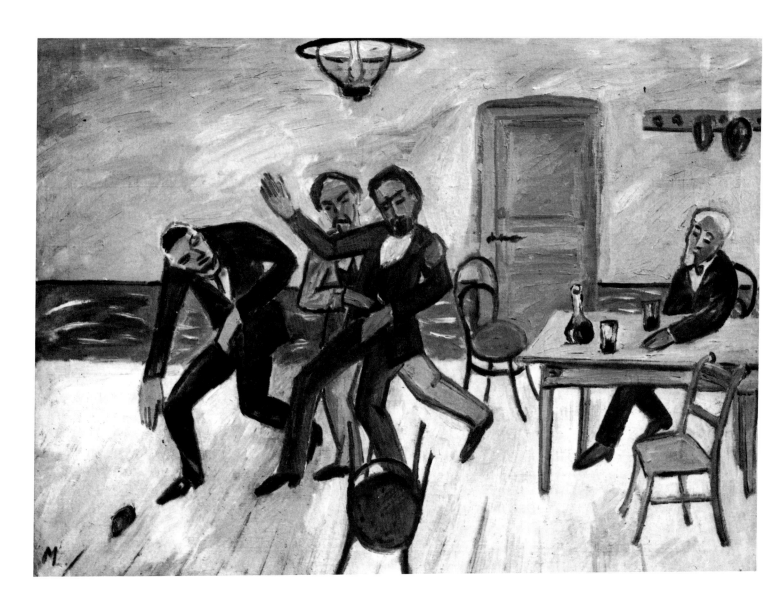

FIG 2 Sofia Boduen de Kurtene [Baudouin de Courtenay], *Scene in a tavern*, 1911 (present whereabouts unknown; photograph courtesy of Jeremy Howard, St Andrews, Fife)

Another version of *Quarrel in a tavern*, dated 1911, is in the State Art Museum, Nizhnii-Novgorod (fig.1), and in the list of works that he compiled for Larionov (under the year 1907), Eganbiuri [Ilia Zdanevich] (op.cit., p.XIX) also mentions a work entitled *Quarrel in a pub (brown and yellow). A study*. The painting in question reduces the scene to the minimal components of the four figures and the two chairs, one of which denies terrestrial gravity as it flies off into the blue void, while the other, as in the Nizhnii-Novgorod version, seems to be falling out towards us. But in contrast to the Nizhnii-Novgorod Museum version, this *Quarrel in a tavern* lacks the definition of the floor, the wall and the faces, something that imparts a non-finite and 'infantile' character to the scene and that once again allies the Neo-Primitivist Larionov with the German Expressionists, especially Erich Heckel and Ernst Ludwig Kirchner. Tavern scenes attracted other Russian artists of the avant-garde such as Sofia Boduen de Kurtene [Baudouin de Courtenay] who painted a similar *Scene in a tavern* in 1911 (fig.2).

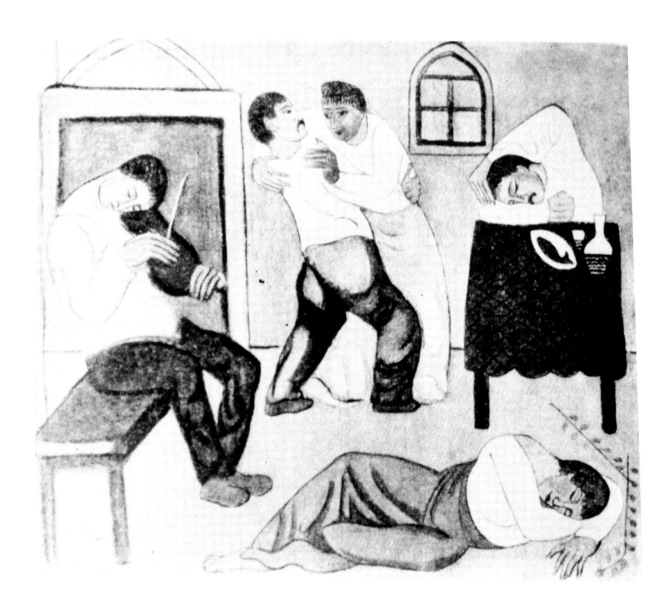

Mikhail Fedorovich Larionov 1881–1964

32 Street with lamps

1913
Oil on canvas, 34.7 × 50.5 cm
Signed with the initials and dated upper right: 'M.L. 910'
The heavy burlap canvas has not been relined, but the stretcher is not original. It is not varnished. Certain areas
 of the surface are cupping, but the general condition is good
Accession no.1977.35

Provenance
Mikhail Larionov, Paris
Solomon R. Guggenheim Museum, New York
Leonard Hutton Galleries, New York
Thyssen-Bornemisza Collection, 1977

Exhibitions
Paris, Galerie Paul Guillaume, 17–30 June 1914, *Larionov–Gontcharova*
Verviers, Societé Royale des Beaux Arts/Ghent, Cercle Royal Artistique et Littéraire/Brussels, Palais des Beaux-
 Arts, 22 Oct–Dec. 1950, *La Peinture sous le signe d'Apollinaire* [ex catalogue]
Paris, Galerie de l'Institut, 25 May–13 June 1956, *Exposition Michel Larionov*, no.25, illus. [unpaginated]
Saint-Etienne, Musée d'Art et d'Industrie, 1957, *Art Abstrait, les premières générations 1910–1939*, no.69
New York, The Solomon R. Guggenheim Museum, 1957, *Recent Acquisitions and Loans II*, no.107
New York, The Solomon R. Guggenheim Museum, 1959, *The Inaugural Selection*, no.118
Laguna Beach, CA, Laguna Beach Art Association, and other institutions, 1962–3, *Elements of Modern Art.*
 Selections from The Solomon R. Guggenheim Museum
New York, Leonard Hutton Galleries, 18 March–28 May 1977, *Der Blaue Reiter und Sein Kreis*, no.43; colour illus.
 p.53 [as *Street with lantern*]
Lugano 1978, no.59, colour illus.
Milan 1979–80, no.422, illus. [as *Street with lanterns*]
Cologne 1986, p.126, colour illus. p.127
Leningrad/Moscow 1988, no.16, colour illus. p.44
Cologne, Galerie Gmurzynska, 29 April–26 July 1991, *Malerei in Prisma. Freundeskreis Sonia und Robert Delaunay*,
 p.222, colour illus. p.223

Literature
M. Calvesi, 'Il futurismo russo', *L'Arte Moderna*, V, no.44, Milan, 1967, colour illus. p.293
A. del Guercio, *Le avanguardie Russe e Sovietiche*, Milan (Fabbri) 1970, colour illus. p.50
H. Read, *A Concise History of Modern Painting*, London (Thames and Hudson) 1968, p.295, illus. no.22
P. Kaplan and S. Manso, eds., *Major European Art Movements, 1900–1945, A Critical Anthology*, New York
 (Dutton) 1977, no.110, illus. p.303
Ruzsa, *Larionov*, no.36

Street with lamps is an example of the theory and style called Rayonism that Larionov elaborated in 1912–13 and it elicits direct comparisons with *Illumination in the street*, (1913; fig.1) and with the *Red and blue Rayonism (beach)* (1913; fig.2). All three works depict intersections of rays and prismatic luminescence – and also sequences of light spots which may represent the after-images remaining on the retina after the effect of strong electric light. Of particular proximity to *Street with lamps* is *Brown–yellow Rayonism* (1912?; fig.3) because of its greenish-yellow colour scale and white spots and rays, and, in its fractured forms and ochre emphasis, Goncharova's *Forest* [19] also comes to mind.

Larionov compiled his ideas on Rayonism in the summer of 1912 and issued them as a manifesto and separate booklet the following year, although, according to one source it was Goncharova who first used the term.[1] While Rayonism had apparent connections with the

Notes
1 Loguine, *Gontcharova et Larionov*, p.28
2 M. Larionov, 'Luchistaia zhivopis' in M. Larionov et al., *Oslinyi khvost i mishen*, Moscow (Miunster) 1913, p.90

Italian Futurists and perhaps with Franz Marc and Lyonel Feininger, the general upsurge of interest in photography and cinematography in Russia also provided an important stimulus to Larionov's theory, according to which:

> a ray is depicted provisionally on the surface by a coloured line…The picture appears to be slippery; it imparts the sensation of the extra-temporal, of the spatial.[2]

As a matter of fact, Larionov contributed several 'photographic studies' and the painting *Stage (cinematographic)* (1912, Paris, Musée National d'Art Moderne, Centre Pompidou) to the *Donkey's Tail* exhibition in Moscow in 1912.

The effect of new optical devices, including domestic electric light and street-lamps, on the formulation of certain avant-garde pictorial styles (for example, Rayonism) should not be underestimated. Physical phenomena such as incandescence, luminescence, radioactivity and

the X-ray (invented by Wilhelm Conrad Röntgen in the 1890s and propagated in Russia by his follower Abram Ioffe) left an indelible imprint on young Russian artists, not least, Larionov. What X-ray photography, for example, meant for both science and art students in the early twentieth century was of momentous importance: one could actually see the world beyond appearances. For the rationally minded, here was undeniable proof of natural, indefeasible connections between outer and inner constructions; for the irrational, these photographs were proof of the existence of the 'real' reality beyond the facade of physical objects. No sooner was the X-ray developed, than the concept immediately entered the world of occult science and was investigated by all manner of diviners of the ultimate truth, especially in St Petersburg in the early 1910s. Larionov, of course, was not drawn to this particular application, but he was intrigued by the many 'miracles' and 'illusions' rendered by X-ray photography at fairground booths and downtown arcades such as the so-called Cabarets of Nothing. In any case, he could not fail to have been fascinated by the essential capability of the X-ray – its ability to record the invisible. He wrote in his 1913 essay on Rayonist painting:

> Perception, not of the object itself, but of the sum of rays from it, is, by its very nature, much closer to the symbolic surface of the picture than is the object itself. This is almost the same as the mirage that appears in the scorching air of the desert and depicts distant towns, lakes, and oases in the sky (in concrete instances). Rayism erases the barriers that exist between the picture's surface and nature.[3]

The discovery and wide application of electric illumination also had immediate consequences in modern painting and Larionov was quick to interpret the theme – prompted, no doubt, by the example of the Italian Futurists. Even though Larionov could not have seen original paintings by Umberto Boccioni and Giacomo Balla such as the latter's *Street light* (1909; fig.4), since there seem to have been no Italian Futurist paintings in Russia at this time, he knew of their ideas through their manifestos, including Marinetti's 'electric hearts' in his 'Manifeste du Futurisme' of 1909.[4] Larionov was not averse to borrowing and plagiarizing and it is no surprise to hear the echo of Marinetti's 'three hundred electric moons'[5] at the beginning of his own 1913 manifesto, *Why We Paint Ourselves*, with the words 'To the frenzied city of arc lamps'[6] and, of course, he presented a special kind of illumination in his Rayonist statements of 1913–14. Although Larionov's treatment of street-lamps was new and innovative, the actual theme of electric light was explored by many of his colleagues in the Russian avant-garde, including Alexandra Exter (e.g. *City at night*, Russian Museum, St Petersburg), Olga Rozanova (see [49]), and, of course, Goncharova (see [19]).

Notes

3 M. Larionov, 'Luchistaia zhivopis' (1913); Eng. trans. in Bowlt (1988), p.99. Larionov published five major tracts on his theory of Rayonism (sometimes known as Rayism), i.e. (with N. Goncharova), 'Luchisty i buduschniki' in *Oslinyi khvost i mishen*, Moscow (Miunster) 1913, pp.9–48; 'Luchistaia zhivopis', ibid., pp.83–124; the booklet *Luchizm*, Moscow (K and K) 1913; the French article 'Le Rayonnisme Pictural', *Montjoie!*, no.4/5/6, Paris, April/May/June 1914, p.125; and (with Goncharova) the Italian booklet *Radiantismo*, Rome, 1917 [publisher not indicated]

4 F.T. Marinetti, 'Manifeste du Futurisme', *Le Figaro*, Paris, 20 Feb. 1909. Marinetti declared that he and his colleagues 'avions veillé toute la nuit' and that they now had 'coeurs électriques'. Russian trans. as 'Manifest o futurizme' in G. Tasteven, *Futurizm*, Moscow (Iris) 1914; these quotations are on p.3 of the Supplement there

5 F. Marinetti, *Uccidiamo il chiaro di luna!*, Milan (Poesia) 1911, p.16

6 M. Larionov, 'Pochemu my raskrashivaemsia' (1913); Eng. trans. in Bowlt (1988), pp.79–83

FIG 1 Mikhail Larionov, *Illumination in the street*, 1913, 28 × 40 cm, oil on canvas (Houston, TX, Museum of Fine Arts)

FIG 2 Mikhail Larionov, *Red and blue Rayonism (beach)*, 1913, 68 × 52 cm, oil on canvas (Cologne, Museum Ludwig)

FIG 3 Mikhail Larionov, *Brown–yellow Rayonism*, 1912–13, 49 × 61 cm, oil on canvas (present whereabouts unknown)

FIG 4 Giacomo Balla, *Street light*, 1909, 174.7 × 114.7 cm, oil on canvas (New York, Museum of Modern Art; Hillman Periodicals Fund)

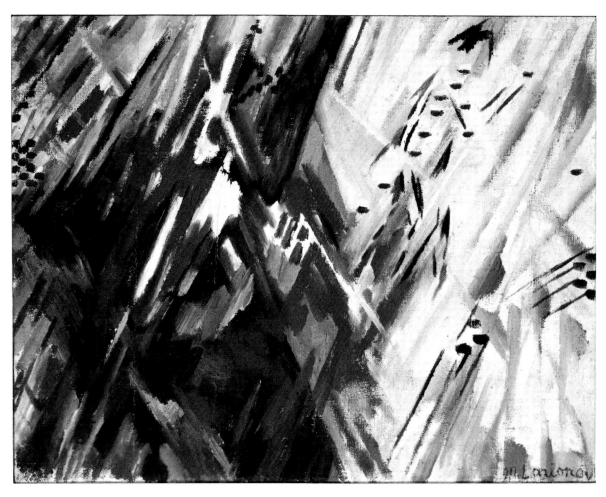

Mikhail Fedorovich Larionov 1881–1964

33 The carousel

1920s
Pencil and watercolour on paper, 56.5 × 77 cm
Signed lower left in blue 'M. Larionov'
The paper carries a slight cockling near the edges and the top edge is yellowed, but the general condition is good.
 Some fading of colours probable
Accession no.1977.113

Provenance:
J. Spreiregen, Paris
Sotheby Parke Bernet, New York
Thyssen-Bornemisza Collection, 1977

Exhibitions
Milan, Galleria del Levante, 1964 *Maestri Russi* [no catalogue]

Traditionally, this piece has been dated to the early part of Larionov's career, when he was in touch with the World of Art artists such as Alexandre Benois and Konstantin Somov, with their themes of the fun-fair, Punch and Judy shows and the *commedia dell'arte*. When *Carousel* first appeared at auction in 1977, it was even described as a design for a carousel from Josef Bayer's *Puppenfee* [*La Fée des poupées*], although there is little evidence to assume that this is the case. After all, the action in Bayer's ballet is supposed to take place inside the toy shop where the toys come alive under the spell of the Fairy Queen, although perhaps some of the Larionov characters here could be construed as the 'passers-by' such as a Spanish lady, a French lady, etc. Still, there is little reason to accept this early association, since both stylistically and thematically the work seems to date more from the 1920s when Larionov was already installed

FIG 1 Mikhail Larionov, stage design for *Le Renard*, 1922, 17 × 24 cm, gouache on paper (London, Collection of Nina and Nikita Lobanov-Rostovsky)

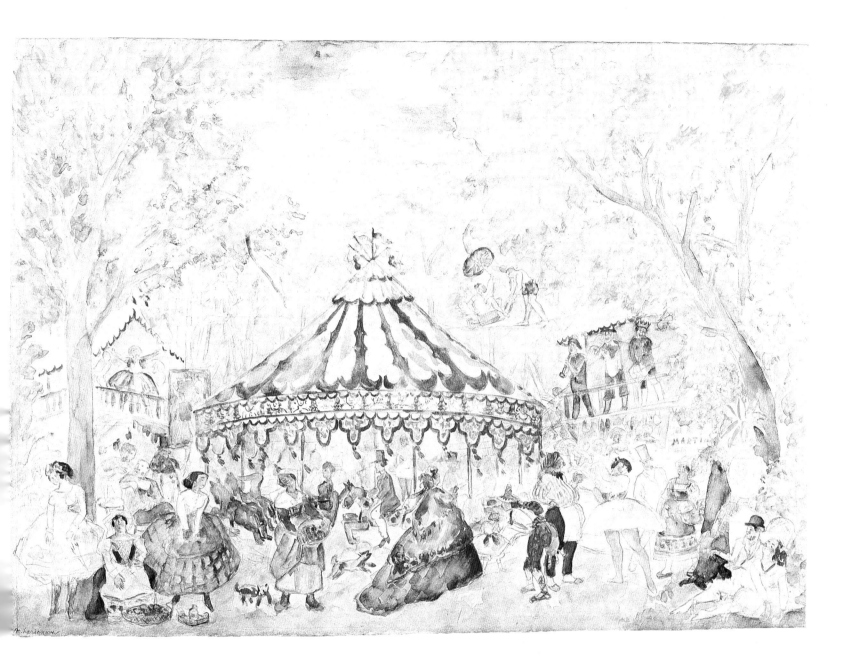

in Paris: the desultory execution of the foliage and figures, the French words and the merry theatrical scene in some urban park indicate a statement of the later Larionov. In any case, with its ballerina waiting in the wings on the left and in its general playfulness and joviality, *The carousel* reminds us of Larionov's concurrent theatrical involvement, especially Sergei Diaghilev's productions of Igor Stravinsky's *Le Renard* in 1922 and 1929 for which Larionov made the sets and costumes (fig. 1), and the initial provenance of the piece – the J. Spreiregen Collection in Paris – contained many theatrical works by Larionov. Although Larionov continued to design for the theatre in Paris throughout the 1930s, there seems to be no production that could accommodate this particular image and it may be that the spectacle for which the design was made was never realized.

Mikhail Fedorovich Larionov 1881–1964

34 Still-life with carafe and curtains

Undated
Oil on panel, 41 × 29 cm
Signed and dated upper right: 'Larionow'
The lower half of the unvarnished surface carries extensive paint losses which have not been inpainted and
 scattered pin-holes. The general condition is fair
Accession no.1979.7

Provenance
Mikhail Larionov, Paris
Alexandra Tomilina, Paris
François Daulte, Lausanne
Thyssen-Bornemisza Collection, 1979

New York, Acquavella Galleries, 22 April–24 May 1969, *Larionov*, no.39 [as *Nature morte aux carafons et rideaux*
 and dated 1914], colour illus. [unpaginated]
Brussels, Musée d'Ixelles, 1976, *Larionov–Gontcharova*, no.48, [as *Nature morte aux carafons et rideaux* and dated
 *c*1914] illus. [unpaginated]
Leningrad/Moscow 1988, no.17, colour illus. p.45

One of the fundamental problems encountered in Larionov scholarship is that of the dating of his oeuvre, since, much in the Futurist spirit, Larionov was not always concerned with accuracy and consistency when defining the chronology of his life. This was especially true of the later Larionov when his constant recourse to mystification, combined with a failing memory, often confused and misdirected his authors and supporters such as Waldemar George. When they organized the Larionov and Goncharova retrospective in England in 1961, Mary Chamot and Camilla Gray were well aware of the problem, as they indicated in the introduction to their catalogue,[1] but the mythology of chronology has persisted and, while not quite as asymmetrical as David Burliuk's, it still presents the researcher with major difficulties.

Note
1 *Larionov and Goncharova*, Leeds/ Bristol/London, 1961, op.cit. [unpaginated]

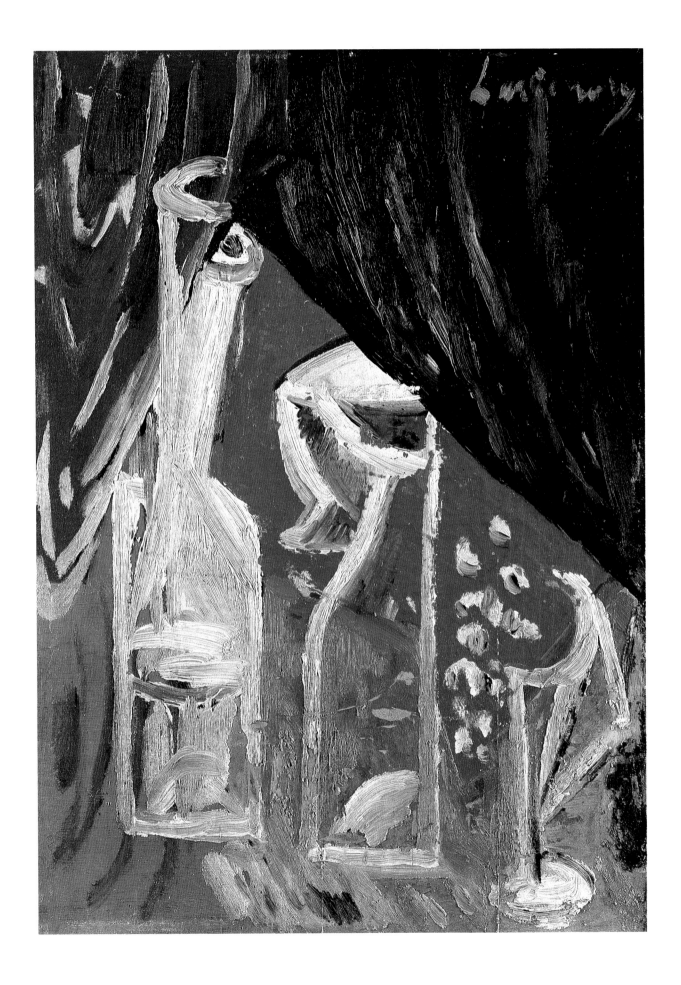

Still-life with carafe and curtains is a case in point. Its first public appearance seems to have been in 1969 at the Larionov exhibition at the Acquavella Galleries in New York. In the catalogue there it is dated 1914, although there is no reference to a documentary source that would support this assumption. Although the work is signed (in Latin letters), it is not dated either on the front or on the back, it is not reproduced in earlier publications and does not seem to have been shown at previous exhibitions, at least under the present title. Unfortunately, the work has few analogies, although the incorporation of glassware, curtains and flowers (especially what seems to be mistletoe or lilies of the valley) recurs in many of Larionov's compositions, early and late (cf. *Still-life with beer*, 1904, St Petersburg, Russian State Museum; *Still-life with lobster*, 1907 (?), Cologne, Ludwig Collection; *Glass*, 1912, New York, Solomon R. Guggenheim Museum; and *Still-life with glass*, 1909 (?); fig.1),[2] but none of them repeats the same turbulent surface in vigorous red and ochre or the 'Cubist' refractions of the glassware here. Indeed, these vital qualities are more identifiable with the younger, Neo-Primitivist Larionov and not with the calmer and more mature Larionov in emigration (see [33]). The sheer energy of brushstroke, the heavy impasto and the experimental technique of *Still-life with carafe and curtains*, then, would reinforce the argument for an early date (1912–14). On the other hand, the fact that the work surfaced only in 1969, that its closest parallels such as *Still-life with glass* and *Still-life* (fig.2) are from the Paris period, and that the signature is not in Cyrillic suggest a later period. Consultation with Russian colleagues has not clarified the question of dating; some, such as Dmitrii Sarabianov, preferring an earlier date, others, such as Elena Basner, arguing for the late 1920s or early 1930s.

Note
2 *Still-life with beer*, (1904, 40 × 48 cm), St Petersburg, State Russian Museum) is reproduced in colour in Pospelov (1990), no.39; *Still-life with lobster* (1907?, 80 × 95 cm, Cologne, Museum Ludwig) is reproduced in colour in E. Weiss, *Russische Avantgarde 1910–1930 Sammlung Ludwig*, Cologne and Munich (Prestel) 1986, p.71; *Glass* (1912, 110 × 105 cm, New York, Solomon R. Guggenheim) is reproduced in George, *Larionov*, p.123

FIG 1 Mikhail Larionov, *Still-life with glass*, 1909 (?), 36 × 52 cm, gouache on paper (present whereabouts unknown)

FIG 2 Mikhail Larionov, *Still-life*, 1907 (?), 33 × 26 cm, tempera on paper (private collection; courtesy of Arte Centro, Milan)

Vladimir Vasilievich Lebedev 1891–1967

35 Portrait of an old lady

1950s
Double sided
Oil on canvas, 85.5 × 68.5 cm
The medium to heavy canvas is becoming brittle and has not been relined (painted on both sides). The stretcher is
 presumed original. The canvas has been patched in three areas. Extensive losses in the paint layer seem to be
 the result of mishandling
Accession no.1983.35a

Cubist portrait *verso*
(Formerly attributed to Vladimir Lebedev)

1920 (?)
Oil and sand on canvas, 85.5 × 68.5 cm
Signed in Russian with initials lower right: 'VL'
The canvas is exposed in some places and the very matte and dry surface shows some inpainting, but the general
 condition is pristine: no varnish and no surface grime
Accession no.1983.35b

Exhibitions
Cologne 1986, no.128, colour illus. p.127
Luxembourg/Munich/Vienna 1988–9, no.45, colour illus. p.113

Provenance
Estate of the artist
Galerie Gmurzynska, Cologne
Thyssen-Bornemisza Collection, 1983

After his experimental paintings and reliefs of the 1920s, Lebedev returned to a figurative style at first reminiscent of a slightly ironical Impressionism as in his various female portraits of the 1930s (e.g. the series of *Girls with bouquets* of 1933) and then supportive of a more academic Realism, as in *Portrait of an old lady*. In these tamer portraits, Lebedev tended to repeat subjects, objects and poses – his wife (Ada Lazo) and relatives, the wicker chair and the frontal position of the model, with emphasis on the eyes and hands. Portraits such as that of Ada Lazo of 1954 (fig.1) represent the artist's competent interpretation of the new Realism that, for better or for worse, replaced his energetic enquiries into Cubism and abstract art just after the Revolution.

Lebedev's technique of the later period was not always of the highest level, especially when compared to his remarkable graphic artistry of the 1910s and 1920s. At that time, as a graduate of the Academy of Arts in St Petersburg, Lebedev possessed a fine talent for drawing and illustration, sharing the same facility and acuity of Yurii Annenkov (see [1]) and Boris Grigoriev (see [21]). However, in the late works such as *Portrait of an old lady*, Lebedev seems to have been drawn more to the model's state of mind, concentrating on the face and often giving less attention to other details, and it seems that the more he investigated psychological Realism, the less he concerned himself with academic precision. This is especially noticeable here in his treatment of the hands, which in his younger years he drew and painted with a much stronger sense of anatomical resolution.

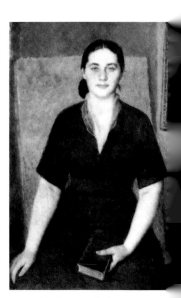

FIG 1 Vladimir Lebedev, *Portrait of A.S. Lazo*, 1954, 51 × 33 cm, oil on canvas (St Petersburg, Collection of Ada Lebedeva)

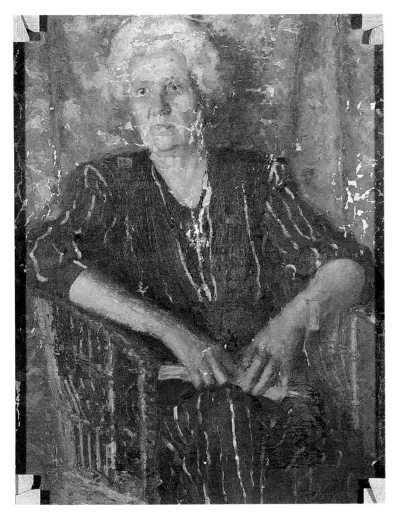

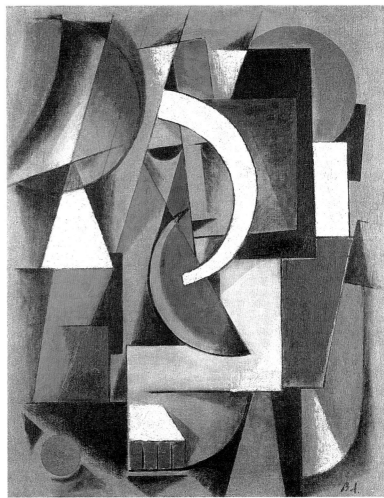

Notes
1 In 1921 Lenin introduced a
New Economic Policy (NEP) that
allowed a partial return to the
free enterprise system and that,
in turn, created a new
bourgeoisie; Stalin ended NEP in
1929
2 V. Petrov, *Vladimir Vasilievich
Lebedev*, Leningrad (Khudozhnik
RSFSR) 1972, p.261

Portrait of an old lady is, of course, neither an avant-garde work, nor a Socialist-Realist exemplar. However, it is the direct extension of a pictorial aesthetic preached and practised during the Stalin era. In its sobriety of expression and celebration of decency, it maintains a direct lineage with the 'official portrait' of the 1930s and 1950s – and is, therefore, quite different from the earlier Lebedev famous for his social caricatures of the NEP era – such as his saucy ballerinas and hustling sailors.[1]

Cubist portrait, painted on the reverse of the *Portrait of an old lady* [35], presents the researcher with a number of enigmatic issues, not least the curious fact that the portrait of the 1950s is cracked, flaking and retouched, while the Cubist work on the reverse, traditionally dated 1920, is in a clean and wholesome condition. After all, Lebedev began to investigate the Realist style of *Portrait of an old lady* only many years after his Cubist phase of the late 1910s and early 1920s. In general, the artistic heritage of Lebedev, especially from the 1910s and 1920s is very limited, since, as his friends, the artist Petr Neradovsky and the critic Vsevolod Petrov recalled, Lebedev had no qualms about destroying those drawings and paintings that he felt to be 'unsuccessful' and, after a session, his studio floor would often be covered with the remnants of rejected works.[2] In any case, the inventory of Lebedev's paintings, reliefs and drawings that Petrov compiled on the basis of Lebedev's holdings in the major Russian museums and the artist's estate with his widow, Ada Lazo, contains no reference to a *Cubist portrait* of 1920.[3] When

shown a photograph of the work in 1990, Lazo refused to attribute it to Lebedev and denied any knowledge of it, even though the provenance was supposed to be the 'artist's widow'.[4]

The actual composition of *Cubist portrait* also raises a number of questions. First of all, in his semi-abstract works such as *Woman ironing* (1920; fig.2), Lebedev followed a consistent and logical system of geometrical reduction, so that the white half-moon in the latter still represents the arm of the woman ironing. In *Cubist portrait*, however, there is no reasonable justification for the half-moon cutting across the partial face. Furthermore, in his experimental works, Lebedev favoured a strict compositional play of vertical and horizontal elements manifest, for example, in his two paintings of 1922 called *Cubism* (figs.3, 4) which, in any case, are total reductions to a geometric configuration of his leitmotiv of the woman ironing. *Cubist portrait* relies on a series of diagonal planes and triangular and spherical elements that are not

FIG 2 Vladimir Lebedev, *Woman ironing*, 1920, 187 × 82 cm, oil on canvas (St Petersburg, State Russian Museum)

FIG 3 Vladimir Lebedev, *Cubism*, 1922, 108 × 62 cm, oil on canvas (St Petersburg, State Russian Museum)

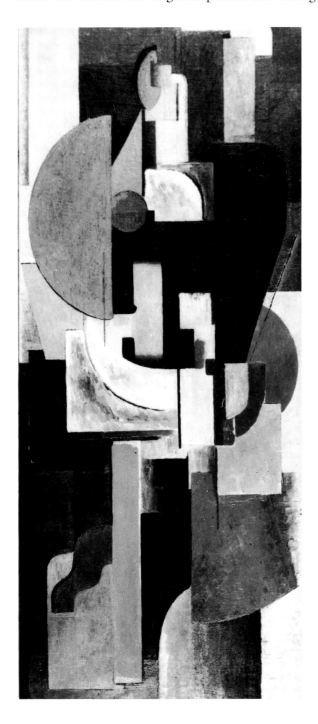

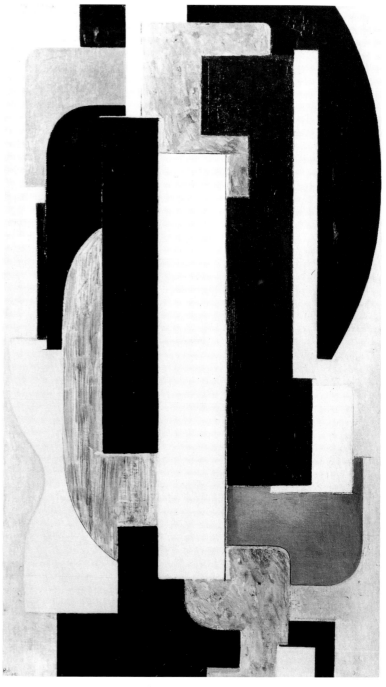

Notes
3 Ibid., pp.262–3
4 Statement to Nicoletta Misler and John E. Bowlt by Ada Lebedeva in Leningrad, 26 June 1990
5 N. Punin, 'Znachenie kubizma v tvorchestve V. Lebedeva' in *V. Lebedev*, exh. cat. Leningrad State Russian Museum, 1928, pp.25–47. See also the list of works compiled by Anikieva, ibid., pp.51–68
6 *Cubist portrait* was subjected to laboratory tests in January 1993; the report is in the archives of the Thyssen-Bornemisza Collection

FIG 4 Vladimir Lebedev, *Cubism*, 1922, 109 × 71 cm, oil on canvas (St Petersburg, State Russian Museum)

encountered elsewhere in Lebedev's paintings. Lastly, according to the critics Nikolai Punin and Vera Anikieva, Lebedev began to work on Cubist oils only in 1921 and continued with them until 1924, numbering them one to five.[5]

The above arguments are not absolute and the question still awaits further investigation. Vasilii Rakitin, a leading authority on the Russian avant-garde, for example, is willing to acknowledge the attribution to Lebedev, although curators at the St Petersburg Museum and the Tretiakov Gallery are hesitant to accept this. Laboratory tests do not reveal suspicious ingredients, although technicians have noticed that the paint surface, which seems not to have been cleaned by a restorer, is too fresh for a canvas that is supposed to be more than seventy years old.[6]

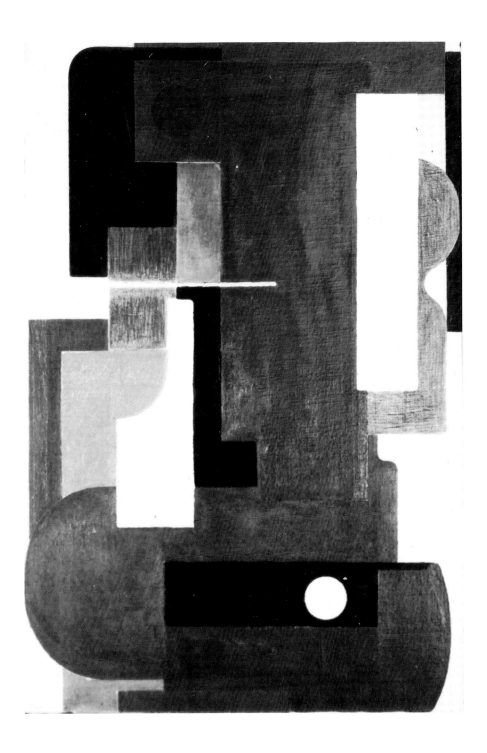

El Lissitzky 1890–1941

36 Proun 1C

1919
Oil and tinfoil on plywood, 68 × 68 cm
Titled, signed and dated on the reverse in Russian: 'Proun 1C El Lissitzky 1919'
The *verso* carries a number of significant inscriptions in Russian: top right: 'EL LISSITZKY' underlined above
 'PROUN 1C'; upper centre: a painted red square within a circle above the word 'UNOVIS'; bottom centre: a Greek
 customs stamp (?); in addition, the support top right carries the stamp in Russian: 'FROM THE G.D. COSTAKIS
 COLLECTION TRANSFERRED TO THE MUSEUM AS A GIFT'; the support lower left carries the letters (in Russian)
 and numbers: 'g 16969 gg'
The stretcher is nailed to the strainer and the resultant paint loss around the nails has been treated recently. The
 unvarnished surface carries overall cracking, mostly vertical, and numerous, discoloured repairs. The general
 condition is weak
Accession no.1988.20

Provenance
Sophie Lissitzky-Küppers, Novosibirsk
George Costakis, Moscow
Galerie Gmurzynska, Cologne
Thysssen-Bornemisza Collection, 1988

Exhibitions
Eindhoven, Stedelijk van Abbemuseum/Basel, Kunsthalle/Hanover, Kestner-Gesellschaft, 3 December–17 April
 1965–6, *El Lissitzky*, no.A13
Los Angeles/Washington, DC, 1980–81, no.123, illus. p.184
New York, The Solomon R. Guggenheim Museum, Sept. 1981–Jan. 1982, *Art of the Avant-garde in Russia:
 Selections from the George Costakis Collection*, no.137, illus. p.176
Hanover, Kestner-Gesellschaft, 23 March–13 May 1984, *Russische Avantgarde aus der Sammlung Costakis*, no.137,
 illus. p.199

Literature
S. Lissitzky-Küppers, *El Lissitzky*, p.28 [photograph of Lissitzky standing in front of the painting in his studio in
 Vitebsk in 1919]
Rudenstine, *Russian Avant-garde*, no.454, colour illus. p.245

Although indebted to the theory and practice of Kazimir Malevich, Lissitzky rejected the sometimes mystical, irrational connotations that Suprematism had for his mentor. But he, too, advocated its universal application and regarded architecture and design in general as obvious vehicles for the transference of basic Suprematist schemes into life itself. In this respect, Lissitzky's so-called Prouns [*proekty utverzhdeniia novogo* – projects for the affirmation of the new] which he designed between 1919 and 1924 were of vital significance, since they served as intermediate points between two and three dimensions or, as Lissitzky himself said, 'as a station on the way to constructing a new form'.[1]

'Ich kann nicht *absolut* definieren, was Proun ist', wrote Lissitzky in 1923.[2] Even so, Lissitzky wrote and spoke a great deal about his Prouns and gave at least one public lecture on the subject at Inkhuk, according to which:

Notes
[1] I. Erenburg, *A vse-taki ona vertitsia*, Berlin (Gelikon) 1922, p.85
[2] El Lissitzky on his exhibition at the Graphische Kabinett J.B. Neumann, Berlin, 1923; quoted in J. Tschichold, *Werke und Aufsätze von El Lissitzky (1890–1941)*, Berlin (Gerhardt) 1971, p.18

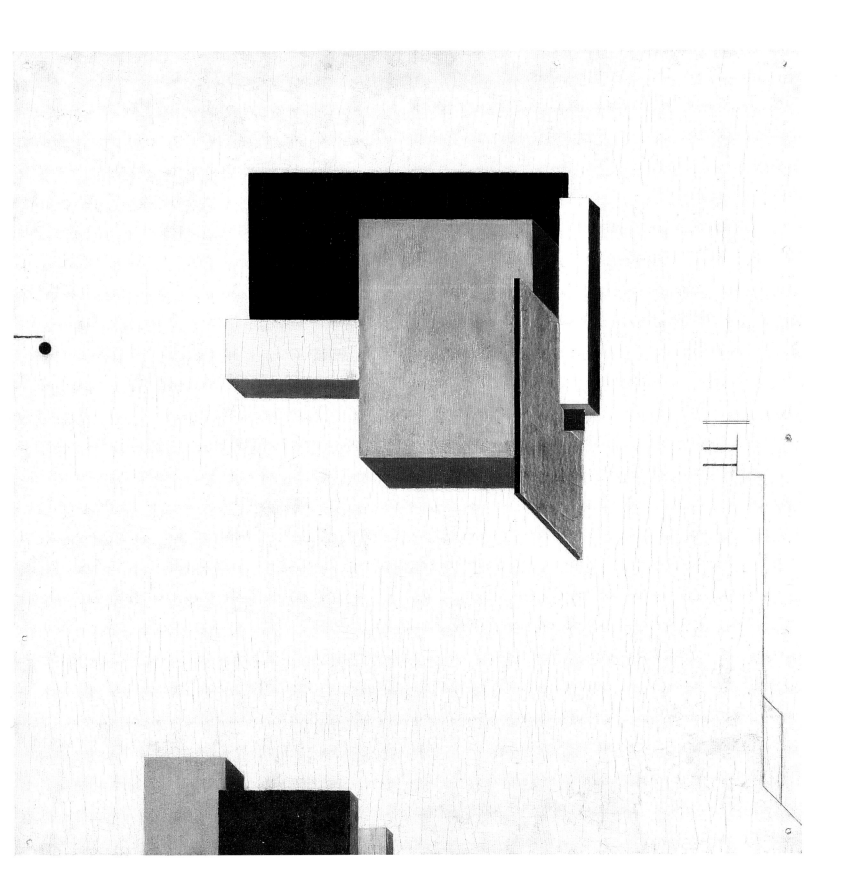

Notes
3 El Lissitzky, 'Proun'; quoted in *El Lissitzky*, 1976, pp.60, 67, 68, 70. The typescript of this particular text is dated 24 Oct. 1924 although 1921 would seem to be a more appropriate year
4 Ibid., p.61
5 P. Nisbet, 'Annotated Transcript of El Lissitzky's Proun Inventory' in *El Lissitzky 1890–1941*, 1987, pp.155–6
6 See Lissitzky's article, 'Kniga s tochki zreniia zritelnogo vospriiatiia – vizualnaia kniga' in *Iskusstvo knigi*, Moscow, 1962, Book 3, pp.164–8
7 Erenburg, op.cit., p.45
8 According to Vasilii Rakitin; undated statement in the archives of the Thyssen-Bornemisza Collection
9 The photograph has been reproduced in many publications

PROUN is the name we have given to the station on the road towards constructing a new form. It grows on earth fertilized by the corpses of the painting and its artist...

When we saw that the content of our canvas was no longer a pictorial one, that it had now begun to rotate...we decided to give it an appropriate name. We called it PROUN...

The forms with which the Proun makes its assault on space are constructed not from aesthetics, but from material. In the initial stations of the Prouns this material is colour. It is taken as the purest aspect of the energic state of matter in its material embodiment...

The Proun advances towards the creation of a new space, and, by dividing it into the elements of its first, second and third dimensions passing through time, it (the Proun) constructs a polyhedral, but uniform image of nature.[3]

The real significance of the Proun lies in the removal of a central axis and consequently, in its dependence on the canons of disharmony and asymmetry, and that is why the word 'art' does not form part of the Proun definition (sometimes the term is translated erroneously as 'Project for the affirmation of the new in art'), inasmuch as art as mere aesthetic ornament was quite alien to Lissitzky's lexicon. Now, instead of one 'entrance' and 'exit', the Proun has many; instead of one focus, the Proun is open from all standpoints; and instead of a constant terrestrial connection, the Proun free-floats in space.

In his endeavours to explain the meaning and function of the Proun, Lissitzky often referred to arithmetical analogies and, indeed, to the evolution of higher mathematics and the fourth dimension, although he also argued that 'art creates BEYOND NUMBERS'.[4] In this sense, Lissitzky's mathematical concepts may be closer to the inspired numbers games of Velimir Khebnikov rather than to his sober training as an architect and draughtsman, and it is important to take account of the numerological rather than numerical inspiration behind much of Lissitzky's oeuvre. As Peter Nisbet has pointed out in the introduction to Lissitzky's Proun inventory, the numbers and letters (sometimes superscript, sometimes normal) that often accompany Lissitzky's Prouns (e.g. 1^C, $\Pi5^A$, 4^B) are not necessarily mathematical or algebraical referents.[5] Their function can be much simpler, since they often refer to the position in the sequence of the *Proun* list that Lissitzky himself compiled in 1924, to the name of an owner, or to some private association. In other words, Lissitzky's cryptic numerical system was essentially a mnemonic one and only occasionally do the codes carry a scientific meaning, such as the formula for the circumference of the circular element in *Proun 2ΠR*.

The principles of the Proun – the rejection of the single axis, the convenience of entering the work at any junction, the idea of the 'flotation device' – are operative in most aspects of Lissitzky's work during the 1920s, but especially in his graphic designs. The formative influence of his residence in Vitebsk when he extended the Suprematist system into his formulation of the Proun can be seen, for example, in his book *Suprematicheskii skaz pro dva kvadrata* [A Suprematist Tale about Two Squares] (conceived in Vitebsk in 1920; published in Berlin in 1922). This extraordinary 'biblio-construction', which is, in many ways, similar to the Moscow and Kestner portfolios of Prouns (also conceived in Vitebsk), has to be experienced as a 'film' rather than as a 'book'. The organization of this publication demonstrates how closely Lissitzky paid attention to the visual appearance of the object, convinced that design, especially pure, geometric design, could serve as an international language and replace some of the traditional functions of verbal language. In his endeavour to 'fuse art and life'[6] Lissitzky never lost his sense of humour, and one of the appealing ingredients in his Constructivist compound is the gentle irony and whimsical jocularity evident in his collocation of forms and colours. In a wider context, Lissitzky's Prouns, the spatial graphcs of Petr Miturich, the linear paintings of Alexander Vesnin (see [59]) and the mono- and duochromatic paintings of Alexander Rodchenko, all done *c*1919–20, symbolized the general endeavour to give painting a constructive dimension and to project art into life. More obviously, the Suprematist constructions – the so called *arkhitektony* and *planity* – that Malevich and his disciples modelled in the early 1920s (see [9], [40]) also supported this trend, thereby supporting Ilia Ehrenburg's assertion that the 'aim of the new art is to fuse with life'.[7] Such sentiments, and Lissitzky's

[36] *verso*

Prouns, anticipated the emergence of Constructivism in 1921, the emphasis on industrial design and the general concern with *veshch* [the object as such] which Ehrenburg and Lissitzky took as the title of the international review that they published in Berlin in 1922 (*Veshch/ Gegenstand/Objet*).

According to one source, *Proun 1^c* was shown at the Unovis exhibition in Vitebsk in 1920,[8] and the work in question seems to be the version hanging on the wall of Lissitzky's Vitebsk studio in 1919.[9] (fig.1) Another version of the painting (fig.2), now lost, entitled *Proun: hovering body*, is listed as no.12 in Lissitzky's Proun Inventory and was formerly in the collection of the

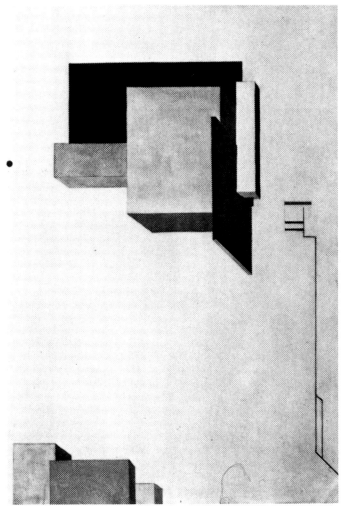

Hanover Provinzialmuseum, after being included in Lissitzky's famous Abstract Cabinet in Hanover of 1927–37[10] (figs.3, 4) and Sándor Bortnyik reproduced part of this Proun in his own painting called *The new Adam* of 1924 (see [3], fig.3).[11] Although the similarities between *Proun 1*C and *Proun: hovering body* are very strong and the compositions are basically identical, the former is square while the latter is rectangular. In addition, the graphic notation on the right is less compressed in *Proun 1*C, a freedom that enhances the formal harmony of the bodies floating against the white background, eliciting the same sensation of weightlessness that Malevich's *arkhitektony* (1923 onwards) do (see [9]). *Proun 1*C also exists in a reverse lithographic version of 1919–20 (fig.5) which was included in the 1921 portfolio of eleven Prouns (*Proun-Mappe*) called *Prouny*, copies of which are in the collections of the Stedelijk Museum, Amsterdam, and the Tretiakov Gallery.[12] An impression from this image or from the work under discussion was used in the cover design for the catalogue of Lissitzky's one-man show at the Kestner-Gesellschaft in Hanover in 1923, *El Lissitzky. Prounen, Aquarelle – Graphik. Theaterfiguren* (fig.6).

Of particular interest in *Proun 1*C is the fact that Lissitzky painted it while he was living in Vitebsk and working closely with Malevich. The red square within a circle above the inscription 'UNOVIS' on the reverse of the picture was the seal that Lissitzky designed for the group and that he himself applied to the end page of his *Suprematicheskii skaz pro dva kvadrata* [A Suprematist Tale about Two Squares] (Berlin, 1922) – as opposed to the black square that Malevich and other Vitebsk Suprematists preferred to use. As Alexandra Shatskikh has written recently:

> Only Lissitzky employed the red square as an emblem of Unovis. . .and that was in tribute to the prevailing atmosphere in society: 'Draw the red square in your workshops as a sign of the world revolution in the arts'.[13]

FIG 1 El Lissitzky in his Vitebsk studio in 1919. Behind him hangs [36], or a version of it (courtesy of VEB Verlag der Kunst, Dresden)

FIG 2 El Lissitzky, *Proun: hovering body*, 100 × 67 cm (whereabouts unknown; reproduced from *El Lissitzky: 1890–1941*, exh. cat. Cambridge MA, Busch-Reisinger Museum, 1987, p.159)

Notes
10 Nisbet, op.cit., p.159
11 Bortnyik also used his painting *The new Adam* in his design for the cover of the magazine *Uj Föld* [New Land], no.2, Budapest, 1927. For a reproduction of this see J. Szabó, *A magyar activizmus müvészete*, Budapest (Corvina) 1981, no.236

FIG 3 El Lissitzky's Abstract Cabinet, Hanover, 1927 (destroyed in 1937; reproduced in *El Lissitzky – 1890–1941 – Retrospektive*, exh. cat. Hanover, Sprengel Museum, 1988, p.226)

FIG 4 Photograph (*c*1928) of El Lissitzky's Abstract Cabinet, Hanover, 1927 (destroyed in 1937; reproduced in *El Lissitzky – 1890–1941 – Retrospektive*, exh. cat. Hanover, Sprengel Museum, 1988, p.226)

4

FIG 5 El Lissitzky, *Proun 1C*, 1919–20, 23.2 × 23.3 cm, lithograph. Issued in the Proun portfolio called *Prouny*, Moscow, 1921 (Moscow, State Tretiakov Gallery)

FIG 6 Cover of exhibition catalogue for *El Lissitzky. Prounen, Aquarelle – Graphik. Theaterfiguren* at the Kestner-Gesellschaft, Hanover, 1923 (private collection)

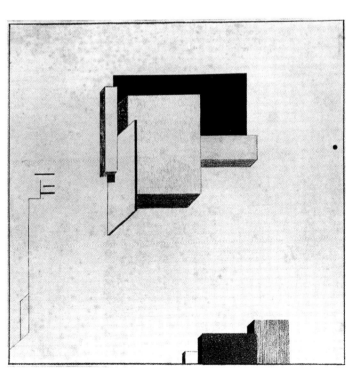

EL LISSITZKY

PROUNEN

AQUARELLE — GRAPHIK

THEATERFIGURINEN

12 See *El Lissitzky – 1890–1941*, 1988, p.101. The lithograph is reproduced in E. Kàllai, 'El Lissitzky', *Der Cicerone*, XVI, 1924, p.1059
13 A. Shatskikh, 'Unovis: Epicenter of a New World' in Frankfurt/Amsterdam/New York 1992–3, p.63

El Lissitzky

37 Proun 5A

1919
Gouache and pencil on draught paper, 13.9 × 13.5 cm (image)
Inscribed lower left 'П 5A'
The *verso* of the work carries a statement in pencil written by Yen Lissitzky (Lissitzky's son): 'Original aus der El
 Lissitzky-Archiv – Novosibirsk. 14.11.75. Yen Lissitzky'
The paper is slightly discoloured, otherwise the general condition is good
Accession no.1977.103

Provenance
Sophie Lissitzky-Küppers, Novosibirsk
Galerie Gmurzynska, Cologne

Exhibitions
Cologne, Galerie Gmurzynska, 9 April–June 1976, *El Lissitzky*, colour illus. no.23, p.109
Cologne 1977, no.54, colour illus. p.88
Edinburgh/Sheffield 1978, no.21, p.26
Cologne 1986, colour illus. p.131 and on cover
Eindhoven, Municipal Van Abbemuseum/Madrid, Fundaçion Caja des Pensiones/Paris, Musée d'Art Moderne de
 la Ville de Paris, 15 Dec. 1990–26 Sept. 1991, *El Lissitzky. Architect. Painter. Photographer. Typographer* [shown
 at the Madrid venue only and not listed or reproduced in the catalogue]

Literature
S. Lissitzky-Küppers, *El Lissitzky*, Dresden (VEB) 1967, colour illus. pl.26
Ludmilla Vachtova, 'Zauberformel Proun', *Neue Züricher Zeitung*, 16 May 1976, p.63
El Lissitzky, 1987, p.164
El Lissitzky 1890–1941, 1988, p.47

However radical Lissitzky's elaboration of the Proun, it enhanced and developed his earlier artistic experiments. For example, there is a strong resemblance between the abrupt conjunctions of the Futurist strongman and the sun that Lissitzky integrated in his cover for Konstantin Bolshakov's book of poetry *Solntse na izlete* [Spent Sun] of 1916 and the forcelines and articulations of *Proun 5A*. Moreover, examination of the formal methods that Lissitzky applies in *Proun 5A* indicates that Lissitzky was drawing upon similar devices – albeit in other contexts – that the older avant-garde artists had been using in the 1910s. For example, a central motif of *Proun 5A* is the denial of the terrestrial pull, for the large cube is floating, taking off and landing all at the same time – a simultaneous affirmation and cancellation of direction that most of the Prouns elicit. Certainly, Lissitzky attains this effect with elegance and economy, but it is a visual game that had been anticipated by Ivan Kliun, Malevich and Olga Rozanova *c*1913 with their exercises in *zaum* (transrationality). We think of Kliun's relief painting *Landscape rushing by* (1914–15, Moscow, State Tretiakov Gallery) where the wooden cone at the centre of the work has been displaced in order to remove the logical axis; or of Malevich's *Woman at an advertisement column* (1914, Amsterdam, Stedelijk Museum) with its truncated phrases and syncopation of the embroidery collage at the top. Of course, Lissitzky went even further, liberating his own painting from the last vestiges of the narrative tradition, and the Prouns mark the culmination to this new system of visual manipulation. But in terms of two-dimensional abstraction, there was little else that Lissitzky could do and, no doubt, this realization served as a strong impetus for him to move into the world of utilitarian design.

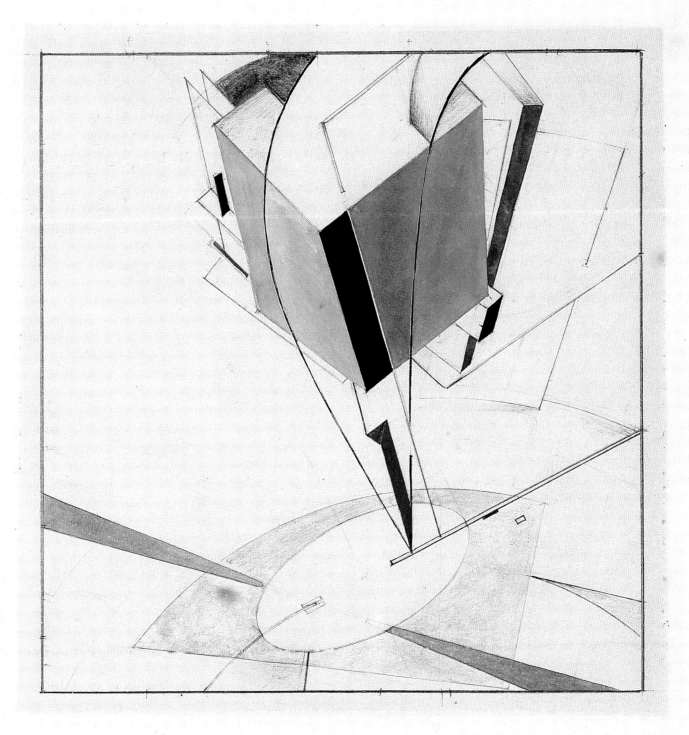

Π5ᴬ

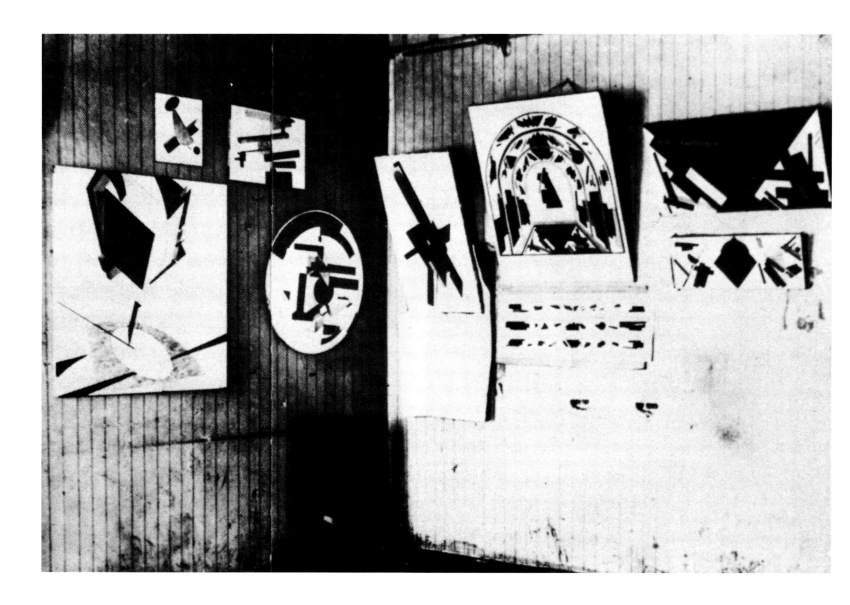

The prototype of this *Proun 5A* and its several versions seems to have been the oil (?) painting on the same subject exhibited at the *Unovis* exhibition in Moscow in 1921 (fig.1). There is also a very close composition also dated 1919 and called *Proun 5A* that was sold at Sotheby's in 1974 (fig.2), except that the image here is reversed. In addition, the Tretiakov Gallery, Moscow, possesses a study for *Proun 5A* (fig.3). The same Proun was also issued in a lithograph edition as part of the portfolio of eleven Prouns (*Prouny*, Moscow, 1921; fig.4).[1] As is often the case with Lissitzky's Prouns, formal elements and interrelationships from *Proun 5A* recur in other works such as the 'falling' cube and encompassing curve in the Proun dated 1923–5 in the Museum of Art, Rhode Island School of Design, or in the similar composition at Yale University Art Gallery.[2] Lissitzky also used the concept of a celestial body threatening or falling on to earth in his last illustration to *About two squares*.

Notes
1 The work is listed under Proun Inventory no.40, where Lissitzky himself describes it precisely as a drawing for the lithographed image in the 'Moscow Portfolio' (the 'First Proun Moscow Portfolio' issued in Moscow in 1921). Another lithographic copy of the *Proun 5A* from the same portfolio, dated 1919–20, is in the Tretiakov Gallery, Moscow, 27.5 × 26.9 cm (image) 45.5 × 37.2 cm (sheet). The lithograph from the portfolio is reproduced in Shadova/Zhadova (1978/1982) as pl.121
2 For a colour illus. of the pen, ink and watercolour collage (64.6 × 49.7 cm) see *El Lissitzky 1890–1914*, p.114; for an illus. of the 1925 Proun in the Yale University Art Gallery (129 × 99.1 cm) see ibid., p.115

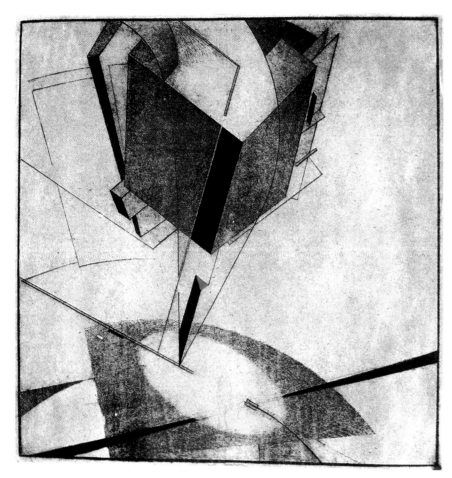

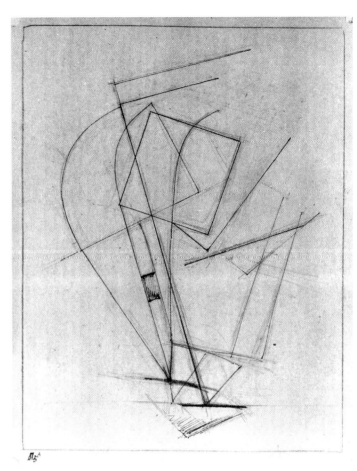

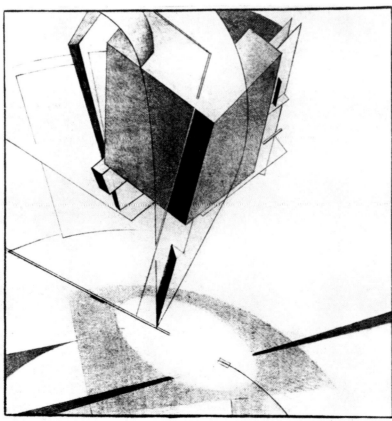

FIG 1 Photograph of the
Unovis exhibition in Moscow
in 1921, showing El
Lissitzky's oil painting(?)
Proun 5ᴬ (photograph
courtesy of Larisa Oginskaia,
Moscow)

FIG 2 El Lissitzky, *Proun 5ᴬ*,
1919, 28.5 × 27.5 cm,
charcoal, indian ink and
gouache on paper (courtesy
of Sotheby's, London)

FIG 3 El Lissitzky, study for
Proun 5ᴬ, 1919 (?),
21 × 16.5 cm, pencil with
black ink on paper (Moscow,
State Tretiakov Gallery)

FIG 4 El Lissitzky, *Proun 5ᴬ*,
1919 (?), 27.5 × 26.1 cm
(image), 46.2 × 34.4 cm
(sheet), lithograph on paper
mounted on paper (Art Co.
Ltd, George Costakis
Collection)

El Lissitzky

38 Proun 4B

1919–20 (?)
Oil(?) on canvas, 70 × 55.5 cm
Titled on the reverse: 'π 4B'
The light-weight canvas has not been relined and the apparently orginal stretcher has caused creases along the edges. The unvarnished, matte paint surface is dirty and carries fine cracking and rubbing, but the general condition is good
Accession no.1977.65

Provenance
El Lissitzky
Radak Collection(?)
Galerie Jean Chauvelin, Paris

Exhibitions
Paris 1977, no.23, colour illus. p.128
Lugano 1978, no.63, colour illus.
Milan 1979–80, no.473, illus. no.473
Los Angeles/Washington DC 1980–81, no.136, illus. p.188
USA tour, 1982–4, no.21, colour illus. p.30
Modern Masters from the Thyssen-Bornemisza Collection, 1984–6, no.69, colour illus. p.91

Nuremberg, Kunsthalle and Norishalle, 1986, *Der Traum vom Raum. Gemalte Architektur aus 7 Jahrhunderten*, no.203, p.510, colour illus.
Luxembourg/Munich/Vienna 1988–9, no.48; colour illus. p.118
Zurich 1989, p.44, colour illus. p.45
Eindhoven, Municipal Van Abbemuseum/Madrid, Fundaçion Caja des Pensiones/Paris, Musée d'Art Moderne de la Ville de Paris, 15 Dec. 1990–26 Sept. 1991 *El Lissitzky. Architect. Painter. Photographer. Typographer* [shown at the Madrid venue only and not listed or reproduced in the catalogue]

Apart from this tempera, there seem to be at least two other versions of *Proun 4B* – the watercolour and pencil on paper dated 1920 (fig.1),[1] and the watercolour on paper (fig.2). The Tretiakov Gallery, Moscow, also possesses a sketch carrying the designation *Proun 4B* (Inv. no.Arkh-gr.3555), but it has little in common with the work under discussion.

Note
1 The same work has since been sold at two auctions, although carrying slightly different curatorial details, i.e. 'watercolour, gouache and pencil with image size of 15.5 × 13.5 cm' as lot 75 at Sotheby's, 12 April 1972, and as 'gouache, watercolour, and pencil on thin buff paper with image size of 13.5 × 12.5 cm, and paper size 22 × 17.5 cm' as lot 75 at Sotheby Parke-Bernet, 3 Nov. 1978, with the provenance of Charmian von Wiegand, New York, and the Grosvenor Gallery, London. According to Los Angeles/Washington, DC, 1980–81, p.186, this study now belongs to Mr and Mrs Ahmet Ertegün.

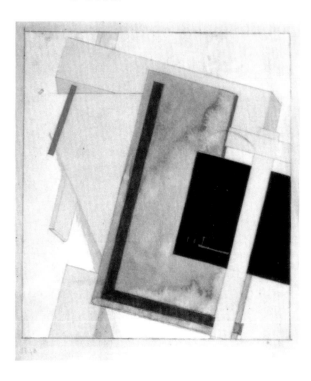

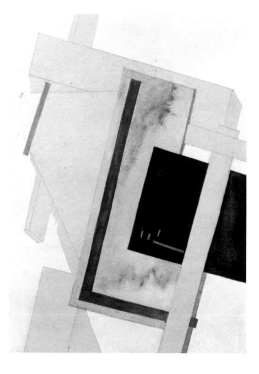

FIG 1 El Lissitzky, *Proun 4B*, 1920, 15.5 × 13.5 cm, watercolour and pencil on paper (courtesy Sotheby's, London)

FIG 2 El Lissitzky, *Proun 4B*, 1920?, 23.2 × 17.4 cm, watercolour on paper (London, Marlborough Gallery)

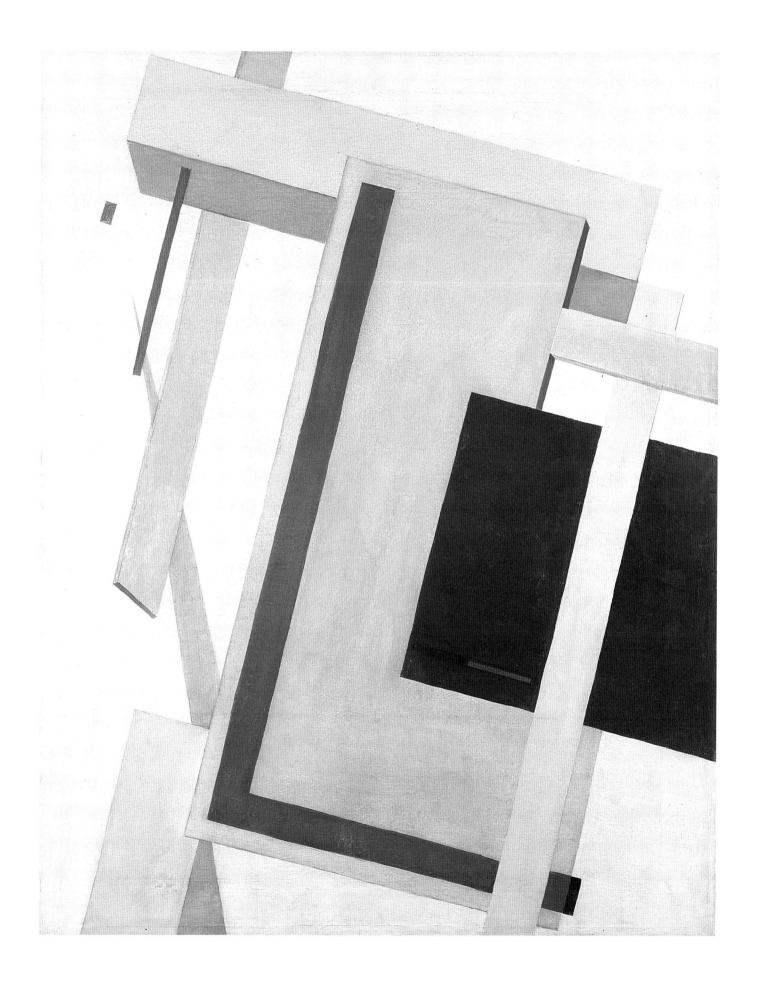

Kazimir Severinovich Malevich 1878–1935

39 Untitled

1919 (?)
Gouache on paper, 31.7 × 23.8 cm
The paper is discoloured. General condition is good
Accession no.1980.53

Provenance
Anna Leporskaia, Leningrad
Jean Chauvelin, Paris
Rachel Adler, New York
Andrew Crispo Gallery, New York
Thyssen-Bornemisza Collection, 1980

Exhibitions
New York, Andrew Crispo Gallery, December 1980, *American and European Abstract Masters of the Twentieth Century*, no.12
Luxembourg/Munich/Vienna 1988–9, no.19, colour illus. p.61
Zurich 1989, p.54, colour illus. p.55

Malevich stated that there were three stages of Suprematism – black, coloured and white.[1] The first two seem to have developed simultaneously, for both the first *Black square* (1915, Moscow, State Tretiakov Gallery) and examples of colour Suprematism were at the exhibition *0.10* in Petrograd in 1915–16, the first pubic showing of Suprematism. In its earlier phase, Suprematism was not necessarily a complex system, relying on the 'ability to construct. . . on the basis of weight, speed and direction of movement',[2] and on the 'primacy of the colour problem',[3] but it quickly assumed a more intricate and abstruse character which Malevich tried to describe in his ponderous writings:

> . . .in Suprematism black and white serve as energy revealing form. This is only the case when projects of volumetrical Suprematism are constructed in the canvas; in real, tangible action it plays no role, for the revelation of form is left to right, but in the forms of Suprematism which is already real there remain only black and white.[4]

Many of Malevich's Suprematist paintings and designs rely on this colour combination and even his later figurative works such as *Girl with a comb* (1932–3, Moscow, State Tretiakov Gallery) still emphasize black, white and red.

An important aspect of Suprematism, however, was not only its application as a form of non-objective painting, but also its rapid emergence as a total world view, as an ideological system. In this sense, Suprematism may be regarded as an outgrowth of the Russian cultural tradition, often overlaid with narrative, philosophical and moral preoccupations. Malevich's momentary concern with 'pure abstraction' in 1915–16, therefore, was alien to this tradition and we should not be surprised by his subsequent concentration on extra-pictorial interests, including his porcelain, book and textile designs and his architectural experiments. Malevich's 1915 prediction that Suprematist forms 'will not be copies of living things, but will themselves be a living thing'[5] indicates that for him Suprematism was a phenomenon of 'superhuman' magnitude. The invariable white ground upon which the Suprematist forms float, as in the work in question, came to symbolize infinite space, while the forms themselves became 'superterrestrial. . .having nothing in common with the technology of the earth's surface'.[6] It was with this cosmic conception that Malevich entered the stage of aerial Suprematism in

Notes
1 Malevich affirmed this, for example, in the introduction to his collection *Suprematizm. 34 risunka*, Vitebsk, 1920; trans. as 'Suprematism. 34 Drawings' in Andersen, ed., *Malevich. Essays*, p.123
2 K. Malevich, *Ot kubizma i futurizma k suprematizmu. Novyi zhivopisnyi realizm* (Moscow, 1916); trans. as 'From Cubism and Futurism to Suprematism. The New Realism in Painting' in Andersen, op.cit., p.24
3 Quoted in Khardzhiev, *K istorii russkogo avangarda*, p.95
4 Malevich, *Suprematizm*, op.cit.; trans. in Andersen, op.cit., pp.125–6
5 Malevich, *Ot kubizma i futurizma k suprematizmu*, op.cit.; trans. in Andersen, op.cit., p.33
6 Malevich, *Suprematizm*, op.cit.; trans. in Andersen, op.cit., pp.124

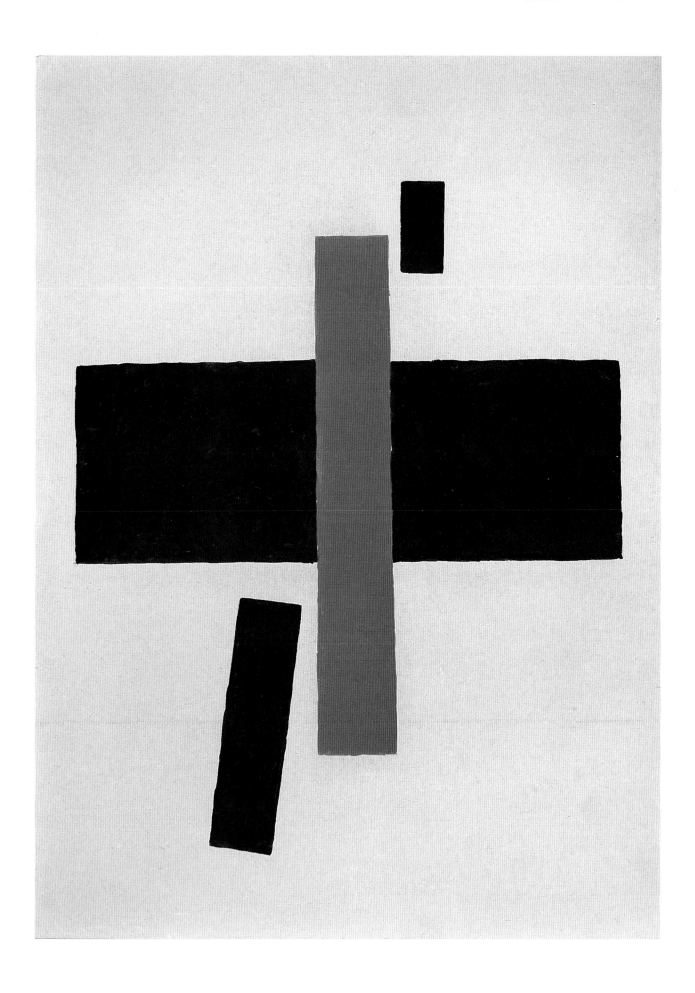

1917, creating a series of drawings and paintings whose shapes recall planetary surfaces and floating satellites; and in 1920 he asserted that Suprematism was 'growing as a new architectural construction in space and time'[7] – a sentiment that related directly to his work on the *arkhitektony* and *planity* (see [9]).

Malevich rarely used gouache on cardboard, although there are many gouaches on paper, some of which come from the estates of Malevich's students such as Anna Leporskaia and El Lissitzky. In the 1970s the Galerie Jean Chauvelin possessed several gouaches attributed to Malevich, including the piece in question and *Suprematism* (1920 (?); fig.1). The Galleria Fonte d'Abisso d'Arte in Milan included another gouache deriving from Chauvelin in its 1991 exhibition called *Avanguardie Russe* (fig.2). The Chauvelin gouaches are interrelated by their common arrangement of severe and sparse elements scattered in loose configurations. The Costakis Collection also contains gouaches by Malevich, although these seem to be more compressed and compact.[8] One or two of Malevich's larger canvases are close in composition, if not in medium – for example, the black on red on white oil *Suprematist painting*, of before 1927 (fig.3). The Thyssen-Bornemisza gouache has much in common with the Stedelijk piece because both have a basic cruciform structure that juxtaposes red and black in two rectangular blocks upon a white background. Moreover, the gouache and the Stedelijk oil both rely on an essential harmony of horizontal and vertical segments, even if the gouache has an implied diagonal escalation. The resulting tension between these linear directions is, of course, a central

Notes
7 Ibid.
8 For relevant illustrations see Rudenstine, *Russian Avant-garde*, p.257, no.488, i.e. *Red square*, undated 6.1 × 5.7 cm, gouache on lined paper, and p.262, no.503, untitled, 22 × 17.6 cm, gouache and pencil on paper

FIG 1 Kazimir Malevich, *Suprematism*, 1920 (?), 29.5 × 22.5 cm, gouache on paper (private collection; courtesy of Jean Chauvelin, Paris)

FIG 2 Kazimir Malevich, *Suprematism*, 1916, 27 × 14.3 cm, gouache on paper (Lugano, private collection; courtesy of Galleria Fonte d'Abisso Arte, Milan)

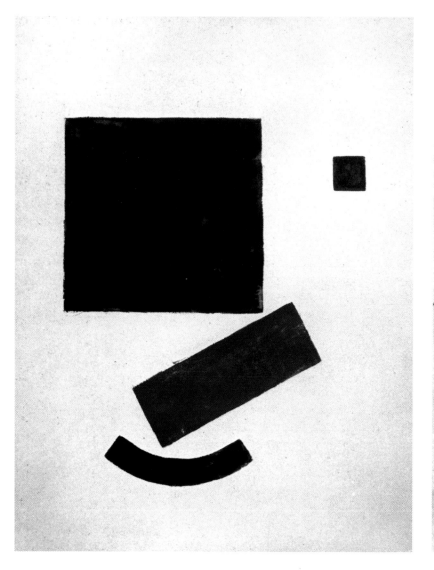

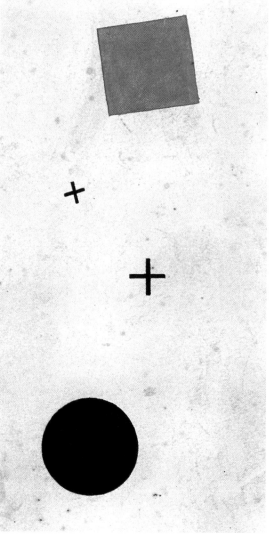

FIG 3 Kazimir Malevich, *Suprematist painting*, before 1927, 84 × 69.5 cm, oil on canvas (Amsterdam, Stedelijk Museum)

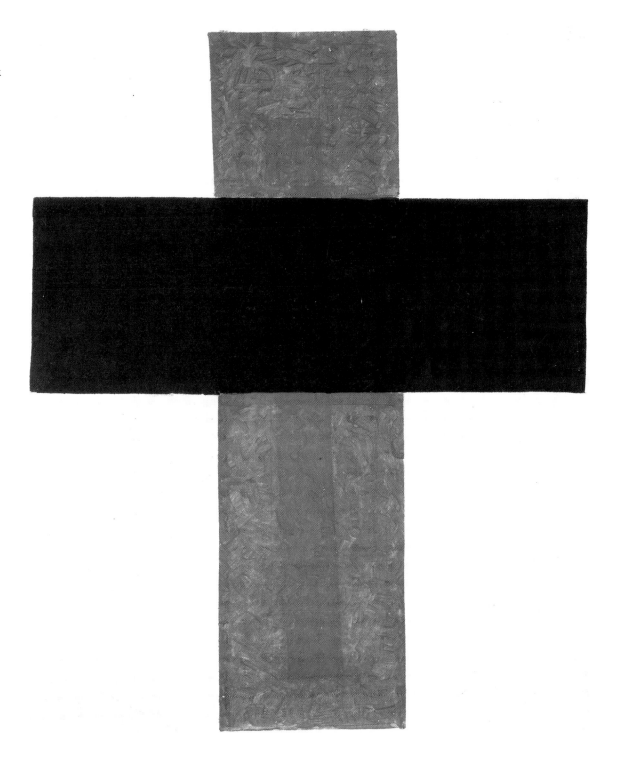

characteristic of Malevich's Suprematism and can be identified in particular with the cruciform paintings of *c*1920, which, admittedly, also served as departure-points for the exercises of many of his students.

As with so many of the Suprematist works now attributed to Malevich, it is extremely difficult to prove or disprove the authenticity of this piece, the more so since the original owner, the Leningrad artist and disciple of Malevich, Anna Alexandrovna Leporskaia (1900–82), died eleven years ago. Even though the Malevich specialist Charlotte Douglas accepts the work as a genuine Malevich, Russian experts such as Alexandra Shatskikh have serious doubts.

Kazimir Severinovich Malevich 1878–1935

40 Untitled

1919
Pencil on graph paper, 21.5 × 15 cm
The very thin paper is yellowed and brittle. The general condition is fair
Accession no.1981.24

Provenance
Anna Leporskaia, Leningrad
Galerie Gmurzynska, Cologne
Thyssen-Bornemisza Collection, 1981

Exhibitions
Cologne 1975, no.79, illus. p.109
Quadrat, Bottrop, Moderne Galerie 1976, *Osteuropäischer Konstruktivismus*
Cologne, Galerie Gmurzynska 1978, *Kazimir Malewitsch. Zum 100 Geburtstag*, illus. p.152
Caracas, Museo de Arte Contemporanea 1980, *The Dada Spirit*, illus. p.86

There are many Suprematist pencil drawings ascribed to Malevich in private and public collections, although not all of them are genuine. In this respect, the establishment of the original provenance is of fundamental importance in distinguishing positive from negative attributions. Some drawings, for example, derived from Gustaf Von Wiesen, with whom Malevich deposited his corpus of material in 1927, and some of these were auctioned in West Germany in the early 1960s. Others belonged to Malevich's pupils El Lissitzky and Nikolai Suetin, and, above all, Anna Leporskaia, who owned several of Malevich's exercise-books and sketching-pads and who parted with many of these shortly before she died in 1982.

These notebooks contain numerous ideas and concepts for diverse projects that Malevich was elaborating in the late 1910s and 1920s, especially for Suprematist paintings and constructions. Often each sheet contains several different proposals and resolutions in pencil, most of them within a square or rectangular format. Many of these studies are on lined graph paper which provided Malevich with a clearer sense of dimension, scale and proportion, and some of the designs are complemented by statistical notations such as the '60 × 100' on the

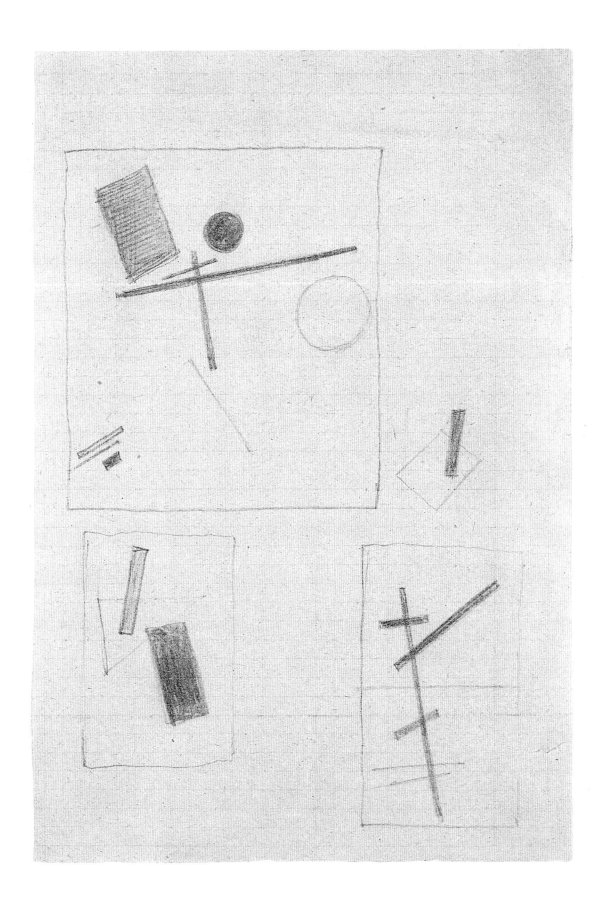

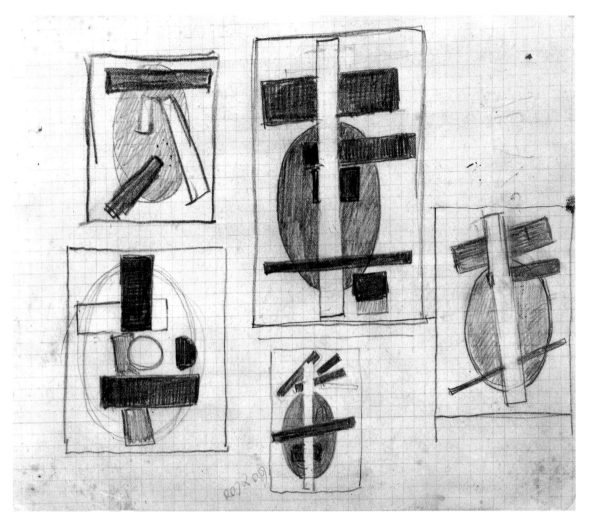

FIG 1 Kazimir Malevich, untitled sheet of Suprematist pencil drawings, 1916–20, 16.5 × 20.5 cm, pencil on paper (Cologne, Museum Ludwig)

untitled sheet of pencil drawings in the Museum Ludwig, Cologne (fig.1) and the colour instructions in *Magnetic suprematism* (1916; fig.2). It is difficult to determine for which specific paintings or illustrations Malevich made these four sketches and perhaps they were actually intended as teaching aids during Malevich's tenure in Vitebsk, for it is known that he used to give groups of numbered, experimental drawings to his students. At the same time, at least one of the studies here, the one divided into two halves in the lower left of the sheet, is close to the lithographic composition with five intersecting beams that appeared as lithograph no.21 in Malevich's *34 Drawings* of 1920 (fig.3) a correspondence that reinforces the provisional dating of 1919. Of course, individual elements from all the sketches on this untitled sheet recur in many of the major Suprematist paintings as well as in many other drawings, such as the sheet carrying two Suprematist compositions in the Julia A. Whitney Foundation (fig.4).

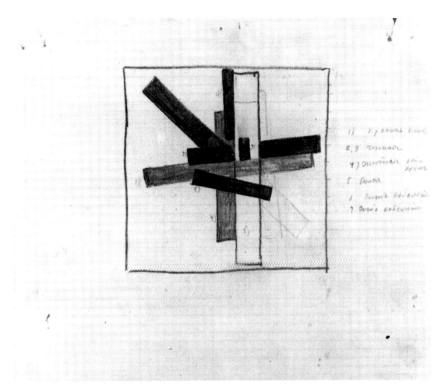

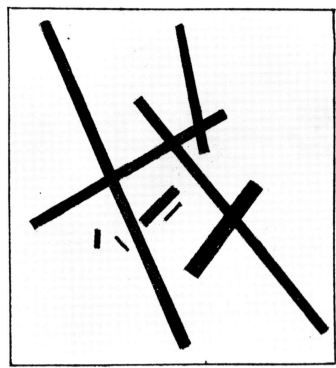

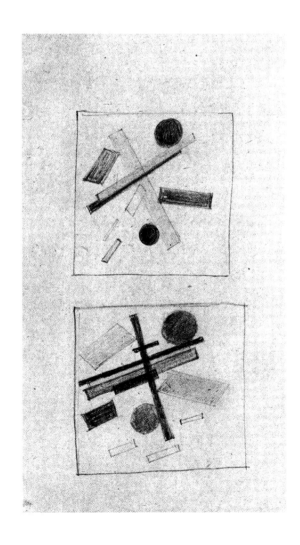

FIG 2 Kazimir Malevich, *Magnetic suprematism*, 1916, 17.2 × 20.7 cm, pencil on paper (Cologne, Museum Ludwig)

FIG 3 Kazimir Malevich, *Composition with five intersecting beams*, 26.8 × 20.2 cm, lithograph no.21 from Malevich's *Suprematizm. 34 risunka* [Suprematism. 34 Drawings], Vitebsk (Unovis) 1920 (Los Angeles, Institute of Modern Russian Culture)

FIG 4 Kazimir Malevich, *Two Suprematist compositions*, c1920, 17.8 × 10.2 cm, charcoal on paper (Washington, CT, The Julia A. Whitney Foundation)

Paul Mansouroff (Pavel Andreevich Mansurov) 1896–1983

41 Painterly formula
Zhivopisnaia formula

1918(?)
Oil on panel, 133 × 26.3 cm
Signed and dated lower right in Russian 'P. Mansurov 1918 Petersburg'
The unvarnished, flat, wooden panel is split at the lower end and the signature (in ballpoint pen) has faded badly
Accession no.1977.114

Provenance
Paul Mansouroff, Paris
Galerie Gmurzynska, Cologne
Thyssen-Bornemisza Collection, 1977

Exhibitions
Paris, Musée National d'Art Moderne, 12 Dec.–29 Jan. 1972–3, *Paul Mansouroff*, no.6 [as *Peinture*]
Cologne 1974, p.108, illus. no.24, p.109
Lugano 1978, no.66, colour illus.
Cologne 1986, p.134, illus. p.135
Luxembourg/Munich/Vienna 1988–9, no.51, colour illus. p.125
Zurich 1989, p.58, colour illus. p.59

Perhaps Mansouroff's strongest claim to fame within the Russian avant-garde lies in his activities at Ginkhuk in the early 1920s. He was an important personality there, elaborated and disseminated the main principles of his artistic system and, in spite of his youth and comparative inexperience, headed its Experimental Department. By the spring of 1923 Mansouroff was already in close professional contact with Pavel Filonov, Kazimir Malevich and Mikhail Matiushin, all of them associated with Ginkhuk: like them he contributed to the *Exhibition of Paintings by Petrograd Artists of All Directions* (see [7]) that year and also published two manifestos in the journal *Zhizn iskusstva* [Life of Art] (see [10]),[1] where, incidentally, Filonov and Mansouroff made sure to quote each other. True, Mansouroff was a researcher at Ginkhuk for less than three years (1923–5), but, like his colleagues, he had access to laboratories, studios and display premises. Within these conditions Mansouroff pursued his primary aim to: 'investigate the various forms of organic structures including man', to categorize the 'so-called kinds of "beauty" (various superfluous, "stylish" appendages, "architectural" forms, etc.)', and to analyse the 'expediency of "decorations" affecting vision, touch, smell, hearing, taste and sex'.[2] After much criticism of the Experimental Department, Mansouroff was relieved of his post in 1925 and the Department was closed in mid-1926, although he still contributed to the Ginkhuk exhibition in June of that year where he was condemned for 'counter-revolutionary sermonizing'.[3] In December Ginkhuk itself was terminated by official decree and its activities transferred to the Institute of Art History (which functioned until 1931). Owing to his short tenure, Mansouroff was unable to propagate his ideas on an extensive scale and his 'insolvent extremism of abstracted attainments'[4] did not attract wide critical appreciation.

As he tried to demonstrate by his Ginkhuk experiments, Mansouroff maintained that a true work of art was like an efficient machine which, in turn, was like a bird, a dog or a tree. He argued, as the Constructivists did, that function determines form and that a machine is free and beautiful in the same way that a bird's plumage or a butterfly's wings or the bark of a tree,

Notes
1 The two manifestos, both published in *Zhizn iskusstva*, Petrograd, 1923, no.20, p.15, and no.22, p.7, are 'Deklaratsiia' [Declaration] and '1) Ot kubizma k bezpredmetnosti. 2) Cherez bezpredmetnost (kak ekonomiia) – k utilitarizmu' [1) From Cubism to Non-objectivity. 2) Via Non-objectivity (as Economy) to Utilitarism]. For Eng. trans. see *Pavel Andreevich Mansurov*, 1987, pp.42–4. The journal *Zhizn iskusstva* played an important role in the lives of several avant-garde artists (see [1, 10])
2 'The Museum of Artistic Culture' (Protocol of a meeting of the Museum Commisson on 3 Nov. 1928); quoted in *Kazimir Malewitsch. Zum 100 Geburtstag*, exh. cat. Cologne, Galerie Gmurzynska, 1978, pp.276–7
3 G. Seryi, 'Monastyr na gossnabzhenii', *Leningradskaia pravda*, Leningrad, 10 June, 1926
4 K. Redko, *Dnevniki, vospominaniia, stati*, Moscow (Sovetskii khudozhnik) 1974, p.69

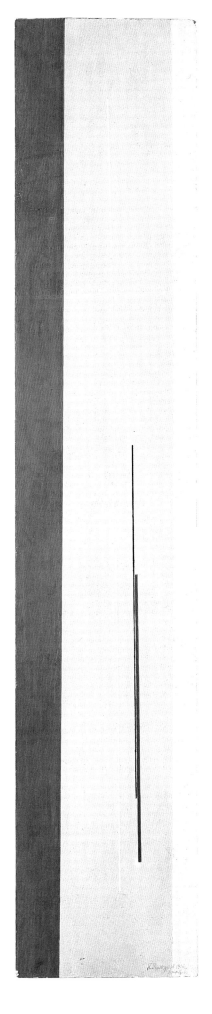

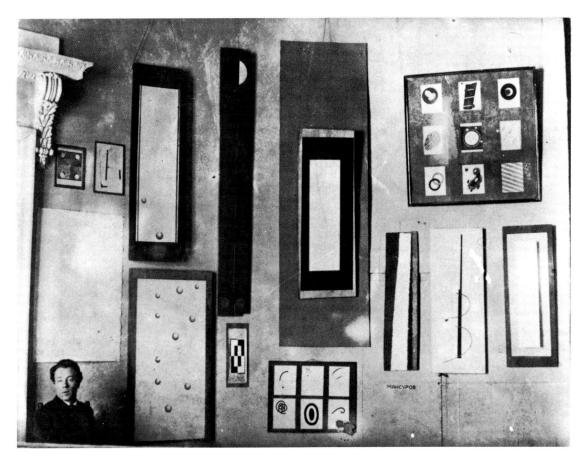

FIG 1 Paul Mansouroff at the *Exhibition of Paintings by Petrograd Artists of All Directions* in the Museum of Painterly Culture, Petrograd, 1923 (photograph courtesy of Galerie Gmurzynska, Cologne)

entirely utilitarian, are beautiful. In the charts that Mansouroff used at Ginkhuk as well as in the photographs of his display at the Museum of Painterly Culture in 1923 (fig.1), we can see many visual references to his endeavour to combine 'nature' and 'technology': his 'painterly formulae' and 'painterly tensions' hang next to a stuffed bird, a hunk of wood and a 'Dada' collage with a butterfly on a piece of wood. The tabulations at Ginkhuk also emphasize Mansouroff's cardinal principle of the economic system of colour and form, showing diagrams and photographs of rock formations, feathers, fossils, spiders' webs, masonry, etc.

If Mansouroff's interest in particular geometric groupings and regularities can be explained, at least in part, by his observation of natural forms, if his concentation on the wooden board as the literal base of his paintings may derive from the icon board, and if certain disparate motifs and compositions of the early 1920s can be explained through his ready assimilation or plagiarization of other avant-garde ideas, how can his almost total allegiance to the longitudinal painting and verticality be understood? An answer to this question is suggested by one of his letters of the early 1960s in which he commented on his *Painterly formula. Beer* of 1922:

> at that time I first noticed that my many drawings had a traditional, atavistic connection with the painterly formulae of the old Russian artists. I encountered these forgotten rules in the compositions of icons by common painters. *Beer* is a signboard (an ad) in front of a bar. Since my childhood I used to pass by, but never imbued it with any meaning, and I noticed its meaning only [when I saw] its resemblance to my gouaches of 1921–22. In this way, I am, organically, carrying on these traditions, so to speak, within the conditions of our age.[5]

The kind of signboard that Mansouroff had in mind was, no doubt, figurative, and it would have shown a larger than life bottle or bottles, a mug or glass, perhaps even a drinker and a waiter. The image or images, highly stylized, would have been painted in bright colours and would

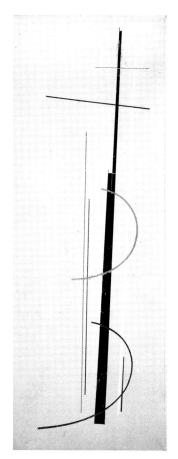
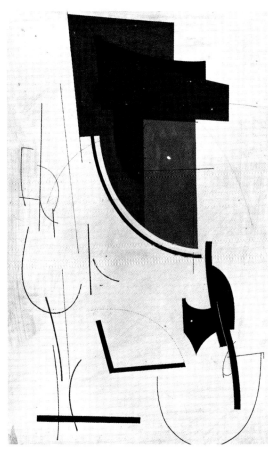

Notes
5 Letter from Paul Mansouroff to
Carlo Belloli (undated).
Reproduced in Belloli, *Mansouroff*,
p.151
6 A copy of Mansouroff's
statement is in the archives of the
Thyssen-Bornemisza Collection
7 For colour illus. of
Mansouroff's *Composition
(Suprematist composition)* (1917?,
39 × 49.5 cm, Omsk, Museum of
Visual Arts) see Sarabianov/
Gurianova (1992), p.174
8 The Tretiakov Gallery gouache
is proably the same as the work
called *Konstruktion* which
Mansouroff contributed to the
Erste Russische Kunstausstellung
at the Galerie Van Diemen,
Berlin, in 1922 (no.408)

have hung above the entrance to the bar or on the wall outside. Mansouroff approached his own studio paintings in a similar way, using the vertical thrust of the signboard as a device to draw attention to the activity of the surface and compelling the viewer to think about the calculated interactions of horizontals and verticals, black and white, negative and positive, tranquillity and tension.

Nevertheless, although inspired by the narrative of the traditional signboard, Mansouroff was one of the most consistent practitioners of abstract painting, and even during emigration to Italy and then France (1928 onwards), he resorted to similar formats and resolutions, using elementary forms on a long, vertical board. Mansouroff tended to apply the paint directly on to the board and he had little interest in producing constructions and volumes, in spite of a brief flirtation with Constructivist design. Essentially, Mansouroff remained deeply committed to the intrinsic components of painting, especially the balance and tension between the 'shape' of the surface and the totality of that surface.

Until his death, Mansouroff continued to create his higly original, pure abstractions – something that often makes distinctions between early and later works hard to recognize. This particular piece was dated '1918' by the artist himself on 8 December 1977, in the prcsence of the buyer (the Galerie Gmurzynska) for whom he also made a written statement: 'Je certifie que le tableau reproduit au verso est un oeuvre authentique fait par moi en 1918'.[6] Even so, it is hard to imagine that a young student of twenty-two years old with a very incomplete training as an artist could have produced such a sophisticated and mature painting, and the Russian specialist, Evgenii Kovtun, who has studied Mansouroff's work, argues that the artist was still a 'Realist' in 1917–18. On the other hand, those few pieces that are known to date from c1920, such as *Composition (Suprematist composition)* (1917)[7] and *Construction* (1920–21; fig.2) and *Non-objective* (1917–18; fig.3)[8] are, indeed, abstract and Malevich would hardly have invited a

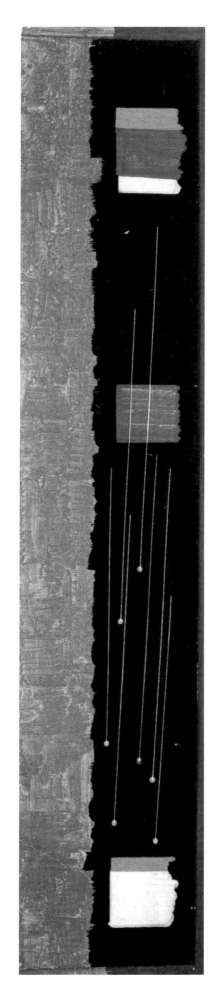

FIG 4 Paul Mansouroff, *Pictorial forms*, 1920, 135.5 × 37 cm, tempera on panel (courtesy of Sotheby's, London)

FIG 5 Paul Mansouroff, *Form II*, 1917, 53.5 × 76.5 cm, oil on panel (courtesy of Waddington Galleries, London)

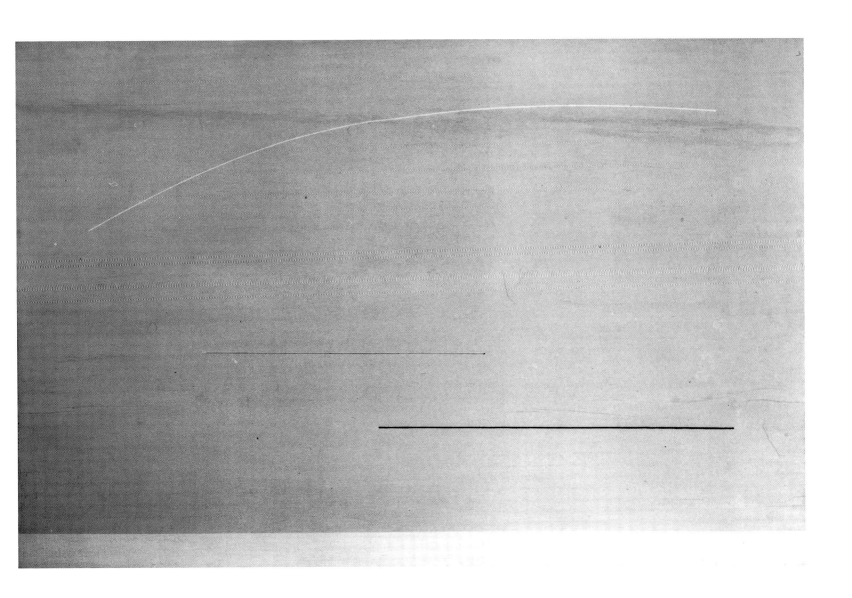

'Realist' to head the Experimental Department at Ginkhuk. As far as these two Mansouroff works are concerned, chemical tests reveal nothing incommensurate with a pictorial age of seventy or seventy-five years (except, of course, for the signature added in 1977).

The fact remains, however, that there is a surprisingly large number of Mansouroff's 'painterly formulae' on the market and that they are nearly all dated from the same period, the late 1910s and early 1920s. For example, the *Pictorial forms* (1920) and *Form II* (1917), auctioned recently in London (figs.4, 5), bear a strong linear resemblance to the work under discussion. Since Mansouroff continued to paint abstract works throughout his long years of emigration, it is possible that he regarded them as mere extensions of his initial inspiration and associated them with the earlier period. No doubt, in accordance with this rationale, he felt justified in antedating them.

Paul Mansouroff (Pavel Andreevich Mansurov) 1896–1983

42 Untitled

1923–4 (?)
Oil and mixed media with indian ink on panel, 127 × 41 cm
Signed bottom centre 'P. Mansouroff'
The irregular wooden panel is unvarnished and generally in good condition
Accession no.1983.5

Provenance
Paul Mansouroff, Paris
Patricia L. Learmonth, New York
Andrew Crispo Gallery, New York
Thyssen-Bornemisza Collection, 1983

Exhibitions
Leningrad/Moscow 1988, no.21, colour illus. p.4

Mansouroff often repeated and paraphrased earlier works, especially in the 1960s and 1970s, and a date later than 1923–4 for this particular piece should not be excluded. However, chemical tests provide no concrete evidence to doubt a date of the 1920s.

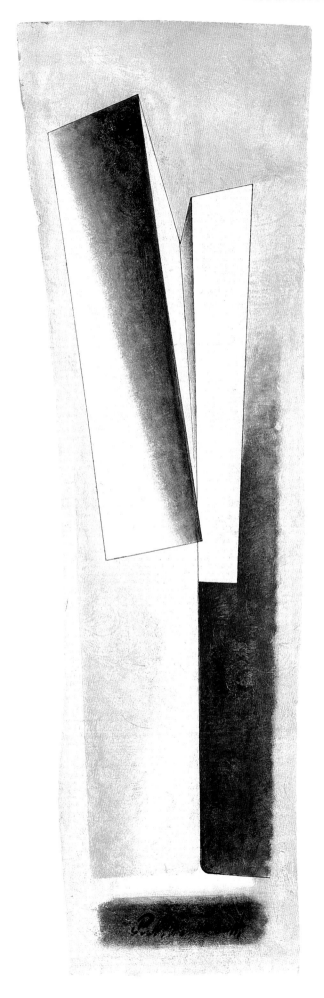

László Moholy-Nagy 1895–1946

43 Large railway painting
Das grosse Eisenbahnbild

1920–21
Oil on canvas, 100 × 77 cm
Signed lower right: 'Moholy-Nagy'
The keyed stretcher is original and the canvas is very thin but not relined. The unvarnished, matt paint surface
 carries some scratches and spots, but the general condition is good
Accession no.1974.41

Provenance
Studio of the artist, Chicago
Marlborough Fine Art, London
Mr and Mrs Fred Shore, New York
Galleria La Medusa, Rome
Thyssen-Bornemisza Collection, 1974

Exhibitions
Berlin, Galerie Der Sturm, February 1924, *Béla Kádár, László Moholy-Nagy, Henryk Berlewi*, no.37
London, Malborough Fine Art, March–April 1962, *Painters of the Bauhaus*, no.145, p.22
West Berlin, Deutsche Gesellschaft für Bildende Kunst (Kunstverein Berlin), October–November 1967, *Avantgarde
 1910–30 Osteuropa*, no.209, colour illus. p.125
Eindhoven, Stedelijk Van Abbemuseum, 1967, *László Moholy-Nagy*
Chicago, Museum of Contemporary Art, New York, The Solomon R. Guggenheim Museum, 1969, *Moholy-Nagy*,
 no.6, illus. p.22
London 1973–4, no.105, colour illus. pl.83
Bremen, Kunsthalle, 2 Feb.–30 March 30 1975, *Moderne Kunst aus der Sammlung Thyssen-Bornemisza*, no.50,
 colour illus. [unpaginated]
Japanese tour 1976, no catalogue no., unpaginated
Berlin 1977, no.1/187, illus., p.1/145
Brussels, Musée d'Ixelles, 14 Oct.–15 Jan. 1977–8, *La Collection Thyssen-Bornemisza. Tableaux Modernes*, no.60,
 colour illus. [unpaginated]
Lugano, Villa Malpensata, 1 Sept.–5 Nov. 1978, *Maestri europei del XX secolo dalle collezioni d'arte private ticinesi*,
 no.73, colour illus. on cover
Paris, Musée d'Art Moderne de la Ville de Paris, 21 Feb.–20 May 20 1978, *La Collection Thyssen-Bornemisza.
 Tableaux Modernes*, no.61, colour illus. [unpaginated]
Lugano 1978, no.73, colour illus.
Perth, Art Gallery of Western Australia/Adelaide, Art Gallery of South Australia/Brisbane, Queensland Art
 Gallery/Melbourne, Art Gallery of New South Wales/Wellington, National Art Gallery/Auckland, Auckland City
 Art Gallery/Christchurch, Robert McDougall Art Gallery, 1979–80, *America and Europe. A Century of Modern
 Masters from the Thyssen-Bornemisza Collection*, no.29, colour illus.
USA tour 1982–4, no.20, colour illus.
Modern Masters from the Thyssen-Bornemisza, Collection 1984–6, no.72, colour illus. p.94
Luxembourg/Munich/Vienna 1988–9, no.53, colour illus. p.129
Valencia, IVAM Centre Julio González/Kassel, Museum Fridericianum/Marseilles, Musée Cantini, 11 Feb.–15 Sept.
 1991, *László Moholy-Nagy*, no.12, colour illus. p.33

Literature
E. Roters, *Painters of the Bauhaus*, New York (Praeger) 1969, illus. pl.78
K. Passuth, *Moholy-Nagy*, 1985, colour illus. pl.33

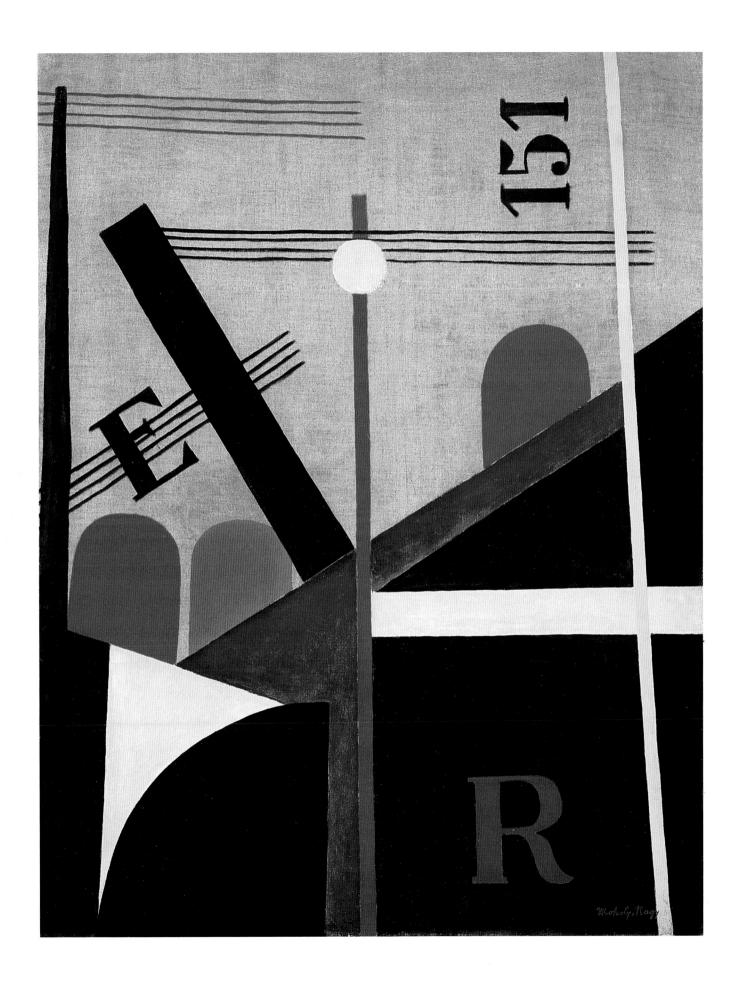

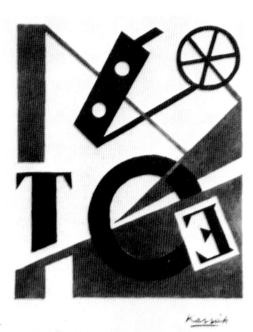

FIG I Lajos Kassák, *ET*, 1920, 20 × 16 cm, gouache on paper (private collection)

Moholy-Nagy came to art by chance – after turning to painting and drawing during his military convalescence on the Eastern Front in 1916. Although he had trained as a lawyer in Budapest before the War, Moholy-Nagy was so impressed by visual communication that he never forsook his new metier. During the late 1910s, as a self-taught artist, Moholy-Nagy, therefore, assimilated many styles, although it was Italian Futurism and German Expressionism that left the deepest imprint at this time, as is manifest from works such as *Hills of Buda* (1918, Budapest, Collection of Levente Nagy) and *Self-portrait* (1919, Budapest, Collection of Iván Bach). He said of this kind of work:

> Through my 'problem' of expressing everything only with lines, I underwent an exciting experience…The drawings became a rhythmically articulated network of lines, showing not so much objects as my excitement about them.[1]

As a member of the Activists in Budapest, Vienna and Berlin, Moholy-Nagy shared radical views on art and politics similar to those of Kassák (see [24]) and they collaborated on a number of projects, not least, the Vienna issues of *MA* and the important *Buch neuer Künstler* (1922). Kassák even repeated motifs from the *Large railway painting* in some of his own designs at this time (fig.1). Perhaps at Kassák's bidding, Moholy-Nagy also gave attention to the Russian avant-garde, and his meeting with El Lissitzky in Germany in 1922 produced a profound impression on his artistic psychology, inspiring his own re-elaborations of the Prouns (see [36– 8]) in his *Kestnermappe* (1923) and the abstract oils such as *E IV construction* (1922, Munich, Galerie Klihm) and *A X 1* (1923, Chicago, IL, Museum of Contemporary Art). Moholy-Nagy later recalled such encounters with great fondness.[2]

Like Sándor Bortnyik and Lajos Kassák (see [2], [3] and [24]), Moholy-Nagy was a master of many disciplines – abstract painting, photography, film, typographical design and exhibition layout and, as a member of the International Constructivists, he emphasized the functional, promotional purpose of artistic enterprise. In this respect, works such as *Large railway painting* and *Circle segments* can be regarded as laboratorial preparations for the public resolutions that Moholy-Nagy applied to his commercial advertising, scenography and interior design of the 1930s. Even so, Moholy-Nagy never abandoned the 'pure' or aesthetic bias of Constructivism and, throughout his life, continued to experiment on form for form's sake, expressed, for

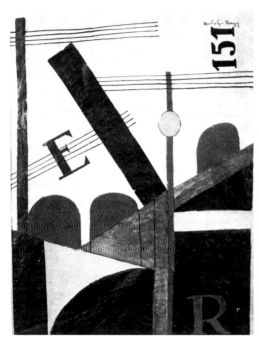
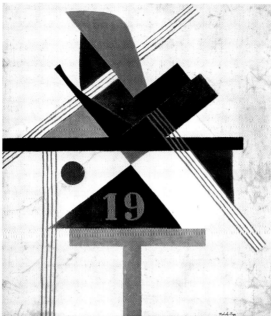
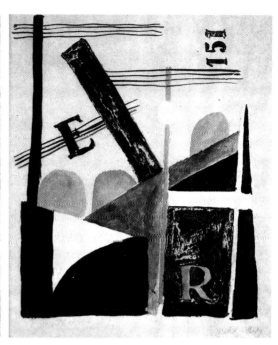

FIG 2 László Moholy-Nagy, *Design for the 'Large railway painting'*, 1920 (formerly Basel, Collection of Carl Laszlo)

FIG 3 László Moholy-Nagy, *Construction 19*, c1920, 111.8 × 92.7 cm, oil on canvas (Cambridge, MA, Harvard University, Busch-Reisinger Museum; gift of Sibyl Moholy-Nagy)

FIG 4 László Moholy-Nagy, *Railway painting*, 1920–21, 38.5 × 23.5 cm, watercolour on paper (Berlin, Nationalgalerie, Staatliche Museum Preussischer Kulturbesitz)

Notes

1 L. Moholy-Nagy, *The New Vision and Abstract of an Artist* (1967); quoted in Passuth, *Moholy-Nagy*, 1985, p.17
2 L. Moholy-Nagy, *Abstract of an Artist* (1944); quoted in Passuth, op.cit., p.381
3 Passuth, op.cit., p.22

example in his famous *Lichtrequisit* or *Light-space modulator* (1922–30, Harvard University, Busch-Reisinger Museum).

Large railway painting is one of the most familiar icons of the Hungarian avant-garde and it marks an important juncture in Moholy-Nagy's own career. Still thematic – with its references to telegraph wires, tunnels, a train number-plate (?) and the blades of a semaphor – the painting seems to be more an exposition of energy via repeated forcelines and fragments rushing past the compartment window than the concrete depiction of a particular train. The impression of the clashing metal and crackling wires of this machine hurtling through space must have reminded Moholy-Nagy of his experiences in the First World War trenches when he was exposed to a different kind of galvanic technology.

In spite of its clear references to a specific subject (the Berlin railway and its junction), *Large railway painting* is also an exercise in the kind of formal reduction that Moholy-Nagy would later explore in his so-called telephone pictures and numbered compositions. The strong vertical, horizontal and diagonal thrusts, the division into uneven abstract masses, the shifting perspectives amd ambiguity of space are characteristic of his constructive paintings. The Hungarian historian Krisztina Passuth has written of works like *Large railway painting*:

> The composition is always centred, a typical feature being a strong horizontal axis appearing in the lower or upper third of the picture below or above which are various more playful and lively motifs such as numbers or letters. Upward-inclining diagonals are emphasized to the same extent as the horizontal strip; they float freely in the picture space, not extending as far as the frame, thus giving an impression of inconclusiveness...[3]

The railway motif figures prominently in Moholy-Nagy's early work and *Large railway painting* is the culmination of several studies and variations, for example *Design for the 'Large railway painting'* (1920; fig.2) *Construction 19* (c1920; fig.3)) and especially *Railway painting* (1920–21; fig.4) Moholy-Nagy applied similar motifs of bridges, cranes and wheels in other works of the same period such as *Bridges* (1920–21; fig.5) and also recorded scenes of industrial construction in his photography of the same years (fig.6). In any case, *Large railway painting* is one of many avant-garde pictorial interpetations of the theme of rapid transit and 'networking'. Both the Italian Futurists and the Russian Cubo-Futurists paid homage to the railway as a

FIG 5 László Moholy-Nagy, *Bridges*, 1920–21, 33.5 × 25.5 cm, watercolour and indian ink on paper (The Hague, Gemeentemuseum)

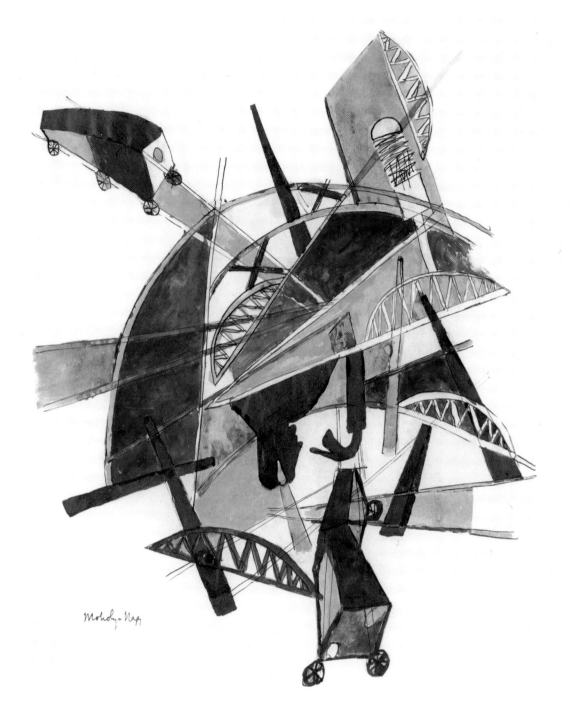

symbol of twentieth-century technology (cf. Natalia Goncharova's *Aeroplane over a train* (*landscape with a train*), 1913, Kazan, Museum of Visual Arts of the Republic of Tatarstan; Ivan Kliun's *Landscape rushing by*, 1914–15, 74 × 58 cm, oil on wood, wire, metal and porcelain, Moscow, State Tretiakov Gallery; and Rozanova's *Urban landscape* [50]). The Hungarian Activists were also drawn to the subject as a symbol of industrial progress, as is evident from Bortnyik's *Red locomotive (train leaving a tunnel)* (1918; see [3], fig.2) or Kassák's similar rendering of 1922,[4] and Bortnyik's abstract paraphrase of the same vertical and diagonal grids, letters and colour planes of *Large railway painting* in *Bildarchitektur II* for his *MA Album* of 1921 (fig.7). However, while the railway tracks, tunnels and train numbers in *Large railway painting*

Notes
4 This untitled gouache by Kassák is reproduced in Cologne 1975, no.45, p.87
5 L. Moholy-Nagy, *Von Malerei zur Architektur* (1929); quoted in Caton, *The Utopian Vision of Moholy-Nagy*, p.27

FIG 6 László Moholy-Nagy,
Scaffolding, 1920,
38 × 28.5 cm (photograph
Berlin, Kunstbibliothek,
Staatliche Museum
Preussischer Kulturbesitz)

FIG 7 Sándor Bortnyik,
Bildarchitektur II for his *MA
Album* of 1921,
33.5 × 24 cm, pochoir print
on paper (Budapest,
Hungarian National Gallery)

provide the outward meaning of the picture, the composition is perhaps more a celebration of science and technology in general than a particular laudation of trains, of the triumph of objective calculation over private vision, something that is implied in Moholy-Nagy's other masterpiece of the same period, *Large emotion meter* (1920, Amsterdam, Stedelijk Museum). He emphasized this in his Bauhausbuch of 1929:

> With the more scientific approach to every phenomenon of life, the neo-plasticists, suprematists and the constructivists have clearly recognized and tried to organize their materials. They have departed entirely from the traditional desire to mirror nature.[5]

László Moholy-Nagy

<div align="right">1895–1946</div>

44 Circle segments
Kreissegmente

1921
Oil on canvas, 78 × 60 cm
Signed on the *verso*: 'Moholy'
The light-weight canvas has been relined with glass fibre, but the stretcher is original. The paint layer carries fine
vertical crackle and the surface is extremely smooth from former lining, but the general condition is good
Accession no.1981.31

Provenance
Ida Bienert, Dresden
Marlborough Fine Arts, London
Kurt Forberg, Düsseldorf
Galerie Gmurzynska, Cologne
Thyssen-Bornemisza Collection, 1981

Exhibitions
London, Marlborough Fine Arts, 1968, *Moholy-Nagy*, illus. no.4
Düsseldorf, Kunstverein für die Rheinlande und Westfalen, 1970, *Sammlung Forberg*
Stuttgart, Württembergischer Kunstverein/Cologne, Kölnischer Kunstverein/Zurich, Kunstgewerbemuseum der
Stadt Zürich, Zurich/Paris, Musée National d'Art et de la Culture, Centre Georges Pompidou, 31 Oct. 1974–
spring 1976, *Laszlo Moholy-Nagy*, p.119, illus. no.149
Cologne 1986, p.184, colour illus. p.185
Luxembourg/Munich/Vienna 1988/9, no.54, colour illus. p.131

Literature
W. Grohman, *Die Sammlung Ida Bienert Dresden*, Potsdam (Müller & Kiepenheuer) 1933, p.33, illus. no.69

One of Moholy-Nagy's abiding artistic interests was in the juxtaposition or, rather, integration
of apparent opposites – black and white, static and dynamic, horizontal and vertical. In some
sense, this lifelong concern with action and reaction reached its apogee in his construction of
the *Light-space modulator*, an abstract machine that functioned precisely in accordance with
modulations between light and shadow, mobility and immobility. *Circle segments* is one of many
gestures to the Suprematist and Constructivist concern with formal encounters such as the
relationship between weight and weightlessness, and similar enquiries can be identified with
the concurrent work of Bortnyik, Rodchenko and Unovis (see [7]). Moholy-Nagy's pictorial
statements, however, tend to be even more sober and simpler and it was his ability to reduce the
composition to absolute contrasts that provided his typographical and commercial designs with
clarity and accessibility.

Moholy-Nagy repeated the basic composition of *Circle segments* in a number of versions and
studies, and the *verso* of this work even carries a draft of two superimposed semi-circles, one
vertical, the other horizontal, the latter containing the name 'Moholy'. Obviously, the
combination of circle segments was of particular importance to Moholy-Nagy's formal

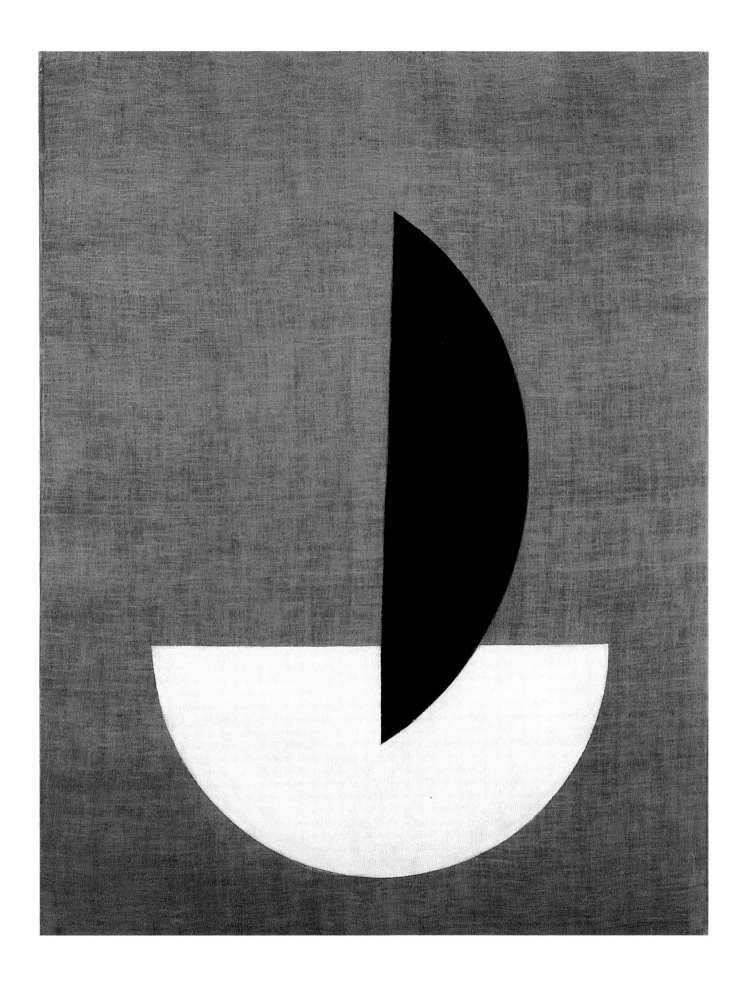

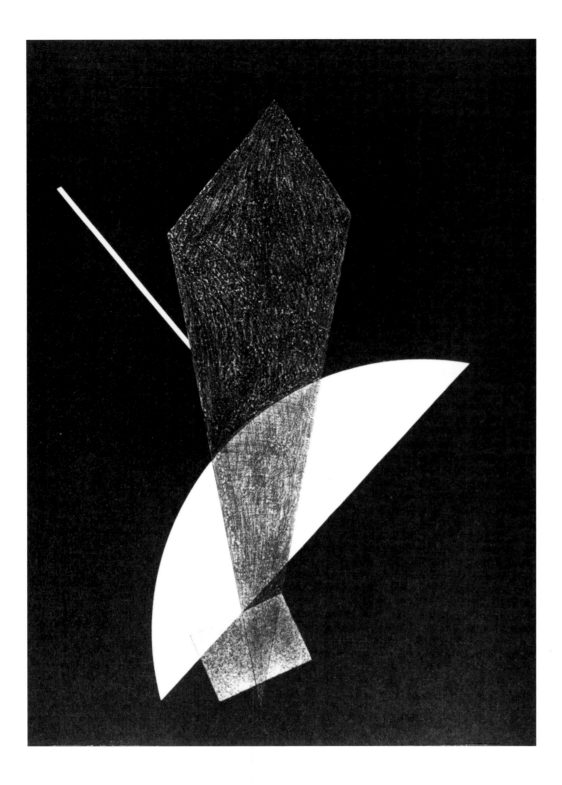

FIG 1 László Moholy-Nagy, sheet from the *Kestnermappe* 1923, 60.5 × 44.5 cm, lithograph (private collection)

explorations at this time, and it assumed many guises – as in the interplay of two semicircles in perpendicular and horizontal positions in the several lithographs for his *Kestnermappe* (1923; fig. 1) and in the concurrent woodcuts such as *Three crescents and cross* (c1922; fig.2)[1]. The motif of whole and fragmented circles also reappears in his structure of the *Light-space modulator*. Moholy-Nagy created *Circle segments* and its attendant variations at the moment of his new passion for photography and the deliberate focus and crisp framing of the camera seems to have

FIG 2 László Moholy-Nagy,
Three crescents and cross,
*c*1922, 14.8 × 15.1 cm,
woodcut (New Haven, CT,
Yale University Art Gallery)

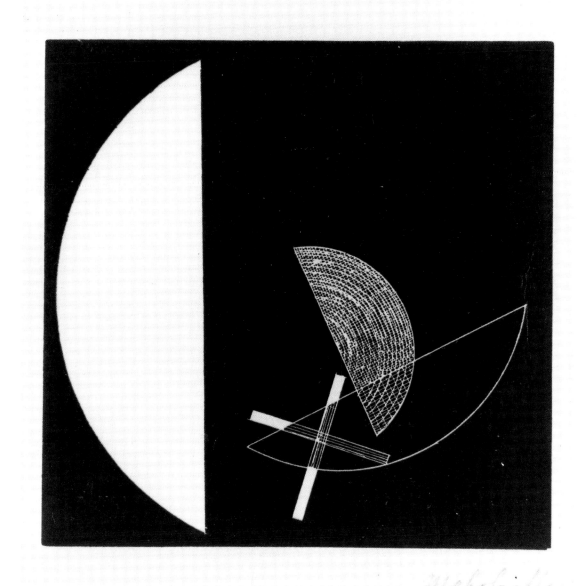

Notes
1 Moholy-Nagy also applied the
circle motif to collages: see, for
example, the 1921 and 1922
collages illustrated in *Szabó*
1981), nos XXI and 153
2 S. Moholy-Nagy, *Moholy-Nagy*,
p.29

left an appreciable imprint on his abstract paintings of the 1920s. As Sibyl Moholy-Nagy wrote in her biography:

> His canvases from 1922 are photogrammatic compositions, decisively influenced by the technical eye of the camera. The superimposition of planes, the activation of light, and the smooth, textureless handling of the surface are photographic in character.[2]

Liubov Sergeevna Popova 1889–1924

45 Painterly architectonics (Still-life. Instruments)
Zhivopisnaia arkhitektonika (Natiurmort. Instrumenty)

1916
Oil on canvas, 105.5 × 69.2 cm
The paint layer shows extensive cracking and former paint loss with considerable restoration and retouching. The medium-weight canvas has been relined and the soft gloss varnish seems to be synthetic. The general condition is fair
Accession no.1976.88

Provenance
Artists's family, Moscow
George Costakis, Moscow
Sotheby's, London
Grosvenor Gallery, London
Leonard Hutton Galleries, New York
Thyssen-Bornemisza Collection, 1976

Exhibitions
Buffalo, NY, Albright-Knox Art Gallery, 3 March–14 April 1968, *Plus by Minus: Today's Half Century*, no.159
London, Grosvenor Gallery, 2–27 July 1968, *20th-century Paintings and Sculptures*, no.62, illus. [unpaginated]
New York 1971–2, no.87, colour illus. p.68
London 1973–4, no.61, colour illus. pl.41
Lugano 1978, no.93
Milan 1979–80, no.443
Milan 1980, illus. p.104
Los Angeles/Washington DC, 1980–81, no.241, p.218, illus. p.219
Modern Masters from the Thyssen-Bornemisza Collection, 1984–6, no.67, colour illus. p.89
Cologne 1986, p.136, illus. p.137
Luxembourg/Munich/Vienna 1988–9, no.61, colour illus. p.165
Zurich 1989, p.60, colour illus. p.61
Los Angeles, CA, County Museum of Art/New York, The Museum of Modern Art/Cologne, Museum Ludwig/Madrid, Centro de Arte Reina Sofia, 13 Feb. 1991–16 Feb. 1992, *Liubov Popova*, no.46, colour illus. p.60

Literature
Impressionist and Modern Paintings and Sculptures, London, Sotheby's, 26 April 1967, lot 53
S. Jacoby, 'Russian Art Comes out of the Dark', *The Washington Post*, 31 Oct. 1971, illus.
R. Fabri, 'Russian Avant-garde', in *Today's Art*, New York, Feb. 1972, colour illus.
Bowlt, 'From Surface to Space', illus. p.85
Adaskina and Sarabianov, *Liubov Popova*, 1990, illus. p.119

By the time Popova went to Paris in the autumn of 1912, she was well prepared for the lessons in Paris Cubism. She already had a sound knowledge of modern French art from her visits to the Morozov and Shchukin collections in Moscow and from discussions of the subject with her colleagues such as Vladimir Tatlin and Nadezhda Udaltsova at the collective studio called the Tower during the spring and summer of 1912 (see [55–7], [59]). Popova apprehended Cubism literally, and her paintings of this time, like those of Marie Vassilieff (see [58]), demonstrate obvious borrowings from Braque, Léger, Le Fauconnier, Metzinger and Picasso. La Palette, the studio that Popova attended in Paris, served, so to speak, as a laboratory for the Cubist experiment in Russian art, since, apart from Popova, the Russian contingent there in 1911–14

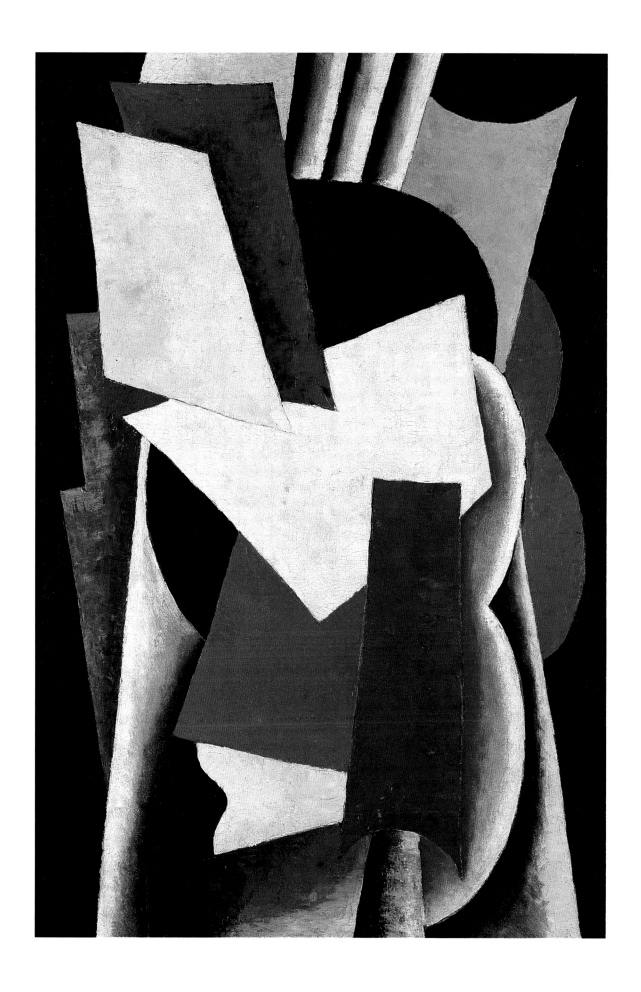

included at various times Aristarkh Lentulov, Vera Mukhina, Vera Pestel and Udaltsova. La Palette was where Le Fauconnier and Metzinger 'preached the "bible of Cubism"'[1] and Popova found confirmation of the doctrine in her visits to exhibitions of contemporary art such as the 1913 *Salon des Indépendants* (with its panorama of Cubism, Orphism and Futurism) and through her discussions with the international community at the Café Closerie de Lilas and the Café Rotonde.

Popova absorbed many lessons from La Palette. First of all, she was encouraged to think in terms of pictorial analysis and to regard the object as a departure-point for investigation into the basic qualities of texture, form and colouration. Secondly, Popova discovered the visual effect of collage and its emphasis on the spatial ambiguity of the picture. Thirdly, she was brought to the notion of pictorial paradox, that is to say of de-realizing and then re-realizing the composition. Just how mechanical Popova's assimilation of Cubist principles was at this time is evident from her careful paraphrases of works by Braque and Picasso; and that these are routine class assignments rather than original interpretations is clear from almost identical studies done by colleagues at La Palette, especially Udaltsova. Popova studied both the motifs and the methods of Cubism. The guitar or violin that appears in numerous Cubist paintings also became Popova's leitmotiv whether in her studies in Cubist composition such as, for example, *Italian still-life. Violins and cannons* (1914; Moscow, State Tretiakov Gallery), in her figurative architectonic paintings, such as the work under discussion, or even in her non-figurative architectonic paintings – in which the arc or curve on a vertical axis and the parallel black lines are pictorial recollections of the edge of a guitar and its strings. The fundamental structure of [45], for example, relies on the vertical strings and the dissolving planes of the circumferential arches of the sounding-board of the guitar. Certainly, as current researchers into Popova's work remind us, these musical reminiscences should not be exaggerated because 'Popova's memory held not only those objects, but also the forms of recent reliefs executed in 1915'.[2]

Still, the Cubist influence on Popova was not exclusive and, as Udaltsova recalled: '[Popova] understood little of what Le Fauconnier said. She kept going off into a thousand lines and had no sense of plane'.[3] In any case, when Popova returned to Moscow from Paris, she was immediately exposed to other ideas which diluted the Cubist impact and guided her towards a new understanding of painting. Popova again joined the Tower, where she worked side by side with Alexei Grishchenko, Viktor Midler, Tatlin, Udaltsova, Alexander and Viktor Vesnin et al. It was here that Popova was confronted with two important aesthetic principles or directions: firstly, she renewed her interest in ancient Russian art and architecture – by then a topical subject among Russian artists; secondly, she began to investigate a volumetric, spatial perception in addition to the planar, pictorial one, just at the time that Tatlin was moving towards his concept of the relief. Well before her trip to Paris, Popova displayed a particular interest in medieval church architecture and icons, partly under the influence of her early art teacher, Konstantin Yuon, and now under the influence of her husband, Boris von Eding, a connoisseur of Russian art and architecture. However, it was only after her Cubist training in formal analysis that Popova fully appreciated the artistic properties of the Russian icon. Her study of the icon – which coincided in Russia with a flurry of related exhibitions and restoration projects and with a fad for collecting ancient Russian art – heightened her awareness of colour. The vivid reds, blues and ochres of early Russian icons, unrelieved by shadow and chiaroscuro, are, in this respect, not very distant from Popova's montages of colour planes such as the work under discussion and *Painterly architectonics* (see [46], [47]). Indeed, one of the primary aims of the group of artists working at the Tower was to re-establish an organic connection between their contemporary experimental painting and the Russian icon. As Grishchenko wrote at this time:

> Artists of the new Russian art are deeply convinced of the true path of painting. They have begun to build a bridge to the finest period of their indigenous art above the chasm of false Realism and retrospective individualism.[4]

Notes

1 N. Ternovets, *Pisma. Dnevniki. Stati*, Moscow (Sovetskii khudozhnik) 1977, p.99
2 Adaskina and Sarabianov, *Liubov Popova* 1990, p.111
3 Quoted from O. Voronova, *V.I. Mukhina*, Moscow (Iskusstvo) 1976, p.27
4 A. Grishchenko, *O sviaziakh russkoi zhivopisi s Vizantiei i Zapadom XIII–XX vv.*, Moscow (Grishchenko) 1913, p.89
5 From Popova's lecture on her set for *The Magnanimous Cuckold* which she delivered at the Institute of Artistic Culture, Moscow, on 27 April 1922; quoted in E. Rakitina, 'Liubov Popova. Iskusstvo i manifesty,' in E. Rakitina, *Khudozhnik, stsena, ekran*, Moscow (Sovetskii khudozhnik) 1975, vol.I, p.154

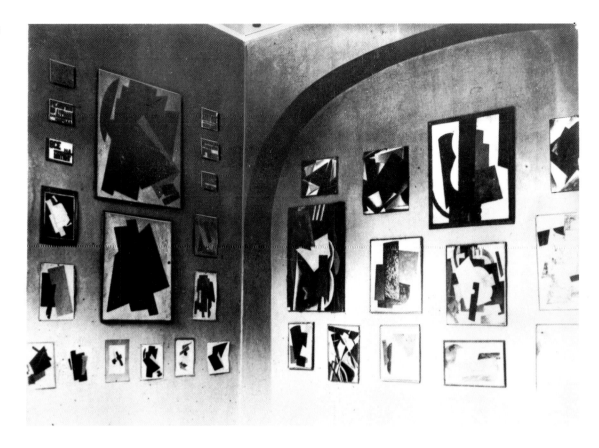

Like Alexandra Exter, El Lissitzky and Alexander Rodchenko, Popova possessed the rare gift for thinking in terms both of two dimensions and of three. Her desire to introduce space as a creative agent into her art, encouraged by her friendship with Mukhina and Tatlin, became especially evident in 1915 in her series of still-lifes and paintings which she subtitled 'plastic painting' and in her occasional reliefs of the same period. Popova's interest in sequential, spatial relationships occurred without reserve in her graphics and linocuts of 1920–21 where she applied a method of rigid stratification – the imposition of a grid of conflicting lines above a complex of colour planes – an idea that she used with great success in her textile designs of 1923–4. Of course, a logical outcome of Popova's interest in pictorial space was her work on theatrical design in the early 1920s which, she felt, would enable her to use space so as to avoid the 'frontal, visual character [of art]'.[5] It was in such radical productions as Vsevolod Meierkhold's *Magnanimous cuckold* of 1922 that Popova showed herself to be one of the very few authentic Constructivists of the Russian theatre, for in her economy of means, her austerity of organization, her subtle combination of real form and real space, she transformed the conventional notions of set and costume design. Whatever the responses to her designs, Popova's work for Meierkhold's theatre marked the culmination in her relentless effort to resolve the dichotomy between surface and space and to move from pictorial space to open, real space.[6]

There are many preparatory studies for, and variations of, *Painterly architectonics (Still-life. Instruments)*, and some of these were included in the Popova retrospectives in Moscow in 1924 and in Moscow and Leningrad in 1990 (fig.1). For example, several watercolours on paper are in a private collection in Moscow (figs.2–4). In particular, the watercolour in fig.3 is especially close, by virtue of the arrangement of its colour planes and its concrete references to the sounding-board and strings of musical instruments – a further abstraction of the Cubist works

such as *Guitar* (1914; fig.5). Also similar is the *Painterly architectonics with yellow* (1916?; Moscow, State Tretiakov Gallery), the *Painterly architectonics* dated 1917–18 (fig.6) and especially the *Painterly architectonics with three bands* (1916; fig.7). The latter version carries the 'strings' on the right and the outline of the 'sounding-board' on the left. Documents accompanying the transmission of *Painterly architectonics (Still-life. Instruments)* to the Thyssen-Bornemisza Collection include references to *0.10* (Petrograd, 1915–16) and to Popova's posthumous exhibition held at the Stroganov Institute, Moscow, in December 1924 in the exhibition history. According to these records, the work was 'no.89' at *0.10* (= *Still-life*) and 'no.69' at the posthumous show (= *Spatial-force construction*, 1921). However, this indication is not supported by other evidence and the Popova specialists, Natalia Adaskina and Dmitrii Sarabianov, confirm 1916, not 1915, and certainly not 1921, as the most probable year of execution, the more so since all the studies for, and versions of, *Painterly architectonics (Still-life. Instruments)* are dated 1916. It is possible that the *verso* of the canvas carries or carried the inscriptions 'no.89' and/or 'no.69' and that they prompted former owners to assume that the numbers corresponded to Popova's contributions to *0.10* and the posthumous show. But as is clear from the inscriptions on the *versos* of other Popova paintings (see [46] and [47]), these numbers refer to the posthumous list of works compiled by Ivan Aksenov and Alexander Vesnin rather than to exhibitions. In any case, the *0.10* catalogue makes no reference to a *Painterly architectonics (Still-life. Instruments)* or a *Painterly architectonics*, while the 1924 catalogue describes nos.13, 14, 34, 35 and 38 as *Painterly architectonics* for 1916, and no.20 as *Musical instruments*, dated, however, 1913. Unfortunately, because of technical reasons, the backing of *Painterly architectonics (Still-life. Instruments)* could not be removed.

Note

6 Popova was the subject of the most varied evaluations in the early 1920s. On the one hand, she was nicknamed (benevolently) the 'mother of scenic Constructivism' ('Samoe predstavlenie 'Velikogo rogonostsa'' [unsigned] in *Zrelishcha*, Moscow, no.67, 1923, p.8); on the other, people wondered whether or not her designs were a 'charlatanism or stupidity' (P. Krasikov, 'Sharlatanstvo ili glupost', *Rabochaia Moskva*, no.16 Moscow, 1922)

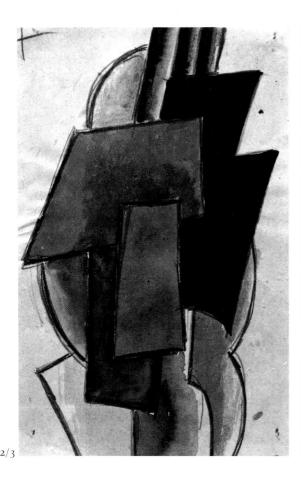

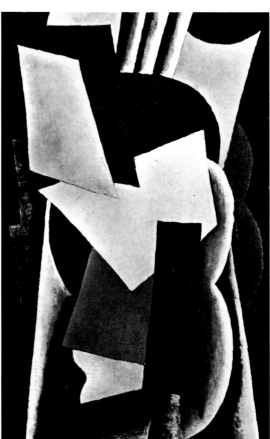

FIG 2 Liubov Popova, *Painterly architectonics. (Still-life. Instruments)*, 1916, 18.7 × 12 cm, watercolour, gouache and pencil on paper (private collection)

FIG 3 Liubov Popova, *Painterly architectonics. (Still-life. Instruments)*, 1916, 33.6 × 24.6 cm, watercolour, gouache and varnish on paper (private collection)

FIG 4 Liubov Popova, *Painterly architectonics. (Still-life. Instruments)*, 1916, 34 × 21.5 cm, watercolour, gouache and pencil on paper (private collection)

FIG 5 Liubov Popova, *Guitar*, 1914, 88 × 70 cm, oil on canvas (private collection)

FIG 6 Liubov Popova, *Painterly architectonics*, 1917–18, 33 × 24 cm, watercolour on paper (Yaroslavl, Rostov-Yaroslavl Museum)

FIG 7 Liubov Popova, *Painterly architectonics with three bands*, 1916, 107 × 89 cm, oil on canvas (private collection)

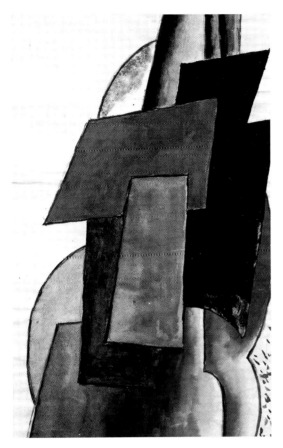
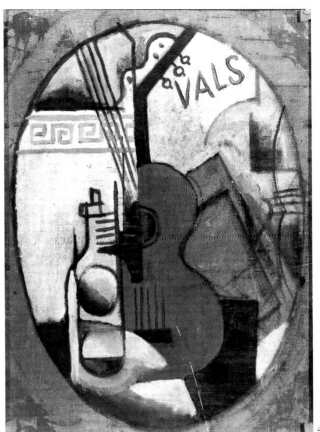

4/5

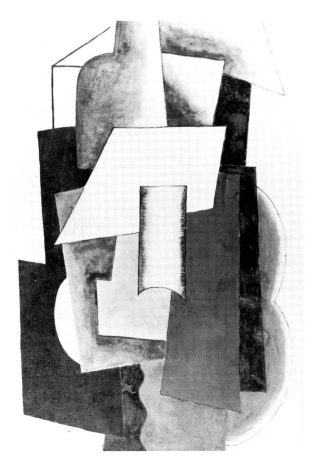
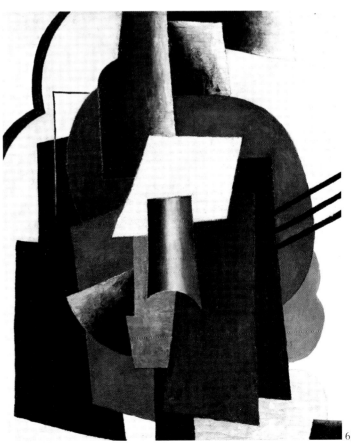

6/7

Liubov Sergeevna Popova

46 Painterly architectonics

1918
Oil on canvas, 70.5 × 70.5 cm
Inscribed on the reverse: 'no.112'
The coarse canvas has not been relined, and is attached to its original stretcher. The corners are torn at the edges.
 The unvarnished paint layer shows heavy cupping and cleavage with numerous repairs. The general condition
 is fragile
Accession no.1977.52

Provenance
Pavel Popov (the artist's brother), Moscow
George Costakis, Moscow
Sotheby's, London
Sotheby Parke Bernet, New York
Thyssen-Bornemisza Collection, 1977

Exhibitions
Edinburgh/Sheffield 1978, no.48
Bern, Kunstmuseum, 17 March–13 May 1984, *Die Sprache der Geometrie*, p.36, illus. p.37
Los Angeles/Washington DC 1980–81, no.245
Leningrad/Moscow 1988, no.27, colour illus. p.55
Luxembourg/Munich/Vienna 1988–9, no.62, colour illus. p.147

Literature
Impressionist and Modern Paintings and Sculptures, London, Sotheby's, 26 April 1967, lot 54
Important Impressionist and Modern Paintings and Sculptures, New York, Sotheby Parke Bernet, 11 May 1977, lot 80

According to the Moscow historian of Popova's oeuvre, Dmitrii Sarabianov, the 'no.112' refers to the unpublished list of Popova's works that Ivan Aksenov and Alexander Vesnin compiled after her death in 1924 and designates 'Painterly architectonics with a black square'.[1] Although, strictly speaking, there is no square in this picture, the reference may well be to the triangular shape, according to Sarabianov. There are several paintings of the same period that

Note
1 Letter from Dmitrii Sarabianov to John E. Bowlt dated 10 Feb. 1992

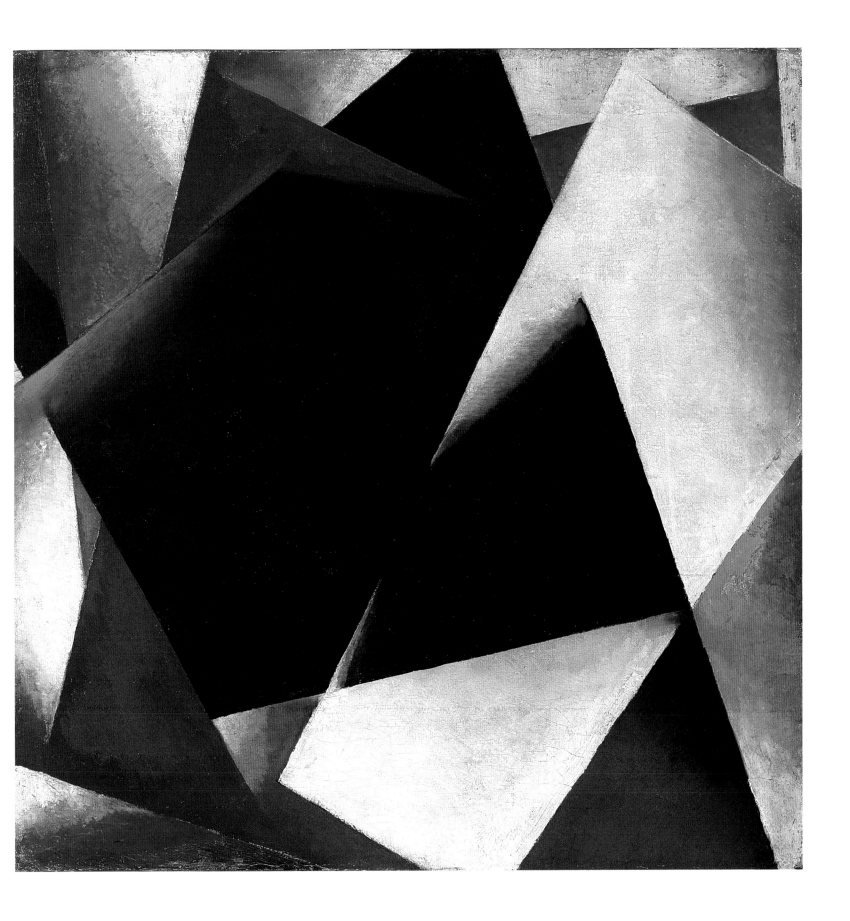

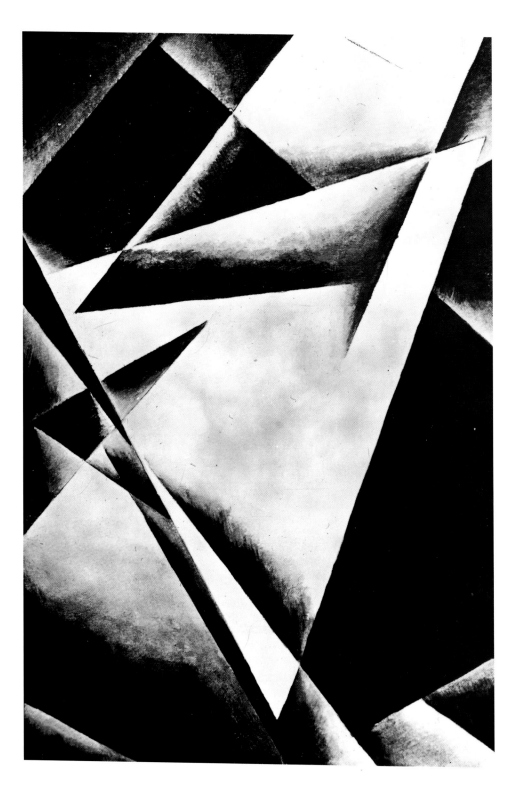

FIG I Liubov Popova,
Painterly architectonics, 1918,
73.1 × 48.1 cm, oil on canvas
(Art Co. Ltd, George Costakis
Collection)

relate closely to *Painterly architectonics* and that may be regarded as versions (e.g. fig.1). The latter relies on the same contrast of dark blue and white angular planes as does the work in question, evoking a similar dynamic sense. Sometimes the planar gradations from one colour to another in Popova's series of painterly architectonics are reminiscent of Malevich's 'dissolutions of sensation' (see [25], fig.2), although her sequence is at once more chromatic and constructive, something especially manifest in the work under discussion and in *Painterly architectonics* (1918; fig.2) For further commentary see [45] and [47].

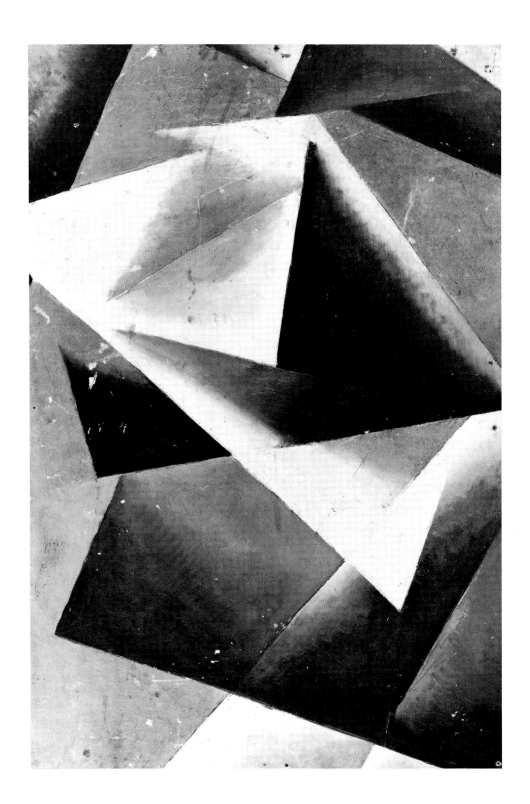

FIG 2 Liubov Popova, *Painterly architectonics*, 1918, 59 × 39.5 cm, oil on canvas (Yaroslavl, State Art Museum)

Liubov Sergeevna Popova 1889–1924

47 Painterly architectonics

1918
Oil on canvas, 45 × 53 cm
Signed and dated on reverse in Russian: 'L. Popova Summer1918'
Inscribed on the reverse upper right: 'no.61, 1918, 120'
The very taut canvas has been relined with glue-paste and is on a new stretcher. The paint layer shows a history
 of flaking in the brown area and parts of the high impasto are broken off. The general condition is weak
Accession no.1976.17

Provenance
Leonard Hutton Galleries, New York
Annely Juda Fine Art, London/Michael Tollemache, London
Thyssen-Bornemisza Collection, 1976

Exhibitions
Moscow, Stroganov Institute, December 1924, *L.S. Popova. Posmertnaia vystavka* [L.S. Popova. Posthumous
 Exhibition], no.61
Paris, Galerie Chauvelin, 25 April–25 May 1969, *Aspects de l'avant-garde russe*, no.54, illus. [unpaginated]
Ithaca, NY, Andrew Dickson White Museum of Art of Cornell University/New York, Brooklyn Museum of Art, 24
 Feb.–25 July 1971, *Russian Art of the Revolution*, no.43, illus. [unpaginated]
New York 1971–2, no.88, colour illus. p.69
London, Annely Juda Fine Art/Toronto, Art Gallery of Ontario, May–September 1975, *Russian Consructivism,
 Laboratory Period*, no.11, colour illus. on cover
Edinburgh/Sheffield 1978, no.47
Milan 1979–80, no.465
Los Angeles/Washington DC 1980–81, no.251
USA tour 1982–4, no.18, colour illus. p.27
Luxembourg/Munich/Vienna 1988–9, no.62, colour illus. p.147
New York, The Museum of Modern Art/Los Angeles, CA, Los Angeles County Museum of Art/Cologne, Museum
 Ludwig/Madrid, Centro de Arte Reina Sofia, 1991–2, *Liubov Popova*, no.73, colour illus. p.61 [not in exhibition]

Literature
Bowlt, 'From Surface to Space', illus. p.85

Painterly architectonics is one of several oils bearing the same or similar title that Popova painted in *c*1918. For example, there are strong points of reference here to the three 1918 *Painterly architectonics* in the collections of the Tretiakov Gallery, Moscow (fig.1), the Leonard Hutton Galleries, New York (fig.2), and of the Local Ethnographical Museum of Slobodsk Kirov Region (fig.3). A painting called *Painterly architectonics* in the Museum Ludwig, Cologne, is almost identical in size, formal configuration and colour-scale (fig.4), although it is normally displayed and reproduced vertically. As with the painting under discussion, all these pieces rely on an interweaving of coloured planes that undermines the conventional sense of perspectival recession.

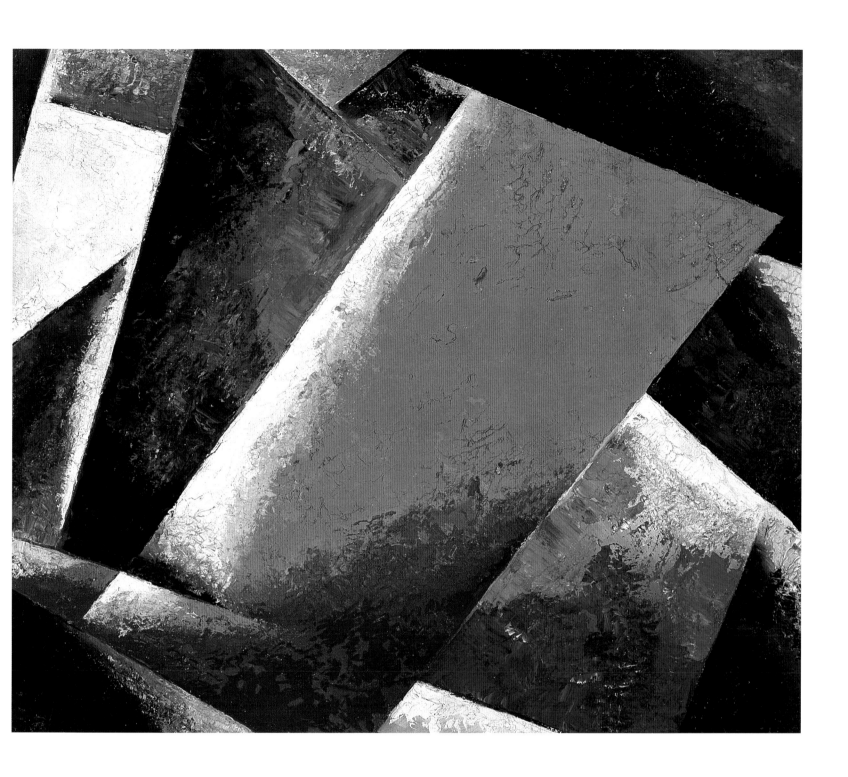

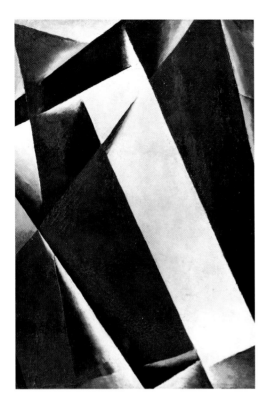

FIG 1 Liubov Popova, *Painterly architectonics*,
1918, 62.2 × 44.5 cm, oil on canvas
(Moscow, State Tretiakov Gallery)

FIG 2 Liubov Popova, *Painterly architectonics*,
1918, 59.2 × 39.4 cm, oil on board
(private collection, courtesy of Leonard Hutton Galleries,
New York)

FIG 3 Liubov Popova, *Painterly architectonics*,
1918, 105 × 80 cm, oil on canvas
(Slobodsk, Local Ethnographical Musuem of Slobodsk-
Kirov Region)

FIG 4 Liubov Popova, *Painterly architectonics*,
c1920, 57.5 × 44 cm, oil on canvas; here reproduced
horizontally (Cologne, Museum Ludwig)

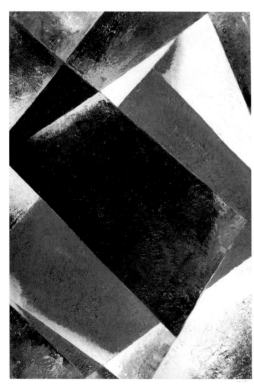

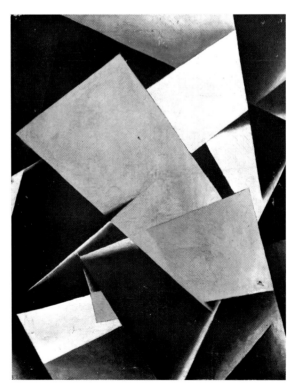

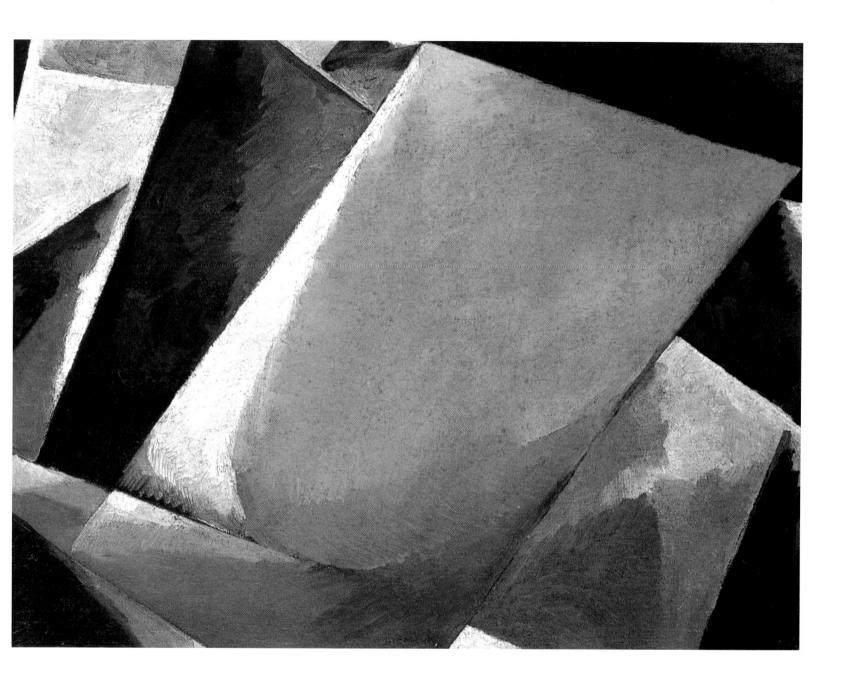

Note
1 For further information on Popova's textural and material experiments see E. Ordonez, 'Popova's Working Methods and Materials' in *Liubov Popova*, 1991–2, pp.113–17

The combination of coloured planes and the textured, material transition from the dominant dark blue to the white ground was a common device in Popova's experimental painting and can be recognized even in the more figurative canvases such as *Grocery shop* of 1916 (54 × 42.9 cm, oil on canvas, St Petersburg, State Russian Museum). Popova also introduced abrasive, 'non-artistic' materials into her Cubist works as in *Study for a portrait* (1915, 70.6 × 47 cm, oil and marble dust on canvas, private collection), producing effects similar to the turbulent surface treatment manifest in the painting under discussion.[1]

The inscriptions on the reverse refer to the catalogue of Popova's posthumous exhibition of 1924, where nos.58–64 designate *Painterly architectonics* of 1918. According to Dmitrii Sarabianov, the 'no.61' can be deciphered as follows:

no.61 is from Popova's own list. This list is not extant, although in the description of the works that remained in Popova's studio after her death (compiled by Aksenov, Vesnin, P. Popov, Shamshin), there is a heading: 'No[s]. of the List of L.S.P.' Apart from this, the Aksenov-Vesnin description also has its own numeration.

Under the number 120 in the description we find 'Painterly Architectonics. Orange and Blue, 1918'. Next to this within the same heading 'L.S.P. No[s].' we find '61'. In other words, everything coincides here which, I think, imparts complete security to the painting. However, we should bear in mind that this title (orange and blue) was hardly that of the artist. More likely, it was designated by the authors of the description.

Some points remain unclear. After the word 'summer' (Popova often noted the season [summer, winter, etc.] on the verso or the stretcher) there should be the year. One can see the letter 'g' [year], and '19', but the following characters are quite incomprehensible.

I can't guess what 'L.a.' means.

Still, the main thing is the coincidence of the numbers '61' and '120' according to the list and the description...[2]

Popova's work of 1916 onwards was a logical culmination of her Cubist training (see [45]), of her researches under Tatlin at the Tower studio in Moscow, and, to a lesser extent, of her acquaintance with Malevich. Although Popova was never as close to Malevich as she was to Tatlin, she was certainly familiar with his Suprematist system and played a leading role in the Moscow Supremus society, creating its insignia, designing part of its unpublished journal and hosting some of its meetings during the winter of 1916–17.[3] Even before entering the non-objective world, Popova subtitled a number of her paintings with analytical denotations such as 'plastic painting' (applied to *Vase of fruit* shown at 0.10 in Petrograd in 1915–16) and 'painterly plastic equilibrium' (applied to *Card game* shown at *The Store* in Moscow in 1916); she even subtitled her six pictures of the Shakh-Zinda mosque in Samarkand, shown at the 1916 *Jack of Diamonds* exhibition in Moscow, 'painterly architectonics'.

The term 'architectonic', a vogue word in the mid-1910s, may have been suggested to Popova by the painter Yuon, one of her first teachers. He believed that modern art had recaptured the

forgotten culture of the statics of form, i.e. 'painterly architectonics' and that the 'root' of all my artistic and painterly researches and sympathies is...predominantly of an architectonic nature.[4]

The importance of Popova's painterly architectonics and architectonic paintings is twofold. On the one hand, Popova used them as exclusive experiments in qualities such as colour saturation, weight, texture, dynamism devoid of narrative commitment; on the other hand, she used the architectonic compositions precisely as a series – a scale of exercises preparatory for a new 'objectivity'. This was implicit in Popova's statement written on the occasion of the Moscow exhibition $5 \times 5 = 25$ of 1921:

Our work on each of the elements (line, plane, volume, space, textural colour, material, etc.) goes beyond the bounds of a mere abstract exercise in elements. The results of this research compel us to set ourselves a specific aim: to concretize the element, i.e. to reduce it to a defined and concrete form so that the artist can use it freely and assuredly for his general constructive objectives.[5]

Naturally, over the several years that Popova painted in the architectonic style, her particular interests changed, and the Vesnin-Aksenov inventory of Popova's works includes forty-four painterly architectonics, and about thirty were included in her posthumous exhibition in 1924.[6] Popova developed her system of painterly architectonics between 1916 and 1918, except perhaps for a single specimen produced in 1915.[7] During 1916–17 she was especially concerned with the notion of the superimposed, juxtaposed colour plane – with the placing of one coloured form upon another, independent of the cool/warm colour sequence. In her attempt to remove the last vestiges of illusionism from the painting, Popova renounced Malevich's constant white background and resorted to a variegated one. By 1917–18 Popova

Notes

2 Letter from D. Sarabianov to John E. Bowlt and Nicoletta Misler dated 2 Oct. 1991

3 At one of these meetings Popova introduced her friend, the sculptress Vera Mukhina, to Alexandra Exter; see B. Ternovets, *V.I. Mukhina*, Moscow and Leningrad (Ogiz) 1937, p.9

4 K. Yuon, *Avtobiografiia*, Moscow (GAKhN) 1926, pp.24 and 34

5 Quoted from Cologne 1979–80, p.212

6 The list was compiled by Ivan Aksenov and Alexander Vesnin after Popova's death in 1924. See Adaskina and Sarabianov, p.133

7 Adaskina and Sarabianov, ibid.

8 Adaskina and Sarabianov, *Lioubov Popova*, 1989. This is the Fr. edn of the Eng. edn of the Adaskina and Sarabianov monograph quoted above. The Eng. version of this passage (also p.136) also describes the work in question, but omits the reference to the Thyssen-Bornemisza Collection. Instead, the reader is requested to consult the illus. 'page 153, bottom' which, it transpires, is the almost identical work in the Museum Ludwig, Cologne. The *Painterly architectonics with turquoise rear plane* (1917, 107 × 89 cm, oil on canvas, private collection) is illustrated in both Eng. and Fr. edns on p.131

9 N. Tarabukin, *Opyt teorii zhivopisi*, Moscow (Vserossiiskii proletkult) 1923, p.12. According to the editorial statement, the book was written in 1916

had removed the very concept of 'background' in her endeavour to reduce the painting to its absolute, two-dimensional meaning. To this end, she interpenetrated colour planes at irregular intervals so that green might appear above blue in one part of the canvas, but below it in another. The Russian specialists in Popova's works, Natalia Adaskina and Dmitrii Sarabianov, have identified these qualities with the painting in question:

> Une des compositions de 1918 – un plan jaune – orangé sur un plan bleu – (collection Thyssen-Bornemisza, Lugano), par sa relative simplicité, penche vers les oeuvres de la période antérieure, et par ses glissements du bleu au blanc rappelle *l'Architectonique picturale avec arrière-plan turquoise*...L'eclairage des plans à leurs extrémités est plus importante: il aide les plans colorés à vaincre leur côté charnel, matériel. L'harmonie se crée non plus sur terre, mais dans l'espace: elle continue toutefois à donner toute sa valeur à l'architectonique.[8]

In this respect, Popova's painting illustrated Nikolai Tarabukin's theory of painting written in 1916:

> The form of the work of art consists of two basic aspects: *material* (paints, sounds, words) and *construction*, thanks to which the material is organized into a finished whole which then acquires its artistic logic and meaning...In the work of painting, the elements of form would be: *colouration, texture, form of the planar depictedness and construction.*[9]

Popova was able to experiment extensively with these concepts, especially with the property of facture (texture or the processing of the painted surface), and to disseminate results when she became head of the Texture Course at Vkhutemas in Moscow and, with Alexander Vesnin (see [62]), head of the Colour Construction Department within the Pedagogical Section of Inkhuk in 1920–22.

Alexander Mikhailovich Rodchenko 1891–1956

(formerly attributed to)

48 Composition

1918 (?)
Oil on paperboard, 40.7 × 30.2 cm
The canvas shows a moderate convex warp and the paint layer shows losses and restoration at the edges and
 corners. Although unvarnished, it is remarkably clean. The general condition is good
Accession no.1975.45

Provenance
Galerie Jean Chauvelin, Paris.
Thyssen-Bornemisza Collection, 1975

Exhibitions
Edinburgh/Sheffield 1978, no.63, colour illus. on cover
Luxembourg/Munich/Vienna 1988–9, no.65, colour illus. p.153

Rodchenko was active in many fields – studio painting, book illustration, commercial design, architecture, and photography – and it is impossible to discuss one aspect of this complex legacy without referring to the other fields of his artistic endeavour. Perhaps Rodchenko himself would not have wished to divide his oeuvre according to the orthodox hierarchy of medium, discipline and 'quality' in the way that historians, museologists and collectors do. Rather, for Rodchenko, each painting, drawing or design was a project of equal strength and potential, which constituted a single artistic equilibrium. To some extent, this total or panoramic observation of the world was germane to the Constructivist worldview, for artists such as Liubov Popova, Rodchenko and Vladimir Tatlin were, indeed, concerned with the notions of democracy, universality and interchangeability. As Rodchenko himself stated:

> Constructivism is a contemporary worldview.
> Constructive life is the art of the future.
> Down with art as a brightly coloured patchwork in human life.
> It is time for art to fuse with life in an organized fashion.
> Down with art as a means to escape life.[1]

Perhaps this would explain Rodchenko's intense concern with the essential structure of things, whether a painted composition, a wooden hexagon or a sweet-wrapper. For Rodchenko line rather than colour or texture was the element that defined these basic mechanisms, for, as he explained in his 1919 essay, line is:

> a factor of the principal construction in any organism in life as a whole...the skeleton or the basis, the framework or system. Both in painting and in any construction line is the first and last thing. Line is the path of advancement, it is movement, collision, facetation, conjunction, combination, section.[2]

Notes
1 A. Rodchenko, 'Iz rukopisi "Rabota s Maiakovskim"' in Rodcenko et al., *A.M. Rodcenko*, p.64
2 A. Rodchenko, 'Liniia' (1919) [Line]; Eng. trans. in Cologne 1974, pp.66–7

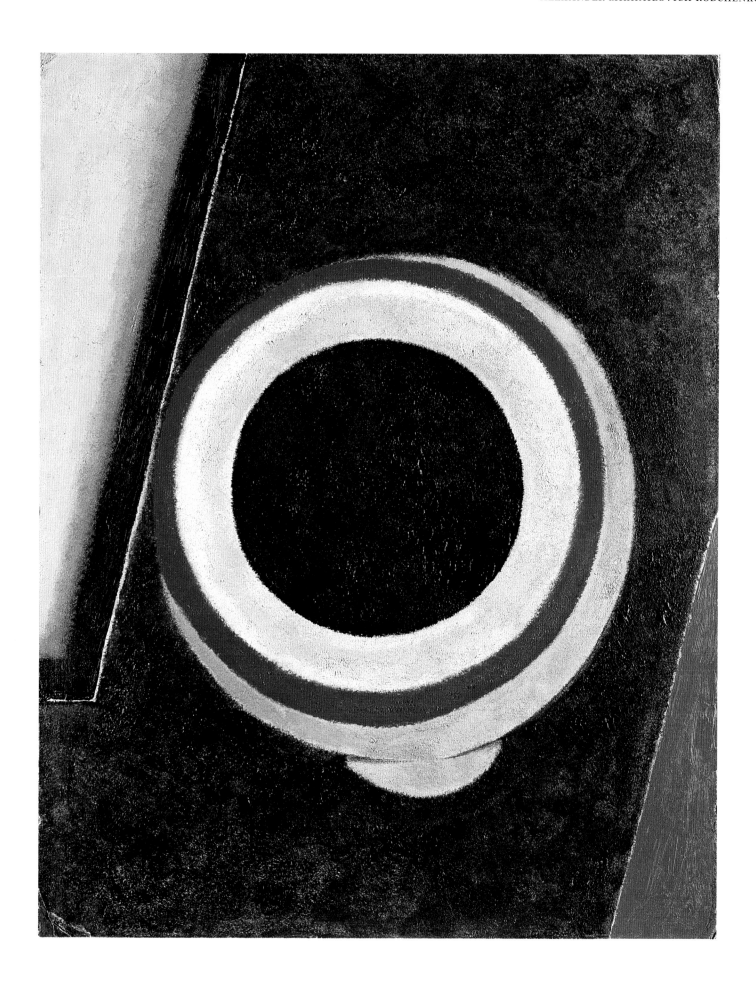

Of course, Rodchenko was not alone in this desire to perceive the work of art in terms of fundamental, abstract schemes and, through their Suprematist paintings on the one hand, and their reliefs on the other, his mentors Malevich and Tatlin contributed much to this development. Malevich, however, represented the culmination to a traditional acceptance of art as an inspired, alchemical practice wherein the artist and the work of art occupied a special aesthetic and philosophical detachment. Rodchenko abandoned this position, subscribing wholeheartedly to the tenet whereby 'Art is a branch of mathematics, like all sciences'.[3] He did not conceive of the 'finished' work of art – the oil on canvas or watercolour on paper – as an infallible and sacred object, but merely as one step across an unending space. This attitude helps explain why Rodchenko was especially interested in the multiple edition such as the book illustration and the photograph, where the concept of the 'original' or the 'authentic' image loses much of its traditional force. Moreover, the artist gave particular attention to the sketch and the study, because he seemed to realize that any visual rendering was merely a momentary improvisation that could be modified, multiplied or thrown away as circumstances dictated. Rodchenko and his colleagues, Exter, Popova, Varvara Stepanova and Alexander Vesnin made this clear in their verbal and visual contributions to the $5 \times 5 = 25$ exhibition in Moscow in 1921 at which they dismissed the notion of the 'fine arts', of the artist painting and sculpting in the privacy of the studio and of art as an activity of privilege and prestige. They shared the Constructivist platform, according to which the artist was to 'rationalize artistic labour'[4] and replace the traditional, aesthetic function of art with a utilitarian one.

That is why, like Popova, Stepanova and many other avant-garde artists, Rodchenko transferred his energies to stage design, typography and especially photography. At the same time, Rodchenko did not forget his experiments in painting and – consciously or unconsciously – applied many of his formal discoveries to his new disciplines, and, in photography, for example, 'Rodchenko perspective' and 'Rodchenko foreshortening' became common terms. Furthermore, it seems probable that Rodchenko's innovative use of light and shadow exerted an appreciable influence on Sergei Eisenstein, Lev Kuleshov and Dziga Vertov.

In his abstract paintings and constructions Rodchenko repeated and elaborated basic structures, and a number of compositions analogous to *Composition* can be found in other works of the same period, especially in arrangements of, and variations on, the motif of the circle. During his tenure at the Moscow Inkhuk, Rodchenko returned frequently to discussions of fundamental geometric forms, including the circle, and at the beginning of 1921 he even illustrated his conception of 'construction' as opposed to 'composition' with an enamel painting called *Two circles*.[5] A similar superimposition of two unequal, interacting circles can be found in *Composition no.61* (1918) from the series called 'Colour Concentration' (fig.1),[6] and in the black on black circles of *Construction* (1918; fig.2). A feature common to many of the circle compositions is the *sfumato* or eclipse effect that Rodchenko created through the gradual interfusion of the outlines of one circle with the next as in the *Composition. Two circles* of 1918 (fig.3). In most cases, the circle or circles are pronounced, although the work under discussion contains only a vestige of the minor circle in the form of a yellow arc eclipsed by the main structure. A similar superimposition of duplicated circles along a diagonal axis can be found in *Study of a circle* (1919, 45.5×40 cm, oil on wood, collection of the late Roald Dahl), a work which bears a striking resemblance to *Composition* – also in a western collection. Rodchenko also experimented with the circle motif as a graphic exercise as in his *Two circles no.127* of 1920 (fig.4) which he placed in a series called 'Line'.[6]

Although the above comparisons might be offered as evidence to reinforce the authenticity of the work under discussion, there are still serious questions. For example, microscopic examination reveals no dirt on the painting and it appears that the red portion has been dirtied artificially by the addition of indian ink. Alexander Lavrentiev, Rodchenko's grandson, does not believe the work to be by his grandfather, and most Russian scholars of the Russian avant-garde have serious reservations.

FIG 1 Alexander Rodchenko, *Composition no.61*, 1918, 42×36 cm, oil on canvas (Tula, Regional Art Museum)

FIG 2 Alexander Rodchenko, *Construction*, 1918, 71×62.5 cm, oil on canvas (Makhachkala, Daghestan Republic Museum)

FIG 3 Alexander Rodchenko, *Composition. Two circles*, 1918, 25.4×21.3 cm, oil on paperboard (Art Co. Ltd., George Costakis Collection)

FIG 4 Alexander Rodchenko, *Two circles no.127*, 1920, 62.5×53 cm, oil on canvas (Moscow, Pushkin Museum of Fine Arts)

Notes
3 A. Rodcenko, 'Slogan'; quoted in Khan-Magomedov, *Rodchenko*, p.291
4 Grigorii Miller et al., 'Pervaia rabochaia gruppa konstruktivistov' [First Working Group of Constructivists] (1924). Eng. trans. in Bowlt (1988), p.241
5 For further commentary see Rudenstine (1981), p.205, no.166
6 Also cf. Rodchenko's *Composition no.65* (from the series called 'Colour Concentration'), 1918, 90×62 cm, oil on canvas (St Petersburg, State Russian Museum)

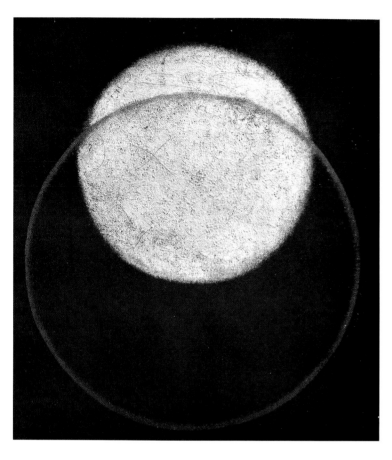

1/2

3/4

Olga Vladimirovna Rozanova 1886–1918

49 Man in the street (analysis of volumes)
Chelovek na ulitse

1913
Oil on canvas, 83 × 61 cm
The stretcher is not original. The slightly gloss to matte paint layer which seems not to have been varnished
shows signs of insecurity. But the medium-weight canvas has been relined and the general condition is good
Accession no.1976.89

Provenance
Marinetti family, Rome
Leonard Hutton Galleries, New York

Exhibitions
St Petersburg, 73 Nevskii Propsect, 10 Nov.–10 Jan. 1913–14, *Union of Youth*, no.105
Rome, Galleria Sprovieri, 13 April–25 May 1914, *Esposizione internazionale libera futurista*, no.4, [as *L'Uomo nella strada*]
Milan, Galleria del Levante, Oct.–Nov. 1964, *Il contributo russo alle avanguardie plastiche*, no.1 [under 'Olga Wladimirowna Rosanova', illus. unpaginated]
West Berlin, Deutsche Gesellschaft für Bildende Kunst (Kunstverein Berlin), Oct.–Nov. 1967, *Avantgarde 1910–30 Osteuropa*, no.104
Milan, Galleria Vittorio Emmanuele, 1970, *Astrattisti Russi*, no.27
New York 1971–2, no.110, colour illus. p.76
Los Angeles, CA, Los Angeles County Museum of Art/Pittsburgh, PA, Museum of Art, Carnegie Institute/New York, Brooklyn Museum, 21 Dec.–13 March 1976–7, *Women Artists 1550–1950*, no.133, illus. p.299
Lugano 1978, no.96 illus.
Milan 1979–80, illus. no.429
Milan 1980, illus. p.97
Los Angeles/Washington DC 1980–81, no.328, illus. p.241
Modern Masters from the Thyssen-Bornemisza Collection 1984–6, no.46, colour illus. p.68
Luxembourg/Munich/Vienna 1988–9, no.66, colour illus. p.155

Literature
G. Veronesi, 'Suprematisti e Costruttivisti in Russia' *L'Arte Moderna*, v, no.44, 1967, colour illus. p.305
A. del Guercio, *Le avanguardie Russe e Sovietiche*, Milan (Fabbri) 1970, colour illus. no.LIV, p.80
A. del Guercio, *Russische Avantgarde von Marc Chagall bis Kasimir Malewitsch*, Herrsching (Schuler) 1988, colour illus. no.54, p.78
J.-C. Marcadé, *Le Futurisme Russe*, colour illus. p.53

Man in the street was one of four paintings that Rozanova submitted to the *Esposizione libera futurista internazionale. Pittori, scultori. Italiani russi-inglesi-belgi-nordamericani* at the Galleria Futurista di Sprovieri, Rome, in the spring of 1914 (see [13]), the others being *The port* (1913, private collection), *Dissonance* (also called *Dissonance (directional lines)*; [50], fig.3), and *Factory and the bridge* (1913, New York, Museum of Modern Art). In addition, Rozanova submitted two examples of her graphic illustrations for the booklets *Utinoe gnezdyshko* [Duck's nest] (1913) and *Te li le* (1914). No doubt, the four canvases were brought from St Petersburg to Rome by Marinetti who had first seen Rozanova's work during his visit to Russia in January and February of that year, and after the exhibition they found their way into his own collection. It is not known why or when the title of *Man in the street* was supplemented with *Analysis of volumes*.

 As a member of the Union of Youth in St Petersburg, Rozanova was in close touch with Nikolai Kulbin, one of Marinetti's hosts and translators during the trip, and, presumably, it

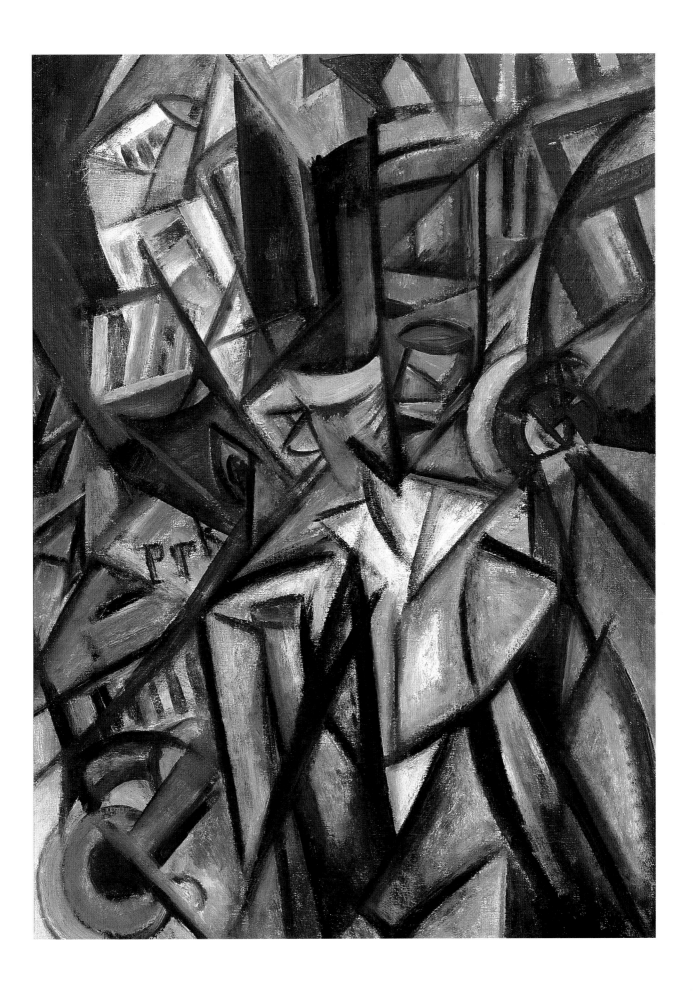

was on his recommendation that Marinetti selected Rozanova's works. In any case, Marinetti visited St Petersburg just after the closing of the *Union of Youth* to which Rozanova contributed sixteen works and just before the publication of the third Union of Youth almanac (*Soiuz molodezh*) which contained Rozanova's important essay, 'The Bases of the New Creation and the Reasons Why It Is Misunderstood' (see [50]). Furthermore, Marinetti's presence in St Petersburg concided with the publication there at the end of January of the scandalous miscellany *Rykaiushchii parnas* [Roaring Parnassus] to which David and Vladimir Burliuk, Pavel Filonov, Ivan Puni and Rozanova contributed illustrations and for which the collection was censored.[1] In other words, by the time Marinetti made the acquaintance of Rozanova, she already enjoyed a certain notoriety as a Cubo-Futurist. As Benedikt Livshits recalled:

> She was an outstanding individual. She was someone who really knew what she wanted in art and who'd advanced towards her goal by paths different from everybody else's. Despite their differences of opinion, artists such as Goncharova and Exter, who were uncompromising in their tastes, took her very seriously.[2]

No doubt, Rozanova's reception and refraction of Italian Futurism as well as her youthful charms endeared her to Marinetti, and a photograph of one of his presentations shows us Rozanova, as well as Nadezhda Dobychina, Kulbin, Artur Lurie, etc. in the audience.[3]

Rozanova's contribution of sixteen works to the 1913–14 *Union of Youth* exhibition demonstrated her interpretation of Futurism as 'dynamism, rhythmical "displacement", dissonance'[4] which she explored in paintings such as *Man in the street*. As the critic Abram Efros asserted in his obituary of 1919, Rozanova's Futurism was:

> enormous and roaring...It is neither intimate nor peaceful and quiet, since it was born in Italy, where a house resembles a street and a street is like a house. It is nourished by the city life of people and is addressed to those who crowd its streets and squares.[5]

On this level, Rozanova shared her fragmented urban imagery with several other Russian and Ukrainian artists, including Alexander Bogomazov (e.g. *Tramway*, 1914; fig.1), Alexandra Exter (e.g. *City at night*, 1913, St Petersburg, State Russian Museum), Natalia Goncharova (e.g. *Electric light*, 1912, Paris, Musée National d'Art Moderne), Mikhail Le-Dantiu (e.g. *Automobile turning*, 1912, Orel, Regional Art Museum), Kazimir Malevich (whose *Knife-grinder*, 1914, New Haven, CT, Yale University Art Museum, was also at the 1913–14 *Union of Youth* exhibition), and even Vladimir Maiakovsky (e.g. *Yellow jacket*, 1918; fig.2). Incidentally, in December 1913 Rozanova also designed the poster for the so-called *The First World Productions by the Futurists of the Theatre – Victory over the Sun* and *Vladimir Maiakovsky. A Tragedy*.

As in the case of other Russian Futurists, Rozanova's images of the city blend and interweave as they fall victim to the pressures and energies of the metropolis. In his *Building a city* (1913, 45 × 68 cm, pen and pencil on paper, St Petersburg, State Russian Museum) for example, Filonov fuses houses and people, as Rozanova does in her *Building a house* (1913, 91.5 × 110 cm, oil on canvas, Samara, Regional Art Museum). The latter has strong parallels with *Man in the street* both in the interplay of black and ochre, the diagonal and circular arrangement of the composition, and in the juxtaposition of the façades of the houses which become part of the man's top-hat (?) in *Man in the street*. There are a number of curious 'futurist landscapes' on the market attributed to Rozanova, such as *Landscape (decomposition of forms)* (1913, Cologne, Museum Ludwig) and *Futurist landscape* (1913, private collection), but these require extensive study before an informed opinion can be reached and before they can be accepted into the artist's oeuvre.[6]

FIG 1 Alexander Bogomazov, *Tramway*, 1914, 142 × 74 cm, oil on canvas (Moscow, Collection of Valerii Dudakov and Marina Kashuro)

FIG 2 Vladimir Maiakovsky, *Yellow jacket* (also called *Self-portrait*), 1918, 51 × 32 cm, oil on canvas (Moscow, Collection of Vasilii Katanian; courtesy of Natan Fedorowskij)

Notes

1 Allegedly, the miscellany was withdrawn from circulation because the censor considered Filonov's drawings to be pornographic. For some discussion of the incident see N. Misler and J. Bowlt, *Pavel Filonov: A Hero and His Fate*, Austin (Silvergirl) 1983, p.12
2 Livshits/Bowlt (1977), p.128
3 The photograph is published in *Olga Rozanova*, 1992, p.7. For information on Marinetti in Russia see Livshits/Bowlt (1933/ 1977), pp.181–213; K.B. Jensen, 'Marinetti in Russia: 1910, 1912, 1913, 1914?', *Scando-Slavica*, xv, Copenhagen, 1969, pp.21–6; J.-C. Marcadé ed., *Présence de F.T. Marinetti*, Lausanne (L'Age d'Homme) 1982, pp.179–274; N. Kotrelev, 'F.T. Marinetti i Rossiia' in N. Kurennaia et al., eds., *Italiia i slavianskii mir*, Moscow (Akademiia nauk) 1990, pp.95–6
4 N. Gurianova, 'Zhivopis Olgi Rozanovoi' [text only in Russian] in *Olga Rozanova*, 1992, p.89
5 A. Efros, 'Vo sled ukhodiashchim' (1919); Eng. trans. in *Olga Rozanova*, 1992, pp.21–2
6 For a colour illus. of *Landscape (decomposition of forms)*, 1913, 57 × 40 cm, Cologne, Museum Ludwig, see *Vanguardia Rusa*, 1985, p.157; for a colour illus. of *Futurist landscape*, 1913, oil and gouache on canvas, 75.5 × 53.5 cm, private collection) see *Russian Constructivism and Suprematism*, 1991, p.67

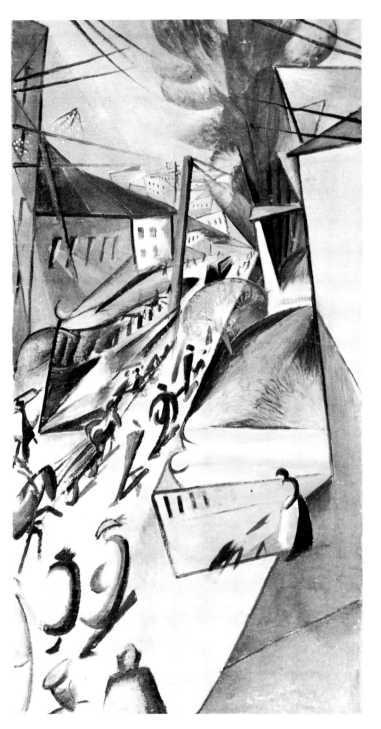

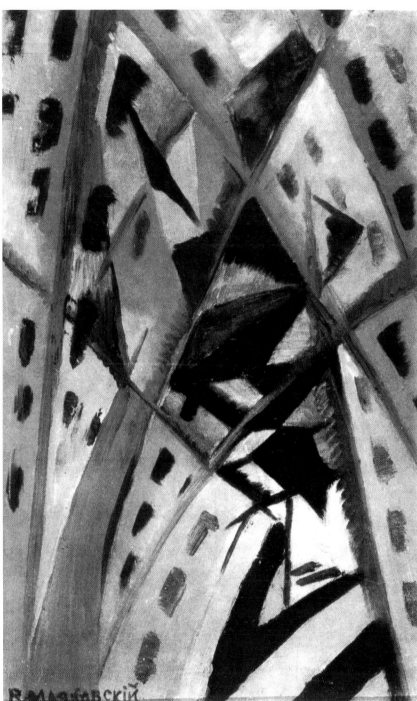

Olga Vladimirovna Rozanova 1886–1918

50 Urban landscape

1913–14
oil on cardboard, 66 × 51 cm
The cardboard has been split and glued to a panel. The unvarnished paint layer shows pronounced horizontal
 splits and some repairs. The general condition is fair
Accession no.1980.25

Provenance
Kirill Zdanevich, Tiflis
Vasilii Rakitin, Moscow
Galerie Gmurzynska, Cologne
Thyssen-Bornemisza Collection, 1980

Exhibitions
Cologne 1979–80, no.72, p.216, colour illus. p.217
Cologne 1986, p.138, colour illus. p.139
Leningrad/Moscow 1988, no.29, colour illus. p.57

Literature
R. Cembalest, 'Lighter and Brighter', *Art News*, New York, April 1993, p.59

Olga Rozanova was one of the few members of the Russian avant-garde to translate and paraphrase the principles of Italian Futurism in any consistent manner without imbuing them with 'extraneous' ideas. Certainly, her interest in the new technology of trains, aeroplanes and phonographs was shared by colleagues such as Alexandra Exter, Ivan Kliun and Kazimir Malevich, but she did not, for example, use the humorous non-sequiturs that Mikhail Larionov tended to apply to his Futurist paintings such as *Boulevard venus* (1912, private collection). As in *Man in the street (analysis of volumes)* [49], Rozanova's *Urban landcape* pays homage to this new technology which she has intepreted as a source of almost destructive power and energy. Rozanova took the 'chaotic street scene where fragments of buildings collide and slide into telegraph poles'[1] and, in emphasizing the forcelines and abrupt articulations of the town (which, presumably, she discovered in the port, bridges, and railways of St Petersburg), reduced her vision to a schematic configuration in which the emotional effect of the clashing lines, screeching colours and centrifugal movement was more important than the actual representation of particular machines or buildings. It is a process that led Rozanova to her theoretical affirmation of abstract art in 1913 and her Suprematist paintings of 1916 onwards, for the art of painting, she wrote, is

> the decomposition of nature's ready-made images into the distinctive properties of the common material found within them and the creation of different images by means of the interrelation of these properties...The artist determines these properties by his visual faculty...
>
> Only modern Art has advocated the full and serious importance of principles such as pictorial dynamism, volume and equilibrium, weight and weightlessness, linear and planar displacement, rhythm as a legitimate division of space, design, plane and surface dimension, texture, colour correlation and others...They are principles...which signify the rise of a new era in creativity – an era of purely artistic achievements.[2]

By 1913–14 Rozanova was already using sharp juxtapositions of colours without necessarily alluding to the traditional narrative or even perspectival role of colour and form. Rozanova was consistent and rational in her methodology, whether in paintings, drawings or book designs, and her premature death in 1918 was 'one less world in the universe'[3] She wrote experimental

Notes
1 Howard, *Union of Youth*, p.176
2 O. Rozanova, 'Osnovy novogo tvorchestva i prichiny ego neponimaniia' (1913) [The Bases of the New Creation and the Reasons Why It Is Misunderstood]; Eng. trans. in Bowlt (1988), pp.103, 108
3 Y. Annenkov, *Teatr chistogo metoda*, undated MS in Russian State Archive of Literature and Art, Moscow, Call no.: f. 2618, op.1, ed. khr. 14, l. 173

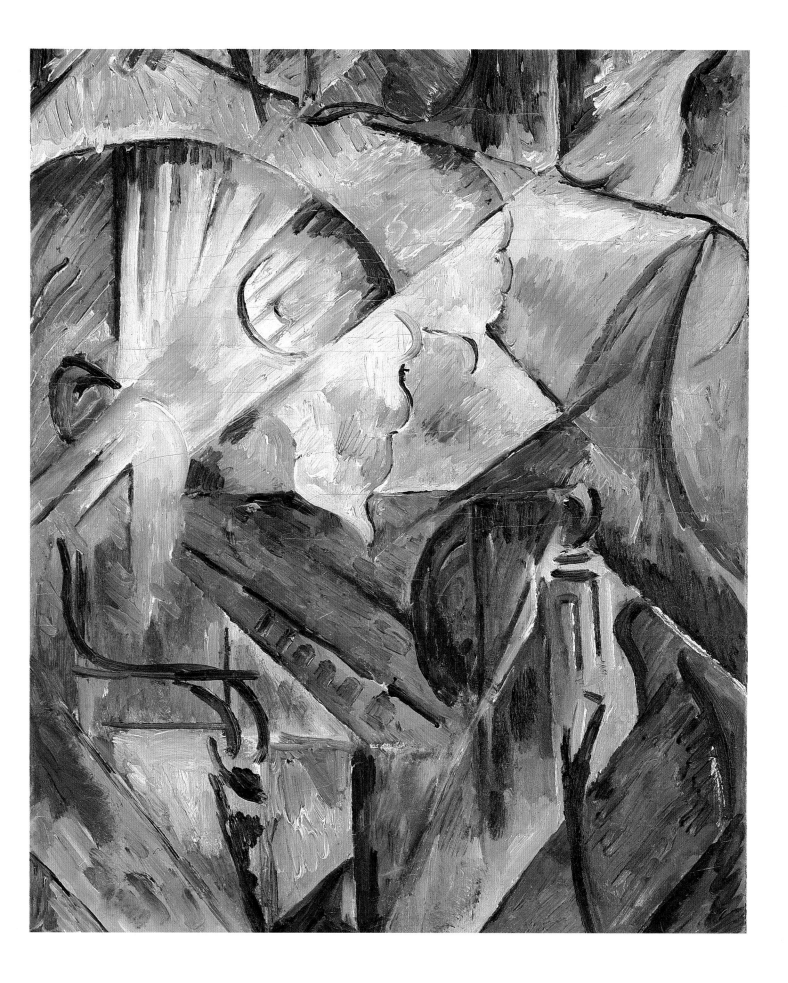

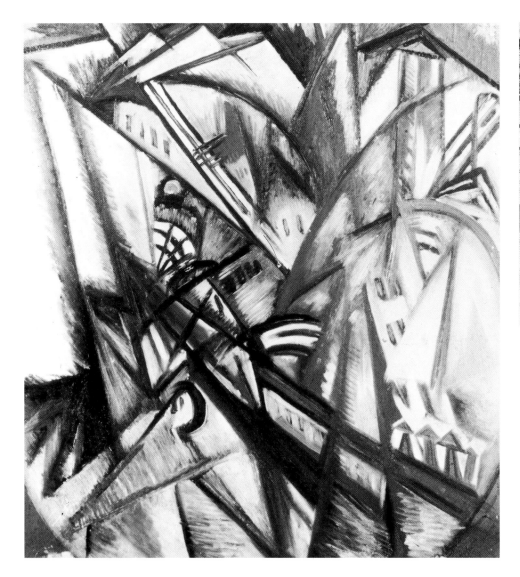

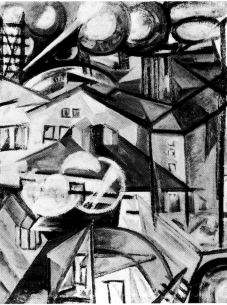

poetry, as many of the avant-garde artists did, and although she did not achieve the heights of Varvara Stepanova's graphic poetry, she published some of it and even thought of becoming a poet rather than a painter.[4] Her friend Kliun wrote on the occasion of her posthumous exhibition in 1919:

> Her ever-searching soul, her exceptionally developed sense of intuition could never compromise with the old forms and always protested against all repetition whether in everyday life or in art.[5]

The cityscape with its machines, electric lights and bustling crowds was a subject that Rozanova interpreted in many of her paintings and drawings of the 1910s, and the catalogue of her posthumous exhibition in Moscow in 1919 contains several urban themes such as *City landscape* (nos.15, 34) and *Railway landscape* (no.17), although it is impossible to conclude whether the work in question was among the exhibits. Rozanova's dynamic conception of the new metropolis had much in common with that of the Italian Futurists' whose celebration of 'the formidable noise of enormous double-decker streetcars'[6] must have appealed to her. According to Vasilii Rakitin, one of the previous owners, *Urban landscape* was originally in the collection of the Georgian Cubo-Futurist artist, Kirill Mikhailovich Zdanevich (1892–1969), although where and how he acquired it is not known.

Almost abstract, *Urban landscape* still contains vestiges of concrete reality, for the 'windows' that advance diagonally across the canvas are, presumably, the windows of the same train that

Notes
4 Some of Rozanova's experimental poetry was published in *Iskusstvo*, no.4, Moscow, 1919, p.1
5 I. Kliun, intro. to the catalogue of Rozanova's posthumous exhibition, *Gosudarstvennaia vystavka. Katalog posmertnoi vystavki kartin, etiudov eskizov i risunkov O.V. Rozanovoi*, Moscow (Kushnerev) 1919, p.i
6 F.T. Marinetti, 'Manifeste du futurisme' in *Le Figaro*, Paris, 20 Feb. 1909; quoted in M.D. Gambillo and T. Fiori, eds., *Archivi del futurismo*, Rome (De Luca) I, 1958, p.15
7 N. Gurianova, 'Zhivopis Olgi Rozanovoi' [text only in Russian] in *Olga Rozanova*, 1992, p.89

FIG 1 Olga Rozanova, *Urban Landscape*, 1913–14, 71 × 71 cm, oil on tin (Samara, Samara Art Museum)

FIG 2 Olga Rozanova, *City (industrial landscape)*, c1913, 103 × 80 cm, oil on canvas (Slobodsk, Local Ethnographical Museum of Slobodsk-Kirov Region)

FIG 3 Olga Rozanova, *Dissonance (directional lines)*, 1913, 104.1 × 81.9 cm, oil on canvas (Des Moines, IA, Louise Noun Collection)

FIG 4 Olga Rozanova, *Composition*, 1914–15, 35.5 × 51 cm, oil on tin (Yaroslavl, State Art Museum)

rushes through the skyscrapers of *Urban landscape* (1913–14; fig.1) while the blazing lights on the right and the smoke in the centre repeat the same prismatic refractions of lights or chimneys in *City (industrial landscape)* (c1913; fig.2). The windows of the skyscraper leaning sharply to the right in the bottom right of the painting here reappear in the Samara *Urban landscape*. The axial encounter of the diagonal forcelines generated by the train and the lights recurs as an abstract version in the painting called *Dissonance (directional lines)* (1913; fig.3). By 1914–15 the last references to the objects that generate these sensations of speed and light have virtually disappeared in Rozanova's dynamic exercises in textural and linear collision such as *Composition* (1914–15; fig.4) and the composition called *Landscape* (1913, 40.5 × 32 cm, oil on canvas, private collection). Rozanova's highly textured brushstrokes intensified even more by the deposition of the paints on a white base is also characteristic of her Futurist engagement, even in the more serene interiors and still-lifes such as the *Still-life with a green jug* (c1912, St Petersburg, State Russian Museum). Nina Gurianova, the Russian specialist in Rozanova's work, writes that in *Urban landscape*:

> the eye can make out the subject only by the individual details amidst this apparent chaos and fortuity – the parapet of an embankment, reflections on the water. The colour scale is restrained: grey, brown and lilac tones. Moreover, Rozanova has used a thick layering of paint and has then gone over it again with a hatching, pointed or thick brushstroke. This produces the impression of a self-sufficient texture, flowing and palpitating.[7]

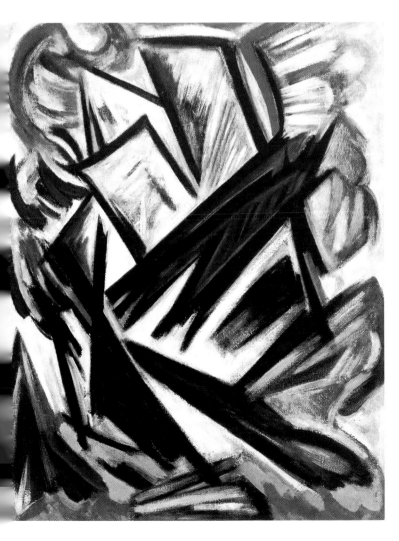

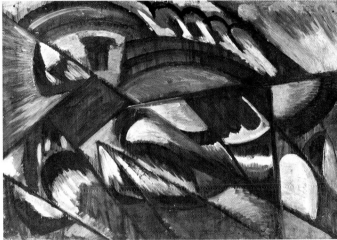

Varvara Fedorovna Stepanova 1894–1958

51 Billiard players
Igroki v biliard

1920
Oil on canvas, 66 × 129 cm
Signed and dated in Russian lower right: 'Varst Step 20'
Signed and dated on *verso* upper left in Russian: 'Varst V. Stepanova 1920'
The *verso* also carries the inscription lower left in Russian: 'No.14 M 1920'
The canvas shows much cockling and bulging and the white and thick paint layers show overall cracking and are
 yellowed and dirty. The varnish has been applied unevenly. The general condition is fair
Accession no.1986.18

Provenance
Varvara Rodchenko, Moscow
Galerie Gmurzynska, Cologne

Exhibitions
Moscow, Art Salon, 2 Oct.–Nov. 1920, 11 Bolshaia Dmitrovka, *XIX State Exhibition*, no.14
Moscow, Institute of Artistic Culture, autumn 1920, *Exhibition of Four Artists*, no.114
Cologne 1984, no.14, colour illus. p.275
Cologne 1986, p.140, colour illus. pp.140–41

Literature
A. Lavrentiev, *Varvara Stepanova*, p.43 [as *Men playing billiards*]

Vladimir Maiakovsky once described Stepanova as a 'frenzied artist'.[1] Indeed, never satisfied with any one style, idea or discipline, Stepanova seemed to live in a constant frenzy of artistic activity. She explored an entire mosaic of artistic trends from Symbolism to Socialist Realism, although she is now recognized above all for her interpretations of the Constructivist aesthetic. She was in touch with the leading artists, poets and film-makers of her time such as Alexei Gan, Vasilii Kandinsky, Liubov Popova, Esfir Shub and, of course, her husband Alexander Rodchenko, and was attached to the primary centres of the avant-garde movement after the Revolution, Inkhuk and Svomas/Vkhutemas.

Until *c*1921 Stepanova was concerned primarily with studio painting and graphics and was an enthusiastic supporter of transrational poetry, as she demonstrated in her statement in the catalogue of the *X State Exhibition* in 1919:

> Non-objective creativity is still only the beginning of a great new epoch, of an unprecedented Great Creativity, which is destined to open the doors to mysteries more profound than science and technology.[2]

Of all the leading members of the Russian avant-garde who concerned themselves with industrial and functional design in the 1920s, only Stepanova had received training in the applied arts (at the Stroganov Central Industrial Art Institute in Moscow). She drew particular benefit from this while working on her textile designs at the First State Textile Factory and it was there that Stepanova, like Popova, tried 'to propagate the productional tasks of Constructivism'.[3] Perhaps the most remarkable consequence of Stepanova's theory was her several designs for sports clothes in which she combined an economy of material with emphatic contrasts in colour while rejecting all ornamental or 'aesthetic' elements as superfluous.

Notes
1 In a dedication in one of the books that he gave to Stepanova in 1923, Maiakovsky wrote 'To the frenzied Stepanova with tenderest feelings.
V. Maiakovsky'. The page is reproduced in Lavrentiev, *Varvara Stepanova*, p.10
2 V. Stepanova, 'Bespredmetnoe tvorchestvo' (1919); Eng. trans. in Bowlt (1988), p.142
3 Statement by Stepanova; quoted in T. Strizhenova, *Iz istorii sovetskogo kostiuma*, Moscow (Sovetskii khudozhnik) 1972, p.97

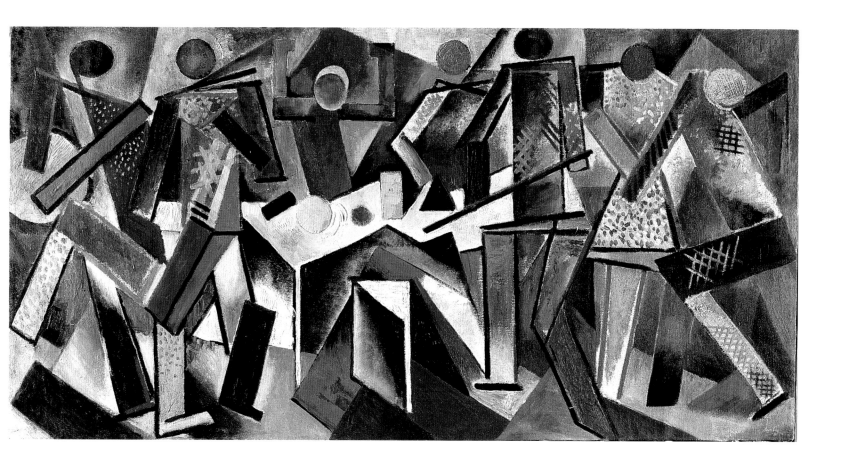

Stepanova followed a similar conception in her work for the theatre, as indicated by her sets and costumes for *The Death of Tarelkin* (1923) and her various projects for evenings of propaganda entertainment at the Academy of Communist Education in Moscow in the early 1920s.

In other words, Stepanova has every right to be considered a major contributor to the avant-garde cause and, together with Alexandra Exter, Natalia Goncharova, Popova and Olga Rozanova, is, as Benedikt Livshits would have said, 'an amazon, a Scythian rider'.[4] Even so, critics have perhaps tended to associate her too readily with her male companion and to relegate her to the same kind of artistic partnership that has befallen the fate of Goncharova and Mikhail Larionov, Rozanova and Alexei Kruchneykh and Valentina Kulagina and Gustav Klucis. Of course, Stepanova's married life with Rodchenko was a happy one and the couple engaged in many joint enterprises – photography, book design, exhibitions, conferences – and, in living together, they often shared the same artistic materials, commissions and theoretical elaborations. As a result, there are many parallel points of reference between the two artists, whether in the visual poetry and collages of 1918–19, the linocut figures of 1919–20 or in the layouts for the propaganda albums of the 1930s. But Stepanova was not a student of Rodchenko, just as he was not a student of Stepanova, and, ultimately, her artistic physiognomy was different from his. For example, she was not especially drawn to non-objective painting, did not regard photography as a replacement for painting and did not investigate the three-dimensional and architectural constructions that fascinated Rodchenko, even though her involvement in the $5 \times 5 = 25$ exhibition in Moscow in 1921 and her support of utiliarian Constructivism at Inkhuk might indicate otherwise. On the other hand, both Stepanova and Rodchenko approached the artistic experience as one of public, not private, communication. The enharmonic chords of her visual poetry play to us, her syncopated figures invite us to arise and move, her posters and book illustrations refer to the telephone, the radio, film and other instruments of mass media. In this respect, Stepanova's orientation towards the human being on the one hand and to utilitarian art on the other is logical and understandable, for, far from ignoring the human figure in her experimental work of the late 1910s and early 1920s, Stepanova remained with it. Perhaps one reason why she investigated the medium of the collage, using photographic fragments, pieces of newspaper and advertisements with their direct references to concrete life, is that it helped to reintroduce a 'readable' content into the work of art and, in this sense, opposed the abstract systems, such as Suprematism, of the same period. It would be an exaggeration to claim that Stepanova felt a nostalgia for the art of Realism, but anthropomorphic forms recur in many of her experimental paintings and graphics of 1918–21, especially in the cycle of 'stick figure' compositions to which *Billiard players* belongs.

Stepanova's figures, single and in groups, may give the impression of casuality and spontaneity, but they actually relate to a rigorous theoretical construct that she elaborated from 1919 onwards. Firstly, these figures represent Stepanova's concept of the new Socialist human being – robotic, automatic, dynamic – that also attracted El Lissitzky, Malevich and Popova and that is summarized so well in Lissitzky's puppet called *The new man*, of 1923.[5] Secondly, these faceless individuals represent action, for they all are engaged in some kind of sports, musical or motor activity. Thirdly, in spite of their mechanical quality, they also illustrate particular emotional states – excitement, obsession, serenity – which provides them with an ordinary, everyday context. As Stepanova's grandson, Alexander Lavrentiev, explains:

> Stepanova investigated typical poses: sitting, standing, dancing, jumping, talking. The area around the figures was composed of the same elements, though larger in scale. Figures embodied a particular view of the world, based on geometry, structure and order. Only one step separated these compositions from her new conception of clothing and geometric fabric design...Angled brushstrokes predominate, as in Cubist painting. Still another new kind of cross-wise brushstroke is introduced, but in painting with colour this stroke is perceived not as rigid hatching, but as a coloured fabric, an ornamental structure.[6]

Notes

4 Livshits/Bowlt (1977), pp.128–9

5 The reference is to the figure called *Neuer* on the tenth sheet in El Lissitzky's portfolio of lithographs for *Die plastische Gestaltung der Elektro-Mechanischen Schau 'Sieg über die Sonne'*, Hanover (Leunis and Chapman) 1923. For a colour illus. see, e.g., S. Lissitzky-Küppers *El Lissitzky, Life, Letters, Texts*, London (Thames and Hudson) 1968; pl.62

6 Lavrentiev, *Varvara Stepanova*, pp.43–4

FIG 1 Photograph of a wall in the studio that Stepanova shared with Rodchenko in Moscow, 1921 (Moscow, Alexander Rodchenko and Varvara Stepanova Archive)

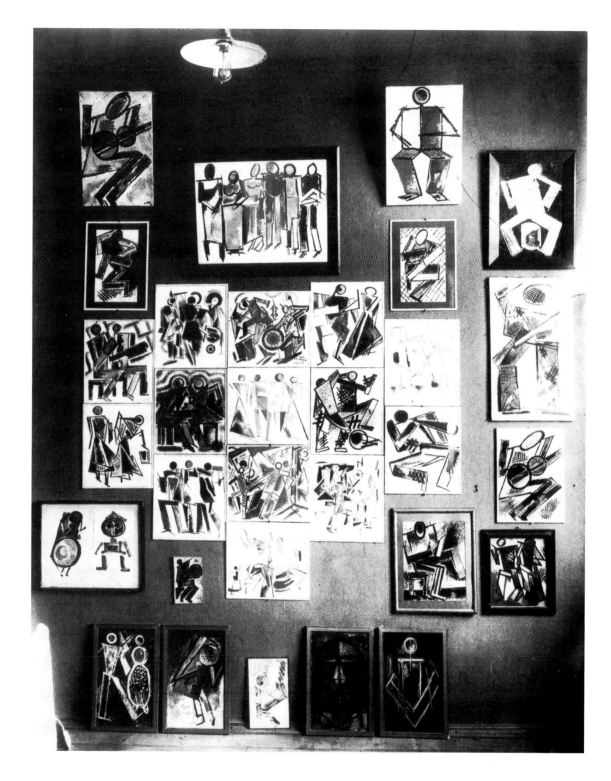

Obviously, Stepanova set great store by these experiments and by 1921 they occupied a wall of the studio that she shared with Rodchenko (fig. 1). She was careful to solicit the opinions of her colleagues, including Robert Falk and Kandinsky, and she contributed twenty-two paintings and thirty-eight graphic works on the same theme to the *XIX State Exhibition* in October 1920

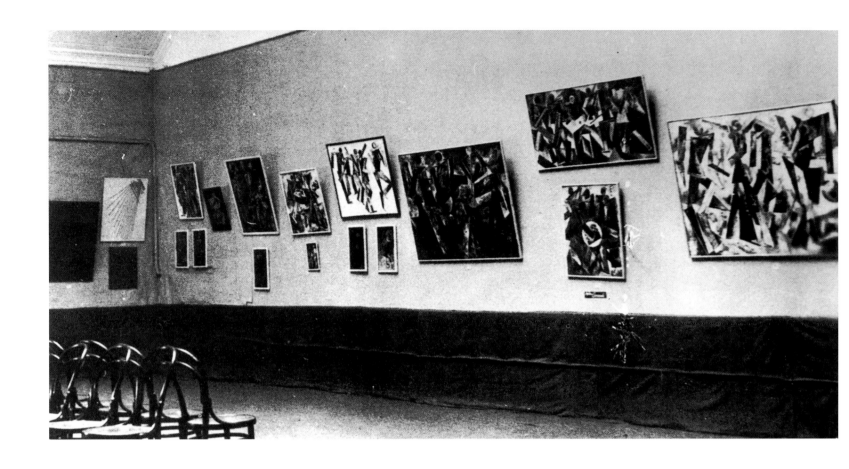

(fig.2) covering an entire wall with her works, including *Billiard players*. This was an important venue, because it presented works by artists of different persuasions – from the avant-garde such as Kandinsky, Nikolai Ladovsky and Rodchenko to the more traditional such as Sergei Konenkov and Nikolai Krymov. Stepanova noted in her diary after the vernissage that 'everyone congratulated me as if it were my name-day'.[7] Clearly, the positive response prompted Stepanova to pursue her avenue of enquiry further and she contributed similar works, again including *Billiard players*, to *Four Artists* later that year.[8]

Billiard players is an unusually large work in the Figures series, although the basic theme and formal arrangement recur in many graphic and painted works of the time, for example *Five figures* (1920; fig.3), *Three figures* (1920; fig.4), and *Draughts players* (1920; fig.5). Although *Billiard players* is a painting, to a certain extent Stepanova approached the assignment as a graphic exercise, defining the shapes with strong clarity, emphasizing the grey and white areas and adding the dotted, criss-cross patterns as if the base material were graph paper. Not surprisingly, Stepanova repeated the musicians, dancers and sportsmen in indian ink, pencil and linocuts where the contrasts are particularly abrasive.

Notes
7 Quoted in ibid., p.44. For other comments by Stepanova on the *XIX State Exhibition* see Cologne 1984, pp.250–60
8 *Four Artists* also included Kandinsky, Rodchenko and Nikolai Sinezubov

FIG 2 Photograph of a wall at the *XIX State Exhibition*, Moscow, 1920, showing part of Stepanova's contribution, including *Billiard players* (Moscow, Alcxander Rodchenko and Varvara Stepanova Archive)

FIG 3 Varvara Stepanova, *Five figures*, 1920, 89 × 98 cm, oil on canvas (Moscow, Alexander Rodchenko and Varvara Stepanova Archive)

FIG 4 Varvara Stepanova, *Three figures*, 1920, 39.5 × 35 cm, tempera on paper (Moscow, Alexander Rodchenko and Varvara Stepanova Archive)

FIG 5 Varvara Stepanova, *Draughts players*, 1920, 78 × 62 cm, oil on plywood (Moscow, Alexander Rodchenko and Varvara Stepanova Archive)

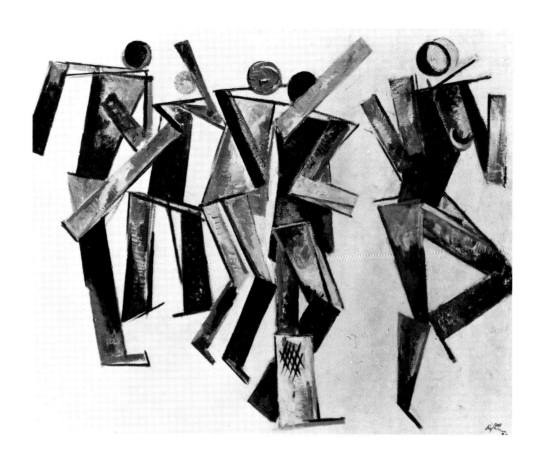

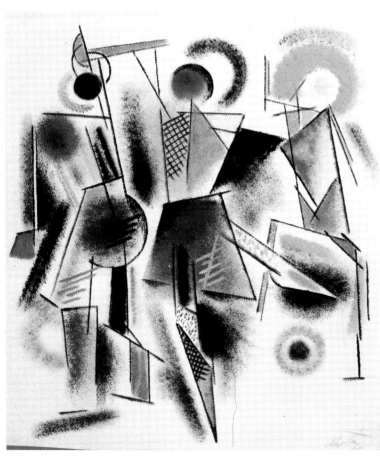

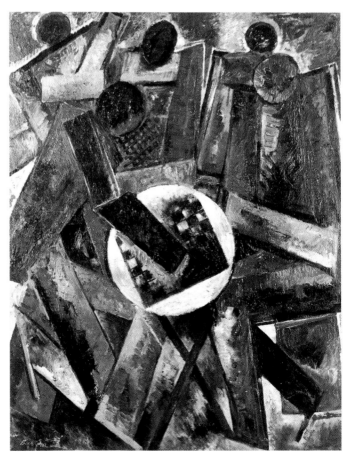

Varvara Fedorovna Stepanova 1894–1958

52 Two figures at a table

1921
Gouache and pencil on paper, 28.2 × 28.2 cm
Signed and dated in Russian lower right: 'Varst 21'
The paper has yellowed considerably. The general condition is good
Accession no.1983.28

Provenance
Given by Alexander Rodchenko to Alfred Barr Jr., as a donation to the Museum of Modern Art in 1936
Museum of Modern Art, New York
Adler-Castillo Gallery, New York
German Jimenez, Caracas
Rachel Adler Gallery, New York
Andrew Crispo Gallery, New York
Thyssen-Bornemisza Collection, 1983

Exhibitions
New York, Museum of Modern Art, 29 July–1 Nov. 1971, *Ways of Looking* [unnumbered]
New York, Andrew Crispo Gallery, 28 Jan.–1 March 1983, *Development and Aesthetics of the Early 20th Century*,
 no.51

Two figures at a table belongs to another series of figures that Stepanova produced in 1920 and also contributed to the *XIX State Exhibition*. Although Stepanova has reduced her 'new people' to the same kind of mechanical scheme that we see in [51], this other series relies on a different technique and is intended to serve a rather different purpose. Writing of the very similar composition of 1920 (fig.1) also called *Two figures at a table*, Lavrentiev explains:

> The entire image is constructed using tools 'untouched by human hands': a paper stencil and an even, 'mechanical' colouring of the surface using a half-dry bristle brush. Technique and style both create the image of a unified world where the forms of the human body, the furniture, and the picture on the wall are governed by the same general constructive laws.[1]

Note
1 Lavrentiev, *Varvara Stepanova*, p.36

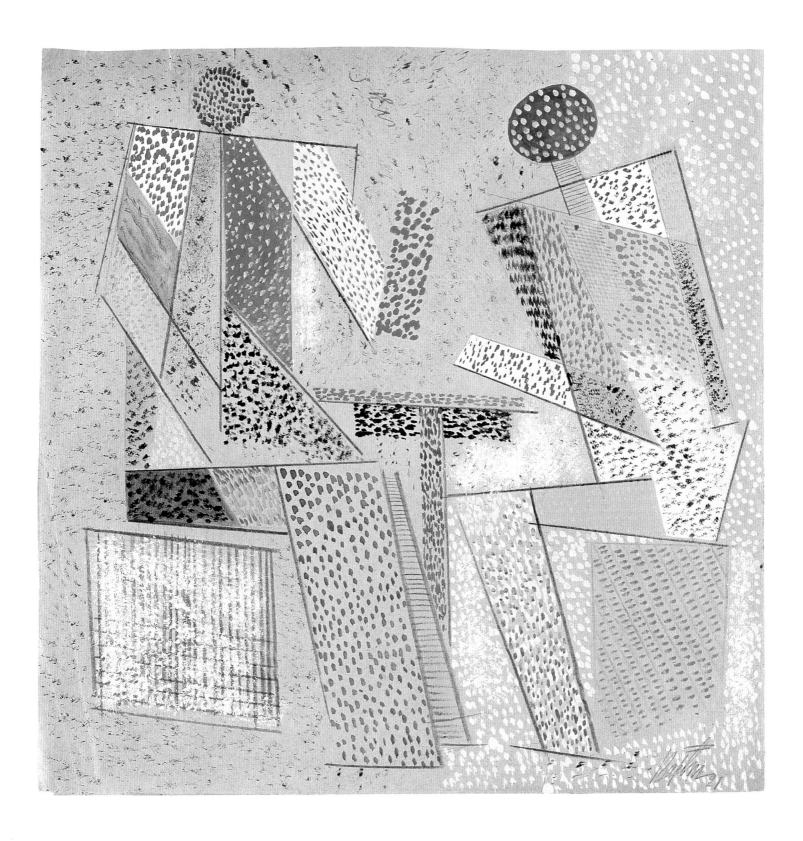

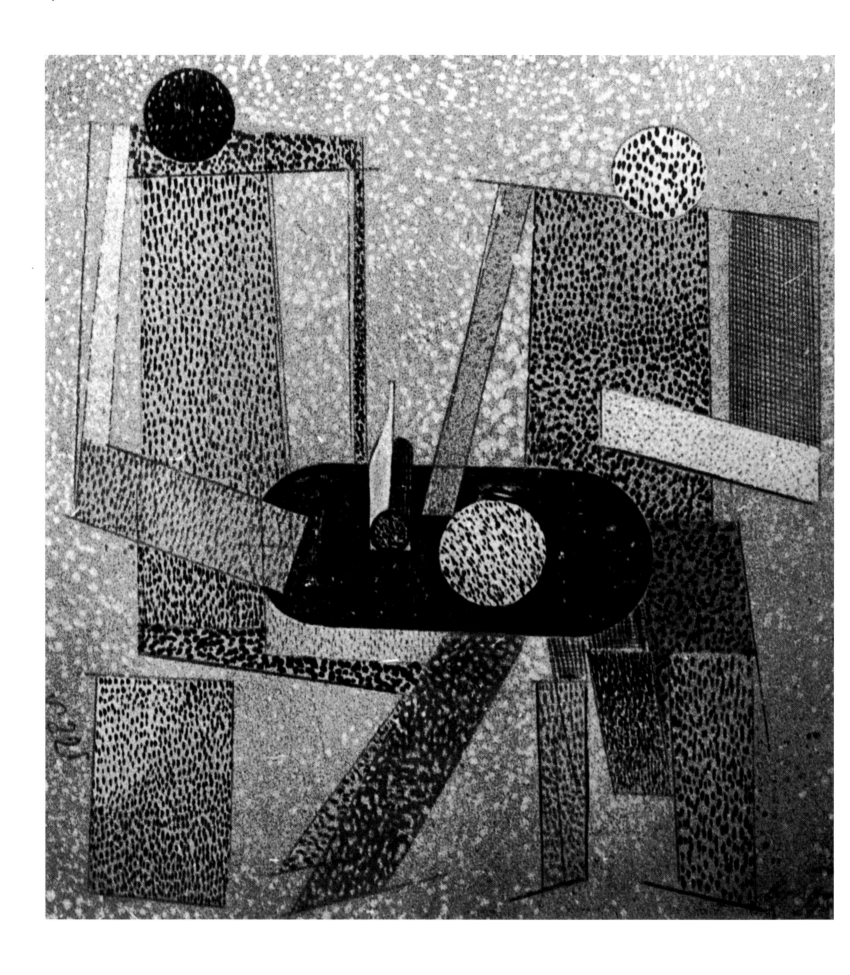

While the visual focus here is on the surface treatment and texture of the composition, the strong contrasts between the grey, white and black dots and the criss-cross patterns remind us of Stepanova's graphic experiments with the human figure. In particular, there is a strong analogy with the 'humanoids' that she drew as illustrations for Alexei Kruchenykh's play *Gly-Gly* (1919; fig.2) although the conception also looks forward to the rigorous designs that she made for sports clothes and textiles in 1923–4 with their rhythmical angularity and simple geometric contrasts. Still, the *pointillisme* of *Two figures at a table* is rather unusual for Stepanova, although it does reappear in Rodchenko's work, such as his title-page for the portfolio of costume designs for Alexei Gan's play *Us* (1919–20; fig.3).

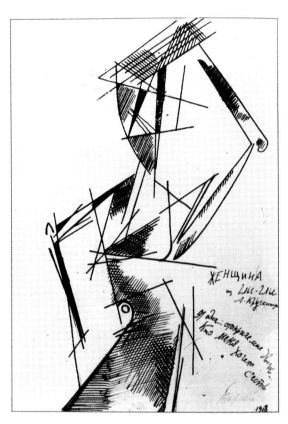

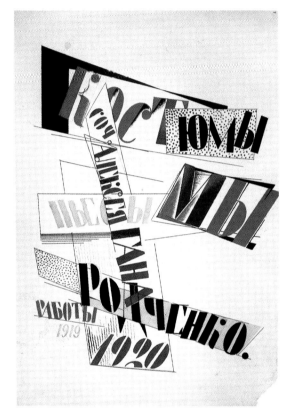

Władysław Strzemiński 1893–1952

53 Untitled

1946–8
Gouache and pencil on paper, 38.6 × 49.6 cm
Signed lower right: 'ws'
The *verso* carries four sketches for a costume and is signed lower left 'Danuta Kulanka' and upper right 'sv 3'
The paper is slightly bulging. The unvarnished paint layer shows numerous scratches and abrasions. The general
 condition is fair
Accession no.1978.67

Provenance
Danuta Kulanka, Warsaw
Galerie Gmurzynska, Cologne
Thyssen-Bornemisza Collection, 1978

Exhibitions
Cologne 1986, p.10, illus. p.101
Leningrad/Moscow 1988, no.3,
 colour illus. p.58

[53] *verso*

While a student in Russia between 1917 and 1921, Strzemiński studied the radical artistic systems of both Kazimir Malevich and Vladimir Tatlin, interpreting Suprematism and the relief in an original and distinctive fashion. His counter-relief entitled *Tools and industrial products* of 1919 (St Petersburg, State Russian Museum), for example, seems to use Tatlin's assemblage of materials as its departure-point, although in its improbable conglomeration of 'bits and pieces' it also brings to mind the Merz compositions of Kurt Schwitters. On the other hand, Strzemiński's early abstract paintings such as *Cubism. Tension of material structure* (1919–21, Warsaw, Muzeum Narodowe) tell us of his formal researches into Cubist and Futurist painting and of the influence of Malevich's artistic and didactic methods disseminated via the Unovis movement (see [7]). While a student, Strzemiński was an active member of the Smolensk affiliation of Unovis, and Suprematism, with its formal reduction, monochromatic interplay and constant white background, left a clear imprint on his paintings of the 1920s such as *Composition* (1923, Cologne, Galerie Stolz) and *Architectonic composition I* (1926, Lodz, Muzeum Sztuki).[1]

Note
1 *Tools and industrial products*
and *Cubism. Tension of material
structure* are reproduced in
Présences Polonaises, 1983,
pp.213, 214; *Composition* and
Architectonic composition I are
reproduced in *Konstruktivistische
Internationale*, 1992, pp.279, 278

In spite of the debt to the Russian avant-garde, Strzemiński and his immediate colleagues, Katarzyna Kobro and Henryk Stażewski, contributed a new and vital element to the development of Suprematism outside Russia. Unlike Malevich and his main disciples such as Ilia Chashnik and Nikolai Suetin, from the 1920s onwards Strzemiński continued to regard the studio painting as the primary, potential means of artistic expression:

> A modern painting is the more perfect, the more clearly it displays its flatness; the better are its shapes connected with each other and united with the plane of the picture...A picture is a rectangular world, flat, self-sufficient within its limits, isolated from everything that is going on beyond its frame.[2]

FIG I Władysław Strzemiński, *Unist composition 13*, 1934, 50 × 50 cm, oil on canvas (Lodz, Muzeum Sztuki)

FIG 2 Władysław Strzemiński, *Man and woman 4*, 1934, 30 × 38 cm, pencil on cardboard (Lodz, Muzeum Sztuki)

FIG 3 Władysław Strzemiński, *Seascape*, 1934, tempera on cardboard (Lodz, Muzeum Sztuki)

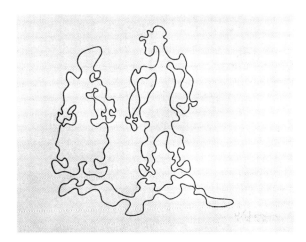

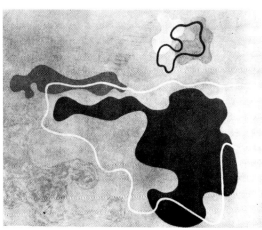

Notes
2 W. Strzemiński and S. Syrkus, 'The Present in Architecture and Painting' (1928); quoted in *Constructivism in Poland 1923–1936*, 1973–7, p.106
3 W. Strzemiński, 'Unism in Painting' (1928); quoted in ibid., p.94
4 W. Strzemiński, 'What Is Legitimately Called New Art...' (1924); quoted in ibid., p.75
5 K. Kobro and W. Strzemiński, 'Composition in Space' (1931); quoted in ibid., p.107
6 W. Strzemiński: 'Unism in Painting' (1928); quoted in ibid., pp.86–7

Strzemiński is now remembered for his theory of Unism, according to which 'calculation must go together with intuition'[3] and the work of art 'exists all by itself'.[4] He went on to argue that the painting must always be a plane, its effect must rely on the laws of visual economy, it must be universal and must reject the traditional notion of a single focus, entry and exit. Furthermore, although a leader of the Polish Constructivist movement, Strezmiński refused to replace studio painting with industrial design, even though he recognized its aesthetic and practical value and often investigated its possibilities.

This untitled gouache follows the theory of Unism and repeats the visual principles that Strzemiński was using in many paintings and drawings of the late 1920s and 1930s such as the *Unist composition 13* (1934; fig.1). The characteristics of plasticity of composition, neutrality of ground and repetition of form are identifiable with all these works each of which was, for Strzemiński, an 'organic unity... a uniform visual phenomenon'.[5] While these elements may bring to mind the abstract paintings of Ivan Kliun, Malevich, Olga Rozanova and other Suprematists, the Unist works also evoke a series of very different associations. Sometimes Strzemiński's compositions are also formal reductions of 'real' phenomena such as plants, flowers, people and landscapes (fig.2), as becomes clear from a comparative analysis of the sketches of the late 1930s. At other times, the insistent curves and rhythmic patterning of Strzemiński's surfaces (fig.3) remind us of the biomorphic metaphors in Surrealism. Alternatively, the dynamic forms that travel across the canvas or paper may also be read as the vestiges of the new alphabet that Strzemiński designed in the 1930s. There is often a calligraphic impetus that emphasizes the artist's tactile, physical involvement with the painted or drawn surface and reminds us that the work of art is, ultimately, a manual exercise and not the mechanical production that El Lissitzky and Alexander Rodchenko envisaged. Perhaps it is in this sense that both Strzemiński and Kobro declared their art to be a continuation of the Baroque tradition:

> A line in Baroque is conceived as a sign of a directed tension. Every Baroque line is a dynamic sign...colour has also been made dynamic by the Baroque. The colour construction of a picture is independent of its linear construction.[6]

This untitled gouache was formerly in the possession of one of Strzemiński's students, Danuta Kulanka (b.1924), wife of the poet Julian Przybós, who, in turn, was a close friend of Strzemiński and Kobro. In fact, the four preliminary pencil drawings for a dress on the *verso* may be by her, although the double signature – 'Danuta Kulanka' lower left and 'sv' [Strzemiński, Władysław?) top right – and the desultory nature of these sketches make a conclusive attribution very difficult.

Nikolai Mikhailovich Suetin 1897–1954

54 Suprematism

1920–21
Oil on canvas, 70.5 × 53 cm
The stretcher is original, and the unrelined canvas shows stretcher creases. The paint layer shows fine crackle
 and considerable repainting of the composition and background. The general condition is fragile
Accession no.1984.18

Provenance
Anna Leporskaia, Leningrad
Galerie Gmurzynska, Cologne
Thyssen-Bornemisza Collection, 1984

Exhibitions
Cologne 1984–5, colour illus. p.79
Budapest, Magyar Nemzeti Galeria [Hungarian National Gallery]; Szombately, Keptar [New Gallery], Oct. 1985–9
 Feb. 1986, 15.–20. szazadi remekmuevek a baro Thyssen-Bornemisza gyuejtemenybol ('Meisterwerke des 15.–20.
 Jahrhunderts aus der Sammlung Thyssen-Bornemisza'), no.46, colour illus. p.131 [Catalogue in Hungarian
 and German]
Cologne 1986, p.144, colour illus. p.145
Luxembourg/Munich/Vienna 1988–9, no.74, colour illus. p.171
Zurich 1989, p.94, colour illus. p.95

Along with Ilia Chashnik (see [7–10]) and El Lissitzky (see [36–8]), Suetin was one of the most talented disciples of Kazimir Malevich in Vitebsk in 1919–22 and then in Petrograd/Leningrad throughout the 1920s. In Vitebsk Suetin was a founding member of Unovis and did much to propagate the Suprematist system through publications, exhibitions and his own theoretical formulations. As an Affirmer of the New Art, Suetin also supported the move to infuse art with the Communist ideology, designing posters and murals carrying slogans such as 'Religion Is the Opium of the People' (1921).[1] But Suetin was also committed to the pure play of abstract forms, and his abstract paintings retained the constant white background and minimal confrontations of black, white and red of Malevich's Suprematism. Both artists were drawn to a similar lexicon of concepts such as fission, the metabolism of materials, physical collision and interpenetration, and, naturally, strong visual parallels between Suetin and Malevich can be traced, for example between the work under discussion and Malevich's *Suprematism. Painterly realism of a football player in the fourth dimension* (1915, 70 × 44 cm, oil on canvas, Amsterdam, Stedelijk Museum) or between another canvas called *Suprematism* (1920–21, Cologne, Ludwig Museum) and Malevich's *Eight red rectangles* (1915, Amsterdam, Stedelijk Museum).[2]

But Suetin also offered other avenues of elaboration, aspiring to transfer Suprematism from the level of pure composition (painting) to that of construction (architecture). Malevich remained a painter throughout his life, exploring two and perhaps four dimensions, but rarely three. Suetin, however, moved rapidly from an exclusive concern with the pictorial surface – with what Malevich called the 'psychosis of modern artists'[3] – to the spatial application of Suprematism, even projecting a few reliefs c1920, and many of Suetin's Suprematist paintings evoke a sense of three-dimensional perspective and depth. Some of them, such as *Suprematism*, appear as ground-plans or as free-floating bodies, and their complex structures of geometric

Notes
1 Suetin's design for the poster is illus. in colour in Cologne 1992, p.143
2 For a colour illus. of the work called *Suprematism* and dated 1920–21 (68.5 × 50.5 cm, oil on canvas, Cologne, Museum Ludwig) see *Vanguardia Rusa*, 1985, p.165. For a colour illus. of Malevich's *Eight red rectangles* (57.5 × 48.5 cm, oil on canvas, Amsterdam, Stedelijk Museum) see *Malevich*, exh. cat. Leningrad, Russian Museum/Moscow, State Tretiakov Gallery/Amsterdam, Stedelijk Museum, 1988–9, p.138
3 Quoted from L. Andreeva, *Sovetskii farfor 1920–1930-kh godov*, Moscow (Sovetskii khudozhnik) 1975, p.121

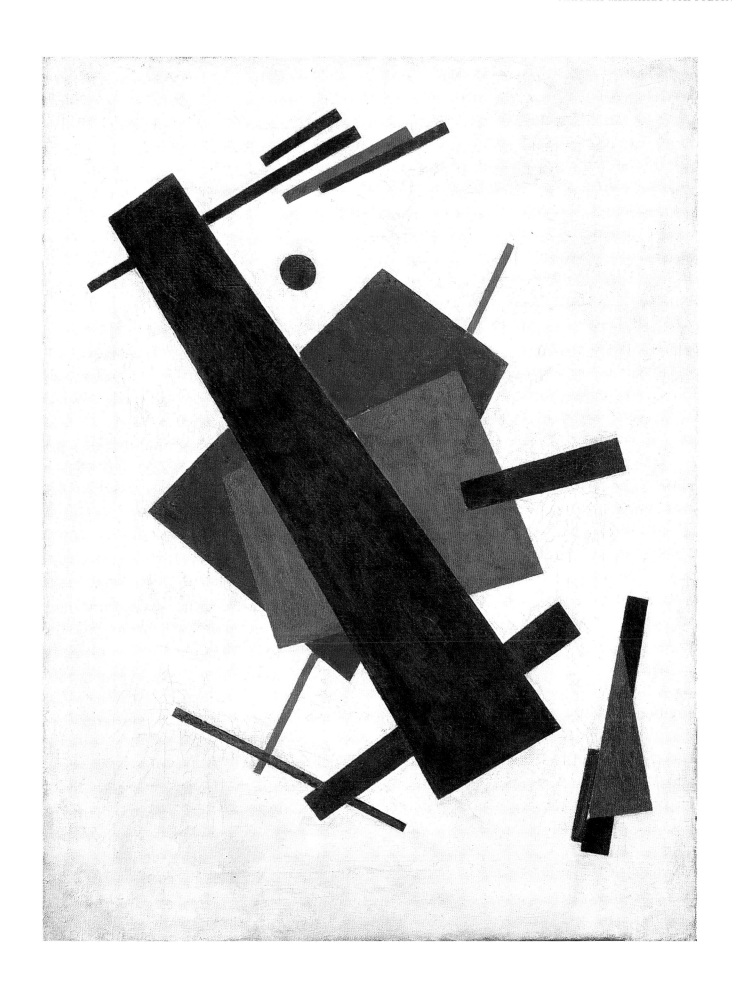

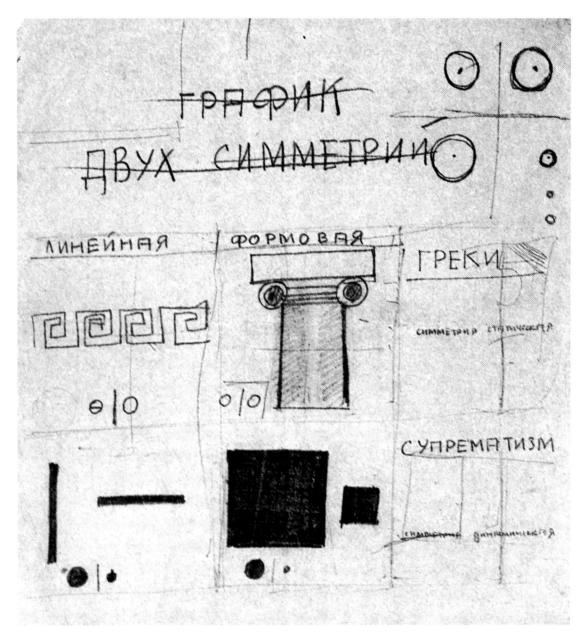

FIG 1 Nikolai Suetin,
Analytical scheme, 1924–5,
32.6 × 30.4 cm, pencil on
paper (Cologne, Galerie
Gmurzynska)

elements seem to anticipate the *arkhitektony* and *planity* of the mid-1920s (see [9], [39], [40]). Perhaps it is not so very far from these compositions to the designs for the experimental tea-cups and plates that Suetin made for the Lomonosov State Porcelain Factory in Leningrad between 1923 and 1934 and for the interiors of government buildings and exhibitions, including the Soviet pavilion for the *Exposition Internationale* in Paris in 1937. But unlike his mentor Malevich, who died in 1935, and his friend Chashnik, who died in 1929 aged only twenty-seven, Suetin was obliged to adjust his system to more mundane and expedient demands and, after *c*1930, worked almost exclusively as an applied artist, minimizing explicit references to the Suprematist legacy.

Although Suetin maintained that he was 'beyond systems',[4] he developed his interpretation of the new art in a number of terse, but illuminating comments on Cubism and Suprematism. Of particular relevance to the work in question is his discourse on the the plane or pictorial surface, which, in its elementary logic, reminds us of Vasilii Kandinsky's deliberations on the same subject:

Notes
4 From one of Suetin's pencil notations on a drawing of 1924 illus. in Cologne 1992, p.181
5 From one of Suetin's pencil notations on a drawing of 1924 illus. in Cologne 1992, p.183

FIG 2 Kazimir Malevich, *Suprematism (supremus no.56)*, 1916, 80.5 × 71 cm, oil on canvas (St Petersburg, State Russian Museum)

FIG 3 Nikolai Suetin, design for a poster for an exhibition of porcelains designed by Ilia Chashnik and Suetin, 1925–26, 91 × 53 cm, gouache and collage on paper (private collection; courtesy of Galerie Gmurzynska, Cologne)

For all systems in painting there exists one law whereby the plane can be filled. This law is dictated by the sensation that the plane cannot have a dead place, i.e. each point of the plane is in a state of active effect on us and thereby on the whole of our physical feeling.[5]

In the early 1920s Suetin illustrated his arguments with numerous Suprematist exercises in which he gave attention to the notions of rhythm, weight and movement. For him Suprematism had liberated art from its traditional contemplative position and he offered some of his drawings as evidence that art was now dynamic. For example, in *Analytical scheme* (1924–5; fig.1) he describes Greek symmetry as static while the Suprematist is dynamic, implying that the black circle in his composition represents the volute of a Doric column or the floor-plan of a Greek temple. This explanation helps us to decipher the meaning of the small painted circle that recurs in both Suetin's and Chashnik's work, for, understood in the light of Suetin's argument, it symbolizes equilibrium as opposed to the Suprematist shapes that collide and intersect. The small black circle or point reappears in Malevich's paintings, especially in the ones entitled or subtitled 'dynamic' of c1916–17 such as *Dynamic suprematism* (1916, 80.2 × 80.3 cm, oil on canvas, London, Tate Gallery) and *Suprematism (supremus no.56)* (1916; fig.2). The latter, in particular, is close to the Suetin piece, thanks to the subtle interlacing of the 'trapezoid' scaffolding that supports the geometric elements on the first level. It also reminds us of the Suprematist poster of 1925–6 advertising the New Government Porcelain designed by Chashnik and Suetin together (fig.3).

As in the cases of Chashnik and Nina Kogan (see [28]), not all of Suetin's paintings and drawings come with well defined provenances. According to tradition and hearsay, *Suprematism* was once owned by Anna Alexandrovna Leporskaia (1900–82), Suetin's companion, a student of Malevich and, from the 1940s onwards, a leading designer at the Lomonosov State Porcelain Factory in Leningrad. However, there is no documentary evidence to prove this ownership and Suetin's daughter, Nina Ilinichna Suetina, does not accept the attribution. Some Russian specialists in the history of Suprematism such as Alexandra Shatskikh feel that the work is too sophisticated for a student of twenty or twenty-one years old, but while ultraviolet examination reveals that the entire white ground has been repainted, the general impression is that the picture could still be commensurate with an age of seventy years.

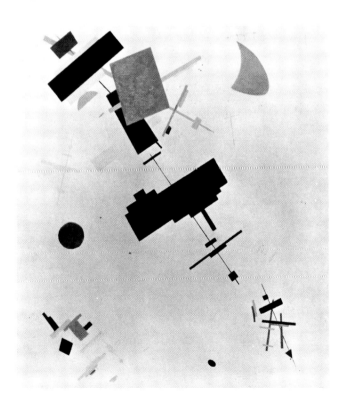

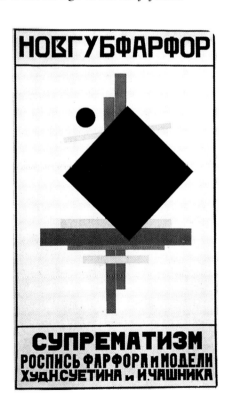

Nadezhda Andreevna Udaltsova

1885–1961

55 Cubism

1914–15
Oil on canvas, 72 × 60 cm
The heavy-weight canvas is not relined and on its original stretcher. The paint layer shows a history of flaking
 and retouching and a network of crackling with slight cupping. Even so, the general condition is good
Accession no.1984.19

Provenance
Family estate, Moscow
Galerie Gmurzynska, Cologne
Thyssen-Bornemisza Collection, 1984

Exhibitions
Budapest, Hungarian National Gallery/Szombately, Keptar, Oct. 1985– 9 Feb. 1986, *15.–20. szazadi remekmuevek
 a baro Thyssen-Bornemisza gyuejtemenybol* ('Meisterwerke des 15.–20. Jahrhunderts aus der Sammlung
 Thyssen-Bornemisza'), no.44, colour illus. p.126
Cologne 1984, colour illus. p.81
Cologne 1986, p.148 colour illus. p.149
Luxembourg/Munich/Vienna 1988–9, no.77, colour illus. p.177

Udaltsova came to her mature style by way of French Cubism. Like Liubov Popova (see [45–7]), she also studied the new painting in the collections of Ivan Morozov and Sergei Shchukin in Moscow before travelling to Paris in 1912 and enrolling at La Palette under Henri Le Fauconnier, Jean Metzinger and André Dunoyer de Segonzac. As a colleague of Popova in Moscow and then in Paris, Udaltsova shared a common artistic denominator and her figure drawings of 1912–13 bear a remarkable resemblance to those of her friend – and also to those of Vera Mukhina and Vera Pestel, all of whom studied at La Palette. Udaltsova and Popova even shared the same experimental vocabulary, and, as if in deference to her friend, Udaltsova subtitled one her paintings 'architectonic composition' (at the *Tramway V* exhibition in Petrograd in 1915). Indeed, the colour planes superimposed upon the circular or undulating motif of *Composition* bear more than a casual likeness to Popova's *Painterly architectonics (Still-life. Instruments)* ([45]). Udaltsova's paintings and drawings of 1913–15 are a strong reflection of the Cubist apprenticeship which, formally and psychologically, prepared her for her brief engagement with the abstract systems of Rayonism and Suprematism. In fact, like Olga Rozanova's urban landscapes of 1913–14 (see [49], [50]), *Cubism*, with its intersecting lines or 'rays' and multicoloured, colliding planes is reminiscent of Natalia Goncharova's and Mikhail Larionov's Rayonist experiments (see [19], [32]) and their synthetic derivations from Russian Neo-Primitivism, French Cubism and Italian Futurism. The exploratory impulse and stylistic plurality of Cubism illustrate the young Udaltsova's conviction that:

Art is free. Creativity is free.
The person born for creativity and art is free.
The creator who has brought the world new forms should be greeted with joy.[1]

On her return from Paris in the winter of 1913, Udaltsova, again like Popova, joined the Tower studio where she came into contact with Alexei Grishchenko, Viktor Midler, Vladimir Tatlin, Alexander Vesnin and other young artists who were especially concerned with the

Note
1 Statement by Udaltsova in *Anarkhiia*, no.38, 1918; quoted in Sarabianov and Gurianova (1992) p.265

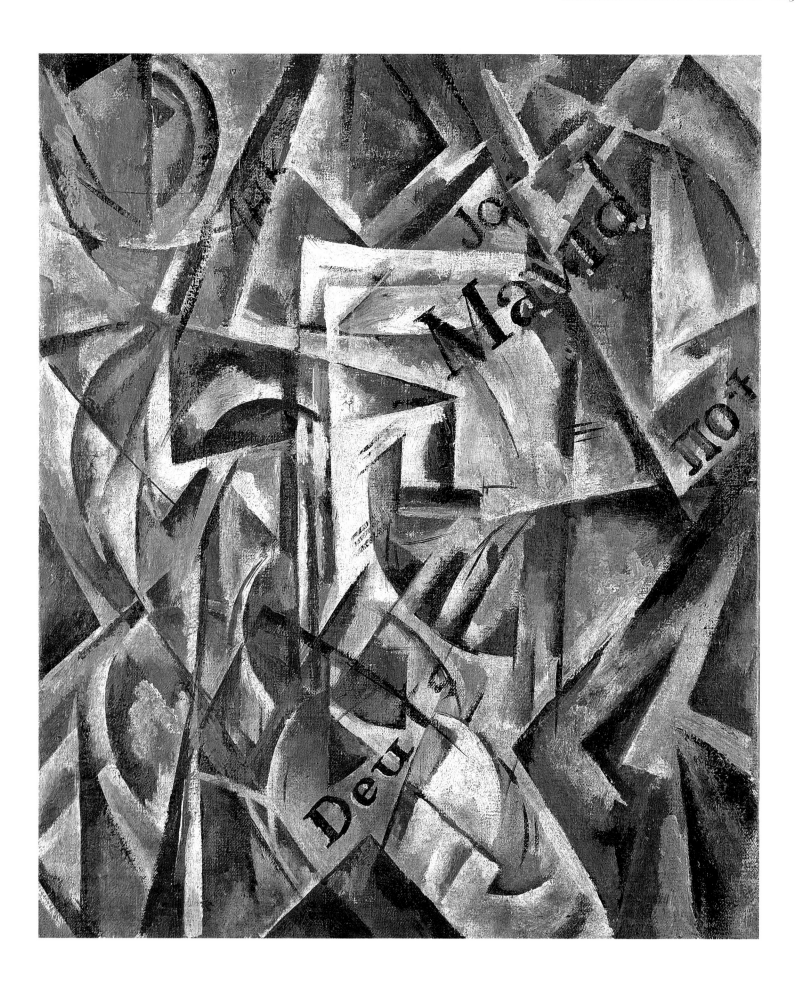

relationship of the new, experimental art with more distant traditions, for example Byzantine art (see [45], [59]). Although Udaltsova did not investigate the aesthetic of the Tatlin relief, the two artists admired each other, Udaltsova edited the booklet *Vladimir Evgrafovich Tatlin* (Petrograd, Zhurnal dlia vsekh, 1915), she contributed to his exhibition *The Store* in March 1916 and Tatlin is even listed as the owner of one of her works – the *Bottle and glass* (present whereabouts unknown) shown at the *0.10* exhibition in December 1915. But by then, under the influence of Kazimir Malevich, Udaltsova was already investigating Suprematism, and the *Composition* [56] and untitled piece [57] are clear examples of her special interpretation of this abstract system. Udaltsova contributed three such works – so called 'painterly constructions' – to the *Jack of Diamonds* exhibition in Moscow in 1916 and seems to have continued to produce such works, often small watercolours and gouaches, through 1917. Many repeat the same basic configurations of triangular, trapezoid and circular shapes and are intended as 'laboratory' exercises in the manipulation and adaptation of particular ideas on colour, weight, direction and rhythm, rather than as finished works of art. Indeed, while Udaltsova did describe some of her abstract compositions as Suprematist, her commitment to Suprematism was less enthusiastic than Ivan Kliun's or Popova's, and Malevich was not especially happy with her constant orientation towards the Cubist object, as he declared in 1924:

> [Udaltsova] possessed a rich individuality, but it is one that is obsolete. . .she did not fully understand Suprematism, and sensed everything in terms of objects.[2]

In fact, it transpires that Udaltsova did not follow a consistent path from Cubism or Futurism to Suprematism in the way other avant-garde artists such as Kliun and Popova did (and, no doubt, as Malevich would have wished). On the contrary, she continued to use the Cubist reminiscences of musical instruments, collage and lettrisme throughout the 1910s, even parallel to her Suprematist paintings, and the Cubist compositions, with their 'restrained, but

FIG 1 Nadezhda Udaltsova, *Still-life*, 1916, 44.5 × 35.5 cm, oil on canvas (Nizhnii-Novgorod Regional Museum)

FIG 2 Pablo Picasso, *'Ma Jolie'*, 1911–12, 100 × 675.4 cm, oil on canvas (New York, Museum of Modern Art; acquired through the Lillie P. Bliss Bequest))

FIG 3 Nadezhda Udaltsova, *The model. Cubist composition*, 1915, 106 × 71 cm, oil on canvas (St Petersburg, State Russian Museum)

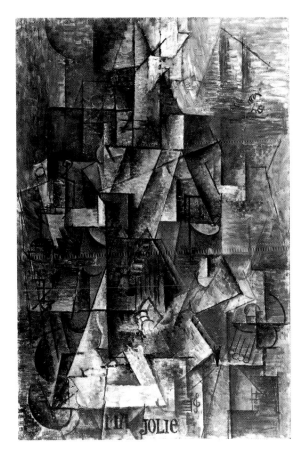 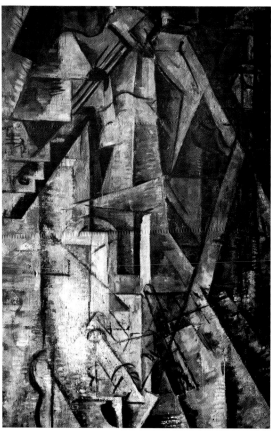

Notes
2 Statement by Malevich on Udaltsova's teaching duties at Vkhutemas in 1924; quoted in Los Angeles/Washington, DC, 1980–81, p.258
3 V. Denisov: 'Moskovskie zhivopistsy v Leningrade (Vystavka N. Udaltsovoi i A. Drevina v Russkom muzee)', *Zhizn iskusstva*, no.8, Leningrad, 1928; quoted in Miasin, *Stareishie*, p.221
4 N. Udaltsova, 'How Critics and the Public Relate to Contemporary Russian Art' (1915); quoted in Cologne 1979–80, p.307

powerful colours and well finished textures',[3] such as *Still-life* (1916; fig.1) remain the strongest part of her oeuvre. Perhaps because of her concentration on Cubism rather than Suprematism – on the objective rather than the non-objective – Udaltsova was able to return more easily to a more documentary style in the 1920s and 1930s when she adjusted her vision to the ideological requirements of Socialist Realism. But the ability to explore the convergence rather than divergence of Cubism, Suprematism and Realism might also reflect Udaltsova's inner dynamic, for, as she once asserted:

In science the law of evolution is acknowledged, so why should art be doomed to stand still and go on with the same old truths?[4]

As far as *Cubism* is concerned, the connections with Picasso's analytical Cubism of 1911–12 – as extended by Le Fauconnier and Metzinger – are obvious in the apparent reference to the words 'Ma Jo[lie]' or 'Jo[urnal]' that Picasso often used as collage elements (cf. *'Ma Jolie'*, 1911–12; fig.2). Udaltsova's painting entitled *The model. Cubist composition* (1915; fig.3) might even be a paraphrase of the Picasso work. At the same time, Udaltsova, like Alexandra Exter (see [13]), distributed an international vocabulary of Russian and German as well as French morphemes across her painting and applied a colour-scale very different from that of the Paris Cubists. In 1914 and 1915 Udaltsova produced several canvases relying on the same formal devices as *Cubism* – denial of three-dimensional perspective, reduction to overlapping or translucent planes, basic delineations in trapezoid or rectangular shapes – of which *At the piano* (1914; 106 × 188.9 cm, oil on canvas, New Haven CT, Yale University Art Gallery) and *Musical instruments* (1915, 67 × 80 cm, oil on canvas, St Petersburg, State Russian Museum) are important examples. However, Udaltsova rarely incorporated the words 'Cubism' or 'Cubist' into her titles and no painting called 'Cubism' figures in her contributions to the pre-Revolutionary avant-garde exhibitions such as the *Jack of Diamonds*, *Tramway V* or *0.10*.

Nadezhda Andreevna Udaltsova 1885–1961

56 Composition

1916
Gouache, watercolour and pencil on brown wrapping paper, 44.2 × 36.3 cm (visible surface)
The paper has been relined and heavily restored and shows many stains, smudges, smears and creases. The paint
layer, applied unevenly, has faded, and there are signs of compositional changes. The general condition is fair
Accession no.1980.26

Provenance
Family estate, Moscow
Galerie Gmurzynska, Cologne
Thyssen-Bornemisza Collection, 1980

Exhibitions
Cologne 1979–80, no.125, colour illus. p.287
Cologne 1986, no.150, colour illus. p.151

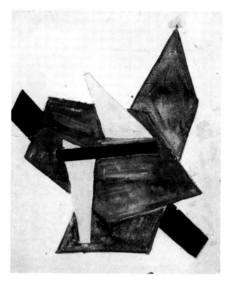
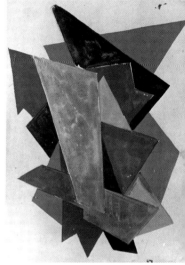

Towards the end of 1915, and in connection with her contribution of ten paintings to the *0.10* exhibition in Petrograd, Udaltsova wrote:

> A whole group of artists has gradually adjusted the principle of Cubist construction to the painterly, planar construction, albeit in a somewhat graphic manner. Artists have rejected the textures and collages that imitate nature and have arrived at pure colour, pure painterly composition. That is how non-objective art has been created, that is how the pure, colour form of Suprematism evolved.[1]

Although Udaltsova's works at both *0.10* (Petrograd, December 1915–January 1916) and *The Store* (Moscow, March 1916) seem to have all been 'Cubist', her acquaintance with Malevich and his theory of Suprematism left an immediate and appreciable imprint on her artistic career, prompting her to become a member of the Supremus group. Both *Composition* and the untitled piece [57] are two of the many results of this encounter, for there exist numerous analogous oils, gouaches and pencil drawings that share the basic composition of a series of superimposed geometric planes and the colour-scale of red, black and yellow. Some of these – such as the gouaches *Suprematist composition* (1916; fig.1) and *Composition* (1916, Cologne, Museum Ludwig; fig.2) – appear to be preparations for larger works, and even the work under discussion bears pencil traces of compositional modifications, indicating that Udaltsova had been experimenting with formal alternatives. Similar gouaches also bear instructions regarding colour imposition, and for her contribution to the autumn 1917 *Jack of Diamonds* exhibition in Moscow (ex-catalogue) Udaltsova also marked in sequential numbers on her Suprematist compositions (328–46).[2]

FIG 1 Nadezhda Udaltsova, *Suprematist composition*, 1916, 32.7 × 24.1 cm, gouache on paper (Des Moines, IA, Louise Noun Collection)

FIG 2 Nadezhda Udaltsova, *Composition*, 1916, 46.2 × 37.5 cm, gouache over pencil on grey paper (Cologne, Museum Ludwig)

Notes
1 N. Udaltsova, 'How Critics and the Public Relate to Contemporary Russian Art' (1915; quoted in Cologne 1979–80, p.308
2 Some of these are illus. in Cologne 1984, pp.324–38

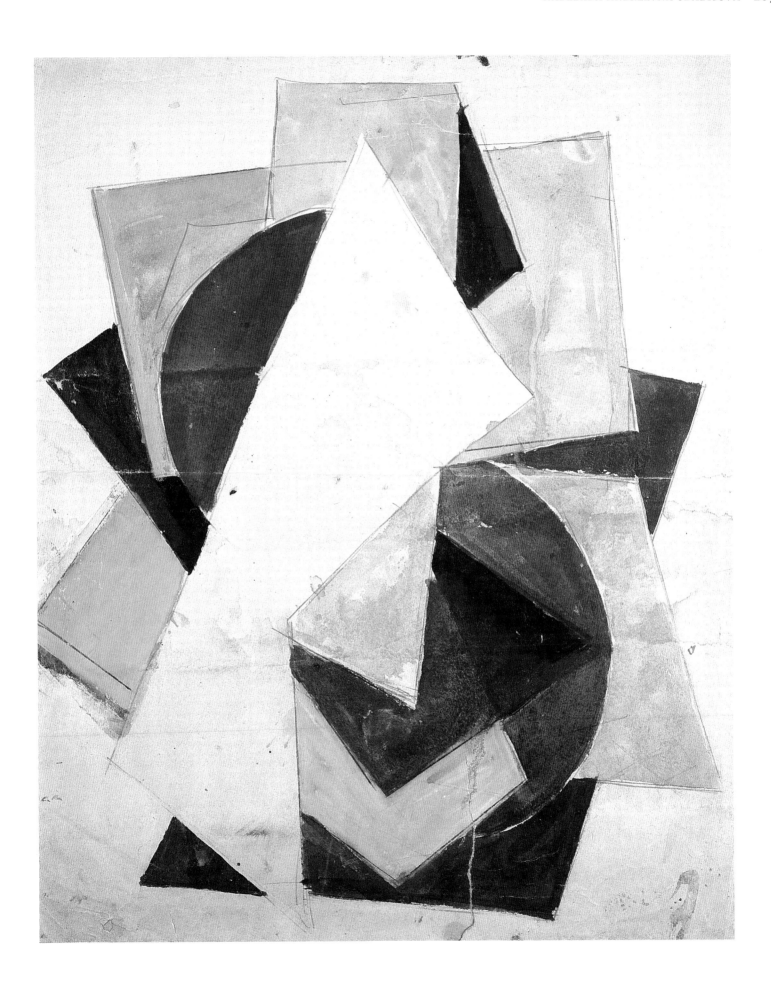

Nadezhda Andreevna Udaltsova 1885–1961

57 Untitled

1917
Watercolour and pencil on heavy paper, 35.7 × 23.6 cm (visible surface)
Signed and dated lower left in Russian: 'N. Udaltsova 1917'
The heavy, light brown paper shows dark brown stains and creases at the lower edge where it has been folded.
 The faded paint layer shows smudges, but the general condition is good
Accession no.1977.105

Provenance
Family estate, Moscow
Galerie Gmurzynska, Cologne
Thyssen-Bornemisza Collection, 1977

Exhibitions
Cologne 1977, no.185, colour illus. p.141
Milan 1980, illus. p.95
[dimensions given are erroneous]

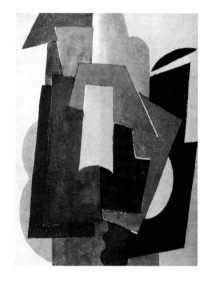

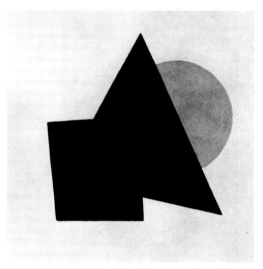

As in the case of Udaltsova's *Composition* [56], this untitled gouache is one of many similar experiments and exercises in the exploration, adjustment and variation of basic Suprematist schemes that Udaltsova was undertaking in 1916–17. Given the close proximity of Udaltsova to Kliun, Malevich, Popov and Pestel in those years, it is not surprising to find works by her colleagues that also bear a close resemblance to her conclusions, such as the series of Suprematist linocuts that Popova produced in 1917–19 (fig.1) or Kliun's colour investigations of the late 1910s (fig.2). In turn, all these experiments in the purely abstract correlations of form and colour must be related to the broader concern, especially at Inkhuk and Ginkhuk in the early 1920s, with the elaboration of the many didactic tabulations that Gustav Klucis, Kliun and Mikhail Matiushin compiled on the basis of such researches. Some of the avant-garde artists, including Udaltsova, then took these reductions and inserted them in a decorative vocabulary that they applied to ceramics, textiles, posters and other items of applied art. No doubt, as a professor in the Textile and the Polygraphical Institutes in Moscow in the late 1920s, Udaltsova also referred to these Suprematist compositions in order to illustrate and explain her design theories. Although Udaltsova categorized very few of her works as specifically textile or fabric designs, she retained a constant interest in the external relevance or applicability of the work of art. Even as late as 1956, in his introduction to the catalogue of a group show at the Moscow Union of Soviet Artists, Vladimir Kostin still referred to the 'decorative quality' and 'rich colour structure' of Udaltsova's paintings.[1]

FIG 1 Liubov Popova, *Untitled*, c1917–19, 34.1 × 26.1 cm, linocut on paper (Art Co. Ltd, George Costakis Collection)

FIG 2 Ivan Kliun, *Suprematism. 3 Colour composition*, c1917, 35.7 × 35.2 cm, oil on board (Art Co. Ltd, George Costakis Collection)

Note
1 V. Kostin, untitled article in *V. Vakidin, A. Zelensky, E. Maleina, N. Udaltsova, V. Elkonin*, exh. cat., Moscow, Union of Soviet Artists, 1958, p.5

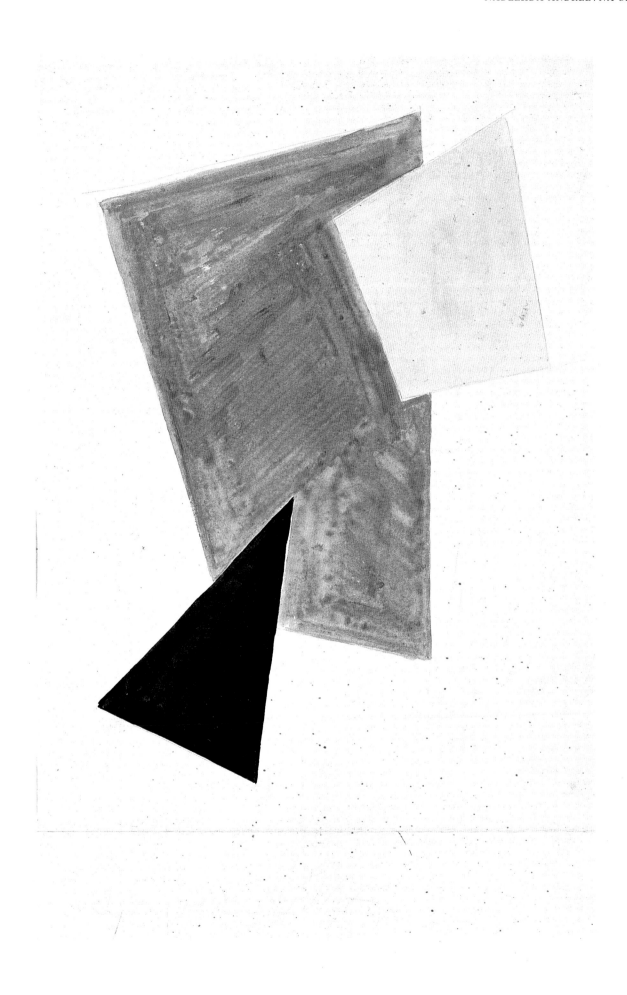

Marie Vassilieff (Mariia Ivanovna Vasilieva) 1884–1957

58 Woman with a fan
Femme à l'éventail

1910 (?)
Oil on canvas, 59.5 × 72.5 cm
The canvas is badly deformed, is bulging and shows old tears. It is not relined. The unkeyed stretcher is the
 original one. The paint layer, too, shows tears and signs of previous repairs. The canvas has been painted on
 both sides, but the paint on the reverse has been scraped off. The glossy varnish is yellowed and dirty. The
 general condition is fair
Accession no.1978.79

Provenance
Artist's estate, Paris
Galerie Hupel, Paris
J. Kriegler, Paris
Le Monde Gallery, New York
Sotheby Parke Bernet, New York
Andrew Crispo Gallery, New York
Thyssen-Bornemisza Collection, 1978

Literature
Sotheby Parke Bernet, Nov. 3 1978, lot 315

Exhibitions
Paris, Galerie Hupel, 5 June–5 July 1969, *Une peintre cubiste méconnue, Marie Vassilieff 1884–1957*, no.12a illus.
 [unpaginated]
New York, Andrew Crispo Gallery, 10 Jan.–4 Feb. 1979, *Masters of Twentieth-century Art from 1900 to 1950*,
 no.88
Paris, Centre Georges Pompidou, Musée National d'Art Moderne, 1979, *Paris–Moscou 1900–1930*, illus. p.136

Marie Vassilieff was one of the many Russian and Ukrainian expatriates who were living
permanently in Paris before the October Revolution. Others included Alexander Archipenko,
Chana Orloff and Léopold Survage whose artistic careers were fashioned more by their Parisian
encounters with Cubism than by their Slavic roots and who achieved their real recognition as
members of the international, rather than the Russian, avant-garde. Their life and work were
tempered by a Gallic elegance and restraint foreign to the Russian Cubo-Futurists and
Suprematists, and Vassilieff conforms to this context, for she owed little to the radical cultural
innovations in Moscow and St Petersburg in the 1910s.

However, Vassilieff was not entirely isolated from artistic developments in Russia and the
many artists who visited her Académie Libre and Académie Vassilieff must have reported on the
new movements and individuals back home. In any case, from time to time Vassilieff made brief
visits to Russia – in 1914 and, in spite of the war, in 1915.[1] This would explain her contribution
of six Cubist works to the *0.10* exhibition in Petrograd from December 1915 to January 1916,

Note
1 The 'Elements Biographiques'
included in *Oeuvres postérieures au
cubisme de Marie Vassilieff*, 1971
[unpaginated] mention that
Vassilieff travelled in
Scandinavia, Romania, Poland
and Russia between 1909 and
1914. The biographical entry for
Vassilieff in *L'Avant-garde au
féminin*, 1983, p.30, however,
mentions that she was in Russia
in 1915

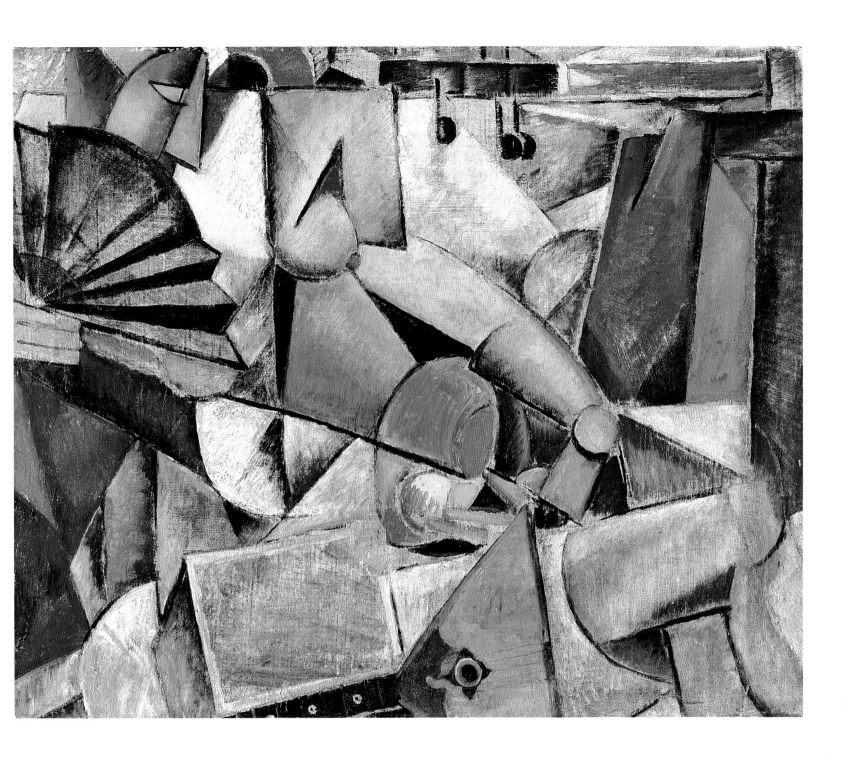

and of eleven Cubist works to *The Store* in Moscow in March 1916, a fact that would indicate her acquaintance with both Malevich and Tatlin, the respective organizers of these exhibitions. The occasion for her participation in such radical enterprises is not clear, although her acquaintance with Liubov Popova and Nadezhda Udaltsova in 1912–13 must have facilitated the alliance, the more so since both Popova's and Udaltsova's contributions to the two exhibitions were also Cubist rather than Suprematist.

The exact chronology of Vassilieff's evolution is difficult to establish, although evidence, including observations by André Salmon, suggests that she was already the adept of a 'violent and lyrical Cubism' in 1909.[2] By then, the year she founded her Académie, she was well informed of Cubism and counted Braque and Picasso among her personal friends. That she mastered the principles of early and high Cubism – the division of the object into particular elements, the reduction to intersecting planes and the diffraction of light – is demonstrated by works conventionally dated 1909–10, such as *Jeune fille au pavot* (1909, 65 × 46 cm, oil on canvas, Paris, Galerie Hupel) and *Femme assise* (1910, 92 × 60 cm, oil on canvas, Paris, Galerie Hupel). On the other hand, works that are also conventionally dated 1912–14, such as *Clown* (1912, 73 × 54 cm, oil on canvas, Paris, Galerie Hupel) and *Femme aux bas noir* (1913–14; fig.1) do not seem to represent a marked development of the initial Cubist language. Given the uncertainty surrounding the dating of Vassilieff's oeuvre, we might be justified in ascribing a slightly later year to *Woman with a fan*, the more so since she became especially close to Fernand Léger in 1912–13 when he gave two lectures at her Académie, 'Les Origines de la peinture et sa valeur représentative' and 'Les Réalisations picturales actuelles', and she must have been well aware of his early tubular paintings such as *Nudes in a landscape* (1909–10; 1909–10, 120 × 169 cm, oil on canvas (Otterlo, Rijksmuseum, Kröller-Müller) to which the *Woman with a fan* bears some resemblance. Be that as it may, what Waldemar George wrote of Vassilieff's Cubist paintings is quite applicable to *Woman with a fan*, for here the artist

> accède à la synthèse: au cubisme synthétique, dont le prince incontesté est Gris. Elle domine ses moyens d'expression. Sa couleur à basse de gris et d'ocres est ponctuée de tons purs.[3]

Vassilieff continued to investigate the Cubist style in the 'voluptuous science'[4] of her portraits and landscapes for several years, but even so, good Cubist works by Vassilieff are comparatively rare.[5] *Woman with a fan* is one of her more accomplished pieces and illustrates a theme that recurs in at least two other paintings with similar titles, *Femme à l'éventail noir* (1909–10, 60 × 92 cm, oil on canvas, Paris, Galerie Hupel) and *Femme au journal et à l'éventail*.[6] Waldemar George once observed of Vassilieff that 'j'ai rarement vu quelqu'un présenter un tel contraste entre ses attitudes et sa réalité intérieure',[7] and it was this more subjective quirk of character that expressed itself in the 1920s and 1930s in a style informed by Surrealism and the metaphysical school.

Notes

2 P. Hupel, 'Marie Vassilieff vue par André Salmon' in *Une peintre cubiste méconnue*, 1969 [unpaginated]

3 W. George, 'L'Epoque cubiste de Marie Vassilieff' in *Une peintre cubiste méconnue*, 1969 [unpaginated]

4 Statement by Guillaume Apollinaire in 1910; quoted in *L'Avant-garde au féminin*, 1983, p.30

5 For examples of other Cubist works by Vassilieff see Milan 1980, p.66, and *L'Avant-garde au féminin*, p.30. An undated oil by Vassilieff called *Le Ménage* (69.5 × 103.5 cm) was auctioned as lot 57 at Phillips, 26 Nov. 1990 (colour illus. on cover and p.63)

6 *Femme au journal et à l'éventail* was included in the exhibition *Une peintre cubiste méconnue*, op.cit. as no.13

7 Hupel, op.cit. [unpaginated]

FIG I Marie Vassilieff, *Femme aux bas noir*, 1914, 92 × 73 cm, oil on canvas (Paris, Collection of Yvette Moch)

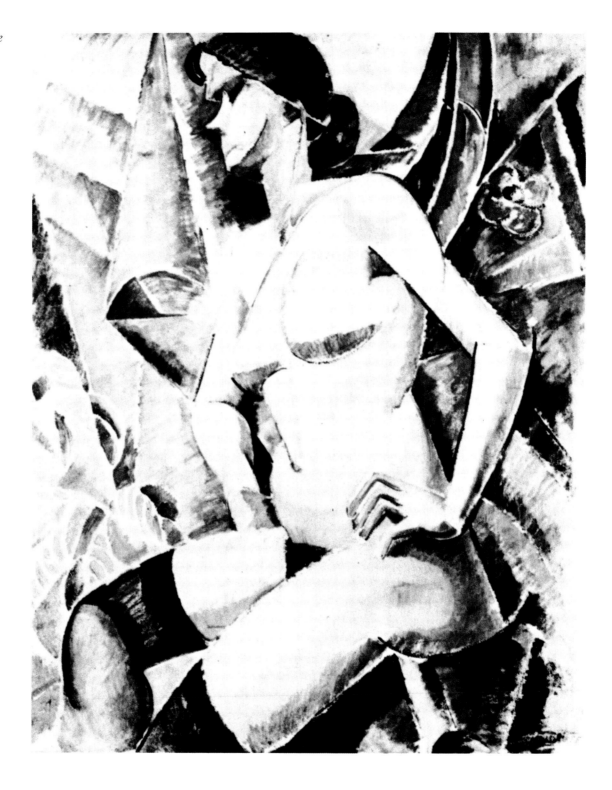

Alexander Alexandrovich Vesnin 1883–1959

59 Untitled

1921–22
Indian ink and sepia(?) on paper, 33 × 25 cm
Signed lower left in French: 'A. Vesnine'
The yellowed paper shows pin-holes in the corners and the paint layer is grimy, but the general condition is good
Accession no.1979. 41

Provenance
Le Corbusier, Paris
Le Corbusier Foundation, Paris
Galerie Jean Chauvelin, Paris
Rosa Esman Gallery, New York
Andrew Crispo Gallery, New York
Thyssen-Bornemisza Collection, 1979

Exhibitions
Berlin 1977, p.1/126, no.1/237
New York, Andrew Crispo Gallery, 1979, *Masterpieces of Twentieth-century Works on Paper*, no.48
Los Angeles/Washington DC, 1980–81, no.378, illus. p.261

Note
1 For colour illus. of Vesnin's abstract paintings of 1917–18 see Frankfurt/Amsterdam/New York 1992–3, nos.67, 68; Khan-Magomedov (1986)

The youngest of three brothers, all architects, Alexander Vesnin was active as a studio painter and stage designer as well as a practising architect. Although his principal training was in building and engineering in Moscow and St Petersburg, he also collaborated with Alexei Grishchenko, Liubov Popova, Vladimir Tatlin et al, at the collective studio in Moscow known as the Tower (see [45], [55–7]), where he investigated Cubism which, with other influences, guided him towards his abstract chromatic compositions of 1917 onwards.[1] At the Tower, Vesnin became especially interested in the work of Popova, who became his constant companion until her death in 1924.

There are many formal parallels between Vesnin and Popova, particularly in their emphasis on basic geometric structures and in their endeavour to reduce art to a branch of the exact sciences. The rejection of the narrative and ornamental function, the calculated junctions and disjunctions, the stratification and 'building' of the image – such elements conspire to elicit an architectural and constructive sense. Popova's 'spatial force constructions' and Vesnin's 'constructions of colour space according to force lines' that they contributed to the $5 \times 5 = 25$ exhibition, Moscow 1921, demonstrated their proximity of thought and coincided with their complex designs for the 'mass action' of *Struggle and Victory of the Soviets*, projected, but not realized, for the III Communist International in Moscow in 1921. This architectural fantasy was to have included zeppelins, searchlights and suspended slogans – an extravagant scheme that, at the time of the Civil War, was completely unfeasible physically and financially. Nevertheless, Vesnin's involvement in this utopian experiment expressed his strong interest in spectacle, which he put to more practical use in his productions for Alexander Tairov's Chamber Theatre in Moscow, such as *Phèdre* (1922) and *The Man Who Was Thursday* (1923; fig.1). With its undecorated, functional construction on stage looking more like the scaffolding at a building site than a piece of theatre, Vesnin's stage set for *The Man Who Was Thursday* might almost be accepted as a three-dimensional extension of the work under discussion. As he declared in 1922:

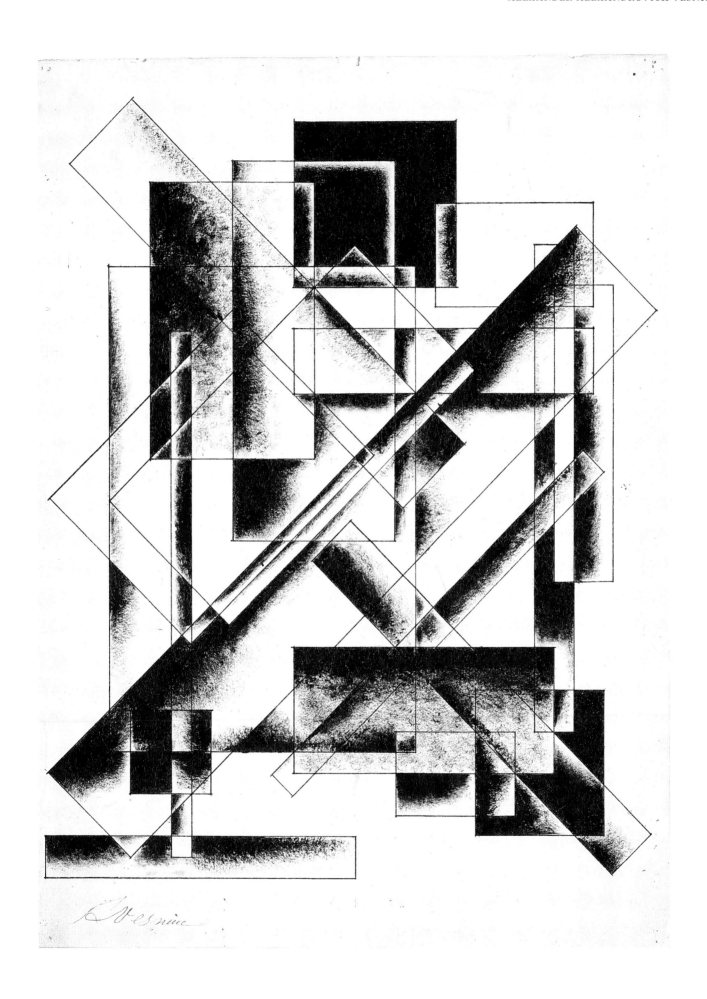

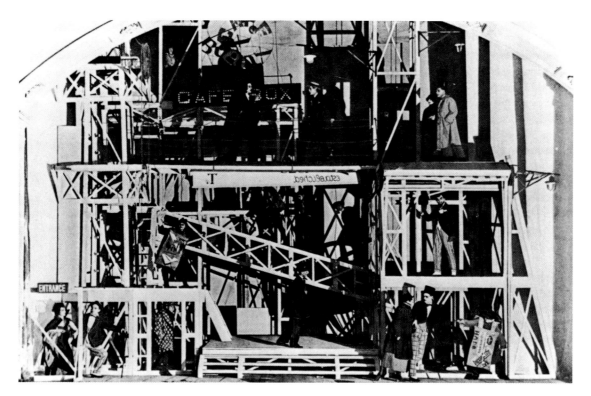

FIG I Photograph of
Alexander Vesnin's stage
design for Alexander Tairov's
production of
G.K. Chesterton's *The Man
Who Was Thursday* at the
Chamber Theatre, Moscow,
1923 (Los Angeles, Collection
of the Institute of Modern
Russian Culture)

It is clear that the objects being created by the contemporary artist must be pure constructions without the ballast of depictiveness; they must be built according to the principle of economy within the maximum of action.[2]

This untitled ink drawing is also a 'pure construction' which relies for its visual effect on economy of means and dynamic interaction. In this sense, it is an extension of the Constructivist doctrine formulated in Moscow in 1921–2 by Alexei Gan, Popova, Nikolai Tarabukin and others, and even though Vesnin did not practise architecture between 1917 and 1922 and this sketch is 'useless', it can be regarded (rather like Udaltsova's Suprematist exercises) as a 'laboratory' deduction, capable of being adapted to utilitarian ends. Consequently, this drawing also relates to the contention at Inkhuk that art was no longer a means of individual expression, but a mass communication and that art was now to join with industrial production. The work under discussion is fully typical of the kind of abstract design that Vesnin was creating at this time: for example, he contributed five similar pieces to the $5 \times 5 = 25$ exhibition (fig.2), although the drawing here is more complex in its arrangement and integration of planes.

Vesnin's visual production of 1921–2, then, represents an important stage in his artistic development, for, on the one hand, he is still paying homage to the abstract principles of the 1910s, but on the other, he is clearly moving closer to the concept of art as design. Indeed, Vesnin's drawings of 1921–2 would have been impossible not only without exposure to Cubism and Suprematism, but also without the abstract 'compass-and-ruler' compositions that Rodchenko was making as early as 1915 (fig.3). Like Rodchenko, Vesnin also emphasized a monochromatic contrast, often in black and white, he treated line as a skeletal definition and he favoured rectangular and circular (fig.4) correlations or combinations of both. At the same time, however, Vesnin used the indian ink as a manual intervention that contrasted with the mechanical effect of the geometric forms, the result being a complex structure that combines the detachedness of a technical drawing with the subtle texture of a traditional painting. This ambiguity holds even for the abstract paintings of c1921–2.[3]

The work under discussion depends upon an interplay between the background of

Notes
2 A. Vesnin, 'Kredo' (1922);
quoted in M. Barkhin et al., eds.,
*Mastera sovetskoi arkhitektury ob
arkhitekture*, Moscow (Iskusstvo)
1975, II, p.14
3 See, e.g., the two *Painterly
compositions* (1921 and 1922)
illus. in colour in Khan-
Magomedov, *Alexander Vesnin
and Russian Constructivism*,
op. cit., pp.98 and 99

FIG 2 Alexander Vesnin,
Drawing for the catalogue of
the exhibition 5 × 5 = 25,
Moscow, 1921,
11.5 × 9.5 cm, gouache on
paper (Moscow, Shchusev
Museum)

FIG 3 Alexander Rodchenko,
Composition, 1915,
25.5 × 21 cm, pen and ink on
paper (Moscow, Alexander
Rodchenko and Varvara
Stepanova Archive)

FIG 4 Alexander Vesnin,
*Circular constructivist
composition*, 1922,
33.5 × 24.5 cm, ink and
gouache over pencil laid on
board (Collection of Thomas
P. Whitney)

parallelograms and the two intersecting diagonals, a configuration that reappears in several other drawings of the time such as the very similar *Architectonic composition* of 1922 (fig.5) which may be another version of the one given to Le Corbusier. All these pieces were, as Selim Khan-Magomedov has written, the 'architectural drafts of future Constructivist façades',[4] and perhaps that is why, during Le Corbusier's sojourn in Moscow in October 1928, Vesnin presented the visitor with several such drawings. That this untitled piece is part of Vesnin's gift is demonstrated by its provenance and also by the signature inscribed in French rather than Russian. Another of the drawings, *Drawing for a monument for the Third Congress of the Communist International*,[5] is signed and dedicated to Le Corbusier while, for his part, in a dedication that Le Corbusier made to Vesnin, the French architect called his Russian colleague the founder of Constructivism.[6] Vesnin's compact and tightly organized drawings of 1921–2 illustrate his basic premise that

> Content always has this or that form. Only via form can it become a particular, concrete structure. In this sense, there always exists the indivisibility of form and content. But a particular content is not always concretized in an appropriate form. It often happens that an important and meaningful content is distorted beyond recognition thanks to an inappropriate form and can even turn into its opposite.[7]

FIG 5 Alexander Vesnin, *Architectonic composition*, 1922, 33.5 × 24 cm, ink and gouache over pencil laid down on board (Collection of Thomas P. Whitney)

Notes

4 Ibid., p.91

5 The *Drawing for a monument to the Third Congress of the Communist International* (1921, 53 × 70.5 cm, gouache on paper, New York, Museum of Modern Art) is illus. in Los Angeles/Washington, DC, 1980–81, p.260. For information on Le Corbusier and the USSR see J.-L. Cohen, *Le Corbusier and the Mystique of the USSR*, Princeton (Princeton University Press) 1992; S.F. Starr, Le Corbusier and the USSR. New Documentation, *Cahiers du Monde russe et soviètique*, XXI, no.2, Paris, 1980, pp.209–21

6 The reference is to the dedication in a book that Le Corbusier gave to Vesnin; see Khan-Magomedov, *Alexander Vesnin*, op. cit., p.38

7 A. and V. Vesnin, 'Forma i soderzhanie' (1935); quoted in Barkhin, *Mastera sovetskoi arkhitektury ob arkhitekture*, op. cit., p.62

Abbreviations

Berlin 1977
Berlin, Neue Nationalgalerie, Akademie der Künste, and the
Grosse Orangerie des Schlosses Charlottenburg, 14 August–16
Oct. 1977, *Tendenzen der Zwanziger Jahre*

Cologne 1972
Cologne, Galerie Gmurzynska-Bargera, Sept.–end Dec. 1972,
Konstruktivismus. Entwicklungen und Tendenzen seit 1913

Cologne 1974
Cologne, Galerie Gmurzynska, 18 Sept.–Nov. 1974, *Von der
Fläche zum Raum 1916–24/From Surface to Space 1916–24*

Cologne 1975
Cologne, Galerie Gmurzynska, 3 June–Sept. 1975, *Die 20er
Jahre in Osteuropa/The 1920s in Eastern Europe*

Cologne 1977
Cologne, Galerie Gmurzynska, 11 May–June 1977, *Die
Kunstismen in Russland/The Isms of Art in Russia 1907–30*

Cologne 1979–80
Cologne, Galerie Gmurzynska, Dec. 1979–March 1980, *Die
Künstlerinnen der russischen Avantgarde 1910–1930/Women
Artists of the Russian Avant-Garde 1910–1930*

Cologne 1981
Cologne, Galerie Gmurzynska, Oct.–Dec. 1981, *Von der Malerei
zum Design/From Painting to Design*

Cologne 1984
Cologne, Galerie Gmurzynska, 12 April–15 July 1984, *Sieben
Moskauer Künstler/Seven Moscow Artists 1910–1930*

Cologne 1984–5
Cologne, Galerie Gmurzynska, Oct. 1984–Jan. 1985,
Neuerwerbungen/New Acquisitions, 1984

Cologne 1986
Cologne, Galerie Gmurzynska, 1–30 Sept. 1986, *Pioniere der
abstrakten Kunst aus der Sammlung Thyssen-Bornemisza*

Cologne 1992
Cologne, Galerie Gmurzynska, 13 June–31 July 1992,
Malewitsch. Suetin. Tschaschnik

Edinburgh/Sheffield 1978
Edinburgh, Scottish National Gallery of Modern Art/Sheffield,
Graves Art Gallery, 10 Aug.–autumn 1978, *Liberated Colour
and Form. Russian Non-objective Art 1915–1922*

Frankfurt/Amsterdam/New York 1992–3
Frankfurt, Schirn Kunsthalle, *Die Grosse Utopie. Die russische
Avantgarde 1915–1932*/Amsterdam, Stedelijk Museum, *De
Grote Utopie. Russische Avantgarde 1915–1932*/New York,
Solomon R. Guggenheim Museum, *The Great Utopia. The
Russian and Soviet Avant-garde 1915–1932*, 1 March 1992–
January 1993.[1] Opened in Moscow, Tretiakov Gallery, in 1993
with a smaller number of works, under the title *Velikaia Utopiia*

Grosse Utopie
German version of exhibition and catalogue of Frankfurt/
Amsterdam/New York, only

Japanese tour 1976
Tokyo, Seibu Museum of Art/Kobe, Hyōgo Prefectural
Museum/Fukuoka, Kitakyushu Municipal Museum, 1976, *The
Origin of the 20th Century in the World of Abstract and Surrealist
Painting*

Leningrad/Moscow 1988
Leningrad, State Russian Museum/Moscow, State Tretiakov
Gallery, 16 June–9 Oct. 1988, *Shedevry zhivopisi XX veka iz
sobraniia Tissen-Bornemisa* [Masterpieces of 20th-century
Painting from the Thyssen-Bornemisza Collection]

London 1973–4
London, Fisher Fine Art, Nov. 1973–Jan. 1974, *Tatlin's Dream*

London 1976
London, Annely Juda Fine Art, 27 May–18 Sept. 1976,
Russian Pioneers at the Origins of Non-objective Art

London 1977
London, Annely Juda Fine Art, 30 June–30 Sept. 1977, *The
Suprematist Straight Line. Malevich, Suetin, Chashnik, Lissitzky*

London/Austin, 1973
London, Annely Juda Fine Art/Austin, TX, University Art
Museum, 5 July–15 Dec. 1973, *The Non-objective World 1914–
1955*

Los Angeles/Washington, DC, 1980–81
Los Angeles, CA, Los Angeles County Museum of Art/
Washington, DC, Hirshhorn Museum and Sculpture Garden, 8
July 1980–15 Feb. 1981, *The Avant-Garde in Russia 1910–
1930. New Perspectives*

Lugano 1978
Lugano, Villa Malpensata, 1 Sept.–5 Nov. 1978, *Collezione
Thyssen-Bornemisza. Arte Moderna*

Luxembourg/Munich/Vienna 1988–9
Luxembourg, Villa Vauban/Munich, Haus der Kunst/Vienna,
Museum des 20. Jahhunderts, 30 April–15 Jan. 1988–9, *Wege
zur Abstraktion. 80 Meisterwerke aus der Sammlung Thyssen-
Bornemisza*

Milan 1979–80
Milan, Palazzo Reale, 18 Oct. 1979–18 Jan. 1980, *Origini
dell'Astrattismo*

Milan 1980
Milan, Palazzo Reale, spring 1980, *L'altra metà dell'avanguardia
1910–1940*

Milan 1991
Milan, Galleria Marconi, Dec. 1991, *Suprematisti russi degli anni
20. Suetin, Casnik, Leporskaja*

Modern Masters from the Thyssen-Bornemisza Collection 1984–6
Tokyo, National Museum of Modern Art/Kumamoto,
Prefectural Museum/London, Royal Academy of Arts/
Nuremburg, Germanisches Nationalmuseum/Düsseldorf,
Stadtische Kunsthalle/Florence, Palazzo Pitti/Paris, Musée d'art
moderne de la Ville de Paris/Madrid, Biblioteca Nacional, Salas
Pablo Ruiz Picasso/Barcelona, Palacio de la Virreina, 19 May
1984–16 Nov. 1986

New York 1971–2
New York, Leonard Hutton Galleries, 16 Oct. 1971–Feb. 1972,
Russian Avant-garde: 1908–1922[2]

Paris 1977

Paris, Galerie Jean Chauvelin, 25 Oct.–25 Dec. 1977, *Suprématisme*

Santa Barbara/Kansas City/Champaign 1991–2

Santa Barbara, CA, Santa Barbara Museum of Art/Kansas City, MI, Nelson Atkins Museum/Champaign, IL, Krannert Art Museum, 16 March 1991–1 March 1992, *Standing in the Tempest. Painters of the Hungarian Avant-garde 1908–1930*

Turin 1989

Turin, Lingotto, 21 June–20 Oct. 1989, *Arte Russa e Sovietica 1870–1930*

USA tour 1982–4

Washington, DC, National Gallery of Art/Hartford, CT, Wadsworth Atheneum/Toledo, OH, Museum of Art/Seattle, WA, Art Museum/San Francisco, CA, San Francisco Museum of Modern Art/New York, Metropolitan Museum of Art/Phoenix, AZ, Phoenix Art Museum, 1982–4: *20th-century Masters. The Thyssen-Bornemisza Collection*

Zurich 1989

Zurich, Stiftung für konstruktive und konkrete Kunst, 8 June–3 Sept. 1989, *Vor den Toren der unbekannten Zukunft*

Notes

1 Although the dates in the catalogues are 1 March–15 Dec. 1992, the New York venue was extended until Jan. 1993
2 Although the dates in the catalogue are 16 Oct.–18 Dec. 1971, the exhibition was extended until the end of February 1972

THE FOLLOWING ABBREVIATIONS HAVE BEEN USED IN THE AUCTION REFERENCES (FOR A FULL LIST OF RELEVANT AUCTIONS SEE SELECT BIBLIOGRAPHY)

Sotheby's, 1 July 1970

Twentieth-century Russian Paintings, Drawings and Watercolours, 1900–1925, London, Sotheby's, 1 July 1970

Sotheby's, 12 April 1972

Twentieth-century Russian Paintings, Drawings and Watercolours, 1900–1930, London, Sotheby's, 12 April 1972

Sotheby's, 29 March 1973

Twentieth-century Russian Paintings, Drawings and Watercolours, 1900–1930, London, Sotheby's, 29 March 1973

Sotheby's, 4 July 1974

Twentieth-century Russian and East European Paintings, Drawings and Sculpture, 1900–1930, London, Sotheby's, 4 July 1974

Sotheby Parke Bernet, 1 Dec. 1976

Important Impressionist and Modern Drawings and Watercolours, London, Sotheby Parke Bernet, 1 December 1976

Sotheby Parke Bernet, 3 Nov. 1978

Russian and European Avant-Garde Art, 1905–1930, New York, Sotheby Parke Bernet, 3 November 1978

Sotheby Parke Bernet, 6 Nov. 1979

Russian and East European Avant-garde Art and Literature 1905–1930, New York, Sotheby Parke Bernet, 6 November 1979

Sotheby Parke Bernet, 2 April 1981

Impressionist and Modern Paintings and Sculpture, London, Sotheby Parke Bernet, 2 April 1981

Sotheby's, 15 Feb. 1984

Russian Pictures, Icons and Russian Works of Art, London, Sotheby's, 15 February 1984

Sotheby's, 2 April 1987

Russian Twentieth-century and Avant-garde Art, London, Sotheby's, 2 April 1987

Sotheby's, 18 May 1988

Impressionist and Modern Art, Twentieth-century Russian and Avant-garde Art, London, Sotheby's, 18 May 1988

Sotheby's, 6 April 1989

Russian Twentieth-century and Avant-garde Art, London, Sotheby's, 6 April 1989

Drouot, 14 May 1990

Tableaux Russes et Soviètiques, Paris, Drouot, 14 May 1990

Sotheby's, 23 May 1990

Russian Twentieth-century and Avant-garde Art, London, Sotheby's, 23 May 1990

Christie's, 10 Oct. 1990

Imperial and Post-Revolutionary Russian Art, London, Christie's, 10 October 1990

Phillips, 26 Nov. 1990

Russian Art, London, Phillips, 26 November 1990

Glossary of terms and acronyms

Academy of Arts
Academy of Fine Arts, St Petersburg/Petrograd/Leningrad, founded in 1757; the first president was Catherine the Great. In 1918 the Academy was replaced by Svomas (q.v.) and then reinstated in 1921. In the 1920s it was also referred to as Vkhutemas (q.v.).

AKhRR
Assotsiatsiia khudozhnikov revoliutsionnoi Rossii [Association of Artists of Revolutionary Russia]. Founded in 1922 by Alexander Grigoriev, Evgenii Katsman and other artists who supported the style of Heroic Realism. Functioned primarily as an exhibition society based in Moscow. In 1928 changed its name to AKhR [Assotsiatsiia khudozhnikov revoliutsii – Association of Artists of the Revolution]. Disbanded in 1932.

Apollo
Title of an art and literary journal [*Apollon*] published by Sergei Makovsky in St Petersburg 1909–17 (last issues actually appeared in 1918). *Apollo* published articles and exhibition reviews dealing with the new art and also organized exhibitions in its editorial offices.

Askranov
Assotsiatsiia krainikh novatorov [Association of Extreme Innovators]. Founded in Moscow in 1919 by Alexander Drevin, Alexei Gan, Alexander Rodchenko and Varvara Stepanova.

Blue Rose
Group of Moscow and Saratov Symbolist artists consisting of Pavel Kuznetsov, Nikolai Sapunov, Sergei Sudeikin et al. Held one exhibition in Moscow in 1907.

Café Pittoresque
A bohemian café and cabaret founded in Moscow in 1917. Functioned for only a few months. Interior design by Georgii Yakulov, assisted by Alexander Rodchenko, Nadezhda Udaltsova et al.

Comintern
Communist International. Unification of Communist Parties worldwide through debate and convocation. Vladimir Tatlin designed his Tower in 1919–20 for the III International held in Moscow in 1921.

Contemporary Trends
Exhibition organized by Nikolai Kulbin in St Petersburg in 1908. David Burliuk, Aristarkh Lentulov et al. took part.

Donkey's Tail
Group organized by Larionov in 1911. Held one exhibition in Moscow in 1912 with contributions by Natalia Goncharova, Mikhail Larionov, Kazimir Malevich, Alexander Shevchenko et al.

Erste Russische Kunstausstellung
The first major Soviet art exhibition abroad, held at the Galerie Van Diemen, Berlin, in 1922, before travelling on to Amsterdam in modified form. Although the avant-garde was well represented, this commercial exhibition was a survey of many trends.

Exhibition of Paintings by Petrograd Artists of All Directions
Broad survey of new trends organized in Petrograd in 1923. Among the many contributors were Ilia Chashnik, Pavel Filonov, Pavel Mansouroff and Vladimir Tatlin.

Exposition Internationale des Arts Décoratifs
International exhibition of industrial design and applied art in Paris in 1925. Many of the Soviet Suprematists and Constructivists such as Ilia Chashnik, Liubov Popova, Alexander Rodchenko, Varvara Stepanova and Alexander Vesnin contributed to the Soviet Pavilion designed by Konstantin Melnikov.

5 × 5 = 25
Exhibition in Moscow in 1921 at which Alexandra Exter, Liubov Popova, Alexander Rodchenko, Varvara Stepanova and Alexander Vesnin contributed five works each. Generally regarded as a major development in the history of Constructivism. A second show was planned, but not implemented.

Four Arts
An exhibition society founded in Moscow in 1924 by Lev Bruni, Vladimir Lebedev, Petr Miturich, Kuzma Petrov-Vodkin et al. While oriented towards the lyrical and decorative qualities of art, Four Arts was eclectic and included such diverse artists as Ivan Kliun, El Lissitzky and Ivan Puni as well as several architects at its four exhibitions (1925, 1926, 1928, 1929).

GAKhN
See RAKhN.

Ginkhuk
Gosudarstvennyi institut khudozhestvennnoi kultury [State Institute of Artistic Culture]. The Petrograd/Leningrad counterpart to Inkhuk (q.v.). which developed from the Petrograd affiliation of the Museums of Painterly Culture (q.v.) in 1923 (ratified 1924). The Museum/Ginkhuk contained five basic departments: the Department of Form and Theory headed by Kazimir Malevich; the Department of Material Culture headed by Vladimir Tatlin (1922–5); the Department of Organic Culture headed by Mikhail Matiushin; the Department of Experimentation headed by Pavel Mansouroff; the Department of General Ideology headed by Pavel Filonov and then Nikolai Punin.

Golden Fleece
Title of an art and literary journal [*Zolotoe runo*] published by Nikolai Riabushinsky in Moscow 1906–9 (last issues actually appeared in 1910). The *Golden Fleece* also organized three exhibitions that did much to propagate the cause of Goncharova and Larionov, the *Salon of the Golden Fleece* (Moscow, 1908; contributions by Russian and Western European artists); *Golden Fleece* (Moscow, 1909; contributions by Russian and Western European artists); *Golden Fleece* (Moscow, 1909–10; contributions by Russian artists only).

Inkhuk
Institut khudozhestvennoi kultury [Institute of Artistic Culture]. Founded as a research institute in Moscow in 1920. Many of the avant-garde were associated with it and Vasilii Kandinsky was its first President. Inkhuk had affiliations in Petrograd, Vitebsk and other cities. Active until 1924.

Izdebsky Salons
Vladimir Izdebsky organized two important exhibitions or salons of the new Russian art, the *International Exhibition of Paintings, Sculpture, Engravings and Drawings* (Odessa and other

cities, 1909–10; contributions by Russian and Western European artists), *Salon-2* (Odessa 1910/opened 1911; contributions by Russian artists only).

IZO
Izobrazitelnye iskusstva [the Visual Arts]. The Visual Arts Section of NKP (q.v.) founded in 1918 under David Shterenbrg. IZO was responsible for art exhibitions, official commisions, art institutes, art education, etc. At first, many of the avant-garde were involved in its activities.

Jack of Diamonds
Group organized by Mikhail Larionov in Moscow in 1910 and supported at first by many radical artists, including Natalia Goncharova and Kazimir Malevich. After the first exhibition in Moscow in 1910–11, the group split into two factions, one led by Larionov giving rise to the Donkey's Tail (q.v.), the other by Robert Falk, Petr Konchalovsky, Aristarkh Lentulov, Ilia Mashkov et al. The Jack of Diamonds organized regular exhibitions in Moscow and St Petersburg between 1910 and 1917, some of them international in scope.

Lef
Levyi front iskusstv [Left Front of the Arts]. A Moscow group of radical writers and artists including Vladimir Maiakovsky, Alexander Rodchenko and Sergei Tretiakov. Published a journal of the same name in 1923–5 and then *Novyi lef* [New Left] in 1927–8. The group was an enthusiastic proponent of Constructivism and new media such as photography and cinematography.

Link
Exhibition organized by David Burliuk, Alexander Bogomazov, Alexandra Exter and other artists in Kiev in 1908. Accompanied by a manifesto, this was one of the first avant-garde exhibitions of Russian and Ukrainian art.

Lubok
A cheap, handcoloured print or broadsheet, often depicting allegorical and satirical scenes from Russian life. The bright colours and crude outlines of the *lubok* attracted many twentieth-century Russian artists.

Morozov Gallery
The Moscow collection of Impressionist and Post-Impressionist paintings belonging to the businessman Ivan Morozov. In 1918 the collection was nationalized.

Moscow Institute of Painting, Sculpture and Architecture
The main Moscow art school at which many of Russia's nineteenth- and twentieth-century artists studied, including most of the avant-garde. After 1917 it merged with the Central Stroganov Institute of Technical Drawing to form Svomas (q.v.)

Moscow Painters
See OMKh.

Moscow Salon
A society that held regular exhibitions in Moscow between 1910 and 1918 at which some of the avant-garde, including Natalia Goncharova, Petr Konchalovsky and Varvara Stepanova were represented.

Museums of Painterly Culture
In 1919 a network of Museums of Painterly (also called Artistic or Plastic) Culture was established for Moscow, Petrograd and other cities. Natan Altman, Vasilii Kandinsky, Alexander Rodchenko and other avant-garde artists were involved in the organization of this network, the purpose of which was to collect works by modern Russian artists. The most important Museum was the Moscow one that functioned 1919–24.

New Society of Artists
A society that held regular exhibitions in St Petersburg between 1904 and 1915 at which some of the avant-garde, including Alexandra Exter, Vasilii Kandinsky, Petr Konchalovsky and Ilia Mashkov were represented.

NKP
Narodnyi komissariat prosveshcheniia [People's Commissariat for Enlightenment]. Established under Anatolii Lunacharsky just after the Revolution, this radical Ministry of Culture opened various subsections responsible for the arts such as TEO (Theatre), MUZO (Music) and IZO (q.v.).

No.4
Group organized by Mikhail Larionov in 1914. Held one exhibition in Moscow with contributions by Alexandra Exter, Natalia Goncharova, Mikhail Larionov, Alexander Shevchenko et al.

0.10
Short title of the *Last Futurist Exhibition of Paintings, 0.10*, held in Petrograd in 1915–16 with contributions by Ivan Kliun, Liubov Popova, Ivan Puni, Olga Rozanova, Vladimir Tatlin et al. This was also the first public showing of Kazimir Malevich's Suprematism.

Obmokhu
Obshchestvo molodykh khudozhnikov [Society of Young Artists]. A society that held four exhibitons in Moscow between 1919 and 1923 with contributions by Konstantin Medunetsky, Alexander Rodchenko, Georgii and Vladimir Stenberg et al. Obmokhu was a primary exponent of Constructivism.

OMKh
Obshchestvo moskovskikh khudozhnikov [Society of Moscow Artists]. A society based on the Moscow Painters group of 1925 which was based, in turn, on the Jack of Diamonds (q.v.). Held two exhibitions in 1928 and 1929 at which Alexander Drevin, Robert Falk, Aristarkh Lentulov, Vasilii Rozhdestvensky, Nadezhda Udaltsova et al. were represented.

October
A Moscow group, founded in 1928, that supported the principles of Constructivist applied and industrial art. Among the members were Sergei Eisenstein, Gustav Klucis, Solomon Telingater, Alexander Rodchenko, and Alexander Vesnin. One of the last avant-garde groups, it was disbanded in 1932.

OST
Obshchestvo khudozhnikov-stankovistov [Society of Studio Artists]. A group of young painters and sculptors that often used Expressionist and Surrealist styles to illustrate the new reality of industry, sports, etc. It held exhibitions between 1925 and 1928 at which Alexander Deineka, Yurii Pimenov, Alexander Tyshler, David Shterenberg et al. were represented.

Plan of Monumental Propaganda
In 1918 Lenin composed his Plan of Monumental Propaganda whereby many Tsarist monuments, reliefs and street-names were to be removed from the cities and replaced by revolutionary ones. The Plan, which attracted numerous artists, was implemented only in part.

Proletkult
Proletarskaia kultura [Proletarian Culture]. This movement, established formally in February 1917, maintained that only the proletariat could create a proletarian art and that much of Russia's cultural heritage could be ignored. Supported by a number of the avant-garde artists, including Olga Rozanova, Proletkult operated studios in urban centres and its emphasis on industry allied it with the emergent Constructivist groups. It was annexed to NKP (q.v.) in 1922.

Pushkin Museum of Fine Arts
The principal Moscow collection of Western art, ancient and modern. Founded in 1912, it was called the Alexander III Museum of Fine Arts until 1917.

RAKhN
Rossiiskaia Akademiia khudozhestvennykh nauk [Russian Academy of Artistic Sciences]. Founded in Moscow in 1921 under Petr Kogan, RAKhN, also known as GAKhN [Gosudarstvennaia Akademiia khudozhestvennykh nauk – State Academy of Artistic Sciences], was a research institution that attracted a number of important artists and critics, including Anatolii Bakushinsky, Vasilii Kandinsky, Fedor Shmit and Gustav Shpet. It functioned until 1931.

RSFSR
Rossiiskaia Sovetskaia Federativnaia Sotsialisticheskaia Respublika [Russian Soviet Federative Socialist Republic].

Russian Museum
The principal Leningrad collection of Russian art. Founded in St Petersburg in 1898, it was called the Alexander III Russian Museum until 1917.

Shchukin Gallery
The Moscow collection of Impressionist and Post-Impressionist paintings belonging to the businessman Sergei Shchukin. In 1918 the collection was nationalized.

Society of Studio Artists
See OST.

State Exhibitions
IZO NKP (q.v.) organized twenty-one state exhibitions in Moscow in 1919–21 of which the following were particularly important: the tenth, *Non-objective Creativity and Suprematism* (1919), the twelfth, *Colour-Dynamos and Tectonic Primitivism* (1919), the sixteenth (one-man show of Kazimir Malevich, 1919), and the nineteenth (included works by Vasilii Kandinsky, Nikolai Krymov, Alexander Rodchenko and Varvara Stepanova, 1920).

Stroganov Institute
Central Stroganov Institute of Technical Drawing, Moscow (also known as the Stroganov Art and Industry Institute). After 1917 it merged with the Moscow Institute of Painting, Sculpture and Architecture to form Svomas (q.v.).

Supremus
A Moscow group of artists consisting of Ivan Kliun, Kazimir Malevich, Liubov Popova, Vladimir Tatlin, Nadezhda Udaltsova et al. formed in 1916 to propagate the new art, particularly Suprematism, through lectures, discussions and a journal (projected, but not realized). Ceased activities in 1917.

Svomas
Svobodnye gosudarstvennye khudozhestvennye masterskie [Free State Art Studios]. In 1918 the Moscow Institute of Painting, Sculpture and Architecture (q.v.) and the Stroganov Institute (q.v.) were integrated to form Svomas, and leading art schools in other major cities, including the Academy of Arts, Petrograd, were also removed. In 1920, however, Svomas, Moscow, was renamed Vkhutemas (q.v.) and the Academy in Petrograd was reinstated. Many avant-garde artists, including Ivan Kliun, Liubov Popova, Alexander Rodchenko and Vladimir Tatlin, contributed to the radical educational and administrative developments that accompanied these name changes.

Target
Group organized by Mikhail Larionov in 1913. Held one exhibition in Moscow in 1913 with contributions by Marc Chagall, Natalia Goncharova, Larionov, Kazimir Malevich, Alexander Shevchenko et al.

Tramway V
Short title of *Tramway V, the First Futurist Exhibition of Paintings* held in Petrograd in 1915 with contributions by Ivan Kliun, Kazimir Malevich, Liubov Popova, Olga Rozanova, Vladimir Tatlin et al.

Tretiakov Gallery
The principal Moscow collection of Russian art. Founded in 1892 on the basis of the collection of Pavel Tretiakov, a Moscow businessman.

Triangle
Exhibition organized by Nikolai Kulbin in St Petersburg in 1910 and supported by some of the avant-garde artists, including David and Vladimir Burliuk.

Union of Russian Artists
A society that held regular exhibitions in Moscow/St Petersburg between 1910 and 1924 with contributions by predominantly moderate artists such as Sergei Ivanov, Sergei Vinogradov and Konstantin Yuon.

Union of Youth
Group of artists, critics and aesthetes initiated by Vladimir Markov, Olga Rozanova, Iosif Shkolnik et al. in St Petersburg in 1910. Published an art journal under the same name 1912–13 and sponsored a series of exhibitions 1910–1914 to which many of the avant-garde contributed, including David Burliuk, Pavel Filonov, Mikhail Larionov and Ivan Puni.

Unovis
Utverditeli (or Utverzhdenie) novogo iskusstva [Affirmers (or Affirmation) of the New Art]. A group of Suprematist artists founded by Kazimir Malevich in Vitebsk at the end of 1919 and including Ilia Chashnik, Nina Kogan, El Lissitzky and Nikolai Suetin. Unovis had affiliations in Smolensk, Samara and other cities, and held exhibitions in Vitebsk and Moscow.

Victory over the Sun
The Cubo-Futurist opera produced in St Petersburg in 1913 with libretto by Alexei Kruchenykh and Velimir Khlebnikov, music by Mikhail Matiushin and designs by Kazimir Malevich.

Vkhutein
Vysshii gosudarstvennyi khudozhestvenno-tekhnicheskii institut [Higher State Art-Technical Institute]. Vkhutein replaced Vkhutemas (q.v.) in 1926 and was replaced by the Moscow Institute of Visual Arts in 1930.

Vkhutemas
Vysshie gosudarstvennye khudozhestvenno-tekhnicheskie masterskie [Higher State Art-Technical Studios]. Vkhutemas replaced Svomas (q.v.) in 1920 and was replaced by Vkhutein (q.v.) in 1926. Although the Moscow Vkhutemas is the most famous, the name was also applied to other art schools such as the reinstated Academy of Arts in Petrograd/Leningrad.

Vsekokhudozhnik
Vserossiiskoe kooperativnoe tovarishchestvo 'Khudozhnik' [All-Russian Co-operative Association 'Art']. Founded in Moscow in 1934 as an artists' trade union with exhibition and publishing facilities. Discontinued with the establishment of the Union of Artists of the USSR in 1939.

Wanderers
Short title of the Association of Wandering Exhibitions founded in 1870. Held regular exhibitions in St Petersburg, Moscow, and other cities between 1871 and 1923 with contributions by Isaak Levitan, Ilia Repin, Vasilii Surikov and other Realist artists.

World of Art
Group of St Petersburg artists, critics and aesthetes founded by Alexandre Benois, Sergei Diaghilev et al. in the late 1890s.

Published an art journal under the same name 1898–1904 and sponsored a series of exhibitions 1899–1906 so as to propagate contemporary art. Revived as an exhibition society in 1910 (until 1924).

Wreath

Exhibition organized in St Petersburg in 1908 with contributions by the Burliuks, Alexandra Exter, Aristarkh Lentulov et al.

Wreath-Stephanos

Exhibiton organized in Moscow in 1907–8 with contributions by David and Vladimir Burliuk, Mikhail Larionov, Aristarkh Lentulov, Georgii Yakulov et al; also opened in St Petersburg and other cities with a similar contingent.

Year 1915

Short title of *Exhibition. The Year 1915* organized by Konstantin Kandaurov in Moscow in 1915 with contributions by Vasilii Kamensky, Mikhail Larionov, Aristarkh Lentulov, Kazimir Malevich, Olga Rozanova et al.

Zhivskulptarkh

Kollektiv zhiviopisno-skulpturno-arkhitekturnogo sinteza [Collective of Painting-Sculpture-Architecture Synthesis]. Group founded in Moscow in 1919 consisting of Boris Korolev, Vladimir Krinsky, Nikolai Ladovsky, Alexander Rodchenko, Alexander Shevchenko et al. Active through 1920.

Select bibliography

RUSSIA

The bibliography for Russia is divided into three parts: monographs; exhibition catalogues; auction catalogues.
The titles listed below form only a small part of the total bibliography pertaining to the history of the Russian avant-garde and are intended only as a guide to further reading.
For works on individual artists, see the bibliographies at the end of each biography.

Monographs
in alphabetical order by author or editor

M. Allenov et al., *L'Art Russe*, Paris (Citadel) 1991

T. Andersen, *Moderne russisk kunst 1910–1930*, Copenhagen (Borgen) 1967

M. Anikst and E. Chernevich, *Russian Graphic Design 1880–1917*, New York (Abbeville) 1990

A. Bird, *A History of Russian Painting*, Oxford (Phaidon) 1987

S. Bojko, *New Graphic Design in Revolutionary Russia*, New York (Praeger) 1972

J. Bowlt, *The Silver Age. Russian Art of the Early Twentieth Century and the 'World of Art' Group*, Newtonville (ORP) 1979

– *Khudozhniki russkogo teatra 1880–1930. Sobranie Nikity i Niny Lobanovykh-Rostovskikh*, Moscow (Iskusstvo) 1990

J. Bowlt, ed., *Russian Art of the Avant-garde. Theory and Criticism 1902–1934*, New York (Viking) 1976; 2nd edn., London (Thames and Hudson) 1988; Japanese trans., Tokyo (Shoten) 1988

– *Soviet Union*, III, pt.2, 1976 [special issue devoted to Soviet Constructivism]

– *Soviet Union*, VI, pts.1–2, 1980 [special issue devoted to Soviet art of the 1920s]

– *Journal of Decorative and Propaganda Arts*, no.5, 1987, [special issue devoted to Russian design 1880–1980]
Journal of Decorative and Propaganda Arts, no.11, 1989, [special issue devoted to Russian design 1880–1980]

M. Bown and B. Taylor, *Art of the Soviets: Painting, Sculpture and Architecture in a One-Party State, 1917–1922*, Manchester (Manchester University Press) 1992

S. Chan-Magomedow, *Pioniere der sowjetischen Architektur*, Dresden (VEB) 1983; Eng. trans. *Pioneers of Soviet Architecture*, New York (Rizzoli) 1987

– *Vkhutemas-Vkhutein*, Paris (Sers) 1991

S. Compton, *The World Backwards. Russian Futurist Books 1912–16*, London (British Library) 1978

G. Conio, ed., *L'Avant-garde russe et la synthèse des arts*, Lausanne (L'Age d'Homme) 1990

C. Cooke, ed., *Architectural Design*, LIII, 1983 [special issue devoted to Russian avant-garde art and architecture]

D. Elliott, *New Worlds. Russian Art and Society 1900–1937*, London (Thames and Hudson) 1986

S. Fauchereau et al., *Moscou 1900–1930*, New York (Rizzoli) 1988

A. Flaker, *Ruska avangarda*, Zagreb (Globus) 1984

A. Flaker, ed., *Glossarium der russischen Avantgarde*, Graz (Droschl) 1989

H. Gassner and E. Gillen, *Zwischen Revolutionskunst und Sozialistischen Realismus. Dokumente und Kommentare. Kunstdebatten in der Sowjetunion von 1917 bis 1934*, Cologne (DuMont) 1979

C. Gray, *The Great Experiment. Russian Art 1863–1922*, London (Thames and Hudson) 1962; reissued as *The Russian Experiment in Art: 1863–1922*, London (Thames and Hudson) 1970; rev. edn., London (Thames and Hudson) 1986

M. Guerman, *Art of the October Revolution*, New York (Abrams) 1979; also in Russian, German and French

– *Soviet Art 1920s-1930s*, New York (Abrams) 1988

G. Harrison, *Ex Libris 6. Constructivism and Futurism in Russia and Other*, New York (TJ Art) 1977

J. Howard, *The Union of Youth*, Manchester (Manchester University Press) 1992

G. Janecek, *The Look of Russian Literature. Avant-garde Experiments 1900–1930*, Princeton (Princeton University Press) 1984

F. Karpfen, *Gegenwartskunst. Russland*, Vienna (Literaria) 1921

N. Khardzhiev, *K istorii russkogo avangarda/The Russian Avant-Garde*, Stockholm (Almqvist and Wiksell) 1976

E. Kovtun, *Russkaia futuristicheskaia kniga*, Moscow (Kniga) 1989

E. Kovtun et al., *Sovetskoe iskusstvo 20–30-kh godov*, Leningrad (Iskusstvo) 1988

– *Avangard, ostanovlennyi na begu*, Leningrad (Avrora) 1989

J. Kovtun, *Russische Avantgarde*, Munich (Neimanis) 1991

J. Kovtun, *Die Wiedergeburt der kunstlerischer Druckgraphik*, Dresden (VEB) 1984

E. Kuznecov, *L'Illustrazione del libro per bambini e l'avanguardia russa*, Florence (Cantini) 1991

L. Lang, *Konstruktivismus und Buchkunst*, Leipzig (Edition Leipzig) 1990

C. Leclanche-Boule, *Typographies, Photomontages Constructivistes*, Paris (Papyrus) 1984

D. Lichacev, *Le Radici dell'arte russa*, Milan (Fabbri) 1992

B. Livshits, *Polutoraglazyi strelets*, Leningrad (Izdatelstvo pisatelei) 1933; Eng. trans. by John E. Bowlt as *Benedikt Livshits. The One and a Half-eyed Archer*, Newtonville (Oriental Research Partners) 1977

C. Lodder, *Russian Constructivism*, New Haven (Yale University Press) 1983

L. Lozowick, *Modern Russian Art*, New York (Museum of Modern Art) 1925

L. Magarotto et al., eds., *L'Avanguardia a Tiflis*, Venice (Università degli Studi) 1982

L. Magarotto et al., *Zaumnyi futurizm i dadaizm v russkoi kulture*, Bern (Lang) 1991

V. Manine, *L'Art Russe 1900–1935. Tendances et Mouvements*, Paris (Sers) 1989

J.-C. Marcadé, *Le Futurisme Russe*, Paris (Dessain et Tolra) 1989

V. Marcadé, *Le Renouveau de l'art pictural russe*, Lausanne (L'Age d'Homme) 1971

– *L'Art d'Ukraine*, Lausanne (L'Age d'Homme) 1991

V. Markov, *Russian Futurism*, Berkeley (University of California Press) 1968

J. Milner, *Russian Revolutionary Art*, London (Oresko) 1979

– *Vladimir Tatlin and the Russian Avant-garde*, New Haven (Yale University Press) 1983

N. Misler, *Avanguardie russe*, Roma (Giunti) 1989

M. Mudrak, *The New Generation and Artistic Modernism in the Ukraine*, Ann Arbor (UMI) 1986

A. Nakov, *Abstrait/Concret. Art Non-objectif Russe et Polonais*, Paris (Editions de Minuit) 1981

– *L'Avant-garde Russe*, Paris (Hazan) 1984

G. Pospelov, *Bubnovyi valet*, Moscow (Sovetskii khudozhnik) 1990

A. Povelikhina and E. Kovtun, *Russian Painted Shop Signs and Avant-*

garde Artists, Leningrad (Aurora) 1991

V. Quilici, *Il Costruttivismo*, Rome (Laterza) 1991

G. Roman and V. Marquardt, eds., *The Avant-garde Frontier. Russia Meets the West, 1910–1930*, Gainesville, FL (University Press of Florida) 1992

A. Rudenstine, S.F. Starr and G. Costakis, eds, *Russian Avant-garde Art: The George Costakis Collection*, New York (Abrams) 1981

D. Sarabianov, *Russian Art. From Neo-Classicism to the Avant-Garde*, London (Thames and Hudson) 1990

A. Sarabianov and N. Gurianova, *Neizvestnyi avangard*, Moscow (Sovetskii khudozhnik) 1992

L. Shadowa, *Suche und Experiment. Russische und sowjetische Kunst 1910 bis 1930*, Dresden (VEB) 1978; Eng. trans., L. Zhadova, *Malevich. Suprematism and Revolution in Russian Art 1910–1930*, London (Thames and Hudson) 1982

B. Taylor, *Art and Literature under the Bolsheviks*, London (Pluto) 1991

V. Tolstoi, ed., *1917–1932. Agitatsionno-massovoe iskusstvo. Oformlenie prazdnestv*, 2 vols, Moscow (Iskusstvo) 1984

V. Tolstoi et al., *Art décoratif soviètique 1917–1937*, Paris (Editions du Regard) 1989

V. Tolstoy, I. Bibikova and C. Cooke, *Street Art of the Revolution*, London (Thames and Hudson) 1990

A. Turowski, *W kregu konstruktywizmu*, Warsaw (Wydawnictwa Artystyczne i Filmowe) 1979

– *Wielka utopia awangardy*, Warsaw (Panstwowe Wydawnictwo Naukowe) 1990

K. Umanskij, *Neue Kunst in Russland, 1914–1919*, Potsdam and Munich (Kiepenheuer/Golitz) 1920

R. Williams, *Russian Art and American Money 1900–1940*, Cambridge, MA (Harvard University Press) 1980

M. Yablonskaya, *Women Artists of Russia's New Age 1900–1935*, London (Thames and Hudson) 1990

B. Zelinsky, *Russische Avantgarde, 1907–1921, Vom Primitivismus zum Konstruktivismus*, Bonn (Grundmann) 1983

Exhibition catalogues
listed in chronological order

Die Erste Russische Kunstausstellung, Berlin, Galerie Van Diemen, 1922

Russian Art Exhibition, New York, Grand Central Palace, 1924

XIV Esposizione internazionale d'arte della città di Venezia (Padiglione del USRR), Venice, 1924

L'Exposition Internationale des Arts Décoratifs et Industriels Modernes (Section russe: l'art décoratif et industriel de l'URSS), Paris, 1925

Beitrag der Russen zur modernen Kunst, Frankfurt, Städtische Galerie, 1959

Two Decades of Experiment in Russian Art (1902–1922), London, Grosvenor Gallery, 1962

Il contributo russo alle avanguardie plastiche, Milan, Galleria del Levante, 1964

Avantgarde 1910–30 Osteuropa, West Berlin, Akademie der Künste, 1967

L'Art d'avant-garde Russe, 1905–1925, Paris, Musée d'Art Moderne, 1968

Russische Künstler aus dem 20. Jahrundert, Cologne, Galerie Gmurzynska, 1968

Aspects de l'avant-garde Russe, 1905–1925, Paris, Galerie Jean Chauvelin, 1969

Osteuropäische Avantgarde, Cologne, Galerie Gmurzynska, 1970–71

The Non-objective World 1914–1924, London, Annely Juda Fine Art, and other cities, 1971

The Non-objective World 1924–1939, London, Annely Juda Fine Art, and other cities, 1971

Russian Art of the Avant-garde 1908–1922, New York, Leonard Hutton Galleries, 1971

Russian Art of the Revolution, Ithaca, NY, Andrew Dickson White Museum of Art/Brooklyn, Brooklyn Museum, 1971

Art in Revolution. Soviet Art and Design Since 1917, London, Hayward Gallery, and other cities, 1971–2. Opened as *Kunst in der Revolution* in Frankfurt, West Germany, and other cities, 1972–3

Konstruktivizmus. Entwicklungen und Tendenzen seit 1913, Cologne, Galerie Gmurzynska, 1972

The Non-objective World 1914–1955, London, Annely Juda Fine Art/Austin, TX, University Art Museum 1973

Progressive Russische Kunst, Cologne, Galerie Gmurzynska, 1973

Vision Russe, Geneva, Galerie Motte, 1973

Der Beitrag Russlands zur der Geschichter der Avantgarde der zehner und zwanziger Jahre, Nuremberg, Galerie R. Johanna Ricard, 1974

Tatlin's Dream. Russian Suprematist and Constructivist Art 1910–23, London, Fischer Fine Art, 1974

Von der Fläche zum Raum. Russland 1916–24/From Surface to Space. Russia 1916–24, Cologne, Galerie Gmurzynska, 1974

2 Stenberg 2. The 'Laboratory' Period (1919–1921) of Russian Constructivism, Paris, Galerie Jean Chauvelin, 1975

Russian Constructivism. Laboratory Period, London, Annely Juda Fine Art/Toronto, Art Gallery of Ontario, 1975

Die 20er Jahre in Osteuropa/The 1920s in Eastern Europe, Cologne, Galerie Gmurzynska, 1975

Russian Avant Garde, New York, Carus Gallery, 1975

Russian Pioneers at the Origins of Non-objective Art, London, Annely Juda Fine Art, 1976

Russian Suprematist and Constructivist Art 1910–1930, London, Fischer Fine Art, 1976

Die Kunstismen in Russland/The Isms of Art in Russia, Cologne, Galerie Gmurzynska, 1977

Russian and Soviet Painting, New York, Metropolitan Museum of Art, 1977

Suprématisme, Paris, Galerie Jean Chauvelin, 1977

The Suprematist Straight Line. Malevich, Suetin, Chashnik, Lissitzky, London, Annely Juda Fine Art, 1977

Liberated Colour and Form. Russian Non-Objective Art 1915–1922, Edinburgh, Scottish National Gallery of Modern Art/Sheffield, Graves Gallery, 1978

Russische Avantgarde 1910–1930, Cologne, Galerie Bargera, 1978

Paris–Moscou 1900–1930, Paris, Centre Pompidou, 1979

The Russian Revolution in Art, New York, Rosa Esman Gallery, 1979

Künstlerinnen der russischen Avantgarde/Women-Artists of the Russian Avant-garde 1910–30, Cologne, Galerie Gmurzynska, 1979–80

L'altra metà dell'avanguardia 1910–1940, Milan, Comune di Milano, 1980; opened as *L'autre moitié de l'avant garde 1910–1940*, Paris, Des Femmes, 1982

The Avant-garde in Russia 1910–1930. New Perspectives, Los Angeles, CA, Los Angeles County Museum/Washington, DC, Hirshhorn Museum and Sculpture Garden, 1980–81

Invention and Tradition. Selected Works from the Julia A. Whitney Foundation and the Thomas P. Whitney Collection of Modernist Russian Art, Charlottesville, VA, University of Virginia, and other cities, 1980–81

Moskva–Parizh 1900–1930, Moscow, State Pushkin Museum of Fine Arts, 1981

Von der Malerei zum Design/From Painting to Design, Cologne, Galerie Gmurzynska, 1981

Art of the Avant-garde in Russia: Selections from the George Costakis Collection, New York, Guggenheim Museum, and other cities, 1981–83

Art and Revolution, Japan, Seibu Museum of Art, 1982

Plastyka Radziecka. Sztuka okresu pazdziernika 1917–1930, Warsaw, Zacheta, 1982

Architettura nel paese dei Soviet 1917–1933, Rome, Palazzo delle Esposizioni, 1982–3

L'Avant-Garde au Féminin. Moscou, Saint-Petersbourg, Paris (1907–1930), Paris, Artcurial, 1983

The First Russian Show, London, Annely Juda Fine Art, 1983

Umetnost Oktobarske epohe, Belgrade, Museum of Contemporary Art/ Zagreb, Gallery of Contemporary Art, 1983

Dada-Constructivism, London, Annely Juda Fine Art, 1984

Russische Kunst des 20 Jahrhunderts. Sammlung Semjonow, Esslingen am Neclear, Galerie der Stadt, 1984

Sieben Moskauer Künstler/Seven Moscow Artists 1910–1930, Cologne, Galerie Gmurzynska, 1984

Art into Production, Oxford, Museum of Modern Art, 1984–5.

Russische und Sowjetische Kunst. Tradition-Gegenwart, Düsseldorf, Städtische Kunsthalle, and other cities, 1984–5

Masterpieces of the Avantgarde, London, Annely Juda Fine Art/Juda Rowan Gallery, 1985

Contrasts of Form. Geometric Abstract Art 1910–1980, New York, Museum of Modern Art, 1985

Vanguardia Rusa 1910–1930. Museo y coleccion Ludwig, Madrid, Fundacion Juan March, 1985

Futurismo i futurismi, Venice, Palazzo Grassi, 1986

Pioniere der abstrakten Kunst aus der Sammlung Thyssen-Bornemisza, Cologne, Galerie Gmurzynska, 1986

Avant-garde Russe 1910–1930, Paris, Galerie Georges Lavrov, 1987

Meister des XX Jahrhunderts, Cologne, Galerie Gmuryznska, 1987

Iskusstvo i revoliutsiia II. Art and Revolution II, Tokyo, Seibu Museum, 1987

Novoe iskusstvo, Novyi byt, 1917–1927, Moscow Collectors' Club, 1987

Müvészet és Forradalom. Art and Revolution, Budapest, Palace of Exhibitions, then opened under the title *Kunst und Revolution. Art and Revolution*, Vienna, Österrreichische Museum für angewandte Kunst, 1987–8

Avant Garde Revolution Avant Garde. Russian Art from the Michail Grobman Collection, Tel Aviv, Tel Aviv Musuem of Art, 1988

Moderne – Postmoderne, Geneva, Cabinet des estampes, 1988

Michail Grobman. Kunstler und Sammler, Bochum, Museum Bochum, 1988

Muutoksen aika förändringens tid. Time of Change, 1905–1930, Helsinki, Art Hall, 1988

A New Spirit, New York, Barry Friedman, 1988

Revolutionäre Kunst aus sowjetischen Museen 1910–1930, Lugano, Fondazione Thyssen-Bornemisza, 1988

Russian and Soviet Painting 1900–1930, Washington, DC, Hirshhorn Museum and Sculpture Garden, 1988

Shedevry zhivopisi XX veka iz sobraniia Tissen-Bornemisa, Leningrad, State Russian Museum, 1988

Dada and Constructivism, Tokyo, Seibu Museum, and elsewhere, 1988–89

Konstruktivismus-Suprematismus, Zurich, Galerie Stolz, 1988–9

Osteuropäische Avantgarde, Bochum, Museum Bochum, 1988–9

Arte Russa e Sovietica 1870–1930, Turin, Lingotto, 1989

Avantgarde. Neuostoaidetta 1920–1930, Helsinki, Galerie Art, 1989

Avantgarde 1910–1930. Russian-Soviet Art, Turku, Art Musuem, 1989

Avanguardia Russa dalle collezioni private sovietiche. Origini e percorso 1904–1934, Milan, Palazzo Reale, 1989

Kunst der 20er und 30er Jahre, Iserlohn, Stadmuseum, 1989

Von der Revolution zur Perestroika. Sowjetische Kunst aus der Sammlung Ludwig, Lucerne, Kunstmuseum, 1989

Russische Kunst 1900–1930, Munich, Galerie Pabst, 1989

The Russian and Soviet Avant-Garde. Works from the Collection of George Costakis, Montreal, Montreal Museum of Fine Arts, 1989

Vor den Toren der unbekannten Zukunft. Russische Avantgarde der 10er und 20er Jahre. Werke aus Schweizer Privatbesitz, Zurich, Stiftung für konstruktive und konkrete Kunst, 1989

100 Years of Russian Art 1889–1989 from Private Collections in the USSR, London, Barbican Gallery/Oxford, Museum of Modern Art, 1989

50 Años de Arte sovietico, Barcelona, Centre Cultural Metropolità, 1990

Art into Life, Seattle, WA, Henry Art Gallery, 1990

La epoca heroica. Obra grafica de las vanguardias rusa y hungara 1912–1925, Valencia, IVAM Centre Julio Gonzalez, 1990

Grafica Russa 1917–1930, Florence, Palazzo Strozzi, 1990

Majakovskij e l'avanguardia russa del primo '900, Senigallia, Rocca Roveresca, 1990

Moscow. Treasures and Traditions, Washington, DC, Smithsonian Traveling Exhibition Service, 1990

Russian Avant-garde, London, Cooling Gallery, 1990

The Russian Experiment, New Rochelle, NY, College of New Rochelle, 1990

Russishche Avantgarde 1910–1930, Duisburg, Wilhelm-Lehmbruck Museum, 1990

Russische und Sowjetische Zeichnungen und Aquarelle von 1900 bis 1930 aus dem Puschkin-Musuem, Moskau, Mannheim, Städtische Kunsthalle, 1990

La Tipografia Russa 1890–1930, Città di Castello, Palazzo Vitelli a Sant'Egidio, 1990

Tradition and Revolution in Russian Art, Manchester, City Art Gallery, and other insitutions, 1990

Ukrajinska Avangarda 1910–1930, Zagreb, Muzej suvremene umjetnosti, 1990

Artisti Russi 1900–1930, Rome, Palazzo delle Esposizioni, 1991

Avanguardie Russe, Milan, Fonte d'Abisso d'Arte, 1991

Avantgarde I 1900–1923. Russisch-sowjetische Architektur, Tübingen, Kunsthalle, 1991

Matjuschin und die Leningrader Avantgarde, Karlsruhe, Zentrum für Kunst und Medientechnologie, 1991

Russian Avant-garde Art – 1910–1930 from the Gilbert Collection, Akron, OH, Akron Art Museum, 1991

Russian Constructivism and Suprematism, 1914–1930, London, Annely Juda Fine Art, 1991

Russie-URSS 1914–1991, Changements de regards, Paris, Musée d'histoire contemporaine, 1991

Sovetskoe iskusstvo 1920–1930-kh godov iz sobraniia Gosudarstvennogo muzeia iskusstv Karakalpakskoi ASSSR, Leningrad, State Russian Museum, 1991

Suprematisti Russi degli Anni 20, Milan, Galleria Marconi, 1991

Spirit of Ukraine. 500 Years of Painting, Winnipeg, Winnipeg Art Gallery, 1991

Taide Tulevaisuutta Luomassa 1920–1930, Helsinki, Taideteollisuusmuseo, 1991

Vanguardismo Ruso 1900–1935 de Colleciones Privadas, Valencia, Museo de la Ciudad, 1991

Abstraktion und Konstruktion, Berlin, Stolz, 1992

Arte Nascosta. Itinerario attraverso la pittura russa del primo '900, Milan, Galleria Capitani, 1992

Avanguardie Russe, Rome, Galeria Fontanella Borghese, 1992

Avant-garde and Russian Art 1900–1930, Sapporo, Maruiimai, 1992

Konstruktivistische Internationale. 1922–1927. Utopien für eine europäische Kultur, Düsseldorf, Kunstsammlung Nordrhein-Westfalen/Moritzburg, Staatliche Galerie Moritzburg Halle, 1992

Die Welt der Lilja Brik, Berlin, Galerie Natan Fedorowskij, 1992

Die Grosse Utopie. Die russische Avantgarde 1915–1932, Frankfurt, Kunsthalle/*De Grote Utopie. Russische Avantgarde 1915–1932*, Amsterdam, the Stedelijk Museum/*The Great Utopia. The Russian and Soviet Avant-garde 1915–1932*, New York, Solomon R.Guggenheim Museum, 1992–3/*Velikaia Utopia*, Moscow, Tretiakov Gallery, 1993 (with fewer works)

L'avant-garde russe, 1905–1925. Chefs-d'oeuvre des musées de Russie, Nantes, Musée des Beaux-Arts, 1993

Auction Catalogues
in chronological order
This section does not list the sales devoted only to Russian *objets d'art* and icons held regularly at the main auction houses in the US and Western Europe.

Twentieth-century Russian Paintings, Drawings and Watercolours 1900–1925, London, Sotheby's, 1 July 1970

Twentieth-century Russian Paintings, Drawings and Watercolours 1900–1930, London, Sotheby's, 12 April 1972

Twentieth-century Russian Paintings, Drawings and Watercolours 1900–1930, London, Sotheby's, 29 March 1973

Twentieth-century Russian and East European Paintings, Drawings and Sculpture 1900–1930, London, Sotheby's, 4 July 1974

Russian and European Avant-garde Art, 1905–1930, New York, Sotheby Parke Bernet, 3 November 1978

Russian and European Avant-garde Art and Literature, 1905–1930, New York, Sotheby Parke Bernet, 6–7 November 1979

Russian Paintings, Drawings, Watercolours and Sculpture, London, Sotheby's, 14 May 1980

Russian Paintings, Drawings, Watercolours and Sculpture, London, Sotheby's, 5 March 1981

Art Russe, Paris, Nouveau Drouot, 15 and 16 February 1982

Russian Paintings, Drawings and Watercolours, London, Sotheby's, 3 March 1982

Art Russe, Paris, Nouveau Drouot, 17 and 18 May 1982

Nineteenth and Twentieth-century European Paintings, Drawings, Watercolours and Sculpture and Russian Paintings, Drawings and Watercolours, London, Sotheby's, 28 February 1983

Russian Pictures, Icons and Russian Works of Art, London, Sotheby's, 15 February 1984

Icons, Russian Pictures, Works of Art and Fabergé, London, Sotheby's, 20 February 1985

Art Russe, Paris, Nouveau Drouot, 12 and 13 March 1985

Art Russe, Paris, Hotel des Ventes de l'Isle-Adam, 17 March 1985

Art Russe, Paris, Nouveau Drouot, 24 May 1985

Art Russe, Paris, Hotel des Ventes de l'Isle-Adam, 20 October 1985

Russian Pictures, Works of Art and Fabergé, London, Sotheby's, 13 February 1986

Icons, Russian Pictures and Works of Art, London, Christie's, 6 March 1986

Livres et Tableaux Russes des Années 1910–1930, Paris, Binoche et Godeau, 20 April 1986

Important Modern and Contemporary Prints, London, Christie's, 25 June 1986

Art Russe, Paris, Nouveau Drouot, 15 December 1986

Russian Twentieth-century and Avant-garde Art, London, Sotheby's, 2 April 1987

Icons, Russian Pictures and Works of Art, London, Sotheby's, 1 May 1987

Icons, Russian Pictures and Works of Art, London, Christie's, 21 October 1987

Alexandre Sementchenkoff Collection, London, Christie's, 22 October 1987

Icons, Russian Pictures and Works of Art, London, Christie's 21 April 1988

Art Russe, Paris, Verrières-le-Buisson, 15 May 1988

Impressionist and Modern Art, Twentieth-century Russian and Avant-garde Art, London, Sotheby's, 18 May 1988

Russian Avant-garde and Contemporary Art, Moscow, Sotheby's, 7 July 1988

Artwork of the Soviet Union, New York, Guernsey's, 22 and 23 October 1988

Icons, Russian Pictures and Works of Art, London, Sotheby's 14 November 1988

Collection of Russian and German Works of Art, Phelps, NY, Davis Auction House, 26 February 1989

Russian Twentieth-century and Avant-garde Art, London, Sotheby's, 6 April 1989

Icons, Russian Pictures and Works of Art, London, Sotheby's, 7 April 1989

Art Russe Impérial et Post-Révolutionnaire, Paris, Drouot Montaigne, 23 April 1989

Imperial and Post-Revolutionary Russian Art, London, Christie's, 5 October 1989

Avant-garde du XXe Siècle, Paris, Hôtel Drouot, 20 October 1989

Collection Léon Aronson dit Dominique (1893–1984), Paris, Drouot, 15 November 1989

Russian 20th-century and Avant-garde Art, London, Phillips, 27 November 1989

Russian Pictures, Works of Art and Icons, London, Sotheby's, 6 December 1989

Russian Art, Phillips, London, 2 April 1990

Russian Avant-garde. Pictures from the Collection formed by George Costakis, London, Sotheby's, 4 April 1990

A Selection of Russian Avant-garde Works Formerly the Property of Kurt Benedikt, London, Christie's, 5 April 1990

Important Russian Works of Art, New York, Christie's, 19 April 1990

Icons, Russian Pictures and Works of Art, London, Christie's, 27 April 1990

Tableaux Russes et Soviètiques, Paris, Drouot, 14 May 1990

Art Russe, Paris, Drouot, 16 May 1990

Russian Twentieth-century and Avant-garde Art, London, Sotheby's, 23 May 1990

Moderne Literatur und Kunst, Cologne, Venator und Hanstein, 20 September 1990

Russland 1910–1930. Buchkunst und literatur der Avantgarde, Cologne, Venator und Hanstein, 20 September 1990

Imperial and Post-Revolutionary Russian Art, London, Christie's, 10 October 1990

Russian Works of Art, New York, Christie's, 31 October 1990

Russian Art, London, Phillips, 26 November 1990

Icons, Russian Pictures and Works of Art, London, Christie's, 27 November 1990

Icons, Russian Pictures and Works of Art, London, Sotheby's, 30 November 1990

Art russe XXe siècle, Paris, Drouot-Richelieu, 10 February 1991

Russian Art, London: Phillips, 23 April 1991

Icons, Russian Pictures, Avant-garde Books and Works of Art, London, Christie's, 24 April 1991

Les Avant-gardes Russes XXe Siècle, Rares Affiches, Oeuvres sur Papier, Paris, Drouot-Richelieu, 22 May 1991

Icons, Russian Pictures and Works of Art, London, Sotheby's, 24 November 1991

Icons, Imperial and Post-Revolutionary Russian Art, London, Christie's, 27 November 1991

Nineteenth and Twentieth-century Scandinavian, Russian and Continental Pictures and Water-Colours, London, Christie's, 22 May 1992

Icons, Russian Pictures and Works of Art, London, Sotheby's, 16 June 1992

Icons, Russian Pictures and Works of Art, London, Sotheby's, 24 November 1992

Hungary

The bibliography for Hungary is divided into two parts: monographs and exhibition catalogues.

The titles listed below form only a small part of the total bibliography pertaining to the history of the Hungarian avant-garde and are intended only as a guide to further reading. For a comprehensive bibliography of relevant titles see Santa Barbara/Kansas City/Champaign, 1991–2, pp.213–27. For works on individual artists, see the bibliographies at the end of each biography.

Monographs
in alphabetical order by author or editor
D. Bizo et al., eds., *Sovetsko-vengerskie sviazi v khudozhestvennoi kulture*, Moscow (Nauka) 1975
L. Congdon, *Exile and Social Thought. Hungarian Intellectuals in Germany and Austria, 1919–1933*, Princeton (Princeton University Press) 1991
E. Kállai, *Vision und Formgesetz*, Leipzig (Kiepenheuer) 1986
L. Kassák and L. Moholy-Nagy, *Buch neuer Künstler*, Vienna (MA) 1922
F. Merényi, *Cento anni architettura ungherese*, Rome (Accademia ungherese) 1965
L. Németh, *Modern magyar müvészet*, Budapest (Corvina) 1972
L. Németh, ed., *Magyar müvészet 1890–1919*, 2 vols, Budapest (Akadémiai Kiadó) 1981
K. Passuth, *Magyar müvészet az euruópai avantgarde-ban*, Budapest (Corvina) 1974
J. Szabó, *A magyar aktivizmus története*, Budapest (Akadémiai Kiadó) 1971
– *A magyar aktivizmus müvészete*, Budapest (Corvina) 1981
A. Turowski, *Existe-t'il un art de l'Europe de l'Est?*, Paris (Les Editeurs de la Villette) 1986

Exhibition Catalogues
listed in chronological order
Avantgarde 1910–30 Osteuropa, West Berlin, Akademie der Künste, 1967
Ungarische avantgarde, Munich and Milan, Galerie del Levante, 1971–2
Hungarian Art. The Twentieth-century Avant-garde, Bloomington, IN, Indiana University Art Museum, 1972
Die 20er Jahre in Osteuropa/The 1920s in Eastern Europe, Cologne, Galerie Gmurzynska, 1975
Kunst in Ungarn 1900–1950, Lucerne, Kunstmuseum, 1975
Ungarische Kunst seit 1914, Chur, Bündner Kunstmuseum, 1976
The Hungarian Avant-garde. The Eight and the Activists, London, Hayward Gallery, 1980
Klassiker der Avantgarde – die Ungarischen Konstruktivisten, Innsbruck, Galerie im Taxispalais, 1983
Wechsel Wirkungen. Ungarische Avantgarde in der Weimarer Republik, Kassel, Neue Galerie/Bochum, Museum Bochum,1986–7
Master Works of the Hungarian Avant-garde 1916 to 1933, New York, Kovesdy Gallery, 1987
Standing in the Tempest. Painters of the Hungarian Avant-garde 1908–1930, Santa Barbara, CA, Santa Barbara Museum of Art, and other institutions, 1991–2

Poland

The bibliography for Poland is divided into two parts: monographs and exhibition catalogues.

The titles listed below form only a small part of the total bibliography pertaining to the history of the Polish avant-garde and are intended only as a guide to further reading. A comprehensive bibliography of relevant titles is to be found in the three volumes edited by Janina Wiercinska. For works on individual artists, see the bibliographies at the end of each biography.

Monographs
in alphabetical order by author or editor
Z. Baranowicz, *Polska awangarda artystyczna 1918–1939*, Warsaw (Wydawnictwa Artystyce i Filmowe) 1975
B. Carpenter, *The Poetic Avant-garde in Poland 1918–1939*, Seattle (University of Washington Press) 1983
W. Juszczak, ed., *Teksty o malarzach. Antologie polskiej krytyki artystycznej 1890–1918*, Warsaw (Academy of Sciences) 1976
– *Malarstwo Polskie. Modernizm*, Warsaw (Auriga) 1977
P. Lukaszewicz, *Zrzeszenie artystùw plastykùw artes 1929–1935*, Warsaw (Academy of Sciences) 1975
K. Passuth, *Les Avant-gardes de l'Europe Centrale 1907–1929*, Paris (Flammarion) 1988
J. Starzynskiego, ed., *Z zagadnien plastyki polskiej w latach 1918–1939*, Warsaw (Academy of Sciences) 1963
A. Turowski, *Konstruktywizm polski*, Warsaw (Academy of Sciences) 1981
J. Wiercinska et al., eds., *Polska bibliografia sztuki 1801–1944*, Warsaw (Academy of Sciences) 1975–86, three vols
A. Wojciechowskiego, *Polskie zycie artystyczne w latach 1915–1939*, Warsaw (Academy of Sciences) 1974

Exhibition Catalogues
listed in chronological order
Avantgarde 1910–30 Osteuropa, West Berlin, Akademie der Künste, 1967
Constructivism in Poland 1923–1936. BLOK. Prasens. a.r., Essen, Museum Folkwang/Otterlo, Rijksmuseum Kröller–Müller, and other cities, 1973–7
Die 20er Jahre in Osteuropa/The 1920s in Eastern Europe, Cologne, Galerie Gmurzynska, 1975
L'Avanguardia Polacca, Rome, Palazzo delle Esposizioni, 1979
Avant-garde Polonaise/Awangarda Polska/The Polish Avant-garde. Wrocław, Muzeum Architektury/Paris, Ecole Spéciale d'Architecture, 1981
Présences Polonaises. Witkiewicz. Constructivisme. Les Contemporains, Paris, Centre Georges Pompidou, 1983
Constructivism in Poland 1923 to 1936, Cambridge, Kettle's Yard Gallery/Lódz, Muzeum Sztuki, nd

Artists' biographies

Full details of the publications given in short form below will be found in the Abbreviation lists or the Select bibliography.

Yurii Pavlovich Annenkov

Born 11 July 1889, Petropavlovsk-on-Kamchatka; died 18 July 1974, Paris.

1908 entered St Petersburg University and simultaneously began to take art lessons at Savelii Zeidenberg's private studio; 1909–10 attended the studio of Yan Tsionglinsky; 1911–12 worked in Paris, studying under Maurice Denis and Félix Vallotton; 1913 after travelling in Switzerland, returned to St Petersburg where he began to work for the caricature magazines *Satirikon* and *Novyi satirikon* and for the Crooked Mirror satirical theatre where he designed the sets and costumes for Nikolai Evreinov's *Homo Sapiens* and other plays; 1913–14 close to the Union of Youth group of artists and writers, including Nikolai Kulbin and Ivan Puni; worked as an illustrator for various magazines including *Teatr i iskusstvo* [Theatre and Art]; during these years Annenkov often visited the *dacha* region of Kuokkala where Nikolai Evreinov, Mikhail Matiushin, the Punis, and other artists and writers resided in the summer; this proximity led to a number of joint ventures, e.g., Annenkov's illustrations (and Kulbin's) to Evreinov's three-volume *Teatr dlia sebia* [Theatre for Itself] (Petrograd, 1915–16), and to his cover for the separate edition of Evreinov's *Predstavlenie liubvi* [Presentation of Love] (Petrograd, 1916); 1917 attended the 'leftist' meetings at Sergei Isakov's apartment in the Academy of Arts; from 1917 Annenkov designed a number of experimental spectacles including George Kaiser's *Gas* (1922) and Alexei Tolstoi's *Mutiny of the Machines* (1924); 1918 taught at Svomas (Free State Art Studios) in Petrograd; 1918–19 was associated with the Today Workshop (with Natan Altman, Vera Ermolaeva, Nikolai Lapshin et al.); 1918 took part in the decoration of the Field of Mars, Petrograd, for the May Day celebrations; 1920 with Mstislav Dobuzhinsky and Vladimir Shchuko decorated the mass drama *Hymn to Liberated Labour* in front of the old St Petersburg stock-exchange; 1921 designed the mass drama *The Storming of the Winter Palace*; 1922 member of the World of Art association; contributed to the *Erste Russische Kunstausstellung*, Berlin; 1924 emigrated to Paris; during emigration Annenkov was particularly active as a stage and film designer and as a book illustrator, e.g. for Pierre Bost's *Les Cirques et le Music-hall*, Paris (Au sans pareil) 1931; 1945 onwards gave considerable attention to abstract painting.

M. BABENCHIKOV, 'Annenkov-grafik i risovalshchik', *Pechat i revoliutsiia*, Moscow, June 1925, Book 4, pp.101–29
P. COURTHION, *Georges Annenkov*, Paris (Chroniques du Jour) 1930
G. ANDREEV, 'Na razgromlennom Parnase', *Novoe Russkoe Slovo*, New York, 15 Sept. 1974, p.3
A. DE SAINT-RAT, 'The Revolutionary Era Through the Eyes of Russian Graphic Artists', *Sbornik. Study Group on the Russian Revolution*, no.2, Leeds, 1979, pp.34–43
B. BERMAN, 'Zametki o Yurii Annenkove', *Iskusstvo*, no.2, Moscow, 1985, pp.34–9
Annenkov's memoirs also provide a valuable insight into his own artistic conception and cultural milieu: Y. Annenkov, *Dnevnik moikh vstrech*, 2 vols, New York (Inter-Language Literary Associates) 1966; and *La révolution derrière la porte*, Paris (Lieu Commun) 1987

Sándor Bortnyik

Born 3 July 1893 Marosvásárheky, Hungary (now Tirgu Mures, Romania); died 31 December 1976, Budapest.

1910 arrived in Budapest; 1913 entered the Academy of Fine Arts there, studying under Károly Kernstock and József Rippl-Rónai; influenced by the Fauves; 1915 associated with the avant-garde magazine *A Tett* [Deed], coming into contact with Lajos Kassák, Béla Uitz et al.; 1916 close to the *MA* [Today] group, especially Sándor Barta and Kassák; later made the acquaintance of László Moholy-Nagy; 1918 after the fall of the Hungarian Soviet Republic emigrated to Vienna; 1921 with Kassák developed the theory of Bildarchitektur, publishing an album under that title; 1922 one-man show at Der Sturm Gallery, Berlin; 1922–4 lived in Weimar, maintaining close contact with the Bauhaus; 1924 returned to Budapest; one-man show there; founded the Green Donkey, an avant-garde theatre; 1928 opened the Mühely school of design, known as the Budapest Bauhaus, and taught there until its closure in 1938 – among the students was Victor Vasarely; 1933 worked mainly as a graphic and design artist, publishing a portfolio called *Tatters and Scraps. Two Paper Dolls in Toyland* in Chicago; 1943 with Iván Hevesy and Marius Rabinowsky published the book *Zweitausend Jahre Malerei*; 1949–56 Dean of the Academy of Fine Arts, Budapest; active as a writer and editor for several art magazines; 1969 large one-man show at the National Gallery, Budapest.

L. BORBÉLY, *Bortnyik*, Budapest (Corvina) 1971
Santa Barbara 1991–2, *passim*

David Davidovich Burliuk

Born 9 July 1882, Semirotovshchina, near Kharkov, Ukraine; died 15 January 1967, Southampton, NY.

Born into a talented family; his mother was a painter as were his brother Vladimir (q.v.) and two sisters, Liudmila and Nadia; his brother Nikolai was a poet. 1899–1901 took art courses in Kazan and then Odessa (where he was a colleague of Boris Anisfeld and Isaak Brodsky); 1901 studied under Anton Azbè in Munich; 1904 attended Cormon's academy in Paris, mid-1900s co-organized and/or contributed to various exhibitions, including *Wreath-Stephanos* (Moscow, 1907), *The Link* (Kiev, 1908) and *Jack of Diamonds* (Moscow, 1910); 1907–13 Burliuk's father managed an estate in Chernianka, near Kherson, which became a meeting-place for young artists and poets; in 1912 the ancient name of the locality, Hylaea, became the title of the group which included Velimir Khlebnikov, Alexei Kruchenykh, Benedikt Livshits and Vladimir Maiakovsky; 1909 moved to St Petersburg; 1910 co-edited the miscellany *Sadok sudei* [A Trap for Judges] which marked the beginning of intense publicist activity, leading to the publication of many Futurist books of poetry and manifestos such as *Trebnik troikh* [Prayerbook of Three] and *Tango s korovami* [Tango with Cows]; 1910 returned to Odessa, where he met Vasilii Kandinsky; 1911 contributed to the *Blaue Reiter* exhibition in Munich; entered the Moscow Institute of Painting, Sculpture and Architecture where he met Maiakovsky (both were expelled in 1914); 1912 contributed to the *Blaue Reiter* almanac; married Mariia (Marusia) Elenevskaia; compiled and published *Poshchechina obshchestvennomu vkusu* [A Slap in the Face of Public Taste]; 1914 edited *Gazeta futuristov* [Newspaper of the Futurists]; 1915 family moved to the Urals; 1917 Burliuk back in Moscow; 1918, with Maiakovsky, worked on the film *Not Born for Money*; 1918–19 lived in Siberia; 1920–22 lived in Japan; 1922 settled in New York; 1925 welcomed Maiakovsky on his visit to New York; 1930–66 with Marusia published a journal called *Color and Rhyme*.

D. BURLIUK ed., *Color and Ryhme*, New York (Burliuk) 1930–66
LIVSHITS/BOWLT (1933/1977), *passim*

K. DREIER, *Burliuk*, New York (Wittenborn) 1944
F.P. INGOLD, 'Eine vergessene Deklaration von David Davidovic
Burliuk' in P.Brang et al., eds., *Schweizerische Beiträge zum VII.
Internationalen Slavistenkongress in Warschau. August 1973*, Zurich
(C.J.Bucher) 1973, pp.51–64
H. LADURNER, 'David D. Burljuks Leben und Schaffen 1908–1920'
Wiener Slawistischer Almanac, Vienna, 1978, I, pp.27–55
K. KUZMINSKY, *Titka rodiny*, Orange, CT (Goloveiko) 1982
A. PARNIS, 'D. Burliuk. Vospominaniia o Khlebnikove', *Literaturnoe
obozrenie*, no.12, Moscow, 1985, pp.95–7
J. BOWLT, ed., *A Slap in the Face of Public Taste. A Jubilee for David
Burliuk and the Cause of Russian Futurism*. Special issue of *Canadian-
American Slavic Studies*, XX, Pts.1–2, Irvine, 1986
A. PROKHOROV ET AL., *Russkie pisateli 1800–1917. Biograficheskii
slovar*, Moscow (Sovetskaia entsiklopediia), 1989, I, pp.367–70
Ukrajinska avangarda 1910–1930, 1990–91, p.81 *et seq.*
David Burliuk, exh. cat. Ufa Nesterov Museum, 1993

Vladimir Davidovich Burliuk

Born 15 March 1886, Kharkov; died 1917 in action in Salonica,
Greece.
Born into a talented family; his mother was a painter as were his
brother David (q.v.) and two sisters, Liudmila and Nadezha; his
brother Nikolai was a poet. 1903 studied under Anton Azbè in
Munich; 1904 attended Cormon's academy in Paris; took part in
the Russo-Japanese War (1904–5); 1907 contributed to the
Exhibition of Paintings, Kharkov; 1908–10 active in Kiev art life,
contributing to the *Link* exhibition in 1908 at which Alexander
Bogomazov, David Burliuk, Alexandra Exter, Mikhail Larionov et
al. were represented; 1909 contributed to the *Wreath* exhibition in
St Petersburg; 1910 contributed to Nikolai Kulbin's *Triangle*
exhibition in St Petersburg and to the *Jack of Diamonds* in Moscow;
member of the Neue Künstlervereinigung in Munich, contributing
an article to the catalogue of its second exhibition; 1910–11
contributed to Vladimir Izdebsky's *Salon 2* in Odessa; made
illustrations for the first 'Futurist' collection *Sadok sudei* [A Trap
for Judges]; member of the Jack of Diamonds and Union of Youth
societies; 1911–15 attended the Penza Art Institute; contributed
to the first *Blaue Reiter* exhibition in Munich; 1912 contributed to
the Blaue Reiter almanac; 1913 contributed to the *Erste Deutsche
Herbstsalon* at Der Sturm Gallery in Berlin; 1913–14 illustrated
many Futurist collections, including *Dokhlaia luna* [Croaked Moon]
and *Moloko kobylits* [Milk of Mares]; 1915 represented at the *Year
1915*, Moscow; mobilized.

LIVSHITS/BOWLT (1933/1977), *passim*
MARKOV (1968), *passim*
RUDENSTINE (1981), p.81
TURIN 1989, pp.228–9
Ukrajinska avangarda 1910–1930, 1990–91, p.83 *et seq.*

Marc Chagall (Mark Zakharovich Shagal)

Born 7 July 1887, Vitebsk; died 28 March 1985, St Paul-de-
Vence, France.
1907 enrolled in the School of the Society for the Encouragement
of the Arts, St Petersburg; 1908 switched to Savelii Zeidenberg's
private art school and then to Elizaveta Zvantseva's school where
he studied with Lev Bakst and Mstislav Dobuzhinsky; 1910 moved
to Paris; 1912 contributed to the *Salon des Indépendants* and the
Salon d'Automne; also contributed to Mikhail Larionov's *Donkey's
Tail* in Moscow; 1913 contributed to Larionov's *Target* exhibition
in Moscow; 1915 married Bella Rosenberg; 1914 contributed
over forty works to the *Jack of Diamonds* exhibition in Moscow;
1917 moved back to Vitebsk; 1918 became head of the Vitebsk
Popular Art Institute, although he was soon ousted by Kazimir
Malevich; 1920–21 worked as a stage designer for Alexander
Granovsky's State Jewish Theatre in Moscow; 1922, via Kaunas,
emigrated to Berlin; paid particular attention to lithographs and
woodcuts; contributed to the *Erste Russische Kunstausstellung*;

1923 settled in Paris; 1924 first comprehensive retrospective at
the Galerie Barbazanges-Hodebert; mid-1920s executed a series of
gouaches for La Fontaine's *Fables*; represented at many
exhibitions in Paris, particularly at the Galerie Katia Granoff;
1931 travelled to Palestine in preparation for his work on the
Bible etchings; 1935 visited Poland; 1941–6 lived in the US;
1968 exhibition of his works from private collections organized by
the Academy of Sciences in Novosibirsk; 1973 travelled to
Moscow in connection with a small retrospective of his work
there.

F. MEYER, *Marc Chagall*, New York (Abrams) 1964
M. CHAGALL, *My Life*, London (Owen) 1965 (and other eds)
S. ALEXANDER, *Marc Chagall*, New York (Putnam) 1978
Marc Chagall. Oeuvres sur papier, exh. cat. Paris, Centre Georges
Pompidou, 1984
Chagall, exh. cat. London, Royal Academy of Art, Philadelphia, PA,
Museum of Art, 1984–5
M. BESSONOVA ET AL., *Shagal. Vozvrashchenie mastera*, Moscow
(Sovetskii khudozhnik) 1987
Mark Shagal, exh. cat. Moscow, Pushkin Museum of Fine Arts, 1987
A. KAMENSKY, *Chagall: Periode Russe et Soviètique 1907–1922*, Paris
(Editions du Regard) 1988
L. BERINSKY, ed., *Mark Shagal. Angel nad kryshami*, Moscow
(Sovremennik) 1989
V. RAKITIN, *Chagall. Disegni inediti dalla Russia a Parigi*, Milan (Fabbri)
1989
Marc Chagall: Mein Leben – Mein Traum, Berlin und Paris 1922–1940,
exh. cat. Ludwigshafen, Wilhelm-Hack Museum, 1990; Eng. trans.,
S.Compton, *Marc Chagall. My Life–My Dream. Berlin and Paris, 1922–
1940*, Munich (Prestel) 1990
Chagall en nuestro siglo, exh. cat. Mexico City, Centro Cultural Arte
Contemporaneo, 1991
Marc Chagall (Chagall en Russie), exh. cat. Martigny, Fondation Pierre
Gianadda, 1991
Marc Chagall. Die russischen Jahre 1906–1922, exh. cat. Frankfurt,
Schirn Kunsthalle, 1991
D. SARABIANOV, *Mark Shagal*, Moscow (Izobrazitelnoe iskusstvo) 1992
Marc Chagall, exh. cat. Ferrara, Palazzo dei Diamanti, 1992
Marc Chagall: Gli anni russi, exh. cat. Florence, Palazzo Medici Riccardi,
1993

Ilia Grigorievich Chashnik

Born 25 June 1902, Liuzin (Lyucite), Latvia; died 4 March 1929,
Leningrad.
1913 apprenticed to an optical workshop; also took drawing
lessons; 1917 visited the studio of Yehuda Pen (one of Marc
Chagall's teachers) in Vitebsk; 1919 travelled to Moscow to try
and enroll in Svomas; returning to Vitebsk, took lessons from
Chagall before joining Kazimir Malevich; 1920 principal member
of Unovis, elaborating the Suprematist system together with Vera
Ermolaeva, Lazar Khidekel, Nikolai Suetin et al.; developed his
project for a speaker's rostrum for Smolensk; 1920–21
contributed to the *Unovis* and *Aero* journals; 1920–22 contributed
to the Unovis exhibitions in Vitebsk and Moscow; 1922 with
Malevich left for Petrograd; entered the State Porcelain Factory;
1923 contributed to *Exhibition of Paintings by Petrograd Artists of
All Directions*; 1924–6 attached to Ginkhuk; 1925 with Malevich
worked at the Decorative Institute, Leningrad; 1925–7 worked on
architectural projects, porcelain, posters; contributed to the
Exposition Internationale des Arts Décoratifs in Paris; 1927–9 with
Malevich worked at the Institute of Art History, Leningrad; 1928
contributed to the *Pressa* exhibition in Cologne; 1928–9 with
Suetin worked on decorative projects for residential and
recreational buildings in Leningrad.

London 1977
Ilja G.Tschaschnik, exh. cat. Düsseldorf, Kunstmuseum/Berlin,
Bauhaus-Archiv, 1978
Ilya Grigorevich Chashnik, exh. cat. New York, Leonard Hutton
Galleries, 1979–80

Ilya Chashnik and the Russian Avant-garde: Abstraction and Beyond,
exh. cat. Austin, TX, University of Texas, 1981
Shadowa/Zhadora (1978/1982)
Malevich. Suetin. Chashnik, exh. cat. New York, Leonard Hutton
Galleries, 1983
Milan 1991
Cologne 1992

Kseniia (Xenia) Vladimirovna Ender

Born 8 June 1894, Slutsk; died 14 March 1955, Leningrad.
Born into a talented family; her brother Boris was a painter as was
her elder sister Mariia; 1918–22 studied at Svomas/Academy of
Arts, Petrograd; became especially interested in the research and
teachings of Mikhail Matiushin, working with him to develop the
theory of Zorved (lit.: See-Know), an experiment in expanded
vision; 1923 represented at the *Exhibition of Paintings by Petrograd
Artists of All Directions* in Petrograd; 1923–6 worked at Ginkhuk –
in the Department of Organic Culture headed by Matiushin,
contributing to its exhibitions; 1924 represented at the *Esposizione
internazionale d'arte della città di Venezia* in Venice; mid-1920s
onwards worked with Matiushin and Boris and Mariia Ender on
tabulating and editing research data connected with Zorved;
1925–7 worked in a design office and at the Decorative Institute,
Leningrad; 1932 collaborated with Matiushin et al. on the
publication of his colour primer, *Zakonomernost izmeniaemosti
tsvetovykh sochetanii* [The Conformity of the Changeability of
Colour Combinations]; 1930s onwards worked as a designer in an
architectural office in Leningrad.

L. ZHADOVA, Tsvetovaia sistema M.V.Matiushina, *Iskusstsvo*, no.8,
Moscow, 1974, pp.38–42
Boris Ender. Pittore d'avanguardia nell'Unione Sovietica, exh. cat. Rome,
Calcografia Nazionale, 1977
Z. ENDER AND C. MASETTI, 'Gli esperimenti del gruppo di Matjusin',
Rassegna sovietica, Rome, May–June 1978, pp.100–25
Rudenstine (1981), pp.276–300
G. DI MILA AND Z.E. MASETTI, *Boris Ender 1914–1928*, Rome (Centro
Culturale) 1989
Matjuschin und die Leningrader Avantgarde, exh. cat. Karlsruhe, Zentrum
für Kunst und Medientechnologie, 1991, *passim*

Alexandra Alexandrovna Exter

Born 6 January 1882, Belestok, near Kiev; died 17 March 1949,
Paris.
Until 1907 attended the Kiev Art Institute; 1908 onwards was a
regular visitor to Paris and other European cities; took part in
several Kiev exhibitions including David Burliuk's *The Link*, the
first of many involvements with the avant-garde; 1912 moved to
St Petersburg; continued to travel abroad frequently; associated
with the Union of Youth; 1915–16 contributed to the exhibitions
Tramway V and *The Store*; began her professional theatre work
with designs for *Thamira Khytharedes* produced by Alexander
Tairov at the Chamber Theatre, Moscow; 1918 founded her own
studio in Kiev where many artists of later fame studied, such as
Isaak Rabinovich, Alexander Tyshler and Pavel Tchelitchew;
1920 worked at the Theatre of the People's House, Odessa, as a
stage designer; 1921 contributed to the exhibition $5 \times 5 = 25$,
Moscow; 1923 turned to textile and fashion design for the Atelier
of Fashions, Moscow; began work on the costumes for the movie
Aelita (released 1924); 1924 emigrated to Paris; worked for the
Ballets Romantiques Russes with Léon Zack and Pavel
Tchelitchew; became a professor at the Académie d'Art Moderne;
during the 1920s and 1930s continued to work on stage design
and interior design; 1925 designed costumes for seven ballets
performed by Bronislava Nijinska's Théâtre Choréographique;
1926, with Nechama Szmuszkowicz, created a set of marionettes;
1937–46 illustrated a number of de luxe limited editions such as
Marie Collin-Delavaud's *Panorama de la Montagne* (Paris,

Flammarion, 1938) and *Panorama de la Côte* (Paris, Flammarion,
1938) and her own *Mon Jardin* (Paris, Flammarion, 1936).

Y. TUGENDKHOLD, *Alexandra Exter*, Berlin (Zaria) 1922
A. NAKOV, *Alexandra Exter*, Paris (Galerie Chauvelin) 1972
Artist of the Theatre, Alexandra Exter, exh. cat. New York, Center for the
Performing Arts, the New York Public Library at Lincoln Center, 1974
Alexandra Exter. Marionettes, exh. cat. New York, Leonard Hutton
Galleries, 1975
Alexandra Exter, Marionettes and Theatrical Designs, exh. cat.
Washington, DC, Hirshhorn Museum and Sculpture Garden, 1980
Alexandra Exter, exh. cat. Moscow, Bakhrushin Museum, 1988
Alexandra Exter (1884–1949), exh. cat. Odessa, Odessa Art Museum,
1989
G. KOVALENKO, 'Exter v Parizhe', *Teatralnaia zhizn*, no.17, Moscow,
1990, pp.20–23
Alexandra Exter e il Teatro da Camera, exh. cat. Rovereto, Archivio del
'900, 1991
G. KOVALENKO, 'Alexandra Exter v Parizhe', *Teatr*, no.2, Moscow,
1992, pp.103–22

Pavel Nikolaevich Filonov

Born 8 January 1883, Moscow; died 3 December 1941,
Leningrad.
1897, an orphan, Filonov moved to his married sister's apartment
in St Petersburg; 1897–1901 attended classes at the Society for
the Encouragement of the Arts; 1903–8 attended the private
studio of the Academician Lev Dmitriev-Kavkazsky; 1908–10
attended the Academy of Arts; 1910 expelled from the Academy;
1910–14 close to the Union of Youth, contributing to three of its
exhibitions; 1912 travelled for six months in Italy and France;
1913 with Iosif Shkolnik designed Vladimir Maiakovsky's tragedy
Vladimir Maiakovsky; 1914 published his first manifesto *Sdelannye
kartiny* [Made Paintings]; 1914–15 illustrated Futurist booklets;
1915 published his own poem with illustrations, *Propoven o
prorosli mirovoi* [Chant of Universal Flowering]; continued to
elaborate his Ideology of Analytical Art and Theory of Madeness;
1916–18 served on the Romanian front; 1919 represented at the
1st State Free Exhibition of Works of Art in Petrograd; 1923
represented at the *Exhibition of Paintings by Petrograd Artists of All
Directions, 1919–1923*; briefly associated with Ginkhuk in
Petrograd; published his 'Declaration of Universal Flowering' in
Zhizn iskusstva [Life of Art]; 1925 established the Collective of
Masters of Analytical Art (the Filonov School); 1927 supervised
the designs for Igor Terentiev's production of Nikolai Gogol's
Inspector-General at the Press House, Leningrad; 1929–31 one-
man exhibition planned at the Russian Museum, Leningrad, but
not opened; 1929 supervised the designs for a production of the
agit-play *King Gaikin I* at the Vasilii Island Metalworkers' Club;
1931–3 supervised the illustrations for the Academia edition of
the *Kalevala*; 1932 contributed to the exhibition *Artists of the
RSFSR of the Last 15 Years* in Leningrad and then Moscow
(1933); 1936 delivered a lecture at the House of the Artist,
Leningrad; 1967 first one-man exhibition opened in Novosibirsk.

J. KŘIŽ, *Pavel Nikolajevič Filonov*, Prague (Nakladatelství
československých výtvarných umělců) 1966
Pervaia personalnaia vystavka. Pavel Filonov 1883–1941, exh. cat.
Novosibirsk, Picture Gallery of the Siberian Section of the USSR
Academy of Sciences, 1967
N. MISLER AND J. BOWLT, *Pavel Filonov: A Hero and His Fate*, Austin
(Silvergirl) 1983
Pavel Filonov, exh. cat. Leningrad, Russian Museum, 1988
N. MISLER AND J. BOWLT, *Pavel Filonov, Analiticheskoe iskusstvo*,
Moscow (Sovetskii khudozhnik) 1990
Pawel Filonow, exh. cat. Düsseldorf, Kunsthalle, 1990
Pavel Filonov, exh. cat. Paris, Centre Pompidou, 1990
*Die Physiologie der Malerei. Pawel Filonow in der 20er Jahren/The
Physiology of Painting. Pavel Filonov in the 1920s*, exh. cat. Cologne,
Galerie Gmurzynska, 1992
Malévitch-Filonov, exh. cat. Paris, Galerie Piltzer, 1992

Tatiana Nikolaevna Glebova

Born 28 March, 1900, St Petersburg; died 4 March 1985, Leningrad.

1924–6 studied at the Academy of Arts in Leningrad under Alexander Savinov before enrolling in Pavel Filonov's school called the Collective of Masters of Analytical Art, also in Leningrad; Filonov exerted a profound and permanent influence on her artistic development and she remained one of the most faithful of the *filonovtsy* [disciples of Filonov]; 1928 began professional career as a book illustrator with illustrations for Ershov's *Konek-Gorbunov* [Little Hunchbacked Horse]; after this exhibited regularly as a painter and designer, especially for children's books, e.g. by Samuil Marshak; 1931–3 under Filonov's supervision collaborated with Alisa Poret et al. on illustrations for the Academy edition of the *Kalevala* (published in 1933); during the 1930s and 1950s illustrated classics by Jack London and H.G.Wells and also made didactic books for children such as *Zoologicheskii sad* [Zoo] (1956) and *Solntse i dozhd* [Sun and Rain] (1959); 1949 one-woman exhibition in Leningrad; 1930s onwards was also active as a stage designer, especially for operas and ballets in Leningrad (such as *Die Meistersinger* in 1932), on which she collaborated with a number of prominent scenic designers such as Vladimir Dmitriev; 1940s lived in Alma-Ata; 1949 one-woman exhibition in Leningrad.

Nothing substantial has been published on Glebova, although the catalogue of her one-woman show contains some bio-bibliographical information, *Tatiana Nikolaevna Glebova*, exh. cat. by Evgenii Kovtun, Leningrad, Union of Artists of the RSFSR, 1981. Also useful is *Filonow und seine Schule*, exh. cat. Kunsthalle, Düsseldorf, 1990, *passim*. Relevant information on Glebova's artistic connections with Filonov and the Russian avant-garde can also be found in the following sources:
Pervaia personalnaia vystavka. Pavel Filonov 1883–1941, exh. cat. Novosibirsk, Picture Gallery of the Siberian Section of the USSR Academy of Sciences, 1967
J. KŘÍŽ, *Pavel Nikolajevič Filonov*, Prague (Nakladatelství československých výtvarných umělců) 1966
T. GORINA, *Khudozhniki narodov SSSR. Biobibliograficheskii slovar*, Moscow (Iskusstvo) 1976, III, p.52
N. MISLER AND J. BOWLT, *Pavel Filonov: A Hero and His Fate*, Austin (Silvergirl) 1983
Pavel Filonov, exh. cat. Leningrad, Russian Museum, 1988
N. MISLER AND J. BOWLT, *Pavel Filonov. Analiticheskoe iskusstvo*, Moscow (Sovetskii khudozhnik) 1990
Pavel Filonov, exh. cat. Paris, Centre Georges Pompidou, 1990
Pavel Filonow und seine Schule, exh. cat. Düsseldorf, Kunsthalle, 1990

Natalia Sergeevna Goncharova

Born 22 June 1881, Nagaevo, near Tula; died 17 October 1962, Paris.

1898 enrolled at the Moscow Institute of Painting, Sculpture and Architecture to study sculpture; 1900 changed to painting; met Mikhail Larionov (q.v.) who became her lifelong companion; 1906 contributed to the Russian Section at the *Salon d'Automne*, Paris; 1908–10 contributed to the three exhibitions organized by Nikolai Riabushinsky, editor of the journal *Zolotoe runo* [The Golden Fleece]; manifested a deep and serious interest in Russian peasant art; 1910 founder-member with Larionov of the Jack of Diamonds group, in 1911 of the Donkey's Tail group, and in 1913 of the Target group; 1912–13 moved from her Neo-Primitivist style to a more synthetic one which relied on elements of Futurism and Rayonism; 1914 with Larionov exhibited at the Galerie Paul Guillaume, Paris; designed Sergei Diaghilev's production of *Le Coq d'Or*, the first of several spectacles for Diaghilev and other impresarios; 1915 designed Alexander Tairov's production of Carlo Goldoni's *Il Ventaglio* at the Chamber Theatre, Moscow; 1917 settled in Paris with Larionov; 1922 with Larionov exhibited at the Kingore Gallery, New York, and in 1923

at the Shiseido Gallery, Tokyo; 1924 designed puppets for Yuliia Sazonova's Puppet Theatre, Paris; 1920s onwards continued to paint, illustrate books, and design productions, e.g. Boris Romanov's *A Romantic Adventure of an Italian Ballerina and a Marquis* for the Chauve-Souris, New York, in 1931; after 1930, except for occasional contributions to exhibitions, Larionov and Goncharova lived unrecognized and impoverished; 1954 their names were resurrected at Richard Buckle's *The Diaghilev Exhibition* in Edinburgh and London; 1961 Arts Council of Great Britain organized a major retrospective of Goncharova's and Larionov's works.

Larionov and Goncharova, exh. cat. Leeds, City Art Gallery/Bristol, City Art Gallery/London, Arts Council Gallery, 1961
T. LOGUINE, *Gontcharova et Larionov*, Paris (Klincksieck) 1971
M. CHAMOT, *Gontcharova*, Paris (La Bibliothèque des Arts) 1972
Rétrospective Gontcharova, exh. cat. Bourges, Maison de la Culture, 1973
M. CHAMOT, *Gontcharova. Stage Designs and Paintings*, London (Oresko) 1979
Nathalie Gontcharova. Michel Larionov, exh. cat. Milan, Arte Centro, 1984
Gontcharova, exh. cat. Wellington, National Art Gallery, 1987
Natalia Gontcharova, exh. cat. San Antonio, TX, McNay Art Museum, 1987
N. GURIANOVA, 'Voennye graficheskie tsikly N.Goncharovoi i O.Rozanovoi', *Panorama iskusstv*, Moscow, no.12, 1989, pp.63–88
J. BOWLT, 'Natalia Goncharova and Futurist Theater', *Art Journal*, New York, April, 1990, pp.44–51
M. TSVETAEVA, *Nathalie Gontcharova*, Paris (Clémence Hiver) 1990

Boris Dmitrievich Grigoriev

Born 11 July 1886, Rybinsk; died 7 February 1939, Cagnes-sur-mer.

1901 the Grigoriev family moved to Moscow; 1903–7 Grigoriev studied at the Stroganov Central Industrial Art Institute in Moscow under Dmitrii Shcherbinovsky; 1907–13 attended the Higher Art Institute at the Academy of Arts in St Petersburg, taking courses under Dmitrii Kardovsky and Alexander Kiselev; 1909 onwards contributed to many exhibitions including the *Impressionists*, the *World of Art* and the Munich *Secession*; 1912–13 contributed caricatures to the journal *Satirikon* and then, in 1914, to *Novyi satirikon* [New Satyricon]; 1912–14 lived in Paris; studied at the Académie de la Grande Chaumière; made many drawings and paintings of Paris life some of which were published in 1918 in the collection *Intimité*; 1916 with Serge Soudeikine and Alexandre Jacovleff decorated the interior of the Petrograd cabaret The Comedians' Halt; during the pre-Revolutionary years Grigoriev was patronized by Alexander Burtsev, a collector and editor of the journal *Moi zhurnal dlia nemnogikh* [My Journal for a Few] in which Grigoriev's works were reproduced; 1917–18 worked on a cycle of pictures which became the basis of the book *Raseia* [Russia] published in Russia in 1918 (and Germany in 1922); 1918 taught at the Stroganov Institute, Moscow; 1919 emigrated to Berlin; 1921 designed *Snegurochka* [snow-maiden] for the Bolshoi Theatre, Moscow (not produced); arrived in Paris where he had a one-man show at the Galerie Povolozky (December 1921–January 1922); in the early 1920s was close to Jacovleff and Vladimir Shukhaev; 1921–6 visited the US several times; 1923 took part in the *Exhibition of Russian Painting and Sculpture* at the Brooklyn Museum, New York; 1927 built a house at Cagnes-sur-mer, the Villa 'Borisella'; 1928 professor at the Academy of Fine Art, Santiago, Chile; had a one-man show at the Museo de Bellas Artes there; 1930 returned to France; 1935 became Dean of the New York School of Applied Arts; 1936 visited Chile; 1938 returned to Cagnes-sur-mer.

V. DMITRIEV AND V. VOINOV, *Boris Grigoriev. Intimité*, Petrograd and Berlin (Yasnyi) 1918

A. TOLSTOI ET AL., *Boris Grigoriev. Raseia*, Potsdam (Müller) and Berlin (Efron) n.d.; Russ. eds, *Boris Grigoriev. Raseia*, Petrograd (Efron) 1918, Potsdam (Müller) and Petrograd and Berlin (Efron) 1922
C. FARÈRE ET AL., *Boris Grigoriev. Boui Bouis*, Berlin (Razum) 1924
L. RÉAU ET AL., *Boris Grigoriev. Faces of Russia*, Berlin and London (Sinaburg) 1924; eds also in French and German
Boris Grigoriev, exh. pamphlet Miami, FL, Museum of Modern Art, 1960
T. GORINA, *Khudozhniki narodov SSSR. Bio-bibliograficheskii slovar*, Moscow (Iskusstvo) 1976, III, pp.175–5
Boris Grigoriev, exh. cat. Château-Musée de Cagnes-sur-mer, 1978–9.
T. GALEEVA, 'Risunki Borisa Grigorieva' *Sovetskaia grafika*, Moscow, no.10, 1986, pp.251–62
Boris Grigoriev, exh. cat. Pskov, Pskov State Combined Historical, Architectural, and Art Museum, 1989
A. KAMENSKY, 'Boris Grigoryev's ''Russia''', *Moscow News Weekly*, no.8–9, Moscow, 1990, p.23

Béla Kádár

Born 14 June 1877, Budapest; died 22 January 1956, Budapest. Early 1890s trained as a machinist; 1896 travelled to Munich and Paris in order to study art; 1900s studied at the Academy of Fine Arts, Budapest, under Jószef Rippl-Rónai, winning the Kohner Prize in 1910; cultivated a particular interest in the colour theories of the Impressionists and the Vienna Secessionists; 1912 moved to Berlin; influenced by Expressionism anbd Futurism; 1914–19 volunteered for the front; 1918 one-man show in Budapest; 1921 joint exhibition with Hugó Scheiber; 1923 show at Der Sturm Gallery, Berlin; 1920s contributed to several exhibitions in the US, including the *International Exhibition of Modern Art* at the Brooklyn Museum, New York, in 1927; 1928–29 spent a year in the US; returned to Budapest; 1930s produced figurative painting reminiscent of Léopold Survage; 1945 having survived the Jewish ghetto in Budapest, he published a book of twenty-four illustrations under the title *Dies Irae* (Budapest) condemning the Nazi atrocities.

Paintings and Drawings by Béla Kádár, exh. cat. Philadelphia, Crillon Gallery, 1930; New York, S.P.R. Galleries, 1931
Kádár Béla Emlékkiálitása, exh. cat. Budapest, Hungarian National Gallery, 1971
Béla Kádár, exh. cat. Saarbrucken, Galerie Ernst, 1976
Béla Kádár. A Leading Expressionist in the Twenties of 'Der Sturm' in Berlin, exh. cat. New York, Kovesdy Gallery, 1985
Santa Barbara/Kansas City/Champaign, 1991–2, *passim*

David Kakabadze

Born 20 August 1889, Kukhi, near Kutaisi; died 10 May 1952, Tbilisi.
1901 attended the Kutaisi Gymnasium; 1908 took lessons from the artists Paevsky and Vasilii Krotkov; 1910 entered the Department of Physics and Mathematics at St Petersburg University; 1910–15 also continued to take art lessons from Lev Dmitriev-Kavkazsky; came into contact with the Union of Youth, and made the acquaintance of Pavel Filonov; 1914 co-signed Filonov's manifesto *Sdelannye kartiny* [Made Paintings]; 1916 graduated from the Petrograd Pyrotechnical Institute; member of the Tbilisi Society of Georgian Artists; 1918 returned to Georgia; major contributor to the Georgian avant-garde, especially to the Tiflis café culture; 1919–27 lived in Paris; exhibited regularly with the Salon des Indépendants; developed and patented a system of stereoscopic cinema; published two treatises – *Du tableau constructif* (1921) and (in Georgian) *Art and Space* (1925) – and (in Georgian) a description of contemporary art in Paris, *Paris 1920–1923* (1924); 1927 travelled in Germany, Italy and Greece, before returning to Georgia; 1928 one-man exhibition in Tbilisi; member of the Association of Revolutionary Artists of Georgia; began to teach at the Tbilisi Academy of Arts; designer for the Kutaisi Dramatic Theatre; 1933–42 Pro-Rector of the Tbilisi Academy of Arts; 1934 supervised the filming of Ancient Monuments of Georgia; 1930s to 1940s painted Georgian architecture and industrial landscapes;1948 removed from the Academy faculty.

G. ALIBEGASHVILI, *David Kakabadze*, Tbilisi (Khelovneva) 1980
L. RCHEULISHVILI, *David Kakabadze*, Tbilisi (Khelevneva) 1983
B. BERIDZE ET AL., *David Kakabadze*, Moscow (Sovetskii khudozhnik) 1989

Lajos Kassák

Born 21 March 1887, Ersekujvar, Hungary; died 22 July 1967, Budapest.
1899–1907 was a locksmith's apprentice and metalworker in various towns; taught himself drawing and painting; 1904 with his mother moved to Budapest; 1909–10 made a grand tour of Austria, Germany, Belgium and France; contact with Apollinaire, the Delaunays, Modigliani, Picasso; ardent supporter of Socialism; c1912 studied Cubism and Futurism; met Filippo Marinetti; 1915 published his first book of poetry; edited the avant-garde journal *A Tett* [Deed] in Budapest, creating an alliance with Sándor Bortnyik, Béla Uitz and other Hungarian Activists; 1916 founded the journal *MA* [Today]; late 1910s wrote poetry much inspired by Dada, publishing several collections such as *Ajándék az asszonyak* [Gift to Woman] (Budapest, 1916); 1919 after the Revolution, took an active part in the cultural reorganization of the Hungarian Soviet Republic; 1920 emigrated to Vienna where he resumed publication of *MA*; with Bortnyik developed the theory of Bildarchitektur; 1921 first one-man exhibition of posters, typographical designs and Bildarchitektur paintings at the Galerie Würtel; 1922 published the journal *2 × 2*; visited *Der Erste Russische Kunstausstellung* in Berlin; strong interest in the work of El Lissitzky and Russian Constructivism; with Moholy-Nagy co-edited *Das Buch neuer Künstler* (in Hungarian, German and English); 1923 published collection of poetry, *MA-Buch*, in Berlin; 1926 returned to Budapest; one-man exhibition there; began to publish the journal *Dokumentum*; 1928 began to publish *Munka* [Labour]; 1930s to 1940s continued to write essays on art and literature, e.g. *Földem virágom* [My Land, My Flower] (1935), *Három történet* [Three Stories] (1936) and *Vallomás tizenöt muvészrol* [On Fifteen Artists] (1942); 1957 one-man exhibition at the Czok Gallery, Budapest; 1960, 1963 and 1967 exhibited at the Galerie Denise, Paris.

F. KÖRNER, *Kassák*, Budapest (Corvina) 1970
Kassák, exh. cat. Cologne, Galerie Gmurzynska-Bargera, 1971
T. STRAUS, *Kassák: Ein ungarischer Beitrag zum Konstruktivismus*, Cologne, Galerie Gmurzynska, 1975
Lajos Kassák, exh. cat. New York, Matignon Gallery, 1984
E. LEVINGER, 'Lajos Kassák, *MA* and the New Artist, 1916–1925' *The Structurist*, Saskatoon, no.25/26, 1985–6, pp.78–84 [this study also contains other materials on Kassák and the Hungarian avant-garde]
Kassák Lajos 1887–1967, exh. cat. Budapest, Hungarian National Gallery, 1987
G. SOMLYÓ, ed., *Lajos 1887–1967*, special issue of *Arion. Almanach International de Poésie*, Budapest (Corvina) no.16, 1988

Kliun (Kliunkov), Ivan Vasilievich

Born 1873, Bolshie Gorki, near Kiev; died late 1942, Moscow.
1890s studied in Warsaw and Kiev; early 1900s attended private studios in Moscow, including Ilia Mashkov's and Fedor Rerberg's; particular interest in Symbolism; 1907 met Kazimir Malevich; 1910–16 co-founder and member of the Moscow Salon exhibition society; 1913–14 contact with the Union of Youth, contributing to its last exhibition; developed his own interpretretations of Cubo-Futurism in painting and sculpture; 1915–16 contributed to *Tramway V. 0.10*, *Store*, *Jack of Diamonds*, and other avant-garde exhibitions; 1917 headed the Central Exhibition Bureau of NKP; 1918 took part in the agit-decorations for Moscow; 1918 contributed to the Fifth and Tenth State Exhibitions, Moscow; 1918–21 professor at Svomas/Vkhutemas; 1919 contributed to

the *First State Exhibition of Vitebsk and Moscow Artists* in Vitebsk; 1920 member of Inkhuk; 1921 member of RAKhN; 1922 contributed to the *Erste Russische Kunstausstellung* in Berlin; 1925 member of Four Arts; invited to join OST; contributed to *Drawings by Contemporary Russian Sculptors*; 1927 contributed to the *Second Exhibition of the Society of Russian Sculptors*; late 1920s much influenced by Amédée Ozenfant, turned away from abstraction to a figurative style of painting; 1928 published an article on Cubism in *Sovremennaia arkhitektura* [Contemporary Architecture].

Los Angeles/Washington, DC, 1980–81, pp.170–71
M. KOLPACHKI, ed., *Skulptura i risunki skulpturov kontsa XIX–nachala XX veka*, Moscow (Sovetskii khudozhnik) 1977, pp.435–7
Rudenstine (1981), pp.139–205
Ivan Vasilievich Kliun. Sketchbook 1916–1922, exh. cat. New York, Matignon Gallery, 1983
Sarabianov and Gurianova (1992), pp.110–15

Gustav Gustavovich Klucis (Klutsis)

Born 4 January 1895, Ruiena, Latvia; died 1938, in a labour camp in Central Asia.
1911–13 attended a teachers' seminary in Volmar; 1914–15 studied at the Riga Art Institute under Vilhelms Purvitis (Purvits); 1915–18 studid at the Society for the Encouragement of the Arts in Petrograd; worked as a scene-painter for the Okhta Workers' Theatre there; 1918 moved to Moscow as a rifleman in the Ninth Latvian Infantry and worked in its art studio, painting scenes from army life; attended Ilia Mashkov's private studio; 1918–21 studied at Svomas/Vkhutemas under Konstantin Korovin and Anton Pevsner; contact with Malevich; 1919–20 began to work on poster, typographical and architectural designs; 1920 exhibited with Gabo and Pevsner; with Sergei Senkin established his own studio within Vkhutemas; 1920–21 contributed to the Unovis exhibitions in Vitebsk and Moscow; 1920–22 influenced by El Lissitzky, became especially interested in constructive projects and photomontage; 1921–3 member of Inkhuk; 1922 began to teach at the Painting Studio of the Sverdlov Club; contributed to the *Erste Russische Kunstausstellung* in Berlin; 1924–30 taught colour theory at Vkhutemas/Vkhutein; 1925 contributed to the *Exposition Internationale* in Paris; 1928 contributed to the *Pressa* exhibition in Cologne; co-founder of the October group; 1929 designed posters for the art department of the State Publishing House; late 1920s taught at the Moscow Polygraphical Institute and the Communist Academy; 1929–32 member of the Association of Revolutionary Poster Artists; until his arrest in 1938 was active as a poster and typographical designer.

L. OGINSKAIA, *Gustav Klutsis*, Moscow (Sovetskii khudozhnik) 1981
Gustav Kluzis, exh. cat. Cologne, Galerie Gmurzynska, 1988
Gunstav Klucis, exh. cat. Kassel, Museum Fridericianum, 1991

Nina Iosifovna Kogan

Born 1887/1889, Vitebsk (St Petersburg?); died 1942 (?), Leningrad.
1911–13 attended the St Ekaterina School, St Petersburg; 1919 started to teach the Preliminary Course at the Vitebsk Practical Art Institute; was a colleague there of Marc Chagall and Mstislav Dobuzhinsky and then of El Lissitzky and Kazimir Malevich; 1919 joined the Unovis group; 1920 with Vera Ermolaeva and Malevich worked on a new version of *Victory over the Sun*; designed a Suprematist ballet; 1922 moved to Moscow where she worked at the Museum of Artistic Culture; took part in the exhibition of Unovis works in Petersburg; contributed to the *Erste Russische Kunstausstellung*, Berlin; 1930s active as a book illustrator; 1938 contributed to the *Exhibition of Works by Women Artists* in Leningrad; 1940 contributed to the *Sixth Exhibition of Works by Leningrad Artists* in Leningrad; 1941 contributed to the *Seventh Exhibition of Works by Leningrad Artists* in Leningrad.

Nothing substantial has been published on Kogan. For some information see:
Cologne 1979–80, pp.160–64
Shadova (Zhadova) (1978/1982), *passim*
Nina Kogan, exh. cat. Zurich, Galerie Schlégl, 1985
Nina Kogan, exh. cat. Stockholm, Galerie Aronowitsch, 1985–6
Grosse Utopie, 1992, p.747
Kogan also wrote a number or articles on Suprematism and design.
e.g. 'O grafike edinoi programmy Unovisa', *Unovis*, no.1, Vitebsk, 1920, p.1

Mikhail Fedorovich Larionov

Born 22 May 1881, Tiraspol, Bessarabia; died 10 May 1964, Fontenay-aux-Roses, France.
1898 entered the Moscow Institute of Painting, Sculpture and Architecture; 1900 met Natalia Goncharova (q.v.) who became his lifelong companion; 1902 expelled from the Institute; 1906 travelled with Sergei Diaghilev to Paris in connection with the Russian Section at the *Salon d'Automne*; thereafter contributed to numerous exhibitions in Russia and abroad, including the three exhibitions organized by Nikolai Riabushinsky, editor of the journal *Zolotoe runo* [Golden Fleece]; 1910 with Natalia Goncharova et al. organized the Jack of Diamonds group, 1911 the Donkey's Tail, and 1913 the Target; at the exhibition *The Target*, in Moscow Larionov showed examples of his Rayonist style of painting; illustrated a number of Cubo-Futurist books at this time; 1914 went to Paris to work for Diaghilev; mobilized into the Russian army; 1915 invalided out of army; left Russia to join Diaghilev in Lausanne; 1916 with Goncharova settled in Paris; 1920–22 designed *Chout* and Le Renard for Diaghilev's Ballets Russes; thereafter worked on several stage productions; with Goncharova exhibited at the Kingore Gallery, New York, and in 1923 at the Shiseido Gallery, Tokyo; after 1930, except for occasional contributions to exhibitions, Larionov and Goncharova lived unrecognized and impoverished; 1954 their names were resurrected at Richard Buckle's *The Diaghilev Exhibition* in Edinburgh and London; 1961 Arts Council of Great Britain organizes a major retrospective of Goncharova's and Larionov's works.

Larionov and Goncharova, exh. cat. Leeds, City Art Gallery/Bristol, City Art Gallery/London, Arts Council Gallery, 1961
W. GEORGE, *Larionov*, Paris (La Bibliothèque des Arts) 1966
T. LOGUINE, *Gontcharova et Larionov*, Paris (Klincksieck) 1971
D. SARABIANOV, 'Primitivistskii period v tvorchestve Mikhaila Larionova' in D.Sarabianov, *Russkaia zhivopis kontsa 1900-kh–nachala 1910-kh godov*, Moscow (Iskusstvo) 1971, pp.99–116
G. RUZSA, *Larionov*, Budapest (Corvina) 1977
M. LARIONOV, *Une Avant-garde Explosive*, Lausanne (L'Age d'Homme) 1978
T. LIBERMAN, 'M.Larionov i N.Goncharova v pismakh i risunkakh', *Chast rechi*, no.1, New York, 1980, pp.243–51
G. POSPELOV, 'M. V. Larionov', *Sovetskoe iskusstvoznanie '79*, II, Moscow, 1980, pp.238–66
Michel Larionov, Nathalie Gontcharova, exh. cat. Geneva, Martini and Ronchette, 1983
Mikhail Larionov, exh. cat. Geneva, Musée Rath/Frankfurt, Schirn Kunsthalle, 1987
Mikhail Larionov, exh. cat. Stockholm, Galerie Aronowitsch, 1987
Michail Larionow, exh. cat. Zurich, Galerie & Edition Schlégl, 1987

Vladimir Vasilievich Lebedev

Born 27 May 1891, St Petersburg; died 21 November 1967, Leningrad.
1909 attended the studio of Alexander Titov, St Petersburg; 1910–11 attended the studio of Frants Rubo, meeting Lev Bruni, Peter Lvov and other young artists there; 1912–14 attended the private studio of Mikhail Bernshtein; met Nikolai Lapshin, Viktor Shklovsky and Vladimir Tatlin; 1912 saw the exhibition *100 Years of French Art* in St Petersburg; 1912–16 attended the

Academy of Arts; contact with Boris Grigoriev, Vasilii Shukhaev, Alexandre Jacovleff; interested in the nude drawings of Rodin; also interested in primitive art forms such as the shop sign and in Cubism; 1918 professor at Svomas in Petrograd; with Vladimir Kozlinsky designed posters for the Okna ROSTA (the propaganda windows of the Russian Telegraph Agency) there; 1922 contributed to the exhibition *Association of New Tendencies in Art*, Petrograd, and the *Erste Russische Kunstausstellung*, Berlin; 1923 designed Konstantin Khokhlov's production of Sem Benelli's *La Cena delle Beffe* at the Bolshoi Dramatic Theatre, Petrograd; began to illustrate many books, especially for children, by authors such as Rudyard Kipling and Samuil Marshak; 1925 contributed to the *Exposition Internationale des Arts Décoratifs* in Paris; 1930s to 1950s continued to paint, design and exhibit.

N. PUNIN, *Vladimir Vasilievich Lebedev*, Leningrad (Komitet populiarizatsii khudozhestvennykh izdanii) 1928
V. PETROV, *V.Lebedev*, Leningrad (Khudozhnik RSFSR) 1972
Vladimir Vasilievich Lebedev, exh. cat. Leningrad, Russian Museum, 1972
V. PUSHKAREV, *V.V. Lebedev. Risunki*, Leningrad (Aurora) 1974
B. SEMENOV, 'Lebedev izdali i v blizi' in his *Vospominaniia. Vremia moikh druzei*, Leningrad (Lenizdat) 1982, pp.245–57
V.V. Lebedev. Sette cicli favolistici, exh. cat. Rieti, Comune di Rieti, 1982 [Essay by R.Messina]
N. MISLER, 'A Public Art: Caricatures and Posters of Vladimir Lebedev', *Journal of Decorative and Propaganda Arts*, no.5, Miami, 1987, pp.60–75

El Lissitzky (Lisitsky, Lazar Markovich)

Born 23 November 1890, Polshchinok, near Smolensk; died 30 December 1941, Moscow.
1909–14 studied at the Technische Hochschule in Darmstadt; also travelled in France and Italy; 1914 returned to Russia; worked in Moscow as an architectural draughtsman; 1916 designed the cover for Konstantin Bolshakov's book of poetry *Solntse na izlete* [Spent Sun]; 1917 exhibited with the World of Art in Petrograd and thereafter at many exhibitions in the Soviet Union and abroad; 1918 member of the Visual Arts Section of the People's Commissariat for Enlightenment; 1919 professor at the Vitebsk Popular Art Institute; close contact with Kazimir Malevich; began to work on his Prouns (Proun = Project for the Affirmation of the New); member of Unovis; close to Vera Ermolaeva, Lazar Khidekel, Ilia Chashnik and Nikolai Suetin; 1920 member of the Inkhuk; 1920–22 professor at Vkhutemas, Moscow; 1922 with Ilya Ehrenburg edited the journal *Veshch/Gegenstand/Objet* in Berlin; began to work increasingly on typographical and architectural design; published *Pro dva kvadrata* [About Two Squares]; created the Proun Room for the *Grosse Berliner Kunstausstellung* of 1923; 1923 published his six Proun lithographs in the *Kestnermappe* in Hanover as well as his album of figures for *Victory over the Sun*; also designed the Berlin edition of Vladimir Maiakovsky's *Dlia Golosa* [For the Voice]; 1925 returned to Moscow; taught interior design at Vkhutemas; thereafter active primarily as an exhibition and typographical designer, creating new concepts for the exhibition room as in his Abstrakte Kabinett at the Niedersächische Landesgalerie in Hanover in 1927–8; 1928 joined the October group; 1930 published his treatise on modern architecture *Russland: Architektur für eine Weltrevolution*; 1930s worked for the propaganda magazine *USSR in Construction*.

H. RICHTER, *El Lissitzky*, Cologne (Czwiklitzer) 1958
S. LISSITZKY-KÜPPERS, *El Lissitzky. Life, Letters, Texts*, London (Thames and Hudson) 1968; 2nd ed, 1976
Lissitzky, exh. cat. Cologne, Galerie Gmurzynska, 1976
El Lissitzky 1890–1941, exh. cat. Oxford, Museum of Modern Art, 1977
S. MANSBACH, *Visions of Totality*, Ann Arbor (UMI) 1980
El Lissitzky, exh. cat. Moritzburg, Staatliche Galerie, Leipzig, Galerie der Hochschule für Grafik und Buchkunst, 1982–3

E. LISSITZKY, *Russia: An Architecture for World Revolution*, Cambridge (MIT) 1984 [trans. from 1930 Viennese edn]
El Lissitzky 1890–1941, exh. cat. Cambridge, MA, Busch-Reisinger Museum, 1987
El Lissitzky – 1890–1941 – Retrospektive, exh. cat. Hanover, Sprengel Museum, 1988
K.-U. HEMKEN, *El Lissitzky. Revolution und Avantgarde*, Cologne (DuMont) 1990
L.M.Lisitsky 1890–1941, exh. cat. Moscow, Tretiakov Gallery, 1990
El Lissitzky, exh. cat. Amsterdam, Stedelijk Museum, and other institutions, 1991

Kazimir Severinovich Malevich

Born 26 February 1878, near Kiev; died 15 May 1935, Leningrad.
1903 entered the Moscow Institute of Painting, Sculpture, and Architecture, c1910, while influenced by Neo-Primitivism, emerged with a distinctive and independent style; 1913 took part in the Futurist conference in Uusikirkko, Finland, with Alexei Kruchenykh and Mikhail Matiushin; designed the sets and costumes for the transrational opera *Victory over the Sun* in St Petersburg; illustrated avant-garde booklets by Velimir Khlebnikov, Alexei Kruchenykh and other poets; 1914 met Filippo Marinetti on the latter's arrival in Russia; 1911–17 contributed to many exhibitions including: the *Union of Youth*, the *Donkey's Tail*, the *Target*, *Tramway V*, *0.10* (the first showing of Suprematist works), the *Store*, the *Jack of Diamonds*, etc.; 1915 publicized his invention of Suprematism; 1918 active on various levels within the Visual Arts Section of the People's Commissariat for Enlightenment; 1919–22 at the Vitebsk Popular Art Institute; co-organized Unovis; attracted many young artists including Ilia Chashnik, Vera Ermolaeva, El Lissitzky and Nikolai Suetin; 1922 moved to Petrograd where he began to work for Ginkhuk; 1920s active on various levels; wrote many essays on art; gave attention to the architectural possibilities of Suprematism, inventing his so-called *arkhitektony*, *planity* and *zemlianity*; 1927 visited Warsaw and Berlin with a one-man exhibition; established contact with the Bauhaus; c1930 returned to a figurative kind of painting, even working on social themes such as 'working woman' and 'the smith'.

T. ANDERSEN, ed., *K.S. Malevich. Essays*, 4 vols, Copenhagen (Borgen) 1968–78
T. ANDERSEN, *Malevich*, Amsterdam (Stedelijk Museum) 1970
A. NAKOV, ed., *Malévitch. Ecrits*, Paris (Champ Libre) 1975
J. BOWLT AND C. DOUGLAS, eds, *Kazimir Malevich 1878–1935–1978*. Special issue of *Soviet Union*, V, pt 2, (Tempe, Arizona), 1978
Malewitsch, exh. cat. Cologne, Galerie Gmurzynska, 1978
J.C. MARCADÉ, ed., *Malévitch. Actes du Colloque international tenu au Centre Pompidou, Musée national d'art moderne, Paris*, Lausanne (L'Age d'Homme) 1979
C. DOUGLAS, *Swans of Other Worlds: Kazimir Malevich and the Origins of Abstraction in Russia*, Ann Arbor (UMI) 1980
J.H. MARTIN, *Malévitch: Oeuvres de Casimir Severinovitch Malévitch. (1878–1935)*, Paris (Centre Georges Pompidou) 1980
Journey into Non-objectivity. The Graphic Work of Kazimir Malevich and other members of the Russian Avant-garde, exh. cat. Dallas TX, Museum of Fine Arts, 1980
Kasimir Malewitsch (1878–1935). Werke aus sowjetischen Sammlungen, exh. cat. Düsseldorf, Kunsthalle, 1980
W.S. SIMMONS, *Kasimir Malevich's Black Square and the Genesis of Suprematism 1907–1915*, Ann Arbor (UMI) 1981
Shadova (Zhadova) (1978/1982)
L.C. Y ARAGON, *Malevich*, Mexico City (Universidad Nacional) 1983
Malevich, exh. cat. Leningrad, Russian Museum/Moscow, State Tretiakov Gallery/Amsterdam, Stedelijk Museum, 1988–9
C. COOKE ET AL., *Malevich*, London (Academy) 1989
Kazimir Malevich, exh. cat. Washington, DC, National Gallery/Los Angeles, Armand Hammer Museum and Cultural Center/New York, Metropolitan Museum of Art, 1990
E. PETROVA ET AL., *Kazimir Malevich. Artist and Theoretician*, Paris (Flammarion) 1990

R. CRONE AND D. MOOS, *Kazimir Malevich. The Climax of Disclosure*, Chicago (University of Chicago) 1991
J.-C. MARCADÉ, *Malévitch*, Paris (Casterman) 1991
G. STEINMÜLLER, *Die suprematischen Bilder von Kasimir Malewitsch: Malerei über Malerei*, Cologne (Eul) 1991
S. FAUCHEREAU, *Malévitch*, Paris (Cercle d'Art) 1992
A. HILTON, *Kazimir Malevich*, New York (Rizzoli) 1992
V. ZAVALISHIN AND J. BOWLT, *Kazimir Malevich*, New York (Effect) 1992
Malevich, exh. cat. Madrid, Fondacion Juan March, and other cities, 1993
Malevič, exh. cat. Florence, Palazzo Medici Riccardi, 1993

Paul Mansouroff (Pavel Andreevich Mansurov)

Born 25 March 1896, St Petersburg; died 3 February 1983, Nice. 1909 onwards studied at the Steiglitz Institute of Technical Drawing, St Petersburg; 1911–14 attended the Society for the Encouragement of the Arts; c1914 made the acquaintance of Nikolai Kulbin; 1915–17 served in the Imperial Airforce; 1917 studied at Svomas in Petrograd; 1917–18 made his first abstract paintings; 1918 contributed decorations for the Public Library and the Hotel Angleterre, Petrograd, commemorating the first anniversary of the October Revolution; made sets and costumes for a ballet by Artur Lourié; 1919 contributed to the *First Free State Exhibition of Works of Art* in the Winter Palace; worked in Tatlin's studio in Moscow; 1920 organized exhibitions for the delegates to the III Comintern at the Hotel Continental in Moscow; 1922 contributed to the *Erste Russische Kunstausstellung*, Berlin; 1923, with Filonov, Malevich, Matiushin and Nikolai Punin, established Ginkhuk in Petrograd where he headed the Experimental Department; published two declarations in the journal *Zhizn iskusstva* [Journal of Art]; contributed to the *Exhibition of Paintings by Petrograd Artists of All Directions*; 1924 represented at the *Esposizione internazionale d'arte della città di Venezia* in Venice; 1927 contributed to the *First All-city Exhibition of Visual Arts* at the Academy of Arts, Leningrad; 1928 emigrated to Italy; 1929 one-man exhibition at the Galleria Bragaglia, Rome; moved to Paris; 1931 began to work on textile designs for fashion houses; 1945 worked as a painting restorer; 1940s to 1980s continued to paint abstract paintings.

Mansouroff, exh. cat. Brunswick, Haus Salve Hospes, 1960
C. BELLOLI, *Mansouroff o delle funzioni lineari*, Milan (Salto) 1963
Paul Mansouroff, exh. cat. Paris, Musée National d'Art Moderne, 1972–3
Paul Mansouroff, exh. cat. Milan, Galleria Lorenzelli, 1975
T. OMUKA, 'A Short Note on Paul Mansouroff', *Soviet Union*, III, pt2 (Pittsburgh, 1976) pp.188–96
Mansouroff. Opere 1918–1980, exh. cat. Rome, Il Carpine, 1985
Pavel Andreevich Mansurov (1896–1983), exh. cat. Milan, Lorenzelli Arte, 1987
Mansouroff. Peintures, reliefs, gouaches, dessins, 1918–82, exh. cat. Paris, Grand Palais, 1989

László Moholy-Nagy

Born 20 July 1895, Bácsborsod, Hungary; died 24 November 1946, Chicago.

1913 attended Law School at University of Budapest; 1914 mobilized into the Austro-Hungarian Army; 1915 while recuperating from shell-shock began to draw; 1917 while convalescing in an Odessa hospital, continued to draw and paint; 1918 returned to Budapest; 1919 became especially interested in the work of El Lissitzky and Kazimir Malevich; emigrated to Vienna and, with Lajos Kassák, resumed the publication of *MA*; 1920 began to experiment with photograms; moved to Berlin, where he encountered the Dada movement; 1921 met Lissitzky in Düsseldorf; made first trip to Paris; began to elaborate his concept of the Light-Space Modulator; 1922 with Kassák published *Das Buch neuer Künstler*; first one-man show at Der Sturm Gallery, Berlin; 1923 began to teach at the Bauhaus; close to Oskar

Schlemmer; concentrated on photography; with Gropius edited the fourteen *Bauhausbücher*; 1925 moved with the Bauhaus to Dessau; 1926 concentrated on industrial materials such as aluminum and bakelite; 1928 resigned from the Bauhaus and switched to stage design, working at the Krollopera and the Pisacator Theater in Berlin until 1938; 1930s gave increasing attention to exhibition design, film and typographical layout, while experimenting with his space modulators; 1930 produced his film *Lichtspiel Schwarz-Weiss-Grau*; 1932–6 contributed to the exhibitions of the Abstraction-Création group in Paris; 1934 moved to Amsterdam; 1935 moved to London; 1937 became director of the New Bauhaus in Chicago; 1938 opened his school of design in Chicago; 1941 joined the American Abstract Artists.

L. MOHOLY-NAGY, *Vision in Motion*, Chicago (Theobald) 1947
S. MOHOLY-NAGY, *Moholy-Nagy. Experiment in Totality*, New York (Harper and Row) 1959, and subsequent edns
R. KOSTELANETZ, ed., *Moholy-Nagy*, New York (Praeger) 1970
J. HARRIS CATON, *The Utopian Vision of Moholy-Nagy*, Ann Arbor (UMI) 1984
K. PASSUTH, Moholy-Nagy, London (Thames and Hudson) 1985
László Moholy-Nagy, exh. cat. Valencia, IVAM Centre Julio González, 1990

Liubov Sergeevna Popova

Born 24 April 1889, near Moscow; died 25 May 1924, Moscow. 1907–8 attended the private studios of Konstantin Yuon and Stanislav Zhukovsky in Moscow; late 1902 made many trips to ancient Russian cities such as Pskov and Vologda, studying Russian church architecture and art; 1910 travelled to Italy where she was especially impressed by Giotto; 1912 worked in the Moscow studio known as the Tower with Viktor Bart, Vladimir Tatlin and Kirill Zdanevich; 1912–13 worked in Paris, frequenting the studios of Henri Le Fauconnier and Jean Metzinger; 1913 returned to Russia; again worked closely to Tatlin and also Nadezhda Udaltsova and Alexander Vesnin; 1914 travelled to France and Italy again, accompanied by Vera Mukhina; 1914–16 contributed to the *Jack of Diamonds* (Moscow, 1914 and 1916), *Tramway V*, *0.10*, and the *Store* exhibitions; 1915–21 painted in a non-objective style; 1916–18 painted so-called 'architectonic compositions'; 1919–21 painted so-called 'painterly constructions'; 1918 professor at Svomas/Vkhutemas in Moscow; 1920 member of Inkhuk, Moscow; 1921 contributed to the exhibition 5 × 5 = 25, Moscow; thereafter became active as a utilitarian Constructivist, designing book covers, porcelain, stage sets, textiles; 1922 created the sets and costumes for Vsevolod Meierkhold's production of *The Magnanimous Cuckold*; contributed to the *Erste Russische Kunstausstellung* in Berlin; 1923 designed Meierkhold's production of *Earth on End*; 1923–4 worked on textile and dress designs for the First State Textile Factory.

Posmertnaia vystavka proizvedenii L.S.Popovoi, exh. cat. Moscow, Stroganov Institute, 1924
J. BOWLT, 'From Surface to Space: The Art of Liubov Popova', *The Structurist*, no.15–16, Saskatoon, 1976, pp.80–88
V. RAKITIN, 'Liubov Popova' in Cologne 1979–80, pp.176–214
D. SARABIANOV, 'The Painting of Liubov Popova' in Los Angeles/ Washington, DC, 1980–81, pp.42–5
J. BOWLT, 'Liubov Popova, Painter' in *Transactions of the Association of Russian-American Scholars in USA*, no.15, New York, 1982, pp.227–51
Liubov Popova, exh. cat. New York, Rachel Adler Gallery, 1985
N. ADASKINA AND D. SARABIANOV, *Lioubov Popova*, Paris (Sers) 1989; Eng. edn, *Liubov Popova*, New York (Abrams) 1990
L.S.Popova 1889–1924, exh. cat. Moscow, Tretiakov Gallery/ Leningrad, Russian Museum, 1990
Liubov Popova. exh. cat. New York, Museum of Modern Art and other institutions, 1991–2

Alexander Mikhailovich Rodchenko

Born 23 November 1891, St Petersburg; died 3 December 1956, Moscow.

1910–14 studied at the Kazan Art School under Nikolai Feshin (Fechin); then moved to the Central Stroganov Industrial Art Institute, Moscow; 1913 married Varvara Stepanova (q.v.); 1916 contributed to the *Store* exhibition in Moscow; 1917 with Vladimir Tatlin, Georgii Yakulov et al. designed the interior of the Café Pittoresque, Moscow; 1918 onward worked on various levels in IZO NKP; 1918–26 taught at the Moscow Proletkult [Proletarian Culture] School; 1918–21 worked on spatial constructions; 1920 member of Inkhuk; 1921 contributed to the third exhibition of Obmokhu and to 5 × 5 = 25 in Moscow; 1920–30 professor at Vkhutemas and Vkhutein; 1920 created costumes for Alexei Gan's unrealized spectacle *We*; 1922–8 associated with the journals *Lef* [Left Front of the Arts] and *Novyi lef* [New Left Front of the Arts], which published some of his articles and photographs; 1925 designed a worker's club, exhibited at the *Exposition Internationale des Arts Décoratifs* in Paris; 1930 joined October, a group of designers which also included Gustav Klucis and El Lissitzky; late 1920s onwards concentrated on photography; early 1940s produced paintings in an Abstract Expressionist style.

G. KARGINOV, *Rodcsenko*, Budapest (Corvina) 1975; and subsequent trans. into Fr. and Eng.
Rodchenko and the Arts of Revolutionary Russia, exh. cat. Oxford, Museum of Modern Art, 1979
V. RODCHENKO, compiler, *A.M. Rodchenko. Stati. vospominaniia. Avtobiograficheskie zapiski. Pisma*, Moscow (Sovetskii khudozhnik) 1982
Alexander Rodtschenko und Warwara Stepanowa, exh. cat. Duisburg, Wilhelm-Lehmbruck Museum, 1982
W. RODTSCHENKO AND A. LAWRENTJEW, *Alexander Rodtschenko*, Dresden (VEB) 1983
Alexander Rodtschenko, exh. cat. West Berlin, Galerie Werner Kunze, 1983
Rodcenko/Stepanova, exh. cat. Perugia, Palazzo dei Priori and Palazzo Cesaroni, and elsewhere, 1984
H. GASSNER, *Alexander Rodschenko. Konstruktion 1920*, Frankfurt (Fischer) 1984
S. KHAN-MOGOMEDOV, *Rodchenko: The Complete Work*, Cambridge, MA, (MIT) 1987
Alexander Rodchenko, exh. cat. New York, American Institute of Architects, 1987
A. LAVRENTIEV, compiler, *Alexandre Rodtchenko. Ecrits complets sur l'art, l'architecture et la révolution*, Paris (Sers) 1988
D. SHMARINOV ET AL. eds., *A. Rodchenko, V. Stepanova*, Moscow (Kniga) 1989
A. LAVRENTIEV, *A.M. Rodchenko, V.F. Stepanova*, Moscow (Kniga) 1989
The Rodchenko Family Workshop, exh. cat. Glasgow, New Beginnings, London, Serpentine Gallery, 1989
D. ELLIOTT AND A. LAVRENTIEV, *Alexander Rodchenko. Works on Paper, 1914–1920*, London (Sotheby's) 1991
Alexander M. Rodtschenko. Warwara Stepanowa. 'Die Zukunst ist under einziges Ziel . . .' exh. cat. Vienna, Museum für angewandte Kunst, Moscow, Pushkin Museum of Fine Arts, 1991
Ornament and Textile Design. Nadezhda Udaltsowa, Varvara Stepanova, Alexandr Rodchenko, exh. cat. Frankfurt, Gallery Manège, 1991
N. ILJINE AND T. BÖTTGER, eds, *Rodchenko. Flying Objects*, Göttingen (Arkana) 1991
A. LAVRENTIEV, *Rakursy Rodchenko*, Moscow (Iskusstvo) 1992
The Family. The Rodchenko Family Darkroom, exh. cat. New York, Sander Gallery, 1993

Olga Vladimirovna Rozanova

Born 21 June 1886, Melenki, Vladimir Province, Russia; died 8 November 1918, Moscow.
1896–1904 attended the Women's Gymnasium in Vladimir-on-Kliazma; 1904–10 attended the Bolshakov Painting and Sculpture Institute, Moscow; 1907–10 audited courses at the Central Stroganov Industrial Art Institute in Moscow; 1911 moved to St Petersburg; attended the Zvantseva Art School; close contact with the Union of Youth; 1911–18 contributed to the *Union of Youth*, *Tramway V*, *0.10*, *Jack of Diamonds*, and other

avant-garde exhibitions; 1912 made the acquaintance of Alexei Kruchenykh; 1912 onwards illustrated many Cubo-Futurist books such as *Te li le* (St Petersburg, 1914), *Zaumnaia kniga* [Transrational Gook] (Moscow, 1915) and *Balos* (Tiflis, 1917); c1915 executed a series of fashion and textile designs; 1914 met Filippo Marinetti in St Petersburg; 1915 moved to Moscow; 1916 worked with Kruchenykh on the albums *Voina* [War] (Petrograd, 1916) and *Vselenskaia voina* [Universal War] (Petrograd, 1916); 1917 with Kazimir Malevich, Mikhail Matiushin, Liubov Popova, Nikolai Roslavets et al. was a member of the Supremus group and worked on its journal (not published); 1918 member of IZO Narkompros and Proletkult; with Alexander Rodchenko was in charge of the Art-Industry Sub-section of IZO; helped to organize Svomas in several provincial towns; 1919 the *1st State Exhibition* was devoted to her posthumous exhibition; 1922 represented at the *Erste Russische Kunstaustellung* in Berlin.

I. KLIUN: untitled essay in the exh. cat. *Pervaia Gosudarstvennaia vystavka. Katalog posmertnoi vystavki kartin, etiudov, eskizov i risunkov O.V. Rozanovoi*, exh. cat. Moscow, 1, Rozhdestvenka St., 1919, pp.1–VI
A. EFROS, 'O.V. Rozanova' in *Profili*, Moscow (Federatslia) 1930, pp.228–9 [an obituary first published as 'Vo sled ukhodiashchikshim', *Moskva. Zhurnal literatury i iskusstva*, no. 3, Moscow, 1919, pp.4–6]
Rudenstine (1981), pp.453–61
Cologne 1979–80, pp.215–56
N. GURIANOVA, 'Na puti k novomu iskusstvu. Olga Rozanova', *Iskusstvo*, Moscow, no. 1, 1989, pp.24–30
N. GURIANOVA, 'Voennye graficheskie tsikly N. Goncharovoi i O. Rozanovoi', *Panorama iskusstv*, Moscow, no.12, 1989, pp 63–88
V. TEREKHINA, 'Nachalo zhizni tsvetochno aloi . . .', *Panorama iskusstv*, no.12, Moscow, 1989, pp 38–62
Olga Rozanova 1886–1918, exh. cat. Helsinki, Helsingin Kaupungin Taidemuseo, 1992

Varvara Fedorovna Stepanova

Born 5 November 1894, Kovno (Kaunas), Lithuania; died 20 May 1958, Moscow.
1911 studied at the Kazan Art School where she met Alexander Rodchenko (q.v.); 1912 moved to Moscow; studied under Ilia Mashkov and Konstantin Yuon; 1913 married Rodchenko; 1913–14 attended the Central Stroganov Industrial Art Institute, Moscow; gave private lessons; 1914 exhibited with the *Moscow Salon*; 1918 onwards closely involved with IZO NKP; 1920 member of Inkhuk, Moscow; 1921 contributed to the exhibition 5 × 5 = 25; 1922 designed sets and costumes for Vsevolod Meierkhold's production of *The Death of Tarelkin*; 1923 with Liubov Popova, Rodchenko et al. worked at the First State Textile Factory, Moscow as a designer; 1923–8 closely associated with the journals *Lef* [Left Front of the Arts] and *Novyi lef* [New Left Front of the Arts]; 1924–5 professor in the Textile Department of Vkhutemas; mid-1920s onwards worked mainly on typographical and poster design.

A. LAVRENTIEV, 'Poeziia graficheskogo dizaina v tvorchestve Varvary Stepanovoi', *Tekhnicheskaia estetika*, no.5, Moscow, 1980, pp.22–6
V. STEPANOVA, 'Aufzeichnungen/Occasional Notes (1919–1940)' in Cologne 1981, pp.122–44
A. LAVRENTIEV, 'The Graphics of Visual Poetry in the Work of Varvara Stepanova', *Grafik*, no.1, Budapest, 1982, pp.46–51
Cologne 1984, *passim*
Rodcenko/Stepanova, exh. cat. Palazzo dei Priori and Palazzo Cesaroni, and elsewhere, 1984
A. LAVRENTIEV AND J. BOWLT, *Varvara Stepanova, A Constructivist Life*, Cambridge, MA (MIT) 1988
A. LAVRENTIEV AND N. MISLER, *Stepanova*, Milan (Idea Books) 1988

Władysław Strzemiński

Born 21 November 1893, Minsk; died 26 December 1952, Lodz.
Grew up in Russia; 1911–14 attended the Military Institute of Land Engineering in St Petersburg; 1914 mobilized as an

engineering officer; 1917 wounded in the Battle of Osowiec, convalesced in Moscow hospitals; developed an interest in painting; met the artist Katarzyna Kobro, whom he later married; 1917–22 studied at Svomas/Vkhutemas, coming into close contact with the avant-garde; 1919 contributed to the *First State Exhibition of Paintings by Local and Moscow Artists* in Vitebsk; ardent supporter of Suprematism; 1920–21 worked at the Svomas in Smolensk; 1922 with Kobro left for Poland, where they quickly assumed a leading position in the Polish Constructivist movement; 1923 with Witold Kajruksztis organized an exhibition of *New Art* in Vilnius; formulated his theory of Unism which culminated in the publication of his book *Unizm w malarstwie* [Unism in Painting] in 1928; 1924 co-founder of the group Blok in Warsaw, contributing to its group exhibition in the Laurin-Clement Automobile Showrooms; 1925 one-man exhibition at the Trade Union of Polish Plastic Artists; left Blok; 1926–9 member of Szymon Syrkus' Praesens group; began to give increasing attention to the functional and applied arts; taught at factory schools in Koluszki and Brzeziny; 1929 left Praesens and, with Kobro and Henryk Stazewski, formed a new group called a.r. [revolutionary artists]; 1931 with Kobro published *Kompozycja przestrzeni, obliczanie rytmu czasoprzestrrzennego* [The Composition of Space: Definition of the Rhythm of Temporal Space]; moved to Lodz; with Kobro founded his School of Modern Typography.

Katarzyna Kobro. Władysław Strzemiński, exh. cat. Lodz, Centralne Biuro Wystaw Artystycznych, 1956–7
Constructivism in Russia, 1973, *passim*
W. STRZEMIŃSKI, *Pisma*, Warsaw (Academy of Sciences) 1975
W. STRZEMIŃSKI AND K. KOBRO, *L'Espace Uniste*, Lausanne (L'Age d'Homme) 1977
Turowski (1981), *passim*
Władysław Strzemiński, exh. cat. Düsseldorf, Städtische Kunsthalle, 1980

Nikolai Mikhailovich Suetin

Born 25 October 1897, Miatlevskaia Station, near Kaluga; died 22 January 1954, Leningrad.
While a cadet at Military School became interested in drawing and in the art of Mikolajaus Ciurlionis and Mikhail Vrubel; 1914 mobilized; 1918 enrolled in the Vitebsk Popular Art Institute; contact with Mare Chagall and Ivan Puni; 1919 close collaboration with Kazimir Malevich; founding member of Unovis, moving closely with Ilia Chashnik, Vera Ermoloaeva, Lazar Khidekel and Lev Yudin and contributed to the Unovis exhibitions in Vitebsk and Moscow; 1920 involved in the propaganda decorations for Vitebsk; 1922 followed Malevich to Petrograd where he began to work at the State Porcelain Factory; mid-1920s assisted Malevich with the design of *arkhitektony* and *planity*; also became interested in furniture design and the issue of colour in architecture; 1923 contributed to the *Exhibition of Paintings by Petrograd Artists of All Directions*; 1923–6 worked at Ginkhuk; contributed to the *Exposition Internationale des Arts Décoratifs* in Paris; 1927–30 worked on furniture design and colour in architecture at the Institute of Art History, Leningrad; 1928 with Anna Leporskaia worked on the interior design of the House of the NKVD in Leningrad; 1930 contributed to the *First All-city Exhibition of Visual Arts* at the Academy of Arts, Leningrad; 1932 appointed artistic director of the Lomonosov Porcelain Factory in Leningrad; contributed to *Artists of the RSFSR over the Last 15 Years* at the Academy of Arts, Leningrad; 1935 designed the monument for Malevich's tomb at Nemchinovka; 1937 worked on the interior design of the Soviet pavilions for the *Exposition Universelle* in Paris and two years later for the *World's Fair* in New York, for which he received the Grand Prix; 1940s continued to work as a designer and to exhibit.

London 1977
Malevich. Suetin. Chashnik, exh. cat. New York, Leonard Hutton Galleries, 1983
Milan 1991
Cologne 1992
Grosse Utopie 1992, pp.773–4

Nadezhda Andreevna Udaltsova

Born 30 December 1885, Orel; died 25 January 1961, Moscow. 1906 entered Konstantin Yuon's private art school in Moscow, studying under Ivan Dudin and Nikolai Ulianov; 1908 travelled in Germany; visited the Shchukin collection of French Impressionists and Post-Impressionists in Moscow; 1909–11 worked in various private studios in Moscow, including Karol Kish's and Vladimir Tatlin's; 1912 studied at La Palette in Paris under Henri Le Fauconnier, Jean Metzinger, and André Dunoyer de Segonzac; 1913 back in Moscow, worked in Tatlin's studio, where she was in close contact with Alexei Grishchenko, Liubov Popova and Alexander Vesnin; 1913–14 influenced by Mikhail Larionov, painted a number of Rayonist compositions; 1914 contributed to the *Jack of Diamonds* exhibition in Moscow; thereafter contributed to many avant-garde exhibitions, including *Tramway V* and *0.10*; 1916–17 member of the Supremus society; 1917–19 took an active part in IZO NKP and the new state administration for art; 1917–18 helped Georgii Yakulov et al. with the interior design for the Café Pittoresque in Moscow; 1918–20 taught at Svomas; 1920 married Alexander Drevin; 1920–30 taught at Vkhutemas/Vkhutein; 1920s contributed to many exhibitions at home and abroad, including the *Erste Russische Kunstausstellung* in Berlin; moved from her Cubism to a more Realist style; 1927–8 member of the Society of Moscow Artists; 1928 with Drevin had a two-person exhibition at the Russian Museum, Leningrad; 1930s travelled in Central Asia; 1941 returned to Moscow; 1945 one-woman exhibition in Moscow; 1950s continued to paint landscapes and to exhibit.

Vystavka N.A. Udaltsovoi i A.D. Drevina exh. cat. Leningrad, Russian Museum, 1928
M. MIASIN, compiler, *Katalog. Stareishie sovetskie khudozhniki o Srednei Azii i Kavkaze*, Moscow (Sovetskii khudozhnik) 1973, pp.220–5
Cologne 1979–80, pp.286–312
Milan, 1980, pp.93–5
Cologne, 1984, pp.291–339

Marie Vassilieff (Mariia Ivanovna Vasilieva)

Born 12 February 1884, Smolensk; died 1957, Nogent-sur-Marne, France.
1902 studied medicine and the fine arts in St Petersburg; received a stipend from the Tsarina to study in Paris; 1905 extended visit to Paris; 1907 moved to Paris permanently, where she became a correspondent for Russian newspapers; was especially interested in the work of Henri Matisse who sponsored her; close contact with Max Jacob; 1908 sent an essay by Matisse to the Moscow art journal *Zolotoe runo* [Golden Fleece] (published as 'Zametki khudozhnika' [An Artist's Notes] in no.6, 1909); 1909 established the Académie Libre (also known as the Académie Russe) in Paris; met Paul Poiret, André Salmon and many other artistic and literary celebrities; began to exhibit regularly with professional societies, including the Salons d'Automne and the Salons des Indépendants; 1909–14 travelled extensively in Western Europe, Scandinavia, Romania, Poland and Russia; 1910s contributed to a number of avant-garde exhibitions in Russia; 1911 withdrew from the board of the Académie; 1912 founded the Académie Vassilieff; 1913–4 Fernand Léger gave two lectures at her Académie; 1914 joined the French Red Cross as an ambulance attendant; 1915 contributed to exhibitions in New York and Kharbin; 1915–16 visited Russia; contributed to the *0.10* exhibition in Petrograd; 1915–17 turned her studio into a canteen to help friends during wartime conditions, welcoming many artists, writers, musicians, and dancers such as Georges Braque, Emile-Othon Friesz, Léger, Amedeo Modigliani, Francio Picabia, Suzanne Valadon, Blaise Cendrars, André Gide, Max Jacob, Francis Poulenc and Erik Satie; 1916 contributed eleven works to Vladimir Tatlin's exhibition *The Store* in Moscow; 1917 being a Russian citizen, she was placed in confined residence in

Fontainebleau as a result of the Brest-Litovsk Treaty; 1920s exhibited often in London and Paris; 1924–37 created costumes and sets for various companies, including the Ballet Suédois; 1925 contributed to the *Exposition Internationale des Arts Décoratifs* in Paris; gave particular attention to furniture design; 1928–30 one-woman exhibitions in London and Rome; 1937 contributed to the *Exposition Universelle* in Paris; 1938 settled in the south of France; 1945 returned to Paris.

Nothing substantial has been published on Vassilieff, although the following sources provide some information:
Une peintre cubiste méconnue, Marie Vassilieff 1884–1957, exh. cat. Paris, Galerie Hupel, 1969
Oeuvres postérieures au cubisme de Marie Vassilieff. Toiles des années 1920 et 1930, exh. cat. Paris, Galerie Hupel, 1971
A. SHATSKIKH, 'Russkaia akademiia v Parizhe', *Sovetskoe iskusstvoznanie*, no.21, Moscow, 1986, pp.352–65

Alexander Alexandrovich Vesnin

Born 16 May 1883, Yurevcts, Volga Province; died 7 November 1959, Moscow.
The youngest of the three Vesnin brothers (Leonid, Viktor and Alexander) who worked closely on many architectural and design projects during the 1910s, 1920s and early 1930s; 1901–12 after graduating from the Moscow Practical Academy, Alexander Vesnin entered the Institute of Civil Engineers, St Petersburg; 1912–14 worked in Vladimir Tatlin's studio in Moscow, establishing close contact with Liubov Popova, Nadezhda Udaltsova et al.; 1918 worked on agit-decorations for the streets and squares of Petrograd and Moscow; 1920 designed sets and costumes for Paul Claudel's *L'Annonce faite à Marie* produced by Alexander Tairov at the Chamber Theatre, Moscow; thereafter active in a number of stage productions, including his most experimental, G.K.Chesterton's *The Man Who Was Thursday*, produced by Tairov in 1923; member of Inkhuk, Moscow; 1921 contributed to the exhibition $5 \times 5 = 25$ in Moscow; 1923–5 close to *Lef* [Left Front of the Arts]; keen supporter of Constructivism; 1923–33 worked with his brothers on various architectural and industrial designs; co-founded OSA [Association of Contemporary Architects]; late 1920s with his brothers worked on important projects such as the Lenin Library, Moscow, the Palace of Soviets for Moscow, house-communes for Stalingrad, etc.; 1930s to 1940s with the death of Leonid (1933) and the censure of Constructivism, Alexander Vesnin reduced his architectural and artistic activities considerably.

A. CHINIAKOV, *Bratia Vesniny*, Moscow (Stroiizdat) 1970
K. USACHEVA, 'Teatralnye raboty A.A.Vesnina' in I.Kriukova et al., eds., *Voprosy sovetskogo izobrazitelnogo iskusstva i arkhitektury*, Moscow (Sovetskii khudozhnik) 1975, pp.304–31
E. VASIUTINSKAIA ET AL., compilers, *Katalog-putevoditel po fondam muzeia. Vesniny*, Moscow (TsNTI) 1981
S. KHAN-MAGOMEDOV, *Alexandr Vesnin*, Moscow (Znanie) 1983
Arkhitektory bratia Vesniny, exh. cat. Moscow, Shchusev Museum, 1983
Alexandre Vesnine, exh. cat. Paris, Institut Français d'Architecture, Dec. 1984
S. KHAN-MOGOMEDOV, *Alexander Vesnin and Russian Constructivism*, New York (Rizzoli) 1986

Photographic acknowledgements

AMSTERDAM
Stedelijk Museum [25] 2, [39] 3

BARI
Michele Costantini [19] 4

BERLIN
Natan Fedorowskij [49] 2
Staatliche Museum Preussischer Kulturbesitz [43] 4, [43] 6

BUDAPEST
Corvina Press [43] 4
Hungarian National Gallery [3] 3, 4, [22] 2, [24] 1, [43] 7

CAMBRIDGE, MA
Busch-Reisinger Museum, Harvard University [43] 3

COLOGNE
Galerie Gmurzynska [7] 1, 2, [8] 2, 4, [9] 1, [10] 4, [14] 1, [15] 1, [27] 5, 6, [28] 5, [30] 4, [41] 1, [54] 1, 3
Museum Ludwig [23] 2, [27] 4, [32] 2, [40] 1, 2, [47] 4, [56] 2

DES MOINES, IA
Louise R.Noun [18] 2, [28] 4, [50] 3, [56] 1

DRESDEN
VEB Verlag der Kunst [36] 1

THE HAGUE
Gemeentemuseum [43] 5

HANOVER
Sprengel Museum [36] 3, 4

HONOLULU, HI
Honolulu Academy of Arts [14] 2

HOUSTON, TX
Museum of Fine Arts [32] 1

JERUSALEM
Sam and Ayala Zachs [19] 6

LIEGE
Musée des Beaux-Arts [6] 2

LODZ
Muzeum Sztuki [53] 1, 2, 3

LONDON
Art Co., Ltd. (George Costakis Collection) [11] 2, 3, [12] 1, 2, [16] 3, [25] 3, 4, [27] 1, 7, [37] 4, [46] 1, [48] 3, [57] 1, 2
Arts Council [18] 1
Christie's [28] 3
Courtauld Institute Galleries [29] 2
Marlborough Gallery [38] 2
Nina and Nikita D.Lobanov-Rostovsky [3] 1, [8] 5, [17] 4, [33] 1
Sotheby's [20] 2, [37] 2, [38] 1, [41] 4
Waddington Galleries [41] 5

LOS ANGELES
Institute of Modern Russian Culture [8] 1, [40] 3, [59] 1
Los Angeles County Museum of Art [6] 3

LUDWIGSHAFEN-AM-RHEIN
Wilhelm-Hack Museum [1] 1

LUGANO
Peter Ludwig [28] 2

MILAN
Arte Centro [34] 2
Galleria Fonte D'Abisso [39] 2
Laura Mattioli [13] 2

MOSCOW
Valerii Dudakov [5] 1, [49] 1
Galart [4] 1, 2, [5] 2, [6] 1, [10] 2, 3, [13] 1, 3, 5, 6, [16] 2, [17] 2, 3, [23] 1, [25] 1, [27] 2, 3, [29] 1, 2, 4, [30] 1, 2, 3, 5, [31] 1, [35] 1, 2, 3, 4, [36] 5, [37] 3, [41] 2, 3, [45] 2, 3, 4, 5, 6, 7, [46] 2, [47] 1, 3, [48] 1, 2, [50] 1, 2, 4, [54] 2, [55] 1, [59] 2
Larisa Oginskaia [37] 1
Pushkin Museum of Fine Arts [48] 4
Alexander Rodchenko and Varvara Stepanova Archive [51] 1, 2, 3, 4, 5, [52] 1, 2, 3, [59] 3

NEW HAVEN, CT
Yale University Art Gallery [3] 2, [44] 2

NEW YORK
Barry Friedman Ltd [7] 3
Paul Kovesdy [22] 1, [26] 1, 2
Leonard Hutton Galleries [13] 4, [19] 3, [47] 2
Museum of Modern Art [1] 2, [19] 2, [32] 4, [55] 2

ORANGE, CT
Lev Nussberg [9] 2

PARIS
Christina Burrus [6] 4
Jean Chauvelin [1] 3, [10] 1, [39] 1, [45] 1
Hotel Drouot [17] 5
Yvette Moch [58] 1

PRAGUE
Narodni Galerie [21] 3

ROME
Andrea Miele [19] 5

ST ANDREWS, FIFE
Jeremy Howard [31] 2

ST PETERSBURG
Alla Povelikhina [11] 1
Alena Spitsyna [17] 1

STUTTGART
Staatsgalerie [19] 1

WASHINGTON, CT
Mr Thomas Whitney [59] 4, 5
Julia A.Whitney Foundation [40] 4

Remaining photographs supplied by the authors

We are very grateful to Giuseppe Pennisi for taking the photographs of paintings in the Thyssen-Bornemisza Collection reproduced in this catalogue. The following individuals and institutions must also be thanked for kindly supplying copyright monochrome photographic material and for granting their permission to reproduce it. Figure numbers follow square-bracketed catalogue numbers.

For works by Georges Annenkov, Lázló Moholy-Nagy, Amédée Ozenfant and Pablo Picasso, © DACS, London, 1993; for works by Marc Chagall, Natalia Goncharova and Mikhail Larionov, © ADAGP, Paris and DACS, London, 1993.

Index

Bold type indicates pages on which colour illustrations appear; italic pages on which monochrome illustrations appear